Photoshop Elements 8

for Mac
THE MISSING MANUAL

The book that should have been in the box®

Photoshop Elements 8

for Mac

Barbara Brundage

Photoshop Elements 8 for Mac: The Missing Manual

by Barbara Brundage

Copyright © 2010 O'Reilly Media. All rights reserved. Printed in Canada.

Published by O'Reilly Media, Inc., 1005 Gravenstein Highway North, Sebastopol, CA 95472.

O'Reilly books may be purchased for educational, business, or sales promotional use. Online editions are also available for most titles (*safari.oreilly.com*). For more information, contact our corporate/institutional sales department: (800) 998-9938 or *corporate@oreilly.com*.

Printing History:

October 2009:

First Edition.

Nutshell Handbook, the Nutshell Handbook logo, the O'Reilly logo, and "The book that should have been in the box" are registered trademarks of O'Reilly Media, Inc. *Photoshop Elements 8 for Mac: The Missing Manual*, The Missing Manual logo, Pogue Press, and the Pogue Press logo are trademarks of O'Reilly Media, Inc.

Many of the designations used by manufacturers and sellers to distinguish their products are claimed as trademarks. Where those designations appear in this book, and O'Reilly Media, Inc. was aware of a trademark claim, the designations have been printed in caps or initial caps.

While every precaution has been taken in the preparation of this book, the publisher and author assume no responsibility for errors or omissions, or for damages resulting from the use of the information contained herein.

This book uses Otabind, a durable and flexible lay-flat binding.

ISBN: 978-0-596-80496-1

Table of Contents

The Missing Credits	xiii
Introduction	
Part One: Introductory Elements	
Chapter 1: Finding Your Way Around Elements	15
The Welcome Screen	15
Adobo Pridge—Decisions Decisions	10
The Photo Downloader	19
Editing Your Photos	Z0
Panels Rins and Tabs	Z I
Flements' Tools	20
Cotting Help	25
Eccapa Poutes	
Getting Started in a Hurry	34
Chapter 2: Importing, Managing, and Saving Your Photo	3
Importing from Cameras	3
Opening Photos in Flements	······ J
Bridge Basics	4
Opening Stored Images	4
Sending Images from Other Programs	4
Working with PDF Files	Δ
Scanning Photos	

Capturing Video Frames	4
Creating a New File	
Picking a File Size	
Choosing a Resolution	
Selecting a Color Mode	5
Choosing Background Contents	5
The Many Uses for Bridge	52
Moving and Organizing Your Photos	53
Rating and Labeling Photos	54
Keywords	56
Searching and Filtering	57
Saving Your Work	59
File Formats Elements Understands	59
Changing the File Format	63
Burning CDs and DVDs	63
Chapter 3: Rotating and Resizing Your Photos	67
Straightening Scanned Photos	67
Straightening Two or More Photos at a Time	67
Straightening Individual Photos	69
Rotating Your Images	70
Rotating and Flipping Options	70
Straightening the Contents of an Image	71
Straighten Tool	
Free Rotate Layer	73
Cropping Pictures	
Using the Crop Tool	
Cropping with the Marquee Tool	80
Zooming and Repositioning Your View	82
Image Views	83
The Zoom Tool	
The Hand Tool	
Changing the Size of an Image	90
Resizing Images for Email and the Web	90
Resizing for Printing	93
Adding Canvas	97
Chapter 4: The Quick Fix	99
The Quick Fix Window	
The Quick Fix Toolbox	100
The Quick Fix Panel Bin	102
Different Views: After vs. Before and After	107
Editing Your Photos	103
Fixing Red Eye	104
Smart Fix	
Adjusting Lighting and Contrast	107
Color	

Part Three: Retouching

Chapter 7: Basic Image Retouching	191
Fixing Exposure Problems	192
Deciding Which Exposure Fix to Use	192
Fixing Major Exposure Problems	193
The Shadows/Highlights Command	194
Correcting Part of an Image	196
Controlling the Colors You See	200
Calibrating Your Monitor	202
Choosing a Color Space	204
Using Levels	206
Understanding the Histogram	207
Adjusting Levels: The Eyedropper Method	210
Adjusting Levels: The Slider Method	211
Removing Unwanted Color	213
The Remove Color Cast Command	214
Using Color Variations	215
Choosing Colors	216
The Color Picker	217
The Eyedropper Tool	219
The Color Swatches Panel	220
Sharpening Images	222
Unsharp Mask	223
Adjust Sharpness	225
The High-Pass Filter	227
The Sharpen Tool	229
Chantor 9: Elements for Digital Dhata and have	
Chapter 8: Elements for Digital Photographers	231
The Raw Converter	232
Using the Raw Converter	233
Adjusting White Balance	238
Adjusting Tone	240
Adjusting Vibrance and Saturation	244
Adjusting Sharpness and Reducing Noise	245
Finishing Up	248
Converting to DNG	249
Blending Exposures	251
Automatic Merges	252
Manual Merges	253
Photo Filter	256
Processing Multiple Files	258
Choosing Your Files	258
Renaming Your Files	260
Changing Image Size and File Type	261

Applying Quick Fix Commands	262
Attaching Labels	262
Chapter 9: Retouching: Fine-Tuning Your Images	265
Fixing Blemishes	265
The Spot Healing Brush: Fixing Small Areas	267
The Healing Brush: Fixing Larger Areas	269
The Clone Stamp	272
Applying Patterns	276
The Healing Brush	276
The Pattern Stamp	278
Recomposing Photos	278
Color Curves: Enhancing Tone and Contrast	282
Making Colors More Vibrant	285
The Hue/Saturation Dialog Box	287
Adjusting Saturation with the Sponge Tool	288
Changing an Object's Color	290
Using an Adjustment Layer	291
Replacing Specific Colors	291
The Color Replacement Tool	294
Special Effects	295
Special effects	
Chapter 10: Removing and Adding Color	299
Method One: Making Color Photos Black and White	299
Method Two: Removing Color from a Photo	302
Creating Spot Color	304
Brushing Away Color	305
Erasing Colors from a Duplicate Layer	306
Removing Color from Selections	307
Using an Adjustment Layer and the Saturation Slider	308
Colorizing Black-and-White Photos	310
Tinting a Whole Photo	313
Chapter 11: Photomerge: Creating Panoramas, Group Shots,	
and More	319
Creating Panoramas	320
Manual Positioning with Interactive Layout	322
Merging Different Faces	326
Arranging a Group Shot	329
Tidying Up with Scene Cleaner	329
Correcting Lens Distortion	332
Transforming Images	337
Skew, Distort, and Perspective	338
Free Transform	341

Part Four: Artistic Elements

Chapter 12: Drawing with Brushes, Shapes, and Other Too	de za
Picking and Using a Basic Brush	iis34
Modifying Your Brush	34
Saving Modified Brush Settings The Specialty Brushes	350
The Specialty Brushes	352
Making a Custom Brush	353
The Impressionist Brush The Pencil Tool	354
The Pencil Tool	355
The Paint Bucket	356
Dodging and Burning	357
Dodging	358
BurningBlending and Smudging	359
Blending and SmudgingBlend Modes	359
Blend Modes	361
The Smudge Tool The Eraser Tool	361
The Eraser Tool	362
Using the Eraser The Magic Fraser	365
The Magic Eraser	365
acing out a Liaser	
The strapes	
Rectangle and Rounded Rectangle	770
Linpse	
. 5./8611	
The eastorn Shape 1001	
mape selection 1001	
The Cookie Cutter Tool	3/6
Chapter 13: Filters, Effects, Layer Styles, and Gradients	381
Osing Fillers	
r pprymg r mers	70-
are edication	
oscial Fitter Soldtions	
Series in the series of the se	7.0-
53116 / Tedolis	
and a styles	
Try-6 statistis	
The Gradient 1001	
or deferre the Edycro	
-alang Gradiens	
Gradiens	
Gradient Maps	415

Adding Text to an Image	Chapter 14: Text in Elements	419
Text Options	Adding Text to an Image	419
Creating Text 424 Editing Text 425 Warping Text 427 Adding Special Effects 429 Text Effects 430 Text Gradients 430 Applying the Liquify Filter to Text 431 Type Masks: Setting an Image in Text 434 Using the Type Mask Tools 435 Creating Outlined Text 437 Part Five: Sharing Your Images Chapter 15: Creating Projects Working With the Content and Favorites Panels 441 Creating Multipage Documents 447 Working with the Content and Favorites Panels 449 The Favorites Panel 450 The Favorites Panel 452 Photo Books 452 Greeting Cards 454 CD/DVD Jackets 452 CO/DVD Jackets 454 CD/DVD Jackets 454 CD/DVD Jackets 454 CD/DVD Jackets 454 Chapter 16: Printing Your Photos 459 Ordering Prints 460	Text Options	420
Editing Text	Creating Text	424
Warping Text 427 Adding Special Effects 429 Text Effects 430 Text Gradients 431 Applying the Liquify Filter to Text 431 Type Masks: Setting an Image in Text 434 Using the Type Mask Tools 435 Creating Outlined Text 437 Part Five: Sharing Your Images Chapter 15: Creating Projects Photo Collages 441 Creating Multipage Documents 447 Working with the Content and Favorites Panels 449 The Content Panel 450 The Favorites Panel 452 Photo Books 452 Greeting Cards 454 CD/DVD Jackets 454 CD/DVD Labels 454 CD/DVD Labels 455 PDF Projects 455 Chapter 16: Printing Your Photos 459 Getting Ready to Print 459 Ordering Prints 460 Printing at Home 460 Printing Topitons 465	Editing Text	425
Adding Special Effects	Warping Text	427
Text Effects	Adding Special Effects	429
Text Gradients	Text Effects	430
Applying the Liquify Filter to Text	Text Gradients	430
Type Masks: Setting an Image in Text	Applying the Liquify Filter to Text	431
Using the Type Mask Tools Creating Outlined Text	Type Masks: Setting an Image in Text	434
Creating Outlined Text	Using the Type Mask Tools	435
Part Five: Sharing Your Images Chapter 15: Creating Projects 441 Photo Collages 441 Creating Multipage Documents 447 Working with the Content and Favorites Panels 449 The Content Panel 450 The Favorites Panel 452 Photo Books 452 Greeting Cards 454 CD/DVD Jackets 454 CD/DVD Labels 455 PDF Projects 455 Chapter 16: Printing Your Photos 459 Getting Ready to Print 459 Ordering Prints 460 Printing at Home 460 Printing One Photo Per Page 461 Positioning Your Image 463 Additional Print Options 468 The OS X Print Dialog Box 468 Printing Multiple Images 469 Contact Sheets 469 Picture Packages 471 Chapter 17: Email and the Web 475 Lingge Formats and the Web 475 Saving Images for the Web or Email	Creating Outlined Text	437
Creating Multipage Documents 447 Working with the Content and Favorites Panels 449 The Content Panel 450 The Favorites Panel 452 Photo Books 452 Greeting Cards 454 CD/DVD Jackets 454 CD/DVD Labels 455 PDF Projects 455 Chapter 16: Printing Your Photos 459 Getting Ready to Print 459 Ordering Prints 460 Printing at Home 460 Printing One Photo Per Page 461 Positioning Your Image 463 Additional Print Options 465 The OS X Print Dialog Box 468 Printing Multiple Images 469 Contact Sheets 469 Picture Packages 471 Chapter 17: Email and the Web 475 Image Formats and the Web 475 Saving Images for the Web or Email 476 Using Save For Web 478	Chapter 15: Creating Projects	441
Working with the Content and Favorites Panels 449 The Content Panel 450 The Favorites Panel 452 Photo Books 452 Greeting Cards 454 CD/DVD Jackets 454 CD/DVD Labels 455 PDF Projects 455 Chapter 16: Printing Your Photos 459 Getting Ready to Print 459 Ordering Prints 460 Printing at Home 460 Printing One Photo Per Page 461 Positioning Your Image 463 Additional Print Options 465 The OS X Print Dialog Box 468 Printing Multiple Images 469 Contact Sheets 469 Picture Packages 471 Chapter 17: Email and the Web 475 Image Formats and the Web 475 Saving Images for the Web or Email 476 Using Save For Web 478	Photo Collages	
The Content Panel	Creating Multipage Documents	449
The Favorites Panel 452 Photo Books 452 Greeting Cards 454 CD/DVD Jackets 454 CD/DVD Labels 455 PDF Projects 455 Chapter 16: Printing Your Photos 459 Getting Ready to Print 459 Ordering Prints 460 Printing One Photo Per Page 461 Positioning Your Image 463 Additional Print Options 465 The OS X Print Dialog Box 468 Printing Multiple Images 469 Contact Sheets 469 Picture Packages 471 Chapter 17: Email and the Web 475 Saving Images for the Web or Email 476 Using Save For Web 478	Working with the Content and Favorites Pariets	450
Photo Books 452 Greeting Cards 454 CD/DVD Jackets 454 CD/DVD Labels 455 PDF Projects 455 Chapter 16: Printing Your Photos 459 Getting Ready to Print 459 Ordering Prints 460 Printing at Home 460 Printing One Photo Per Page 461 Positioning Your Image 463 Additional Print Options 465 The OS X Print Dialog Box 468 Printing Multiple Images 469 Contact Sheets 469 Picture Packages 471 Chapter 17: Email and the Web 475 Image Formats and the Web 475 Saving Images for the Web or Email 476 Using Save For Web 478		
Greeting Cards 454 CD/DVD Jackets 455 CD/DVD Labels 455 PDF Projects 455 Chapter 16: Printing Your Photos 459 Getting Ready to Print 459 Ordering Prints 460 Printing at Home 460 Printing One Photo Per Page 461 Positioning Your Image 463 Additional Print Options 465 The OS X Print Dialog Box 468 Printing Multiple Images 469 Contact Sheets 469 Picture Packages 471 Chapter 17: Email and the Web 475 Image Formats and the Web 475 Saving Images for the Web or Email 476 Using Save For Web 478		
CD/DVD Jackets 454 CD/DVD Labels 455 PDF Projects 455 Chapter 16: Printing Your Photos 459 Getting Ready to Print 459 Ordering Prints 460 Printing at Home 460 Printing One Photo Per Page 461 Positioning Your Image 463 Additional Print Options 465 The OS X Print Dialog Box 468 Printing Multiple Images 469 Contact Sheets 469 Picture Packages 471 Chapter 17: Email and the Web 475 Image Formats and the Web 475 Saving Images for the Web or Email 476 Using Save For Web 478	Photo Books	454
CD/DVD Labels 455 PDF Projects 455 Chapter 16: Printing Your Photos 459 Getting Ready to Print 459 Ordering Prints 460 Printing at Home 460 Printing One Photo Per Page 461 Positioning Your Image 463 Additional Print Options 465 The OS X Print Dialog Box 468 Printing Multiple Images 469 Contact Sheets 469 Picture Packages 471 Chapter 17: Email and the Web 475 Image Formats and the Web 475 Saving Images for the Web or Email 476 Using Save For Web 478	Greeting Cards	454
PDF Projects 455 Chapter 16: Printing Your Photos 459 Getting Ready to Print 459 Ordering Prints 460 Printing at Home 460 Printing One Photo Per Page 461 Positioning Your Image 463 Additional Print Options 465 The OS X Print Dialog Box 468 Printing Multiple Images 469 Contact Sheets 469 Picture Packages 471 Chapter 17: Email and the Web 475 Image Formats and the Web 475 Saving Images for the Web or Email 476 Using Save For Web 478	CD/DVD Jackets	455
Chapter 16: Printing Your Photos. 459 Getting Ready to Print 459 Ordering Prints 460 Printing at Home 460 Printing One Photo Per Page 461 Positioning Your Image 463 Additional Print Options 465 The OS X Print Dialog Box 468 Printing Multiple Images 469 Contact Sheets 469 Picture Packages 471 Chapter 17: Email and the Web 475 Saving Images for the Web or Email 476 Using Save For Web 478	CD/DVD Ladels	455
Getting Ready to Print 459 Ordering Prints 460 Printing at Home 460 Printing One Photo Per Page 461 Positioning Your Image 463 Additional Print Options 465 The OS X Print Dialog Box 468 Printing Multiple Images 469 Contact Sheets 469 Picture Packages 471 Chapter 17: Email and the Web 475 Saving Images for the Web or Email 476 Using Save For Web 478	PDF Projects	
Getting Ready to Print 459 Ordering Prints 460 Printing at Home 460 Printing One Photo Per Page 461 Positioning Your Image 463 Additional Print Options 465 The OS X Print Dialog Box 468 Printing Multiple Images 469 Contact Sheets 469 Picture Packages 471 Chapter 17: Email and the Web 475 Saving Images for the Web or Email 476 Using Save For Web 478	Chanter 16: Printing Your Photos	459
Ordering Prints 460 Printing at Home 460 Printing One Photo Per Page 461 Positioning Your Image 463 Additional Print Options 465 The OS X Print Dialog Box 468 Printing Multiple Images 469 Contact Sheets 469 Picture Packages 471 Chapter 17: Email and the Web 475 Saving Images for the Web or Email 476 Using Save For Web 478	Cetting Ready to Print	459
Printing at Home 460 Printing One Photo Per Page 461 Positioning Your Image 463 Additional Print Options 465 The OS X Print Dialog Box 468 Printing Multiple Images 469 Contact Sheets 469 Picture Packages 471 Chapter 17: Email and the Web 475 Image Formats and the Web or Email 476 Using Save For Web 478	Ordering Prints	460
Printing One Photo Per Page 461 Positioning Your Image 463 Additional Print Options 465 The OS X Print Dialog Box 468 Printing Multiple Images 469 Contact Sheets 469 Picture Packages 471 Chapter 17: Email and the Web 475 Image Formats and the Web or Email 476 Using Save For Web 478	Printing at Home	460
Positioning Your Image 463 Additional Print Options 465 The OS X Print Dialog Box 468 Printing Multiple Images 469 Contact Sheets 469 Picture Packages 471 Chapter 17: Email and the Web 475 Image Formats and the Web or Email 476 Using Save For Web 478	Printing One Photo Per Page	461
Additional Print Options 465 The OS X Print Dialog Box 468 Printing Multiple Images 469 Contact Sheets 469 Picture Packages 471 Chapter 17: Email and the Web 475 Image Formats and the Web web or Email 476 Using Save For Web 478	Positioning Your Image	463
The OS X Print Dialog Box	Additional Print Options	465
Printing Multiple Images	The OS X Print Dialog Box	468
Contact Sheets	Printing Multiple Images	469
Picture Packages	Contact Sheets	469
Image Formats and the Web	Picture Packages	471
Image Formats and the Web	Chapter 17: Email and the Web	475
Saving Images for the Web or Email	Image Formats and the Web	475
Using Save For Web	Saving Images for the Web or Email	476
Previewing Images and Adjusting Color481	Using Save For Web	478
	Previewing Images and Adjusting Color	481

Creating Animated GIFs Emailing Photos	482
Emailing Photos	484
Creating a Web Photo Gallery	486
Part Six: Additional Elements	
Chapter 18: Beyond the Basics	491
Graphics Tablets	401
Free Stuff from the Internet	493
when You Really Need Photoshop	495
Beyond This Book	496
Part Seven: Appendixes	
Appendix A: Elements, Menu by Menu	501
Appendix B: Installation and Troubleshooting	531
Appendix C: Bridge CS4, Menu by Menu	537
Index	553

The Missing Credits

About the Author

Barbara Brundage is the author of *Photoshop Elements 6 for Mac: The Missing Manual*, an Adobe Community Expert, and a member of Adobe's prerelease groups for Elements 3, 4, 5, 6, 7, and 8. She's been teaching people how to use Photoshop Elements since it came out in 2001. Barbara first started using Elements to create graphics for use in her day job as a harpist, music publisher, and arranger. Along the way, she joined the large group of people finding a renewed interest in photography thanks to digital

cameras. If she can learn to use Elements, you can, too! You can reach her at bbrundage@me.com.

About the Creative Team

Dawn Frausto (editor) is assistant editor for the Missing Manual series. When not working, she plays soccer, beads, and causes trouble. Email: dawn@oreilly.com.

Nellie McKesson (production editor) lives in Brighton, Mass., where she makes t-shirts (www.endplasticdesigns.com) and plays music with her various bands. Email: nellie@oreilly.com.

Carla Spoon (copy editor) is a freelance writer and copy editor. She works and feeds her tech gadget addiction from her home office in the shadow of Mount Rainier. Email: carla_spoon@comcast.net.

Angela Howard (indexer) has been indexing for over 10 years, mostly for computer books, but occasionally for books on other topics such as travel, alternative medicine, and leopard geckos. She lives in California with her husband, daughter, and two cats.

Raymond Robillard (tech reviewer) is a software analyst for human interface applications. He likes digital photography, tasting micro-brewed dark beers, long walks in nature with friends, and a good performance from his favorite hockey team, the Montreal Canadiens.

Francine Schwieder (tech reviewer) has used Macs and Photoshop since 1994, and runs a monthly Mac User Group Workshop focused on using Mac graphics programs. She also travels, remodels her home and yard, and brings all her varied interests together on her website at http://pinkmutant.com.

Acknowledgments

Many thanks to Ray Robillard and Francine Schwieder for reading this book and giving me the benefit of their advice and corrections. I'm also grateful for the help I received from everyone at Adobe, especially Bob Gager, Sumeet Gupta, Gaurav Jain, and Divesh Nayyar.

Special thanks also to graphic artist Jodi Frye (*lfrye012000@yahoo.com*) for allowing me to reproduce one of her Elements drawings to show what can be done by those with more artistic ability than I have. My gratitude also to Florida's botanical gardens, especially McKee Botanical Garden (*www.mckeegarden.org*), Historic Bok Sanctuary (*www.boktower.org*), Heathcote Botanical Gardens (*www.heathcotebotanicalgardens.org*), and Harry P. Leu Gardens (*www.leugardens.org*) for creating oases of peace and beauty in our hectic world. Finally, I'd like to thank everyone in the gang over at the Adobe Photoshop Elements support forum for all their help and friendship.

-Barbara Brundage

The Missing Manual Series

Missing Manuals are witty, superbly written guides to computer products that don't come with printed manuals (which is just about all of them). Each book features a handcrafted index; cross-references to specific pages (not just chapters); and RepKover, a detached-spine binding that lets the book lie perfectly flat without the assistance of weights or cinder blocks.

Recent and upcoming titles include:

Access 2007: The Missing Manual by Matthew MacDonald

AppleScript: The Missing Manual by Adam Goldstein

AppleWorks 6: The Missing Manual by Jim Elferdink and David Reynolds

CSS: The Missing Manual, Second Edition, by David Sawyer McFarland

Creating a Web Site: The Missing Manual, Second Edition by Matthew MacDonald

David Pogue's Digital Photography: The Missing Manual by David Pogue

Dreamweaver 8: The Missing Manual by David Sawyer McFarland

Dreamweaver CS3: The Missing Manual by David Sawyer McFarland

Dreamweaver CS4: The Missing Manual by David Sawyer McFarland

eBay: The Missing Manual by Nancy Conner

Excel 2003: The Missing Manual by Matthew MacDonald

Excel 2007: The Missing Manual by Matthew MacDonald

Facebook: The Missing Manual by E.A. Vander Veer

FileMaker Pro 9: The Missing Manual by Geoff Coffey and Susan Prosser

FileMaker Pro 10: The Missing Manual by Susan Prosser and Geoff Coffey

Flash 8: The Missing Manual by E.A. Vander Veer

Flash CS3: The Missing Manual by E.A. Vander Veer and Chris Grover

Flash CS4: The Missing Manual by Chris Grover with E.A. Vander Veer

FrontPage 2003: The Missing Manual by Jessica Mantaro

Google Apps: The Missing Manual by Nancy Conner

The Internet: The Missing Manual by David Pogue and J.D. Biersdorfer

iMovie 6 & iDVD: The Missing Manual by David Pogue

iMovie '08 & iDVD: The Missing Manual by David Pogue

iMovie '09 & iDVD: The Missing Manual by David Pogue and Aaron Miller

iPhone: The Missing Manual, Second Edition by David Pogue

iPhoto '08: The Missing Manual by David Pogue

iPhoto '09: The Missing Manual by David Pogue and J.D. Biersdorfer

iPod: The Missing Manual, Seventh Edition by J.D. Biersdorfer and David Pogue

JavaScript: The Missing Manual by David Sawyer McFarland

Living Green: The Missing Manual by Nancy Conner

Mac OS X: The Missing Manual, Tiger Edition by David Pogue

Mac OS X: The Missing Manual, Leopard Edition by David Pogue

Microsoft Project 2007: The Missing Manual by Bonnie Biafore

Netbooks: The Missing Manual by J.D. Biersdorfer

Office 2004 for Macintosh: The Missing Manual by Mark H. Walker and Franklin Tessler

Office 2007: The Missing Manual by Chris Grover, Matthew MacDonald, and E.A. Vander Veer

Office 2008 for Macintosh: The Missing Manual by Jim Elferdink

Palm Pre: The Missing Manual by Ed Baig

PCs: The Missing Manual by Andy Rathbone

Photoshop Elements 8 for Windows: The Missing Manual by Barbara Brundage

Photoshop Elements 7: The Missing Manual by Barbara Brundage

Photoshop Elements 6 for Mac: The Missing Manual by Barbara Brundage

PowerPoint 2007: The Missing Manual by E.A. Vander Veer

Premiere Elements 8: The Missing Manual by Chris Grover

QuickBase: The Missing Manual by Nancy Conner

QuickBooks 2009: The Missing Manual by Bonnie Biafore

QuickBooks 2010: The Missing Manual by Bonnie Biafore

Quicken 2008: The Missing Manual by Bonnie Biafore

Quicken 2009: The Missing Manual by Bonnie Biafore

Switching to the Mac: The Missing Manual, Tiger Edition by David Pogue and

Adam Goldstein

Switching to the Mac: The Missing Manual, Leopard Edition by David Pogue

Wikipedia: The Missing Manual by John Broughton

Windows XP Home Edition: The Missing Manual, Second Edition by David Pogue

Windows XP Pro: The Missing Manual, Second Edition by David Pogue, Craig Zacker, and Linda Zacker

Windows Vista: The Missing Manual by David Pogue

Windows Vista for Starters: The Missing Manual by David Pogue

Word 2007: The Missing Manual by Chris Grover

Your Body: The Missing Manual by Matthew MacDonald

Your Brain: The Missing Manual by Matthew MacDonald

Introduction

Photos are everywhere these days. Once upon a time, you only hauled out the camera to record important events that you wanted to remember forever. But in our digital era, when almost every cellphone has a camera, people take photos of everything from what they had for lunch to the weird faucet fitting they're trying to install so they can email it to friends for advice.

Photo sharing is now a part of daily life, and Adobe is right there with you. Not only does Photoshop Elements offer terrific tools for editing and improving photos, it also makes it easy to prepare photos for sharing. You can even create galleries of your photos to post to a website for your friends' viewing pleasure.

For Mac folks, the big news is that Adobe put the Mac and Windows versions of Elements back on the same schedule. Previously, Mac owners had to wait for months after the Windows version of Elements was released for their version, if a Mac version was released at all. For Elements 8, Adobe is releasing both versions within a few weeks of each other, which is great news for those who prefer OS X.

Why Photoshop Elements?

Adobe's Photoshop is the granddaddy of all image-editing programs, the industry standard against which everything else is measured. Every photo you've seen in a book or magazine over the last, say, 15 years has almost certainly passed through Photoshop on its way to print.

And for good reason: You can't buy anything that gives you more control over your photos than Photoshop does. But Photoshop has some big drawbacks: It's darned hard to learn, it's horribly expensive, and many of its features are overkill if you don't work on photos for a living.

For years, Adobe tried to cram Photoshop's key features into a smaller package that normal people could use, but the right formula was elusive. First came Photo-Deluxe, a program that was lots of fun but came up short for fine-tuning how the program worked. Adobe tried again with Photoshop LE, which was as difficult to use as the full version was, and had too few of the features people needed to do top-notch work.

Finally—sort of like the three bears—Adobe got it "just right" with Photoshop Elements. Because Elements offers much of Photoshop's power in a program that almost anyone can learn, it was an immediate hit. With Elements, you, too, can work with the same tools that the pros use.

The earliest versions of Elements had something of a learning curve. It was a super program, but not one where you could just sit down and expect to get perfect results right off the bat. In each new version, Adobe added various push-buttoneasy ways to correct and improve photos. Elements 8 includes some high-tech editing tools, new ways to arrange your workspace, and new ways to share your photos online more easily than ever.

What You Can Do with Elements 8

Elements not only lets you make your photos look great, but it also helps you organize your photos and gives you some pretty neat projects in which to use them. The program also comes loaded with lots of easy ways to share your photos. The list of what Elements can do is pretty impressive. You can use Elements to:

- Enhance your photos by editing, cropping, and color-correcting them, including fixing exposure and color problems.
- Add special effects to your images, like turning a garden-variety photo into a drawing, painting, or even a tile mosaic.
- Combine photos into a panorama or montage.
- Move someone from one photo to another, and even remove people (your ex?) from last year's holiday photos.
- · Repair and restore old and damaged photos.
- Use Adobe Bridge to organize your photos and assign keywords to them so you can search by subject or name.
- · Add text to your images, and turn them into things like greeting cards and flyers.
- Make digital artwork from scratch, even without a photo to work from.

- Create web galleries and slideshows, and email your photos (although you've already got pretty good tools for doing all these things with OS X and the programs that came with your Mac).
- · Create and edit graphics for websites, including fancy navigation buttons.
- Create wonderful collages that you can print or share with your friends digitally. Scrapbookers—get ready to be wowed.

It's worth noting, though, that there are still a few things Elements *can't* do. While the program handles text quite competently, at least as photo-editing programs go, it's still no substitute for QuarkXPress, InDesign, or any other desktop-publishing program. And Elements can do an amazing job of fixing problems in your photos, but only if you give it something to work with. If your photo is totally overexposed, blurry, and the top of everyone's head is cut off, there's a limit to what Elements can do to help you out. (C'mon, be fair.) The fact is, though, you're more likely to be surprised by what Elements *can* fix than by what it can't.

What's New in Elements 8

Elements 8 brings some cool new editing features, as well as some helpful new organizing tools:

- Recompose your photos (page 278). You know how it is: You try and try to get a photo of all the kids together, but in the best one there's an awkward gap between your son and daughter because they wouldn't stand close together. Or you got a perfect shot of that mountain landscape, except for that pesky condo in the background. Wouldn't it be great if you could squeeze the edges of your photo together and get rid of the empty space or unwanted objects? Well, with the new Recompose tool you can. A couple of scribbles to tell Elements what to lose and what to keep, drag the edge of your picture, and presto!—a recomposed photo with no distortion. It's an awesome use of computer intelligence.
- Exposure Merge (page 251). Combine two or more different exposures of the same scene for one image that's well exposed everywhere. It's perfect for situations like night portraits where properly exposing your subject can wash out the dramatic lighting of the skyline behind him.
- New look (page 21). You can view your images as floating windows, as in previous versions of Elements, or as fixed tabs, and you have more options for arranging your Elements workspace to suit you. What's more, you can quickly change it all if you decide you want a different setup for your current task.
- Use Photoshop actions (page 398). The new Action Player (page 399) makes it simple to add actions (little automated scripts that automatically run through multi-step projects) to Elements.
- Smart Brush (page 196). This new tool makes all sorts of corrections and enhancements as easy as drawing a line.

- Scene Cleaner (page 329). Eliminate unwanted elements (like unknown tourists) from your photos to create just the scene you want.
- New Touch-Up tools (page 113). Just a quick click and drag can whiten teeth, make the sky bluer, or convert part of your photo to black and white, right in the Elements Quick Fix window.
- Improve Skin Texture (page 395). The new Surface Blur filter lets you soften areas without melting edges or losing detail. Great for use on portraits.
- Guides (page 74). This was one of the Elements' most-requested features: non-printing guidelines you can position in your file to help you arrange text and objects. They're finally here in Elements 8—a real boon for scrapbookers and other project makers.
- Quick Fix previews (page 102). If you're using the easy Quick Fix window, you can see thumbnail previews of different settings for the tool you're using. Click one or drag back and forth on it with your cursor to see its effect on your image and adjust the image's intensity.
- Adjustments panel (page 161). Experienced Elements folks will appreciate the new Adjustments panel, which lets you see the settings for any of your Adjustment layers just by clicking the layer.
- Adjustable brightness (page 23). If Elements 6's dark interface bothered you, you'll be pleased to know that you can choose a dark version or a light (well, medium, anyway) version of what you see in Elements 8. But it's only Bridge that really lets you lighten things up—the "light" option for Elements is more of medium gray.
- Intel only (page 48). Elements 8 works only on Macs that have Intel processors, so if you have a Mac with one of the older PowerPC processors (a G5 or earlier model), you need to stick to Elements 6 or earlier. Adobe went Intel all the way with Elements 8—it doesn't give you a way to use Rosetta, the part of OS X that lets you run older programs that were written for PowerPC Macs. This means that if you have any older plug-ins (like a scanner driver) that need Rosetta, you won't be able to use them in Elements 8.
- Activation (page 533). You may not love this new feature, but Adobe only lets you use your copy of Elements 8 on two computers, so it's important to deactivate Elements on your old computer before installing it on a new one. Page 535 explains how.

If you've used Elements before and you're not sure which version you have, look for the version number on the CD. If the program is already installed, see page 16 for help figuring out which version you have.

Incidentally, all versions of Elements are totally separate programs, so you can run all of them on the same computer if you like, as long as your operating system is compatible. (Elements 3 is the oldest version that will run in 10.5, and while some

people have success with versions 3 and 4 in 10.6, Elements 6 is the oldest version that's completely reliable in Snow Leopard.) So if you prefer the older version of a particular tool, you can still use it. If you've used one of the earlier versions, you'll feel right at home in Elements 8. You'll just find that it's easier than ever to get stuff done with the program.

If You Use Windows

This book covers Elements 8 for Macs. Adobe is releasing Elements 8 for Mac a few weeks after the Windows version, and there's a separate version of this book, *Photoshop Elements 8 for Windows: the Missing Manual*, which you should get if you're using the Windows version. Editing is pretty much the same on both Windows and Mac computers, but the Mac version of Elements doesn't include a feature called the Organizer. Instead, you get Adobe Bridge (the deluxe photo-browser that comes with Photoshop). This means that the parts of this book about organizing your photos, using online services, and many of the projects are different than the Windows version.

Elements vs. Photoshop

You could easily get confused about the differences between Elements and the full version of Adobe Photoshop. Because Elements is so much less expensive, and because many of its more advanced controls are tucked away, a lot of Photoshop aficionados tend to view Elements as a toy version of their program.

They couldn't be more wrong. Elements *is* Photoshop, but it's Photoshop adapted for use with a home printer, and for the Web. The most important difference between Elements and Photoshop is that Elements doesn't let you work or save in CMYK mode, which is the format used for commercial color printing. (CMYK stands for Cyan, Magenta, Yellow, and black. Your inkjet printer also uses those ink colors to print, but it expects you to give it an RGB file, which is what Elements creates. This is all explained in Chapter 7.)

Elements also lacks several tools that are basic staples in any commercial art department, like the ability to write actions or scripts (to help automate repetitive tasks), the extra color control you can get from Selective Color, and the Pen tool's special talent for creating vector paths. Also, for some special effects, like creating drop shadows or bevels, the tool you'd use—Layer styles—doesn't have as many settings in Elements as it does in Photoshop. The same holds true for a handful of other Elements tools.

And although Elements is all most people need to create graphics for the Web, it doesn't come with the advanced Photoshop tools that let you do things like automatically slice images into smaller pieces for faster Web display. If you use Elements and want to do that, you'll need another program to help with those tasks.

Introduction

The Key to Learning Elements

Elements may not be quite as powerful as Photoshop, but it's still a complex program, filled with more features than most people ever use. The good news is that the Quick Fix window (Chapter 4) lets you get started right away, even if you don't understand its every option. And you also get Guided Edit mode (page 30), which provides a step-by-step walkthrough of some popular editing tasks, like sharpening your photo or cropping it to fit on standard photo paper.

As for the program's more complex features, the key to learning how to use Elements—or any other program, for that matter—is to focus only on what you need to know for your current task. For example, if you're trying to use Quick Fix to adjust the color of your photo and crop it, don't worry that you don't get the concept of "layers" yet. You won't learn to do everything in Elements in a day or even a week. The rest will wait until you need it, so take your time and don't worry about what's not important to you right now. You'll find it much easier to master Elements if you go slowly and concentrate on one thing at a time.

If you're totally new to the program, you'll find only three or four big concepts in this book that you really have to understand if you want to get the most out of Elements. It may take time for some ideas to sink in—resolution and layers, for instance, aren't the most intuitive concepts in the world—but once they click, they'll seem so obvious that you'll wonder why they seemed confusing at first. That's perfectly normal, so persevere. You *can* do this, and there's nothing in this book that you can't understand with a little bit of careful reading.

The best way to learn Elements is to dive right in and play with it. Try all the different filters to see what they do. Add a filter on top of another filter. Click around on all the different tools and try them. You don't even need to have a photo to do this. See page 50 to learn how to make an image from scratch in Elements, and read on to learn about the many downloadable practice images you'll find at this book's companion website, *www.missingmanuals.com*. Get crazy—you can stack up as many filters, effects, and Layer styles as you want without crashing the program.

About This Book

Elements is a cool program and lots of fun to use, but figuring out how to make it do what you want is another matter. Elements 8 comes only with a quick reference guide, and it doesn't go into as much depth as you might want. The Elements Help files are good, but you need to know what you're looking for to use them to your best advantage. (The Help files that ship with Elements are sometimes incomplete, but you can download a more polished version from Adobe's Elements support pages at www.adobe.com/support/photoshopelements/.)

You'll find a slew of Elements titles at your local bookstore, but most of them assume that you know quite a bit about the basics of photography and/or digital imaging. It's much easier to find good intermediate books about Elements than one designed to get you going with the program.

That's where this book comes in. It's intended to make learning Elements easier by avoiding technical jargon as much as possible, and explaining *why* and *when* you'll want to use (or avoid) certain features of the program. That approach is as useful to people who are advanced photographers as it is to those who are just getting started with their first digital cameras.

NOTE This book periodically recommends *other* books, covering topics too specialized or tangential for a manual about Elements. Careful readers may notice that not every one of these titles is published by Missing Manual parent O'Reilly Media. While we're happy to mention other Missing Manuals and books in the O'Reilly family, if there's a great book out there that doesn't happen to be published by O'Reilly, we'll still let you know about it.

You'll also find instructions throughout the book that refer to files you can download from the Missing Manual website (www.missingmanuals.com) so you can practice the techniques you're reading about. And throughout the book, you'll find several different kinds of short articles. The ones labeled "Up to Speed" help newcomers to Elements do things, or explain concepts with which veterans are probably already familiar. Those labeled "Power Users' Clinic" cover more advanced topics that won't be of much interest to casual photographers.

NOTE Elements 8 works in both the Leopard (10.5) and Snow Leopard (10.6) versions of OS X. There are very few differences between the two as far as Elements is concerned, and they're noted in the text. Also, since the program's darkness/brightness is adjustable (page 23), the illustrations show whichever setting best displays the described feature. Elements 8 can also run in Mac OS X Tiger (10.4.11), but if you're still using Tiger you'd probably be a lot happier with the performance of Elements 6, so this book focuses on Leopard and Snow Leopard. If you decide to go the Elements 6 route, you can pick up a copy of *Photoshop Elements 6 for Mac: The Missing Manual*.

About the Outline

This book is divided into seven parts, each focusing on a certain kind of task you may want to do in Elements:

- Part One: Introductory Elements. This section of the book helps you get started with Elements. Chapter 1 shows how to navigate Elements' slightly confusing layout and mishmash of programs within programs. You'll learn how to decide which window to start from and how to set up Elements so it best suits your working style. You'll also read about some important keyboard shortcuts, and where to look for help when you get stuck. Chapter 2 covers how to get photos into Elements, the basics of using Bridge, and how to open files and create new images from scratch. You'll also find out how to save your images and burn them to disc. Chapter 3 explains how to rotate and crop photos, and includes a primer on that most important digital imaging concept—resolution. Finally, Chapter 4 shows how to use the Quick Fix window to dramatically improve your photos.
- Part Two: Elemental Elements. Chapter 5 and Chapter 6 cover two key concepts—making selections and layers—that you'll use throughout the book.

- Part Three: Retouching. Having Elements is like having a darkroom on your computer. In Chapter 7, you'll learn how to make basic corrections, such as fixing exposure, adjusting color, sharpening an image, and removing dust and scratches. Chapter 8 covers topics unique to people who use digital cameras, like Raw conversion and batch-processing your photos. In Chapter 9, you'll move on to more sophisticated fixes, like using the Clone Stamp for repairs, making a photo livelier by adjusting its color intensity, and adjusting light and shadows in an image. Chapter 10 shows you how to convert color photos to black and white, and how to tint and colorize black-and-white photos. Chapter 11 helps you to use Elements' Photomerge feature to create panoramas from several photos, and to make perspective corrections to your images.
- Part Four: Artistic Elements. This part covers the fun stuff: painting on your photos and drawing shapes (Chapter 12), using filters and effects to create a more artistic look (Chapter 13), and adding text to images (Chapter 14).
- Part Five: Sharing Your Images. Once you've created a great image in Elements, you'll want to share it, so this part is about how to create fun projects like photo books (Chapter 15); how to get the most out of your printer (Chapter 16); and how to create images for the Web and email, as well as basic web galleries (Chapter 17).
- Part Six: Additional Elements. You can get literally hundreds of plug-ins and additional styles, brushes, and other nifty tools to customize your copy of Elements and increase its abilities; the Internet and your local bookstore are chockfull of additional info. Chapter 18 offers a look at some of these, as well as info about using a graphics tablet in Elements, and some resources to turn to after you finish this book.
- Part Seven: Appendixes. Appendixes A and B cover all the menu items in Bridge and Elements, respectively. Appendix C helps you get your copy of Elements up and running, and suggests what to do if Elements starts misbehaving.

For Newcomers to Elements

This book holds a lot of information, and if you're new to Elements, you don't need to digest it all at once, especially if you've never used any kind of photo-editing program before. So what do you need to read first? Here's a four-step plan for using the book if you're brand-new to photo editing:

1. Read all of Chapter 1.

This is important for understanding how to get around in Elements.

2. If you aren't sure how to get photos onto your Mac, or if you want to organize your photos or assign keywords to them, read about Bridge in Chapter 2.

That chapter also tells you how to open photos in Elements.

3. When you're ready to edit your photos, read Chapters 3 and 4.

Chapter 3 explains how to adjust your view of photos. Chapter 4 shows you how to use Elements' Quick Fix window to easily edit and correct your photos. Guided Edit (page 30) can also be helpful when you're getting started. To understand your options for saving photos, go back and read the section of Chapter 2 that explains them (page 59).

4. When you're ready to print or share your photos, flip to the chapters on sharing images.

Chapter 16 covers printing. Chapter 17 explains how to email photos and put them online.

That's all you need to get started. You can come back and pick up the rest of the info in the book as you get more comfortable with Elements and want to explore more of the wonderful things you can do with it.

The Very Basics

This book assumes you know how to perform basic activities on your computer like clicking and double-clicking and dragging objects onscreen. Here's a quick refresher:

Since you have a Mac, you have a choice between using a one-button mouse or a two-button mouse. (If you have the Apple Mighty Mouse that comes with recent Macs, you can use it either way: Go to ♠ → System Preferences → Keyboard & Mouse → Mouse to set your mouse's behavior.) You can do all the same things with a one-button mouse that you can do with a two-button mouse. Here's the lowdown:

To *click* means to move the point of your cursor over an object onscreen and press the left (or only) mouse or trackpad button once. To *double-click* means to press the left (or only) mouse or trackpad button twice, quickly, without moving the cursor between clicks. To *drag* means to click an object and use the mouse or trackpad to move it while holding down the mouse or trackpad button (let go of the button when you're done moving the object).

For two-button mousers, to *right-click* means to press the right mouse button once. For one-button folks, holding down the Control key while you click does the same thing as right-clicking, so you'll see "right-click (Control-click)" in the instructions in this book. Right-clicking typically calls up a menu of options you can choose from.

Most selection buttons onscreen are pretty obvious, but you may not be familiar with *radio buttons*: To choose an option, you click one of these little empty circles that are arranged like a list. If you're comfortable with basic concepts like these, you're ready to get started with this book.

In Elements, you'll often want to use keyboard shortcuts to save time, and this book gives you keyboard shortcuts when they exist (and there are a lot of them in Elements). So if you see "Press \mathbb{H}-S to save your file," that means to hold down the \mathbb{H} key while pressing the S key.

About → These → Arrows

Throughout *Photoshop Elements 8 for Mac: The Missing Manual* (and in any Missing Manual, for that matter) you'll see sentences that look like this: "Go to Filter → Artistic → Paint Daubs."

This is a shorthand way of helping you find files, folders, and menu choices without having to read through excruciatingly long, bureaucratic-style instructions. So, for example, the sentence in the previous paragraph is a short way of saying: "In the menu bar at the top of your screen, click the word "Filter". In that menu, choose the Artistic item, and then go to Paint Daubs in the pop-out menu." Figure I-1 shows you an example in action.

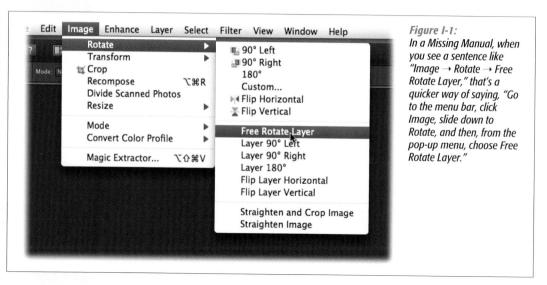

About MissingManuals.com

If you head over to this book's Missing CD page (www.missingmanuals.com), you'll find links to downloadable practice images mentioned throughout this book.

A word about these downloadable files: To make life easier for folks with slow Internet connections, the files have been kept pretty small. So you probably won't want to print the results of what you create since you'll end up with a print about the size of a matchbook. But that doesn't really matter because the files are meant for onscreen use. You'll see notes throughout the book about which images are available to practice on for any given chapter.

At the website, you can also find articles, tips, and updates to this book. If you click the Errata link, then you'll see any corrections to the book's content. If you find something you think is wrong, feel free to report it by using that same link. Each time this book is printed, we'll update it with any confirmed corrections. If you want to be certain that your own copy is up to the minute, check the Missing Manuals website for any changes. And thanks for reporting any errors or suggesting corrections.

We'd love to hear your suggestions for new books in the Missing Manual line. There's a place for that on missingmanuals.com, too. And while you're online, you can also register this book at www.oreilly.com (you can jump directly to the registration page by going here: http://tinyurl.com/yo82k3). Registering means we can send you updates about this book, and you'll be eligible for special offers like discounts on future editions.

Safari® Books Online

Safari® Books Online is an on-demand digital library that lets you easily search over 7,500 technology and creative reference books and videos to find the answers you need quickly.

With a subscription, you can read any page and watch any video from our library online. Read books on your cell phone and mobile devices. Access new titles before they are available for print, and get exclusive access to manuscripts in development and post feedback for the authors. Copy and paste code samples, organize your favorites, download chapters, bookmark key sections, create notes, print out pages, and benefit from tons of other time-saving features.

O'Reilly Media has uploaded this book to the Safari Books Online service. To have full digital access to this book and others on similar topics from O'Reilly and other publishers, sign up for free at http://my.safaribooksonline.com/.

Part One: Introductory Elements

Chapter 1: Finding Your Way Around Elements

Chapter 2: Importing, Managing, and Saving Your Photos

Chapter 3: Rotating and Resizing Your Photos

Chapter 4: The Quick Fix

Finding Your Way Around Elements

Photoshop Elements lets you do practically anything you want to your digital images. You can colorize black-and-white photos, remove demonic red-eye stares, or distort the faces of people who've been mean to you. The downside is that all those options can make it tough to find your way around Elements, especially when you're new to the program.

This chapter helps get you oriented in Elements. You'll learn what to expect when you launch the program, how to use Elements to fix photos with just a couple of keystrokes, and how to sign up for and connect to all the goodies that await you on Photoshop.com. You'll also learn how to use Guided Edit mode to get started editing your photos. Along the way, you'll find out about some of Elements' basic controls, and how to get to the program's Help files.

The Welcome Screen

If you're lucky, all you need to do to launch Elements for the first time is click the Elements icon (the blue square with Elements' initials—pse—on it) in the Dock. If Elements didn't automatically create a Dock icon when you installed it, go to your hard drive's Applications folder and open the Adobe Photoshop Elements 8.0 folder. Double-click the Photoshop Elements icon (the bright blue square with "pse" on it) to start the program. When you do, the same icon appears in your Dock. To keep Elements in your Dock even after you quit the program, right-click (Control-click) the icon and choose "Keep in Dock".

NOTE Elements will take a while to start up the first time you launch it, because it's building a database for the Content and Effects panels, which you'll learn about later. So don't be concerned if the program seems to hang—just give it a minute to finish. Once Elements creates the database, future launches go quicker.

UP TO SPEED

Which Version of Elements Do You Have?

This book covers the Mac version Photoshop Elements 8. If you're not sure which version of Elements you have, the easiest way to find out is to look at the program's icon (the file you click to launch Elements). The icon for Elements 8 is quite distinctive—it's a bright blue square that says "pse". But if you're still not sure, check your Applications folder: Elements is listed there as "Adobe Photoshop Elements" followed by the version number.

You can use this book if you have an earlier version of Elements because a lot of the basic editing procedures

are the same. But getting around in Elements is a little different in Elements 8, so you'll see lots of references to screen features and tools you don't have. There are *Missing Manuals* for Elements 3, 4, and 6, too, and you may prefer to track down the right book for your version of Elements. If you have Elements 8 for Windows, there's a separate edition of this book for that version, which has very different tools for organizing and sharing photos, although editing them is pretty much the same on both platforms.

When you first launch Elements, you get a veritable smorgasbord of options, neatly laid out for you in the Welcome screen (Figure 1-1). It offers you no less than four options for where to start:

- Start from Scratch. Clicking this button brings up the New File dialog box, where you set your options for a new, blank file. You can read more about your choices in this dialog box on page 50.
- Browse with Adobe Bridge. Choose this option and Elements launches Adobe Bridge, a second program that comes with Elements. Bridge lets you—among other things—look through your photos and choose one to work on. There's more about Bridge on page 39.

NOTE If you use iPhoto, you shouldn't use Bridge to try to see into your iPhoto library. See the next section to learn why.

- Import from Camera. You got yet another extra program with Elements: the Adobe Photo Downloader. If you click this button, Elements sends you over to Bridge and launches the Photo Downloader. However, you may not want to do this, especially if you use another program like iPhoto to organize your photos, or if you use another download program like Canon's ImageBrowser. There's more about the Downloader on page 19.
- Import from Scanner. If your scanner driver lets you scan directly into Elements, click this button and, in the window that appears, select your scanner from the pull-down menu. Of course, you need to have your scanner driver and

Figure 1-1: The Elements Welcome screen aives you four icons to pick from for different starting points. If vou've opened Elements before, the Welcome screen remembers the images you've opened most recently. To work on one of them, click its name in the list in the lower-left part of the screen; Elements opens your file and closes the Welcome screen.

any necessary Photoshop plug-ins (page 47) for your scanner installed or this won't get you anywhere. (Many scanners come with software that lets you scan and save your image. You can then open the resulting file in Elements like any other image, as long as you saved it in a format that Elements understands—see page 59.) If you have a Mac with an Intel processor and your scanner plug-in is old, when you launch Elements, you see a message about plug-ins not loading. See page 48 for more about that.

TIP If Elements doesn't recognize your scanner but you know you should be able to scan into Elements, try reinstalling your scanner driver and any scanner plug-ins.

If this isn't the first time you've launched Elements, you'll also see a list of recently opened files in the lower-left part of the window. Click a photo's file name to open it.

You don't have to choose any of these options if you don't want to. Just click the Close button (the X) in the screen's upper right and you'll find yourself in Elements, free to do whatever you want. You can even turn off the Welcome screen altogether, as explained in the box on below.

FREQUENTLY ASKED QUESTION

Say Goodbye to the Welcome Screen

How do I get rid of the Welcome screen?

If you get to feeling like you've been welcomed enough, you can turn off the Welcome screen so you don't have to click through it every time you start the program.

It's easy to put the Welcome screen away permanently. Just turn off the checkbox in the lower-right corner of the window that says "Show at Startup". If you want to bring the Welcome Screen back again, go to Window — Welcome, and turn the checkbox back on. The next time you launch Elements, it'll be there to greet you.

Adobe Bridge-Decisions, Decisions

When you first start using Elements 8, you have a decision to make: How do you want to organize and search for your photos?

Of course, you can decide *not* to organize your photos, but that sure can make them hard to find. These days, everyone has lots of photos to deal with, whether you take them with your camera or cellphone or you're busy scanning in old prints. Most people want to organize photos so they can easily find particular photos when they need 'em.

With that in mind, Adobe gives you Adobe Bridge CS4 (Figure 1-2), the image browser that comes with full Photoshop and the other Creative Suite programs. In some ways, Bridge is a big step up from the file browser in early editions of Elements or the Organizer that comes with the Windows version, especially if you shoot Raw images (Chapter 8 has info about Raw formats). You can use Bridge to search for, move, and assign keywords and ratings to your photos, and to get detailed information about them.

Figure 1-2:
Bridge makes it easy to find photos to work with in Elements. You can see info about your photos in the lower-right Metadata panel, and assign keywords to your images using the Keywords panel (hidden here).

But if you're like a lot of Mac folks, you already use some kind of photo organizer. iPhoto, which comes with all new Macs, is by far the most popular, but Apple's Aperture and Adobe's Lightroom also have big followings. If you use one of these programs, you probably don't want to use Bridge most of the time. For one thing, bad things can happen when you try to get into your photo database (like the iPhoto library file, for example) from Bridge or any application other than the program that created it. The iPhoto library file, in particular, is prone to getting corrupted if you mess with it from outside iPhoto.

The good news is that you can send your photos directly to Elements from any of these organizer programs (page 46 has the details). So for most photo-organizing tasks, it's best to avoid Bridge entirely if you use one of these programs.

But if you want to create some of the projects that are built into Elements, like a web gallery (see page 486), you'll get bounced over to Bridge in the process, so you'll need to deal with Bridge a little bit, even if it's not your main way of organizing photos. Page 39 gives you a rundown of the Bridge basics you need to know.

If you're not already locked into another photo organizer, Bridge lets you do a lot of useful things with your photos, like rate them, move and rearrange them, and assign keywords to them that lots of programs can understand. You can even group your photos into collections so you can work with them more easily. For many people, Bridge can be a valuable tool, especially if you prefer creating your own folder structure rather than letting a photo management program like iPhoto decide where to put your photos. You may find that Bridge is all you need for organizing your photos. There's a lot more about it on page 52.

The Photo Downloader

Along with Bridge, you get the Adobe Photo Downloader. You can use the Downloader to get photos from your camera, but in OS X, you already have Image Capture to handle that part for you, and it does a fine job. For most people, the Downloader isn't terribly useful, and Adobe makes it easy to forget it even exists, since you can only launch it from Bridge or Elements. (It's not a standalone program like the Downloader that comes with the Windows version of Elements, although you can set it to launch automatically any time you connect a camera or card reader, even if Bridge and Elements aren't running; the Missing CD page at www. missingmanuals.comhas more info about the Downloader.)

NOTE Although both the Mac and Windows versions of Elements include a Photo Downloader, there are a number of differences between the two. The Mac version doesn't let you choose among different types of media to view and import, or let you correct red eye or create automatic stacks as you download your photos.

Few Mac people use the Downloader at all, but it can be useful in a couple of situations:

- Convert to DNG. If you shoot Raw files (page 232) and you want to convert them to DNG files as you import them, the Downloader can do this automatically. (Page 249 has info about the DNG format.) You can convert to DNG in a couple of other ways in Elements, though, as Chapter 8 explains.
- Add metadata. This is the Downloader's most important feature. As you import your photos, you can tell the Downloader to add an author or copyright holder to the photo's file info. Or you can create your own custom metadata template (a list of info about the picture that gets stored as part of the file, like who took it or a keyword to help you find the photo by searching) and apply it to every

photo you import. (Page 55 has lots more about metadata.) You can also use Bridge to add or edit metadata (even for batches of pictures) if you prefer—see page 55.

To launch the Downloader so you can check it out, in Elements go to File \rightarrow Adobe Photo Downloader; in Bridge, it's File \rightarrow Get Photos from Camera. (Since most people with Macs aren't too interested in the Downloader, it's not covered in depth in this book. If you want to know more about how to use it, you'll find detailed Downloader instructions on this book's Missing CD page at www. missingmanuals.com.)

Page 39 talks more about getting photos into Elements, including some of the nifty ways of browsing through your pictures right in the Finder.

Editing Your Photos

The Editor is the main component of Elements (Figure 1-3). This is the fun part of the program, where you get to edit, adjust, transform, and generally glamorize your photos, and where you can create original artwork from scratch with the drawing tools and shapes. The Editor has three different modes:

• Full Edit. The Full Edit window gives you access to Elements' most sophisticated tools. You have far more ways to work on your photo in Full Edit than in the other modes, and if you're fussy, it's where you'll do most of your retouching work.

Figure 1-3:
The main Elements
editing window, which
Adobe calls Full Edit. In
some previous versions
of Elements it was known
as the Standard Editor,
something to keep in
mind in case you ever try
any tutorials written for
Elements 3 or 4.

- Quick Fix. For many beginners, Quick Fix (Figure 1-4) ends up being their main workspace. It's where Adobe has gathered the basic tools you need to improve most photos. It's also one of the two places in Elements where you can choose to have a before-and-after view while you work. (Guided Edit, described below, is the other.) Chapter 4 gives you all the details on using Quick Fix.
 - TIP Most Quick Fix commands are also available via menus in the Full Edit window.

Figure 1-4: The Ouick Fix window. Use the pull-down menus in the Edit tab at the top of the screen (circled, right) to hop from Full Edit to the Ouick Fix window (and to Guided Edit, if you like) and back again. To compare your fixes with the original photo, fire up Before & After view. which you get by clicking the View menu (circled, left).

• Guided Edit. This window can be a big help if you're new to Elements. It provides step-by-step walkthroughs for popular projects such as cropping photos and removing blemishes from them. Like Quick Fix, Guided Edit offers a before-and-after view of your photo as you work on it (see page 31) and also has some advanced features, like the new Action Player (page 399).

The rest of this chapter covers some of the Editor's basic concepts and key tools.

Panels, Bins, and Tabs

When you first open Elements, you may be dismayed at how cluttered it looks. There's stuff everywhere, and maybe not a lot of room left for the photos you're editing, especially if you have a small screen. Don't fret: One of Elements 8's best features is the way you can customize your workspace. There's practically no limit to how you can rearrange things. You can leave everything the way it is if you like a

cozy area with everything at hand. Or if you want a Zen-like, empty workspace with nothing visible but your photo, you can move, hide, and turn off almost everything. Figure 1-5 shows two different views of the same workspace.

Figure 1-5: Here are two ways of working with the same images, panels, and tools. You can use any arrangement that suits you.

Top: Elements' standard panel arrangement, with the images in the new tabbed view (page 83).

Bottom: This image shows how you can customize your panels. Here the Project bin has been moved into the Panel bin, and the whole thing is collapsed to icons (they're to the right of the image being worked on). Click an icon and that panel pops open so you can work with it. The images here are in floating windows.

What's more, in Elements 8 you can hide *everything* in your workspace except for your images and the menu bar: no tools, panels, or Options bar. This is handy when you want a good, undistracted look at what you've just done to your photo. To use that view, just press the Tab key; to bring everything back, press Tab again.

NOTE If you used Elements 6, you'll be pleased to know that you can resize the Elements 8 window by dragging its lower-right corner. If you were one of the few people who loved the giant Elements 6 window that clung to the edges of your screen so the only way to reach your other programs was through the empty area in the center of the workspace, you can have that in Elements 8, too: Just go to the Window menu and turn off Application Frame for a view just like how Elements 6 looked with "Show workspace background" turned off.

WORKAROUND WORKSHOP

Turning the Lights On

You may find Elements' snazzy dark color scheme hard to see or just plain annoying. Elements 8 gives you a choice of a dark or light color scheme, although the "light" version is really more medium than light. Just go to Photoshop Elements → Preferences → General, and in the Appearance Options section of the dialog box that appears, use the radio buttons to choose Light or Dark. Unfortunately, Adobe hasn't been very consistent with the lighter choice, so it can be hard to read in spots, like the boxes where you can type in numbers or settings. Luckily, it's easy to switch back and forth between the two color schemes. (Bridge also lets you adjust how it

looks—you can pick anything from black to white. Go to Adobe Bridge CS4 → Preferences, and in the General tab of the dialog box that pops up, use the Appearance sliders to customize your view.)

When you pick a new color scheme, the change takes effect immediately, so you don't need to relaunch Elements to see the difference.

The images in this book include ones taken in both color schemes, so don't be alarmed if the graphics in these pages look darker or lighter than what you see on your screen.

The Panel bin

When you're in Full Edit, the right side of the Elements window displays the *Panel bin*. Panels let you do things like keep track of what you've done to your photo (Undo History panel) and apply special effects to your images (the Effects and Content panels). You'll learn about the various panels in detail throughout this book.

NOTE In previous versions of Elements and in older versions of Photoshop, panels were called "palettes." If you run across a tutorial that talks about the "Content palette" for example, that's exactly the same thing as the "Content panel."

You might like the Panel bin, but many people don't. If you don't have a large monitor, you may find it wastes too much desktop acreage, and in Elements, you need all the working room you can get. Fortunately, you don't have to keep your panels in the bin; you can close the bin and just keep your panels floating around on your desktop, or you can minimize them.

You can't close the bin completely when it has panels in it, but you can minimize it to just a narrow strip of icons by clicking the bin's topmost bar (the one with the double arrows on it). To expand it again, click the top bar once more. (If you pull all the panels out of the bin so that it's empty, it disappears. To bring it back, click Reset Panels at the top of the Elements window, which resets all your panels, not just the bin.) You can pull a panel out of the bin by dragging the panel's top tab; you now have a floating panel. Figure 1-6 shows how to make panels even smaller once they're out of the bin by collapsing them in one of two ways. You can also combine panels, as shown in Figure 1-7; this works with both panels in the bin and freestanding panels.

Figure 1-6:

You can free up space by collapsing your panels, accordion-style, once they're out of the bin.

Top: A full-sized Effects panel.

Middle: The same panel collapsed by double-clicking where the cursor is.

Bottom: The Effects panel collapsed to an icon by clicking the very top of it (where the cursor is here) once. Click the top bar again to expand it.

When you launch Elements for the first time, the Panel bin contains only two panels: Layers and Effects. To see how many more panels Elements has, check out the main Window menu (the one at the top of your screen). Everything listed in the menu's middle section—from Adjustments to Undo History—is a panel you can put in the Panel bin.

When you select a new panel from the Window menu, it appears in the bin if you're using the bin, floating on the desktop if you don't have any panels in the bin, or right where it was when you closed it last time. In addition to combining panels as shown in Figure 1-7, you can also collapse the Panel bin or any group of panels to icons. Then, to use a panel, click its icon and it jumps out to the side of the group, full size. To shrink it back to an icon, click the double arrows at the panel's upper right. You can combine panels in icon view by dragging their icons onto each other. Then those panels open as a combined group, like the panels in Figure 1-7. Clicking one of the icons in the group collapses the opened, grouped panels back to icons. (Combined panel icons don't show a dark gray line between them in the group the way separate icons do.) To separate combined panels in icon view, drag a panel's icon away from the other icon(s).

Adobe sometimes refers to floating panels as "tabs" in Elements' menus. To close a floating tab, click the Close button (the dot) at its upper left, or click the barely visible square (made up of four horizontal lines) in the panel's upper right, and choose Close from the menu that appears. If you want to put a panel back in the bin, drag it over the bin and let go when you see a blue line, or drag it onto the tab of a panel that's already in the bin to create a combined panel within the bin.

Figure 1-7: You can combine two or more panels once you've dragged them out of the Panel bin.

Top: Here, the Histogram panel is being pulled into, and combined with, the Layers panel. To combine panels, drag one of them (by clicking on the panel's name tab) and drop it onto the other panel.

Bottom: To switch from one panel to another after they're grouped, just click the tab of the one you want to use. To remove a panel from a group, simply drag it out of the group. If you want to return everything to how it looked when you first launched Elements, click Reset Panels (not visible here) at the top of your screen.

NOTE If you lose panels or you move stuff around so much that you can't remember where you put things, you can always go home again by clicking the Reset Panels button at the top of the Elements window, which puts *all* your panels back in their original spots.

The Project bin

The long, narrow section at the bottom of your screen is called the Project bin. It shows you what photos you have open, as explained in Figure 1-8. It also includes a pull-down menu labeled "Project Bin Actions", which gives you shortcuts to the Create or Share tabs and their projects.

You can drag your photos' thumbnails in the bin to rearrange them if you want to use the images in a project, and you can drag photos into your projects by dragging their thumbnails out of the bin into images or Create projects (page 441).

The Project bin is useful, but if you have a small monitor, you may prefer to use the space it takes up for your editing work. In Elements 8, the Project bin behaves like any of the other panels: You can drag it from the bottom of the screen and combine it with other panels, collapse it to an icon, or drag it into the Panel bin. (If you combine it with other panels, the combined panel may be a little wider than it would be without the Project bin, although you can still collapse the combined group to icons.) If you've used the past couple of versions of Elements, you know this is a *great* improvement over the old, fixed Project bin.

Figure 1-8: The Proiect bin runs across the bottom of the Flements window, and holds a thumbnail of every photo vou have open. Here vou see the bin three ways: as it normally appears (top), as a floating panel (middle), and collapsed to an icon (bottom). You can also click the Close button (the dot) at the bin's upper left when the bin is floating, or right-click (Control-click) its tab and choose Close to hide it completely. To bring it back go to Window → Project bin.

Image windows

In Elements 8, you can choose how you want to see the images you're working on. Older versions of Elements used floating windows, where each image appears in a separate window that you can drag around. Elements 8 starts you out with floating windows, but you can also put your images into a new, tabbed view, which is something like the tabs in a web browser or the tabs on paper file folders. The advantage of tabbed view is that you have plenty of workspace around the image, which is handy when you're editing near the edges of an image, or using a tool that requires you to be able to get outside the image's boundaries. All the things you can do with image windows are explained on page 83. Incidentally, clicking Reset Panels doesn't do anything to your image windows or tabs; it just resets the panels.

NOTE Because your view may vary, most of the illustrations in this book show only the image itself and the tool in use, without a window frame or tab boundary around it.

Elements' Tools

Elements gives you an amazing array of tools to use when working on your photos. You get almost two dozen primary tools to help select, paint on, and otherwise manipulate images, and many of the tools have as many as six subtools hiding beneath them (see Figure 1-9). Bob Vila's workshop probably isn't any better stocked than Elements' virtual toolbox.

NOTE To explore every cranny of Elements, you need to open a photo (File \rightarrow Open). Lots of the menus are grayed out if you don't have a file open.

Figure 1-9:
Like any good toolbox, Elements' Tools panel has lots of hidden drawers in it.
Many Elements tools are actually groups of tools, which are represented by tiny
black triangles on the lower-right side of the tool's icon (you can see several of

black triangles on the lower-right side of the tool's icon (you can see several of these triangles here). Right-clicking (Control-clicking) or holding the mouse button down when you click the icon brings out the hidden subtools. The little black sayare next to the Eraser tool means it's the active tool right now.

The long, skinny strip on the left side of the Full Edit window (shown back in Figure 1-3—page 20) is the Tools panel. It stays perfectly organized so you can always find what you want without ever having to lift a finger to tidy it up. If you forget what a particular tool does, just hover your cursor over the tool's icon, and a label (called a *tooltip*) appears telling you the tool's name. To activate a tool, click its icon. Each tool comes with its own collection of options, as shown in Figure 1-10.

Figure 1-10:
When a tool is active, the
Options bar changes to
show settings specific to
that tool. Elements' tools
are highly customizable,
letting you do things like
adjust a brush's size and
shape. Here you see the
Brush tool's options. (The
black squiggle at the left is
a sample of the
brushstroke you'd get using
the tool's current settings.)

Elements starts you out with a single-column Tools panel, but if you if want, you can have a double-columned one. If you prefer a more compact Tools panel, see the box on page 28.

Other windows in Elements, like Quick Fix and the Raw Converter (see page 232), also have toolboxes, but none is as complete as the one in Full Edit.

NOTE If you've used Elements 4 or earlier, you'll notice an important difference in getting to subtools in Elements 8: You can't switch from one tool in a subgroup to another by using the Options bar anymore. Now you can choose a tool from a group only by using the tool's pop-out menu in the Tools panel, or by pressing its shortcut key repeatedly to cycle through the tool's subgroup. Stop tapping the key when you see the icon for the tool you want.

POWER USERS' CLINIC

Doubling Up

If you have a single-column Tools panel and want a double-columned version instead (maybe you don't like your tools spread out so much, for example, or maybe the bottom of the Tools panel extends off the bottom of your screen), here's good news: Just click the double arrows at the top of the Tools panel and it changes to a nice, compact double-column panel, with extra large color squares (page 216). To switch back to one column, click the arrows again. Be careful, though—in Elements 8, you can close

the Tools panel just like any other panel by clicking the Close button (the dot) at the panel's upper-left corner (the dot appears when you drag the panel out of its standard location). To bring the panel back, go to Window → Tools. You can also move the Tools panel like any other panel, but you can't combine it with other panels or collapse it. If you want to hide it temporarily, press the Tab key and it disappears along with your other panels; press Tab again to bring it back.

Don't worry about learning the names of every tool right now, but if you want to see them all, they're on display in Figure 1-11. (It's easier to remember what a tool is once you've used it.) And don't be overwhelmed by all of Elements' tools. You probably have a bunch of Allen wrenches in your garage that you only use every year or so. Likewise, you'll find that you tend to use certain Elements tools more than others.

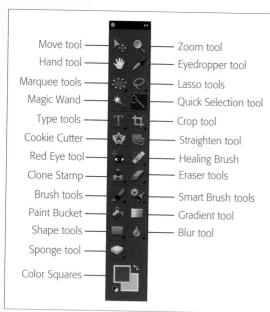

Figure 1-11:

The mighty Tools panel. Because some tools are grouped in the same slot (indicated by the little black triangles next to the tool icons), you can't ever see all the tools at once. (This Tools panel has two columns; the box above explains how to switch from one to two columns.) For grouped tools, the icon you see is the icon for the last tool in the group you used.

TIP You can save a *ton* of time by activating tools with their keyboard shortcuts, since you don't have to interrupt what you're doing to trek over to the Tools panel. To find out a tool's shortcut key, hover your cursor over its icon. A label pops up indicating the shortcut key (it's the letter to the right of the tool's name). To activate the tool, just press the appropriate key. If the tool you want is part of a group, all the tools in that group have the same keyboard shortcut, so just keep pressing that key to cycle through the group until you get to the tool you want.

FREQUENTLY ASKED QUESTION

The Always-On Toolbox

Do I always need to have a tool selected?

When looking at the Tools panel, you'll probably notice that one tool icon is highlighted, indicating that the tool is active. You can deactivate it by clicking a different tool. But what happens when you don't want *any* tool to be active? How do you fix things so that you don't have a tool selected?

You don't. In Elements, one tool always has to be selected, so you probably want to get in the habit of choosing a

tool that won't do any damage to your image if you accidentally click it. For instance, the Pencil tool, which leaves a spot or line wherever you click, probably isn't a good choice. The Marquee selection tool (page 125), the Zoom tool (page 86), and the Hand tool (page 88) are all safe bets. When you open the program, Elements activates the tool you were using the last time you closed the program.

Getting Help

Wherever Adobe found a stray corner in Elements, they stuck some help into it. You can't move anywhere in the program without being offered some kind of guidance. Here are a few of the ways you can summon assistance if you need it:

- Help menu. Choose Help → Photoshop Elements Help. Elements launches your web browser, which displays Elements' Help files, where you can search or browse a topic list and glossary. You'll also see a blue Search box where you can type in a search term. This doesn't search the Elements Help files, but rather lets you search the Elements menus, a cool feature, as explained in Figure 1-12.
- Tooltips. When you see a tooltip (page 27) pop up under your cursor as you move around Elements, check whether the tooltip's text is blue; if it is, that means it's linked to the appropriate section in Elements' Help. You can click blue-text tooltips for more info about whatever your cursor is hovering over.
- Dialog box links. Most Elements dialog boxes have a few words of bright blue text somewhere in them. That text is actually a link to Elements' Help. If you get confused about what Remove Color Cast does, for instance, then, in the Remove Color Cast dialog box, click the blue "color cast" text for a reminder.

Figure 1-12: You can easily find Elements menu items by typing the name of what you're looking for into this search box. For instance, if you don't know where the Gaussian Blur filter (page 392) is located, type in the word "Gaussian". and then click the file path that appears below the search box. Leopard expands your menus and displays a big, floating arrow to show you where to find it. (You need to have an image open to search all the menu items.)

Guided Edit

If you're a beginner, Guided Edit, shown in Figure 1-13, can be a big help. It walks you through a variety of popular editing tasks, like cropping, sharpening, correcting colors, and removing blemishes. It also includes some features that are useful even if you're an old Elements hand, like the Action Player (page 399) and the new Exposure Merge (page 251).

Guided edit is really easy to use:

1. Go to Guided Edit.

Click the Edit tab → EDIT Guided.

2. Open a photo.

Press \$\mathbb{H}\$-O, and then from the window that appears, choose your photo. If you already have a photo open, it appears in the Guided Edit window automatically. If you have several photos in the Project bin, you can switch between images by double-clicking the thumbnail of the one you want to work on.

3. Choose what you want to do.

Your options in the Guided Edit panel are grouped into major categories like Basic Photo Edits and Color Correction, with a variety of specific projects under each heading. Click a task in the list, and the panel displays the relevant buttons and/or sliders for that task.

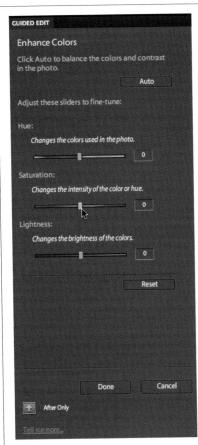

Figure 1-13:

Guided Edit gives you step-by-step help with basic photo editing. Just use the tools that appear in this panel once you choose a task. After you select a task, you can change the view to Before & After. Keep clicking the little blue button (circled) at the bottom of the window to toggle views between After Only, Before & After - Horizontal, and Before & After - Vertical.

4. Make your adjustments.

Just move the sliders and click the buttons till you like what you see. If you want to start over, click Reset. If you change your mind about the whole project, click Cancel.

If several steps are involved, Elements shows you only the buttons and/or sliders you need for the current step, and then switches to a new set of choices for the next step as you go along.

If you need to adjust your view of your photo while you work on it, Guided Edit has a toolbox that includes the Hand (page 88) and Zoom (page 86) tools to help you out.

5. Click Done to finish.

If there are more steps to your task, you may see another set of instructions. If you see the main list of topics again, you're all through. Don't forget to save your changes (page 59). To close your photo, press \(\mathbb{H}\)-W, or leave it open and switch to another tab to share it or use it in a project.

NOTE Guided Edit is a great tool for starting out; it shows you quick and easy ways to change your image. But remember that what you see here isn't necessarily the best you can possibly make your images look. Once you're more comfortable in Elements, Quick Fix (Chapter 4) is a good next step.

Escape Routes

Elements has a couple of wonderful features to help you avoid making permanent mistakes: the Undo command and the Undo History panel. After you've gotten used to them, you'll probably wish it were possible to use these tools in all aspects of your life, not just Elements.

Undo

No matter where you are in Elements, you can almost always change your mind about what you just did. Press \(\mathbb{H} - Z \), and the last change you made goes away. Pressing \(\mathbb{H} - Z \) works even if you've just saved your photo, but only while it's still open—if you close the file, your changes are permanent. Keep pressing \(\mathbb{H} - Z \) and you keep undoing your work, step by step.

If you want to *redo* what you just undid, press **%**-Y. These keyboard shortcuts are great for toggling changes on and off while you decide whether you really want to keep them.

TIP You have a bit of control over the key combination you use for Undo/Redo. If you don't like \Re -Z/ \Re -Y, go to Photoshop Elements \rightarrow Preferences \rightarrow General, where Elements gives you two other choices, both of which involve pressing the Z key in combination with the \Re , Option, and Shift keys.

Undo History panel

In the Full Edit window, you have even more control over the actions you can undo, thanks to the Undo History panel (Figure 1-14), which you open by choosing Window → Undo History.

Figure 1-14:

For a little time travel, just slide the pointer (on the left, under the cursor here) up and watch your changes disappear. You can go back only sequentially. Here, for instance, you can't go back to the Crop tool without first undoing what you did with the Paint Bucket, Deselect, and Eraser tools. Slide the pointer down to redo your work. You can also hop to a given spot in the list by clicking the place where you want to go instead of using the slider.

This panel holds a list of the changes you've made since you opened your image. Just drag the slider up and watch your changes disappear one by one as you go. Like the Undo command, Undo History even works if you've saved your file: As long as you haven't *closed* the file, the panel tracks every action you take. You can also slide the other way to redo changes that you've undone.

Be careful, though: You can back up only as many steps as Elements is set to remember. The program is initially set up to record 50 steps, but you can change that number by going to Photoshop Elements → Preferences → Performance and, in the History & Cache section of the dialog box, adjusting the History States setting. You can set it as high as 1,000, but remembering even 100 steps may slow your system to a crawl if you don't have a superpowered processor, plenty of memory, and loads of disk space. If Elements runs slowly on your machine, reducing the number of history states it remembers may speed things up a bit (try 20).

The one rule of Elements

As you're beginning to see, Elements lets you work in lots of different ways. What's more, people tend to approach projects in different ways. What works for your neighbor with her pictures may be quite different from how you'd work on the same shots.

But you'll hear one suggestion from almost every Elements veteran, and it's an important one: *Never, ever work on your original. Always, always, always make a copy of your image and work on that instead.* (If you use a program like iPhoto, it can make *version sets* for you. In other words, you can tell it to remember one edited version plus your original. See page 46 for more about version sets.)

You can easily make a copy of a file in the Finder before you even launch Elements. Click the file once to select it, and then press **%**-D, or Option-drag it away from the original and then let go of the mouse button. Either way, the new file automatically gets a name that lets you know it's not the original, one ending in "copy" or "2," for example.

Follow these steps to make a copy of your image in Elements:

1. Go to File → Duplicate.

You can also right-click (Control-click) the photo's Project bin thumbnail and choose Duplicate there.

2. Name the duplicate, and click the Close button on the original.

Now the original is safely tucked out of harm's way.

3. Save the duplicate using \%-S.

Choose Photoshop (.psd) as the file format when you save it. (You may want to choose another format after you've read Chapter 3 and understand more about your different format options.)

Now you don't have to worry about making a mistake or changing your mind, because you can always start over.

NOTE Elements doesn't have an autosave feature, so you should get into the habit of saving frequently as you work. Page 59 has more about saving.

Getting Started in a Hurry

If you're the impatient type and you're starting to squirm because you want to be up and doing something to your photos, here's the quickest way to get started in Elements: Adjust an image's brightness and color balance, all in one step.

1. Open a photo.

Press #-O and navigate to the image you want, and then click Open.

2. Press Option-\.M.

You've just applied Elements' Auto Smart Fix tool (Figure 1-15).

Voilà! You should see quite a difference in your photo, unless the exposure, lighting, and contrast were almost perfect before. The Auto Smart Fix tool is one of the many easy-to-use features in Elements. (Of course, if you don't like what just happened to your photo, no problem—simply press \%-Z to undo it.)

Figure 1-15: Auto Smart Fix is the easiest,

quickest way to improve the quality of your photos.

Top: The original, unedited picture.

Bottom left: Auto Smart Fix makes quite a difference, but the colors are still slightly off.

Bottom right: By using some of the other tools you'll learn about in this book (like Auto Contrast and Adjust Sharpness), you can make things look even better. If you're really raring to go, jump ahead to Chapter 4 to learn about the Quick Fix commands. But it's worth taking the time to read the next two chapters so you understand which file formats to choose and how to make some basic adjustments to your images, like rotating and cropping them.

Don't forget to give Guided Edit a try if you see what you want to do in the list of topics. Guided Edit can be a big help while you're learning your way around.

Importing, Managing, and Saving Your Photos

Now that you've had a look around Elements, it's time to start learning how to get photos *into* the program, and how to keep track of where these photos are stored. As a digital photographer, you don't have to deal with shoeboxes stuffed with prints, but you still have to face the menace of photos piling up on your hard drive. Fortunately, Elements gives you some great tools for organizing your collection and quickly finding individual pictures.

In this chapter, you'll learn how to import your photos from cameras, memory card readers, and scanners. You'll also find out how to import individual frames from videos, open files that are already on your computer, and create a new file from scratch. After that, you'll learn how to use Adobe Bridge to sort and find your pictures once they're on your Mac. Finally, you'll find out how to save the work you create in Elements and how to make backups.

NOTE In addition to the info about Bridge in this chapter, Appendix C (page 537) contains a complete list and descriptions of Bridge's menu items.

Importing from Cameras

You have four ways to get photos from your camera or memory card reader onto your computer:

NOTE Take a moment to read the instructions from your camera's manufacturer. If those directions tell you to do something differently than anything you read here, follow the manufacturer's instructions.

- iPhoto. Your Mac comes set up to launch iPhoto whenever it detects incoming photos from a camera or card reader, and that's convenient—if you want to use iPhoto. But if you prefer another program for organizing your photos, or if you just like to be disorganized, you don't have to use iPhoto.
- Image Capture. OS X also has a built-in downloading program called Image Capture, which you can set to open any program you like (you can have it open Bridge, for instance, if you want to first sort through your photos there).

Choosing the program that Image Capture launches works a little differently depending on whether you have OS X 10.5 or 10.6. In Leopard (10.5), start up Image Capture when you don't have a camera or card reader connected (go to Applications → Image Capture). (You'll see a window telling you that nothing is connected, but you know that, so ignore it.) Then go to Image Capture → Preferences and use the Camera pull-down menu to browse to the program you want to use. In Snow Leopard (10.6), wait till your camera or reader is connected to launch Image Capture, and then proceed as above. In 10.6 you can tell OS X to do different things for each device you connect, so you might choose to have iPhoto open when you plug in a camera and Image Capture when you plug in a card reader, for example. (You don't *have* to use any application to download photos, though, as explained later in this list.)

NOTE If you're downloading directly from a camera, be sure your camera is set to the correct mode for transferring files before you connect it to the computer. It's not a bad idea to use a card reader: It's slightly safer than getting photos directly from your camera and, if your camera has a USB 1.0 port, a USB 2.0 or FireWire card reader will be much faster. In addition, computers almost always recognize card readers, but they sometimes don't recognize cameras.

- Adobe Photo Downloader. This program came with Elements, and it's set up to grab your photos and launch Bridge so you can sort through them. (The Downloader isn't really an independent program—you have to launch it from Elements or Bridge, at least the first time you use it.) As with Image Capture, you can set the Downloader not to open Bridge (turn off the checkbox in the Downloader window). But for most people most of the time, the Downloader isn't very useful, and you can safely ignore it. The situations where the Downloader offers you an advantage are outlined on page 19. If the Downloader interests you, there are detailed instructions on how to use it on this book's Missing CD page at www.missingmanuals.com.
- Drag and drop. You don't actually need to use any program to get your photos onto your Mac. Dragging and dropping files is a popular method with people who don't want to launch a program to view newly downloaded images. To set things up this way, follow the directions given above for Image Capture, but instead of selecting a program from the pull-down menu, choose "No application". That way, the next time you plug in your card reader, it will appear on your desktop like a removable drive and you can drag the folder containing your photos to wherever you want it. (This method works much better with a card reader than with a direct camera download.)

Once you've downloaded your photos, be sure to eject the card before unplugging your card reader from the computer, as explained in Figure 2-1. (Applications like iPhoto have an Eject button or command right in the program.) Incidentally, it's best to let your *camera* erase photos from your memory card rather than using your computer to do that, since your camera understands its own file structure better than any computer does.

Figure 2-1:
If you prefer to drag your photos from the memory card instead of using Image Capture, be sure to properly remove your card or camera when you're done—don't just yank it out of the port. First, right-click (Controlclick) its icon on your desktop, and then choose Eject, or use the Eject button next to its name in a Finder window. The card might get damaged if you don't do this step.

Opening Photos in Elements

Now that your photos are on your Mac, you need to get them into Elements so you can work on them. This section explains the many ways to open files in Elements. One option is to use Bridge, Adobe's browsing program that comes with Elements, but you can do lots of things with Bridge besides open photos in Elements (see page 52) You'll also learn how to send photos to Elements from other programs, like Aperture or iPhoto. You can even browse for files to open in Elements without using any special programs like Bridge or iPhoto, as Figure 2-2 explains.

Bridge Basics

Instead of the Organizer that comes with the Windows version of Elements, you get Adobe Bridge, you lucky Mac person. Bridge is the ultra-deluxe file browser that comes with Photoshop CS4. (See the box on page 41 for the differences between the Elements and Photoshop versions of Bridge.) You can use Bridge to view and organize your picture files—and other kinds of files, if you want. You can do a ton of different things with your photos in Bridge: browse, arrange, categorize, delete, search, apply keywords, view, edit, and apply metadata info (page 55). This section just explains the minimum you need to know to find your way around Bridge. The more advanced features are discussed later in this chapter, beginning on page 52.

Figure 2-2: The Finder makes a handy photo browser. First, open a Finder window (click once on vour desktop and then press %-N) and click the button for Cover Flow view (circled). In the top of the Finder window. vou can auickly scroll through thumbnails of any folder's contents. To aet a closer look at a photo, right-click (Control-click) its name in the list in the bottom half of the window, and then choose Quick Look or press the space bar. A larger view of your image appears, but the file doesn't actually open. You can even aet a full-screen view of it by clicking the arrows at the bottom of the preview window (where the cursor is here); click the arrows again to close the full-screen view. To close the preview, click the X in the upper left of the window (or at the bottom of the window if vou're in full-screen view).

If you're already in Elements, you can launch Bridge by going to File \rightarrow "Browse with Bridge", or by clicking the orange square with "Br" on it next to the New File button in the Shortcuts bar (in the upper-left part of your screen, just above the Options bar). If Elements isn't running, go to Applications \rightarrow Adobe Bridge CS4 and double-click Adobe Bridge CS4.

The Bridge window

If you launch Bridge from Elements, the Elements window moves to the background and the Bridge window appears in front of it. If you used the old File Browser that came with early versions of Elements, you should understand Bridge's layout right away, and it's pretty straightforward even for newbies.

NOTE The first time you launch Bridge, it asks if you want it to start up automatically every time you log in. You don't have to decide now. You can tell Bridge to do that anytime by going to Adobe Bridge CS4 → Preferences → Advanced.

FREQUENTLY ASKED QUESTION

Bridge: Elements vs. Photoshop

Do I get the full version of Adobe Bridge with Elements?

Almost. You get nearly every useful feature from the more exalted Photoshop version of Bridge, minus a few not-very-critical ones. For instance, you don't get the meetings feature, which lets graphics pros collaborate on projects, but that isn't a big deal for most people who use Elements.

The one big feature in Bridge for many people is the complete Adobe Raw Converter (see page 232 for more about Raw).

While Elements includes a somewhat simplified Converter, opening your photos from Bridge gives you every single tool that comes with the Photoshop version. Page 235 has more about how to do this, and you can edit all image formats there, not just Raw files.

Incidentally, if you happen to have both Elements and Photoshop CS4 installed on your Mac, when you install Elements, you automatically get access to all Creative Suite CS4's features, whether you access Bridge from Photoshop or from Elements.

Like the windows in your house, the Bridge window is divided into panes, which are similar to the bins in Elements. Within each pane are tabbed panels, which are something like Elements' panels—you can move and combine them, but they never come out of the panes (you can drag a panel from one pane to another, though).

At the very top of the window are a number of shortcuts for navigating through your images, viewing recent files, launching the Photo Downloader (page 19), sending selected files to projects like contact sheets and web galleries, and customizing the workspace as explained below. Below that is the helpful *Path bar*, where you can see the file path for the currently selected file or folder, control how Bridge displays thumbnails, rate your photos, rotate and sort them, create new folders, open recent files, and delete files.

On the left side of the Bridge window is the Favorites panel; the Folders panel (which is covered by the Favorites panel; it gives you a folder view of your hard drive); the Filter panel, which you can use to set search criteria (it starts you off with some basic info about the folders you can see right now); and the Collections panel, where you can gather photos into groups to use in projects. The middle area of the window—the Content panel—shows all the folders and images at the level of your hard drive selected in the Favorites or Folders panel.

The upper-right part of the Bridge window shows a larger preview of any image(s) you select, and the bottom right has panels for keywords and metadata (these are explained on page 55). You aren't stuck with this view, though. You can customize Bridge's layout (called your *workspace*), as explained below. For now, what you need to know is that to see the contents of a folder, you click its thumbnail (double-click in the Content panel, single click in the Favorites or Folders panel), or use the handy command shown in Figure 2-3. You can see any folder on your hard drive by selecting it in the Folders or Favorites panel.

Figure 2-3: Top: Feeling too lazy to open all those folders to see what's in them? No problem.

Bottom: Go to View →
"Show Items from
Subfolders" and Bridge
displays the contents of
all the folders and
subfolders currently in
the Content panel, as
well as the folders
themselves. (If you don't
want to see the folders,
go to the View menu and
turn off Show Folders,
and you see only their
contents, as shown
here.)

Use the slider at the bottom right of the Bridge window to change the size of the thumbnails. To see even more detail, in the Preview panel, click the area of your photo you want to examine. Bridge presents a cool loupe view that ultra-magnifies the spot you clicked. (A *loupe* is the kind of magnifying glass jewelers use.) Click another spot, and the loupe moves there. You can also drag the loupe around in your photo. This feature is great for things like finding the best-focused shot in a group of similar photos.

IMG 0016

. IPC

IMG 0017

JPG

To see more than one photo at a time in the Preview panel, select all the photos you want to view. You can have a separate loupe on each photo so you can compare the differences between shots. Click on a loupe to make it go away.

IMG 0010

JPG

IMG_0011

JPG

IMG 0012

JPG

IMG_0013

IPC

IMG_0014

IPC.

IMG 0015

.IPG

Figure 2-6:
You can open multipage
PDF files in Elements. To
open just one page of the
file, double-click the
page's thumbnail. To
open multiple pages of
the file, Shift-click or %
click to select the pages
you want before you
double-click to open
them

To control your scanner from within Elements, go to File → Import, and you'll see your scanner's name on the list that appears. If you have a Mac with an Intel processor and your scanner driver (the software that lets it talk to your computer) is old, you may see the message shown in Figure 2-7 when you start up Elements.

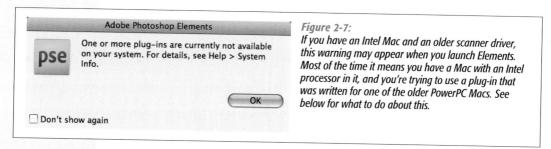

Unfortunately, as explained back on page 4, Adobe decided not to let Elements 8 run in Rosetta, the part of OS X that allows programs written for the older PowerPC Macs (G5 and earlier) to run on Intel Macs. So your old scanner plug-in isn't going to work in Elements 8. There are a couple of workarounds: You can keep an older version of Elements around for scanning, if you have one, or you can use the standalone scanner software that your scanner manufacturer may provide. In OS X 10.6, you can also scan from Preview and send the scan straight to Elements. To do that, launch Preview with your scanner connected and then go to File → Import from Scanner. You can even tell Preview to send your scan to Elements when

Another way to send photos to Elements is to use your organizing program's Export command (it's usually under File → Export) to send them to your desktop. Next, open them in Elements, save them under a new name, and then import the edited files back into whatever program you started in. This is more of a nuisance, but it has the advantage of letting you save as many different edits of your photo as you like, as long as you give each version a new name.

INFORMATION STATION

Bridge for People Who Don't Use Bridge

As stated on page 18, if you already use another program to organize your photos (like Aperture, iPhoto, or Lightroom), most of the time you're better off sending your photos directly to Elements from within your organizing program. One of the nice things about Bridge is that, unlike the Organizer in the Windows version of Elements, Bridge doesn't care whether you use it.

However, you may want to check out the Elements web galleries that only work from Bridge. Or maybe you occasionally want to use Bridge, like the way some people only use iPhoto to create projects like slideshows. For

example, Bridge can be helpful for tracking down photos that never made it into your regular organizing program.

There are a few Bridge basics you should understand even if you don't plan to use it much. They're explained on page 39. At the very least, you should set the file associations for Bridge in case you ever want use it for anything, and while you're in Bridge, you might want to set up your workspace to suit you (see page 44).

Working with PDF Files

If you open a PDF file in Elements, you'll see the Import PDF dialog box (Figure 2-6), which gives you options related to how you want Elements to treat your file. You can import whole pages or just the images on the pages, import multiple pages (if the PDF is more than one page), and choose the imported pages' color mode (page 51) and resolution, as well as whether you want Elements to use anti-aliasing (page 137).

Scanning Photos

Elements comes bundled with many scanners because it's the perfect software for making scans look their best. You have two main ways of getting scans into Elements. Some scanners come with a *driver plug-in*, a little program that lets you scan directly into Elements. Look on your scanner's installation software for info about Elements compatibility or check the manufacturer's website for a Photoshop plug-in to download. (If you can scan into Photoshop, you should be able to scan into Elements.) You may also be able to scan into Elements if your scanner uses the *TWAIN interface*, which is an industry standard used by many scanner manufacturers.

Figure 2-5:

The easiest way to call up Bridge from Elements is to click this icon, but you can also go to File \rightarrow "Browse with Bridge". Select the photo(s) you want to work on, and then double-click them to open them in Elements. You can also launch Bridge from Elements' Welcome screen (page 15).

Sending Images from Other Programs

If you use a program other than Bridge to keep track of your photos (like iPhoto or Lightroom) but you want to open them in Elements, it's best to send your photos from that program to Elements rather than trying to find them using Elements or Bridge.

There are two reasons for this. First, you can corrupt your library file—the program's database of your photos—by poking around in it from outside the program that owns it. (This is especially true of the iPhoto library file—never try to see into that file from outside iPhoto.) Secondly, most photo-organizing programs can create version sets if you send photos over for editing in a way they can understand. A version set means that iPhoto, say, keeps a record of your original image and the saved, edited version you create in Elements, as long as you don't change the file name. iPhoto keeps only one version plus the original (the next time you edit, the previously saved version is lost), but other programs can keep more.

To send a photo to Elements:

- From iPhoto. Go to iPhoto → Preferences, and in the upper section of the dialog box that appears, make sure General is selected; in the Edit Photo menu, select "In Application", and then choose Elements from the list. After that, when you want to edit a photo in Elements, you just double-click it in iPhoto and the program automatically sends it to Elements for editing. (In that same preferences window, you may need to go to "Double-click photo" and choose Edit Photo to make this happen. If you prefer to leave this option set up so that a double-click magnifies the photo instead, you can open the photo for editing by right-clicking [Control-clicking] its thumbnail and choosing "Edit in External Editor" from the menu that appears.) When you're done, just save your changes and iPhoto remembers them (don't use the Save As command and rename your file or iPhoto won't create a version set for it—see above).
- From Aperture. Pretty much the same as iPhoto: In Aperture's preferences, choose Elements as your external editor, and then right-click (Control-click) a thumbnail and select "Open with External Editor".
- From Lightroom. Go to Lightroom → Preferences, click the External Editor tab, and then browse to Elements. Then, when you're in the Edit or Library modules, right-click (Control-click) a thumbnail and choose the external editor.

There are lots of other programs you can use to manage your files, and the majority of them have similar settings.

Figure 2-4: You can create as many workspaces as you want. Just go to Window → Workspace → New Workspace and give your workspace a name in the window that opens. You can also choose to save your sort order (see page 546) so that you can create different workspaces for different sorts. For example, you can have one workspace where your photos are sorted by name, and another where they appear by rating. Once you create a workspace, its name appears as a button at the top of the Bridge window. You can switch from one to another by clicking the name of the workspace you want. Draa the dotted lines (circled, where the cursor is) to the left if you can't see all your workspaces' names.

Opening Stored Images

Adobe gives you several ways to open photos in Elements:

- From the Finder. If the image is one whose file type is set to automatically open in Elements, just double-click the file's name to launch Elements (if it's not already open) and open your image in the main editing window. If it's a file that's not set to open in Elements, drag it to the Elements icon in the Dock, or right-click (Control-click) the photo's icon, and then choose Open With → Adobe Photoshop Elements.
 - **TIP** To change which application opens files of a particular type, in the Finder, find a file of that type. Click once to select it, and then press **%**-I. This brings up the Get Info window, which has lots of data about your file. Expand the Open With section by clicking the flippy triangle next to it, choose the program you want from the pull-down menu, and then click the Change All button. Voilà—from now on, those kinds of files will open in the program you chose.
- From Adobe Bridge. Click once on a thumbnail to select it, or select multiple thumbnails by Shift-clicking (to select a range) or ૠ-clicking (to select scattered files). Then press ૠ-O, double-click the file(s), or go to File → Open. Your photos open in Elements, as long as you've set the Bridge file associations for them to do so (see page 43).
- From Elements. Press #-O or go to File → Open and navigate to the file you want to open. If you'd rather choose your photos in Bridge, click the "Browse with Bridge" icon (circled in Figure 2-5) in the upper-left part of the Elements window or use one of the other methods described in Figure 2-5.

TIP You can speed things up by turning on the Hide Undefined File Associations checkbox at the bottom of the Preferences window before you start, since those undefined file types aren't ones you'll likely use in Elements.

Customizing your Bridge workspace

You may not be thrilled with the view you get when you first launch Bridge: There's a limit to how large you can make the thumbnails, and the Preview panel isn't very big. Not to worry—you can adjust your view (a.k.a. your workspace) in all sorts of ways. To start, go to Window → Workspace.

The submenu that appears gives you a choice of no less than six layouts. You can choose myworkspace, for instance, to see a large Preview panel with the Content panel as a scrolling line of thumbnails across the bottom of the window. There are keystroke shortcuts for changing workspaces, too, which you can see next to their names in the menu. Your workspace options are described in detail in Appendix C (page 550).

What's more, you can move the panels around to suit you, and hide ones you don't want:

- Move a panel. Drag it by its top tab (the one that says Content or Preview or whatever) to where you want it. You can combine panels to make a multitabbed panel, like you can do with Elements' panels (see page 24). Bridge panels never float, though—they always have to be in one of the panes.
- Add or remove a panel. Go to the Window menu and select a panel you want to appear in Bridge. Select it again to turn it off. (Visible panels have checkmarks next to their names.)
- Collapse a panel. To temporarily get a panel out of your way, double-click its tab and it collapses. Double-click the tab again to expand it. You can also double-click the edge of a *pane* to collapse it, and then double-click it again to bring it back.

After all that work customizing Bridge, you'll be pleased to know Bridge remembers how you left things when you closed the program last time. What's more, you can create multiple customized workspaces and save them as explained in Figure 2-4.

There's more about Bridge's many other features later in this chapter, starting on page 52.

TIP Like iTunes, Bridge has a compact mode that turns it into a smallish window that doesn't take up much of your desktop. Press **ૠ**-Return, click the button in the upper-right corner of the Bridge window, or go to View → Compact Mode to shrink Bridge. Do the same thing to return it to full size (in the View menu, choose Full Mode).

You can use the left- and right-facing arrows at the top left of the Bridge window (or the pull-down menu next to them that shows as a down-facing arrow) to move backward and forward through the folders you're looking in. To move up or down through your folder structure, click where you want to go in the Path bar (if it's not visible, go to Window → Path Bar to call it up).

You can also browse through all the photos in a folder as a slideshow by going to View → Slideshow (press Esc to leave Slideshow view). You can change the settings for Slideshow view in View → Sideshow Options. (This is just a way of browsing through your photos—you can't save a slideshow from this menu item. See page 455 for info about creating slideshows you can save and share, although slideshows aren't one of Elements 8's strong points.)

You can rearrange the Bridge window in a number of ways, but before you do that, there's one very important task you need to perform: Choosing your file associations.

Setting file associations

If you've already played around with Bridge, you may have had one of those "What the...?" moments. Say you found a JPEG file you wanted to edit, confidently double-clicked it, and the photo opened in...Preview? Yes, you've learned the hard way that Bridge isn't wedded to Elements even though it comes with it. Bridge is a general file browser, and it can send photos to lots of different programs. It was designed for use with Adobe Creative Suite, where you might use it to send TIFF files to Photoshop, Illustrator files to InDesign, and so on.

TIP Bridge isn't just for photos. You can see all kinds of files in Bridge, and even watch movies from your digital camera in the Preview panel.

To make Bridge open your photos in Elements, you may have to tell Bridge that's what you want. (Bridge comes already set up to open most graphics formats in Elements, but you may want to change how it behaves.) Go to Adobe Bridge CS4 → Preferences, and then click File Type Associations on the left side of the dialog box that appears. That brings up an impressive list of *all* the types of files that Bridge recognizes. Next to each type is the application that Bridge will use to open those kinds of files. What you need to do is to go through the list and tell Bridge to open your image files in Elements (see page 59 for more about file formats).

To do that, skim through the list and, for the file types that aren't set properly, click the name of the current program for a pull-down menu where you can choose Elements. It's a bit of a nuisance to have to do this, but you only have to do it once—Bridge remembers your choices. Note that this only changes where Bridge opens files. If you normally open JPEGs from the Finder in Preview, say, that won't change.

You don't need to do anything about file types you won't open, or won't open in Elements (like .cda files from compact disk recordings, for instance). Likewise, if you have a Nikon camera, you don't care about the file associations for Canon Raw files (.cr2). If you stick to the file types you expect to use, it doesn't take long to go through the list.

you're done scanning. However, if you have a really old scanner, 10.6 may not acknowledge its existence, in which case you have to use the software provided by the manufacturer.

If you don't have an Elements plug-in for your scanner and the Adobe TWAIN driver doesn't work for you, you'll have to use the scanning program that came with your scanner. Then, once you've saved your scanned image in a format that Elements understands, like TIFF (.tiff, .tif) or Photoshop (.psd), open the file in Elements like any other photo.

TIP If you do a lot of scanning, check out the Divide Scanned Photos command (page 67) to learn how to scan in lots of photos at the same time. Also, you can save yourself a lot of drudgery in Elements if you make sure that both your scanner's glass and the prints you're scanning are as dust-free as possible before you start.

Capturing Video Frames

Elements lets you snag a frame from a video and use it the way you would any still photo. This feature works only for videos that are already on your computer (as opposed to streaming video from the Internet, for example).

Elements can open video files in most formats your Mac can open. But Elements *can't* open Windows Media files (.wmv files) or any video files that include *DRM* (digital rights management, which is code that restricts who can view the file).

NOTE Elements' video-capture tool isn't really designed for use with long movies. You'll get the best results with clips that are less than a minute or two long.

To import a video frame, go to File → Import → Frame From Video, and then in the Frame From Video import dialog box:

1. Find the video that contains the frame you want to copy.

Click the Browse button and navigate to the movie file you want. After you choose the movie, the first frame appears in the dialog box's preview window.

2. Navigate to the frame you want.

Either click the Play button or use the slider below the dialog box's window to move through the movie until you see what you want.

3. Copy the frame by clicking the Grab Frame button.

You can grab as many frames as you want. Each frame shows up in Elements as a separate file.

4. When you have everything you need, click Done.

While grabbing video frames is fun thing to do, it has certain limitations. Most important, your video appears at a fairly low resolution, so don't expect to get a great print from a video frame.

Creating a New File

You can create a new, blank Elements document when you're using Elements as a drawing program or when you're combining parts of images together, for example. To create a new file, go to File \rightarrow New \rightarrow Blank File (or press \Re -N) to bring up the New File dialog box. You have lots of choices to make each time you start a new file, including what to name it. All your options are covered in the following sections.

Picking a File Size

The next thing you need to decide after you name your new file is how big you want it to be. Elements 8 gives you two ways to do this:

• Start with a Preset. Preset, the second item in the New File dialog box, lets you choose the general kind of document you want to create. If you plan to print the file, pick from the second group in the menu. The third group contains choices for onscreen viewing. Once you make a selection in this menu, the next menu—Size—changes to display suitable sizes for your choice. Figure 2-8 shows how it works.

TIP If you're into scrapbooking, you'll be pleased to see that Elements offers some standard scrapbook page sizes as presets.

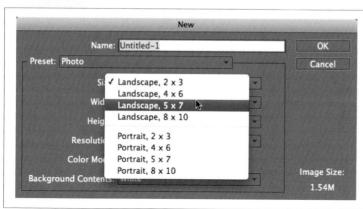

Figure 2-8:
Elements helps you pick an appropriate size when you use the Preset menu. Choose a general category—here, Photo is selected. The Size menu then changes to show you standard photo paper sizes, each available in either landscape or portrait orientation. Default Photoshop Elements Size is 4"×6" at 300 pixels per inch, which works well if you're just playing around and trying things out.

• Enter the numbers yourself. Ignore the Preset and Size menus and type what you want in the Width and Height boxes. You can choose inches, pixels, centimeters, millimeters, points, picas, or columns as your unit of measurement. Just pick the unit you want in the boxes' pull-down menus and then enter a number.

Choosing a Resolution

If you decide not to use one of the presets, you need to choose a resolution for your file. You'll learn a lot more about resolution in the next chapter (page 90), but a good rule of thumb is to go with 72 pixels per inch (ppi) for files that you'll look at only on a monitor, and 300 ppi for files you plan to print.

Selecting a Color Mode

Elements gives you lots of color choices throughout the program, but *color mode* is probably your most important one because it determines which tools and filters you can use in your document. Your options in the Color Mode menu are:

- RGB Color. Choosing this mode (whose name stands for red, green, and blue) means that you're creating a color document, as opposed to a black-and-white one. You'll probably choose RGB Color mode most of the time, even if you don't plan on having color in your image, because this mode gives you access to all of Elements' tools. (Page 200 has more about color in Elements.) You can use RGB Color mode for black-and-white photos if you like, and many people do, since it gives you the most options for editing your photo.
- Bitmap. Every pixel in a bitmap mode image is either black or white. Use Bitmap mode for true black-and-white images—shades of gray need not apply here.
- Grayscale. Black-and-white photos are called *grayscale* because they're really made up of many shades of gray. In Elements, you can't do as much editing on a grayscale photo as you can in RGB (for example, you can't use some of Elements' filters on a grayscale image).

NOTE Sometimes you may need to change the color mode of an existing file to use all of Elements' tools and filters. For example, there are quite a few things you can do only in RGB color mode. So if you need to use a filter (page 383) on a black-and-white photo and your choice is grayed out in the Filter menu, go to Image \rightarrow Mode and select RGB Color. Changing the mode won't suddenly colorize your photo; it just changes the way Elements handles the file. (You can always switch back to the original color mode when you're done.) If you use Elements' "Convert to Black and White" feature (page 299), you still have an RGB-mode photo afterward, not a grayscale-mode one.

If you have a 16-bit file (page 247), you need to convert it to 8-bit color or you won't have access to many of Elements' commands and filters. Make the change by choosing Image \rightarrow Mode \rightarrow 8 Bits/Channel. You're most likely to have 16-bit files if you import your images in Raw format (page 232); some scanners also let you create 16-bit files. JPEG files are always 8-bit.

Choosing Background Contents

The last choice you have to make when you start a new file is what you want as the file's *background contents*. This setting tells Elements what color to use for the empty areas of the file, like the background. You can be a traditionalist and choose white (almost always a good choice), or pick a particular color or *transparency* (more about transparency in a minute). To select a color other than white, use the Background color square, as shown in Figure 2-9.

"Transparent" is the most interesting option. To understand transparency and why it's such a wonderful invention, you need to know that *every* digital image is either rectangular or square. A digital image *can't* be any other shape.

Figure 2-9:

To choose a new Background color, click the Background color square (the aqua one shown here) to bring up the Color Picker. Then select the color you want. Your new color appears in the square, and the next time you do something involving the Background color, that's the shade you get. The color-picking process is explained in detail on page 216.

But digital images can *appear* to be a different shape—sunflowers, sailboats, or German Shepherds, for example. How? By placing your object on a transparent background so that it looks like it was cut out and only its shape appears, as shown in Figure 2-10. The actual photo is still a rectangle, but if you placed it into another image, you'd see only the shell and not the surrounding area, because the rest of the photo is transparent.

Figure 2-10:
This checkered background doesn't mean you've somehow selected a patterned background; it's Elements' way of indicating that an area is transparent. If you place this photo into another image, all you'll see is the seashell, not the checkerboard or the rectangular outline of the photo. If you don't like the size or color of the grid, you can adjust them in Photoshop Elements → Preferences → Transparency.

To keep the clear areas transparent when you close your image, you need to save the image in a format that allows transparency. JPEGs, for instance, automatically fill transparent areas with solid white, so they're not a good choice. TIFFs, PDFs, and Photoshop files (.psd), on the other hand, let the transparent areas stay clear. Page 476 has more about which formats allow transparency.

The Many Uses for Bridge

Earlier in this chapter, you learned the basics of finding photos with Adobe Bridge. But you can do lots more with Bridge than that: You can use it to organize your photos; search for photos; assign keywords, labels, and ratings to them; and create and edit their metadata (page 55).

Before you do anything in Bridge, there's one important thing you should understand: When you move or delete a file in Bridge, you're moving or deleting *the original*. Bridge doesn't keep copies of your images or need to have a perfect database of them all the time. It's just for browsing files.

One benefit of this is that Bridge doesn't care what you do to your photos when you're not in Bridge. Unlike iPhoto, which wants you to use it for all your photomoving tasks, Bridge just shows you your files and folders as they are right now. If you move a file from the Finder, Bridge won't complain that it can't find that file anymore, the way other organizing programs do when you don't use them for every move you make with the photos you've catalogued with them.

Moving and Organizing Your Photos

Bridge is great for arranging your photo collection. In Bridge, you can:

- Move a photo or folder. To move a photo, drag it to where you want it. Use the Folders panel (page 41) to find the folder you want to put it in (just keep clicking the flippy triangles to expand your view down to the folder you want), and then drag the photo's thumbnail to the folder's icon. You can move folders by dragging, too. You can also drag a photo, a group of photos, or a folder out of Bridge onto the OS X desktop. Then you can store it on the desktop or drag it into another program.
 - **TIP** Option-dragging a file copies it to the new location instead of moving the original.
- Create a new folder. In the Folders panel, click where you want your folder to appear, and then go to File → New Folder or click the New folder icon (in the upper right of the Bridge window) and then name your folder.
- Delete a photo. Click to select a photo (or photos), and then click the Delete icon (the little trashcan in the upper right of the Bridge window). Bridge sends your selection to the OS X trash, so if you change your mind, you can retrieve it—as long as you haven't emptied the trash. You can also select a photo and press the Delete key to bring up a window that lets you delete the photo (send it to the trash) or assign it the Reject rating (page 54).
- Rename photos. Click a thumbnail, and then click its name and type the new one. You can also batch rename in Bridge (see page 548 to learn how).
- Sort Photos. Select a group of photos and right-click (Control-click) one for a pop-out menu. Choose Sort from the menu and you get a submenu offering a long list of sorting options, like date created, file size, and file name. You can also choose to sort in ascending or descending order.
- Stack Photos. If you want to tidy things up, you can group related photos into *stacks* so that you only see one image from the group unless you expand the stack. To create a stack, select the photos you want to include, and then press

 \Re -G or go to Stacks → Group as Stack. Bridge groups the photos so they only take up as much space as one unstacked photo, and you see the stack icon shown in Figure 2-11, which explains how to expand stacks. To unstack photos, expand the stack, select all the images in the stack, and then press Shift- \Re -G, or go to Stacks → Ungroup from Stack.

Figure 2-11:

When you stack photos in Bridge, you see this distinctive icon with the number of photos in the stack in its upper-left corner. To expand the stack and see all the photos, press \(\mathbb{R}\) and the right arrow key; to collapse it again, press \(\mathbb{R}\) and the left arrow key. If you double-click a stack, you open all the photos in the stack in Elements (or whatever program you've set for that file type—see page 43). If you have at least ten photos in a stack, you can click the stack to see the controls shown here. Press the Play button (the triangle) to see your photos one after the other in a sort of animated preview, or use the slider (the black circle in the gray bar) to scroll through the stack.

Rating and Labeling Photos

In Bridge, you can assign star ratings and labels to your photos to make it easier to sort through them and find the ones you want. Here's how:

- Ratings. Click a photo, and then press \(\mathbb{H} \) and the number key for the amount of stars you want to give it (between 1 and 5), or go to the Label menu and choose a rating there. To change a rating, just apply a different one, or press \(\mathbb{H} \)-0 (that's the number zero) to unrate your photo. Once you've rated your photos, you can go to the Path bar's pull-down menu (the down-facing triangle next to the star) and search for photos with specific ratings. You can also assign a special red Reject tag to photos you're displeased with by pressing Option-Delete. This doesn't delete them; it just marks them so you can find them easily later. (You can show or hide your rejected files using the View menu.)
- Labels. You can assign labels to photos, which appear as colored bars beneath their thumbnails. You get five label colors to use, four of which have keyboard shortcuts assigned to them (to apply them, press **%** and a number key from 6 to 9). Or you can right-click (Control-click) a photo's thumbnail and choose a label from the pop-out menu. If you go to the Label menu, you can see how Adobe pre-assigned the labels. But head to Adobe Bridge CS4 → Preferences and then click the word "Labels" on the left side of the dialog box and you can enter any label text you want, and it'll appear in the Label menu instead. You can also use labels as criteria in the Filter panel (page 58). To remove a label from a photo, select the photo, and then go to Label → No Label.

POWER USERS' CLINIC

Metadata and Metadata Templates

The information about a photo that is stored in the image's file is called *metadata*. Metadata includes *EXIF* (Exchangeable Image Format) data, which is info your camera records about the photo, including what camera you used, when you took the picture, the exposure, file size, ISO speed, aperture setting, and much more. By paying attention to EXIF data, you can learn a lot about what makes for good shots—and what doesn't. Bridge displays some EXIF info in the *metadata placard*, the gray rectangle at the top left of Bridge's Metadata panel that displays the shooting settings (the aperture, the shutter speed, and so on) the way you'd see it on your camera's screen.

There are many kinds of metadata besides camera info, and Bridge gives you a lot of control over your metadata. For instance, you can add metadata—like a description of your image or copyright info—to the file. One way to do this is in the Metadata panel. Scroll down it, and you see a huge list of metadata types (the categories you can edit

have a tiny pencil icon on their right). Click one of the categories, and then you can type in any of the boxes. This is a great way to add metadata to a single photo, but Bridge also lets you apply metadata to a bunch of files at once. (For Raw files, Bridge can't write to the file, so your metadata gets stored in a separate XMP file in the folder with the image. See page 232 for more on Raw files.)

Creating a metadata template sounds technical and scary, but it's actually an easy and useful thing to do. You can create a template that lists you as the author of a photo, the terms under which people can use it, your contact info, and your website's address—so all that info is stored right in the photo file. To make a template in Bridge, go to Tools → Create Metadata Template, and you see the window in Figure 2-12.

You can view metadata in Elements and add metadata to a single file by going to File → File Info, or pressing Option-Shift-%-I.

rem	emplate Name: Untitled		
Cho	ose the metadata to i	nclude in this template:	
W	IPTC Core		
L	Creator		
	Creator: Job Title		-
1	Creator: Address		
[Creator: City		
	Creator: State/Province		\dashv
1	Creator: Postal Code		
	Creator: Country		
1	Creator: Phone(s)		
1	Creator: Email(s)		-
1	Creator: Website(s)		
1	Headline	1	
1	Description		
1	Keywords		
1	IPTC Subject Code	¥	_
1	Description Writer		
1	Date Created		
1	Intellectual Genre		
1	IPTC Scene		
1	Location		
11	City	1	

Figure 2-12:
To add metadata to your images, type the info you want to include into this window, name the template, and then click Save. To add that template info to photos, select them in Bridge and then go to Tools → Append Metadata and choose the template (you can create as many metadata templates as you want). Be sure not to choose Replace Metadata, since that will obliterate the existing metadata in your file(s).

Keywords

One of the most useful things you can do in Bridge is assign descriptive keywords to your photos to help you find them. Bridge writes these keywords into the file's metadata (see the box on page 35) so that any program that understands metadata—and there are a lot of them—can read them. So, for instance, you can use OS X's Spotlight to search for the keywords in your files, even when Bridge and Elements aren't running. Moreover, when you send photos to other people, they can see the keywords in Elements, Photoshop, or any other program that understands metadata. Once you've assigned keywords, it's easy to search by them in Bridge, as explained in the next section. Here's how to assign and work with keywords in Bridge:

• Assign a keyword. First make sure the Keywords panel shown in Figure 2-13 is visible (if it's not, go to Window — Keywords Panel). Select a photo, and then click the plus-shaped New Keyword button at the bottom of the panel, or click the icon on the upper right of the panel and, from the pop-out menu that appears, choose New Keyword. Either way, enter your keyword in the text box that appears and turn on the checkbox next to it to assign it to your photo. Once you've created a keyword, you can assign it to several photos at once by selecting them and then turning on the keyword's checkbox.

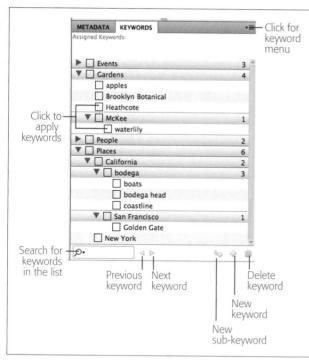

Figure 2-13:

You can use menu commands to create new keywords, but the simplest way is to use these icons. (The Delete keyword button just removes the keyword from the list of keywords, not from your photos. Select the photo and then turn off the keyword in the Keyword panel to remove it from that photo.) The search box isn't for finding images tagged with a particular keyword—it's for keyword mavens who create so many keywords that they need a way to find a particular keyword in the Keyword panel's list. The arrows to the right of the search box let you navigate forward and back through keywords in the order you've used them. The number to the right of a keyword tells you how many sub-keywords are under that keyword.

- Remove a keyword from a photo. Select the photo and, in the Keywords panel, turn off the checkbox next to the keyword you want to get rid of.
- Remove multiple keywords from a photo. Select the photo, click the tiny icon in the Keyword panel's upper left, and then choose Remove Keywords.
- Delete a keyword. Click an item in the Keyword panel list to highlight it, and then click the Delete icon (the trashcan) in the bottom-right corner of the panel or go to the panel's upper-right menu and choose Delete. This doesn't remove it from your photos, only from the list. You need to remove it from individual files, too, to completely get rid of it.
- Change a keyword. Click it in the Keyword panel list, and then go to the panel's menu (click the icon in the upper right), choose Rename, and then type the new keyword.

You can also create as many hierarchical levels of keywords as you want by creating sub-keywords. To do that, click a keyword in the Keyword panel list, and then click the New Sub Keyword icon at the bottom of the panel. You can also drag an existing keyword onto another one to make it a sub-keyword of the target keyword.

COMMUNICATION STATION

Bridge, Keywords, and Other Programs

What happens when you have photos that you assigned tags or keywords to in a program other than Bridge, or when you want to share your Bridge keywords with people using a different program?

You might run into this situation if you've switched from Windows and you used the Windows version of Elements to tag your photos. How can you bring that info into the Mac version? Easy: In Windows, before you copy your photos to your Mac, go to Organizer → File → "Write Tags and Properties to file(s)" (the exact wording of the command depends on which version of Elements you have). That turns your tags into metadata keywords that Bridge can see. (Unfortunately, if you have Raw files—page 232—this command doesn't work reliably, but it works fine for other formats.) You'll lose any categories you assigned in Windows, though, so it's best to assign those as tags before writing the tags to the files. And you'll

need to re-establish any hierarchies you had by creating sub-keywords in Bridge (above).

If you use a recent version of iPhoto, the program should find your Bridge keywords automatically, and display them in the iPhoto Keywords area. However, this is a one-way street: iPhoto uses a tag system that Bridge doesn't understand, but if you do a search on Google, you can find scripts that will write the iPhoto keywords as metadata keywords.

If you import photos from other programs, any metadata keywords that you assigned to them in the other programs should appear in Bridge's Keywords panel under "(Other Keywords)". Just drag these keywords to where you want them. You can make it a sub-keyword and so on, just like the Bridge keywords you create yourself (see page 56).

Searching and Filtering

Keywords and metadata aren't very useful unless you can find them again. Luckily, Bridge gives you two different ways to do just that: filtering and finding.

Bridge has a Filter panel that lets you restrict what you see in the thumbnails section using a variety of different criteria. You can view only photos with three-star ratings, for instance, or photos taken at ISO 200. The filtering options available to you are restricted to whatever is currently in Bridge's Content panel. So, for instance, if you have photos with the keywords "sports," "heli-skiing," and "broken leg" in the Content panel, those keywords appear as filter criteria. If you're looking at photos of your nephew's cello recital, you'll see different keywords listed.

You also get the Find window shown in Figure 2-14, where you can do a custom search. To call it up, go to Edit → Find, or press ૠ-F. Start by telling Bridge where to search. Then you can choose from a variety of criteria, ranging from the document type (JPEG, TIFF, and so on) to the color space (page 204), or even the camera's white balance setting. You can also tell Bridge to *exclude* certain criteria.

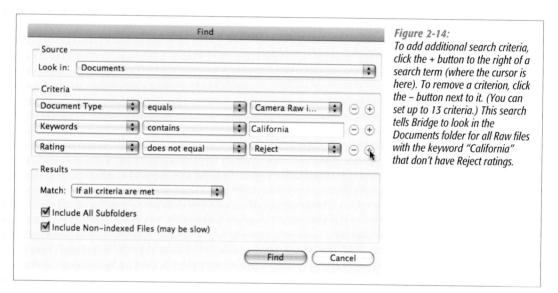

You can save your search results as a *collection*. To do that, select the thumbnails in the Content panel, then go to the Collections panel (select Window → Collections panel if it isn't visible) and click the New Collection button at the bottom of the window. Bridge asks if you want to include the files in the collection. Click Yes and then name the collection, which will appear in the Collections panel from now on. You can add files to it by dragging their thumbnails from the Content panel. To remove files from a collection, click its name to display the photos it includes, then select the ones you want to remove and click the Remove From Collection button at the Content panel's upper right. To delete a collection, click its name in the Collections panel, and then click the trashcan icon. (Changes you make to collections don't do anything to your photos themselves, only to the groupings.)

To add a collection to Bridge's Favorites panel, right-click (Control-click) it and select "Add to Favorites". It then appears in the Favorites panel, and you can see that group of pictures by clicking it there.

Bridge lets you create as many collections as you like. You can even create *smart collections*, where Bridge automatically searches for photos that meet the rules for your collection and include any new photos that it finds. In the Collections panel, click the New Smart Collection button. A window opens where you can choose which folder Bridge should watch for new items, as well as the parameters for your smart collection. You might choose, for instance, all unrated photos taken at ISO 1600 where the flash didn't fire. From now on, whenever you add a photo that meets these qualifications to the folder you chose, Bridge automatically puts it into the collection for you, making it easy to find and review.

Saving Your Work

After all your editing, keywording, and collecting efforts, you don't want to lose any of those files you've worked so hard on. Saving your work is just as easy in Elements as in any other program. (Bridge automatically saves what you do there, like your keywords and ratings—you don't need to do anything special.) Elements' Save As dialog box has a few settings you don't see in other programs, though. Press Shift-%-S to bring it up.

In addition to standard Save As settings (format, location, and so on), Elements also gives you these saving options:

- As a Copy. If you turn on this checkbox, Elements makes a copy of your image, names it "[original file name] copy," and puts the copy away. The original version remains open. If you want to work on the copy, you have to open it (\mathbb{H}-O). Sometimes Elements *forces* you to save as a copy—for instance, if you want to save a layered image and you turn off the layers option. (See Chapter 6 for more about layers.)
- Layers. If your image has layers, turn on this checkbox to keep them. When you turn off this setting, Elements usually forces you to save as a copy. To avoid having to save as a copy, flatten your image (page 179) before saving it. Remember that once you close a flattened image, you can't get your layers back again—flattening is a *permanent* change.
- Embed Color Profile. You can choose to keep a color profile in your image; page 204 has details.

File Formats Elements Understands

Elements gives you loads of file format options. Your best choice depends on how you plan to use your image:

• Photoshop (.psd, .pdd). It's a good idea to save your files as .psd files—the native file format for Elements and Photoshop—before you work on them. A .psd file can hold lots of info, and you don't lose any data by saving in this format. Also, it lets you keep layers, which is important even if you haven't used them much yet.

- Photo Project (.pse). This is a special format for multipage Elements photo creations (see Figure 2-15 and page 450).
- TIFF (.tif, .tiff). This is another format that, like the Photoshop format, preserves virtually all your photo's information and lets you save layers. TIFF files can also be very large like Photoshop files. TIFFs are used extensively in print production, and some cameras let you choose TIFF as a shooting option.
- JPEG (.jpg, jpeg, .jpe). Almost everyone who uses a computer has run into JPEGs, and most digital cameras offer the JPEG format as an option. Generally, when you bring a JPEG into Elements, you want to use another format when you save it to avoid losing data. Keep reading to learn why.
- PDF (.pdf, .pdp). Adobe invented PDF, or Portable Document Format, which lets you send files to people with Adobe Reader (a free program formerly called Acrobat Reader) so they can easily open and view the files. All Macs running OS X can open PDF files in Preview, too. Elements uses PDF files to create presentations like slideshows.

If you add pages to a file (page 447), Elements displays this warning. It's telling you it needs to save your multipage project in a format that almost no other program can open. To learn more about working with this format and how to get your project out of Elements for online printing or use by other programs, see the box on page 450.

UP TO SPEED

File Formats

After you've spent hours creating a perfect image, you want to share it with other people. If everyone who wanted to view your images needed a copy of Elements, you probably wouldn't have a very large audience for your creations. So, Elements lets you save in lots of different file formats.

What does that mean? It's pretty simple, really. A file format is a way in which your computer saves information so that another program or computer can read and use the file.

Because there are many different kinds of programs and several different computing platforms (Windows, Linux, and Mac, for example), the kind of file that's best for one use may be a poor choice for doing something else. That's why many programs, like Elements, can save your work in a variety of different formats, depending on what you want to do with your image. There are lots of formats, like TIFF and JPEG, that many different programs can read. Then there are other formats—like the .pages files that Pages creates—which are easily read only by the program that created them.

- CompuServe GIF (.gif). (Everywhere except this menu, this format is known simply as GIF. Adobe adds "CompuServe" here because CompuServe invented and owns the code for this format.) This format is used primarily for web graphics, especially files without a lot of subtle shadings of color. For more on when to choose GIFs, see Chapter 17. GIFs are also used for web animations; page 482 explains how to create animated GIFs.
- PICT (.pct). PICT is an older Mac format that's still used by some programs. AppleWorks, for example, handles PICTs better than any other graphics format. Also, sometimes larger file formats like Mac-created TIFFs generate their thumbnail previews as PICT Resource files (the type of PICT used within the TIFF file).
- BMP (.bmp). This format is an old Windows standby. It's the one used by the Windows operating system for many graphics tasks.
- PNG (.png). Here's another web graphic format, created to overcome some of the disadvantages of JPEGs and GIFs. It has its own disadvantages, though. See page 476 for more about these files.
- Photoshop EPS (.eps). EPS (Encapsulated PostScript) format is used to share documents among different programs. You generally get the best results printing documents in this format on PostScript printers (laser printers are often PostScript printers, and inkjets usually aren't).
- Digital Negative (.dng). Elements can't save files in this format (except in the Raw Converter—page 248), but it can *open* DNG files. Adobe developed this format to create a more universal way to store all the different Raw file formats (page 232). You can download a special DNG Converter from the downloads area of Adobe's support website (*www.adobe.com/downloads*) that lets you convert your camera's Raw files into DNG files. DNG files aren't ready to use the way JPEG or TIFF files are—you have to run them through the Raw Converter before you can use them in projects. See page 249 for more about DNG.

MOMENT OF SILENCE

Bye-Bye, JPEG 2000

If you've been saving your files in the JPEG 2000 format (.jpf, .jpx, .jp2), you may be perplexed to find that you can't open those files in Elements 8. That's right—Elements can no longer read these files. Back in Elements 2, when JPEG 2000 was a new format, you needed a special plug-in to work with them in Elements, and today there's a special plug-in for Photoshop CS4 if you want to use this format there, but in Elements 8, you're out of luck. (Bridge can still list them, but you may not see an image preview, just a blank square and the file name.)

Fortunately, there's a way around this: OS X Preview still understands JPEG 2000 and you can open your files there and save them in another lossless format. If you have lots of JPEG 2000 files, you can create an Automator workflow to batch process them. Keep this in mind, because many books that include discs of practice images and a lot of downloadable artwork use the JPEG 2000 format.

Not-so-common file formats

Besides the garden-variety formats in the previous list, Elements lets you save in some formats you may never have heard of. Here's a list, and then you can forget all about them, probably:

- PIXAR. Yup, *that* Pixar. This is the special format for the movie studio's highend workstations, although if you're working on one of those, it's unlikely that you're reading this book.
- Scitex CT. This format is used for prepress work in the printing industry.
- Photoshop Raw. This isn't the same as your camera Raw file, but rather an older Photoshop format that consists of uncompressed data.
- Targa TGA or Targa. Developed for systems using the Truevision video board, this format has become a popular graphics format, especially for games.
- PCX. This format was popular for PC graphics back in the days of DOS. Nowadays it's mostly used by some kinds of fax systems and a few document-management programs.

COMPATIBILITY CORNER

Opening Obscure File Formats

You may occasionally run into a file format that Elements doesn't understand. Sometimes you can fake Elements out and con it into opening the document by changing the file extension (the letters after the period near the end of the file's name, like "psd") to a more common one.

For the few file formats that make even Elements throw up its hands in despair, try Graphic Converter (www. lemkesoft.com), a wonderful little program that can open darn near anything. It does great batch conversions, too, and even offers some basic image editing features. (It may

have come bundled with your Mac, if your computer isn't very new.) Graphic Converter is shareware (it currently costs \$35) with a generous demo period, but it's worth every penny.

Very rarely, you'll run across a file that makes even Graphic Converter give up. If that happens, try a Google search. (Use the file's three- or four-letter extension as your search term.) It's unlikely to help you open it, but if you can figure out what kind of file it is, you can probably figure out where it came from and ask whoever sent it to you to try again with a more standard format.

About JPEGs

In the next chapter, you'll read about how throwing away pixels can lead to shoddy-looking pictures. Well, certain file formats were designed to make your files as small as possible, and they do that by throwing out information by the bucketful. These formats are known as *lossy* because they throw out, or lose, some of the file's data every time you save it, to help shrink the file.

Sometimes you want that to happen, like when you want a small (and hence fast-loading) picture for a website. So many of the file formats that were developed for the Web, most notably JPEG, are designed to favor smallness above all. They compress the file's size by letting some data escape.

NOTE Formats that preserve all your data are called *lossless*. (You may also run across the term *non-lossy*, which means the same thing.) The most popular file formats for people looking to preserve all their photos' data are Photoshop and TIFF.

If you save a file in JPEG format, every time you hit the Save button and close the file, your computer squishes some of the data out of the photo. What kind of data? The info your computer needs for displaying and printing the fine details. So you don't want to keep saving your file as a JPEG over and over again, because every time you do, you lose a little more detail from your image. You can usually get away with saving as a JPEG once or twice, but if you keep it up, sooner or later you start to wonder what happened to your beautiful picture.

It's OK that your camera takes photos and saves them as JPEGs—those are usually enormous JPEGs. And just importing a JPEG won't hurt your picture. But once you get your files into Elements, save them as Photoshop or TIFF files while you work on them. If you want the final product to be a JPEG, change the format back to JPEG *after* you're done editing it.

TIP Your camera may give you several different JPEG compression options to help you fit more pictures on your memory card. Always choose the *least* compression possible. This makes the files slightly larger, but the quality is much, much better, so it's worth sacrificing the space.

Changing the File Format

Elements makes it easy to change a file's format. Just press \Re -Shift-S or go to File \rightarrow Save As and, from the Format pull-down menu, select the format you want. Elements makes a copy of your file in the new format and asks you to name it.

Burning CDs and DVDs

It's a snap to burn your photos to discs right from Elements. (Not that it's hard to burn a disc in the Finder, but maybe you're more likely to burn a backup CD if you don't have the extra step of leaving Elements first.) You can burn discs to back up your latest photographic *magnum opus*, or just to share it with your friends. You can burn both photos and the projects you'll learn how to create later in this book. To burn a disc:

1. Choose your files.

You can start from either Elements or Bridge. It's probably best to start from Bridge if you want to burn a lot of files, since you can select as many as you want without opening them. If you start from Elements, you'll burn all your open files—you can't choose which files to include. (If you want to burn images that are open in Elements, save your changes before you start.)

2. Tell Elements or Bridge you want to burn a CD/DVD.

In Elements, go to the Share tab \rightarrow CD/DVD. In Bridge, go to File \rightarrow Burn CD/DVD. Wherever you start, Elements comes to the front of your screen for the actual burning.

3. Put a disc in the drive.

If there isn't already a blank disc in the drive, Elements asks for one. (If you have more than one disk-burning drive, like an external DVD burner, Elements shows you a list of all your available drives.) Put a disc in and make any changes to the burn settings, if you like (see Figure 2-16).

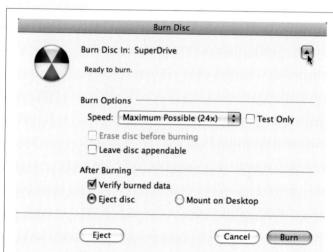

Figure 2-16:

You generally don't need to adjust your burn settings, but if you want to make changes, click the upper-right button (where the cursor is) to expand the Burn Disc window, as shown here. You can change the burn speed, choose settings for erasing rewritable discs, and tell Elements what you want it do with the disc when it's done burning.

BETTER SAFE THAN SORRY

Making Backups

If you're like most people, your photographs are some of your most precious possessions. When trouble strikes, the family photo albums are the usually among the first things people grab. It's important to keep a good backup of your digital photos, too, so you don't lose them.

Apple's Time Machine application is great for backing up of your computer's files. But disks can fail, and prudent people like to keep backup copies somewhere other than where the computer is located, so that it's safely out of harm's way should something happen. Burn copies of your important photos and give the discs to a friend to keep for you, or put them in your safe deposit box for peace of mind.

You can also back up your photos online with many different services, including Apple's Me.com (www.me. com). Careful folks prefer not to trust an online service as their only backup, though, even if they use it regularly. The bottom line: The more backups the better.

4. Click Burn.

Elements burns the disc. Always check it afterward to be sure everything went okay and that your photos are all there and recognizable.

Both Macs and Windows computers can read CDs and DVDs that Elements creates. Burning discs in Elements rather than in the Finder is quick and easy, but there's one disadvantage: You can't choose a name for your disc. It will be called Photo CD0000, like it or not. The next disc you burn in Elements will be Photo CD0001, and so on.

TIP Elements lets you burn *multi-session* discs, that is, discs that you can keep adding photos to and burning again till the disc is full. To do that, turn on the "Leave disc appendable" checkbox in the Elements Burn Disc window.

Rotating and Resizing Your Photos

In the last chapter, you learned how to get your photos *into* Elements. Now it's time to look at how to trim off unwanted areas and straighten crooked photos. You'll also learn how to change the overall size of your images and how to zoom in and out to get a better look at things while you're editing.

Straightening Scanned Photos

Anyone who's scanned old photos can testify to the hair-pulling frustration you feel when your carefully-placed pictures come out crooked onscreen. Whether you're feeding in precious memories one at a time or scanning batches of photos to save time, Elements can help straighten things out.

Straightening Two or More Photos at a Time

If you have a pile of photos to scan, save yourself some time and lay as many of them as you can fit on your scanner. Thanks to Elements' wonderful Divide Scanned Photos command, you'll have individual images in no time. The only limit is how many photos fit on your scanner at once.

Start by scanning in the photos (Figure 3-1). It doesn't matter whether you scan directly into Elements or use your scanner's own software. (See page 47 for more about scanning images into Elements.)

TIP Sometimes it pays to be crooked: Divide Scanned Photos does its best work if your photos are fairly crooked, so don't waste time trying to be precise when placing your pictures on the scanner.

Figure 3-1:
Consumer-grade flatbed scanners are generally pretty slow, so the ability to scan four or even six photos at a time is a huge timesaver. Elements' Divide Scanned Photos command can automatically separate and straighten individual photos in a group scan.

When you're done scanning, follow these steps:

1. Open your scanned image file.

It doesn't matter what file format you used when saving your scanned group of photos: TIFF, JPEG, PDF, whatever. Elements can read 'em all (unless you used JPEG 2000, in which case, see page 61).

2. Divide, straighten, and crop the individual photos.

Go to Image \rightarrow Divide Scanned Photos. Sit back and enjoy the view as Elements does some calculations and then carefully splits, straightens out, and trims each image. You'll see the individual photos appear and disappear as Elements works through the group.

3. Name and save each separated image.

When Elements is done, you'll have the original group scan as one image and a separate image file for each photo Elements has carved out. Remember to save the cut-apart photos.

Elements usually does a crackerjack job splitting your photos, but once in a while it chokes, leaving you with an image file that contains more than one photo. Figure 3-2 explains what to do when Elements doesn't succeed in splitting things up.

Figure 3-2:
Sometimes Elements just can't figure out how to divide up your photos, and you wind up with something like these two not-quite-split-apart images. Rescan the photos that confused Elements, but this time, make sure they're more crooked on the scanner and leave more space between them. Elements should then be able to divide them correctly. Also, check for positioning problems like you see here, where Elements can't split the photos because it can't draw a straight line to divide these two without chopping off the corners. Put a little more space between the photos so Elements can split them.

TIP Occasionally you may find that Elements can't accurately separate a group scan, no matter what you do. In that case, use the Marquee tool (page 125) to select each individual image, paste it into its own document (File \rightarrow New \rightarrow "Image from Clipboard"), and then save it.

Straightening Individual Photos

Elements can also straighten out and crop (trim) a single scanned image. Simply scan the image and then choose Image \rightarrow Rotate \rightarrow "Straighten and Crop Image", and Elements tidies things up for you. Or select the Straighten Image command instead if you'd rather crop the edges yourself. Better still, you can use Divide Scanned Photos on a single image, as explained in the previous section. (Cropping is explained on page 75.) You can also straighten and rotate images in Guided Edit (page 30).

Rotating Your Images

Owners of print photographs aren't the only ones who sometimes need a little help straightening their pictures. Digital photos sometimes need to be rotated, because some cameras don't include data in their image files that tells Elements (or any other image-editing program, for that matter) the correct orientation. Certain cameras, for example, send portrait-orientated photos out on their sides, and it's up to you to straighten things out.

Fortunately, Elements has rotation commands just about everywhere you go. If all you need to do is get Dad off his back and stand him upright, here's where you can perform a quick 90-degree rotation on any open photo:

- Quick Fix (page 99). Click either of the Rotation buttons at the bottom of the preview area.
- Full Edit. Go to Image → Rotate → 90° Left (or Right).
- Project bin. Right-click (Control-click) a thumbnail and choose Rotate 90° Left (or Right).
- Raw Converter (page 238). Click the left or right arrow at the top of the Preview window.

Those commands all get you one-click, 90-degree changes. But Elements has all sorts of other rotational tricks up its sleeve, as explained in the next section.

Rotating and Flipping Options

Elements gives you several ways to change your photo's orientation. To see what's available, go to Image \rightarrow Rotate. You'll notice two groups of Rotate commands in this menu. For now, it's the top group you want to focus on. (The second group does the same things, only those commands work on *layers*, which are explained in Chapter 6.)

In the first group of commands, you'll see:

- 90° Left or Right. These commands produce the same rotation as the rotate buttons explained earlier. Use these commands for digital photos that come in on their sides.
- 180°. This turns your photo upside down and backward.
- Custom. Selecting this command brings up a dialog box where, if you're mathematically inclined, you can type in the precise number of degrees to rotate your photo.
- Flip Horizontal. Flipping a photo horizontally means that if your subject was gazing soulfully off to the left, now she's gazing soulfully off to the right.
- Flip Vertical. This command turns your photo upside down without changing the left/right orientation (which is what Rotate 180° does).

NOTE When you're flipping photos around, remember you're making a mirror image of everything in the photo. So someone's who's writing right-handed becomes a lefty, any text you can see in the photo is backward, and so on.

Figure 3-3 shows these commands in action.

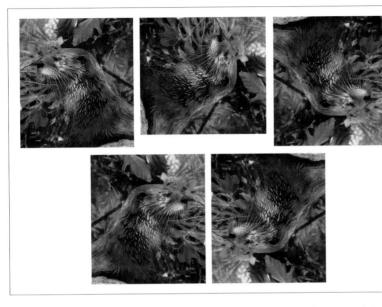

Figure 3-3: Use the Rotate commands to send this otter tumbling.

Top row: From left to right, you see the original, the photo rotated 90 degrees to the right, and the photo rotated 180 degrees.

Bottom row: The photo flipped horizontally (left) and vertically (right).

If you want to position your photo at an angle on a page (as you might in a scrapbook), use the Free Rotate Layer command described on page 73.

Straightening the Contents of an Image

What about all those photos you've taken where the main subject (a person or a building, say) isn't quite straight? You can flip those pictures around forever, but if your camera was off-kilter when you snapped the shot, your subjects will lean like a certain tower in Pisa. Elements has planned for this problem, too, by including a nifty Straighten tool that makes adjusting the horizon as easy as drawing a line.

NOTE About 95 percent of the time, the Straighten tool will do the trick. But for the few cases where you can't get things looking perfect, you can still use the old-school Elements method—the Free Rotate Layer command (page 73).

Straighten Tool

If you can never seem to hold a camera perfectly level, you'll love Elements' Straighten tool. It lives just below the Cookie Cutter tool in Full Edit's Tools panel (or next to it if you have two columns). To straighten a crooked photo:

1. Open the photo, and then activate the Straighten tool.

In the Tools panel, click the tool's icon (two little rectangles, one crooked and one not) or press P.

2. Make any changes to the tool's Options bar settings.

Your choices are described in a moment.

3. Tell Elements where the horizon is.

Drag to draw a line in your photo to show Elements where horizontal *should* be. Figure 3-4 shows how—by drawing a line that traces the boundary between the ocean and the sky. Your line appears at an angle when you draw it. That's fine, because Elements is going to level out your photo, making your line the image's true horizontal plane.

4. As soon as you let go of the mouse button, Elements straightens your photo. It also crops the photo if you chose that setting in the Options bar.

If you don't like what Elements did, press \(\mathbb{H}\)-Z to undo it and draw another line. If you're happy, you're all done, except for saving your work (\(\mathbb{H}\)-S).

TIP If you have a photo of trees, sailing ships, skyscrapers, or any other subject where you'd rather straighten vertically than horizontally, hold down **%** while you drag. That way, the line you draw determines the vertical axis of your photo.

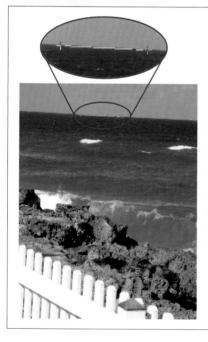

Figure 3-4:
Left: To correct the crooked horizon in this photo, draw a line along the part that should be level. It's easiest to do this by choosing something obvious like the horizon here, but you can draw a line across anything you want to make level.

Right: Elements automatically rotates the photo to straighten its contents.

The Options bar gives you some control over how Elements handles the edges of your newly straightened photo. Once your picture's straightened, the edges will be a bit ragged, so you can tell Elements what to do about that:

- Grow or Shrink Canvas to Fit. Elements adds extra space around the edges of your photo to make sure that every bit of the original image is still there. It's up to you to crop your photo afterward (see page 75).
- Crop to Remove Background. Elements chops off the ragged edges to give you a nice, rectangular image. The downside to this option is that you lose some of the perimeter of your image—though just a bit, so usually it's not a big deal.
- Crop to Original Size. Elements makes sure the dimensions of your photo stay exactly the same—even if that means including some blank spaces along the perimeter.

If your photo has layers (see Chapter 6), you can use the Straighten tool to straighten only the active layer (page 159) by going to the Options bar and turning off the Rotate All Layers checkbox. If you want Elements to straighten all the layers in your image, leave this checkbox turned on.

The Straighten tool is best for photos where you were holding the camera crooked. If you try it and it makes your photo look odd, perhaps straightening isn't really what you need. Architectural photos, for instance, may look a bit crooked before you use this tool—but a lot worse afterward. If that house is *still* leaning even though you're sure the ground line is level, your problem is most likely *perspective distortion* (a visual warping effect). To fix that, use Correct Camera Distortion instead (see page 332).

TIP You can also straighten photos right in the Raw Converter. There's a Straighten tool in its toolbox, right between the Crop tool and the Red Eye tool. You use it just like the Editor's Straighten tool. Page 238 tells you more.

Free Rotate Layer

You can also use the Rotate commands to straighten your photos, or to turn them at angles for use in scrapbook pages or albums you create. The Rotate command that's best for this use is Free Rotate Layer, which lets you grab your photo and spin it to your heart's desire. And if you aren't sure where straight is, Elements gives you some help figuring it out, as explained in the box on page 74.

Incidentally, all the Rotate commands are also available for use on individual layers. Chapter 6 tells you all about layers, but you don't have to understand layers to use the Free Rotate Layer command.

ON THE SQUARE

Grids, Guides, and Rulers

Elements gives you plenty of help when it comes to getting things straightened and aligned. You can turn on:

- **Grid.** You can see your entire image under a network of gridlines, as shown in Figure 3-5. This is really helpful when you're doing a free rotation and you're not sure where straight is. Just go to go to View → Grid to toggle the grid on and off. You can adjust the grid spacing in Photoshop Elements → Preferences → Guides & Grid. You can also change the color of the grid to make it show up better by clicking the color square in the Preference window's Grid section and choosing a color from the Color Picker (page 217).
- Rulers. If you want to accurately measure in your image, go to View → Rulers, and rulers appear along the top and left sides of your image. You can change the measurement unit by going to Photoshop Elements → Preferences → Units & Rulers if you'd rather see, say, pixels or percents rather than inches. You can also right-click (Control-click) the rulers themselves when they're visible for a pop-up menu with the same choices.
- Guides. Guides are a new, much-requested feature in Elements 8. You can create as many guides as you want in your image. If you have visible rulers, just click the ruler and drag to create a guide.

If you don't have the rulers turned, on, go to View → New Guide and choose a horizontal or vertical line in the dialog box that appears. You can also specify where you want to put it in your image by entering a number in the Position field, or just create it anywhere and then use the Move tool to drag it where it you want it. (Guides are always either horizontal or vertical-you can't change the orientation). Once you get your guidelines set up. you can lock them to keep from accidentally moving them (View → Lock Guides). To remove your guides, go to View → Clear Guides. If you save your photo with guides in it and send it to someone using a version of Elements that can display guides (Elements 6 and 7 can see guides; they just can't create them) or Photoshop, that person will be able to see your guides. If someone sends you a file with guides in it, you can see those guides if you turn guides on in the View menu.

Guides are really handy, particularly for projects like scrapbooking, because you can make anything you add into your file jump right to the guide location (View → Snap to → Guides). If you decide you'd rather have free movement, just select that menu item again to toggle it off. (You can also make items snap to the grid, but you can only change this setting when the grid is visible.) Having grids, guides, and rulers makes it easy to create all kinds of projects in Elements.

To use Free Rotate Layer:

1. Go to Image \rightarrow Rotate \rightarrow Free Rotate Layer.

If you have a Background layer, Elements automatically converts to a regular layer for you. (You'll learn about layers in Chapter 6, but for now it doesn't matter.)

2. Use the handle or the curved arrows to adjust your photo (see Figure 3-6).

Your picture may look kind of jagged while you're rotating. Don't worry about that—Elements smoothes things out once you're done.

TIP You can rotate the crop area to any angle. This is a handy way to straighten and crop in one go. If you have a crooked image, turn the crop tool so that the outlines of the area are parallel to where straight should be in your photo and crop. Elements straightens out your photo in the process.

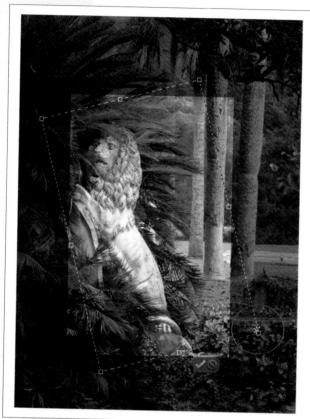

Figure 3-8:
If you want to change your selection from horizontal to vertical or vice versa, move your cursor outside the cropped area and you'll see the rotation arrows (circled). Use them to rotate the crop frame the same way you would an entire photo. Changing your selection doesn't rotate your photo—just the boundaries of the crop. When you're done, press Return or click the Commit button (the green checkmark) to tell Elements you're satisfied. Clicking the red Cancel button cancels your crop. (These buttons appear when you let go of the mouse.)

4. If you change your mind, click the Cancel button (the red circle with a slash) on the photo, or press the Esc key.

That undoes the selection so you can start over.

5. When you're sure you have the crop you want, press Return or click the Commit button (the checkmark) on the photo, or double-click inside the area you want to keep and you're done.

Cropping an image to an exact size

You don't have to eyeball things when cropping a photo. You can enter any dimensions you want in the Options bar's Width and Height boxes or, from the Aspect Ratio menu, you can choose one of the presets, which automatically enters a set of numbers for you. The Aspect Ratio menu offers you several standard photo

Figure 3-7: When you print onto standard-sized paper, you may have to choose the portion of your photo you want to keep.

Left: The photo as it came from the camera.

Right: After cropping ready for a $4" \times 6"$ print.

Using the Crop Tool

You can use the Crop tool in either the Full Edit or Quick Fix window. The Crop tool includes a helpful list of preset sizes to make your work easier; the next section explains how to select them. In most cases the preset sizes are what you need, but if you want to crop to a custom size, here's how:

1. Activate the Crop tool.

Click the Crop icon in the Tools panel or press C.

2. Drag anywhere in your image to select the area you want to keep.

The area outside your selection is covered with a dark shield to indicate that you'll discard it. To move the area you've chosen, just drag the bounding box (the outline) to wherever you want it.

NOTE You may find the Crop tool a little crotchety sometimes. See the box on page 79 for help making it behave.

3. To resize your selection, drag one of the little handles on the sides and corners.

The handles look like little squares, as shown in Figure 3-8. You can drag in any direction, which means you can change the proportions of the crop if you want to. If you just want to move the crop outline without resizing it, you can drag it or use the arrow keys to nudge it to where you want it.

Figure 3-6:
Here's how to straighten the contents of your photo—or even spin it around in a circle. Just grab a corner (circled). (When you move your cursor near the image's corner, it turns into a curved, two-headed arrow.) Then drag to adjust your photo the way you'd straighten a crooked picture on the wall. Click the Commit button (the green checkmark) when you're happy with what you've done, or the Cancel button (the red circle with a slash) to cancel.

A few cameras produce photos that are proportioned exactly right for printing to a standard size like $4"\times 6"$. But most cameras create photos that aren't the same proportions as any of the standard paper sizes like $4"\times 6"$ or $8"\times 10"$. (The width-to-height ratio is also known as the *aspect ratio*.)

The extra area most cameras include gives you room to crop wherever you like. You can also crop out different areas for different size prints (assuming you save your original photo). Figure 3-7 shows an example of a photo that had to be cropped to fit on a 4"×6" piece of paper. If you'd like to experiment with cropping or changing resolution (explained on page 90), download the image in the figure (*river.jpg*) from the Missing CD page at *www.missingmanuals.com*.

If your photo isn't in iPhoto or another program that automatically saves your originals, it's best to perform your crops on a copy, since Elements throws away the pixels outside the area you choose to keep. And you never know—you may want those pixels back someday.

Figure 3-5:
If you need some help figuring out where straight is, you can add a grid or guide. The bright aqua lines are guides; the others are the grid. Neither will show up when you print your photo. Use the grid for help in straightening your image. Guides are helpful when you're adding stuff to your photo, since you can make things like text blocks (page 424) automatically line themselves up by making them snap to the quidelines. The box on page 74 tells you how.

3. When you have your image positioned where you want it, click the green Commit button or press Return. (If you don't like what you did, click the red Cancel button instead, or press the Esc key.)

If you were straightening your photo rather than angling it, you'll have a nice straight picture, but the edges are probably pretty ragged since the original had slanted, unrotated sides. You can take care of that by cropping your photo as explained in the next section.

Cropping Pictures

Whether or not you straightened your digital photo, sooner or later you'll probably need to *crop* it—trim it to a certain size. Most people crop their photos for one of two reasons: To print on standard size photo paper, you usually need to cut away part of your image to make it fit on the paper. Then there's the "I don't want *that* in my picture" reason. Fortunately, Elements makes it easy to crop away distracting background objects or people you'd rather not see.

sizes to choose from, like $4" \times 6"$ and $8" \times 10"$. The Use Photo Ratio menu item lets you crop your image using the same width/height proportions (the *aspect ratio*) as in the original. Figure 3-9 shows you a timesaver: how to quickly switch the width and height numbers.

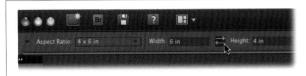

Figure 3-9:

If you want to change which number is the width setting and which is the height, just click these little arrows to swap them. So if you chose 3" × 5" from the Aspect Ratio menu but want to switch to a landscape orientation, click these arrows to get 5" × 3" instead.

TROUBLESHOOTING MOMENT

Crop Tool Idiosyncrasies

The Crop tool is crotchety sometimes. People have called it "bossy," and that's a good word for it. Here are some settings that may help you control it better:

- Snap to Grid. You may find that you just can't position the crop selection exactly where you want it. Does the edge keep jumping slightly away from where you put it? Like most graphics programs, Elements uses a grid of invisible lines—called the autogrid—to help place things exactly. Sometimes the grid is a big help, but in situations like this, it's a nuisance. If you hold down ૠ, you can temporarily disable the autogrid. You can also get rid of the autogrid or adjust its spacing. To turn it off, first make the grid visible by going to View → Grid.
- Then select View → Snap To → Grid. You can adjust the grid's settings—things like the spacing, color, and whether you see solid or dotted lines—in Photoshop Elements → Preferences → Guides & Grid.
- Clear the Crop Tool. Occasionally you may find that the Crop tool won't release a setting you entered, even after you clear the Options bar's boxes. For example, if the Crop tool won't let you drag where you want and keeps insisting on creating a particular sized crop, you need to reset the tool. Simply click the triangle at the left end of the Options bar, and then choose Reset Tool from the pop-up menu, as shown in Figure 3-10.

Figure 3-10:

If the Crop tool stops cooperating, there's an easy way to make it behave: Click this tiny triangle in the Options bar, and then choose Reset Tool from the menu that appears. If you want to make all your tools go back to their original settings, choose Reset All Tools instead.

WARNING If you enter a number in the Options bar's Resolution box that's different from your image's current resolution, the Crop tool *resamples* your image to match the new resolution. (Resolution is explained starting on page 90.) Page 96 explains what resampling is and why it isn't always a good thing.

Cropping with the Marquee Tool

The Crop tool is handy, but it wants to make the decisions for you about several things you may want to control yourself. For instance, the Crop tool may decide to resample the image (see page 96) whether you want it to or not. And the tool doesn't warn you that it's resampling—it just does it.

For better control, you may prefer the Marquee tool. It's no harder than using the Crop tool, but you get to make all the choices.

There's one other big difference between using the Marquee tool and the Crop tool: With the Crop tool, all you can do to the area you selected is crop it. The Marquee tool, in contrast, lets you make many other changes to your selected area, like adjusting the color, which you may want to do before you crop.

To make a basic crop with the Marquee tool, follow these steps:

1. Activate the Marquee tool.

Click the little dotted rectangle in the Tools panel or press M. Figure 3-11 shows you the shape choices you get for the Marquee tool. For cropping, choose the Rectangular Marquee tool.

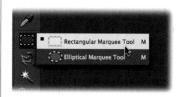

Figure 3-11: Click the Marquee tool's Tools panel icon, and then choose the shape you want from this pop-out menu. The icon shows the shape you've selected.

2. Drag your cursor across the part of your photo you want to keep.

When you let go, your selected area gets surrounded by the dotted lines shown in Figure 3-12. (There's a lot more about making selections in Chapter 5.) These are sometimes called "marching ants." (Get it? The dashes look like ants marching around your picture.) The area inside the marching ants is the part of your photo you're keeping. If you make a mistake, press \$\mathbb{H}\$-D to get rid of the selection and start over.

3. Crop your photo.

Go to Image \rightarrow Crop. The area outside your selection disappears, and your photo is cropped to the area you selected in step 2.

If you want to crop your photo to a particular aspect ratio, you can do that easily. Once the Marquee tool is active, but before you drag, go to the Options bar. In the Mode menu, choose Fixed Ratio. Then enter the proportions you want in the Width and Height boxes. Drag and crop as described earlier, and you end up with an image that has the proportions you entered in the Options bar.

80

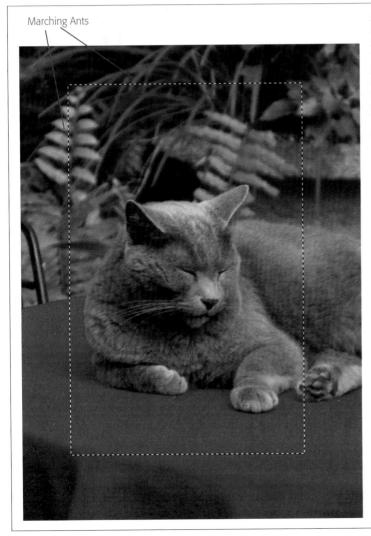

Figure 3-12:
When you let go after making your
Marquee selection, you see the
"marching ants" around the edge of
your selection. You can reposition the
marquee by dragging it. To do so, put
your cursor anywhere inside the
selection marquee and then drag it.
You can also use the arrow keys to
move the outline

You can also crop to an exact size with the Marquee tool:

1. Check the resolution of your photo.

Go to Image → Resize → Image Size (or press Option-ૠ-I) and, in the dialog box that appears, make sure the Resolution number is somewhere between 150 and 300 ppi (pixels per inch) if you plan to print your cropped photo. (Three hundred is best, for reasons explained on page 93.) If the ppi is fine, click OK and go to step 2.

If the ppi is too low, change the number in the Resolution box to what you want. Make sure that the Image Size dialog box's Resample Image checkbox is turned off, and then click OK.

2. Activate the Marquee tool.

Click the Marquee tool in the Tools panel (the little dotted rectangle) or press M. Choose the Rectangular Marquee tool.

3. Enter your settings in the Options bar.

First, go to the Mode menu and choose Fixed Size. Next, enter the dimensions you want in the Width and Height boxes. (You can change the unit of measurement from pixels to inches or centimeters if you want.)

4. Click anywhere in your image.

You get a selection the exact size you chose in the Options bar. You can reposition it by dragging or using the arrow keys.

5. Crop your Image.

Go to Image \rightarrow Crop.

The Cookie Cutter tool also gives you a way to create really interesting crops, as shown in Figure 3-13.

Figure 3-13:
With Elements' Cookie Cutter tool, you don't have to be square. The tool lets you crop your images to various shapes, from the kind of abstract border you see here, to heart- or star-shaped outlines.
Chapter 12 has more on how to use the Cookie Cutter tool.

TIP If you're doing your own printing, there's really no reason to tie yourself down to standard photo sizes like 4"×6"—unless, of course, you need the image to fit a frame of that size. But most of the time, your images could just as well be square, or long and skinny, or whatever proportions you want. You can be especially inventive when sizing images for the Web. So don't feel that every photo you take has to be straitjacketed into a standard size.

Zooming and Repositioning Your View

Sometimes, rather than changing the size of your photo, all you want to do is change how it looks onscreen so you can get a better look at it. For example, you

may want to zoom in on a particular area, or zoom out so you can see how edits you've made have affected your photo's overall composition.

This section is about how to adjust your view of an image in Elements. Nothing you do with the tools and commands in this section changes anything about your actual photo—you're just changing the way you *see* it. Elements gives you lots of tools and keystroke combinations to help with these new views; soon you'll probably find yourself making these changes without even thinking about them.

Image Views

In addition to letting you resize your view of your photos, Elements gives you several different ways to position your image. Back in Chapter 1 you learned how to manage Elements' panels and bins. This section is about image windows, which behave a little differently.

In Elements 8, you have more choices than ever before, because you can choose between viewing your images as tabs or in their own windows. Elements automatically starts out using image windows, but you may prefer to work with tabs. For instance, if you want to use the Transform tools (page 337), putting your image into a tab automatically gives you plenty of room to pull the handles that appear around your image. There are a bunch of options for either view, and even if you're an Elements veteran, you should read this section because you may accidentally wind up in a view you didn't want, at least until you get the hang of the new system. Figure 3-14 shows the difference between tabs and windows.

To give yourself maximum viewing flexibility, go to Photoshop Elements → Preferences → General and make sure the "Allow Floating Documents in Full Edit Mode" checkbox is turned on. When it's off, you're stuck with tabs no matter what you choose in the menus. When it's on, you can quickly switch back and forth between windows, tabs, or even a combination of the two.

NOTE While you may find the whole tab vs. window business a little confusing at first, it does give you more ways to stay organized while you work. The box on page 87 has some additional hints on keeping things under control.

Since accurate image viewing is crucial in Elements, Adobe gives you three main menus to control how your images display: the Window and View menus, logically enough, and the Arrange Documents menu, the gray square at the top of the screen to the right of the Help button (the blue square with the white question mark on it). If you don't see these items, go to Window \rightarrow Application Bar. When you go to Window \rightarrow Images, you get several choices for how to display your image:

• Tile. In this view, your image windows or tabs appear edge to edge so that they fill the available desktop space. With two photos open, each gets half the workspace; with four photos, each gets one quarter of it, and so on. With tabs, you have a lot of additional options when you use the Arrange Documents menu, described in Figure 3-15.

Figure 3-14: Top: Three floating windows in Cascade view.

Bottom: The same three images as tabs. Notice that you really see only one image, with the others tucked away out of sight. You can change which image you see by clicking the tab of the image you want; the tabs are along the top of the image. A tab's background fills all of the Elements workspace that isn't occupied by bins, however large the area is. (The active image has a slightly darker tab, but it can be hard to tell that no matter which color scheme you're using.)

- Cascade. Your image windows appear in overlapping stacks (see Figure 3-15). Most people find Cascading windows the most practical view when they want to compare or work with two images.
- Float in Window. If you want to make a single image tab into a window, click it to make it the active tab, and then choose this menu item.
- Float All in Windows. If you have a bunch of tabs, choose this to make them all into floating windows.
- Consolidate All to Tabs. Have a lot of windows but want to go back to all tabs? Here's the one-step command to snap all the windows back into tabs.

Figure 3-15:

To arrange your tabs so you can easily work with multiple images, use the Arrange Documents menu. Click the thumbnail for the layout you want. The top row includes general arrangements you can apply regardless of how many images you have open. The lower section offers only arrangements possible for the number of images you currently have open (three in this case): the rest are grayed out. If you have floating windows, clicking a thumbnail will consolidate them into tabs in the layout you chose.

- New Window. Choose this command and you get a separate, duplicate window for your active image. This view is a terrific help when you're working on fine details. You can zoom way in on one view while keeping the other window in a regular view so you don't lose track of where you are in the photo. Don't worry about version control or remembering which window you're working in, since both windows represent different glimpses of the same image.
- Minimize. Use this command to send your image window to the Dock to get it
 out of your way. If you don't have any open images, it sends the main Elements
 window to the Dock instead. In either case, go to the Dock and click the window to bring it back.
- Bring All to Front. If you have open windows from several programs (Elements, Preview, and iWork, for example) choose this command in Elements to bring all your Elements image windows to the fore. (In practice, this usually happens anyway when you make Elements the front application.)
- Match Zoom. Select this and Elements applies the magnification level of the active image window (the photo you're currently working on) to all your windows.
- Match Location. This view shows you the same part of each image window, like the upper-right corner or the bottom-left. Elements matches the other windows to the active window.

Some of these commands are duplicated in the new Arrange Documents menu, but this menu also includes a lot of tab-management choices not found elsewhere, as explained in Figure 3-15. The bottom sections of the Arrange Documents menu contain commands described above, and one additional choice:

• Match Zoom and Location. Choose this to see the same part of each of your tabs at the same magnification level.

Elements also gives you five handy commands for adjusting the view of your active image window. Go to the View menu, and you see:

- New Window for. This is the same as the Window menu's New Window command, described above.
- Zoom In/Out. These are shortcuts for zooming, explained below.

TIP You can zoom in or out using the View menu, but it's much faster to learn the keyboard shortcuts so you don't have to keep trekking up to the menu. Press \Re — to zoom in and \Re — (that's the \Re key plus the minus sign) to zoom out. The next section explains the Zoom tool in detail.

- Fit on Screen. This command makes your photo as large as it can be while keeping the whole photo visible. You can also press \$\mathbb{H}\$-0 or double-click the Hand tool in the Tools panel for this view.
- Actual Pixels. For the most accurate look at the onscreen size of your photo, go with this option. If you're creating graphics for the Web, this view shows the size your image will be in your web browser. The keyboard shortcut is \$\mathbb{H}-1\$, or you can double-click the Zoom tool's icon in the Tools panel.
- **Print Size.** This view is an estimate because Elements doesn't know exactly how big a pixel is on your monitor. But this option gives you a rough idea of the size your image would be if you printed it at the current resolution. (Resolution is explained on page 90.)

Elements gives you three useful tools for adjusting the view of a particular image: the Zoom tool, the Hand tool, and the Navigator panel, all of which are explained in the following sections.

The Zoom Tool

When you're using some of Elements' tools, you need to get a very close look at your image to see what's going on. Sometimes you may even need to see the actual pixels as you work, as shown in Figure 3-16. The Zoom tool makes it easy to zoom your view in and out.

The Zoom tool's Tools panel icon is the magnifying glass. Click it or press Z to activate the tool. Once you do that, you see circle icons at the left of the Options bar. If you want to zoom in, click the one with the + sign on it. Then just click the spot in your photo where you want the zoom to focus. The point where you click becomes the center of your view, and the view size increases again each time you click. You can also use the Zoom tool to drag over the area where you want to focus, to make it as large as it can be while still fitting in the available space.

To zoom out instead, in the Options bar, click the circle with the minus (–) sign on it.

TIP If you hold down the Option key as you click, the Zoom tool zooms in the opposite direction; for instance, if you have it set to zoom in, it'll zoom out instead.

ORGANIZATION STATION

Window Management Hints

In addition to the various menu commands discussed in this section, there's another way to control whether you have tabs or windows: dragging. This saves you from trekking all the way up to the menu bar. Here are a few shortcuts:

- Turn a tab into a window. Grab the tab's title bar and pull down. The tab pops off and becomes a floating window.
- Turn a window into a tab. Drag up towards the
 Options bar till you see a blue outline around the
 desktop. Whenever you see the blue outline, know
 that if you let go, your window will consolidate
 with the outlined area, just the way the panels
 (described in Chapter 1) do.
- Make tabs within a floating window. If you want
 to combine two images into one floating window
 (say you're working on combining elements from
 many different images and it's getting hard to
 know which is where), drag the title bar of one

window to the title bar of another and let go when you see the blue outline. You now have a floating window with two tabs, but you can repeat this as many times as you want for a multi-tabbed image window.

- Avoid making tabs. When you're working with floating windows and you place their tops too close together, Elements wants to combine the windows. If you're dragging windows around and you see the telltale blue outline, just keep going till it disappears.
- Undo accidental tabs. If you made a tab and you didn't mean to, grab the top of the image you want to free and drag it loose from the tab group.

Just remember that in Elements 8 anytime you're dragging something and a blue outline appears, what you're dragging will consolidate with something if you let go. If you don't want that to happen, keep moving till the outline disappears.

Figure 3-16:
There are times when you want to zoom way, way in. You may even need to go pixel by pixel in tricky spots, as shown here.

The Zoom tool has several other Options bar settings (some of these commands are also in the View menu):

- **Zoom Percent.** Enter a number here and the view immediately jumps to that percentage. 3200 percent is the maximum, and 1 percent is the minimum.
- Resize Windows To Fit. Turn this checkbox on and your image windows get larger and smaller along with the image size as you zoom. The image always fills the entire window with no gray space around it.
- Zoom All Windows. If you have more than one image window, turn on this checkbox and Elements changes the view in all the windows in sync when you zoom one window. (This option works with tabs, too, if you're using a tiled view, so you can see more than one tab at once.)

TIP If you hold down the Shift key while zooming in, all your windows zoom together. You don't need to go to the Options bar to activate this feature.

- 1:1. For the most accurate look at the onscreen size of your photo, click this button. If you're creating graphics for the Web, for example, this view shows the size your image will be in a web browser. The keyboard shortcut is \$\mathbb{H}-1\$.
- Fit Screen. This button makes your photo as large as it can be while still keeping the entire photo visible. You can also press \$\mathbb{H}\$-0 for this view.
- Fill Screen. This makes your photo fill the whole viewing area, even if the photo doesn't all fit onscreen at once.
- Print Size. This view is an estimate because Elements doesn't know exactly how big a pixel is on your monitor. It gives you a rough idea of the size your image would be if you printed it at the current resolution. (See page 90 for more about resolution.)

TIP You don't need to bother with the actual Zoom tool at all—just use your keyboard instead. Press **%**— to zoom in and **%**— (the **%** key plus the minus sign) to zoom out. Hold down **%** and keep tapping the = or – key until the view is what you want. You can also zoom to 100 percent by double-clicking the Zoom tool's icon. It doesn't matter which tool you're using when you use these keyboard shortcuts—you can always zoom in or out this way. Because you'll do a lot of zooming in Elements, these shortcuts are good ones to remember.

If you have a mouse with a scroll wheel, you can use that to zoom, too. Just hold the Option key and scroll. (There's also a setting in Photoshop Elements \rightarrow Preferences \rightarrow General that you can turn on to zoom without having to use the Option key.)

The Hand Tool

With all that zooming, sometimes you can't see your whole image at once. Elements' Hand tool helps you adjust which part of your image appears onscreen, and it's easy to use. Just click the hand in the Tools panel or press H to activate it.

When the Hand tool is active, your cursor turns into the little glove shown in Figure 3-17. Simply drag to move your photo around in the window. The Hand tool is helpful when you're zoomed in or working on a large image.

Figure 3-17:
The easiest way to activate the Hand tool is to press the space bar on your keyboard (you can tell the Hand tool is active by this white-gloved cursor). No matter what you're doing in Elements, pressing the space bar calls up the Hand tool; it remains on until you release the space bar. Then Elements switches back to the tool you were previously using.

The Hand tool gives you the same "All Windows" option you get with the Zoom tool, but you don't have to use the Options bar to activate it. Just hold down Shift while using the Hand tool, and all your windows scroll in sync. The Hand tool's Options bar also has the same four buttons (Actual Pixels, Fit Screen, Fill Screen, and Print Size) as the Zoom tool. They work the same way as the commands described in the previous section (Actual Pixels is the same as the Zoom tool's 1:1 button). You can also double-click the Hand icon in the Tools panel for the Fit Screen command.

Figure 3-18 shows the Hand tool's somewhat more sophisticated assistant, the Navigator panel, which is useful for working with really big photos or when you want to have a slider handy for micro-managing the zoom level. Go to Window → Navigator to call it up.

Figure 3-18:
Meet the Navigator. You can travel around your image by dragging the little red rectangle—it marks the area of your photo that you see onscreen. You can also enter a percentage for the size you want your photo to display at (100 percent is full size, 50 percent is half size, and so on), or move the slider or click the zoom in/out magnifying glasses on either side of the slider to change the view. The Navigator is perfect for keeping track of where you are in a large image.

Changing the Size of an Image

The previous section explained how to resize your *view* of an image as it appears on your monitor. But sometimes you need to change the size of your actual image, and that's what this section is about.

Resizing photos brings you up against a pretty tough concept in digital imaging: *resolution*, which measures, in pixels, the amount of detail your image can show. Where it gets confusing is that resolution for printing and for onscreen use (like email and the Web) are quite different.

For example, you need many more pixels to create a good-looking print than you do for a photo that's going to be viewed only onscreen. A photo that will print well almost always has too many pixels for onscreen display, and as a result, its file size is usually pretty hefty for emailing. So you often need two different copies of your photo for the two different uses. If you want to know more about the nitty gritty of resolution, a good place to start is www.scantips.com.

This section gives you a brief introduction to both onscreen and print resolution, especially in terms of what decisions you'll need to make when using Elements' Resize Image dialog box. You'll also learn how to add more canvas (more blank space) around your photos to make room for captions below your image, for instance, or to combine two photos.

To get started, open a photo you want to resize and then go to Image → Resize → Image Size (Figure 3-19).

Figure 3-19:

The Image Size dialog box gives you two different ways to change the size of your photo. Use the Pixel Dimensions section (shown here) when preparing a photo for onscreen viewing. (The number immediately to the right of Pixel Dimensions—here, 791K—indicates the size of your file in megabytes or kilobytes [as in this example].) Before you can make any changes here, you have to turn on the Resample Image checkbox in the bottom part of the dialog box (not visible here), since changing pixel dimensions always involves resampling (see page 96).

Resizing Images for Email and the Web

It's important to learn how to size your photos so that they show up clearly—and are easy to view—onscreen. Have you ever had a photo emailed to you that was so huge you could see only a tiny bit of it on your monitor at once? That happens when someone sends an image that isn't optimized for viewing on a monitor. It's easy to avoid that problem—once you know how to correctly size your photos for onscreen viewing.

The Image Size dialog box has two main sections: Pixel Dimensions and Document Size. You'll use the Pixel Dimensions settings when you know your image is will be viewed only onscreen. (Document Size is for printing.)

Monitors are concerned only with the size of a photo as measured in pixels, aptly known as the *pixel dimensions*. A pixel is always the same size on a monitor (unlike with a printer, which can change the size of the pixels it prints out). Your monitor doesn't know anything about pixels per inch (ppi), and it can't change the way it displays a photo even if you change the photo's ppi settings, as shown in Figure 3-20. (It's true that graphics programs like Elements can change the size of your onscreen view by, say, zooming in, but most programs, like your web browser, can't.)

Figure 3-20: This screenshot demonstrates that your monitor doesn't care about the ppi settings you enter. One of these photos was saved at 3 ppi, the second at 300 ppi, and the last at 3000 ppi. Can you tell which is which? Nope. They all look exactly the same on your monitor because they all have exactly the same pixel dimensions, which is the only resolution setting vour monitor understands.

All you have to decide is how many pixels long and how many pixels wide you want your photo to be. You control those measurements in the Pixel Dimensions section of the Image Size dialog box.

What dimensions should you use? That depends a little on who's going to see your photos, but as a general rule, small monitors today are usually 1024 wide by 768 high (some monitors, like the largest Dell and Apple models, have many more pixels than that). If you want to be sure that people who see your photo won't have to scroll, a

good rule of thumb is to make the longer side of your photo no more than 650 pixels, whether that's the width or the height. If you want people to be able to see more than one image at a time, you may want to make your photos even smaller.

Also, some people still set their monitors to display only 800 pixels wide by 600 pixels high, so you may want to make smaller images to send to them. On the other hand, if you send small pictures to people with deluxe, high-resolution monitors where the individual pixels are tiny, they'll likely to complain that the photos are too small to see in detail. So if you send images to a varied group of folks, you may need to make different copies for different audiences. On the whole, it's better to err on the side of caution: Nobody will have trouble receiving and opening an image that's too small, but too large an attachment size can cause problems for people with small mailboxes.

TIP To get the most accurate look at how large your photo displays on a monitor, go to View \rightarrow Actual Pixels or press \Re -1.

Also, although a photo always has the same pixel dimensions, you can't control the exact inch dimensions at which those pixels display on other people's monitors. A pixel is always the same size on any given monitor (as long as you don't change the monitor's screen resolution), but different monitors have different sized pixels these days. Figure 3-21 may help you grasp this concept.

Figure 3-21:
Both these computers
have a screen resolution
of 1024 × 768 pixels, and
the photo they're
displaying takes up
exactly the same
percentage of each
screen. But the picture on
the left is larger because
the monitor is physically
larger—in other words,
the individual pixels
are bigger.

NOTE In the following sections, you'll learn what to do when you want to *reduce* the size of an image. It's much easier to get good results making a photo smaller than larger. Elements lets you *increase* the size of your image, using a technique called *upsampling* (explained on page 96), but you often get mediocre results. The section on resampling (page 96) explains why.

To resize a photo, start by making sure you're not resizing the original. You're going to be shedding pixels that you can't get back again, so resize your photos using a copy (File → Duplicate). Here's what you do:

1. Call up the Image Size dialog box.

Go to Image → Resize → Image Size.

2. Turn on the Resample Image checkbox at the bottom of the dialog box.

Elements won't let you make any changes to the pixel dimensions in the top part of the window until you do this.

3. In the Pixel Dimensions section, enter the dimension you want for the longer side of your photo.

Usually you'd want 650 pixels or less, unless you know for sure that your recipients have up-to-date equipment and broadband Internet connections. Be sure to choose pixels as the unit of measurement if it's not already selected. You just need to enter the number for one side—Elements automatically figures the dimension for the other side as long as the Constrain Proportions checkbox near the bottom of the dialog box is turned on.

4. Double-check the settings at the bottom of the dialog box.

Constrain Proportions should be turned on. (Scale Styles doesn't matter, so leave it off.) Resample Image should be turned on. (Resampling means changing the number of pixels in your image.) The Resample Image menu lists the different resampling methods Elements can use. Adobe recommends choosing Bicubic Sharper when you're making an image smaller, but you may want to experiment with the other menu options if you don't like the results you get with that method. (In Elements 8, you'll see the suggested use for each method in parentheses after its name in the menu.)

5. Click OK.

Elements resizes your photo, although you may not immediately see a difference onscreen. (Go to View \rightarrow Actual Pixels before and after you resize, and you'll see the difference.) Save your resized photo to make your changes permanent.

Sometimes Elements resizes an image automatically—for example, when you use the E-Mail command (see page 484). But the method described here gives you more control than letting Elements make all the decisions for you.

TIP If you're concerned about file size, use Save For Web instead (see page 476), which helps you create smaller files.

Resizing for Printing

If you want great prints, you need to think about your photo's resolution quite differently than you do for images you're emailing. For printing, as a general rule, the

more pixels your photo has, the better. That's why camera manufacturers keep packing more megapixels into their new models—the more pixels you have, the larger you can print your photo and still have it look terrific.

TIP Even before you take photos, you can do a lot toward making them print well if you always choose the largest size and the highest quality setting on your camera (typically Extra Fine, Superfine, or Fine).

When you print a photo, you need to think about two things: the size of the photo in inches (or whatever your preferred unit of measurement is) and the resolution in pixels per inch (ppi). Those settings work together to control the quality of your print.

Your printer is a virtuoso that plays your pixels like an accordion: It can squeeze the pixels together and make them smaller, or spread the pixels out and make them larger. Generally speaking, the denser the pixels (the higher the ppi), the higher the resolution of your photo, and the better it looks. If you don't have enough pixels in your photo, the print will look *pixelated*—jagged and blurry. The goal is to have enough pixels in your photo so that they'll be packed fairly densely—ideally at about 300 ppi.

You usually don't get visibly better results if you go over 300 ppi, though, just a larger file size. And depending on your tastes, you may be content with your results at a lower ppi. For instance, some Canon camera photos come into Elements at 180 ppi, and you may be happy with how they print. But 200 ppi is usually considered about the lowest density for an acceptable print. Figure 3-22 shows why it's so important to have a high ppi setting.

To set the size of an image for printing:

Call up the Image Size dialog box.

2. Check the resolution of your image.

You're concerned with the Document Size section of the dialog box (see Figure 3-23). Start by looking at the Resolution setting. If it's too low, like 72 ppi, go to the bottom of the dialog box and turn off the Resample Image checkbox. Then enter the ppi you want in the Document Size area. The dimensions should become smaller to reflect the greater density of the pixels. If they don't, click OK, and open the dialog box again.

3. Check the physical size of your photo.

Look at the Width and Height numbers in the Document Size area. Are they what you want? If so, you're all done. Click OK.

4. If the dimensions aren't right, resize your photo.

If the dimensions aren't what you want, crop the photo using one of the methods described earlier in this chapter, and then come back to the Image Size dialog box—don't try to reshape an image using this dialog box.

Figure 3-22:
Different resolution settings can dramatically alter the quality of a printout.

Top: A photo with a resolution of 300 ppi.

Bottom: The same photo with resolution set to 72 ppi. Too few pixels stretched too far causes this kind of blocky, blurry printing. (When you can see the individual pixels, a photo is said to be pixelated.) These photos have been printed and then scanned so you can see the results of printing them.

Document Size:

Width: 6.292 inches

Height: 5.611 inches

Pixels/inch

Scale Styles

Constrain Proportions

Resample Image:

Bicubic (best for smooth gradients)

Figure 3-23:
Crop your image to the shape you want (see page 75), and then use this section of the Image Size dialog box to set its size for printing.

Once you've returned to the Image Size dialog box, turn on the Resample Image checkbox and choose Bicubic Smoother from the menu. (This method is Adobe's recommendation, but you may find that you prefer one of the other resampling options.)

Now enter the size you want for the width or height. Make sure that the Constrain Proportions checkbox is turned on so Elements calculates the other dimension for you. (Scale Styles doesn't matter; leave it off.)

5. Click OK.

Your photo is resized and ready for printing. Chapter 16 covers printing in detail.

Resampling

Resampling is an image-editing term for changing the number of pixels in an image. When you resample, your results are permanent, so you want to avoid resampling an original if you can help it. As a rule, it's easier to get good results when you downsample (make your photo smaller) than when you upsample (make your photo larger).

When you upsample, you *add* pixels to your image. Elements has to get them from somewhere, so it makes them up. Elements is pretty good at this, but these pixels are never as good as the pixels that were in your photo to begin with, as you can see from Figure 3-24. You can download the figure (*russian_box.jpg*) from the Missing CD page at *www.missingmanuals.com* if you'd like to try this yourself. Zoom in very closely so you can see the pixels.

The photo as it came from the camera.

Downsampled to 72 ppi.

Upsampled back to the original resolution. See how soft the pixels look compared to the original?

Figure 3-24: Here's a close-up look at what you're doing to your photo when you resample it.

When you enlarge an image to more than 100 percent of its original size, you'll definitely lose some of the original quality. So, for example, if you try to stretch a photo that's 3" wide at 180 ppi to an $8" \times 10"$ print, don't be surprised if you don't like the results.

Elements offers you several resampling methods, and they do a good job when you find the right one for your situation. You select them in the Image Size dialog box's Resample Image menu. Adobe recommends choosing Bicubic Smoother when you're upsampling (enlarging) your images and Bicubic Sharper when you're downsampling (reducing) your photos, but you may prefer one of the others. It's worth experimenting with them all to see which you like best.

Adding Canvas

Just like the works of Monet and Matisse, your photos appear in Elements on a digital "canvas." Sometimes you may want to add more canvas to make room for text or if you're combining photos into a collage.

To make your canvas bigger, go to Image → Resize → Canvas Size. You can change the size of your canvas using a variety of measurements. If you don't know exactly how much more canvas you want, choose Percent. Then you can guesstimate that you want, say, 2 percent more canvas or 50 percent more. Figure 3-25 shows how to get your photo into the right place on the new canvas. (You can add canvas in either tabbed or floating-window view.)

Changing the size of your canvas doesn't change the size of your picture any more than pasting a postcard onto a full-size sheet of paper changes the size of the postcard. In both cases, all you get is more empty space around your picture.

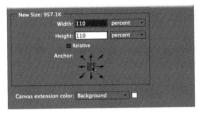

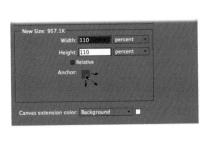

Figure 3-25:

The Canvas Size dialog box isn't as complicated as it looks. The strange little Anchor diagram with arrows pointina everywhere lets you decide exactly where to add canvas to your image. The Anchor box represents your photo's current position, and the arrows around it show where Elements will add the new canvas. By clicking in any of the surrounding arrows, you tell Flements where to position your photo on the newly sized canvas. In the top pair of images, the new canvas has been added eaually around all sides of the existina image. In the bottom pair, the new canvas has been added below and to the right of the existing image.

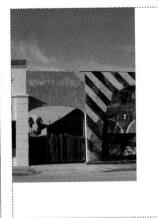

TIP If you just want to add canvas at the bottom of your image for a caption, check out the caption action in Guided Edit (page 399).

The Quick Fix

With Elements' Quick Fix tools, you can dramatically improve your photo's appearance with just a click or two. The Quick Fix window gathers easy-to-use tools to help you adjust the brightness and color of your photos and make them look sharper. You don't even need to understand much about what you're doing—you just click a button or slide a pointer, and then decide whether you like how it looks.

If, on the other hand, you *do* know what you're doing, you may still find yourself using the Quick Fix window for things like shadows and highlights because it gives you a before-and-after view as you work. Also, the Temperature and Tint sliders can come in handy for advanced color tweaking, like finessing the overall color of your otherwise finished photo. You also get two tools—the Selection brush and the Quick Selection tool—to help make changes to only a certain area of your photo. Besides making general fixes, do you want to whiten teeth, make the sky more blue, or make part of a picture black and white? It's a snap to do any of these in the Quick Fix window. And in Elements 8, Adobe has made it easier to decide just what to do by adding a number of presets to the available adjustments, so you can pick one of these as a starting point if you need extra help.

In this chapter, you'll learn how (and in which order) to use the Quick Fix tools. If you have a newish digital camera, you may find that Quick Fix gives you everything you need to take your photos from pretty darn good to dazzling.

NOTE If you can't wait to get started, try out the ultra-fast Auto Smart Fix—a Quick Fix tool for the truly impatient. Page 106 tells you everything you need to know about it. Also, Guided Edit may give you enough help to accomplish what you want to do; page 30 has the full story.

The Quick Fix Window

Getting to the Quick Fix window is easy. Just click the Edit tab's down arrow and choose EDIT Quick. The Quick Fix window that opens looks like a stripped-down version of the Full Edit window (see Figure 4-1).

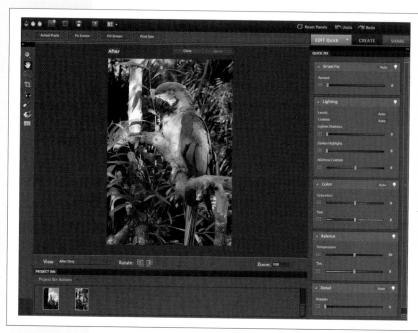

Figure 4-1: The Quick Fix window. If you have several photos open when you launch this window, you can use the Project bin (page 25) at the bottom to choose the one you want to edit. Just double-click any of the image's thumbnail and that photo becomes the active image—the one that appears front and center in the Quick Fix preview area. See Figure 4-2 for a close-up view of the right side of the window.

Your tools are neatly arranged on both sides of the image: On the left side, there's an eight-item toolbox; on the right side, there's a collection of quick-edit panels (Figure 4-2) stored in the Panel bin. This chapter will first explain the Quick Fix tools, and then you'll learn how to actually use them.

TIP If you need extra help, check out Guided Edit (page 30), which walks you through a lot of basic editing projects.

The Quick Fix Toolbox

Quick Fix's toolbox holds an easy-to-navigate subset of the Full Edit window's larger tool collection. All the tools work the same way in both modes, and you can also use the same keystrokes to switch tools here. From top to bottom, here's what you get:

• The Zoom tool lets you telescope in and out on your image—perfect for getting a good close look at details or pulling back to see the whole photo. (See page 86 for more on how this tool works.) You can also zoom by using the Zoom pull-down menu in the lower-right corner of the image preview area.

Figure 4-2:
Here are all the ways you can enhance your photos with Quick Fix. The left figure shows the top section of the Panel bin; the right, the bottom half. Besides these handy tools, you can also use most of the Full Edit menu commands if you need something more than the Panel bin provides.

- The Hand tool helps move your photo around in the image window—just like grabbing it and moving it with your own fingers. You can read more about this tool on page 88.
- The Quick Selection tool lets you apply Quick Fix commands to specific parts of your image. The regular Elements Selection brush is also available in Quick Fix. To get to the Selection brush, in the toolbox, click the Quick Selection tool's icon and choose the Selection brush from the menu that appears. What's the difference between the two tools? The Selection brush lets you paint a selection exactly where you want it (or mask out part of your photo to keep it from getting changed), while the Quick Selection tool figures out the boundaries of your selection based on your much-less-precise marks on the image. Basically, the Quick Selection tool is far more automatic than the regular Selection brush. (You can read more about these brushes beginning on page 129.) To get the most out of both of these tools, you need to understand the concept of selections. Chapter 5 tells you everything you need to know, including the details of using these brushes.
- The Crop tool lets you change the size and shape of your photo by cutting off the areas you don't want (see page 77).
- The Red Eye tool lets you darken those demonic-looking flash reflections in people's eyes. It's explained on page 104.

TIP If the contents of your photo need straightening (see page 71), you need to do that in Full Edit before bringing it into the Quick Fix window, since the Quick Fix toolbox doesn't include the Straighten tool.

You also see the tools described above in Full Edit, but the bottom part of the Quick Fix toolbox includes three tools you won't find anywhere else in Elements:

• Touch Up tools. From top to bottom, these tools let you whiten teeth, make the sky more blue, and turn part of a photo to black and white. Their icons make it clear which is which, and you'll learn how to use them beginning on page 113.

The Quick Fix Panel Bin

When you switch to Quick Fix, the Task panel presents you with the Quick Fix Panel bin, which is where you'll make the majority of your adjustments. Elements helpfully arranges everything into five panels: Smart Fix, Lighting, Color, Balance, and Detail. In most cases, it makes sense to start at the top and work your way down until you get the results you want. (See page 116 for more suggestions on what order to work in.)

NOTE There is one exception to this top-to-bottom order of operations: If you need to fix redeye problems (page 104). The Red Eye tool is in the toolbox on the left of the window. You may want to use that tool before you do your other editing.

The Panel bin always fills the right side of the Quick Fix screen. There's no way to hide it, and you can't drag the panels out of the Panel bin as you can in Standard Edit mode. But you can expand and collapse them, as explained in Figure 4-3.

NOTE If you go into Quick Fix mode *before* opening a photo, you won't see the pointers in the sliders, just empty tracks. Don't worry—the pointers will automatically appear as soon as you open a photo and give them something to work on.

Figure 4-3:
Clicking any of these flippy triangles collapses or expands that section of the Panel bin. If you have a small screen, the Detail section at the bottom of the bin is usually collapsed, so just click the triangle to expand it when you want those tools. There's no need to collapse another section before expanding it—the Balance section automatically collapses to make room for Detail when you open it.

Using presets

Elements 8 brings with it a new feature to help the undecided: *presets*. To the left of the sliders in the Panel bin are little grid-like squares (see Figure 4-4). If you think you need to use a particular slider but you aren't sure what it does, click its square and a grid of nine tiny thumbnails appears below the slider. Each thumbnail represents a different setting for that slider. All the Quick Fix sliders have presets.

Figure 4-4:

Hover your cursor over any of the thumbnails to see the effect displayed in your photo itself. To adjust the strength of the effect, click and drag left or right (this is called scrubbing) and watch as your image changes. To go back to what your image looked like when you opened the previews, click the one with the curled arrow on it.

If you don't have super-micro vision, you probably think these thumbnails are too small for you to tell the difference between them, but not so fast. Run your cursor over a thumbnail and Elements previews that setting in your image, so you can get a view as large as you need. You can even adjust the slider right from the thumbnail as explained in Figure 4-4. Once you like what you see, just click to apply the change to your photo. To reset your image to where it was when you began using your current group of presets, click the thumbnail with the curved arrow on it.

Different Views: After vs. Before and After

When you open an image in Quick Fix, your picture first appears by itself in the main window with the word "After" above it. Elements keeps the Before view—your original photo—tucked away, out of sight. But you can pick from three other layouts, which you can choose at any time: Before Only, "Before and After – Horizontal", and "Before and After – Vertical". Both of the before-and-after views are especially helpful when trying to figure out if you're improving your picture, or not, as shown in Figure 4-5. Switch between views by picking the one you want from the pop-up menu just below your image.

NOTE Quick Fix limits the amount of screen space available for your image. If you want a larger view while you work, click over to Full Edit.

Editing Your Photos

The tools in the Quick Fix window are pretty simple to use. You can try one or all of them—it's up to you. And whenever you're happy with how your photo looks, you can leave Quick Fix and go back to the Full Edit window.

If you want to rotate your photo, click either of the Rotate buttons, below the image preview area. (See page 70 for more about rotating photos.)

Figure 4-5: The Quick Fix window's before-and-after views make it easy to see how you're changing your photo. Here you see the "Before and After -Horizontal" view, which displays the before and after photos side by side. To see them one above the other, choose "Before and After - Vertical". If you want a more detailed view, use the Zoom tool (the magnifying glass icon, not shown) to focus on iust a portion of your picture.

Fixing Red Eye

Everyone who's ever taken a flash photo has run into the dreaded problem of *red eye*—those glowing, demonic pupils that make your little cherub look like someone out of an Anne Rice novel. Red eye is even more of a problem with digital cameras than with film, but luckily, Elements has a simple and terrific Red Eye tool for fixing it. All you do is click the red spots with the Red Eye Removal tool, and Elements fixes the problem.

To use the Quick Fix Red Eye tool:

1. Open a photo.

The Red Eye Removal tool works the same whether you get to it from the Quick Fix window's toolbox or from the main Tools panel in Full Edit.

2. Zoom in so you can see where you're clicking.

Use the Zoom tool to magnify the eyes. You can also switch to the Hand tool if you need to drag the photo so that the eyes are front and center.

3. Activate the Red Eye tool.

Click the Red Eye icon in the toolbox or press Y (this keystroke works in Full Edit, too).

4. Click in the red part of the pupil (see Figure 4-6).

That's it. Just one click should fix it. If a single click doesn't fix the problem, you can also try dragging the Red Eye tool over the pupil. Sometimes one method works better than the other. You can also adjust two settings on the Red Eye tool: Darken Amount and Pupil Size, as explained in a moment.

Figure 4-6:
Zoom in when using the Red Eye tool so you get a good look at the pupils. Don't worry if your photo looks so magnified that it loses definition—just make the red area large enough so you can hit it right in the center. The left eye in this picture has already been fixed. Notice what a good job the Red Eye tool does of keeping the highlights (called catchlights) in the eye that's been treated.

5. Click in the other eye.

Repeat the process on the other eye, and you're done.

NOTE You can also fix red eye in Full Edit or the Raw Converter (page 248).

If you need to adjust how the Red Eye tool works, the Options bar gives you three controls, although 99 percent of the time you can ignore them:

- Pupil Size. Increase or decrease the number here to tell Elements how much area to consider part of a pupil.
- Darken Amount. If the result is too light, increase the percentage in this box.
- Auto. Click this button and Elements automatically finds and fixes red eyes in your photo. At least that's what's supposed to happen. In practice, it's at least as likely to "fix" things like white teeth and bright streetlights. You're almost always better off fixing red eye manually.

POWER USERS' CLINIC

Another Red Eye Fix

The Red Eye tool does a great job most of the time, but it doesn't always work, and it doesn't work on animals' eyes. Elements gives you a couple of other ways to fix red eye that work in almost any situation. Here's one way to do it in Full Edit:

- 1. **Zoom way, way in on the eye.** You want to be able to see the individual pixels.
- Use the Eyedropper tool (page 219) to sample the color from a good area of the eye, or from another photo. Confirm that you have the color you want by checking the Foreground color square (page 216).

- 3. Get out the Pencil tool (page 356) and set its size to 1 pixel.
- 4. Click the bad or empty pixels of the eye to replace the color with the correct shade. Remember to leave a couple of white pixels for a catchlight (the pupil's glinting center highlight).

This method works even if the eye is *blown out* (that is, all white with no color info left).

If you're a layers fan, you can also fix red eye by selecting the bad area, creating a Hue/Saturation Adjustment layer (page 182), and desaturating the red area, but this method doesn't work so well if the eye is blown out.

Smart Fix

The secret weapon in the Quick Fix window is the Smart Fix command, which automatically adjusts a picture's lighting, color, and contrast, all with one click. You don't have to figure anything out—Elements does it all for you.

You'll find the Smart Fix in the aptly named Smart Fix panel, and it's about as easy to use as hitting the speed-dial button on your phone: Click the Smart Fix panel's Auto button, and if the stars are aligned, your picture will immediately look better. (Figure 4-7 gives you a glimpse of its capabilities. If you want to see for yourself how this fix works, download this photo—*iris.jpg*—from the Missing CD page at *www.missingmanuals.com.*)

Figure 4-7: Left: This photo, taken in the shade, is pretty dark.

Right: The Auto Smart Fix button improved it significantly with just one click. You might want to use the tools in the Balance section (page 111) to really fine-tune the color. **TIP** You'll find Auto buttons scattered throughout Elements. The program uses them to make best-guess attempts to implement whatever change the Auto button is next to (Smart Fix, Levels, Contrast, and so on). It never hurts to click these Auto buttons; if you don't like what you see, you can always perform the magical undo: $Edit \rightarrow Undo \text{ or } \Re -Z$.

If you're happy with the Auto Smart Fix button's changes, you can move on to a new photo, or try sharpening your image (see page 112) if the focus is a little fuzzy. You don't need to do anything to accept the Smart Fix changes. But if you're not ecstatic with your results, take a good look at your picture. If you like what Auto Smart Fix has done, but the effect is too strong or too weak, press \(\mathbb{H} - \mathbb{Z} \) to undo it, and try playing with the Smart Fix panel's Amount slider instead.

The Amount slider does the same thing Auto Smart Fix does, but you control the degree of change. Watch the image as you move the slider to the right. If your computer is slow, there's a certain amount of lag time, so go slowly to give it a chance to catch up. If you overdo it, sometimes it's easier to press the Reset button above your image and start again. Use the Accept and Reject buttons (which appear next to the Smart Fix label, as shown in Figure 4-8) to accept or reject your changes.

TIP Usually you get better results with a lot of little nudges to the Smart Fix slider than with one big, sweeping movement.

Incidentally, these are the same Smart Fix commands you see in the Editor's Enhance menu: Enhance → Auto Smart Fix (Option-\(\mathbb{H}\)-M), and Enhance → Adjust Smart Fix (Shift-\(\mathbb{H}\)-M).

Figure 4-8:

When you move a slider in any of the Quick Fix panels, the Accept and Reject buttons appear in the panel you're using. Clicking the X undoes the last change you made, while clicking the checkmark applies the change to your image. If you make multiple slider adjustments, the Reject button undoes everything you've done since you last clicked the Accept button. (The lightbulb takes you to the Elements Help Center.)

Sometimes Smart Fix just isn't smart enough to do everything you want, and sometimes it does things you *don't* want. It does a better job on photos that are underexposed than overexposed, for one thing. Fortunately, you have several other editing choices, covered in the following sections. If you don't like the effect Smart Fix has, undo it before going on to make other changes.

Adjusting Lighting and Contrast

The Lighting panel lets you make sophisticated adjustments to the brightness and contrast of your photo. Sometimes problems that you thought stemmed from exposure or even focus can be fixed by these commands.

Levels

If you want to understand how Levels really works, you're in for a long, technical ride. But if you just want to know what it can do for your photos, the short answer is that it adjusts the brightness of your photo by redistributing the color information. Levels changes (and hopefully fixes!) both brightness and color at the same time.

If you've never used image-editing software before, this may sound rather mysterious, but photo-editing pros will tell you that Levels is one of the most powerful commands for fixing and polishing your pictures. To find out if its magic works for you, click the Levels panel's Auto button. Figure 4-9 shows what a big difference it can make. (Download this photo—ocean.jpg—from the Missing CD page at www.missingmanuals.com, if you'd like to try it yourself.)

What Levels does is really complex. Chapter 7 has loads more details about what's going on behind the scenes and how you can apply this command more precisely.

Figure 4-9:
A quick click of the Auto
Levels button can make a
dramatic difference.

Left: The original photo isn't bad, and you may not realize how much better the colors could be.

Right: This image shows how much more effective your photo is once Auto Levels has balanced the colors.

Contrast

The main alternative to Auto Levels in Quick Fix is Auto Contrast. Most people find that their images tend to benefit from one or the other of these options. Contrast adjusts the relative darkness and lightness of your image without changing the color, so if Levels made your colors go all goofy, try adjusting the contrast instead. You use Auto Contrast the same way you use Auto Levels: Just click the Auto button in the Lighting panel next to the word "Levels".

FREQUENTLY ASKED QUESTION

Calibrating Your Monitor

Why do my photos look awful when I open them in Elements?

Do you find that your photos look really terrible in Elements, even though they look decent in other programs? Maybe your photos look all washed out, or reddish or greenish, or even black and white. If that's the case, you need to calibrate your monitor, as explained on page 202. It's easy to do and it makes a big difference.

Elements is what's known as a *color-managed* program. You can read all about color management on page 200.

For now, you just need to know that color-managed programs pay much more attention to the settings for your monitor than programs like word processors do.

Mac OS X has system-wide color management built in via Apple's ColorSync utility. So if you have a problem with your monitor, you'll probably realize it even before you get into Elements. Color-managed programs like Elements are a little more trouble to set up initially, but the advantage is that you can get truly wonderful results if you invest a little time and effort when you're getting started.

TIP After you use Auto Contrast, look closely at the edges of the objects in your photo. If your camera's contrast was already high, you may see a halo or a sharp line around the photo's subject. If you do, the contrast is too high and you need to undo Auto Contrast (%-Z) and try another fix instead.

Shadows and Highlights

The Shadows and Highlights tools do an amazing job of bringing out details that are lost in the shadows or bright areas of your photo. Figure 4-10 shows what a difference these tools can make.

Figure 4-10: Left: This photo has highlights that are too bright and shadows that are much too dark.

Right: After adjusting the shadows and highlights, you can see there's plenty of detail there. (Use the Color panel's sliders to get rid of the overly orange tone.) The Shadows and Highlights tools are a collection of three sliders, each of which controls a different aspect of your image:

- Lighten Shadows. Nudge the slider to the right and you'll see details emerge from murky black shadows.
- Darken Highlights. Use this slider to dim the brightness of overexposed areas.
- Midtone Contrast. After you've adjusted your photo's shadows and highlights, your photo may look flat and not have enough contrast between the dark and light areas. This slider helps you bring a more realistic look back to your photo.

TIP You may think you only need to lighten shadows in a photo, but sometimes just a smidgen of Darken Highlights may help, too. Don't be afraid to experiment with this slider even if you have a relatively dark photo.

Go easy: Getting overenthusiastic with these sliders can give your photos a washedout, flat look.

Color

The Color panel lets you—surprise, surprise—play around with the colors in your image. In many cases, if Auto Levels or Auto Contrast has done the trick, you won't need to do anything here.

Auto Color

Elements has yet another one-click fix: Auto Color. Actually, in some ways Auto Color should be up in the Lighting section. Like Levels, it simultaneously adjusts color and brightness, but it looks at different information in your photos to decide what to do with them.

When you're first learning to use Quick Fix, you may want to try all three Auto buttons—Levels, Contrast, and Color—to see which generally works best for your photos. Undo between each change and compare your results. Most people find they like one of the three most of the time.

Auto Color could be just the ticket for your photos, but you may also find that it shifts your colors in strange ways. Give it a click and see what you think. Does your photo look better or worse? If it's worse, just click Reset or press **%**-Z to undo it, and go back to Auto Levels or Auto Contrast. If they all make your colors look a little wrong, or if you want to tweak the colors in your photo, move on to the Color sliders, explained next.

The Color sliders

If you want to adjust your photo's colors without changing its brightness, check out the Color sliders. For example, your digital camera may produce colors that don't quite match what you saw when you took the picture; or you may have scanned an old print that's faded or discolored; or you may just want to change the colors in a photo for the heck of it. If so, the Color panel's sliders are for you.

You have two ways to adjust your colors here:

- Saturation controls the intensity of your photo's color. For example, you can turn a color photo to black and white by moving the slider all the way to the left. Move it all the way to the right and everything glows with so much color that it looks radioactive.
- Hue changes the color from, say, red to blue or green. If you aren't looking for realism, you can have fun with your photos by using this slider to create funky color changes.

You probably won't use both these sliders on a single photo, but you can if you like. (Remember to click the Accept checkmark that appears in the Color panel if you want to keep your changes.) For fine-tuning your color, you may want to move on to the next panel: Balance. In fact, you often only need to use the Balance sliders.

TIP If you look at the color of a slider's track, it shows you what happens if you move in that direction. For example, there's less color as you go left in the Saturation track, and more as you go to the right. Looking at the tracks can help you figure out where to move the slider.

Balancing color

Photos often have the right amount of saturation and moving the Hue slider makes everything look funky, but sometimes there's something about the overall color balance that just isn't right. The Balance panel has two sliders for adjusting the overall colors in your image:

- Temperature lets you change the color from cool (bluish) on the left to warm (orangeish) on the right. Use this slider for things like toning down the warm glow you see in photos taken in tungsten lighting, or for fine-tuning your image's color balance.
- Tint adjusts the green/magenta balance of your photo, as shown in Figure 4-11.

Figure 4-11: Left: The greenish tint in this photo is a typical example of a common problem caused by many digital cameras.

Right: A little adjustment of the Tint slider clears it up in a jiffy. It's not always as obvious as it is here that you need a tint adjustment. If you aren't sure, the sky is often a dead giveaway. Does the sky look robin's egg blue when it was really more of a plain blue? If so, tint is what you need. In previous versions of Elements, these sliders were grouped with the Color sliders. You'll often use a combination of adjustments from both groups. Chapter 7 has more about how to use the full-blown Editor to fine-tune your image's color.

Sharpening

Now that you've finished your other corrections, it's time to *sharpen* your photo, so move down to the Detail panel. Sharpening gives the effect of better focus by improving the edge contrast in your photo. Most photos taken with digital cameras need some sharpening because the sharpening your camera applies is usually deliberately conservative. Once again, a Quick Fix Auto button is at your service. Give the Auto Sharpen button (located in the Detail panel) a try to get things started. Figure 4-12 shows what you can expect.

Figure 4-12: Left: The original image. Like many digital photos, it could stand a little sharpening.

Middle: What you get by clicking the Auto Sharpen button.

Right: The results of using the Sharpen slider to get more sharpening than the Auto button did.

NOTE Mac OS X has some pretty sophisticated sharpening tools built right in. Preview lets you apply Luminance Channel sharpening, a complex technique you might like better than Elements' sharpening options. Open a photo in Preview and give it a try (Tools \rightarrow Adjust Color \rightarrow Sharpness) to see whether you prefer it to what the Quick Fix can do.

The sad truth is that there really isn't any way to actually improve the focus of a photo once it's taken. Software sharpening just increases the contrast where the program perceives edges, so using it first can have strange effects on other editing tools and their ability to understand your photo.

If you don't like what Auto Sharpen does (and you may not), you can undo it (press \mathbb{H}-Z) and try the Sharpen slider. If you thought the Auto button overdid things, go very gently with the slider. Changes vary from photo to photo, but usually Auto's results fall at around the 30 to 40 percent mark on the slider.

TIP If you see funny halos around the outlines of objects in your photos or strange flaky spots (making your photo look like your subject has eczema), those are caused by too much sharpening; reduce the Sharpening settings until they go away.

Always try to view Actual Pixels (View → Actual Pixels) whenever you sharpen because that gives you the clearest idea of what you're doing to your picture. If you don't like what the Auto button does, undo it, and then try the slider. Zero sharpening is all the way to the left; moving to the right increases the amount of sharpening Elements applies to your photo.

As a general rule, you want to sharpen photos you plan to print more than images for Web use. You can read lots more about sharpening on page 222.

NOTE If you've used photo-editing programs before, you may be interested to know that the Auto Sharpen button applies Adjust Sharpness (page 225) to your photo. When you use the Auto button, you don't have any control over the settings, as you would if you applied it from the Enhance menu. But the good news is that if you want more control, or if you prefer to use Unsharp Mask (page 223), you can get it—even from within Quick Fix. Just go to the Enhance Menu and choose the sharpener of your choice.

At this point, all that's left is cropping your photo, if you'd like to reduce its size. Page 75 tells you everything you need to know about cropping. You can also give your photo a bit more punch by using the Touch Up tools, explained next.

Touch Ups

The Quick Fix toolbox contains four special tools to help improve your photos. (You can see them back in Figure 4-1.) You've already learned how to use one of them—the Red Eye Removal tool—earlier in this chapter (page 104). Here's what you can do with the other three:

• Whiten Teeth. No surprise here: This tool makes teeth look brighter. What's especially nice is that, as shown in Figure 4-13, it doesn't create a fake, overlywhite look.

Figure 4-13:
Just a quick swipe across the teeth selects them and whitens them, while keeping a realistic look

• Make Dull Skies Blue. It's a common problem with digital cameras: The subject's exposure is perfect, but the sky is all washed out. Unfortunately, if your sky is *really* gray or blown out (white looking), this tool won't help much. Adobe probably should have called it Make Blue Skies Bluer. It is useful for creating more dramatic skies, though.

• Black and White – High Contrast. You're probably wondering what the heck that means. It's Adobe's way of saying, "transform the area I choose from color to black and white." This tool is a great timesaver when you want to create a photo where only part of the picture is in color. ("High Contrast" refers to the style of black-and-white conversion this tool uses.)

All three tools work pretty much the same way: Draw a line over the area you want to change, and Elements makes a detailed selection of the area and applies the change for you:

1. Open a photo and make your other corrections first.

If you're an old hand at using Elements, use the Touch Up tools before sharpening. But if you're a beginner and not comfortable with layers (see Chapter 6), sharpen first. (See the note on page 116 for more about why.)

2. Click the icon for the tool you want to use.

If you aren't sure which is which, hover your cursor over each one until a little label (called a tooltip) pops up telling you the name of that tool.

3. Draw a line over the area you want to change.

When you click one of the Touch Up tools, your cursor turns to a circle with crosshairs in it. Just drag that over the area you want to change. Elements automatically expands the area to include all of the object it thinks you want. (It works just like the Quick Selection tool, only it also applies changes to your image. Page 129 has more about using the Quick Selection tool.) You'll see the marching ants (page 125) appear around the area Elements changes.

4. If Elements included too much or too little, tweak the size of the selected area.

At the left side of the Options bar are three little brush icons. The left icon lets you start a new selection, and the other two let you change what Elements selected in step 3. Click the one on the right and drag over any area you want to remove, or click the middle one and drag to add to the selected area. (You can also just drag to extend your selection, or Option-drag if Elements covered too much area and you need to remove some of it, without going to the Options bar at all.)

5. Once you're happy with the area covered by the change, you're done.

You can back up by pressing **%**-Z to undo your changes step by step. Keep going to eliminate the change completely if you don't like it. (Clicking the Reset button *doesn't* undo the Touch Up changes.)

The Touch Up tools can be helpful, but they work based on the colors in your photo, so they may not always give you the results you want, as you can see in Figure 4-14. If you want to use the Color sliders (page 110) to adjust things, you'll need to switch from the Touch Up tools and use the Selection brush to reselect the area, because the sliders aren't available when the Touch Up tools are active.

NOTE The Touch Up tools create a *layered* file. If you understand layers, you can also go back to Full Edit and make changes after the fact, like adjusting the opacity or blend mode of the layer (see Chapter 6 to learn about layers). You can always discard your Touch Up changes by discarding the layer they're on. You can even edit the area affected by the changes by editing the layer mask, as explained on page 308, or use the Smart Brush tool (page 196) in Full Edit. (The one exception is the "Black and White – High Contrast" tool—you can't change the settings for the adjustments it makes. If you try to, you'll see a weird message that your layer was created in the full version of Photoshop, even though you know it wasn't.)

Figure 4-14:
Make Dull Skies Blue can
help punch up the sky color
in your photos—sometimes.

Left: Smog makes the sky in this photo look dull.

Right: One quick drag across the sky with the Dull Skies tool produces a much more vivid sky—maybe too vivid (and a tad green). Elements used a gradient (see page 404) to give a more realistic shading to the new sky color.

Also, if there isn't enough color to begin with, the Touch Up tools may not produce any visible results. If your subject has very white dentures, Whiten Teeth may not do anything. And Make Dull Skies Blue may prove to be a dud if your sky is just solid gray or completely overexposed. You may find, however, that after using a Touch Up tool, nothing happens when you try to make other changes to your photo. If you run into that problem, read the following Note.

NOTE As mentioned above, Elements leaves you with a layered file after you use the Touch Up tools (except for the Red Eye Removal tool). That isn't normally a problem, even if you don't know anything about layers, but once in a while you may find that nothing happens when you try to make other changes to your photo.

If that happens, at the top of the screen, click the Edit tab and select EDIT Full. Then find the Layers panel. (It should be in the Panel bin unless you've removed it. If you can't find it, go to Window → Layers to bring it back.) In the Layers panel, look for the word Background and click that. That part of the panel should be blue. If it isn't, click it again. Then you can go back to Quick Fix and do whatever you want to your photo, but the part you used the Touch Up tools on may behave differently from the rest of the photo. If that happens, and you haven't closed the photo since using the Touch Up tools, use Undo History (page 32) to back up to before you used the Touch Up tools.

Quick Fix Suggested Workflow

There are no hard-and-fast rules for what order you need to work in when using the Quick Fix tools. As mentioned earlier, Elements lays out the tools in the Panel bin, from top to bottom, in the order that usually makes sense. But you can pick and choose which tools you want, depending on what you think your photo needs. If you're the type of person who likes a set plan for fixing photos, here's one order in which to apply the commands:

1. Rotate your photo (if needed).

Use the Rotate buttons below the image preview.

2. Fix red eye (if needed).

See page 104.

3. Crop.

If you want to crop your photo, now's the time. That way, you get rid of any problem areas before they affect other adjustments. For example, say your photo has a lot of overexposed sky that you want to crop out. If you leave it in, that area may skew the effects of the Lighting and Color tools on your image. So if you already know where you want to crop, do it before making other adjustments for more accurate results. (It's also okay to wait till later to crop, if you aren't sure yet about what you want to trim.)

4. Try Auto Smart Fix and/or the Smart Fix slider. Undo if necessary.

Pretty soon you'll get a good sense of how likely it is that this fix will do a good job on your photos. Some people love it; others think it makes their pictures too grainy.

5. If Smart Fix wasn't smart enough, work your way down through the Lighting, Color, and Balance sliders until you like the way your photo looks.

Read the sections earlier in this chapter to understand what each command does to your photo.

6. Sharpen.

Try to make sharpening your last adjustment because other commands can produce funky results on photos you've already sharpened. But if you're a beginner and not comfortable with layers, you can sharpen *before* using Whiten Teeth, Make Dull Skies Blue, or "Black and White – High Contrast". (See page 115 for more about why you'd wait to use these.)

TIP When you're in Quick Fix mode, you can switch back to Full Edit at any point if you want tools not available in Quick Fix. If you want to close your photo while in Quick Fix, click the Close button above the preview area or press **%**-W.

Adjusting Skin Tones

If you're like most amateur photographers, your most important photos are pictures of people: your family, your friends, or even just fascinating strangers. Elements gives you yet another tool for making fast fixes—one that's designed especially for correcting photos that have people in them: the "Adjust Color for Skin Tone" command, available in both the Quick Fix and Full Edit windows.

The name "Adjust Color for Skin Tone" is a bit confusing. What this command actually does is adjust your entire image based on the skin tone of someone in the photo. The idea behind "Adjust Color for Skin Tone" is that you're probably much more interested in the way the people in your photos look than in how the background looks, so this command gives the highest priority to creating good skin color. It's an automatic fix, but it brings up a dialog box where you can tweak the results once you've previewed Elements' suggested adjustments. To use the "Adjust Color for Skin Tone" command:

1. Call up the "Adjust Color for Skin Tone" dialog box.

In either Quick Fix or Full Edit, go to Enhance → Adjust Color → "Adjust Color for Skin Tone". The dialog box shown in Figure 4-15 appears. (You may need to move it out of the way of your photo so you can see what's happening.)

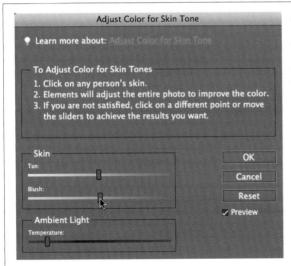

Figure 4-15:
When this dialog box appears, your cursor turns into an eyedropper when you move it over your photo.
Click the best-looking area of skin you can find. (You don't see any sliders in the dialog box's tracks until you click.) After Elements adjusts the photo based on your click, the sliders appear and you can use them to finetune the results. Clicking different spots produces different results, so try clicking different places.

2. Show Elements an area of skin to sample for calculating the color adjustments.

Once the dialog box appears, your cursor turns into an eyedropper. Find a spot in your photo where your subject's skin has relatively good color, and click it.

3. Tweak the results.

Elements is often a bit overenthusiastic in its adjustments. Use the sliders in the dialog box to get a more pleasing, realistic color. The Tan slider increases or decreases the browns and oranges in the skin tones. The Blush slider increases the rosiness of the skin as you move the slider to the right and decreases it as you go left. And the Ambient Light slider works just like the Quick Fix Panel bin's Temperature slider (page 111). You may get swell results with your first click, or you may have to use all the sliders to get a realistic result. It all depends on the photo.

You can preview the changes right in your photo as you work. If you mess up and want to start again, click Reset. If you decide you'd rather use another tool instead, click Cancel.

TIP The "Adjust Color for Skin Tone" sliders are like the Quick Fix sliders in that you can get an idea of which way to move them by looking at the colors in the sliders' tracks.

4. When you like what you see, click OK.

Elements applies your changes. If you want to undo them, press **ℋ**-Z.

"Adjust Color for Skin Tone" seems to work best on fair skin, and not so well on darker skin tones. And it's most suited for making fairly subtle adjustments, so you may have to reduce the amount of change from what Elements first did.

Also, notice that Elements doesn't just change the skin tones—it adjusts *all* the colors in the photo (see Figure 4-16). Sometimes you may find you've acquired quite a color cast by the time you have the skin tones just right (see page 213). If this bothers you, try a different tool. On the other hand, you can create some nice late-afternoon light effects with this command.

While "Adjust Color for Skin Tone" is really meant as a kind of alternative fast fix, you may find it's best for making small adjustments to photos you've already edited using other tools.

TIP If you understand layers (explained in Chapter 6), you can make a duplicate layer and apply this command to your duplicate. Then you can adjust the intensity of the result by adjusting the layer's opacity (see page 166).

Figure 4-16: Top: This photo shows a slight greenish cast, giving the boy a somewhat unappealing skin tone.

Bottom: "Adjust Color for Skin Tone" warms up his skin tones, and it even removes the greenish tinge to the wood of the bench he's sitting on.

Part Two: Elemental Elements

Chapter 5: Making Selections

Chapter 6: Layers: The Heart of Elements

Figure 5-2:
To make a perfectly circular or square selection, hold down the Shift key while you drag with one of the Marquee tools. You can reposition your selection after you draw it by using the arrow keys, or by dragging it. You can also adjust it by using Transform Selection, explained on page 147.

To use the Marquee tools to make a selection:

1. Activate the Marquee tool by pressing M or clicking its icon in the Tools panel.

The Marquee tool is the little dotted rectangle right below the Eyedropper icon in a single-row Tools panel, or below the Hand tool if you have two rows. (The icon may be a dotted oval instead, if you used the Elliptical Marquee tool last.)

2. Choose the shape you want to draw: a rectangle or an ellipse.

In the Tools panel's pop-out menu for the Marquee tools, choose the rectangle or the ellipse.

3. Enter a feather value in the Options bar, if you want one.

Feathering makes the edges of your selection softer or fuzzier for better blending (when you're trying, say, to replace Brad Pitt's face with yours). The box on page 137 explains how feathering (and anti-aliasing) work.

4. Drag in your image to make your selection.

Wherever you initially put your cursor becomes one of the corners of your rectangular selection or a point just beyond the outer edge of your ellipse (you can draw perfectly circular or square selections, as shown in Figure 5-2). The selection outline expands as you drag your mouse.

If you make a mistake, just press the Esc key. You can also press either \Re -D to get rid of all current selections, or \Re -Z to remove the most recent selection.

Figure 5-1:
The popular name for these dotted lines is "marching ants" because they march around your selections to show you where the edges lie. When you see the ants, your selection is active, meaning what you do next happens only to the selected area.

Selecting Rectangular and Elliptical Areas

Selecting your whole picture is all well and good, but many times your reason for making a selection is precisely because you *don't* want to make changes to the whole image. How do you select just part of the picture?

The easiest way is to use the Marquee tools. You met the Rectangular Marquee tool back in Chapter 3, in the section on cropping (page 75). If you want to select a block of your image or a circle or an oval from it, the Marquee tools are the way to go. As the winners of the Most Frequently Used Selection Tools award, they get the top spots in the Selection area of the Editor's Tools panel. You can modify how they work, like telling them to create a square instead of a rectangle, as explained in Figure 5-2.

TIP It's much easier to select an object that's been photographed against a plain, contrasting background. So, if you know you're going to want to select a bicycle, for example, shoot it in front of a blank wall rather than, say, a hedge.

Selecting Everything

Sometimes you want to select your whole photo, like when you want to copy and paste the entire thing. Elements has some commands to help you make basic selections in no time:

• Select All (Select → All or ૠ-A) tells Elements to select your whole image. You'll see those "marching ants" you learned about in Chapter 3 (see Figure 5-1) around the outer edge of your picture.

To copy your image into another picture or program, Select All is the fastest way to go. But if your photo contains layers, which you'll learn about in Chapter 6, you may not be able to get everything you want with the Select All command. In that case, use Edit → Copy Merged, or press Shift-#-C.

NOTE If you're planning on pasting an image into another program, like Microsoft Word or Keynote, make sure you have Export Clipboard turned on in Photoshop Elements → Preferences → General.

- Deselect Everything (Select → Deselect, Escape, or **%**-D) removes any current selection. Remember this command's keystroke combination because it's one you'll probably use often.
- Reselect (Select → Reselect or Shift-ૠ-D) tells Elements to reactivate the selection you just canceled. Use Reselect if you realize you still need a selection you just got rid of. Or you can just press ૠ-Z to back up a step.
- Hide/View a Selection (#-H) keeps your selection active while hiding its outline. Sometimes the marching ants make it hard to see what you're doing, or they can be distracting, so use this command. To see the ants again, press #-H a second time.

TIP Sometimes it's easy to forget you have a selection. When a tool acts goofy or won't do anything, start your troubleshooting by pressing **%**-H to be sure you don't have a hidden selection you forgot about.

If you want to quickly select an irregular area, try the Quick Selection tool, explained on page 129.

Making Selections

One of Elements' most impressive talents is that it lets you *select* part of your image and make changes only to that area. Selecting something tells Elements, "Hey, *this* is what I want to work on—don't touch the rest of my picture." You can select your entire image or any part of it.

Using selections, you can fine-tune your images in sophisticated ways. You could change the color of just one rose in a whole bouquet, for instance, or change your nephew's festive purple hair back to something his grandparents would appreciate. Graphics pros will tell you that good selections make the difference between shoddy, amateurish work and a slick, professional job.

Elements gives you a whole bunch of different Selection tools to work with. You can draw a rectangular or circular selection with the Marquee tools, for instance. Or paint a selection on your photo with the Selection brush, or just draw a line with the Quick Selection tool and let Elements figure out the exact boundaries of your selection. And when you're looking to pluck a particular object (a beautiful flower, say) from a photo, the Magic Extractor works wonders.

For most jobs, there's no right or wrong tool, but with experience, you may find you prefer working with certain tools more than others. Often you'll use more than one tool to create a perfect selection. This chapter teaches you about all the different Selection tools and how to use each one. And Elements 8 ushers in a new tool—Transform Selection—that lets you resize your selections in a snap. You'll learn how on page 147.

There are a few Options bar controls for this tool, which are explained below, but you mostly won't need to think about them, at least not till you make your selection. Then you'll probably want to try Refine Edge (explained in the next section).

3. Adjust the selection.

Odds are that you won't get a totally perfect selection that includes everything you wanted on the first click. To increase the selected area, drag in the direction where you want to add to the selection. A small move usually does it, and the selection jumps outward to include the area that Elements thinks you want, as shown in Figure 5-5.

Figure 5-5:
Left: It would be a nuisance to select this water lily by hand because of the many pointy-edged petals. The first drag with the Quick Selection tool produced this partial selection. Notice how well the tool found the edges of the petals.

Right: Another drag across the lily told Elements to select the whole blossom. This took less than 5 seconds to complete. (Notice that the tool missed a little bit on the edges in a couple of spots. Reduce the brush size when dragging to add those, or switch to the regular Selection brush to finish up.)

To remove an area from the selection, hold Option and drag or click in the area you don't want.

Once you're happy with your selection, you're done, unless you want to tweak the edges using Refine Edge (see the next section)—and you probably do.

The Quick Selection tool has a few Options bar choices, but you really don't need most of them:

• New selection, Add to selection, Subtract from selection. These three brush icons work just like the equivalent selection squares in Selection tools (page 128), but you don't need to use them. The Quick Selection tool automatically adds to your selection if you drag toward an unselected area. Shift-drag to select multiple areas that aren't contiguous. Option-drag to remove areas from your selection.

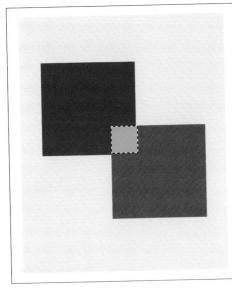

Figure 5-4:

"Intersect with selection" lets you take two separate selections and select only the area where they intersect. If you have an existing selection, when you select something else, your new selection includes only the overlapping area. Here, the blue square is the first selection, and the pink square is the second. The bright green area is what Elements selects after you let go of the mouse button.

Selecting with a Brush

Elements gives you two special brushes to help make selections. The Selection brush has been around since Elements 2, so if you've used Elements before, you probably know how useful it is. These days it often takes a back seat to the amazing Quick Selection tool, which makes even the trickiest selections as easy as doodling. The Quick Selection tool automatically finds the bounds of the objects you drag it over, while the Selection brush selects only the area immediately under your cursor.

The Quick Selection tool and the Selection brush are grouped in the Tools panel, and they appear in both Full Edit and Quick Fix because they're so useful. You may find that with these two tools, you rarely need the other Selection tools.

It couldn't be easier to use the Quick Selection tool:

1. Activate the Quick Selection tool.

Click it in the Tools panel or press A, and then choose it from the Tools panel's pop-out menu. It shares a Tools panel slot with the regular Selection brush. Their icons are very similar, so look carefully—the Quick Selection tool looks more like a wand than a brush and it points up, while the regular Selection brush points down.

2. Drag in your photo.

As you move your cursor, Elements calculates where it thinks the selection's edges should be, and the selection outline jumps out to surround that area. Elements is an amazingly good guesser. There's no need to try to cover the whole area or to go around the edges of your object—Elements does that for you.

Controlling the Selection Tools

If you're the kind of person who never makes a mistake and you never change your mind, you can skip this section. But if you're human, you need to know about the mysterious little squares you see in the Options bar when the Selection tools are active (Figure 5-3).

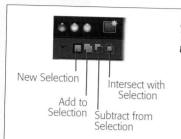

Figure 5-3:
These cryptic squares can save you hours of time once you understand how to use them to control the Selection tools.

These squares don't look like much, but they tell the Selection tools how to do their job: whether to start a new selection each time you click, to add to what you've already selected, or to remove things from your selection. They're available for all the Selection tools except the Selection brush and the Quick Selection tool, which have their own sets of options. From left to right, here's what they do:

- New selection is the standard selection mode that you'll probably use most of the time. When you click this button and start a new selection, your previous selection disappears.
- Add to selection tells Elements to add what you select to what you've already selected. Unless you have an incredibly steady mouse hand, this option is a god-send because it's not easy to get a perfect selection on the first try. (Holding down the Shift key while you use any Selection tool is another way to add to a selection.)
- Subtract from selection removes what you select next from any existing selection. (You can accomplish the same thing by holding down Option while selecting the area you want to remove.)
- Intersect with selection is a bit confusing. It lets you take a selected area, make a new selection, and wind up with only the area where the selections overlap, as shown in Figure 5-4. (The keyboard equivalent is Option-Shift.) Most people don't need this one much, but it can be useful for things like creating special shapes. If you need a selection shaped like a quarter of a pie, for instance, do a circle selection, then switch to "Intersect with Selection" and drag a rectangular selection from the circle's center point. You'll wind up with an arc-shaped area where they intersect.

The Options bar's Mode setting gives you three ways to control the size of your selection: Normal lets you manually control it; Fixed Aspect Ratio lets you enter proportions in the Width and Height boxes; and Fixed Size lets you enter specific dimensions in these boxes. (The Anti-alias checkbox is explained in the box on page 137.)

Once you've made your selection, you can move the selected area around in the photo by dragging it, or use the arrow keys to nudge your selection in the direction you want to move it. And Elements 8's new Transform Selection command lets you drag your selection to make it larger or smaller or change its shape; page 147 tells you how.

Selecting Irregularly Sized Areas

It would be nice if you could get away with just making simple rectangular or elliptical selections, but is life really ever that neat? You aren't always going to want to select a geometric-shaped chunk of your image. If you want to change the color of one fish in your aquarium picture, for example, selecting a rectangle or square isn't going to cut it.

UP TO SPEED

Paste vs. Paste Into Selection

Newcomers to Elements are often confused by the fact that the program has two Paste commands: Paste and Paste Into Selection. Knowing what each one does will help you avoid problems:

- Paste. Ninety-nine percent of the time, Paste is the one you want. This command simply places your copied object wherever you paste it. Once you paste an object, you can use the Move tool (page 150) to move it.
- Paste Into Selection. This is a special command for pasting a selection into another selection. Your pasted object appears only within the bounds of the selection you're pasting into.

When you use Paste Into Selection, you can still move what you just pasted, but it won't be visible anywhere outside the edges of the selection you're pasting into.

Paste Into Selection is handy if you want to do something like put a beautiful mountain view outside your window: Select the mountain, copy it (%-C), then select the window and use Paste Into Selection to add the view. use Paste Into Selection to add the view. Then you can maneuver the mountain photo around till it's properly centered. And if you move it outside the boundary of your window selection, it just disappears. Once you deselect, your material is permanently in place; you can't move it again.

If you understand layers (see Chapter 6), Paste creates a new layer, while Paste Into Selection puts what you paste on the existing layer.

Thankfully, Elements gives you other tools that make it easy to create precise selections—no matter their size or shape. In this section, you'll learn how to use the rest of the Selection tools. But first you need to understand the basic controls that they (almost) all share.

- Brush. You can make all kinds of adjustments to your brush by clicking this pull-down menu, including choosing from many of the Additional Brush Options palette (page 350), although you'll rarely need any of these except maybe the brush size, once in a while.
- Sample All Layers. Turn on this checkbox and the Quick Selection tool selects from all visible layers in your image, rather than just the active layer.
- Auto-Enhance. This setting tells Elements to smooth out the edges of the selection. It's a more automated way to make the same sort of edge adjustments that you make manually with Refine Edge.
- Refine Edge. This option lets you tweak the edges of your selection so you get more realistic results when changing the selected area or copying and pasting it. The Refine Edge button is grayed out until you actually make a selection. It's explained in detail in the next section.

TIP Depending on what you plan to do with your selection, you may want to check out the Smart Brush tool. It works just like the Quick Selection tool, but it goes beyond simply completing your selection for you; it also automatically applies the color correction or special effect you choose from its pull-down menu. See page 196 for more about working with the Smart Brushes.

The Quick Selection tool doesn't work every time for every selection, but it's a wonderful tool that's worth grabbing first for any irregular selection. You can use the Selection brush or one of the other Selection tools to clean up afterward, if needed.

Refine Edge

This is another tremendously helpful Elements feature. It lets you create smooth, feathered, plausible edges on any selection—a must when you want to realistically blend edited sections into the rest of an image. The Refine Edge button appears in the Options bar for some of the tools for making irregular selections (like Quick Selection), or you can use it on any active selection by going to Select → Refine Edge. To use it, first make a selection, and then:

1. Call up the Refine Edge dialog box.

If there isn't a Refine Edge button in the Options bar (it's not there when you use the Marquee tool, for example), go to Select → Refine Edge to bring it up.

2. Adjust the edges of your selection.

Use the Refine Edge dialog box's controls (which are explained in detail after this list) to fine-tune your selection. The sliders let you tweak and polish the edges of your selection. Use the view buttons to see your selection in either of two different ways, and zoom to 100 percent or more so you can see exactly how you're changing the selection.

3. When you like what you've done, click OK.

If you decide not to refine the edges, click Cancel. To start over, Option-click the Cancel button to turn it into a Reset button. If you play with the sliders and then decide you want to put them back where you started, click Default.

The Refine Edge dialog box has three sliders. You may need to use only one, or any combination of them, to improve your selection. Your choices are:

- Smooth. This removes the jagged edges around your selection. Type a value in pixels or use the slider (move it to the right for more smoothing, to the left for less). Be careful: You can go as high as 100 pixels, which is almost certain to be *much* more smoothing than you need.
- Feather. Feathering is explained on page 137.
- Contract/Expand. You can use this to adjust the size of your selection. Move the slider to the left to contract the selection, or to the right to expand it outward.

It's easy to refine *too* much, so go in small increments and keep checking your selection. Elements makes it easy to monitor things by giving you a choice of views. The buttons above the Description area of the dialog box give you two different ways to see your selection:

- Standard shows the regular marching ants around your selection.
- Custom Overlay Color shows the red mask overlay you'd get when using the Selection brush in Mask mode (see page 133). The red area is *not* part of your selection. Using this view is a good way to check for holes and jagged edges.

TIP Double-click the Custom Overlay button and you can change the color and opacity of the overlay. When the Refine Edge dialog box is open, you can hide your selection by pressing X (press X again to bring it back), and press F to toggle between Standard and Overlay views.

You also get icons for the Zoom (page 86) and Hand (page 88) tools, so you can adjust the view to see more or different details.

The Selection Brush

The Selection brush is one of the greatest tools in Elements. Making complex selections and cleaning up selections are super easy with the Selection brush. You can use it on its own or as a complement to the Quick Selection tool, described in the previous section. The Quick Selection tool is awesome, but sometimes it can't stop your selection exactly where you want. The Selection brush gives you total control because it selects only the area you cover with your brushstroke.

With the Selection brush, you simply paint over what you want to select by dragging over that area. You can let go, and each time you drag again, Elements automatically adds to your selection; there's no need to change modes in the Options bar or hold down the Shift key the way you have to with other Selection tools.

Not only that, but the Selection brush also has a Mask mode, in which Elements highlights what *isn't* part of your selection. Mask mode is great for finding tiny spots you may have missed and for checking the accuracy of your selection outline. In Mask mode, anything you paint over gets *masked* out; in other words, it's protected from being selected.

Masking is a little confusing at first, but you'll soon see what a useful tool it is. Figure 5-6 shows the same selection made with and without Mask mode.

Figure 5-6:
Left: This flower has been selected by painting with the Selection brush set to Selection mode. It looks like a completed selection that you can make using any of the Selection tools.

Right: The same selection in Mask mode. The red covers everything that isn't part of the selection.

The Selection brush is simple to use:

1. Click the Selection brush in the Tools panel or press A.

The Selection shares a spot in the Tools panel with the Quick Selection tool. The Selection brush is the brush that looks like it's painting—the brush points down.

2. In the Options bar, choose either Selection mode or Mask mode and the brush size you want.

Your Options bar choices are explained in the list below.

3. Drag over the area you want.

If you're in Selection mode, the area you drag over becomes part of your selection. If you're in Mask mode, the area you drag over is excluded from becoming part of your selection.

The Selection brush has several Options bar settings:

• Brush Preset. You can use different brushes depending on whether you want a hard- or soft-edged selection. If you want a different brush, choose it from the menu here. (For more about brushes, see page 347.)

• Size. To change the brush's size, type a size in the box, or click the arrow and then use the slider. Or press the close bracket key (]) to increase the size of your brush (keep tapping it until you get the size you want), or the open bracket key ([) to decrease the size. You can also put your cursor on the word Size and scrub to the left or right to make the brush smaller or larger. (Don't know how to scrub? For more on this nifty Elements feature, see page 166.)

TIP The bracket key shortcut works with any brush, not just the Selection brush.

- Mode. This is where you tell Elements whether you're creating a selection (Selection) or excluding an area from being part of a selection (Mask).
- Hardness. This option controls the sharpness of the edge of your brush, which affects your selection. See Figure 5-7.

Figure 5-7:
These Selection brushstrokes show the way the Hardness setting affects the edges of your selection. Here, two different selections were made in the green rectangle. The top selection was made at 100-percent hardness, and the bottom one is at 50 percent. (The selected area was then deleted to show you the outline more clearly.)

Switching between Selection and Mask mode is a good way to see how well you've done when you finish making your selection. In Mask mode, the parts of your image that are *not* part of your selection have a red film over them, so that you can clearly see the selected area.

TIP You don't have to live with a red mask. To change the mask's color, click the Overlay color square in the Options bar while the Selection brush is active and in Mask mode, and then use the Color Picker (page 217) to choose a color you prefer. You can also change the percentage in the Overlay opacity box (labeled simply Overlay in the Options bar) to adjust how well your image shows through the mask.

You can temporarily make the Selection brush do the opposite of what it's been doing by holding down Option while you drag. This can save a lot of time in a tricky selection, since you don't have to keep jumping up to the Options bar to change what's happening, and you can keep the view (either your selection or the mask) the same. For example, if you're in Selection mode and you've selected too large an area, Option-drag over the excess to remove it. If you're masking out an area, Option-drag to add an area to the selection. This may sound confusing, but give it a shot and you'll understand. Some things are easier to learn by doing.

TIP The Selection brush is great for fine-tuning selections made with the other Selection tools. Quickly switching to the Selection brush in Mask mode is a great way to check for spots you've missed—the red makes them easy to spot.

The Magic Wand

The Magic Wand is a slightly temperamental—and occasionally highly effective—tool for selecting an irregularly shaped, but similarly colored, area of an image. If you have a big area of a particular color, the Magic Wand can find its edges in one click. It's not actually all that magical: All it does is search for pixels with similar color values. But if it works for you, you may decide it deserves the "magic" in its name because it's a great timesaver when it cooperates, as Figure 5-8 shows.

Figure 5-8:
Just one click with the Magic Wand created this nearly perfect selection. If the area you want to select isn't very different in color from the neighboring areas, the Wand won't be as effective as it is here.

Using the Magic Wand is simple: Click anywhere in the area you want to select. Depending on your *Tolerance* setting (explained in the following list), Elements may nail the selection right away, or it may take several clicks to get everything. If you need to click more than once, remember to hold down Shift so that each click adds to your selection.

The Magic Wand does its best job when you offer it a solid block of color that's clearly defined and doesn't have a lot of different shades in it. But it's frustrating when you try to select colors that have any shading or tonal gradations—you have to click and click and click. Elements gives you some special Options bar settings that you can adjust to help the Wand do a better job:

- Tolerance adjusts the number of different shades that the tool selects. A higher tolerance includes more shades (resulting in a larger selection area), while a lower tolerance gets you fewer shades (and a more precise selection area). If you set the tolerance too high, you'll probably select a lot more of your picture than you want.
- Anti-Alias is explained in the box on page 137.
- Contiguous makes the Magic Wand select only color areas that touch each other. This checkbox is on by default, but sometimes you can save a lot of time by turning it off, as Figure 5-9 explains.
- Sample All Layers. If you have a layered file (you can learn about layers in the next chapter), turn this on if you want to select the color in all the layers of your image. If you want to select the color only in the active layer, leave it turned off.
- Refine Edge is explained on page 131.

Figure 5-9:
In the left photo, the
Contiguous checkbox is
turned on, so Elements only
selects a single canoe. By
turning it off, as in the
photo at right, you can
select all the red canoes
with just one click. If you
want to quickly clean up the
selection afterward, use the
Selection brush (covered on
page 132).

The big disadvantage of the Magic Wand is that it tends to leave you with unselected contrasting areas around the edge of your selection that are a bit of a pain to clean up. You may want to try out the Quick Selection tool (page 129) before trying the Magic Wand, especially if you want to select a range of colors. If you put a Magic Wand selection on its own layer (Chapter 6 teaches you how layers work), you can use Refine Edge (page 131) or the Defringe command (page 145) to help clean up the edges.

The Lasso Tools

The Magic Wand is pretty good, but it works well only when your image has clearly defined areas of color. A lot of the time, you'll want to select something from a cluttered background that the Magic Wand just can't cope with. Sometimes you may think the easiest way would be if you could just draw around the object you want to select.

Enter the Lasso tool. There are actually three Lasso tools: the Lasso tool, the Polygonal Lasso tool, and the Magnetic Lasso tool. Each tool lets you select an object by tracing around it.

UP TO SPEED

Feathering and Anti-Aliasing

If you're old enough to remember what supermarket tabloid covers looked like before there was Photoshop, you probably had a good laugh at the obviously faked photos. Anyone could see where the art department had physically glued a piece cut from one photo onto another picture.

Nowadays, of course, the pictures of Brad and Angelina's vampire baby from Mars are *much* more convincing. That's because with Photoshop (and Elements) you can add *anti-aliasing* and *feathering* whenever you're making selections.

Anti-aliasing is a way of smoothing the edges of a digital image so that it's not jagged-looking. When you make selections, the Lasso tools and the Magic Wand let you decide whether to use anti-aliasing. It's best to leave anti-aliasing on unless you have a reason to have a hard edge on your selection.

Feathering blurs the edges of a selection. When you make a selection that you plan to move to a different photo, a tiny feather can do a lot to make it look like it's always been part of the new photo. Some Selection tools, like the Marquee tools, let you set a feather value before using them. You can feather existing selections by going to Select → Feather. Generally, a 1- or 2-pixel feather gives your selection a more natural-looking edge without visible blurring.

If you apply a feather value that's too high for the size of your selection, you see a warning that reads "No pixels are more than 50% selected". Reduce the feather number to placate Elements.

A larger feather gives a soft edge to your photos, as you can see in Figure 5-10.

Figure 5-10:
Old-fashioned vignettes like this one are a classic example of where you'd want a fairly large feather. In this figure, the feather is 15 pixels wide. The higher the feather value, the softer the edge effect.

You activate the Lasso tools by clicking their icon in the Tools panel (it's just below or next to the Marquee tool) or by pressing L, and then selecting the particular tool you want in the Tools panel's pop-out menu. You then drag around the outline of your object to make your selection. All the Lasso tools let you apply feathering and anti-aliasing as you make your selection (see the box on page 137), and the basic Lasso and the Polygonal Lasso give you access to Refine Edge (page 131) in the Options bar. The following sections cover each Lasso tool in detail.

The basic Lasso tool

The theory behind the basic Lasso tool is simple: Activate the tool and your cursor changes to the lasso shape shown in Figure 5-11. Just click in your photo, and then drag around the outline of what you want to select. When the end of your selection gets back around to join with the beginning, you have a selection.

Figure 5-11:
The end of the "rope," not the lasso loop, is the Lasso tool's drawing point. If the cursor's shape bothers you, change it to crosshairs by pressing the Caps Lock key.

In practice, it's not always easy to make an accurate selection with the Lasso, especially if you're using a mouse. A graphics tablet is a big advantage when using this tool, since tablets let you draw with a pen-shaped pointer. (There's more about graphics tablets on page 491.) But even if you don't have a graphics tablet lying around, you can make all the tools work just fine with your mouse once you get used to their quirks.

It helps to zoom way in and go very slowly when using the Lasso. (See page 82 for more on changing your view.) Many people use the regular Lasso tool to quickly select an area that roughly surrounds their object, and then go back with the other Selection tools—like the Selection brush or the Magnetic Lasso—to clean things up.

TIP To save time when you need to draw a straight line for part of your selection, hold down Option and click the points where you want the line to start and end. So if you're selecting an arched Palladian window, for instance, once you get around the curve at the top of the window and reach the straight side, press Option and click at the bottom of the side to get the straight part of the side all in one go.

Once you've created a selection, you can use the Options bar's Refine Edge button to adjust and feather the edges (see page 131). Or press Esc or **%**-D to get rid of your selection if you decide you don't want it.

The Magnetic Lasso

The Magnetic Lasso is a handy tool, especially if you were the kind of kid who never could color inside the lines or cut out paper chains neatly. This tool snaps to the outline of any clearly defined object you're trying to select, so you don't have to follow the edge exactly.

As you might guess, the Magnetic Lasso does its best work on objects with well-defined edges. You won't get much out of it if your subject is a furry animal, for instance. This tool also likes a good strong contrast between the object and the background.

Click to start a selection. Then move your cursor around the perimeter of what you want to select; click again back where you began to finish your selection. (You can change the cursor's shape with the Caps Lock key, just as with the basic Lasso.) You can also **%**-click at any point and the Magnetic Lasso closes up whatever area you've surrounded. Figure 5-12 explains how to adjust the number of points the Magnetic Lasso puts down and how sensitive it is to the edge you're tracing.

In addition to Feathering and Anti-aliasing (explained in the box on page 137), the Magnetic Lasso comes with four other Options bar settings:

- Width tells the tool how far away to look when it's trying to find an edge. The value is always in pixels, and you can set it as high as 256.
- Contrast controls how sharp a difference the Magnetic Lasso should look for between the outline and the background. A higher number looks for sharper contrasts, and a lower number looks for softer ones.
- Frequency controls how often Elements puts down the fastening points shown in Figure 5-12.

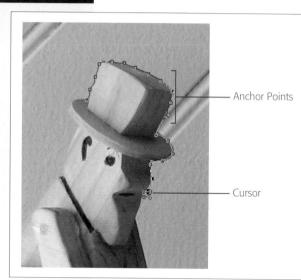

Figure 5-12:

One nice thing about the Magnetic Lasso is that it's easy to back up as you're creating your selection. As you go, it lays down the tiny boxes, called anchor or fastening points, shown in this figure. If you make a mistake with this tool, pressing Delete takes you back one point each time you press the key. (If you want to completely get rid of a Magnetic Lasso selection you've begun but not completed, just press Esc.) If the Magnetic Lasso skips a spot or won't grab onto a place you want it to, you can force it to put down an anchor point by clicking where you want the anchor to go.

• Use tablet pressure to change pen width—the little button with a pen at the right of the Options bar—only works if you have a graphics tablet. When you turn this setting on, how hard you press controls how Elements searches for the edge of objects you're trying to select. When you bear down harder, it's more precise. When you press more lightly, you can be a bit sloppier and Elements will still find the edge.

Many people live full and satisfying lives paying no attention whatsoever to these settings, so don't feel like you have to fuss with them all the time. You can usually ignore them unless the Magnetic Lasso misbehaves.

TIP You get better results with the Magnetic Lasso if you go slowly. Like most people, this tool does better work if you give it time to be sure where it's going.

The Polygonal Lasso

At first, this may seem like a dumb tool. It works something like the Magnetic Lasso in that it puts down anchor points, but it creates only perfectly straight segments. So you may think, "Well that's great if I want to select a Stop sign, but otherwise, what's the point?"

Actually, if you're one of those people who just plain *can't* draw, and you have a hard time following the edge of an object, this is the tool for you. The trick is to move only very short distances between clicks. Figure 5-13 shows the Polygonal Lasso in action.

The big advantage of this tool over the Magnetic Lasso is that it's much easier to keep it from getting into a snarl. Your only options for the Polygonal Lasso are feathering and anti-aliasing (which are explained in the box on page 137) and Refine Edge (page 131).

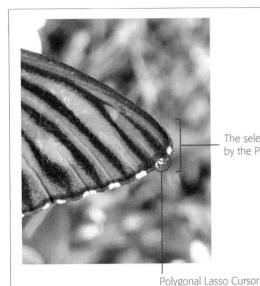

The selection path drawn by the Polygonal Lasso

Figure 5-13:
If you have limited dexterity, the Polygonal Lasso tool and a lot of clicks eventually get you a nice, accurate selection. You need to zoom way, way in to use this tool to select an object that doesn't have totally straight sides. Here, the Polygonal Lasso easily made it around the curve of the wing by clicking to make extremely short segments.

Removing Objects from an Image's Background

Ever feel the urge to pluck an object out of your photo's background? For example, maybe you want to take an amazing shot you got of the moon and stick it in another photo. The traditional procedure is to make your selection, invert it (page 146), and then delete the rest of the image. But Elements streamlines this process with another "magic" tool—the Magic Extractor. It works much like the Quick Selection tool in that you just give Elements a few hints and let it do the rest. When the Magic Extractor's done, your selection is isolated in all its lonely glory, surrounded by transparency (page 51) and ready for use on its own. Like the Quick Selection tool, this tool does a surprisingly good job—most of the time. To conduct your own experiments, download the practice photo (figurine.jpg.) from the Missing CD page at www.missingmanuals.com.

TIP You may find it faster to use the Quick Selection tool (page 129), followed by inverting and deleting the background area as explained on page 146. If that doesn't work, it's time to try the Magic Extractor.

The Magic Extractor has an elaborate dialog box with tools you won't find anywhere else in Elements. To see it, go to Image → Magic Extractor (see Figure 5-14). You see a full-screen dialog box, including a toolbox on the left side, instructions across the top, a preview of your image, and a set of controls at right. It looks complicated, but it's really just a bunch of easy-to-use options for tweaking things before Elements extracts your object. Here's how to use this timesaving tool:

Figure 5-14:
Manually removing this figurine from its background would be a long process. With the Magic Extractor, these few marks are all the help Elements needs to make the selection for you.

1. Go to Image → Magic Extractor or press Option-Shift-%-V.

Your image appears in the preview area of the Magic Extractor window.

TIP The Magic Extractor sometimes has problems with large files. If you need to extract an object from a hefty image, you may get better results if you crop away any large, unnecessary areas first. See page 75 for more about cropping.

2. If necessary, change the marker colors.

On the right side of the window are two color squares. Usually, red is the Foreground brush (the one you use to mark what to keep) and blue is the Background brush (the one that tells Elements what to discard from your image). To make the brush tools easier to see, you can click the squares to call up the Color Picker (page 217) and choose new colors.

3. Use the Foreground brush to tell Elements what to extract.

Make some marks on the object you want to keep. You can draw lines, as shown in Figure 5-14, but making dots on your object may work just as well. With practice, you'll soon get the hang of knowing what kind of marks you need for each object.

4. Click the Background brush and tell Elements what to exclude.

Similarly, make some marks in the areas you *don't* want Elements to include in your selection.

5. Click the Preview button.

The Preview area shows what Elements thinks you want to do, although it may take a few seconds to show up. If what you see isn't right, click Reset and start over.

6. If necessary, use the various tools to help Elements adjust the boundaries of your selection.

For example, if Elements left off an area you want, usually one click with the Foreground brush is enough to tell the program what to add. If there are spots missing within the selection, click the Fill Holes button. If you need to get a better view of your work, use the Zoom and Hand tools (both of which are explained in detail starting on page 86).

7. Fine-tune the edges of your selection, if you wish.

Add a feather (page 137), defringe (page 145), or smooth the edges of the selection with the Smoothing brush.

8. When you like what you see, click OK.

If you want to give up and try another method, click the Cancel button instead. Figure 5-15 shows what the Magic Extractor can do.

Figure 5-15: Just the few marks you saw in Figure 5-14 produce this perfectly extracted selection, all ready to move to another image.

TIP Once you understand layers (Chapter 6), you'll know that the Magic Extractor works only on the active layer of your photo. If you want to extract an object without wrecking the rest of your photo, make a duplicate layer (page 163) and work on that new layer.

The Magic Extractor gives you lots of ways to ensure that Elements makes a perfect selection. The toolbox contains a whole set of special tools just for the Extractor, as you can see in Figure 5-16. Each has its own keyboard shortcut to make it easy to switch tools while you work (given in parentheses after the tool's name in the list below). From top to bottom, you get:

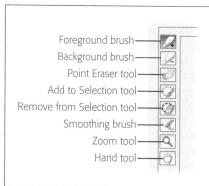

Figure 5-16: The tools in the Magic Extractor's toolbox make it unbelievably easy to make complex selections and get smooth, professional-looking results when you extract objects.

- Foreground brush (Keyboard shortcut: B). Use this brush to mark what you want to include in your extracted object. You can change the brush color by choosing a different Foreground color in the square on the window's right side.
- Background brush (P). This brush tells Elements what to cut away from your selection. Like the Foreground brush, this brush has a color square on the window's right side where you can choose a different marker color.
- Point Eraser tool (E). If you mark something by mistake with the Foreground or Background brush, use this tool to erase the marks.
- Add to Selection tool (A). For adding to the selection you've already made.
- Remove from Selection tool (D). Whatever you paint over with this, Elements removes from your selection.
- Smoothing brush (J). Once you've previewed your selection, you can use this brush to even out any ragged edges. (Try the Touch Up commands on the right side of the window first and you may not need this brush.)
- Zoom tool (Z) and Hand tool (H). These are the same trusty standbys you use to adjust your view elsewhere in Elements. See page 86 for more about using the Zoom tool and page 88 for the Hand tool.

TIP Some of the fine-tuning tools, like the Smoothing brush, work better if you zoom in before using them.

So you can see what you're doing, Elements gives you several ways to adjust the tools and your view of the image. These are on the right side of the window:

- Tool Options. You can choose different colors for the Foreground and Background brushes by clicking the color squares and using the Color Picker (page 217). You can also adjust the brush size, but that's hardly ever necessary, unless the brush is too big for the area you want to select.
- Preview. Choose whether to see just the selected area or your entire image. You can also choose what kind of background you want to see your selection against to get a clearer view. For example, you can choose None (the standard transparency grid), or a black, gray, or white matte, which puts in a temporary solid background to make it easier to check the edges of your selection. Mask is just like the black-and-white view of a layer mask (see page 309). You can paint more of a mask or remove the mask to reveal a larger selection. (Remember that what's masked <code>isn't</code> selected.) Rubylith is just a fancy name for the red mask view as opposed to the black-and-white view you get with Mask.
- Touch Up. Once you've previewed your selection, you also get some helpful options for making sure the selection is perfect:
 - Feather. Enter the amount, in pixels, that you want Elements to feather the edge of your selection. (The box on page 137 explains feathering.)
 - Fill Holes. If Elements left gaps in your selection, you may be able to fill them by clicking this button. This works only for holes that are completely surrounded by selected material, though. If the edges of your selection have bites out of them, use the Smoothing brush (page 144) instead, or give the area an extra click with the Foreground brush.
 - Defringe. If your selection has a rim of contrasting pixels around it, this command can usually eliminate them. Figure 5-17 shows what a difference defringing can make. You can choose a number of pixels for Elements to consider when defringing, but the standard setting is usually fine. Actually, Elements is pretty good about making clean selections, so you probably won't need this button very often.

TIP If the edges of your selection are ragged but not contrasting, or if defringing alone doesn't clean things up enough, try the Smoothing brush (page 144). Just run it along the edge of your selection to polish it until it's smooth.

Extracting objects used to be a time-consuming process, often involving expensive third-party plug-ins to make the job easier. But now the Magic Extractor is all you need in most situations.

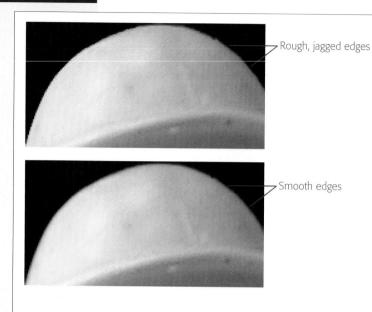

Figure 5-17:
Defringing is a big help in cleaning up the edges of your selections. It's so useful that Adobe makes it available even when you're not using the Extractor. You can always go to Layer → Defringe in Full Edit.

Top: Here's a close-up of the top of the mariner's hat. The black matte background makes the ragged edges stand out. If you place this image into another graphic, it'll look like you cut it out with dull nail scissors.

Bottom: The edges will blend into another image much more believably after you apply defringing. Here you can see how much softer the edges are after defringing. Now you can place the figurine into another file without getting the cut-out effect.

Changing and Moving Selections

Now that you know all about making selections, it's time to learn some of the finer points of using and manipulating them. Elements gives you several handy options for changing the areas you've selected and for actually moving images around once they're selected. You can even save a tough selection so you don't have to do *that* again.

Inverting a Selection

One thing you'll often want to do with a selection is *invert* it. That means telling Elements, "Hey, you know the area I've selected? Well, I want you to select everything *except* that area."

Why would you want to do that? Well, sometimes it's easier to select what you don't want. For example, suppose you have an object with a complicated outline, like the building in Figure 5-18. Say you want to use just the building in a scrapbook of your trip to Europe. It would to be difficult to select the building. But the sky is just one big block of color, so it's a lot faster to select the sky with the Magic Wand (page 135) than to try to get an accurate selection of the building.

To invert a selection:

Make a selection.

Usually, you select what you *don't* want if you're planning to invert your selection. You can use any Selection tool that suits your fancy.

2. Go to Select → Inverse, or press Shift-\#-I.

Now the part of your image that you didn't select is selected.

Figure 5-18:

Left: Say you want to make some adjustments to just the building in this photo. You could spend half an hour meticulously selecting all that Gothic detail, or just select the sky with a couple of clicks of the Magic Wand and then invert your selection to get the building. Here, the sky has the marching ants around it to show that it's the active selection—but that's not what you want.

Right: Inverting the selection (Select → Inverse) puts the ants around the building without the trouble of tracing over the elaborate roofline.

Making a Selection Larger or Smaller

What if you want to tweak the size of your selection? Say you need to move the outline of a selection outward a few pixels to expand it. Elements 8 gives you a handy way to do this: the new Transform Selection command, which lets you drag any selection larger or smaller, rotate it, pull it out longer or wider, or squish it so it's narrower or shorter (think of smooshing a circular selection into an oval, for instance). Transform Selection, as its name implies, does all these things to the *selection*, not to the object you've selected. (If you want to distort an object, use the Move tool [page 150] or the Transform tools [page 337].) This is really handy, as you can see in Figure 5-19.

To use Transform Selection:

1. Make a selection.

Use the Selection tool(s) of your choice. Transform Selection is especially handy when you've used one of the Marquee tools and didn't hit the selection quite right, but you can use it on any selection.

Figure 5-19:
Left: Sometimes it's hard to draw exactly the selection you want. Here, attempting to avoid the sign and the palm fronds led to cutting off part of the rope bumper on the hoat's how

Right: After you've decided that it would be easier to clone out any small unwanted details (see page 272 to learn how to clone), Transform Selection makes it easy to resize the selection to include all the rope

2. Go to Select → Transform Selection

A bounding box and little square handles appear around your image, as shown in Figure 5-19, right.

3. Use the handles to adjust the area covered by your selection.

The different ways you can adjust a selection are explained in a moment.

4. When you get everything just right, click the Commit button (the green checkmark) or press Enter to accept your changes.

If you mess up or change your mind about the whole thing, click the Cancel button (the red No symbol) to revert to your original selection.

You can change your selection in most of the same ways you learned about in the section on cropping on page 75.

- Make your selection wider or narrower. Drag one of the side handles left or right.
- Make your selection taller or shorter. Use the top or bottom handles for this.
- Make your selection larger or smaller. Drag a corner handle. Hold Shift if you want the selection's shape to stay the same.
- Rotate your selection. Grab a corner and spin the selection outline to the angle you want.

Transform Selection is great, but it only expands or contracts your selection in two directions. Elements also gives you a number of other ways to adjust the size of a selection, which may work better in certain situations, though Transform Selection is usually the easiest. But what do you do if you don't care about keeping the selection's shape—you just want to expand the selection to include surrounding areas of the same color, for instance? Adobe has you covered.

Figuring out which of the following commands to use can be confusing because two of them sound so similar: Grow and Expand. You might think they'd do the same thing, but there's a slight but important difference between them:

- Grow (Select → Grow) moves your selection outward to include more similar contiguous colors, no matter what shape your original selection was. The Grow command doesn't care about shape; it just finds more matching, contiguous pixels.
- Expand (Select → Modify → Expand) preserves the shape of your selection and just increases its size by the number of pixels you specify.
- Similar (Select → Similar) does the same thing as Grow but looks at *all* the pixels in your image, not just the adjacent ones.
- Contract (Select → Modify → Contract) shrinks the size of a selection.

So what's the big difference between Expand and Grow? Figure 5-20 shows how differently they behave.

Figure 5-20: Top: In the original selection, the whole wing is selected except some small areas on the edge.

Bottom left: If you use Grow to enlarge the selection, Elements also adds parts of the background that are similar in tone. As a result, your selection isn't shaped like a butterfly wing anymore.

Bottom right: If you instead use Expand, the edges of the selection move outward to include the wing's dark border you missed the first time.

Moving Selected Areas

So far you've learned how to move selections themselves, but often you make selections because you want to move *objects* around—like putting that dreamboat who wouldn't give you the time of day next to you in your senior class photo. You can move a selection in several ways.

Here's the simplest, tool-free way to move something from one image to another:

1. Select it.

Make sure you've selected everything you want—it's really annoying when you paste a selection from one image to another and find you missed a spot.

2. Press \#-C to copy it.

You can use **%**-X if you want to cut it out of your original. Just remember that Elements leaves a hole if you do it that way.

3. Now you have two options:

- To dump the selection into its very own document, choose File → New → "Image from Clipboard". Elements creates a new document with just your selection in it.
- To add the selection to another photo, press \(\mathbb{H}\)-V to paste it into that image in Elements. Once you've pasted your selection, you can use the Move tool (below) to position it, rotate it, or resize it to fit the rest of the photo. You can even paste your selection into a document in *another* program—just be sure you've turned on the Export Clipboard checkbox in Photoshop Elements → Preferences → General.

TIP If you copy and paste a selection and you see it has partially transparent areas in it that you don't want, back up (%-Z) to undo the paste, and go over your selection again with the Selection brush using a hard brush. Then copy and paste again.

The Move tool

You can also move things around *within* your photo with the Move tool, which lets you cut or copy selected areas. Figure 5-21 shows how to use the Move tool to conceal distracting details.

The Move tool lives at the very top of the Full Edit Tools panel. To use it:

Make a selection.

Make sure your selection doesn't have anything in it that you don't want to copy.

2. Switch to the Move tool.

Click the Move tool's icon in the Tools panel or press V. Your selection stays active but is now surrounded by a rectangle with box-shaped handles on the corners.

POWER USERS' CLINIC

Smoothing and Bordering

You'll probably use Refine Edge (page 131) most of the time, but Adobe includes some alternative ways to tweak the edges of your selections:

 Smoothing (Select → Modify → Smooth) is a sometimes-dependable way to clean up ragged spots in a color-based selection (like you'd make with the Magic Wand, for instance). You enter a pixel value, and Elements evens out your selection based on the number you entered by searching for similarly colored pixels.

For example, if you enter 5 pixels, Elements looks at a 5-pixel radius around each pixel in your selection. In areas where most of the pixels are already selected, it adds in the others. Where most pixels aren't selected, it deselects the ones that are selected to get rid of the jagged edges and holes in the selection. This may sound confusing, but it makes sense once you try it.

This is handy, but Smoothing is sometimes hard to control, and it doesn't affect only the edge of your selection. Usually it's easier to clean up your selection by hand with the Selection brush than to use Smoothing.

• Bordering (Select → Modify → Border) adds an anti-aliased (page 137), transparent border to your selection. You might say it selects the selection's outline. You can use it when your selection's edges are too hard and you want to soften them, although you'd probably be better off using Refine Edge. After selecting this command, choose a border size and then click OK. Elements selects only the selection's border, so you can also apply a slight Gaussian blur (see page 392) to soften that part of the photo more if you like.

Figure 5-21:
Left: Here's the original version of the photo used for the feathered vignette on page 137. In the original, there's a distracting fish painted on the wall behind the man. By copying and moving a piece of the wall, you can cover up the fish and create a simpler background to put the focus on him rather than the background. Select a good area of the wall and then activate the Move tool by pressing V.

Right: Hold down the Option key while using the Move tool to copy the selected area. The piece of wall slides into its new position as a fish concealer. (If you use the Move tool without holding down the Option key, Elements cuts out the selection, leaving a hole in your photo.) 3. Move the selection and press Return when you're satisfied with its position.

As long as your selection is active, you can work on your photo in other ways and then come back and reactivate the Move tool. (If you're worried about losing a complex selection, save it as described in the next section.) If you're not happy with what you've done, press \(\mathbb{H}-Z \) as many times as needed to back up and start over.

You can move a selection in several different ways:

- Move it. If you just move a selection by dragging it, you leave a hole in the background where the selection was—the Move tool *truly* moves your selection. So unless you have something under it that you want to show through, that's probably not what you want to do.
- Copy it and move the copy. If you press the Option key as you drag, you copy your selection, so your original remains where it was. You now have a duplicate to move around and play with.
- Resize it. You can drag the Move tool's handles to resize or distort your copy, which is great when you need to change the size of your selection. The Move tool lets you do the same things you can do with Free Transform (see page 338).
- Rotate it. The Move tool lets you rotate your selection the same way you can rotate a picture using Free Rotate (see page 73). Just grab a corner and turn it.

TIP You can save a trip to the Tools panel and move selections without activating the Move tool. To move a selection without copying it, place your cursor in the selection, hold down **%**, and move the selection. To move a *copy* of a selection, do the same thing but also hold down the Option key. You can drag the copy without damaging the original. To move multiple copies, just let go, then press **%**-Option again and drag once more.

The Move tool is also a great way to manage and move objects that you've put on their own layers (Chapter 6). Page 171 explains how to use the Move tool to arrange layered objects.

Saving Selections

You can tell Elements to remember the outline of your selection so that you can reuse it later. This is a wonderful, easy timesaver for particularly intricate selections.

NOTE Elements' saved selections are the equivalent of Photoshop's *alpha channels*. Keep that in mind if you decide to try tutorials written for the full-featured Photoshop. (Incidentally, alpha channels saved in files in Photoshop show up in Elements as saved selections, and vice versa.)

To save a selection:

- 1. Make your selection.
- 2. Choose Select → Save Selection, name your selection, and then save it.

When you want to use the selection again, go to Select \rightarrow Load Selection, and there it is, waiting for you.

TIP When you save a feathered (page 137) selection, use the Refine Edge command (page 131) if you change your mind later about how much feather you want. You can also save a hardedged selection, load it, and then go to Select → Feather to add a feather if you need one. That way you can change the feather amount each time you use the selection, as long as you remember not to save the *change* to the selection.

Making changes to a saved selection

It's probably just as easy to start your selection over if you need to tweak a saved selection, but you can make changes if you want. This can save you time if your original selection was tricky to create.

Say you have a full-length photo of somebody, and you've saved a selection of the person's face (called, naturally enough, "Face"). Now, imagine that after applying a filter to the selection, you decide it would look silly to change only the face and not the person's hands, too. So you want to add the hands to your saved selection. Elements gives you a couple of ways to do this.

The simplest is just to load up "Face," activate your Selection tool of choice, put the tool in "Add to Selection" mode, select the hands, and then save the selection again with the same name.

But what if you've already selected the hands and you want to add *that* new selected area to the existing facial selection? Here's what you'd do:

1. Go to Select → Save Selection.

Choose your saved "Face" selection. All the Operation radio buttons in the bottom of the Save Selection dialog box become active.

2. Choose "Add to Selection".

Elements adds what you just selected (the hands) to the original selection and saves the whole thing, so now your "Face" selection also includes the hands.

Layers: The Heart of Elements

If you've been working mostly in the Quick Fix window so far, you've probably noticed that once you close your file, the changes you've made are permanent. You can undo actions while the file is still open, but once you close it, you're stuck with what you've done.

In Elements, you can keep your changes (most kinds, anyway) and still revert to the original image if you use *layers*, a nifty system of transparent sheets that keeps each element of your image on a separate sliver that you can edit. Layers are one of the greatest image editing inventions ever. By putting each change you make on its own layer, you can rearrange the composition of your image, and add or subtract changes whenever you want.

If you use layers, you can save your file and quit Elements, come back days or weeks later, and still undo what you did or change things around some more. There's no statute of limitations for the changes you make using layers.

Some people resist learning about layers because they fear layers are too complicated. But they're actually really easy to use once you understand how they work. And once you get started with layers, you'll realize that using Elements without them is like driving a Ferrari in first gear. This chapter gives you the info you need to get comfortable working with layers.

Understanding Layers

Imagine you have a bare-bones drawing of a room you're thinking about redecorating. To get an idea of your decorating options, imagine that you also have a bunch of transparent plastic sheets, each containing an image that changes the

room's look: a couch, a few different colors for the carpet, a standing lamp, and so on. Your decorating work is now pretty easy, since you can add and remove, and mix and match the transparencies with ease.

Layers in Elements work pretty much the same way. With layers, you can add and remove objects and make changes to the way your image looks. And you can modify or discard any changes later on.

Figure 6-1 shows an Elements file that includes layers. Each object in that flyer is on a different layer, so it's easy to remove or rearrange things. (If you want to follow along with a layers-heavy file, you can download a version of this file from the Missing CD page at www.missingmanuals.com. Look for gardenpartymac.psd.)

Figure 6-1:
Every object in this flyer—the background, the bench, the balloons, each block of text—is on its own layer, which makes changing things a snap. Want to change the background, get rid of the flowers, or change the date? With layers, you can easily do any of these things.

NOTE It's important to understand that photos from your camera start out with just one layer. That means if you have a photo like the one in Figure 6-2, top, the individual objects—the two people, the ground they're standing on, and so on—all exist on the same layer. At least they do until you select and place a particular object on its own layer.

That said, Elements often generates layers for you when you need them. For example, Elements automatically creates layers when you do certain things, like move an object from one photo to another, or use the Smart Brush tool (page 196), which thoughtfully puts the changes it makes on their own layers.

You can also use layers for many adjustments to your photos, which lets you tweak or eliminate those changes later on. For instance, say you used Quick Fix's Hue slider but decided the next day you didn't like what you did—you're stuck (unless you can dig out a copy of your original). But if you'd used a Hue/Saturation Adjustment *layer* (page 182) to make the change, you could just throw out that layer and keep all your other changes intact. You can also use layers to combine parts of different photos, as shown in Figure 6-2.

Figure 6-2:
Layers make it easy to combine elements from different photos. You may not be able to afford to send your grandparents on a real trip to Europe, but once you understand layers, you can give them a virtual vacation. When you copy part of one photo into another image, as was done here, Elements automatically places the pasted-in material on its own layer. You don't have to do anything special to create the layer—it just happens. (There's more about combining elements from different photos on page 184.)

Once you understand how to use layers, you'll feel much more comfortable making radical changes to an image because mistakes are much easier to fix. Not only that, but by using layers, you can easily make lots of sophisticated changes that are otherwise very difficult and time-consuming. But the main reason to use layers is for creative freedom: Layers let you create special effects that would be difficult to achieve otherwise.

The Layers Panel

The Layers panel is your control center for any kind of layer-related action, like adding, deleting, or duplicating layers. Figure 6-3 shows you the Layers panel for an image that already has lots of layers. The panel displays each layer's name and a thumbnail icon of the layer's contents. You can adjust the size of the icon or turn it off altogether if you prefer, as shown in Figure 6-4.

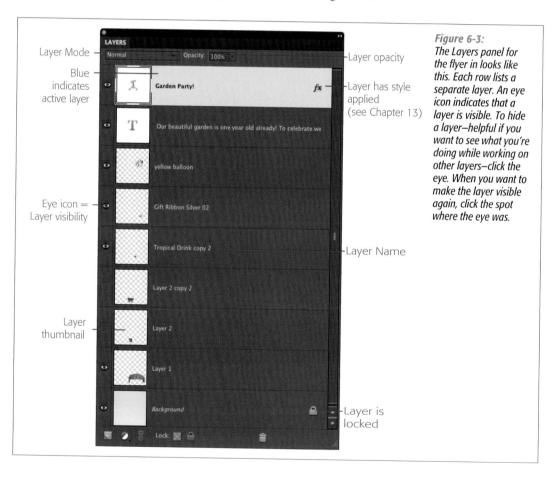

TIP It helps to keep the Layers panel handy whenever you work with layers, not only for the info it gives you, but because you can generally manipulate layers more easily from the panel than directly in your image. And there are many changes, like renaming a layer, that you can make *only* in the Layers panel.

Figure 6-4:
If you want to change the size of the thumbnail icons in the Layers panel, in the panel's upper-right corner, click the hard-to-see square made up of four horizontal lines to open the pop-out menu. Near the bottom of the menu, choose Panel Options, and Elements opens the dialog box shown here. In this case, the medium-size icon is selected.

The Layers panel usually contains one layer that's *active*, meaning that anything you do, like painting, will happen on that layer and that layer only. The active layer's row in the Layers panel is blue so you can see which one it is.

NOTE If you use the layer selection options described on page 175, you can have multiple active layers or none, but generally you want to have only one active layer.

When you look at an image that contains layers, you're looking down on the stack of layers from the top, just the way you would with overlays on a drawing. The layers appear in the same order in the Layers panel—the top layer of your image is at the top of the Layers panel. (Layer order is important because whatever is on top can obscure what's beneath it.)

Elements lets you do lots of different things right in the Layers panel. You can make a layer's contents invisible and then visible again, change the order in which layers are stacked, link layers together, change layers' opacity, add and delete layers—the list goes on and on. The rest of this chapter covers all these options and more.

NOTE The Layers panel is really important, so most people like to keep it visible. Use any of the panel-management techniques described on page 21 to put it where it's easy to get to while you work.

The Background

The bottom layer of any image is a special kind of layer called the *Background*. If you bring any image or photo into Elements, the first time you open it, you'll see that its one existing layer is called Background (assuming nobody has already edited the file in Elements and changed things). The name Background is logical because whatever else you do will happen on top of this layer.

NOTE Elements has two exceptions to the first-layer-is-always-the-Background rule. First, if you create a new image by copying something from another picture, you just have a layer called "Layer 1." Second, Background layers can't be transparent, so if you choose the Transparency option (page 51) when creating a file from scratch, you have a "Layer 0" instead of a Background layer.

As for content, the Background can be totally plain or busy, busy, busy. A Background layer doesn't mean that it literally contains the background of your photograph—your entire photo can be a Background layer. What's on your Background layer is entirely up to you, and the same goes for what you place on other, newly-added layers. With photographs, people often keep the photo's image on the Background layer, and then perform adjustments and embellishments (like adding type) on other layers.

You can do a lot to Background layers, but there are a few things you *can't* do: If you want to change a Background layer's blending mode (see page 168), opacity (page 166), or position in the layer stack, you need to convert it into a regular layer first.

TIP The Background Eraser and Magic Eraser automatically turn a Background layer into a regular layer when you click a background with them. If you have a single object on a solid background and you want transparency around the object, one click with the Magic Eraser turns your background into a layer, eliminates the solid-colored background, and replaces it with transparency. (Page 365 has more on the Eraser tools.)

To change a Background layer to a regular layer, double-click it in the Layers panel or go to Layer → New → Layer From Background. Or, if you try to make certain kinds of changes to the background (like using the Transform commands [page 337]), Elements prompts you to change the Background layer to a regular layer.

You can also transform a regular layer into a Background layer. One reason to do this is to send a layer to the bottom of the stack in a many-layered file. Here's how:

- 1. In the Layers panel, click the layer you want to convert to a Background layer.
- 2. Select Layer → New → "Background from Layer".

It may take a few seconds for Elements to finish calculating. When it does, the layer you've changed moves down to the bottom of the layer stack in the Layers panel, and automatically gets renamed "Background".

COMPATIBILITY

Which File Types Can Use Layers?

You can add layers to any file you can open in Elements, but not every file format lets you *save* those layers for future use.

For instance, if your camera shoots JPEGs, you can open the JPEG in Elements and create lots of layers. But when you try to save the file, Elements presents you with the Save As dialog box instead of just saving your file. If you turn off the dialog box's option to save layers, a warning tells you that you have to save as a copy. That's because you can't have layers in a JPEG file, and Elements is reminding you that you need to save in another format to keep the layers.

You usually want to choose either Photoshop (.psd) or TIFF as your format when saving an image with layers because they both let you keep your layers for future use. PDF files can also have layers. (On the other hand, if you don't need the layers, just save your JPEG as a copy, close

the original file, and click No when asked if you want to save changes.)

If someone using the full-featured version of Photoshop sends you an image that has layers, you'll see them in the Layers panel when you open the file in Elements. Likewise, people with Photoshop can see layers you create in Elements.

If you open a Photoshop file with a layer that says "indicates a set" when you cursor over it in the Layers panel, that means it's what Photoshop calls a Layer Group or layer set (a way to group layers in the Layers panel into what are essentially folders), depending on the version of Photoshop that created the file. Elements doesn't understand these sets, so ask the person who created the file to expand the layer sets and send you the file again. Alternatively, you can use Layer \rightarrow Simplify to convert the set to a single layer that you may or may not be able to edit.

Creating Layers

As you learned earlier in the chapter, your image doesn't automatically have multiple layers. Lots of newcomers to Elements expect the program to be smart enough to put each object in a photo onto its own layer. It's a lovely dream, but even Elements isn't that brainy. To experience the joy of layers, you first need to add at least one layer to your image, which you'll learn how to do in the next few sections.

TIP For the next few sections, it may help you to follow along with a photo of your own or a new file you've created to use for practice. (See page 50 for details on how to create a new file; if you go that route, choose a white background.) Or, you can download either the *gardenpartymac.psd* or *daisies.jpg* file from the Missing CD page at *www.missingmanuals.com*.

Adding a Layer

Elements gives you several ways to add layers:

- Choose Layer \rightarrow New \rightarrow Layer.
- Press Shift-\-R-N.
- In the Layers panel, click the "Create a new layer" icon (the little square shown in Figure 6-5).

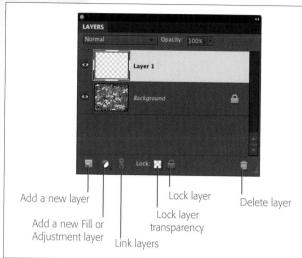

Figure 6-5: At the bottom left of the Layers panel, click the "Create a new layer" icon when you want to quickly add a new layer.

When you create a new layer using any of these commands, the layer starts out empty. You don't see a change in your image until you use the layer for something (for example, painting on it). If you look at the Layers panel, you see that any new layer you add appears just above the layer that was active when you created the new layer. So if you want your new layer at the top of the stack, click the current top layer to make it active before creating your new layer.

NOTE The only practical limit to the number of layers your image can have is your computer's processing power. But if you find yourself regularly creating projects with upward of 100 layers, you may want to upgrade to Photoshop, which has tools that make it easier to manage large numbers of layers.

Some actions create new layers automatically. For instance, if you copy and paste an object from another photo (see page 184 for instructions) or add artwork from the Content panel (page 450), Elements automatically puts the object on its own layer. That's handy for arranging the new item just where you want it, without disturbing the rest of your composition.

You don't always need to make a blank layer before editing your photo. Many times Elements takes care of layer creation for you, depending on what you're doing. An example of when you'd add a layer first is when you plan to do some cloning (page 272). If you don't make a separate layer to clone on, your changes go right onto your Background layer and you can't undo them after closing the photo.

Deleting Layers

If you decide you don't want a particular layer anymore, you can easily delete it. Figure 6-6 shows the simplest way.

Figure 6-6:
To make a layer go away, either drag the layer to the trashcan icon in the Layers panel (circled) or select the layer and then click the trashcan. Elements responds by asking if you want to delete the active layer. Click Yes and it's history. Once you delete a layer, you can get it back using one of the Undo commands (page 32), but once you close the file, it's gone forever.

Elements also gives you a few other ways to delete a layer. You can:

- Select Layer ightarrow Delete Layer.
- Right-click (Control-click) the layer in the Layers panel, and then, from the pop-up menu, choose Delete Layer.
- In the Layers panel's upper-right corner, click the square made of lines, and then, from the pop-up menu, choose Delete Layer.

Duplicating a Layer

Duplicating a layer can be really useful. Many Elements commands, like filters or color modification tools, don't work on a brand-new, *empty* layer. This poses a dilemma because, if you apply those changes to the layer containing your original image, you alter it in ways you can't undo later. The workaround is to create a *duplicate layer* and make your changes on that layer instead. You can ditch the duplicate later if you change your mind, and your original layer is safely tucked away unchanged.

If all this seems annoyingly theoretical, try going to Enhance \rightarrow Adjust Color \rightarrow Adjust Hue/Saturation, for example, when you're working on a new, blank layer. Elements displays the stern dialog box shown in Figure 6-7.

NOTE Very rarely, you may encounter the dreaded "no pixels are more than 50% selected" warning. Several things can cause this, but the most common are too large a feather value on a selection (see the box on page 137) or trying to work in the empty part of a layer that contains objects surrounded by transparency.

Figure 6-7:
Elements is usually pretty helpful when you try to do something that isn't going to work, like applying a Hue/Saturation adjustment to an empty layer. The solution here is just to switch the Layers panel's focus to a layer that has something in it.

Elements gives you a few ways to copy an existing layer and its content. Select the layer you want to duplicate to make it the active layer, and then do one of the following:

- Press \L-I.
- Choose Layer → Duplicate Layer.
- In the Layers panel, drag the layer you want to copy to the "Create a new layer" icon (Figure 6-5).
- In the Layers panel, right-click (Control-click) the layer, and then, from the pop-up menu, choose Duplicate Layer.
- Click the little square at the upper right of the Layers panel and then choose Duplicate Layer.

Creating a new layer using any of these methods copies everything in the active layer into the new layer. You can then mess with the duplicate as much as you want without damaging the original.

GEM IN THE ROUGH

Naming Layers

You might have noticed that Elements isn't terribly creative when it comes to naming your layers. You get Layer 1, Layer 2, and so on. Fortunately, you don't have to live with those names, since it's easy to rename layers in Elements. (Note that you can't rename a Background layer—it changes to a regular layer when you do. And Elements helps you out with Text layers [page 419] by naming them using the first few words of the text they contain.)

Maybe renaming layers sounds like something only people with too much time on their hands would do, but if you get started on a project that winds up with many layers, you may find that you can pick out the layers you want more quickly if you give them descriptive names. To rename a layer:

- Double-click its name in the Layers panel. The name becomes an active text box.
- Type in the new name. You don't even need to highlight the text—Elements does that for you automatically.

As with any other change, you have to save your image afterward if you want to keep the new name.

Copying and Cutting from Layers

You can also make a new layer that consists of only a *piece* of an existing layer. This is helpful for things like applying a Layer style to one object from the layer, for instance. But first you need to decide whether you want to *copy* your selection or *cut* it out and place it on the new layer.

What's the difference? It's pretty much the same as copying versus cutting in your word-processing program. When you use the "New Layer via Copy" command, the area you selected appears in the new layer while remaining in place in the old

layer, too. On the other hand, "New Layer via Cut" removes the selection from the old layer, and then places it on a new layer, leaving a corresponding hole in the old layer. Figure 6-8 shows the difference.

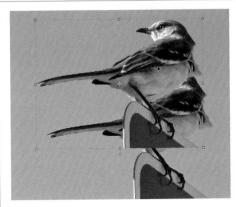

Figure 6-8:
The difference between "New Layer via Copy" and "New Layer via Cut" becomes obvious when you move the newly created layer and reveal what's beneath it.

Top: With "New Layer via Copy", the original bird is still in place in the underlying layer.

Bottom: When you use "New Layer via Cut", the excised bird leaves a hole behind.

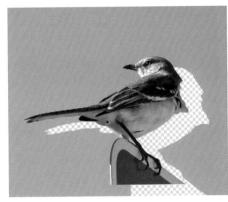

Once you've selected what you want to move or copy, your new layer is only a couple of keystrokes away.

- New Layer via Copy. The easiest way to copy your selection to a new layer is by pressing ૠ-J. (You can also go to Layer → New → "Layer via Copy".) Whichever you use, if you don't select anything beforehand, Elements copies your whole layer. That makes it a good shortcut for creating a duplicate layer.
- New Layer via Cut. To cut your selection out of your old layer and put it on a layer by itself, press Shift-ૠ-J (or go to Layer → New → "Layer via Cut"). Just remember that you leave a hole in your original layer when you do this. (On a Background layer, the hole fills with the current Background color.)

If for some reason you want to cut and move everything in a layer, you can press **%**-A to select it first, although usually it's easier to move your layer instead. Just drag it up or down the stack in the Layers panel to put it where you want it.

TIP If you want to use a layer as the basis for a new document, Elements gives you a quick way to do so. Instead of copying and pasting, you can create a new document by going to Layer \rightarrow Duplicate Layer. You get a dialog box with a pull-down menu that gives you the option of placing the duplicate layer into your existing image, into any image currently open in Elements, or into a new document. (This maneuver works only from the menu; pressing **%**-J doesn't bring up this dialog box.) You can also create a new file with just part of an existing layer by pressing **%**-C to copy it and then going to File \rightarrow New \rightarrow Image from Clipboard.

Managing Layers

The Layers panel lets you manipulate your layers in all kinds of ways, but first you need to understand a few more of the panel's cryptic icons. Some of the things you can do with layers may seem tiresomely obscure when you first read about them, but once you're actually using layers, you'll quickly see why many of these options exist. The next few sections explain how to manipulate layers in several different ways: hide them, group them, change the way you see them, and combine them.

Making Layers Invisible

You can turn the visibility of layers off and on at will. This feature is super useful if you think about it. Say the image you're working on has a busy background, for example, making it hard to see what you're doing when working on a particular layer. Making the Background layer invisible can really help you focus on the layer you're interested in. To turn off visibility, in the Layers panel, click the eye icon to the left of the layer's thumbnail. To make the layer visible again, click where the eye was.

TIP If you have a bunch of hidden layers and decide you don't want them anymore, go to the Layers Panel and click the four-line square in its upper-right corner, and then select Delete Hidden Layers to get rid of them all at once.

Adjusting Opacity

Your choices for layer visibility aren't limited to on and off. You can create really cool effects in Elements by adjusting the *opacity* of layers. In other words, you can make a layer partially transparent so that what's underneath it shows through.

To adjust a layer's opacity, click the layer in the Layers panel, and then either:

- Double-click in the Layer's panel's Opacity box, and then type in the percentage of opacity you want.
- If you'd rather make the adjustment visually (as opposed to entering numbers), click the triangle to the right of the Opacity percentage and adjust the pop-out slider, or put your cursor over the word Opacity and "scrub" (drag) left for less opacity and right for more. (Figure 6-9 explains the advantages of scrubbing.) If you'd like to experiment with creating Fill and Adjustment layers (page 180) and changing their modes and opacity, you can download *daisies.jpg* from the Missing CD page at *www.missingmanuals.com*.

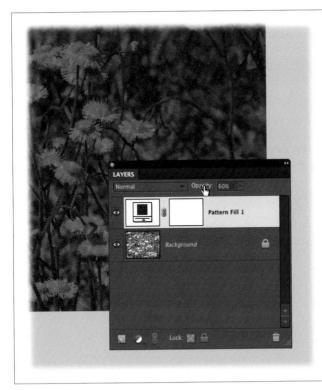

Figure 6-9: You can watch the opacity of your layer change on the fly if you drag your cursor back and forth on the word Opacity. Different blend modes (see page 168) often give the best effect if you adjust the opacity of their layers.

When you create a new layer using either the keyboard shortcut (Shift- \Re -N) or the menu path (Layer \rightarrow New \rightarrow Layer), you can set the layer's opacity right in the New Layer dialog box. If you create a new layer by clicking the Layers panel's New Layer icon, you have to Option-click the New Layer icon (rather than just clicking it) to bring up the New Layer dialog box.

NOTE You can't change a Background layer's opacity. You have to convert it to a regular layer first; page 160 explains how.

Locking Layers

You can protect your image from yourself by *locking* any of the layers. This keeps you from changing a layer's contents. You can also lock just the transparent parts of a layer—helpful when you want to modify an object that sits atop a transparent layer, like the seashell in Figure 6-10. When you do that, the transparent parts of your layer stay transparent no matter what you do to the rest of it. (You're actually locking the pixels' current transparency level, so if you have pixels that are only partly transparent, they stay at their current transparency level, too.)

To lock the transparent parts of a layer, select the layer, and then, in the Layers panel, click the "Lock transparent pixels" checkerboard. It works like a button, and it's grayed out if your photo doesn't have any transparency. When you lock the

transparency, a light-gray padlock appears in the Layers panel to the right side of the layer's name. (The checkerboard icon shows a tiny border when a layer's transparency is locked.) To unlock it, click the checkerboard again.

Figure 6-10:
After you've isolated an object on its own layer, sometimes you want to paint only on the object—and not on the transparent portion of the layer. Elements lets you lock the transparent part of a layer, making it easy to paint only the object

Left: On a regular layer, paint goes wherever the brush does.

Right: With the layer's transparency locked, the stroke stops at the edge of the seashell, even though the cursor (the circle) is now on the layer's transparent portion.

To lock *everything* in a layer so you can't make any changes to it, click the "Lock all" icon (the dark-gray padlock in the Layers panel next to the checkerboard). A dark-gray padlock appears in the Layers panel to the right of the layer's name, and the "Lock all" icon shows a dark gray outline around it. Now if you try to paint on that layer or use any other tools, your cursor turns into a universal No symbol (a circle with a diagonal line through it) as a reminder that you can't edit that layer. To unlock the layer, click the "Lock all" icon once more.

NOTE Locking only keeps you from editing the layer, but it doesn't stop you from merging it into another layer or flattening it, and it doesn't keep you from cropping it, either.

Blend Modes

In the Layers panel, there's a little menu that says "Normal" (there's a similar one in the New Layer dialog box that says "Mode: Normal"). This setting is for your blend mode. When used with layers, blend modes control how the objects in a layer combine, or blend, with the objects in the layer beneath it. By using different blend modes, you can make your image lighter or darker, or even make it look like a poster, with just a few bold colors in it. Blend modes can also control how some tools—those that have blend mode settings—change your image. Changing a tool's blend mode can sometimes dramatically change the results.

Blend modes are fun once you understand how they work. You can use them to fix under- or overexposed photos, or to create all kinds of visual effects. You can also set some tools, like the Brush tool, to different blend modes to achieve different effects. The most common blend mode is Normal, in which everything you do behaves just the way you would expect: An object shows its regular colors, and paint acts just like, well, paint.

Page 361 has lots more about how to use blend modes. For now, check out Figure 6-11, which shows how you can change the way a layer looks just by changing its blend mode.

Figure 6-11:
This photo of fleabane flowers has a Pattern Fill layer over it, showing three different modes. (There's more about Pattern layers on page 181.) In Normal mode at 100-percent opacity, the pattern would completely hide the flowers, but by changing the blend mode and opacity of the pattern layer, you can create very different looks. From top to bottom, the modes are Normal, Dissolve, and Hard Mix. Notice how Dissolve gives a grainy effect and Hard Mix produces a vivid, posterized effect.

TIP Elements' blend modes are grouped in the menus according to the way they affect your image.

Not every blend mode makes a visible change in every circumstance. Some of them may seem to do nothing—that's to be expected. It just means that you don't have anything in your current image that's responding to that particular mode change. See page 227 for one example of a situation where a mode change makes a huge difference.

POWER USERS' CLINIC

Fading in Elements

One great thing you get in the full-featured Photoshop that Elements lacks is the ability to *fade* special effects and filters. Fading gives you control over how much these tools change an image. (Often, filters generate harshlooking results, and Photoshop's Fade command helps you adjust a filter's effect until it's what you intended.)

In Elements, you can approximate the Fade tool: First, apply filters, effects, or layer styles to a duplicate layer. Then, reduce the layer's opacity till it blends in with what's below (and change the blend mode if necessary) to get the result you want.

Rearranging Layers

One of the truly amazing things you can do with Elements is move your layers around. That lets you change the order in which layers are stacked so that different objects appear in front of or behind each other. For example, you can position one object behind another if they're both on their own layers. In the Layers panel, just grab a layer and drag it to where you want it.

TIP Remember, you're always looking down onto the layer stack when you look at your image, so moving something up in the Layers panel's list moves it toward the front of the picture.

Figure 6-12 shows the early stages of the garden party invitation (originally shown in Figure 6-1). The potted plants are already in place, and the bench was brought in from another image. Elements put the bench at the top of the stack, in front of the flowers. To put the bench behind the plants, simply drag the bench layer below the plants layer in the Layers panel.

NOTE A Background layer is the only kind of layer you *can't* move. If you want to put a Background layer in another spot in the layer stack, first convert it to a regular layer (page 160), and then you can move it.

You can also move layers by going to Layer → Arrange and then choosing one of these commands:

- Bring to Front (Shift-\(\mathbb{H}\)-]) sends the selected layer to the top of the stack so the layer's contents appear in the foreground of your image.
- Bring Forward (\(\mathbb{H}\)-]) moves the layer up one level in the Layers panel, so it appears one step closer to the front of your image.
- Send Backward (\(\mathbb{H}-[\)) moves the layer down one level so it hops back one step in the image.
- Send to Back (Shift-\(\mathbb{H}\)-[) puts the layer directly above the Background layer so it appears as far back as you can move anything.

NOTE Adobe used to call this technique "grouping" layers in Elements, but in Elements 8 they changed it to "clipping mask," just as it is in Photoshop. The behavior is exactly the same as the old grouped layers, though—only the name is different.

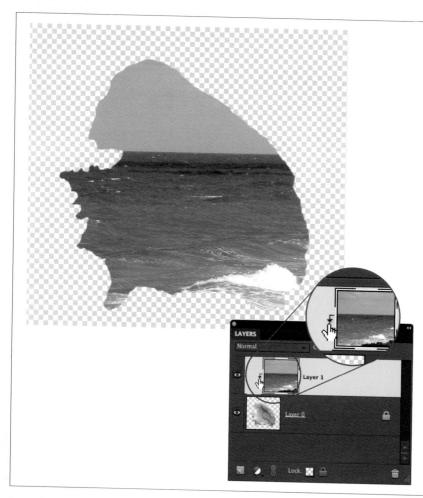

Figure 6-16: This image began life as a picture of a seashell on one layer, and an ocean scene on the layer above it. At first, the ocean image totally hid the seashell, but interesting things happen when you clip the layers: Elements crops the ocean layer automatically to the shape of the bottom layer, the seashell. (The shell is now a clipping mask for the ocean image.) The tiny downward-bent arrow (visible just above the cursor) in the Layers panel shows the ocean layer is clipped to the shell layer.

TIP If you clip two layers together, the bottom layer determines the opacity of both layers.

Once you clip the layers together, you can still slide the top layer around with the Move tool to reposition it so that you see exactly the part of it that you want. So in Figure 6-16, the ocean layer was maneuvered till the wave appeared in the bottom of the shell shape.

To clip two layers together, make the top layer (of the two you want to clip) the active layer. Position the two layers one above the other in the Layers panel by dragging. (Put the one you want to act as the mask below the other image.) Then choose Layer → Create Clipping Mask. You can also clip layers using the keyboard. First, make sure the top layer is the active layer, and then press **%**-G.

To remove a link between layers, select the linked layers by clicking one, and then click the chain icon at the bottom of the Layers panel again. You can also merge the layers (covered in the next section) into one layer if you want. Sometimes, though, you'll want to keep layers separate, while still being able to move them as a group. You perform this trick by linking.

You can also use the layer selection choices, described in the box below and skip the linking. As long as your layers stay selected, they travel as a group. The advantage of linking is that your layers stay associated until you unlink them—there's no need to worry about accidentally clicking somewhere else in the panel and losing your selection group.

STAYING ORGANIZED

Selecting Layers

You can quickly target multiple layers when you want to manage them by doing things like linking, moving, or deleting layers. For your quick-selection pleasure, Elements gives you a whole group of layer-selection commands, which you'll find in the Select menu. Here's what they do:

- All Layers. Choose this command and Elements selects every layer except the Background layer.
 Even if you've turned off a layer's visibility (page 166), that layer still gets selected.
- Deselect Layers. When you're done working with your layers as a group, you can choose this option and no layers are selected until you click one.
- Similar Layers. This command is the most useful. Choose this option, and every layer of the same type gets selected, no matter where it is in the stack. So, for example, if you have a Text layer as your active layer when you choose Similar Layers, Elements selects all your Text layers. Or if you have an Adjustment layer active, it selects all your Adjustment layers. You might use this command to quickly select a stack of Adjustment layers you want to drag to another image, for instance, using the technique described on page 184.

You can also Shift-click to select multiple layers that are next to each other in the Layers panel, or %-click to select layers that are separated. That way, you can avoid the Select menu altogether. Once you're done, you can either use the Deselect Layers command from the menu, or just click another layer to make it the active layer.

Clipping masks-grouping layers

An even more powerful way to combine layers is to group them using a *clipping mask*. This technique sounds complex, but it's actually quite easy to do and very powerful.

With this kind of grouping, one layer (the clipping mask layer) influences the other layers it's grouped with. Clipping layers isn't anything like linking them. The easiest way to understand clipping masks is to look at Figure 6-16, which shows how you can crop an image on one layer using the shape of an object on another layer.

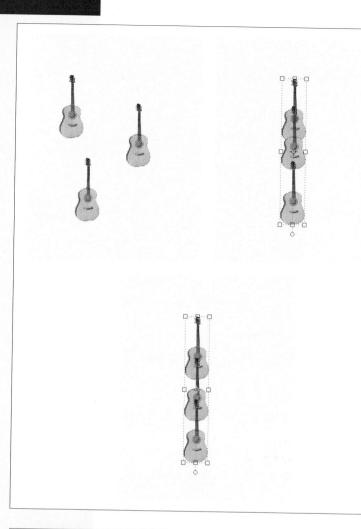

Figure 6-14:

Top: Each of these guitars is on its own layer, but they need to be tidied up if you want them in a neat stack.

Bottom left: Here's what you get if you select the guitars with the Move tool and then pick Align

Horizontal Center. As you see, the centers of the guitars are now aligned, but they're not evenly distributed.

Bottom right: The guitars after a trip to Distribute → Vertical Centers. Note that they're evenly spaced but still overlapping. That's because Distribute doesn't add any additional space between the outermost objects. If you want wider spacing between the shapes, then make sure they're farther apart before you distribute them.

Figure 6-15:

In the Layers panel, Shift-click to select the layers you want to link, and then click the chain icon at the bottom of the panel to link the layers. The chain icon appears to the right of each layer's name to indicate that those layers will now move as a group.

Icon for linked layers You'll also find it a breeze to evenly distribute the *spacing* between multiple objects. The Move tool's *distribute* feature spaces out objects, also letting you choose edges or centers as a guide. If you distribute the top edges, for example, Elements makes sure there's an even amount of space from the top edge of one object to another.

TIP Distributing objects in this way is especially handy when you're creating projects like those described in Chapter 15.

Aligning and distributing layers with the Move tool works much like rearranging layers:

1. Activate the Move tool.

Click its icon in the Tools panel or press V.

2. Select the objects you want to align.

This maneuver works only if each object is on its own layer. If you have multiple objects on one layer, move them to their own layers, one at a time, by selecting each object, and then press \(\mathbb{H} \)-Shift-J.

Shift-click inside the blue outline to select each layer, or Shift-click in Layers panel to select the layers you want.

3. Tell Elements how to align or distribute the objects by selecting from the Options bar menus.

The Align and Distribute menus both give you the same choices: Top Edges, Vertical Centers, Bottom Edges, Left Edges, Horizontal Centers, and Right Edges. You can most easily figure out which one you want by looking at the thumbnails next to each label—they show you exactly how your objects will line up.

TIP You can apply as many different align and distribute commands as you like, as long as the layers you're working with are still inside the bounding box. Figure 6-14 shows how these commands work.

Grouping and Linking Layers

What if you want to move several layers at once? For instance, in the garden party image back on page 156, two layers have potted plants on them. It's kind of a pain to drag each one individually if you need to move them in front of the bench. Fortunately, you don't have to; Elements gives you a way to keep your layers united.

Linking layers

You can *link* two or more layers, and then they'll travel as a unit, as shown in Figure 6-15.

and the bounding box expands to include everything you've selected. You can also drag a selection around multiple layers and choose them that way. For instance, you could drag over all the balloons to move them as a group, so you don't have to rearrange them afterwards.

Figure 6-13:

The Move tool lets you select objects from any layer, not just the active one. When you move the cursor over an object, you see the blue outline around its layer. Here, the coffee cup is the active layer (you can see the bounding box around it), but the Move tool is ready to select the pink balloon, even though it's not on the active layer. If all these outlines annoy you, you can turn them off in the Options bar by turning off the Show Bounding Box and "Show Highlight on Rollover" checkboxes. If you want to force the Move tool to concentrate only on the active layer, turn off the Auto Select Layer checkbox. (Incidentally, everything in this image came from the Content panel [page 450].)

3. Move the Layer.

For example, choose Layer \rightarrow Arrange, or click the Options bar's Arrange Menu, or right-click (Control-click) inside the bounding box in the image. You see the options ("Bring to Front", Bring Forward, and so on) described in the previous section, except for Reverse, which is available only from the Layer menu. You can also use keyboard shortcuts (again, except for Reverse).

NOTE If you selected multiple layers, you may find that some of the commands are grayed out (that is, you can't select them). If that's a problem, just click elsewhere in the image to deselect the layers, and then move the layers one at a time instead of as a group.

Aligning and Distributing Layers

You can easily align objects in any image with the Move tool. The Move tool's *align* feature arranges the objects on each layer so that they line up straight along their top, bottom, left, or right edges, or through their centers. So, for example, if you align the top edges of your objects, Elements makes sure that the top of each object is exactly in line with the others.

TIP Don't forget that in Elements 8 you can set guidelines (page 74) to help you position objects just so in your image.

Figure 6-12:

Top: When you bring a new element into an image, Elements puts it on top of the active layer. Here, the flower layer was active when the bench was brought in.

Bottom: Move the new layer down in the stack, and the new object appears behind the content of the layers you move it below, just as the bench moves behind the plants here.

• Reverse (no keyboard shortcut) switches two layers' locations in the stack; you have to select two layers in the panel (by %-clicking, for example) before Elements makes this command available.

TIP These commands (except Reverse) are also available in the Move tool's Options bar or by right-clicking (Control-clicking) in your photo when the Move tool is active. As a matter of fact, the Move tool is a great way to rearrange layers in your image, as the next section explains.

Arranging layers with the Move tool

Using the Move tool, you can locate and arrange layers right in your image window, without trekking over to the Layers panel. (If you need a refresher on Move tool basics, check out page 150.) To arrange layers with the Move tool:

1. Activate the Move tool.

Click its icon in the Tools panel or press V.

2. Select the layer(s) you want to move.

As soon as you activate the Move tool, you see the bounding box (the dotted lines) around the contents of the active layer in your image. As you move your cursor over the image, you see a blue outline around the contents of the layer the cursor is over—no matter how far down the layer stack the object is (see Figure 6-13). When you click to select the layer you want to move, a dotted-line bounding box appears around that layer. Shift-click to select multiple layers,

You can also clip right in the Layers panel. Hold down Option, and then, in the Layers panel, move your cursor over the dividing line between the layers. Click when you see two overlapping circles appear by your cursor. Now your layers are grouped with a clipping mask.

If you get tired of the layer grouping or you want to delete or change one of the layers, select Layer \rightarrow "Release Clipping Mask" or press Shift- \Re -G to remove the grouping.

TIP Elements gives you an even easier way to group layers: The New Layer dialog box has a checkbox for "Use Previous Layer to Create Clipping Mask". Turn it on, and your new layer is preclipped with the layer below it.

Merging and Flattening Layers

By now, you probably have at least an inkling of how useful layers are. But there's a downside to having layers in your image: They take up a lot of storage space, especially if you have lots of duplicate layers. In other words, layers make files bigger. Fortunately, you aren't committed to keeping layers in your file forever. You can reduce your file size quite a bit—and maybe make things easier to manage—by merging layers or flattening your image.

Merging layers

Sometimes you might have two or more separate layers that could be treated as one layer, like the potted plants in Figure 6-17. You aren't limited to linking those layers; once you have everything arranged to your satisfaction, you can *merge* them into one layer. Also, if you want to copy and paste your image, many times the standard copy and paste commands (page 124) affect only the top layer. So it helps to get everything into one layer, at least temporarily.

You'll probably merge layers quite often when you're working with multilayered files (for example, when you have multiple objects that you want to edit simultaneously).

To merge layers, you have a few different options, depending on what's active in your image at the time. You can get to any of the following commands from the Layers menu, by clicking the button with four lines in the Layers panel's upperright corner, or using keyboard shortcuts:

- Merge Down. This command combines the active layer and the layer immediately beneath it. If the layer just below the active layer is hidden, you don't see this option in the list of choices. Keyboard shortcut: **%**-E.
- Merge Visible. This option combines all the visible layers into one layer. If you want to combine layers that are far apart, turn off the visibility of the layers between them by clicking their eye icons (Shift-%-E).
- Merge Linked. Click any of your linked layers and you see this command, which joins the linked layers into one layer (%-E, just like Merge Down).

• Merge Clipping Mask. You need to select the bottom layer of a clipped layer pair to see this command. Choose it, and the clipped layers join into one layer (also **₩**-E).

Figure 6-17:

Those potted plants again. If you no longer need two separate plant layers, you can merge the layers together.

Top: The Layers panel with the two separate plant layers.

Bottom: The plant layers merged into one layer.

Use the Merge Layers command to combine these two layers into one

POWER USERS' CLINIC

Stamp Visible

Sometimes you want to perform an action on all the visible layers of your image without permanently merging them. You can do this easily—and quickly, too, even if you have dozens of layers in your file-by using what Adobe calls the Stamp Visible command. This command combines the contents of all your layers into a new layer at the top of the stack.

Stamp Visible lets you work on the new, combined layer while leaving your existing layers untouched, in case you want them back later.

Press %-Shift-Option-E or hold down Option while selecting the Merge Visible command from the Layers menu (or from Layers panel's upper-right menu). Elements creates a new top layer for you, and fills it with the combined contents of your other layers.

If you want to keep a layer or two from being included in this new layer, turn off the visibility of those layers you don't want to include before using the Stamp Visible command.

It's important to understand that once you merge layers and save and close your file, you can't just un-merge them again. While your file is still open, of course, you can use any of the Undo commands (page 32). But once you exceed the undo limit you've set in Preferences (page 33), you're stuck with your merged layers.

TIP The box on page 178 shows you another way to combine your layers, while still keeping separate copies of the individual layers.

Sometimes if your layer contains text or shapes drawn with the Shape tool, you can't merge the layer right away. Elements asks you to *simplify* the layer first. Simplifying a layer means converting its contents to a *raster object*. In other words, now it's just a bunch of pixels, subject to the same resizing limitations as any photo. So, for example, if you have a Type layer, you can apply filters to the text or paint on it, but you can't edit the words. (See page 373 for more about simplifying and working with shapes, and see Chapter 14 for working with text.)

Flattening an image

While layers are swell when you're working on an image, they're a headache when you want to share your image, especially if you're sending it to a photo-printing service (their machines usually don't understand layered files). And even if you're printing at home, the large size of such a file can make it take forever to print. Also, if you plan to use your image in other programs, very few non-Adobe programs are totally comfortable with layers, so you may get some odd results if you feed them a layered file.

In these cases, you may want to squash everything in your picture into a single layer. You can do this by *flattening* your image by going to Layer → Flatten Image, or on the Layers panel, click the upper-right square and then select Flatten Image. Or, to keep your original intact, go to File → Save As, and in the Save As dialog box, turn off the Layers checkbox before clicking the Save button. Elements forces you to save "As a Copy", keeping your original file intact and creating a flattened file called "<your image name> copy".

TIP Saving your image as a JPEG file automatically gets rid of layers, too.

There's no keyboard shortcut for flattening, because it's something you don't want to do by accident. Like merging, flattening is a permanent change. Many cautious Elements veterans always do a Save As, instead of a plain Save, before flattening. That way you have a flattened copy *and* your working copy with the layers intact, just in case.

TIP Flattening creates a Background layer out of the existing layers in your image, which means that you lose transparency, just as with a regular Background layer. If you want to create a single layer with transparency, use the Merge Visible command (page 177) instead of Flatten Image.

Adjustment and Fill Layers

Adjustment layers and Fill layers are special types of layers. Adjustment layers let you manipulate the lighting, color, or exposure of the layers beneath them. If you're mainly using Elements to spruce up your photos, you'll probably use Adjustment layers more than any other kind of layer. Adjustment layers are great because they let you undo or change your edits later.

You can also use Adjustment layers to take the changes you've made on one photo and apply them to another photo (see the box below). And after you've created an Adjustment layer, you can limit future edits so they change only the area of your photo affected by the Adjustment layer.

You'll find out more about what you can do with Adjustment layers in the next few chapters. In this section, you'll learn how to create and manipulate them.

Fill layers are just what they sound like: layers filled with a color, pattern, or gradient (a rainbow-like range of colors). There's more about gradients on page 404.

TIP Digital photographers should check out Photo Filter Adjustment layers, which let you digitally make the sort of adjustments that you used to do by attaching a colored piece of glass to the front of your camera's lens. You can read more about these filters on page 256.

GEM IN THE ROUGH

Adjustment Layers for Batch Processing

Page 258 shows you how to perform batch commands: simultaneously applying adjustments to groups of photos using the Process Multiple Files tool. The drawback to Process Multiple Files is that you have access only to some of the auto commands there—your editing options are limited. So what do you do if you're a fussy photographer who has 17 shots that are all pretty much the same, and you'd like to apply the same fixes to all of them? Do you have to edit each one from scratch?

Not in Elements. You can open the photos you want to fix, and then drag an Adjustment layer from the first photo onto each of the other photos (page 184 tells you how to drag layers between images). The new photo gets the same adjustments at the same settings. It's not as fast as true batch processing, but it saves a lot of time compared with editing each photo from scratch.

Adding Fill and Adjustment Layers

Creating an Adjustment or Fill layer is easy. In the Layers panel, click the black-and-white circle shown in Figure 6-18. Elements displays a menu of all your Adjustment and Fill layer options (the first three items are Fill layers; the rest are Adjustment layers).

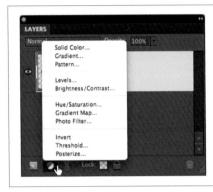

Figure 6-18:

To create a new Adjustment or Fill layer, click the black-and-white circle to get a pop-up menu where you can choose the type of Adjustment or Fill layer you want. If you'd rather work from the menu bar, go to Layer \rightarrow New Adjustment Layer (or Layer \rightarrow New Fill Layer), and then choose the layer type you want.

Fill layers

When you tell Elements to create a Fill layer, it displays a dialog box that lets you tweak the layer's settings. After you make your choices, click OK, and Elements creates the new layer. You have three kinds of Fill layers to choose from: Solid Color, Gradient (a rainbow-like range of colors), and Pattern. See more about patterns on page 276, and gradients on page 404.

You can change the settings for a Fill layer by highlighting the layer in the Layers panel and then going to Layer → Layer Content Options, or, in the Layers panel, double-clicking the layer's left thumbnail icon for the layer. Either way, the layer's dialog box reappears so you can adjust its settings.

Adjustment layers

In Elements 8, when you create an Adjustment layer, the layer automatically appears in your image and the new Adjustments panel opens in the Panel bin so that you can adjust the layer's settings. (Invert Adjustment layers, which are explained in a moment, are the exception—if you create one of these, Elements opens the Adjustments panel, but there are no settings to change.) Figure 6-19 shows you the Adjustments panel.

The Adjustments panel is handy because it shows you the settings for any given Adjustment layer. In the Layers panel, click the left icon (the one with the gears on it) of the layer you want to change; the Adjustments panel's contents change to reflect that layer's settings. Click on a different Adjustment layer and you see the settings for that one—very useful, and less distracting than having dialog boxes popping up all the time.

Here are the kinds of Adjustment layers you can select from:

• Levels. This is a more sophisticated way to apply Levels than using the Auto Levels button in Quick Fix or the Enhance menu's Auto Level command. Page 206 has more about using Levels. For most people, this is the most important kind of Adjustment layer.

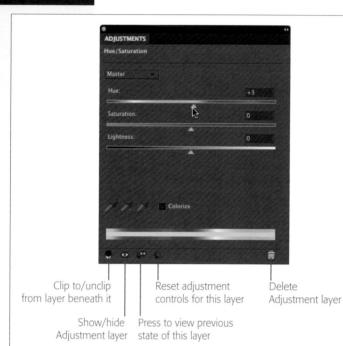

Figure 6-19:

The Adjustments panel is new in Elements 8. It appears when you create a new Adjustment layer so you can tweak the layer's settings. The icons at the bottom of the panel let you see your image with and without the Adjustment layer, so you can judge how you're changing things. There's also an icon for clipping the Adjustment layer to the layer beneath it in the Layers panel, or unclipping it (page 175).

- Brightness/Contrast. This does pretty much the same things as the Auto Contrast Quick Fix adjustment covered on page 108.
- Hue/Saturation. Again, this one is much like the Hue and Saturation Quick Fix commands (page 110), only with slightly different controls.
- Gradient Map. This one is tricky to understand, and is explained in detail on page 415. It maps each tone in your image to a new tone based on the gradient you select. That means you can apply a gradient so that the colors aren't just distributed in a straight line across your image.
- Photo Filter. Use this kind of Adjustment layer to adjust the color balance of your photos by adding warming, cooling, or special effects filters, like those you might attach to the lens of a film camera. See page 256 for details.
- Invert. This type of layer reverses the colors of your image to their opposite values, for an effect similar to a film negative (see page 296).
- Threshold. Use this Adjustment layer to make everything in your photo pure black and pure white with no shades of gray. See page 297.
- Posterize. Reduces the numbers of colors in your image to give a poster-like effect (see page 296).

Deleting Adjustment layers is a tad different from deleting regular layers, as explained in Figure 6-20. (Although Fill layers have a layer mask, Elements deletes them like regular layers.)

Figure 6-20:

When you click the Layers panel's Delete icon (the trashcan), Elements asks if you want to "Delete layer mask?" (The next section has more about layer masks.) Click Delete, and then click the trashcan icon again to fully delete the layer. If you want to get rid of the layer in one step, you have a few choices: Use the Layer menu, right-click (Control-click) the layer in the Layers panel, click the four-line square in the Layers panel's upper-right corner, or click the Delete icon in the Adjustments panel. Whichever route you choose, Elements gives you a Delete Layer choice.

Layer Masks

Adjustment and Fill layers use something called *layer masks*, which dictate which parts of the layers are affected when you make changes (see Figure 6-21). By changing the area covered by a layer mask, you can control which part of your image the adjustments affect.

Figure 6-21:

Adjustment and Fill layers, like the "Hue/Saturation" layer shown here, always have two icons in the Layers panel. The left icon—the one with the two gears—indicates that the layer is making an adjustment (Hue/Saturation, in this case). You can double-click that icon to bring up a dialog box to make changes to your settings for Fill layers. For Adjustment layers, just click the layer you want to change to make it the active layer, and then go to the Adjustments panel. (Fill layers sill have a unique icon for each type of layer, but all Adjustment layers show the gear icon you see here. Elements doesn't use different icons for the different types of Adjustment layers anymore.) The right icon—the white rectangle—is for the layer mask, which you use to control the area that's covered by the adjustment.

Full Photoshop uses layer masks for many other purposes, but in Elements, Adjustment and Fill layers are the only place you encounter layer masks. The great thing about layer masks is that you can edit them by painting on them, as explained on page 308. In other words, you can go back later and change the part of your image that the Adjustment layer affects.

Incidentally, the term *layer mask* may be a bit confusing if you're thinking about masking with the Selection brush. With the Selection brush, masking prevents something from being changed. A layer mask really works the same way, but by definition, it starts out empty; in other words, you can use the mask to prevent your adjustment from affecting parts of the layer, but not until you mask out parts of your image by painting on the layer mask. So at first, your entire layer is affected by the change. Page 308 explains how to edit layer masks.

Moving Objects Between Images

With layers, you can easily combine parts of different photos. In Elements 8, if you're using tabbed image windows, the easiest way to do this is simply by copying and pasting: Select what you want to move (\mathbb{H}-A to select all if it's the whole photo); press \mathbb{H}-C to copy it; next, bring the destination image up as the active image by double-clicking it in the Project bin; and then press \mathbb{H}-V to paste the object. That's all there is to it. Elements puts the pasted material on its own layer and you can use the Move tool (page 150) to rearrange it in its new home.

You can also move items by dragging. To do this, choose one of the tiled views (see page 83) if you're using tabs, or Tile or Cascade (Window → Images → Cascade) if you're using floating windows. Just put what you want from photo A into its own layer, and then drag it onto photo B. You can use the Move tool (page 150) to move the object from one image to another, or you can just drag it. The trick is that you have to drag the layer from photo A *from the Layers panel*. (If you try to drop one photo directly onto another photo's window, you'll wind up with a lot of windows stacked on top of each other.) Figure 6-22 shows you how to move a layer between photos this way.

TIP You can also drag a photo directly from the Project bin onto another image. This feature didn't work in Elements 6, so it's nice to get it back again in Elements 8. It's useful for projects like scrapbooking where you have many objects, each in its own file, to add to a page in Elements

But what if, rather than moving an entire layer, you just want to move a particular object—say, a person—to another photo? Just follow these steps:

1. Open both photos in Full Edit.

It's possible to do this when you're in tabbed view, but most people find it easier to use floating windows when working with several images. To create floating windows, go to the Arrange Documents menu (page 83) and choose "Float All in Windows", and then go to Window → Images and choose Tile or Cascade. If you want to use tabs, go to the Arrange Documents menu and choose a layout that gives you a view of all your images.

2. Prepare both photos for combining.

Go to Image → Resize → Image Size, and then make sure both photos have the same pixels per inch (ppi) setting before you start (see page 93 if you need a refresher on resizing and resolution). Why? If one photo is much bigger than the other, the moved object could easily blanket the entire target image. You don't absolutely have to do this size balancing, but it'll make your life a lot easier since it helps avoid winding up with an enormous or tiny pasted object after you move it. Keep reading for more advice about resolution when moving objects and layers.

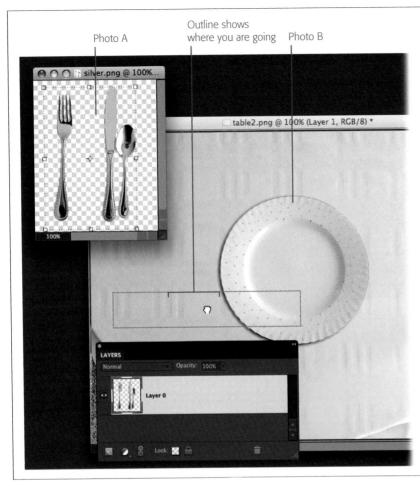

Figure 6-22: This figure shows how to move objects from one photo to another. working from the Layers panel. Here, the goal is to get the silverware from photo A (whose Layers panel is visible) onto the tablecloth in photo B. You always drag from the Layers panel onto a photo window when combining parts of different images into a composite. (If you try to drag from a photo to a photo, it won't work unless you activate the Move tool first.) Use the Move tool to adjust your object's placement once you've dropped it into the other image.

3. Select what you want to move.

Use the Selection tool(s) of your choice (see Chapter 5 if you need help making selections). Add a one- or two-pixel feather to your selection (see page 137) to avoid a hard, cut-out looking edge.

4. Move the object.

You have several ways to get material from one image to another:

- Copy and Paste. Start by pressing \(\mathbb{H}-C \) to copy the object from the first photo. Next, click the second photo to make it active, and then press \(\mathbb{H}-V \) to paste what you copied.
- Use the Move tool. Activate the Move tool (page 150), and then drag from one photo to the other. As you're moving, you may see a hole in the original where the selection was, but as long as you don't let go of the mouse button until you get over the second photo, Elements fixes the hole after you let go. (If seeing this bothers you, just Option-drag to move a copy of the selection.)

• Drag the layer. If the object you want to move is already on its own layer, surrounded by transparency, just drag the layer from the first photo's Layers panel into the second photo's main image window.

No matter which method you use, Elements puts whatever you moved on its own layer in the combined image.

5. If necessary, use the Move tool to position or scale the object after you've moved it, as shown in Figure 6-23.

See page 150 for more about using the Move tool; scaling objects is covered on page 340.

6. Save your work when you're done.

If you may want to make further adjustments to the moved object, save your file as a TIFF or Photoshop (.psd) file to keep the layers. Remember that if you save your file as a JPEG, you'll lose the layers, and you can't easily change or move the new object anymore.

Figure 6-23: If you forget to balance out the relative size and resolution of the photos you're combining, you wind up with a giant object in your photo-like these potted petunias. The solution is simple: Shift-drag a corner of the oversized item (circled). (You may need to drag the new object around a bit in order to expose a size-adjusting corner.) Don't forget that you can use all the Move tool's features on your new object.

Here are a few points to keep in mind when copying from one image to another:

• Watch out for conflicting resolution settings (see page 93). The bottom image (that is, the one receiving the moved layer or object) controls the resolution. So if you bring in a layer that's set to 300 pixels per inch (ppi), and place it on an image that's set to 72 ppi, the object you moved is now set to 72 ppi; its overall size will increase proportionately as the pixels get spread out, which means it'll be much bigger than it was in the original photo.

NOTE It's tricky to work with multiple images in tabs. Instead, try creating floating windows (Arrange Documents menu → "Float All in Windows"), and then go to Window → Images and choose Tile or Cascade. Cascade gives you the most flexibility for positioning your photos.

- Lighting matters. Objects that are lit differently stand out if you try to combine them. If possible, plan ahead and choose similar lighting for photos you're thinking about combining.
- Center your moved layer. If you want the layer you're dragging to be centered in the new image, Shift-drag it.
- Feather with care. A little feathering (page 137) goes a long way toward creating a realistic result.

TIP If you'd like more practice using layers and moving objects between photos, visit the Missing CD page at *www.missingmanuals.com*, and download the Table Tutorial, which walks you through most of Elements' basic layer functions.

Part Three: Retouching

Chapter 7: Basic Image Retouching

Chapter 8: Elements for Digital Photographers

Chapter 9: Retouching: Fine-Tuning Your Images

Chapter 10: Removing and Adding Color

Chapter 11: Photomerge: Creating Panoramas, Group Shots, and More

Basic Image Retouching

You may be perfectly happy using Elements only in Quick Fix mode. And that's fine, as long as you understand that you've hardly scratched the surface of what the program can do for you. Sooner or later, though, you're probably going to run across a photo where your best Quick Fix efforts just aren't enough. Or you may simply be curious to see what else Elements has under its hood. That's when you finally get to put all your image-selecting and layering skills to good use.

Elements gives you loads of ways to fix photos beyond the limited options in Quick Fix. This chapter guides you through fixing basic exposure problems, shows you additional ways to sharpen your photos, and most important, helps you understand how to improve the colors in your photos. You'll also learn how to use the amazing new Smart Brush tool that lets you apply many common fixes by just brushing over the area you want to correct.

If you want to get the most out of Elements, you need to understand a little about how your camera, computer, and printer think about color. Along with resolution (page 90), color is the most important concept in Elements. After all, almost all the adjustments that image-editing programs make consist of changing the color of pixels. So quite a bit of this chapter is about understanding how Elements—and by extension, you—can manipulate your image's color.

TIP Most of Elements' advanced-fixes dialog boxes have a Preview checkbox, which lets you watch what's happening as you adjust the settings. It's a good idea to keep these checkboxes turned on so you can decide if you're improving things. And for a handy "before" and "after" comparison, toggle the checkbox on and off.

Fixing Exposure Problems

Incorrectly exposed photos are *the* number one problem photographers face. No matter how carefully you set up your shot and how many different settings you try on your camera, it always seems like the picture you really, really want to keep is the one that's over- or underexposed.

The Quick Fix commands (page 99) can improve your photo, but if you've tried to bring back a picture that's badly over- or underexposed, you've probably run into the limitations of what Quick Fix can do. Similarly, the Shadows/Highlights command (page 194) can do a lot, but it's not intended to fix a photo whose exposure is totally botched—just ones where the contrast between light and dark areas needs a bit of help. And if you push Smart Fix to its limits, your results may be a little strange. In those situations, you need to move on to some of Elements' more powerful tools to help improve the exposure.

TIP In this section, you'll learn about the more traditional ways of correcting exposure in Elements, as well as how to use the new Smart Brush tool for corrections. But also be sure to check out Elements' Camera Raw Converter (page 232), which can help with your JPEG and TIFF photos, too. Your results with non-Raw photos may vary, but the Raw Converter just might turn out to be your best choice.

UP TO SPEED

Understanding Exposure

What exactly *is* exposure, anyway? You almost certainly know a poorly exposed photo when you see it: It's either too light or too dark. But what specifically has gone wrong?

Exposure refers to the amount of light your film (or the sensor in your digital camera) received when you released the shutter.

A well-exposed photo shows the largest possible amount of detail in *all* parts of your image—light and dark. In a properly exposed photo, shadows aren't just pits of blackness, and bright areas are more than washed-out splotches of white.

Deciding Which Exposure Fix to Use

When you open a poorly exposed photo in Elements, the first thing to do is figure out what's wrong with it, like a doctor diagnosing a patient. If the exposure's not perfect, what exactly is wrong? Here's a list of common symptoms to help figure out what to do next:

- Everything is too dark. If your photo is really dark, try adding a Screen layer, as explained on page 193. If it's just a bit too dark, try using Levels (page 206).
- Everything is too light. If the whole photo looks washed out, try adding a Multiply layer (explained on page 193). If it's just a bit too light, try Levels (page 206).
- The photo is mostly OK, but your subject is too dark or the light parts of the photo are too light. Try the Shadows/Highlights adjustment (page 194) or the Smart Brush tool (page 196).

Of course, if you're lucky (or a really skilled photographer), you may not see any of these problems, in which case, skip to page 206 if you want to make your colors pop. If you're lucky enough to have *bracketed* exposures (multiple exposures of the same image), check out the new Exposure Merge feature (page 251), which makes it easy to blend those into one properly exposed image.

NOTE You may have noticed that you didn't see Brightness/Contrast mentioned in the previous list. A lot of people tend to jump for the Brightness/Contrast controls when facing a poorly exposed photo. That's logical—after all, these dials usually help improve the picture on your TV. But in Elements, you have a whole slew of powerful tools—like Levels and the Shadows/Highlights command—that can do much more than Brightness/Contrast can. However, in recent versions of Elements, Brightness/Contrast is much improved from earlier versions, so feel free to give it a try when you need to make only subtle changes.

Fixing Major Exposure Problems

If your photo is completely over- or underexposed, you need to add special layers to correct the problems. You follow the same steps to fix either problem. The only difference is the blend mode (page 168) you choose: *Multiply layers* darken your image's exposure while *Screen layers* lighten it. Figure 7-1 shows Multiply layers in action and gives you an idea of this technique's limitations if your exposure is *really* far gone. You can download the file *brickwindow.jpg* from the Missing CD page at *www.missingmanuals.com* if you'd like to try the different exposure fixes yourself.

Figure 7-1:
For those who think
photographically, each Multiply layer
you add is roughly equivalent to
stopping your camera down one fstop, at least as far as the dark areas
are concerned.

Left: This photo is totally overexposed, and it looks like there's no detail there at all. Multiply layers darken things enough to bring back a lot of the washed-out areas. This technique can bring out the detail quite a bit.

Right: As you can see in the corrected photo, even Elements can't do much in areas where there's no detail at all, like the sky and the white framing around the windows.

Be careful, though. If your entire photo isn't out of whack, using Multiply or Screen layers can ruin the exposure of the parts that were OK to start with, because they increase or decrease the exposure of the entire photo. Your properly exposed areas may blow out (see page 195) and lose the details if you apply a Screen layer,

for example. So, if your exposure problem is spotty (as opposed to problems that affect the entire image), try the Smart Brush (page 196) or Shadows/Highlights (below) first. If your whole photo needs an exposure correction, here's how to use layers to fix it:

1. Create a duplicate layer.

Open your photo and press \Re -J or go to Layer \rightarrow Duplicate Layer. Be sure the duplicate layer is the active layer.

2. In the Layers panel, change the mode for the new layer in the upper-left popup menu.

This pop-up menu is set to Normal until you change it. Choose Multiply if your photo is overexposed, or Screen if it's underexposed. Make sure you change the mode of the *duplicate* layer, not the original layer.

3. Adjust the opacity of the layer if needed.

If the new layer's effect is too strong, in the Layers panel, move the Opacity slider to the left to reduce the new layer's opacity.

4. Repeat as necessary.

You may need to use as many as five or six layers if your photo is in really bad shape. If you need extra layers, you'll probably want them at 100 percent opacity, so you can just keep pressing **%**-J, which will duplicate the current top layer.

You're more likely to need several layers to fix overexposure than you are for underexposure. And there are limits to what even Elements can do for a blindingly overexposed image. Overexposure is usually tougher to fix than underexposure, especially if the area is blown out, as explained in the box on page 195.

The Shadows/Highlights Command

The Shadows/Highlights command is one of the best features in Elements. It's an incredibly powerful tool for adjusting only the dark or light areas of your photo without messing up the rest of it. Figure 7-2 shows what a great help it can be.

The Shadows/Highlights command in Full Edit works much the same way it does in Quick Fix (page 109). The single flaw in this great tool is that you can't apply it as an Adjustment layer (page 181), so you may want to apply Shadows/Highlights to a duplicate layer. Then, later on, you can discard the changes if you want to take another whack at adjusting the photo. In any case, it's easy to make amazing changes to your photos with Shadows/Highlights. Here's how:

1. Open your photo and duplicate the layer (%-J).

If you haven't edited your photo before, this is usually the Background layer, but you can use this command on any layer. Duplicating your layer is optional but it makes it easier to undo Shadows/Highlights later if you change your mind.

IN THE FIELD

Avoiding Blowouts

An area of a photo is *blown out* when it's so overexposed that it appears plain white—in other words, your camera didn't record any data for that area. (Elements isn't all that great with total black, either, but that doesn't happen quite as often. Most underexposed photos have some tonal gradations in them, even if you can't see them very well.)

A blowout is as disastrous in photography as it is when you're driving. Even Elements can't fix blowouts because there's no data for it to work from. So, you're stuck with the fixes discussed in this chapter, which are never as good as a well-exposed original.

When you're taking pictures, remember that it's generally easier to correct underexposure than overexposure, and choose your camera settings accordingly. So if you live where there's extremely bright sunlight most of the time, you may want to make a habit of backing your exposure compensation down a hair. Depending on your camera, your subject, and the average ambient glare, try starting at –.3 and adjusting from there.

You can also try *bracketing* your shots—taking multiple shots of exactly the same subject with different exposure settings. Then you can combine the two exposures for maximum effect using the new Exposure Merge feature (page 251).

Figure 7-2:
The Shadows/Highlights
command can bring back details
in photos where you were sure
there was no info at all—but
sometimes at a cost

Left: You might think there's no hope for this extremely backlit photo with its overly bright sky and murky foreground.

Right: A dose of Shadows/ Highlights unearths plenty of details, although the overall effect is a bit flat when you push the tool this far. This photo needs more work, but at least now you can see what you're doing.

2. Go to Enhance → Adjust Lighting → Shadows/Highlights.

Your photo immediately becomes about 30 shades lighter. Don't panic. As soon as you select the command, the Lighten Shadows setting automatically jumps to 25 percent, which is way too much for most photos. Just shove the slider back to 0 to undo this change before you start making your corrections.

3. Move the sliders around until you like what you see.

The sliders do exactly what they say: Lighten Shadows makes the dark areas of your photo lighter, and Darken Highlights makes the light areas darker. (Midtone Contrast is explained in a moment.) Pushing a slider to the right increases its effect.

4. Click OK when you're happy.

The Shadows/Highlights tool is a cinch to use because you just make decisions based on what you see. Keep these tips in mind:

- You may want to add a smidgen of the opposite tool to balance things out a little. In other words, if you're lightening shadows, you may get better results by giving the Darken Highlights slider a teeny nudge, too.
- Midtone Contrast is there because your photo may look kind of flat after you're done with Shadows/Highlights, especially if you've made big adjustments. Move the Midtone Contrast slider to the right to increase the contrast in your photo. It usually adds a bit of a darkening effect, so you may need to go back to one of the other sliders to tweak your photo after you use it.
- You can overdo the Shadows/Highlights command. When you see halos around the objects in your photo, you've pushed the settings too far.

TIP If the Shadows/Highlights command washed out your photo's colors—making everyone look like they've been through the laundry too many times—adjust the color intensity with one of the Saturation commands, either in Quick Fix or in Full Edit (as described on page 285). Watch people's skin tones when increasing the saturation—if the subjects in your photo start looking like sunless-tanning-lotion disaster victims, you've gone too far. Also check out the Vibrance slider in the Raw Converter (page 244), or try adjusting things with Elements' Color Curves feature (page 282).

Correcting Part of an Image

Shadows/Highlights is great if you want to adjust *all* the light or dark areas in a photo, but what if you want to tweak the exposure only in certain areas? Or what if you like the photo's background, but you want to tweak the subject a little? You could make a selection in your photo (see Chapter 5 for more about selecting), copy the selected area to a new layer, and then make your adjustments to that layer. But Elements gives you a super simple way to apply a correction to just the area you want, using the new Smart Brush tools.

Correcting color with a brush

The Smart Brush is actually two different tools (the Smart Brush and the Detail Smart Brush) that work just like the Quick Selection tool and the regular Selection brush, respectively—only instead of merely selecting a region of your photo, they also *edit* it as you brush. So you may be able to do targeted adjustments to different areas of your photo just by drawing a line over them. The Smart Brushes don't always work, but they're truly amazing when they do.

In this section, you'll learn how to use the Smart Brush to correct exposure, but you can do all kinds of other things with this tool: Change the color of someone's jacket, apply different special effects, add lipstick to someone's mouth, convert an area to black and white—the list goes on and on. As a matter of fact, if you've been using Quick Fix, you may well have met the Smart Brush already without even knowing it: The new Touch Up tools (page 113) all use the Smart Brush to apply their effects.

Here's how to put this nifty pair of tools to work:

1. Open a photo in Full Edit, and then activate the Smart Brush.

Click its icon in the Tools panel (the brush with the gears next to it) or press F. Use the pop-out menu to be sure you have the regular Smart Brush. It shares its Tools panel slot with the Detail Smart Brush, which works like the Selection Brush in that it changes only the area directly under the brush, instead of automatically expanding your selection to include the whole object you brush over. For now, see if the regular Smart Brush is smart enough to select the area you want.

2. Choose the correction you want to apply.

Go to the Options bar and choose from the pull-down menu. (Both Smart Brushes have the same Options bar settings, discussed below. The important one is explained in Figure 7-3.) Adobe calls these choices Smart Paint.

Figure 7-3:

Your Smart Paint options (the things you can do with the Smart Brush) are grouped into the categories listed in the pull-down menu at the top of this menu. Each thumbnail shows that option applied to the same photo. For exposure issues, start by looking at the choices in the Lighting section, shown here. You can make an area darker, brighter, make the contrast low or high, or even put a spotlight effect on it. Scroll through the list to find the effect you want, click it, and then click somewhere outside your photo to close the menu. You can also drag this menu out of the Options bar and place it where you want, if you'd like to keep it available and out of the way of your photo.

3. Drag over the area you want to change.

This step is just like using the Quick Selection tool—no need to make a careful selection, since Elements figures out the area it thinks you want to include and creates the selection for you. A simple line should do it.

4. Tweak the selection, if necessary.

If Elements didn't quite select everything you want, you can add to the selection by brushing again. If you still need to modify the selection, use the selection-editing tools explained in Figure 7-4. If you're really unhappy with the Smart Brush's selection, head back to the Tools panel and try the Detail Smart Brush instead.

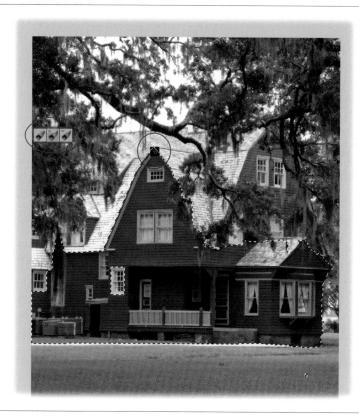

Figure 7-4: Once you've used the Smart Brush. a pin (circled, right) appears in your photo, indicating that the selected region is now under the power of the Smart Brush. (You see the pin any time the Smart Brush is active again, even after you've closed and saved your photo.) Click the pin, and you see a trio of icons (circled, left) that let vou edit the selected area. From left to right the icons mean New Selection, "Add to Selection", and "Remove from Selection". If you're pressed for time, there's an even quicker way to modify your selection: Drag again to add to the area affected by the Smart Brush (or to use the same adjustment on another part of your photo) or Option-drag to remove changes from an area.

You can invert the selection (page 146) by turning on the Options bar's Inverse checkbox. That way Elements *excludes* what you selected with the brush and selects everything else. You can turn on this checkbox before or after using the Smart Brush, as long as it's still the active tool. If you come back to the Smart Brush after using another tool, you need to click the pin shown in Figure 7-4 before you can invert the selection.

5. Once you like the selection, you can adjust the effect, if you want.

The Smart Brush gives you several ways to change what it's done:

 Change what happens to the selected area. While the selection is active, in the Options bar, go to the Smart Paint settings and choose a different adjustment. Elements automatically updates your image.

- Add a different kind of Smart Paint. At the left end of the Options bar, click the tiny triangle and choose Reset Tool. Then the Smart Brush puts down an *additional* adjustment when you use it, instead of just changing what you've already done. You can also use this to double-up an effect—to add Lipstick twice, for instance, if you thought the first pass was too faint. Each Smart Brush adjustment gets its own pin, so if you have two Smart Brush adjustments in your photo, you have two pins in it, too. (Each pin is a different color.)
- Change the settings for Smart Paint you've already applied. Rather than adding another Smart Paint layer to increase the effect, you can adjust the settings for the changes you've already made. Right-click (Control-click) the pin in your image, and then choose Change Adjustment Settings to bring up the Adjustments panel so you can adjust the effect you're brushing on. The Smart Brush uses Adjustment layers for the changes it makes, so the settings are the same as they would be if you created a regular Adjustment layer—if you're using the Brighter option, as shown in Figure 7-3, for example, you get the settings for a Brightness/Contrast Adjustment layer.

6. When you're happy with how things look, you're done.

You can always go back to your Smart Paint changes again. Just activate the Smart Brush (click it in the Tools panel or press F) and the pin(s) appear again so you can easily change what you've done. You can eliminate Smart Brush changes by right-clicking (Control-clicking) the adjusted area and choosing Delete Adjustment (the Smart Brush needs to be active), or by going to the Layers panel and discarding their layers (you can do this anytime, whether or not the Smart Brush is active). You can also edit the Smart Brush adjustment's layer mask the way you'd edit any other layer mask (page 308). But usually it's easier just to click the pin, and then adjust your selection.

The Smart Brush is especially handy for projects like creating images that are part color and part black and white, or even for silly special effects like making one object from your photo look like it's been isolated on a 60s-style psychedelic background.

The Smart Brush has several Options bar settings, but you usually don't need to use them:

- New Selection. Click the leftmost brush icon to add the same effect elsewhere in your photo—though just clicking someplace else with the tool does the same thing.
- Add to Selection. Click this center brush icon to put the Smart Brush in add-to-selection mode, but again, the tool does that automatically without using this icon.
- Remove from Selection. Did the Smart Brush take in more area than you wanted? Click the rightmost brush icon before brushing away what you don't want, or just Option-drag.
- Brush characteristics. You can change the size, hardness, spacing, angle, or roundness of the brush here.

- Inverse. If you want to apply your chosen correction to the area you *didn't* select with the Smart Brush, turn on this checkbox to invert the selection.
- Refine Edge. Use this if you want to make the edges of your effect sleeker (see page 131).
- Smart Paint. Click the thumbnail for a pop-out menu of all the possible Smart Brush adjustments, grouped into categories. (If you hover your cursor over the thumbnail, the tooltip text says "Choose A Preset", but Adobe calls these settings Smart Paint in the Help files and elsewhere.)

If you like the idea of the Smart Brush but never seem to find exactly the adjustments you want, or if you always want to change the settings you apply, you can create your own Smart Paint options, as described in the box on page 201.

Controlling the Colors You See

You want your photos to look as good as possible and to have beautiful, breathtaking color, right? That's probably why you bought Elements. But now that you have the program, you're having a little trouble getting things to look the way you want. Does this sound familiar?

- Your photos look great onscreen but your prints are washed out, too dark, or the colors are all a little wrong.
- Your photos look fine in other programs like Word or Pages, but they look just awful in Elements.

What's going on? The answer has to do with the fact that Elements is a *color-managed* program. That means that Elements uses your monitor info for guidance when deciding how to display images. Color management is the science of making sure that the color in your images is always exactly the same, no matter who opens the file or what kind of hardware they're using to view or print it. If you think of all the different monitor and printer models out there, you get an idea of what a big job this is.

Graphics pros spend their whole lives grappling with color management, and you can find plenty of books about the finer points of the subject. On the most sophisticated level, color management is complicated enough to make you curl up into the fetal position and swear you'll never create another picture.

Lucky for you, Elements makes color management a whole lot easier. Most of the time, you have only two things to deal with: your monitor calibration and your color space. The following pages cover both.

NOTE There are a couple of other color-related settings for printing, too, but you can deal with those when you're ready to print. Chapter 16 explains them.

POWER USERS' CLINIC

Making Smart Paint Presets

While the Smart Brush offers a lot of different Smart Paint choices (the various settings for correcting and enhancing your photos), you may find it frustrating that Elements doesn't have a setting for the particular corrections you use most frequently. No problem—you can create your own Smart Paint settings. As long as you can use Adjustment layers (page 181) to achieve the effect you want, you can configure your own Smart Paint choices, and they appear in the menus right along with the ones from Adobe.

To get started, go to your hard drive \rightarrow Library \rightarrow Application Support \rightarrow Adobe \rightarrow Photoshop Elements \rightarrow 8.0 \rightarrow Photo Creations \rightarrow adjustment layers. You see three files for each Smart Paint preset:

- A PSD file. This file contains the actual settings for the preset.
- A thumbnail file. These JPEG files show up as previews in the menu.
- An XML file. This file tells Elements where in the menus to display the preset, whether to show it in "Black and White" or in Lighting, for instance. The XML files all have the word "metadata" in their names, so they're easy to find.

Essentially, you need to edit *copies* of these files to make new ones for each preset you want to add. Here's how:

- Open one of the .psd files in Elements. To start
 with, pick the one that's the closest to what you
 want to do. Notice how the file is put together: It's
 a 160-pixel square .psd file with an Adjustment
 layer on it. Save the file under a new name so you
 don't mess up the original.
- Change the settings. In the Layers panel, click once on the Adjustment layer to select it, then—in the Adjustments panel—tweak the settings. Then save the file.
- Create a new thumbnail. You can just save the original thumbnail with a new name. Thumbnails are 74-pixel square JPEGs, in case you want to make

- a new one from scratch. Make sure the name ends in ".thumbnail.jpg" (notice the two periods).
- 4. Create a new XML file. For most people, this is the trickiest part. Open the XML file and save it as XML with the name of the new Smart Paint preset you just created. (The easiest way to do this is to download a program like the free TextWrangler [www.barebones.com/products/textwrangler] and use that.) Then look at the contents of the file. Most of it won't make much sense to non-geeks, but what you're looking for is a line like this:

<name value="\$\$\$/content/adjustmentlayers/
ContrastHigh=Contrast High" />

In this example, you'd be adapting the Contrast High preset, so just find the two instances of the name (note that there's no space in the first one), and then change them to the name of your new preset. If you're ambitious, you can also edit the text for tooltips (the text that appears when you hover your cursor over the thumbnail) and the category. You can use an existing category or create a new one.

When you're finished making your changes, save the file. Name the file *my effect.metadata.xml*—but replace "my effect" with the name you gave your new preset. Make sure all three files are in the adjustment layers folder. Then, the next time you start Elements, you should see your new Smart Paint right there along with the ones that came with Elements.

If your new setting doesn't show up, or if you make a mistake creating your preset and don't catch it till after starting Elements again, to correct it, go to your hard drive \rightarrow Library \rightarrow Application Support \rightarrow Adobe \rightarrow Photoshop Elements \rightarrow 8.0 \rightarrow Locale \rightarrow en_US (the last bit is different if you aren't in the US), and then delete MediaDatabase.db3 to refresh the list of presets. (Note that you have three Library folders; this is the one at the top level of your hard drive, not the one in your Home or System folder.)

Calibrating Your Monitor

Most programs pay no attention to your monitor's color settings, but color-managed programs like Elements rely on the *profile*—the info your computer stores about your monitor's settings—when it decides how to print or display a photo onscreen. If that profile isn't accurate, neither is the color in Elements.

So, you may need to *calibrate* your monitor, which is a way of adjusting its settings. A properly calibrated monitor makes all the difference in the world in getting great-looking results. If your photos look bad only in Elements, or if your printed pictures don't look anything like they do onscreen, you can start fixing the problem by calibrating your monitor.

Getting started with calibrating

Calibrating a monitor sounds intimidating, but it's actually pretty easy—and kind of fun. The benefit is that your monitor may look about a thousand times better than you thought it could. Calibrating may even make it easier to read text in Word, for instance, because the contrast is better. Your options for calibrating your monitor are:

• Use a colorimeter. This method may sound disturbingly scientific, but it's actually the easiest. A *colorimeter* is a device with special software that does the calibrating for you. The device is much more accurate than calibrating by eye. For a long time, only a pro could afford one, but these days you can find the Pantone Huey or the Spyder2Express for about \$70 or less. More pro-oriented calibrators like the ColorMunki or the Spyder range from \$200 on up. If you're serious about controlling your colors in Elements, this is by far your best option for calibrating.

NOTE The calibration software that comes with your colorimeter may ask you to set the brightness and contrast before you begin, even though most LCD monitors don't have dials for these anymore. If you're happy with your monitor's current brightness and contrast, you can safely ignore this step. And unless you have a reason to choose differently, for an LCD monitor you usually want to set your white point to 6500 (Kelvin) and your gamma (which is something like the overall contrast) to 2.2 (2.2 is sometimes called "PC gamma," but it's the standard gamma setting for any LCD monitor, including Apple's). If you're using OS X 10.6, Apple starts you at 2.2, so you may not need to make any changes. In OS X 10.5, the starting setting is usually 1.8 or lower.

• Use your Mac's built-in calibrator. If you go to ♠ System Preferences → Displays → Color → Calibrate, you can use Apple's Display Calibration Assistant to calibrate your monitor—sort of (see Figure 7-5). You can also find lots of calibration programs online, but most of them aren't much, if any, better than the Assistant.

If your photos still look a little odd even after you've calibrated your monitor, you may need to turn on the Ignore EXIF setting in Elements' preferences (Figure 7-6).

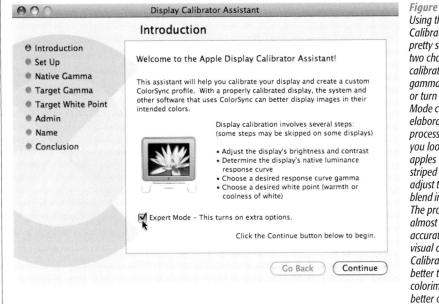

Figure 7-5: Using the Display Calibrator Assistant is pretty simple. You have two choices: Do a basic calibration that sets your aamma and white point. or turn on the Expert Mode checkbox for a more elaborate color-balancina process. In Expert mode, you look at a series of apples (of course!) on a striped background and adjust things till the apples blend into the background. The problem is that it's almost impossible to get accurate results from a visual calibration. The Calibrator Assistant is better than nothing, but a colorimeter is a much better option.

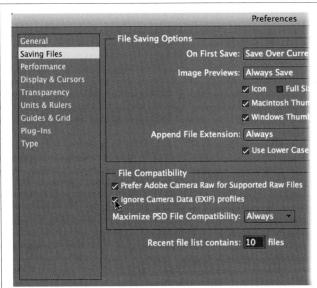

Figure 7-6:

If you still see a funny color cast (usually red or yellow) on all your digital photos, go to Photoshop Elements → Preferences → Saving Files and turn on "Ignore Camera Data (EXIF) profiles". Some cameras embed funky color info in their files, so this setting tells Elements to ignore it, letting your photos display and print properly.

Choosing a Color Space

To get good color from Elements, you can also check what *color space* the program is using. A color space is a standard (there are several) Elements uses to define your colors. Color space can seem pretty abstruse at first, but it's simply a way of defining what colors mean. For example, when someone says "green," what do you envision: a lush emerald color, a deep forest green, a bright lime, or something else?

Choosing a color space is a way to make sure that everything that handles a digital file—Elements, your monitor, your printer—sees the same colors the same way. Over the years, the graphics industry has agreed on standards so that everyone understands what you mean when you say red or green—as long as you specify which set of standards you're using.

Elements only gives you two color spaces to pick from: *sRGB* (also called *sRGB IEC61966-2.1* if you want to impress your geek friends) and *Adobe RGB*. When you choose a color space, you tell Elements which set of standards to apply to your photos.

If you're happy with the color you see on your monitor in Elements and you like the prints you're getting, you don't need to make any changes. But if you aren't perfectly satisfied with what Elements is giving you, you can modify your color space in the Color Settings dialog box (go to Edit → Color Settings or press Shift-**%**-K). Here are your choices:

- No Color Management. Elements ignores any info that your file already contains, like color space data from your camera, and doesn't attempt to add any color info to the file's data. (When you do a Save As, there's a checkbox that lets you embed your monitor's profile. Don't turn on this checkbox, since your monitor profile is best left for the monitor's own use, and putting the profile into your file can make trouble if you send the file someplace else for printing.)
- Always Optimize Colors for Computer Screens. Choose this option to see your photo in the sRGB color space, which is what most web browsers use; this is a good choice for preparing graphics for the Web. Many online printing services also prefer sRGB files. (If you've used an early version of Elements, this is the same as the old Limited Color Management option.)
- Always Optimize for Printing. This option uses the Adobe RGB color space, which is a wider color space than sRGB, meaning it allows more gradations of color than sRGB. Sometimes, but not always, this is your best choice for printing. So despite the note in the Color Settings dialog box about "commonly used for printing," don't be afraid to try one of the other two settings instead. Many home inkjet printers actually cope better with sRGB or no color management than with Adobe RGB. (For old Elements hands, this setting used to be called Full Color Management.)

• Allow Me to Choose. This option assumes that you're using the sRGB space, but lets you assign either an Adobe RGB tag, an sRGB tag, or no tag at all. With this option, each time you open a file that isn't sRGB, you see the dialog box in Figure 7-7, where you can assign a different profile to a photo. Just save it once without a profile (turn off the ICC [International Color Consortium] Profile checkbox in the Save As dialog box), and then reopen it and choose the profile you want from the dialog box. Or the box on page 206 teaches you an easier way to convert a color profile if you need to make a change.

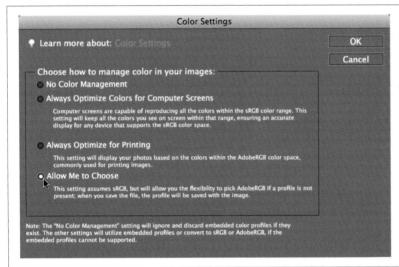

Figure 7-7:
If you select the "Allow Me to Choose" color-management option, you see this dialog box each time you open a previously untagged image, so you can decide whether and how to tag your file.

NOTE Elements automatically opens files tagged with a color space other than the one you're working in without letting you know what it's just done, so you won't know that there's a mismatch between the file's ICC profile and the color space you're working in. (When you open a file in a color mode that Elements can't handle at all, like CMYK, Elements offers to convert it to a mode you can use.) So, if you have an Adobe RGB file and you're working in "Always Optimize Colors for Computer Screens", Elements doesn't warn you about the profile mismatch the way early versions of the program did—it just opens the file. If you consistently get strange color shifts when you open your Elements-edited files in other programs, make sure there isn't a profile mismatch between your images and Elements.

So what's your best option? Once again, if everything is looking good, leave it alone. Otherwise, for general use, you're probably best off starting with No Color Management. Then try the others if that doesn't work.

POWER USERS' CLINIC

Converting Profiles in Elements

If you're a color-management maven, Elements has a feature you'll really appreciate: the ability to convert an image's ICC profile from one color space to another. If you've been working in, say, sRGB and now you want your photo to have the Adobe RGB profile, you can convert it by going to Image → Convert Color Profile → Convert to Adobe RGB Profile. You can also remove a profile via this menu, or convert to sRGB or Adobe RGB (your current color profile is grayed out).

This is a true conversion. Your photo's colors don't shift the way they might if you just tag a photo with a different profile. Why would you want to perform such a conversion? Well, for example, if you use Adobe RGB when editing your photos, but you're sending your pictures to an online printing service that wants sRGB instead, you may want to think about converting.

If you choose one of the other three options, when you save your file, Elements attempts to embed the file with a *tag*, or info about the file's color space—either Adobe RGB or sRGB. If you don't want a color tag—also known as an *ICC Profile*—in your file, turn off the checkbox before you save your file. Figure 7-8 shows where to find the profile information in the Save As dialog box, and how to turn the whole process off.

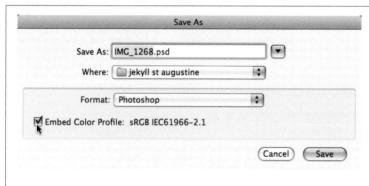

Figure 7-8:

When you save a file, Elements offers to embed a color tag in the file. You can safely turn off the Embed Color Profile checkbox and leave the file untagged. (Assigning a profile is helpful because then any program that sees your file knows what color standards you're working with. But if you're new to Elements, you'll usually have an easier time if you don't embed profiles in files without a good reason.)

Using Levels

Elements veterans will tell you that the Levels command is one of the program's most essential tools. You can fix an amazing array of problems simply by adjusting the level of each *color channel*. (On your monitor, each color you see is composed of red, green, and blue. In Elements, you can make precise adjustments to your images by adjusting these three color channels separately.)

As its name suggests, Levels adjusts the amount of each color within an image. There are several different adjustments you can make using Levels, from generally brightening your colors to fixing a color cast (more about color casts later in this chapter). Many digital photo fans treat almost every picture they take to a dose of Levels, because there's no better way to polish the color in your photo.

The way Levels works is fairly complex. Start by thinking of the possible range of brightness in any photo on a scale from 0 (black) to 255 (white). Some photos may have pixels in them that fall at both those extremes, but most photos don't. And even the ones that do may not have the full range of brightness in each individual color channel. Most of the time, there's some empty space at one or both ends of the scale.

When you use Levels, you tell Elements to consider the range of colors available in *your* photo as the *total* tonal range it has to work with, and the program redistributes your colors accordingly. Basically, you get rid of the empty space at the ends of the scale of possibilities. This can dramatically change the color distribution in your photo, as you can see in Figure 7-9.

It's much, much easier to use Levels than to understand it, as you know if you've already tried Auto Levels in Quick Fix (page 108). That command is great for, well, quick fixes. But if you really need to massage your image, Levels has a lot more under the hood than you can see there. The next section shows you how to get at these settings.

Figure 7-9: A simple Levels adjustment can make a huge difference in the way your photo looks.

Left: The gray-green cast to this photo makes everything look dull.

Right: Levels not only got rid of the color cast, but the photo also seems to have better contrast and sharpness.

Understanding the Histogram

Before you get started adjusting Levels, you need to understand the heart, soul, and brain of the Levels dialog box: the Histogram (Figure 7-10). You can call up this dialog box by pressing **%**+L.

The Histogram is the black bumpy mound in the dialog box. It's really nothing more than a bar graph that shows the distribution of the colors in your photo. (It's a bar graph, but there's no space between the bars, which is why it looks like a mountain.)

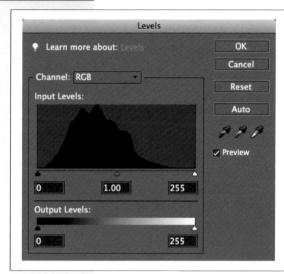

Figure 7-10:

One of the scariest sights in Elements, the Levels dialog box is actually your friend. If it frightens you, take comfort in knowing that you've always got the Auto button here, which is the same Auto Levels command as in Quick Fix (page 108). But it's worth persevering: The other options here give you much better control over the end results.

From left to right, the Histogram shows the brightness range from dark to light (the 0 to 255 mentioned earlier). The height of the "mountain" at any given point shows how many pixels in your photo are that particular brightness. You can tell a lot about your photo by where the mound of color is before you adjust it, as shown in Figure 7-11.

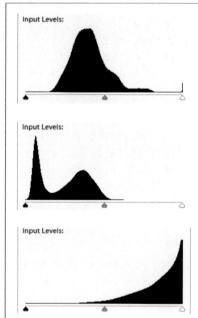

Figure 7-11:

Top: If the bars in your Histogram are all smushed together, your photo doesn't have a lot of tonal range. As long as you like how the photo looks, that's not important. But if you're unhappy with the color in the photo, it'll probably be harder to get it exactly right compared to a photo that has a wider tonal distribution.

Middle: If all your colors are bunched up on the left side, your photo is underexposed.

Bottom: If you just have a big lump on the right side, your photo is overexposed.

Above the Histogram is the Channel menu, which is set to RGB. If you pull that down, you can select a color to see a separate Histogram for that color. You can adjust all three channels at once with the RGB setting, or change each channel separately for maximum control.

The Histogram contains so much info about your photo that Adobe gave it its own panel (Figure 7-12) so you can always see it and use it to monitor how you're changing the colors in an image. Once you get fluent in reading Histogramese, you'll probably want to keep this panel around.

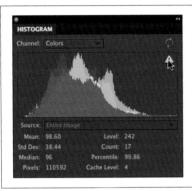

Figure 7-12:
If you keep the Histogram on your desktop, you can always see what effect your changes are having on your photo's color distribution. To get this nifty Technicolor view, go to Window → Histogram and then choose Colors from the panel's Channel menu. To update a Histogram, click the upper-right triangle as shown here. If you're really into statistical information, there's a bunch of it at the bottom of this panel, but unless you're pro, you can safely ignore these numbers

The Histogram is just a graph, and you don't do anything to it directly. What you do when you use Levels is use the Histogram as a guide so you can tell Elements what to consider as the black and white points—that is, the darkest and lightest points—in your photo. (Remember, you're thinking in terms of brightness values, not shades of color, for these settings.)

Once you've set the end points, you can adjust the *midtones*—the tones that would appear gray in a black-and-white photo. If that seems complicated, it's not—at least, not when you're actually doing it. Once you've made a Levels adjustment, the next time you open the Levels dialog box, you'll see that your Histogram now runs the entire length of the scale because you've told Elements to redistribute your colors so that they cover the full dark-to-light range.

The next two sections show you—finally!—how to actually adjust your image's Levels.

TIP Once you learn how to interpret Histograms in Elements, you can try your hand with your camera's histogram (if it has one). It's hard to judge how well your picture turned out when all you have to go by is your camera's tiny LCD screen, so the histogram can be a big help. Your camera's histogram can tell you how well exposed your shot was.

Adjusting Levels: The Eyedropper Method

One way to adjust Levels is to set an image's black, white, and/or gray points by using the eyedroppers on the right side of the Levels dialog box. It's quite simple—just follow these steps:

1. Bring up the Levels Adjustments panel by selecting Layer → New Adjustment Layer → Levels.

If you don't want a separate layer for your Levels adjustment, go to Enhance \rightarrow Adjust Lighting \rightarrow Levels or press \Re -L instead. You'll get a dialog box instead of the panel, but it works exactly the same way. But making the Levels changes on an Adjustment layer gives you more flexibility for making changes in the future.

2. If necessary, move the Adjustments panel or the Levels dialog box out of the way so that you get a good view of your photo.

The dialog box loves to plunk itself in the middle of the most important part of your image. Grab it by the top bar and drag it to where it's not covering up a crucial part of your photo.

3. In the Levels Adjustments panel or the dialog box, click the black eyedropper.

In the Adjustments panel, from top to bottom, the eyedroppers are black, gray, and white. In the dialog box, they're the same, but arranged from left to right.

4. Move your cursor over your photo and click an area that should be black.

Should be, not is. That's a mistake lots of people make the first time they use the Levels eyedroppers: They click a spot that's the same color as the eyedropper rather than one that ought to be that color. For instance, if your photo includes a wood carving that looks black but you know it's dark brown, that's a bad place to click. Try clicking a black coffee mug or belt, instead. This is called "setting a black point."

5. Repeat with the other eyedroppers for their respective colors.

Now find a white point and a gray point. That's the way it's supposed to work, but it's not always possible to use all of the eyedroppers in any one photo. Experiment to see what gives you the best-looking results.

NOTE You don't always need to set a gray point. If you try to set it and think your photo looked better without it, skip that step.

6. If you're using the dialog box, click OK when you're happy with the results.

With the Adjustments panel you don't have to do anything—Elements automatically applies your changes.

See, it's not so hard. If you mess up, click the Reset button and start over. (If you're working with the Adjustments panel, click the square made of four horizontal lines in the panel's upper right corner and choose Reset from the pop-out menu.)

Adjusting Levels: The Slider Method

The eyedropper method works fine if your photo has spots that should be black, white, or gray, but a lot of the time, your pictures don't have any of these colors. Fortunately, the Levels sliders give you yet another way to apply Levels, and it's the most popular method because it gives you maximum control over your colors.

FREQUENTLY ASKED QUESTION

Levels Before Curves

I never know where to start adjusting the colors in my photos. Some photo mavens talk to me about using Levels, others about Curves. Which should I use?

Elements includes a much-requested feature from Photoshop—*Color Curves*. Despite the name, the Curves tool isn't some kind of arc-drawing tool. It's a sophisticated method of adjusting the color in your photos. Curves works something like Levels, but with many more points of correction. Elements has a simplified version of Photoshop's Curves dialog box, with a few preset settings. Because the Elements version doesn't have as many adjustment points, you get much of the advanced control of Curves without the complexity.

A quick Levels adjustment is usually all you need to achieve realistic color. If you still aren't satisfied with the contrast in your image, or you want to create funky artistic effects, check out Color Curves (page 282).

In the Levels dialog box directly under the Histogram are three little triangles called *Input sliders*. The left triangle is the slider for setting the black point in your photo, the right slider sets the white point, and the middle slider adjusts your midtones (gray). You can drag them to make changes to the color levels in your photo, as shown in Figure 7-13.

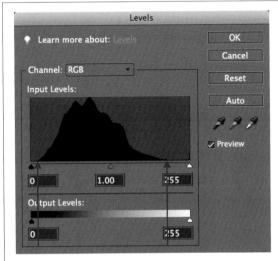

Figure 7-13:

Here's how to use the Levels sliders. Move the left and right sliders from the ends of the track until they're under the outer edges of the color data in the graph. If there's empty space on the end, move the slider until it's under the first mound of data. The red arrows in this figure show where you'd position the left and right sliders for this photo.

When you move the left Input slider, you tell Levels, "Take all the pixels from this point down and consider them black." With the right slider, you're saying, "Make this pixel and all higher values white." The middle slider, the midtones slider, adjusts the brightness values that are considered medium gray. All three adjustments improve the contrast of your image.

NOTE If there are small amounts of color data, like a flat line at the ends or if all your data is bunched in the middle of the graph, watch the photo as you move the left and right sliders to decide how far toward the mountain to bring them. Moving them all the way in may be too drastic. Your own taste should always be the deciding factor when you're adjusting a photo.

Here's the easiest way to use the Levels sliders:

1. Bring up the Levels dialog box or the Levels Adjustments panel.

Use one of the methods described in step 1 of the eyedropper method (page 210). If necessary, move the dialog box or panel so you have a clear view of your photo.

2. Grab the black Input slider and slide it to the right, if necessary.

This is the slider below the left end of the Histogram. Move it until it's under the leftmost part of the Histogram that contains a mound of data. In Figure 7-13, you'd move the left slider to where the left red arrow is. (Incidentally, although you're adjusting the colors in your image, the Levels Histogram stays black and white no matter what you do—you won't see any color in the dialog box itself.)

You may not need to move this slider at all if there's already a good bit of data at the end of the Histogram. It's not mandatory to adjust all the sliders for every photo.

3. Grab the white slider (the one on the right side) and move it left, if necessary.

Bring it under the rightmost area of the Histogram that contains a mound of data.

4. Now adjust the gray slider.

This is called the *midtones* slider because it adjusts your photo's midtones. Move it back and forth while watching your photo until you like what you see. This slider has the most impact on the overall result, so take time to play with it.

5. If you're using the dialog box, click OK.

You can adjust your entire image or each color channel individually. The most accurate way is to first choose each color channel separately from the Channel drop-down menu in the Levels dialog box. Adjust the end points for each channel, and then go back to RGB and tweak just the midtones (gray) slider.

TIP If you know the numerical value of the pixels you want to designate for any of these settings, you can type that info into the Input Levels boxes below the Histogram. You can set the gray value from .10 to 9.99 (it's set at 1.00 automatically). You can set the other boxes anywhere from 0 to 255.

The last control you may want to use in the Levels dialog box is the Output Levels slider. Output Levels work kind of like the brightness and contrast controls on your TV. Moving these sliders makes the darkest pixels darker and the lightest pixels lighter. Image pros call this adjusting the tonal range of a photo.

Adjusting Levels can improve almost every photo you take, but if your photo has a bad *color cast*—it's too orange or too blue—you may need something else. The next section shows you how to get rid of color like that.

Removing Unwanted Color

It's not uncommon for an otherwise good photo to have a *color cast*—that is, to have all the tonal values shifted so that the photo is too blue, as in Figure 7-14, or too orange.

Figure 7-14:
Left: Sometimes you may wind up with a photo like this one if you forget to change the white balance—your camera's setting for the type of light you're shooting in (common settings are daylight, fluorescent, and so on). This is an outdoor photo taken with the camera set for tungsten indoor lighting.

Right: Elements fixes that wicked color cast in a jiffy. The photo still needs other adjustments, but the color is back in the ballpark.

Elements gives you several ways to correct color cast problems:

- Auto Color Correction doesn't give you any control over the changes, but it often does a good job. To use it, go to Enhance → Auto Color Correction or press **%**-Shift-B.
- The Raw Converter may be the easiest way to fix problems, but it works only on Raw, JPEG, and TIFF files. Just run your photo through the Raw converter (page 232) and adjust its white balance there.

- Levels gives you the finest control of all. You can often eliminate a color cast by adjusting the individual color channels (as explained in the previous section) till the extra color is gone. The drawbacks are that Levels can be very fiddly for this sort of work, sometimes this method doesn't work if the problem is severe, and it can take much longer than the other methods.
- Remove Color Cast is a command specially designed for correcting a color cast with one click. The next section explains how to use it.
- The Color Variations dialog box is helpful in figuring out which colors you need more or less of, but it has some limitations (see page 215).
- The Photo Filter command gives you much more control than the Remove Color Cast command, and you can apply Photo Filters as Adjustment layers, too. Photo Filters are covered on page 256.
- The Average Blur Filter, used with a blend mode, also lets you fix color casts. As you'll read on page 394, it's something like creating a custom photo filter.
- Adjust Color for Skin Tone makes Elements adjust your photo based on the skin colors in the image. In practice, this adjustment is often more likely to introduce a color cast than to correct one, but if your photo has a slight bluish cast that's visible in the subject's skin (as explained on page 117), it may do the trick. This command works best for slight, annoying casts that are too subtle for the other methods in this list.

All these tools are useful for fixing color casts, depending on the problem. Usually you'd start with Levels and then move on to the Remove Color Cast command or the Photo Filter command. (To practice any of the fixes you're about to learn, download the photo *doorway.jpg* from the Missing CD page at www. missingmanuals.com.)

The Remove Color Cast Command

This command uses an eyedropper to adjust the colors in your photo based on the pixels you click. With this method, you show Elements where a neutral color should be. As you saw in Figure 7-14, Remove Color Cast can make a big difference with just one click. To use it:

1. Go to Enhance \rightarrow Adjust Color \rightarrow Remove Color Cast.

Your cursor should change to an eyedropper when you move it over your photo. If it doesn't, go to the dialog box and click the eyedropper icon.

2. Click an area that should be gray, white, or black.

You only have to click once in your photo for this tool to work. As with the Levels eyedropper tool, click an area that *should be* gray, white, or black (as opposed to looking for an area that's currently one of these colors). If your image has several of these colors, try different spots in the photo, clicking Reset between each sample, until you find the spot that gives you the most natural-looking color.

3. Click OK.

Remove Color Cast works nicely if your image has areas that should be black, white, or gray, even if they're tiny. It's not as effective when you have an image that doesn't have a good area to sample—when there isn't any black, white, or gray anywhere in the picture. In that case, consider using the Photo Filter command (page 256) instead.

TIP If you generally like what Auto Levels does for your photos but feel like it leaves behind a slight color cast, a click with Remove Color Cast may be the right finishing touch.

Using Color Variations

The Color Variations dialog box (Figure 7-15) appeals to many Elements beginners because it gives visual clues about how to fix the color in your photo. Click the preview thumbnail that shows the color balance you like best, and Elements applies the necessary change to make your photo look like that thumbnail.

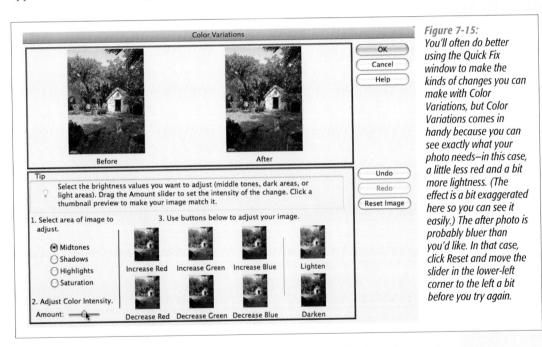

But Color Variations has some serious limitations, most notably the microscopic size of the thumbnails. So it's hard to see what you're doing, and even newcomers can usually get better results in Quick Fix (page 99).

Still, Color Variations is useful when you know something isn't right with your photo's color but you can't figure out what to do about it. And because it's adjustable, Color Variations is good for when you want to make only a tiny change to your photo's color. To use the Color Variations tool:

1. Open a photo.

You may want to make a duplicate layer (page 163) for the adjustments so you'll have the option of discarding your changes if you're not happy with them. If you don't work on a duplicate, keep in mind that you won't be able to undo these changes after you close the file.

2. Go to Enhance \rightarrow Adjust Color \rightarrow Color Variations.

You see the dialog box pictured in Figure 7-15.

3. Under "Select area of image to adjust", click a radio button to choose whether to adjust midtones, shadows, highlights, or saturation.

Elements automatically selects midtones, which is usually what you want. But experiment with the other settings. The Saturation button works just like Saturation in Quick Fix (page 111).

4. Use the slider at the bottom of the dialog box to control how drastic the adjustment should be.

The farther right you drag the slider, the more dramatic the change. Usually, a smidgen is enough to make a noticeable difference.

5. Just below where it says "Use buttons below to adjust your image", click one of the thumbnails to make your photo look more like it.

You can always Undo or Redo using the buttons on the right side of the window, or click Reset Image to put your photo back to where it was when you started.

6. When you're happy with the result, click OK.

Choosing Colors

The color corrections you've read about earlier in this chapter do most of the color assigning for you. But you often want to *tell* Elements what colors to work with—like when you're selecting the color for a Background or Fill layer (page 181), or when you want to paint on an image.

Although you can use any of the millions of colors your screen can display, Elements loads only two colors at a time. You choose these colors using the Foreground and Background color squares at the bottom of the Tools panel (see Figure 7-16).

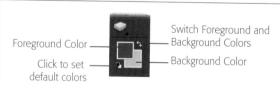

Figure 7-16:

The top square (purple) is the Foreground color; the bottom one is the Background color. To quickly reset them to black and white, respectively, either click the two tiny squares at the bottom left or press D. Click the curved, double-headed arrows or press X to swap the Foreground and Background colors.

Foreground and Background mean just what they sound like—use the Background color to fill in backgrounds, and the Foreground color with tools like the Brush or Paint Bucket. You can use as many colors as you want, of course, but you can only use two at any given time. The color-picking tools at the bottom of the Tools panel let you control the color you're using in a number of ways:

- Reset default colors. Click the black and white squares to return to the standard settings of black for the Foreground color and white for the Background color.
- Switch Foreground and Background colors. Click the curved arrows above and
 to the right of the squares, and your Background color becomes the Foreground color, and vice versa. This is helpful when you've inadvertently made
 your color selection in the wrong box. (For example, if you've set the Foreground color to yellow, but you actually meant to make the Background color
 yellow.)
- Change either the Foreground or Background color. You can choose any color you like for either color square. Click either square to call up the Color Picker (explained in the next section) to make your new choice. There's no limit on the colors you can select. (Well, technically there is, but it's in the millions, so you should find enough choices for anything you want to do.)

You can select your Foreground and Background colors in several ways. The next few sections show you how to use the Color Picker, the Eyedropper tool (to pick a color from an existing image), or the Color Swatches panel.

When working with some of the Elements tools, like the Type tool, you can choose a color in the tool's Options bar settings. Most people prefer to work with either Color Swatches or the Color Picker, so Adobe came up with a clever way to accommodate both camps, as shown in Figure 7-17.

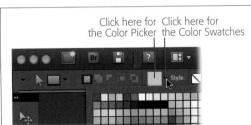

Figure 7-17:

Whether you prefer using Color Swatches or the Color Picker, you can choose your favorite (for most tools) in the Options bar. Click the color sample in the box to bring up the Color Picker, or, if you're a Swatcher, click the arrow to the right of the box to reveal the Color Swatches panel.

The Color Picker

Figure 7-18 shows the Color Picker. It has an intimidating number of options, but, most of the time, you don't need them all. Picking a color is as easy as clicking the color you want.

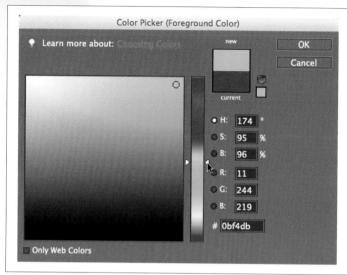

Figure 7-18:
For most beginners, the most important parts of Elements Color Picker are the vertical rectangular slider in the middle (called, appropriately enough, the Color Slider), and the big square box, called the Color Field. Use the slider to get the general color you want, and then click in the field to pick the exact shade.

The Color Picker is easy to use:

1. Click the Foreground or Background color square in the Tools panel.

Elements launches the Color Picker. Some tools—like the Paint Bucket (page 357) and the Selection brush's mask color option (page 134)—also use the Color Picker. It works the same way no matter how you get to it.

2. Choose the color range you want to select from.

Use the vertical Color Slider in the middle of the Color Picker to slide through the spectrum until you see the color you want in the big, square Color Field.

3. In the Color Field, click the shade you want.

You can click around and watch the color in the top box in the window change to reflect what you click. The bottom box shows your original color for comparison.

4. Click OK.

The color you selected now appears in the Foreground or Background square in the Tools panel (depending on which one you clicked in step 1).

That's the basic way to use the Color Picker. The box on page 221 explains how to enter a numeric value for your color if you know it, or to change the shades the Color Picker offers.

TIP You don't have to use Elements' Color Picker—you can use Mac OS X's color picker instead. To change color pickers, go to Photoshop Elements → Preferences → General and select Apple from the Color Picker menu at the top of the dialog box. You might prefer Apple's color picker if you like to choose colors from a color wheel. There's even a fun view where you choose colors from a box of crayons. You can save colors in Apple's color picker by dragging them from the color field at the top of the window into the squares at the bottom. Then click a square to choose that color the next time you want it.

The Eyedropper Tool

If you've ever repainted your house, you've probably had the frustrating experience of spotting the *exact* color you want somewhere—without a way to capture that color. That's one problem you'll never run into in Elements, thanks to the handy Eyedropper tool that lets you sample any color you see on your monitor and make it your Foreground color in Elements. If you can get a color onto your computer, Elements can grab it.

Sampling a color (that is, snagging it for your own use) with the Eyedropper couldn't be simpler. Just put your cursor over the color you want and click. It even works on colors that aren't even in Elements, as explained in Figure 7-19. Sampling is perfect for projects like scrapbook pages, where you might want to use, say, the color from an event program cover as a theme color for the project. In this case, you could scan the program and then sample the color with the Eyedropper.

Figure 7-19:
To use the Eyedropper tool to sample colors outside of Elements, start by clicking anywhere in your Elements file. Then, while still holding your mouse button down, move your cursor over to the non-Elements object (a web page, for instance), until the eyedropper is over the color you want to sample. Then let go of the mouse, and the new color appears in Elements' Foreground color square. If you let go before you get to the non-Elements object, this trick won't work. Here, the Eyedropper (circled) is sampling the teal color from a photo that's open in Preview. If you don't have a big monitor, it can take a bit of maneuvering to get the program windows positioned so that

vou can perform this procedure.

By now, you may think that Elements has more eyedroppers than your medicine cabinet. But this is the *official* Eyedropper tool that has its own place in the Tools panel. It's one of the easiest tools to use:

1. Click the Eyedropper in the Tools panel or press I.

Your cursor changes into an eyedropper.

2. Move the Eyedropper over the color you want to sample.

If you want to watch the color change in the Foreground color box as you move the Eyedropper, hold down the mouse button as you go.

3. Click when you see the color you want.

Elements loads your color choice as your Foreground color so it's ready to use. (To set the Background color instead, Option-click the color you want.)

To keep your color sample around so you can use it later without having to get the Eyedropper out again, you can save it in the Swatches panel, where you can quickly choose it again any time you want. The next section teaches you how to do this.

TIP Since there may be some slight pixel-to-pixel variation in a colored area, you can set the Eyedropper to sample a small block of pixels and average them. In the Eyedropper's Sample Size setting in the Options bar, you can choose between the exact pixel you click (Point Sample), a 3-pixel square average, or a 5-pixel square average. Oddly enough, this setting also applies to the Magic Wand (page 135)—change it here and you change it for the Wand, too.

The Color Swatches Panel

The Color Swatches panel holds several preloaded libraries of colors for you to choose from. Go to Window → Color Swatches to call up this panel. You can park it in the Panel bin just like any other panel or leave it floating on your desktop. When you're ready to choose a color, click the swatch you want, and it appears in the Foreground color square or the color box of the tool you're using.

The Color Swatches panel is handy when you want to keep certain colors at your fingertips. For instance, you can put your logo colors into it to keep those colors available for any graphics or ads you create in Elements.

Elements starts you with several different libraries (groups) of color swatches. Click the pull-down menu on the Swatches panel to see them all. Any swatches you create appear at the bottom of the current library, and you can save them there or create your own swatch libraries.

Using the Color Swatches panel to select your Foreground or Background color is as easy as using the Eyedropper tool. Figure 7-20 shows you how.

Figure 7-20:

When you move your cursor over the Color Swatches panel, it changes to an eyedropper. Simply click to select a color. If you're using a preloaded color library, you'll see labels appear as you move over each square.

POWER USERS' CLINIC

Paint by Number

The Elements Color Picker includes some sophisticated controls that most folks can ignore. For the curious or more advanced, here's what the rest of the Color Picker does:

- H, S, and B fields. These numbers determine the hue, saturation, and brightness of your color, respectively. They control pretty much the same values as the Hue/Saturation adjustment. (See page 285 for more about hue and saturation.)
- R, G, and B fields. These fields let you specify the amount of red, green, and blue you want in the color you're picking. Each one can have a numerical value anywhere from 0 to 255. A lower number means less of the color, a higher number means more. For example, 128 R, 128 G, 128 B is neutral gray. By changing the numbers, you change the blend of the color.
- # (Hex number). Below the radio buttons is a box that lets you enter a special six-character hexadecimal code that you can use when you're creating web graphics. These codes tell web browsers which colors to display. You can also click a color in the window to see the hex number for that shade.
- Only Web Colors checkbox. Turning on this box ensures that the colors you see in the main color box are drawn only from the 216 colors that antique web browsers can display. For example, if you're creating a website and you're worried about color compatibility with Netscape 4.0, this box is for you. If you see a tiny cube just to the right of the color sample box (as shown earlier in Figure 7-18), the color you're using isn't deemed web-safe.

To use the Color Swatches panel:

- To pick a Foreground color, just click the color you want.
- To pick a Background color, \\$-click a color instead.

You can also change the way the Color Swatches panel displays swatch info, as Figure 7-21 explains.

Figure 7-21:

Click the upper-right button on the Color Swatches panel (the square made of four lines) and choose Small List and, depending on the library you're using, you can see the names or hex numbers for each color as well as a thumbnail of the color. Some Elements tools, like the Type tools, bring up these choices via an Options button below the swatch samples.

Saving colors in the Swatches panel

You can save any colors you've picked with the Color Picker or Eyedropper tool as swatches in any of these ways:

- Move your cursor over an empty area in the Color Swatches panel, and click when the cursor turns into a paint bucket. This is the simplest method.
- Click the New Swatch icon at the bottom-right of the Color Swatches panel. (It looks just like the Layers panel's New Layer button.)
- Click the little square with lines on it in the panel's upper-right corner and choose New Swatch.

Regardless of which method you use, you'll get a chance to name the new swatch before you save it. (Just save the swatch where Elements suggests so Elements recognizes it as a swatch.) The name appears as a pop-up label when you hover your cursor over the swatch in the panel. Elements puts your new swatch at the bottom of the current swatch library. To delete a swatch that you've saved, drag it to the Color Swatches panel's trashcan icon, or Option-Click the swatch.

If you want to keep your swatches separate from the ones Elements gives you, you can create your own swatch library. To do that, click the Color Swatches panel's upper-right button and pick Save Swatches. Then give your new library a name and save it.

NOTE When you save a new swatch library, it doesn't show up in the list of libraries until the next time you start Elements.

Sharpening Images

Digital cameras are wonderful, but often it's hard to tell how well-focused your photos are until you download them to your computer. And because of the way cameras' digital sensors process information, most digital image data needs to be *sharpened*. Sharpening is an image-editing trick that makes your pictures look more focused.

Elements includes some almost miraculous tools for sharpening your images. (It's pretty darned good at blurring them, too, if you want; see page 392.)

NOTE If you've used early versions of Elements, you may be searching the Filter menu in vain for the Sharpen filters. It's true—your old friends Sharpen and Sharpen More are gone. In their place, Adjust Sharpness appears at the bottom of the Enhance menu, along with Unsharp Mask. (Both of these features are explained in the following sections.) If you miss the one-click ease of Sharpen and Sharpen More, head over to Quick Fix and use its Auto Sharpen button (page 112) to get the same effect, or go to Enhance → Auto Sharpen.

Unsharp Mask

Although it sounds like the last thing you'd ever want to do to a photo, Unsharp Mask reigned as the Supreme Sharpener for many generations of image correction, despite the fact that it has the most counterintuitive name in all of Elements.

To be fair, it's not Adobe's fault. *Unsharp Mask* is an old darkroom term, and makes sense if you know how our film ancestors used to improve a picture's focus. (Its name refers to a complicated darkroom technique that involved making a blurred copy of the photo at one point in the process.)

For several versions of Elements, Unsharp Mask ranked right up there with Levels as a contender for the most useful tool in Elements, and some people still think it's the best way to sharpen a photo. Figure 7-22 shows how much a little Unsharp Mask can do for your photos.

Figure 7-22: Left: The photo as it came from the camera.

Right: The same photo treated with a dose of Unsharp Mask. Notice how much clearer the individual hairs in the dog's coat are and how much better defined the eyes and mouth are.

To use Unsharp Mask, first finish all your other corrections and changes. Unsharp Mask (or any sharpening tool) can undermine other adjustments you make later on, so always make sharpening your last step. A good rule to remember when sharpening is "last and once," as repeatedly applying sharpening can degrade your image's quality.

NOTE An exception to the rule about sharpening only once is when you're converting Raw images (page 245). You can usually sharpen both in the Raw Converter and then again as a last step without causing problems.

If you're sharpening an image with layers, be sure the active layer has something in it. Applying sharpening to a Levels Adjustment layer, for example, won't do anything. Also, perform any format conversions (page 63) before applying sharpening. Finally, you may want to sharpen a duplicate layer in case you want to undo your changes later on. Press **%**-J to create the duplicate layer.

NOTE It's helpful to understand exactly what Elements does when it "sharpens" your photo. It doesn't magically correct the focus. As a matter of fact, it doesn't really sharpen anything. What it does is increase the contrast where colors meet, giving the *impression* of a crisper focus. So while Elements can dramatically improve a shot that's faintly out of focus or a little soft, it can't fix that double exposure or a shot where the subject is a blur.

When you're ready to apply Unsharp Mask:

1. Go to Enhance → Unsharp Mask.

You can use Unsharp Mask in either Full Edit or the Quick Fix window.

2. Adjust the settings in the Unsharp Mask dialog box until you like what you see.

Move the sliders until you're happy with the sharpness of your photo. Your adjustment options are explained in the following list. In the Preview window, you can zoom in and out and grab the photo to adjust which part you see. It's also a good idea to drag the dialog box off to the side so that you can watch your actual image for a more global view of the changes you're making. Incidentally, you get the most accurate look at how you're affecting the image if you set the view to 100% (or Actual Pixels—see page 86).

3. When you're satisfied, click OK.

The Unsharp Mask sliders work much like other tools' sliders:

- Amount tells Elements how much to sharpen, in percent terms. A higher number means more sharpening.
- Radius lets Elements know how far from an edge it should look when increasing the contrast.
- Threshold is how different a pixel needs to be from the surrounding pixels before Elements considers it an edge and sharpens it. If you leave this slider at zero—the standard setting—Elements sharpens all the pixels in the image.

There are many, many different schools of thought about where to move the sliders or which values to plug into each box. Whatever works for you is fine. The one thing you want to watch out for is *oversharpening*, which is explained in Figure 7-23.

You'll probably need to experiment to find out which settings work best for you. Photos you want to print usually need to be sharpened to an extent that makes them look oversharpened on your monitor. So you may want to create separate versions of your photo (one for onscreen viewing and one for printing).

Figure 7-23:
The perils of
oversharpening. This is just
a normal pumpkin, not a
diseased one, but
oversharpening gives it a
flaky appearance and
makes the straw in the
background look sketched
in rather than real. The
presence of halos (as you
see along the edge of the
pumpkin) is often your best
clue that you've
oversharpened an image.

Adjust Sharpness

Unsharp Mask has been around since long before digital imaging. A lot of people (including the folks at Adobe) thought that, in the computer age, there must be a better way to sharpen, and now there is. The latest tool in the war on poor focus is Adjust Sharpness.

The Unsharp Mask tool helps boost a photo's sharpness by a process that's similar to reducing Gaussian blur (page 392). Problem is, Gaussian blurring is rarely the cause of your picture's poor focus, so there's only so much Unsharp Mask can fix. In real life, blurry photos are usually caused by one of two things:

- Lens blur. Your camera's prime focal point isn't directly over your subject. Or perhaps your lens isn't quite as sharp as you'd like it to be.
- Motion blur. You moved the camera—or your subject moved—when you took the picture.

Adjust Sharpness is as easy to use as Unsharp Mask, and it gives you settings to correct all three kinds of blur—Gaussian, lens, and motion. When you first open the Adjust Sharpness dialog box, its settings are almost identical to Unsharp Mask. It's the *extra* things Adjust Sharpness can do that make it a more versatile tool. Here's how to use it:

1. Make sure the layer you want to sharpen is the active layer.

See Chapter 6 if you need a refresher on layers.

2. Go to Enhance → Adjust Sharpness.

You can reach this menu item from either Full Edit or Quick Fix.

3. Make your adjustments in the Adjust Sharpness dialog box.

As shown in Figure 7-24, the dialog box gives you a nice big preview. It's usually best to stick to 50 or 100 percent zoom (use the plus and minus buttons below the preview) for the most accurate view. The settings are explained in detail in the list below.

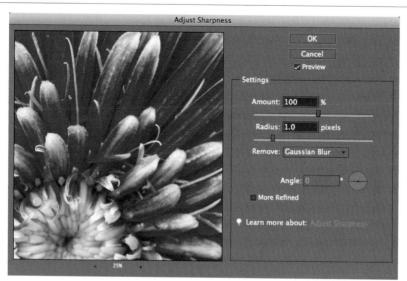

Figure 7-24:
The Adjust Sharpness dialog box shows you a good-sized preview of your image. But it helps if you position the dialog box so you can see the main image window as well. That way you can keep an eye on any changes happening in areas outside the preview's frame.

4. When you like the way your photo looks, click OK.

The first two settings in the Adjust Sharpness dialog box, Amount and Radius, work exactly the same way they do in Unsharp Mask (page 224). Adjust Sharpness also has a few additional settings:

- Remove. Here's where you choose what kind of fuzziness to fix: Gaussian, lens, or motion blur. If you aren't sure which you want, try all three and see which best suits your photo.
- Angle. In a motion blur, you can improve your results by telling Elements the angle of the motion. For example, if your grip on the camera slipped, the direction of motion would be downward. Move the line in the little circle or type a number in degrees to approximate the angle. (It's tricky to get the angle exactly right, so you may find it easier to sharpen without messing with this setting.)
- More Refined. Turn this checkbox on, and Elements takes a tad longer to apply sharpening since it sharpens more details. Generally you'll want to leave this setting off for photos with lots of details, like leaves or fur (and people's faces,

unless you like to look at pores). But you might want it on for bold desert landscapes, for example, or other subjects without lots of small parts. Noise, artifacts (strange spotty areas or white flakes, like the ones shown Figure 7-23), and dust become more prominent when you turn this setting on, since they get sharpened along with the details of your photo. Experiment, and watch the main image window as well as the preview, to see how it's affecting your photo.

NOTE Although Amount and Radius mean the same things as they do in Unsharp Mask, don't assume that you can just plug your favorite Unsharp Mask settings into Adjust Sharpness and get the same results. Don't be surprised if you prefer very different numbers in these settings for this tool.

Many people who've used Smart Sharpening in the full-featured Photoshop swear they'll never go back to Unsharp Mask. Try out Adjust Sharpness—the Elements version of Smart Sharpening—and see if you agree. To give you an idea of the difference between the two methods, Figure 7-25 shows the dog from Figure 7-22 with a dose of Adjust Sharpness applied instead of Unsharp Mask.

The High-Pass Filter

Unsharp Mask is the traditional favorite, and Adjust Sharpness is the latest thing in sharpening, but there's an alternative method that many people prefer because you do it on a dedicated layer and can back off the effect later by adjusting the layer's opacity. Moreover, you can use this method to punch up the colors in your photo as you sharpen. It's called *high-pass sharpening*. All sharpening methods have their virtues, and you may find that you choose your technique according to the content of your photo. Try the following process out for yourself by downloading *waterlillies.jpg* from the Missing CD page at *www.missingmanuals.com*:

- 1. Open your photo and make sure the layer you want to sharpen is the active layer.
- 2. Duplicate the layer by pressing **%**-J.

If you have a multi-layered image and you want to sharpen all the layers, first flatten your image or use the Stamp Visible command (see the box on page 178) so everything is in one layer.

3. Go to Filter → Other → High Pass.

Your photo now looks like the victim of a mudslide, buried in featureless gray. That's what you want for right now.

4. In the High Pass dialog box, move the slider until you can barely see the outline of your subject.

Usually that means picking a setting roughly between 1.5 and 3.5. If you can see colors, your setting is too high. If you can't quite eliminate every trace of color without totally losing the outline, a tiny bit of color is OK. Keep in mind that the edges that show through the gray are the ones that you'll be sharpening the most. Use that as your guide to how much detail to include.

Figure 7-25:
Here's the terrier from page 223, only this time he was sharpened using Adjust Sharpness. Notice how much more each hair in his coat stands out, and how much more detail you can see in his nose and mouth.

5. Click OK.

6. In the Layers panel, set the blend mode for the new layer to Overlay.

Ta-da! Your subject is back again in glowing, sharper color, as shown in Figure 7-26.

TIP There's yet another way to create "pop" in your photos: the Clarity setting in the Raw Converter (page 264), which sharpens and enhances contrast at the same time. (If you know what "local contrast enhancement" means, this setting does something similar.) You can use it on Raw, JPEG, and TIFF files. It's especially useful for clearing haze from your shots.

Figure 7-26: Top: The original photo.

Bottom: Here's what you get if you high-pass sharpen with the Overlay blend mode, which gives you a nice, soft effect. If you choose Vivid Light for your blend mode, it makes the colors more vivid, but the ripples turn out harderedged than in the original. Vivid Light can make your colors pop, but it may also introduce sharpening artifacts, since they'll be more vivid, too. For highpass sharpening, you can use any of the blend modes in the group with Overlay except Hard Mix and Pin Light.

The Sharpen Tool

Elements also gives you a dedicated Sharpen tool, a special brush that sharpens instead of adding color to the areas you drag it over; Figure 7-27 shows it in action. To get to it, go to the Blur tool or press R, and choose the Sharpen tool from the Tools panel's pop-out menu.

The Sharpen tool has some of the same Options bar settings as the Brush tool (see page 347 for more about brush settings). It also has a couple of settings of its own:

• Mode lets you increase the visibility of an object's edge by choosing from several different blend modes, but Normal (the standard setting) usually gives the most predictable results.

Figure 7-27:

The Sharpen tool isn't meant to sharpen an entire photo, but it's great for sharpening details, like eyes and lips in a portrait where you don't want to sharpen the skin details. Here, it's used to touch up the detail in the middle statue. (The red arrow helps you find the cursor.) Approach this tool with caution: It's easy to overdo things with it. One pass too many or with a too-high setting, and you start seeing artifacts right away.

- Strength controls how much the brush sharpens what it passes over. A higher number means more sharpening.
- Sample All Layers makes the Sharpen tool work on all the visible layers in your image. Leave it off if you want to sharpen only the active layer.

Elements for Digital Photographers

If you're a fairly serious digital photographer, you'll be delighted to know that Adobe hasn't just loaded Elements with easy-to-use features aimed at beginners. The program also has a collection of pretty advanced tools pulled straight from the full-featured Photoshop.

Number one on the list is the Adobe Camera Raw Converter, which takes Raw files—a format some cameras use to give you maximum editing control—and lets you convert and edit them in Elements. In this chapter, you'll learn lots more about Raw and why you may (or may not) want to use it. Don't skip to the next chapter if your camera shoots only JPEGs, though: You can use the Raw Converter to edit JPEGs and TIFFs, too, which can come in handy, as you'll see shortly.

NOTE Whereas JPEG and TIFF are acronyms for technical photographic terms, the word Raw—which you may occasionally see in all caps (RAW)—actually refers to the pristine, unprocessed quality of these files.

You'll also get to know the Photo Filter command, which helps adjust image colors by replicating the old-school effect of placing filters over a camera's lens. And Elements includes some useful batch-processing tools, including features that help you rename files, perform format conversions, and even apply basic retouching to multiple photos.

The big news for digital photographers is the new Exposure Merge feature, which lets you combine different versions of your photo to create a single image with a higher dynamic range (a wider range of correctly exposed areas) than you can get from a single shot. Read on to learn all about it.

The Raw Converter

Probably the most useful thing Adobe has done for photography buffs is to include the Adobe Camera Raw Converter in Elements. For many people, this feature alone is worth the price of the program, since you just can't beat the convenience of being able to perform conversions in the same program you use for editing.

NOTE This chapter covers the Raw Converter as you see it when you open it in Elements. However, serious photographers may prefer to do their Raw editing from Bridge, for the reasons explained in the box on page 235.

If you don't know what Raw is, it's just a file format (a group of formats, really, since every camera maker has its own Raw format with its own file extension). But it's a very special one. Your digital camera actually contains a little computer that does a certain amount of processing to your photos right inside the camera itself. If you shoot in JPEG format, for instance, your camera makes some decisions about things like sharpness, color saturation, and contrast before it saves the JPEG files to your memory card.

But if your camera lets you shoot Raw files, you get the unprocessed data straight from the camera. Shooting in Raw lets you make your *own* decisions about how your photos should look, to a much greater degree than with any other format. It's something like getting a negative from your digital camera—what you do to it in your digital darkroom is up to you.

That's Raw's big advantage: total control. The downside is that every camera manufacturer has its own proprietary Raw format, and the format varies even among models from the same manufacturer. No regular graphics program can edit these files, and very few programs can even view them. Instead, you need special software to convert your Raw files to a format you can work with. In the past, you usually needed software from the manufacturer before you could move your photo into an editing program like Elements.

Enter the Adobe Camera Raw Converter, which lets you convert your files right in Elements. Not only that, but the Adobe Camera Raw plug-in that comes with Elements lets you make sophisticated corrections to your photos before you even *open* them. You can often do everything you need right in the Converter, so that you're done as soon as you open your converted file. (You can, of course, still use any of Elements' regular tools once you've opened a Raw file.) Using the Raw Converter saves you a ton of time, and it's compatible with most cameras' Raw files.

TIP Adobe regularly updates the Raw Converter to include new versions produced by different cameras, so if your camera's Raw files don't open, check for a newer version of the converter. You can download the latest version by going to www.adobe.com/downloads/updates/ and choosing Photoshop Elements for Mac from the pull-down menu. (Elements and Photoshop use the same converter plug-in, but you don't see all the features in Elements.) You'll also find a standalone version of the DNG (digital negative) Converter there, which you can use without launching Elements; see page 249.

Using the Raw Converter

For all the options it gives you, the Raw Converter is really easy to use. Adobe designed it so that it automatically calculates and applies what it thinks are the correct settings for exposure, shadows, brightness, and contrast. You can accept the Converter's decisions or override them and do everything yourself—it's your call. While you may find all the Converter's various settings, tools, and tabs overwhelming at first, it's really laid out quite logically. Here's an overview of how to use it (you'll get the details in a moment):

1. Open your file in the Raw Converter.

You can call up the Raw Converter just by opening a Raw file.

2. Adjust your view and do any rotating, straightening, or (if you wish) cropping.

The Raw Converter has its own tools for all these tasks, so you don't need to go into Full Edit for any of them.

3. Adjust the image's settings.

This is the best part of shooting Raw format images: You can tweak settings for things like lighting and color. The Converter also lets you apply final touch-ups: noise reduction, sharpening, and so on.

4. Leave the Converter and go to Full Edit.

The Raw Converter is a powerhouse for improving your photo's basic appearance, but to perform all the other adjustments Elements lets you make—applying filters, adding effects, and so on—you need to move your image to Full Edit, which is also where you save the file in the standard file format of your choice (like TIFF, PSD, or JPEG).

If you'd like some practice with the Converter, you can find a sample image (*Raw_practice.mrw*) on the Missing CD page (*www.missingmanuals.com*), but be warned: It's a big file (7.2 MB).

You can open Raw files from either Bridge or Elements. In Bridge, double-click the thumbnail of the file you want to open. (To open more than one file, select the ones you want, and then double-click any of the selected thumbnails.) If you're starting from Elements, go to File → Open. You can work with multiple files in the Raw Converter, as Figure 8-1 explains.

NOTE If you use iPhoto, you may notice that you aren't seeing the Raw Converter when you send your Raw images to Elements. iPhoto normally does the conversion for you and sends a converted file. To tell iPhoto to send the actual Raw files to Elements, go to iPhoto → Preferences → Advanced → RAW Photos, and turn on "Use RAW files with external editor". (This is only in iPhoto 6, iPhoto '08, and iPhoto '09. Previous versions won't send the Raw file at all.) If you want to convert your Raw files as 16-bit files and save them that way, also turn on "Save edits as 16-bit Tiff Files" in the same iPhoto Preferences window.

Figure 8-1:

When you open a bunch of files at once in the Raw Converter, you get a handy filmstrip view down the left side of the window. You can select a single image from the group by clicking it, and your changes apply only to that file. Shift-click or %-click to select multiple files (or use the Select All button at the top of the list), and your selected files get changed along with the one in the main preview area. When you finish and click Open, all the selected files appear in the Project bin. If you want to save a group of them in another format, use Process Multiple Files (page 258).

In Bridge, you can also batch-apply the settings from one processed file to many other Raw files without even opening them. See page 544 to learn how.

One important point about Raw files: Elements never overwrites your original file. As a matter of fact, Elements can't in any way modify the original Raw file. So your original is always there if you want to try converting it again later using different settings. It's something like having a negative from which you can always get more prints. This also applies to any image you edit in the Raw Converter, not just Raw files. You can crop a JPEG file here, for instance, and your original JPEG doesn't get cropped—only the copy you open from the Converter. There's more on working with non-Raw files in the Converter on page 247.

NOTE OS X has a basic, built-in Raw converter that lets you view your Raw files in Finder windows and in Quick Look (see page 40), and open them in Preview. However, you have to take what you get—you can't adjust the conversion settings, and Apple is notoriously slow at adding new camera profiles (and sometimes drops profiles for old cameras), so if your camera is a really recent or very old model, you may not be able to open its files outside Elements.

HIDDEN FEATURE ALERT

Editing Raw Files in Bridge

For most people, the Elements version of the Raw Converter does a fine job, but if you want even more features, try editing your Raw files in Bridge. One of the big surprises in Elements 8 is Adobe's inclusion of the *entire* complex Raw Converter that comes with Photoshop. It's not obvious that it's there, though. To bring up the Photoshop version, right-click (Control-click) a photo's thumbnail in Bridge and choose "Open in Camera Raw" (choosing Open or double-clicking the thumbnail sends it to Elements and the Elements version of the Converter).

In the full Raw Converter, you see everything you'd see in Photoshop: Tone Curves, Split-toning—all the advanced features, in addition to the ones you get with Elements. There are whole books about the things you can do here. If you want to use these extra features, *Real World Camera Raw with Adobe Photoshop CS4* by Bruce Fraser and Jeff Schewe (Peachpit Press, 2008) is a good place to learn about what they do.

Even if you don't need the extra features, it can make your life easier to edit your photos in the Bridge version of the Converter. You can't go straight into Elements to finish editing your photo there or use it in a project, but the Save Image button in the Bridge version of the Converter lets you save your photo in several common image formats, like TIFF and JPEG, in addition to DNG, so it's easy to save your changes in a new file. Then you can use the new image the way you would any other file in Bridge: Open it into Elements or the program of your choice (see page 43). You can also open multiple non-Raw files (like PSD files or JPEGs) in the Bridge Converter by preselecting their thumbnails before choosing "Open in Camera Raw", the same way you can with multiple Raw files in the Elements version of the Converter.

Adjusting the view

When the Raw Converter opens, you see something like Figure 8-2. Before you decide whether to accept the automatic settings that Elements offers or to do your own tweaking, you need to get a good, close look at your image. The Converter makes it easy to do this by giving you a large preview of your image, and a handful of tools to help adjust what you see:

- Hand and Zoom tools. These tools are in the toolbox above the upper-left corner of the preview window. They work exactly the same here as elsewhere in Elements. (You'll find more about the Hand tool on page 88; the Zoom tool is described on page 86.) The keyboard shortcuts for adjusting the view (page 88) and scrolling (page 88) also work in the Raw Converter.
- View percentage. You get a pop-up menu with preset sizes below the lower-left corner of the preview window. Just choose the size you want, or click the + or buttons to zoom in or out.

NOTE Some adjustments and some of the special views, like the mask views for sharpening, aren't available unless you zoom to 100 percent or more.

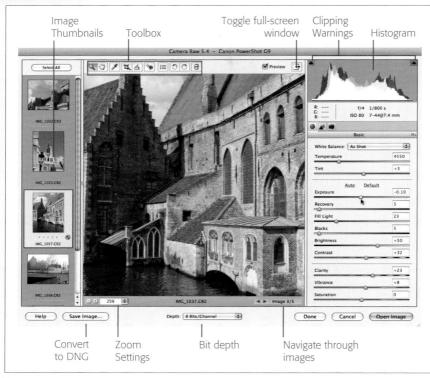

Figure 8-2: Elements' Raw Converter packs a number of powerful tools into one window. Besides the large preview window, you get a small toolset (in the upper-left corner) containing some old friends, a specialized tool for adjusting your white balance (explained on page 238), and a panel on the right where you tweak your settinas. Below your photo, the Converter gives you a few view-adjusting tools, including a drop-down menu (lower-left) where you can choose zoom settings. If you need to rotate your image, use the curved arrows above the preview area, on the right side of the toolbox.

- Full Screen. If you click the icon that looks like a page with a left-facing arrow on it, just to the right of the Preview checkbox above the image area, you put the Raw Converter window into full-screen view. Click it again to toggle back to the normal view.
- Histogram. In the upper-right corner of the Converter is a histogram that helps you keep track of how your changes affect the colors in your photo. (Flip back to page 207 for more on the fine art of reading histograms.)
- **TIP** Another handy feature in the Raw Converter is the panel just below the Histogram, where you can see important shooting info about your photo, like the aperture and ISO speed (ISO is a digital camera's version of film speed). And if you hover your cursor over a pixel in the image, the RGB values for that pixel appear here, as well.

Once you have a close look at your photo, you need to decide: Did Elements do a good enough job of choosing the settings for you? If so, you're done. Just click the Open Image button and Elements opens your photo in Full Edit, ready for any artistic changes or cropping. If you prefer to make adjustments to your photo in the Converter, read on. (If you're happy with Elements' conversion, but you want to sharpen your picture, skip ahead to page 245.)

FREQUENTLY ASKED QUESTION

To Shoot in the Raw or Not

Should I shoot my pictures in Raw format?

It depends. Using Raw format has its pros and cons. You may be surprised to learn that some professional photographers choose not to use Raw. For example, many journalists don't use it, and it's not common for sports photographers, either. Here's a quick look at the advantages and disadvantages, to help you decide if you want to get involved with Raw. On the plus side, you get:

- More control. With Raw you have extra chances to tweak your photos, and you get to call the shots, instead of having your camera make the processing choices.
- More fixes. If you're not a perfect photographer, Raw is more forgiving—you can fix a lot of mistakes in Raw, although even Raw can't make a bad photo great.
- No need to fuss with your white balance all the time while shooting. However, you'll get better input if your camera's white balance settings are correct.
- Nondestructive editing. The changes you make in the Raw Converter don't change your original image one jot. It's always there for a fresh start, if need be.

But Raw also has some significant drawbacks. For one thing, you can't just open a file and start editing it the way you can with JPEG files. You always have to convert it first, whether you use the Elements Converter or one supplied by the manufacturer. Other disadvantages include:

- Larger file size. Raw files are smaller than TIFFs, but they're usually much bigger than the highest quality JPEGs. So you need bigger (or more) memory cards if you regularly shoot Raw.
- Slower Speed. It generally takes your camera longer to save Raw files than JPEGs—something to keep in mind when you're taking action shots. Most cameras these days have a buffer that holds several shots and lets you keep shooting while the camera is working, but you may hit the wall pretty quickly if you're using burst (rapid-advance) mode, especially with a pocket-sized point-and-shoot camera that uses Raw. In that case, you just have to wait. (Most digital single-lens reflex cameras are pretty fast with Raw these days, but they're generally even faster with JPEG.)
- Worse in-camera preview. For older cameras, you have some significant limitations for digitally zooming the view in the viewfinder when using Raw.

You may want to try a few shots of the same subject in both Raw and JPEG to see whether you notice a difference in your final results. Generally speaking, Raw offers the most leeway if you want to make significant edits, but you need to understand what you're doing. JPEG is easier if you're a beginner.

It's your call. Some great photographers wouldn't think of shooting in anything *but* Raw, while others think it's too time consuming.

NOTE Everyone gets confused by the Save Image button. That button is actually the DNG Converter (see page 249), and all you can do when you click it is create a DNG file. To save your edited Raw file, click Done if you just want to save the changes without actually opening the file, or click Open Image and then save in the format of your choice in Full Edit.

Rotating, straightening, and cropping

Before tweaking your settings, you can make these basic adjustments to your photo right in the Converter:

- Rotate it. Click one of the rotation arrows above the image preview.
- Straighten it. The Raw Converter contains its own Straighten tool, which works just like the one in Full Edit's Tools panel (page 26), although it has a different icon and cursor. (It's just to the right of the Crop tool in the Raw Converter's toolbox.) However, you don't see your photo actually straighten out in the Converter—Elements just shows you the outline of where the edges of your straightened photo will be. Opening the photo in Full Edit applies the straightening.
- Crop it. The Raw Converter has the same Crop tool as Full Edit (page 77). You can crop to a particular aspect ratio (page 76) here, if you want. Just right-click (Control-click) your photo when the Crop tool is active to choose from a list of presets. To crop to a particular size, choose Custom from the list, and then, in the dialog box that appears, enter the numbers and select inches or pixels. Your crop info is saved along with the Raw file, so the next time you open the file in the Converter, you see the cropped version.

As with straightening, Elements just draws a mask over the cropped area in the Converter; you can still see the outline of the entire photo. To adjust your crop, in the Raw Converter's toolbox, click the Crop tool again. Then drag one of the handles that appear around the cropped area. To revert to the uncropped original later, right-click (Control-click) the Raw Converter's Crop tool and choose Clear Crop.

TIP You can also fix red eye in the Raw Converter. The Red Eye tool is in the toolbox just to the right of the Straighten tool, and it works the same way it does everywhere else in Elements (page 104).

Adjusting White Balance

The long strip down the right side of the Raw Converter gives you many ways to tweak and correct the color, exposure, sharpness, brightness, and noise level of your photo. The strip is divided into three tabs. Start with the one labeled Basic, which contains the, well, *basic* settings for the major adjustments.

First you want to check your White Balance setting, which is at the top of the Basic tab. Adjusting white balance is often the most important change when it comes to making your photos look their best. The White Balance control adjusts all the colors in your photo by creating a neutral white tone. If that sounds a little strange, think about it: The color you think of as white actually changes depending on the lighting conditions. At noon there's no warmth (no orange/yellow) to the light because the sun is high in the sky. Later in the day when the sun's rays are lower, whites are warmer. Indoors, tungsten lighting is much warmer than fluorescent lighting, which makes whites rather bluish or greenish. Your eyes and brain easily

compensate for these changes, but sometimes your camera may not, or may over-compensate, giving your photos a color cast. The White Balance setting in the Raw Converter lets you create more accurate color by neutralizing the white tones.

Most digital cameras have their own collections of white-balance settings. Typical choices include Auto, Daylight, Cloudy, Tungsten, Fluorescent, and Custom. When you shoot JPEGs, picking the correct setting here really matters, because it's tough to readjust white balance, even in a program like Elements. (Unless, of course, you tweak your JPEG with the Raw Converter, and even then the results may not be what you want.) With Raw photos, you can afford to be a little sloppier about setting your camera's white balance, because you can easily fix things in the Raw Converter.

Getting the white balance right can make a big difference in how your photo looks, as you can see in Figure 8-3.

Figure 8-3: Left: The lighting in this shot has a bluish cast that makes the scene look chilly.

Right: A single click on the swan with the White Balance tool makes the whole photo appear warmer. (It could stand a little additional tweaking, but already the better white balance makes the photo more vivid, and improves its contrast.)

The Raw Converter gives you several ways to adjust your image's white balance:

- Pull-down menu. The White Balance menu starts out set to As Shot, which means Elements is showing you your camera's settings. You can change this setting, choosing from Auto, Daylight, Cloudy, and other options. It's worth giving Auto a try because it picks the correct settings surprisingly often.
- Temperature. Use this slider to make your photo warmer (more orange) or cooler (more blue). Moving the slider to the left cools your photo; moving it to the right warms it. You can also type a temperature in the box in degrees Kelvin (the official measurement for color temperature), if you're experienced in doing this by the numbers. Use the Temperature slider and the Tint slider (described next) together for a perfect white balance.
- Tint. This slider adjusts the green/magenta balance of your photo, pretty much the way it does in Quick Fix (see page 111). Move it to the left to increase the green in your photo, and to the right for more magenta.

• White Balance tool. The Raw window has its own special Eyedropper tool in its toolbox. Click any white or light gray spot in your photo with it, and Elements calculates the white balance based on those pixels. This is the most accurate methods in this list, but you may have a hard time finding neutral pixels to click.

If you're a good photographer, a good white balance and a little sharpening may be all your photo needs before it's ready to share with the world.

Adjusting Tone

The next six sliders—from Exposure down through Contrast—help you improve your image's exposure and lighting (also known as "tone"). If you like Elements to make decisions for you, click the word "Auto" and Elements selects what it thinks are the best slider positions for each of the six sliders. If you don't click anything, Elements starts you off with the Default settings. Here's the difference between Auto and Default:

• Auto. Elements automatically adjusts your photo, using the same software-powered guesswork behind the other Auto buttons throughout the program, as explained in Figure 8-4.

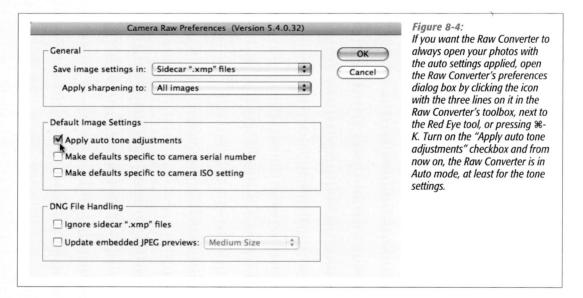

• Default. The Raw Converter contains a database of basic tone settings for each camera model. If you choose Default, you see the baseline settings for your camera. It's up to you to make further adjustments. You can set your own camera *defaults* (where the sliders are when your photo opens), too, as explained on page 243. If you don't like what you got with Auto, click the word "Default" to put your photo back like it was when you opened it.

After you've clicked Auto or Default, you can override any setting by moving that slider. If you go to the trouble of shooting Raw, you may prefer to do that, as Figure 8-5 demonstrates.

Figure 8-5: Left: The Raw Converter's suggested Auto settings for this backlit image.

Right: With a bit of manual adjustment, you can see that the camera actually captured plenty of detail. (Note that the sky is a bit washed out now. This image would be a great candidate for the new Exposure Merge feature, discussed on page 251.)

Here's a blow-by-blow of each of the six tone settings:

- Exposure. A properly exposed photo shows the largest possible range of detail: Shadows contain enough light to reveal details, and highlights aren't so bright that all you see is white. Move this slider to the left to decrease exposure and to the right to increase it. (Note to photo veterans: The values on the scale are equivalent to f-stops.) Too high a choice here will *clip* some of your highlights (meaning they'll be so bright you won't see any detail in them.) See Figure 8-6.
- Recovery. This clever slider brings down overexposed highlights, recovering the details that were lost without underexposing the rest of the photo. Be careful when using it, though—a little goes a long way.
- Fill Light. If your subject is backlit, move this slider to the right to lighten up the shadowed areas the way a photographer's fill light does. Elements' Fill Light is clever enough to bring up the shadowed areas without clipping the highlights in your photos.
- Blacks. This slider increases the shadow values in your photo and determines which pixels become black. Increasing the Blacks value may give an effect of increased contrast in the image. Move the slider to the right to increase shadows or to the left to decrease them. Again, a small change here goes a long way. Move too far to the right, and you *clip* your shadows—in other words, they become plain black, with no details, and your colors may become funky, too.
- Brightness. This is similar to Exposure in that moving the slider to the right lightens your image and moving it to the left darkens it. But this setting doesn't clip your photo the way the Exposure setting may. Use this slider to set the overall brightness of your image after you've used the Exposure, Recovery, and Blacks sliders to set the outer limits of the range of brightness values in your photo.

Figure 8-6: To help you get the tone settings right. Elements includes two triangles above the ends of the Histoaram. Use these to turn on clipping warnings that indicate where your highlights (in red) or vour shadows (in blue) lose detail at your current settings. If the photo contains no clipped areas, the triangle for that end of the Histogram is dark. If the triangle is white or colored, you have a problem; click the trianale to turn the mask on to see the clipping. As vou chanae vour settinas in the controls, the clipping mask changes to show the current state of vour corrections. In this photo, Elements is warning you that the red and blue speckled areas will be clipped when you open the photo in Elements unless you adjust your settings.

• Contrast. This slider adjusts the midtones in your image. Move it to the right for greater contrast in those tones, and to the left for less. People usually use this slider last.

Most of the time, you'll want to use several of these sliders to get a perfectly exposed photo. Pay close attention to the histogram at the top of the window as you work. Once you get things adjusted the way you want, you can go on to the lower group of settings and adjust the clarity, vibrance, and saturation of your photo. You can also save custom settings for use with other photos, or undo all the changes you've made, as explained in the next section. If you don't have anything to save or undo, skip ahead to page 244.

Saving your settings

Most of the time, you'll probably want to use only the adjustments you're making on the particular photo(s) you're editing right now. But Elements also gives you a bunch of ways to save time by saving your settings for future use. Just below the Histogram, to the right of the word "Basic", are three tiny lines with a little arrow

at their bottom right; click this button for a pull-down menu. What you choose from this menu controls how Elements converts your photo:

- Image Settings. This is the "undo all my changes" option. In other words, if you made some changes to your photo in the Converter but you want to revert to the settings Elements originally presented you with, choose this option.
- Camera Raw Defaults. The Raw Converter contains a profile of normal Raw settings for your camera model that it uses as its baseline for the adjustments it makes. That's what you get when you pick this option. You can add your own camera profiles, too (see page 249).
- Previous Conversion. If you've already processed a photo and want to apply the same settings to the photo you're currently working on, choosing this setting applies the settings from the last Raw image you opened (but only if it's from the same camera).
- Custom Settings. Once you start changing settings, this becomes the active choice. You don't need to select it—Elements turns it on automatically as soon as you start making adjustments.

Since individual cameras—even if they're the exact same model—may vary a bit (as a result of the manufacturing process), the Camera Raw Defaults settings may not be the best ones for *your* camera. But you can override the default settings and create a new set of defaults for any camera. Here's how:

- To change your camera's settings: If you know that you *always* want a different setting for one of the sliders—like maybe your Shadows setting should be at 13 instead of the factory setting of 9—move the sliders to where you want them, and then choose Save New Camera Raw Defaults from the menu you get by clicking the button with three lines. From now on, Elements opens your photos with these settings applied.
- To revert to the original Elements settings for your camera: If you want to go back to the way things were originally, click the button with three lines and choose Reset Camera Raw Defaults.

TIP You can apply the same changes to multiple photos at once. See page 234 to learn how.

The Raw Converter's preferences have a couple of special settings that may interest you. To bring up the Raw Converter's Preferences dialog box, in the Raw Converter's toolbox, click the button with three lines. These preferences can be really useful, especially if you have more than one camera:

• Make defaults specific to camera serial number. Turn this on if you have more than one of a particular model camera; for instance, if you carry two bodies of the same model with different lenses when you shoot, or if you and your spouse have the same model. This setting lets you have a different default for each camera body.

• Make defaults specific to camera ISO setting. Since you may shoot very differently at different ISO settings (ISO is equivalent to film speed), you can use this setting to create a default that applies only to photos shot at ISO 100, or at ISO 1600, and so on.

TIP If you regularly share photos with people using other programs, you'll be pleased to know that the Elements Camera Raw preferences let you choose whether your settings are saved in the Camera Raw database or in a sidecar XMP file that goes along with the image. If you choose the XMP file, your settings become portable along with your photo—that is, if you send the file to someone else, the settings travel along with the photo, as long as you send the XMP file, too.

You don't have to create default settings to save the changes you make to a particular photo. If you just want to save the settings for the photo or group of photos you're working on right now without having to open them all in Full Edit and save them in another format, make your changes, and then click Done to update the settings for the image file(s).

TIP You can also add a whole new profile for your camera for the Raw Converter to use as a basis for adjusting your photos. Page 249 explains how.

Adjusting Vibrance and Saturation

The final group of sliders in the Raw Converter's right-hand section controls the vividness of your colors. Most Raw files have lower saturation to start with than you'd see in the same photo shot as a JPEG, so people often want to boost the saturation of their Raw images a bit. Move the sliders to the right for more intense color, and to the left for more muted color. If you know you'll *always* want to change the intensity of the color, you can change the standard setting by moving the slider until you have the intensity you want, and then creating a new camera default setting, as described on page 243.

Here's what each of the three sliders does:

• Clarity. This slider is a bit different from the other two. Clarity isn't strictly a color tool, although it's an amazing feature. If you're an experienced Elements sharpener, you may have heard of the technique called *local contrast enhancement*, where you use the Unsharp Mask (page 223) with a low Amount setting and a high Radius setting to eliminate haze and bring out details. That's sort of what Clarity does: Through some sophisticated computing, it creates an edge mask for your photo that it uses to increase detail. It can do wonderful things for many—maybe even most—of your photos by improving contrast and adding punch. Give it a try, but be sure to look at your photo at 100 percent magnification (or more) so you can see how you're changing things. For some cameras, you may find that the details in the converted photos look rather blocky when viewed at near 100 percent size. If that happens, open the file in the Raw Converter again and choose a lower Clarity setting this time.

- Vibrance. While Saturation (explained next) adjusts all the colors in your photo equally, this slider is much smarter. It increases the intensity of the duller colors, while holding back on those colors that are already so vivid they may over-saturate. If you want to adjust saturation to make your photo pop, then try this slider first; it's one of the handiest features in the Raw Converter.
- Saturation. This slider controls how vivid your colors are by changing the intensity of *all* the colors in your photo by the same amount.

Adjusting Sharpness and Reducing Noise

Once you have your exposure and white balance right, you may be almost done with your photo. But in most cases, you still want to click over to the Raw Converter's Detail tab to do a little sharpening. The tab is above and to the left of the word "Basic" and it has two triangles on it.

Two other important adjustments are available on this tab as well: *Luminance* and *Color* (both described in a moment), used for reducing noise in your photos. None of the adjustments on this tab have Auto buttons, although you can change the standard settings by moving the sliders where you want them, and then creating a new camera default (page 243).

Sharpening increases the edge contrast in your photo, which makes it appear more crisply focused. The Raw Converter's sharpening tools are a bit different from those in Full Edit. But some of the sliders should look familiar if you've sharpened before, since they're similar to the settings for Unsharp Mask (page 223) and Adjust Sharpness (page 225):

- Amount controls how much you want Elements to sharpen. The scale here goes from zero (no sharpening) to 150 (way too much sharpening).
- Radius governs how wide an area Elements should consider as an edge to sharpen. Its scale goes from .5 pixels to 3 pixels.
- Detail controls how Elements applies the sharpening to your image. At 100—the right end of the scale—the effect is most similar to Unsharp Mask (in other words, you can overdo it if you aren't careful). At zero, you shouldn't see any sharpening halos at all.
- Masking is a cool feature that reduces the area where Elements sharpens so that only edges are sharpened. If you find that you're sharpening more details than you'd like, use this slider to create an edge mask that keeps Elements from sharpening areas inside the edges. The farther you move the slider to the right, the more area is protected from sharpening. Elements is doing some amazing behind-the-scenes calculations, so don't be surprised if there's a little lag in the preview when you use this slider.

Masking and Detail work together to perform really accurate sharpening, which is why the sliders go so high. You won't like the effect when just one of them is set all the way up, but by experimenting with using both sliders, you can create excellent sharpening for your photo.

You see an extremely helpful view of your image if you hold the Option key as you move the sliders, as explained in Figure 8-7 (but only if the view is set to at least 100%).

Figure 8-7:
If you've tried High-Pass sharpening (page 227), you won't have any trouble understanding this helpful view. Set the view to 100 percent or higher, and then Optiondrag any of the sharpening sliders to see this black-and-white view of your image. Omitting the color makes it easy to focus on what you're doing to the edge sharpness in your photo. If you pay close attention, you get a highly accurate view of what you're doing as you move the sliders.

If you're not planning on making any further edits to your photo when you leave the Raw Converter, go ahead and sharpen it here. Some people prefer to sharpen after they finish all their other adjustments in Full Edit mode, so they skip these sliders. But you can usually sharpen here, and then sharpen again later on, outside the Converter, without causing any problems.

The final two settings on this tab (under Noise Reduction) work together to reduce the *noise* (graininess) of your photo. Noise is a big problem in digital photos, especially with 5-plus megapixel cameras that don't have the large sensors found in single-lens reflex cameras. These two sliders may help:

- Luminance. This setting reduces grayscale noise, which causes an overall grainy appearance to your photo—something like what you see in old newspaper photos. The slider is always at zero to start with, since you don't want to use more than you need—moving it to the right reduces noise, but it also softens the detail in your photo.
- Color. If you look at what should be evenly colored areas of your photo and you see obvious clumps of different-colored pixels, this setting can help smooth things out. Drag the slider to the right to reduce the amount of color noise.

It may take a fair amount of fiddling with these settings to come up with the best compromise between sharpness and smoothness. It helps if you zoom the view up to 100 percent or more when using these sliders.

Choosing bit depth: 8 or 16 bits?

Once your photo looks good, you have one more important choice to make: Do you want to open it as an 8-bit or a 16-bit file? *Bit depth* refers to the number of pieces of color data, or *bits*, that each pixel in your image can hold. A single pixel of an 8-bit image can have 24 bits of information in it, 8 for each of the three color channels (red, green, and blue). A 16-bit image holds far more color information than an 8-bit photo. How much more? An 8-bit image can hold up to 16 million colors, while a 16-bit image can hold up to 281 *trillion* colors.

NOTE You can adjust 16-bit images with microscopic precision, but in the real world, your home printer only prints in 8-bit color anyway. If you want to do all your editing (or at least 90 percent of it) in 16-bit color, consider upgrading to Photoshop.

HIDDEN FEATURE ALERT

Non-Raw Files in the Raw Converter

If your camera shoots JPEG files and you've always been curious about what this Raw business is all about, you can find out for yourself—sort of. You can open JPEG, PSD, or TIFF files with the Raw Converter, and then process them there. (To try another kind of file, save it as a TIFF, and then open it with the Raw Converter. That way you can take advantage of the special tools in the Converter, like Vibrance or Clarity, for any photo.)

To open non-RAW formats in the Raw Converter, go to File → Open and choose Camera Raw (not Photoshop Raw) as the format before you click Open. Your file opens up in the Converter, and you can work on it just like a Raw file. Actually, it's more accurate to say, "almost like a Raw file." The thing about using other formats in the Converter is this: When your camera processed the JPEG file that it wrote to your memory card, it tossed out the info it didn't need for the JPEG, so Elements doesn't have the same amount of information to work with that it has for a true Raw file. The Converter even lets you create a DNG—digital negative—file (page 249) from a JPEG if you wish, but it can't put back the info that wasn't included in the JPEG, so this feature isn't very useful for most people.

This means that your results can be iffy. You may find that the Raw Converter does a bang-up job on your photo, or you may find that you liked it better before you started messing with it. There are so many variables involved that it's hard to predict the results you'll get. But it's worth giving it a try to see what you think.

If you find you like using the Raw Converter for JPEGs, you might want to experiment with reducing the saturation, contrast, and sharpening in the camera if you have settings that let you do so. You're more likely to get good results from the Raw Converter if your image is fairly neutral to start with.

In Elements you can only open one non-Raw file at a time in the Converter and your image will continue to open in the Raw Converter each time you open it in Elements. To get back to normal image behavior, go to File → Open again and change the format back to its true one of JPEG or whatever before clicking Open. To get around these limitations, you can always open your files from Bridge instead, as explained in the box on page 235.

Most digital cameras produce Raw files with 10 or 12 bits per channel, although a few can shoot 16-bit files. You'd think it makes perfect sense to save your digital files at the largest possible bit depth. But the fact is, you'll find quite a few restrictions on how much you can do to a 16-bit file in Elements. You can open it, make some corrections, and save it, but that's about it. You can't work with layers or

apply the more artistic filters to a 16-bit file, but you can use many of Elements' Auto commands. If you want to work with layers on a 16-bit file, you need to upgrade to Photoshop.

NOTE Your scanner may say it handles 24-bit color, but this is actually the same as what Elements calls 8-bit. Elements goes by the number of bits per color channel, whereas some scanner manufacturers try to impress you by giving you the total for all three channels ($8 \times 3 = 24$). When you see really high bit numbers—assuming it's not a commercial printer—you can usually get the Elements equivalent by dividing by three.

Once you've decided between 8- and 16-bit color, make your selection in the Depth drop-down menu at the bottom of the Raw Converter window. The Raw bit-depth setting is "sticky," so if you change it, all your images open in that color depth until you change it again. If you ever forget what bit depth you've chosen, your image's title bar or tab tells you, as shown in Figure 8-8.

Figure 8-8: You can always tell an image's bit depth by looking at the tab or top of any image window. This image is 8-bit.

TIP If you do decide to create a 16-bit image and later become frustrated by your lack of editing choices, you can convert your image to 8-bit by choosing Image \rightarrow Mode \rightarrow 8 Bits/Channel. (You can't convert an 8-bit image to 16 bits.)

To take advantage of any 16-bit files you have, you can do a Save As for the copy you plan to convert to 8-bit. That way, you still have the 16-bit file for future reference. Incidentally, your Save options are different for the two bit depths: JPEG, for instance, is available only for 8-bit files because JPEGs are always 8-bit files. (If you're looking for JPEG 2000, it's gone from Elements 8—see page 61.)

A popular choice when you're thinking about your order of operations (*workflow*, in photo-industry speak) is to first convert your Raw file as a 16-bit image to take advantage of the increased color information while making any basic corrections, and then convert to 8-bit for the fancy stuff like the artistic filters or layer creation.

Finishing Up

Now that your photo is all tweaked and sleeked and groomed to look exactly the way you want, it's time to get it out of the Raw Converter. To do that, click the Open Image button in the Converter's bottom right, which sends your photo to Full Edit, where you can save it in the format of your choice (TIFF or JPEG, for instance). Everyone gets confused by the Raw Converter's Save Image button—that's actually a link to the DNG Converter, discussed in the next section. If you just want to save your changes without actually opening the file, you don't need to do anything: Just click Done to close the Converter, and the next time you open your Raw file, the Converter will remember where you left off.

Converting to DNG

Lately there's been a lot of buzz about Adobe's DNG (digital negative) format, and if you shoot Raw, you should know what it is. As you read at the beginning of this chapter, every manufacturer uses a different format for Raw files. Even the formats for different cameras from the same manufacturer differ. It's a recipe for an industry-wide headache.

Adobe's solution is the DNG format, which the company envisions as a more standardized alternative to Raw files. Here's how it works: If you convert your Raw file to a DNG file, it still behaves like a Raw file—you can still tweak your settings in the Converter when you open it, and you still have to save it in a standard image format like TIFF or JPEG to use it in a project. But the idea behind DNG is that if you keep your Raw files in this format, you don't have to worry about whether Elements version 35 can open them. Adobe clearly hopes that all camera manufacturers will adopt this standard, putting an end to the mishmash of different formats that make Raw files such a nuisance to deal with. If all cameras used DNG, every time you bought a new camera you wouldn't have to worry whether your programs could view the camera's images.

POWER USERS' CLINIC

Working with Profiles

The Raw Converter has another trick up its sleeve. It's one you can safely ignore if you're a beginner, but for Raw experts it's a very big deal indeed. The Raw Converter has a third tab: Camera Calibration. If you click it, all you see is a pull-down menu that seems to imply you're using an older version of Adobe Camera Raw. What's the point of this cryptic tab?

You can create and edit your own camera profiles and install them in Elements for the Converter to use. If you've ever thought, "Darn, I wish my Raw files opened looking as good as the JPEGs I shoot," or if you've stuck with another Raw converter (like the ones from Nikon or Canon) because you just can't get the same results with Adobe's Converter, this tab's for you.

You can't actually create or edit profiles in Elements, but Adobe has developed a standalone profile editor, along with profiles for many, many cameras. They plan to eventually have profiles for every camera that shoots Raw, but they began with Nikon and Canon (since they're the most popular brands).

Editing camera profiles is beyond the scope of this book, but you can download the DNG Profile Editor and the initial set of camera profiles at http://labs.adobe.com/wiki/index.php/DNG_Profiles. There's an excellent tutorial at www.luminous-landscape.com/reviews/accessories/dng-profiles.shtml.

If you create and install profiles, they appear in the pull-down menu on the Camera Calibration tab, and you can select the one you want to use as the basis for all your setting changes in the Raw Converter. If you haven't done this and you're wondering why your list shows older Adobe Camera Raw versions like 4.2, that's because the list shows the version numbers for when the built-in Adobe Camera Raw profiles were last updated. So if you've been thinking, "I liked the way my Raw files looked better a couple of versions ago," no problem. You can choose the older profile for your camera from the list, and use that instead of the newest one.

You can create DNG files from your Raw files right in the Converter. At the bottom left of the window, click the Save Image button, and you see the DNG Converter (Figure 8-9). Choose a destination, and then select how you want to name the DNG file. You get the same naming options as in Process Multiple Files (page 258), but since you convert only one file at a time here, you may as well keep the photo's current name and just add the .dng extension.

Of course, the jury is still out on whether DNG will become the industry standard, although it does seem to be gaining popularity. People have had other good ideas over the years, like the JPEG 2000 format (see page 61), that never really took off. Whether to create DNG files from your Raw files is up to you, but for now, it's probably prudent to hang onto the original Raw files as well, even if you decide to go with DNG.

TIP If you want to convert a group of your Raw files to DNG in one batch, the easiest way is to go to Adobe's website (www.adobe.com/downloads) and search for "DNG", and then download the standalone DNG Converter, which you can leave on your desktop. Then just drop a folder of Raw images onto its icon, and the DNG Converter lets you process the whole folder at once. The standalone Converter is part of the Raw Converter update (page 232). If your Raw Converter is up to date already, just remove the DNG Converter and discard the rest of the download. You can also batch-save images in the Raw Converter itself by highlighting them in the list on the left side of the window, and then clicking Save Images.

Blending Exposures

If you've been using a digital camera for a while, you know what a juggling act it can be to get a photo that's properly exposed everywhere, from the deepest shadows to the brightest highlights. With most digital cameras, you're likely to hit the clipping point (page 242) in an image much sooner than you want to. If you up the exposure so that the shadows are nice and detailed, you'll likely blow out the highlights. On the other hand, if you adjust your exposure settings down to favor the highlights, your shadows are murkier than an old Enron annual report. Figure 8-10 shows the problem.

Figure 8-10: Here's a classic example of the kind of image that can benefit from exposure merging. This is the same Raw photo processed twice.

Left: To get the beautiful ocean view properly exposed means making the interior much too dark.

Right: Correctly exposing the fancy bath area reduces the view outside to a bright blur.

Digital blending is a technique photographers use to get around these limitations (there's also a more sophisticated method known as *High Dynamic Range*, or HDR for short). To use digital blending, you *bracket* your shots, meaning you take two or more identical photos of your subject at different settings—one exposed for shadows and one for highlights—and then combine them, choosing the best bits of each one. People who are truly fanatical about a perfectly exposed photo may combine several different exposures.

That technique is great for landscapes. But if you're shooting hummingbirds, roller-skating chimps, or toddlers, you know it's just about impossible to get two identical shots of a moving subject. And if you're like many amateur photographers, you may not realize you didn't capture what you wanted until you look at the shot on your computer. But even if you have only one photo of that perfect moment, you can sometimes cheat a bit and get a similar result from processing your photo twice in the Raw Converter, once to favor the shadowy areas, and once for the highlights, as shown in Figure 8-10, so you wind up with two exposures. The problem is how to combine them into one great image.

In previous versions of Elements you had to either manually layer two exposures together and get busy erasing the bad spots on the top layer, or else use expensive third-party plug-ins to blend exposures. But one of the highlights of Elements 8 is Photomerge Exposure, a super easy way to blend images—it's as easy to use as any of the other Photomerge features (see Chapter 11 for more about those). It can even be a one-click fix, if you want. Elements gives you several ways to blend your photos. Your main choice is between an automatic merge, where Elements makes most of the decisions for you, and a manual merge, which gives you more control but requires a little more effort.

NOTE Exposure merging isn't meant for blending two totally different photos together, like replacing the blown-out sky in your photo of the Eiffel tower with a good sky from a photo of your dude ranch trip. To use Photomerge Exposure, your photos should be pretty much identical except for the exposure. Use images you took using your camera's exposure bracketing feature or even one shot you've processed twice or more to get one good version with properly exposed highlights, one with good shadows, and so on.

Automatic Merges

It's incredibly easy to combine your photos using the Automatic Merge option. Elements makes most of the decisions for you. (If that's not for you, you can click the other tab in the Exposure Merge window and opt for a manual merge, where you call the shots, as explained in the next section.) Here's what you do:

1. Prepare, open, and select your images.

You can start with two or more photos where you used exposure bracketing in your camera, or with one image that you processed in two different ways in the Raw processor (page 232), once favoring the shadows and once the highlights. You can use up to 10 photos, so you can create as many versions as you need to make sure every part of the image is properly exposed. Select the photos you want to work with in the Project bin and you're ready for the next step.

2. Call up the Photomerge Exposure window.

In Full Edit, go to File \to New \to Photomerge Exposure, or go to Guided Edit \to Photomerge \to Exposure.

The Photomerge Exposure window opens. It's a lot like the windows for Group Shot, Faces, and Scene Cleaner, if you've used any of those before, and it works much the same way.

3. Choose to make an automatic merge.

If the Exposure Merge window doesn't open with the Automatic tab active, just click it. (It's easy to tell which tab is active even without looking over at the right side of the window, because in Automatic mode, you see only one image in the preview area on the left of the screen; in Manual mode, you see two image previews.)

4. Select a merge option, and make any adjustments, if you wish.

You have two radio buttons to choose between:

- Simple. Elements does everything. All you have to do is click Done.
- Smart Blending. If you pick this option, you can use the three sliders on the right side of the window to adjust what Elements does. (The sliders are explained below.) Elements uses a different kind of analysis on your photo here than it does for the Simple merge, so don't be surprised if your image changes a bit when you click this button.
- 5. When you're happy with what you see, click Done.

Elements blends the photos into a new file so that your originals aren't changed. Don't forget to save the blended image.

That's all there is to it. Elements does a pretty good job, as shown in Figure 8-11, depending on your photos, but you can help the program out by nudging the Smart Blending sliders if you aren't quite satisfied with what Elements proposes for your image. (The sliders won't do anything if you have Simple selected; they only become active when you switch over to Smart Blending.) Here's what each slider does:

- Highlights controls the way Elements blends the bright areas of the two images.
- Shadows adjusts the blend for the darker areas.

NOTE If you've used Shadows/Highlights (page 194), you know everything you need to know about these two sliders.

• Saturation adjusts the color intensity, which is handy if the blend made your photo look a little drab or oversaturated. It's similar to the Saturation slider in the Quick Fix (page 111).

If you prefer to have more control over what Elements does, you can opt to combine your photos manually instead, as explained next.

Manual Merges

Automatic merges are easy to do, even for a beginner, but sometimes Elements doesn't get it quite right, or maybe you like telling Elements what to do rather than accepting its judgment about your images. In either case, manual merges are what you want. You begin a manual merge just like an Automatic one (described above), but once you're in the Merge window, you need to:

1. Click the Manual tab.

Elements displays a window with spaces for two photos, like the windows for Photomerge Faces, Group Shot, or Scene Cleaner (all described in Chapter 11).

Figure 8-11:
Here's what Elements proposes as a Simple Merge for the photo shown in Figure 8-10. You'd probably want to tweak it some in the Editor, but overall Photomerge Exposure did a pretty good job, though you can do even better with a manual merge, where you have more control over how the images blend. The sky is still a tad light in this version, for instance.

2. Choose a background photo.

This is the photo that will be the basis for your merge; the one you'll blend bits of other photos into. Usually this would be the photo with the largest area of correct exposure. (You can use up to 10 photos in a manual merge, but you work with only two at a time.) Drag your background photo into the right-hand slot.

TIP If you're blending several exposures, you may get the best results if you choose the photo with the best midtones as your background photo, even if that's not the photo with the largest properly exposed area. That's because Elements likes to start from the middle and work out when blending several images.

3. Choose a foreground photo.

This is the photo you'll copy bits from and put them over in the background photo. Double-click it to tell Elements it's the one you want to use. It appears in the left-hand slot.

4. Tell Elements what to copy.

Click the Selection Tool button on the right side of the window (the one with the button on it) and drag over the areas in the foreground photo that you want to move to the background photo. This selection tool works much like the Quick Selection tool (page 129) in that it automatically expands the selection from the line or dot you make. If you find you're getting too much material, or if you drag over something by mistake, use the Eraser tool to remove some of your marks (see Figure 8-12).

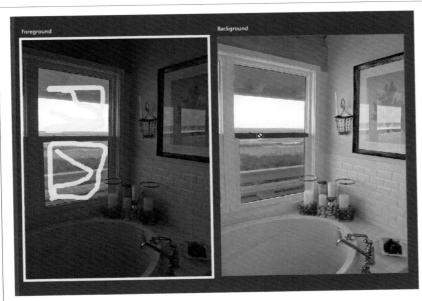

Figure 8-12: Here's the midpoint of creating a manual merge for the image from Figure 8-11. Show Regions is turned on here to make it easier to see what Elements is doing. You can see the selection went a tad too far to the left and Elements is bringing over the underexposed window frame, too. (Look where the cursor is in the righthand photo; it's a No symbol there because you always use the tools on the foreground photo, not the background photo.) A quick erase on the frame in the foreground photo will fix this.

5. Align the photos if you need to.

If you find that your copied material is slightly out of alignment with the background photo (common if you used exposure bracketing for live subjects), scroll down in the Manual tab until you see the words "Advanced Option"; click them, and then click the Alignment Tool button. When you do, three little target marks appear in each preview when you move your cursor over the photo. Drag the marks so they're in the same spot in each photo (like over a tiger's eyes and mouth in bracketed wildlife photos), and then click Align Photos. Elements figures out the difference in perspective between the two images and corrects for it.

6. Tweak the blending.

You may be horrified by how crudely Elements blends the images at first, but that's okay. There are two settings you can use to fix things:

- Transparency. Use this slider to adjust the opacity of the foreground material for a more realistic effect.
- Edge Blending. Turn on this checkbox and Elements automatically refines the edges of the blend to avoid that cut-and-paste effect. (This setting appears second in the list, but try it first.)

7. When you like what you see, click Done.

As with an automatic merge, Elements creates a new layered file for the blended image so your originals are still untouched.

NOTE If you want to add details from another image you preselected, drag it to the foreground image slot and repeat the process before you click Done. You can combine a total of 10 images, if you want. Each additional photo gets a different-colored marker to help you keep track of what came from which photo.

If you need to adjust the view while you're working, Elements gives you some help:

- Zoom and Hand tools. Your old friends, the Hand (page 88) and Zoom (page 86) tools, live in the toolbox on the left of the window. They work the same way here as elsewhere in Elements.
- Show Strokes. This checkbox in the Merge tab lets you show or hide the marks you make with the Selection tool.
- Show Regions. Turn this on and Elements displays a blue mask over the background photo, with yellow over the areas where it's blending in material from the foreground photo, as you can see in Figure 8-12. The window area is yellow because that's what's coming over from the foreground photo. (If you add more photos, each gets a mask colored to match its marker color.)

NOTE Photomerge Exposure is fun, but you may find you want something a bit more powerful. In that case, check out the wonderful program Bracketeer (*www.pangeasoft.net/pano/bracketeer/index.html*). Many people prefer it even to the HDR (high dynamic range) feature in Photoshop.

Photo Filter

The Photo Filter feature gives you a host of nifty filters to work with. They're the digital equivalent of the lens-mounted filters used in traditional film photography. You can use them to correct problems with your image's white balance, as well to perform other fixes from the seriously photographic to the downright silly. For example, you can correct bad skin tone or dig out an old photo of your fifth-grade nemesis and make him green. Figure 8-13 shows the Photo Filter feature in action.

Figure 8-13: You can use the Photo Filter to correct the color casts caused by artificial lighting or reflected light.

Left: This photo had a strong warm cast from nearby incandescent lighting.

Right: The filter named "Cooling Filter (LBB)" took care of it. Use the warming filters to counteract the blue cast from fluorescent lighting. (The numbers following the names of some are the numbers of the glass filters you'd use on a film camera.)

Elements comes with 20 photo filters, but for most people, the top six are the important: three warming filters and three cooling filters. You use these filters to get rid of the color casts caused by poor white balance (seepage 238).

The filters sometimes work better than the Color Cast eyedropper (page 213) because you can control the strength with which you apply them (using the Density slider, explained later). And you can also apply them as Adjustment layers (page 181), so you can tweak them later on. To apply a photo filter:

1. Open the Photo Filter dialog box or create a new Adjustment layer.

Go to Layer → New Adjustment Layer → Photo Filter, or go to Filter → Adjustments → Photo Filter. Either way, you see the Photo Filter adjustment controls. If you make an Adjustment layer, the controls appear in the Adjustments panel after you click OK. If you're applying the Photo Filter directly to your image, you get a dialog box instead, but both offer the same controls.

2. Choose a filter from the pull-down list or click the Color radio button.

The pull-down list gives you a choice of filters in preset colors. If you want to choose a custom color, click the Color button instead.

3. If you chose the Color button, click the color square to bring up the Color Picker (page 217), and select the shade you want.

Click on the color you want, and that color appears in the dialog box's color square. Elements applies the color you select to your image, so you can decide whether you like it. When you have the color you want, click OK to close the dialog box.

4. In the Adjustments panel or dialog box, move the Density slider to adjust the intensity of the filter.

Moving this slider to the right increases the filter's effect; moving it to the left decreases it. If you leave the Preserve Luminosity checkbox turned on, the filter doesn't darken your image. Turn off Preserve Luminosity and your photo gets darker when you apply the filter. Watch your image to see the effect.

5. When your photo looks good, click OK.

Save your image to preserve your changes.

Processing Multiple Files

If you're addicted to batch-processing photos, you'll love the Elements equivalent: Process Multiple Files. In addition to renaming your files and changing their formats, you can do a lot of other useful things with this tool, like adding copyright info or captions to multiple files, or even using some of Quick Fix's Auto commands.

To call up the batch-processing window, in Full Edit, go to File → Process Multiple Files. You see yet another giant, headache-inducing Elements dialog box. Fear not—this one is actually pretty easy to understand. If you look closely, you see that the dialog box is divided into sections, each with a different specialty (see Figure 8-14).

TIP Process *Multiple* Files is the name of the command, but you can run it on only one photo if you want, although you'll usually find it easier to just do a regular Save As (see Chapter 2 for more about saving files). Open your photo, go to File → Process Multiple Files, and then choose Opened Files as your source. You can even save the new version to the desktop without overwriting your original.

The following sections cover each section of the Process Multiple Files dialog box. You *have* to use the first section (which tells Elements which files to process), but you'll probably want to make use of only one or two of the other sections at any one time. (Of course, you can use them all, as shown in Figure 8-14.)

Choosing Your Files

The upper-left section of the dialog box is where you tell Elements which files you want to convert and where to put them once it's processed them. You have several options here, which you pick from the Process Files From pull-down menu: the contents of a folder, files you import, your currently open files, or Bridge.

The "Import" item brings up the same options you get when selecting File → Import. Select this item to convert files as you bring them into Elements—from a camera or scanner, for example. If you want to include files scattered around your hard drive, speed things up by opening the files first or gathering them into one folder. If you have a couple of folders' worth of photos to convert, save time by putting those folders into one folder, and turning on the Include All Subfolders checkbox (explained in a moment). That way Elements converts all the files at once.

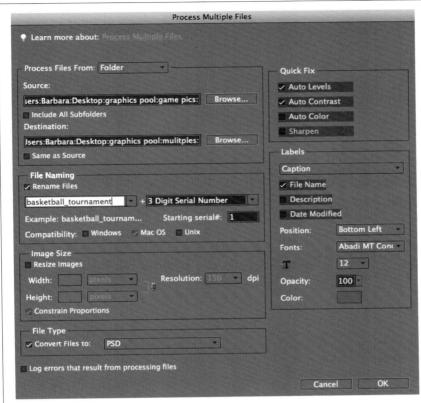

Figure 8-14: You could call Process Multiple Files "Computer: Earn Your Keep". because it can make so many changes at once. This dialoa box is set up to apply the following changes: Rename every file (from something like PICT8983 to basketball_ tournament001, basketball tournament002, and so on), change the images to .psd format, apply Auto Levels and Auto Contrast, and add the file name as a caption. You make all that happen just by clicking the OK button.

Here's a step-by-step tour of the process:

1. Choose the files you want to convert.

Use the Process Files From pull-down menu to select which kind of files you want: a folder, files imported from your camera or scanner, open files, or files from Bridge.

2. If you chose Folder, tell Elements which folder you want.

Click the Browse button and, in the dialog box that appears, choose the folder you want. Files you want to process have to be in a folder if they aren't already open.

If you have folders *within* a folder and you want to operate on all those files, turn on the Include All Subfolders checkbox. Otherwise, Elements changes only the files in the top-level of the folder.

3. Pick a destination.

This is when you decide where the files will end up after Elements processes them. Most of the time, you'll want a new folder for this, so click Browse, and then, in the window that opens, click the New Folder button. Or you can

choose an existing folder in the Browse window, but be careful about choosing "Same as Source", as Figure 8-15 explains.

Renaming Your Files

Being able to rename a group of files in one fell swoop is a cool feature, but it has a few limitations. If you think it means you can give each photo a unique name like "Keisha and Gram at the Park", followed by "Fred's New Newt", and so on, you're going to be disappointed. Instead, what Elements offers is a quick way of applying similar names to a group of files. That means you can easily transform a folder filled with files named *DSCF001.jpg*, *DSCF0002.jpg*, and so on, into the slightly friendlier *Keisha and Gram001.jpg*, *Keisha and Gram002.jpg*, and so on.

To rename your files, turn on the Process Multiple Files dialog box's Rename Files checkbox. Below it are two text boxes with pull-down menus next to them (a + sign separates the menus). You can enter anything you like in these boxes, and it replaces every file name in the group. Or you can choose any of the options in the menus. (Both menus are the same.)

The menus give you a choice of the document name (in three different capitalization styles), serial numbers, serial letters, dates, extensions, or nothing at all (which gives you just the trailing numbers without any kind of prefix). Figure 8-16 shows your options.

NOTE To add serial numbers, tell Elements what to start with in the "Starting serial#" box. Your first choice is always 1, which actually shows up as 001 because your computer needs the leading zeros to recognize the file order. The tenth figure in your batch would be numbered 010, the hundredth would be 100, and so on.

So if you type <code>tongue_piercing_day</code> in the first text box and choose the three-digit serial number from the second, Elements names your photos <code>tongue_piercing_day001.jpg</code>, <code>tongue_piercing_day002.jpg</code>, and so on.

NOTE If you turn on the "Same as Source" checkbox, the Rename Files option is grayed out. If you want to put your renamed files in the same folder with the originals, leave "Same as Source" turned off, but select the same folder as the destination in the top part of the dialog box so Elements places your renamed files in the folder with the originals.

Figure 8-16:
Elements offers loads of naming options. If you select
Document Name, for example, your photos retain their
original names plus whatever you choose from the righthand pull-down menu (if anything). DOCUMENT NAME
gets you the same file names in all capital letters. "1 Digit
Serial Number" starts you off with the number 1, and so on.

You also get to designate which operating systems' naming conventions Elements should use when assigning the new names, as explained in Figure 8-17. If you send files to people or servers that run other operating systems, you know how important this is. If you don't, play it safe and turn on all three checkboxes. You never know when you may need to send a photo to your nephew who uses Linux.

Figure 8-17:

The Compatibility checkboxes tell Elements to watch out for any characters that would violate the naming conventions of the operating systems you check. This is handy if, say, your website is hosted on a Unix server and you want to be sure your file names don't cause problems. You can choose to be compatible with either or neither of the other operating systems, but the Mac OS checkbox is always turned on.

Changing Image Size and File Type

The Image Size and File Type sections of the Process Multiple Files dialog box let you resize your photos and change their file formats. The Image Size settings work best when you're trying to reduce file sizes (say you have a folder of images that you've converted for Web use but found are still too big).

NOTE Before you make any big changes to a group of files, it's important for you to know how changes in an image's resolution and file size affect its appearance. See page 90 for a refresher.

To apply image-size changes, turn on the Resize Images checkbox, and then adjust the Width, Height, and Resolution settings, all of which work the same way as those described on page 94.

261

In the File Type section, you can convert files from one format to another. This is probably the most popular batch-processing activity. If your camera creates JPEGs and you want TIFFs for editing work, you can change an entire folder at once. From the pull-down menu, just select the type of files you want to create.

The final setting in the left half of the dialog box is the "Log errors that result from processing files" checkbox. It's a good idea to turn this checkbox on, because then Elements lets you know if it runs into any problems while converting your files. You'll find a little text log file in the folder with your completed images, whether or not there were problems. (If nothing went awry, the file is blank.)

Applying Quick Fix Commands

In the upper-right corner of the Process Multiple Files dialog box are some of the same Quick Fix commands you have in the regular Quick Fix window. If you consistently get good results with the Auto commands there, you can run them on a whole folder at once here.

You can choose Auto Levels, Auto Contrast, Auto Color, Auto Sharpen, or any combination of those commands that you like on all the files in your folder. If you need a refresher on what each one does, see Chapter 4, beginning on page 108. Unfortunately, you can't batch-run the Auto Smart Fix command from this dialog box.

TIP Don't forget that you can also batch-process corrections in the Raw Converter (see page 234). Then open the files, and use Process Multiple Files to save all the changed files at once.

Attaching Labels

The tools in the Labels section let you add captions and copyright notices, which Elements calls *watermarks*, to your images (see Figure 8-18). Watermarks and captions get imprinted right onto the photo itself. The procedure is the same for creating both; only the content differs. A watermark contains any text you choose, while a caption is limited to your choices from a group of checkboxes.

First, you need to choose between a watermark and a caption (choose from the top pull-down menu in the Labels section). You can't do both at once, so if you want both, add one, run Process Multiple Files, and then add the other, and run Process Multiple Files again on the resulting images. You can download *fall.jpg* from the Missing CD page at *www.missingmanuals.com* if you want to practice adding your own watermarks and captions.

Watermarks

To create a watermark, type some text in the Custom Text box. Then choose the position and appearance of your text as explained in a moment. Text you enter here gets applied to every photo in the batch, so this is a great way to add copyright or contact info that you want on every photo, as shown in Figure 8-19. If you want *different* text on each photo, check out the Description option for captions (explained in a moment).

Figure 8-18: Adobe calls the "Fall Vacations" text in this image a watermark. Elements is flexible about the fonts and sizes you can choose for a watermark or caption, but you don't get much say in where it goes on your photo if you use Process Multiple Files. For more flexibility, use the Type tool, as explained on page 419. The drawback: You can't batch-process using that method.

Figure 8-19:
You just can't beat
Process Multiple Files for
quickly adding copyright
info to your photo,
although some other
methods give a more
sophisticated look, as
described in the Tip at
the end of this chapter
(page 264).

TIP To type the copyright symbol (©), hold down Option and then press G.

Adding captions

For a caption, you can choose any of the following, separately or in combination:

- File Name. Choose this to show the file's name as the caption. If you decide to run the rename option at the same time, you get the new name you're assigning.
- Description. Turn this checkbox on to use any text you've entered in the Description section of the File Info dialog box (File → File Info) as your caption. This is your most flexible option for entering text, and the only way to batch different caption text for each photo. Just enter the text for each photo in File → File Info → Description.
- Date Modified. This is the date your file was last changed. In practice, that usually means today's date, because you're modifying your file by running Process Multiple Files on it.

Once you've decided what you want your caption to say, you need to make some choices about its position and size. These options are the same whether you're adding a watermark or a caption, and if you switch from one to the other before actually running Process Multiple Files, your previous choices appear:

- Position. This tells Elements where to put your caption. Your options are Bottom Left, Bottom Right, or Centered. (Centered puts the text smack in the middle of your image.)
- Font. From the pull-down menu, choose any font on your computer. Chapter 14 has much more about text.
- Size. This setting (whose icon is two Ts) determines the size of your text. Click the menu next to the two Ts to choose from several preset sizes, up to 72 points.
- Opacity. Use this to adjust how solidly your text prints. Choose 100 percent for maximum readability or click the down arrow and move the slider to the left for watermark type that lets you see the image underneath it.
- Color. Use this setting to choose your text color. Click the box to bring up the Color Picker (page 217).

TIP If you want to use a logo as a watermark, the Process Multiple Files command can't help you. But you can apply a logo to a bunch of images: First, create your logo on a new layer in one of the images. Adjust the opacity with the slider in the Layers panel until you like the results, and then save the file. Now you can drag that layer from the Layers panel onto the image window for each photo. (If you Shift-drag the layer, it goes to exactly the same spot on each image, assuming they're all the same size.) You can also do this with Adjustment layers (page 181) to give yourself a sort of batch-processing capability for applying the same adjustments to multiple files. You can also create a custom brush from your logo (page 354) and use that, and then adjust the opacity or apply a layer style (page 401) for a truly custom look.

Retouching: Fine-Tuning Your Images

Basic edits like exposure fixes and sharpening are fine if all you want to make are simple adjustments. But Elements also gives you tools to make sophisticated changes that aren't hard to apply, and that can make the difference between a hohum photo and a fabulous one. This chapter introduces you to some advanced editing maneuvers that can help you either rescue damaged photos or give good ones a little extra zing.

The first part of the chapter shows how to get rid of blemishes—not only those that affect skin, but also dust, scratches, stains, and other photographic imperfections. You'll also learn some powerful color-improving techniques, including using the Color Curves tool, which is a great way to improve your image's contrast and color.

Then you'll learn to use the exciting new Recompose tool, which lets you change the size and shape of your photo, eliminate empty areas between subjects in an image, and even get rid of unwanted elements in your pictures, all without distorting the parts you want to keep. This amazing feature works so well that nobody seeing the results would ever suspect the photo wasn't originally shot that way.

Fixing Blemishes

It's an imperfect world, but in your photos, it doesn't have to be. Elements gives you powerful tools for fixing your subject's flaws: You can erase crow's feet and blemishes, eliminate power lines in an otherwise perfect view, or even hide objects you wish weren't in your photo. Not only that, but these same tools are great for fixing problems like tears, folds, and stains—the great foes of photoscanning veterans. With a little effort, you can bring back photos that seem beyond help.

Figure 9-1 shows an example of the kind of restoration you can accomplish with Elements and little persistence.

Figure 9-1: Top: Here's a section of a water-damaged family portrait. The grandmother's face is almost obliterated.

Bottom: The same image after repairing it with Elements. It took a lot of cloning and healing to get this close, but if you keep at it, you can do the kind of work that would have required professional help before Elements. If you're interested in restoring old photos, check out Katrin Eismann's books on the subject (Photoshop Restoration and Retouching [New Riders, 2006] is a good one to start with). They cover full-featured Photoshop, but you can adapt most of the techniques for Elements. You might also want to investigate The Photoshop Elements 5 Restoration and Retouching Book (Peachpit, 2007) by Matt Kloskowski. (Although it's for Elements 5 for Windows, you can still use the techniques in Elements 8 for Mac.)

Elements gives you three main tools for this kind of work:

• The Spot Healing brush is the easiest way to repair your photo. Just drag over the area you want to fix, and Elements searches the surrounding area and blends that info into the troubled spot, making it indistinguishable from the background. This brush usually works best on small areas, for reasons you'll learn in the next section.

- The Healing brush works much like the Spot Healing brush, only you tell the Healing brush which part of your photo to use as a source for the material you want to blend in. This makes the Healing brush better suited to large areas, because you don't have to worry about inadvertently dragging in unwanted details.
- The Clone Stamp works like the Healing brush in that you sample a good area and apply it to the area you want to fix. But instead of blending the repair in, the Clone Stamp actually covers the bad area with the replacement. This tool is best for situations when you want to *completely* hide the underlying area, as opposed to letting any of what's already there blend into your repair (which is how things work with the Healing brushes). The Clone Stamp is also your best option for creating a realistic copy of detail that's elsewhere in your photo. You can clone over some leaves to fill in a bare branch, for instance, or replace a knothole in a fence board with good wood.

All three tools work similarly: You drag each tool over the area you want to change. It's as simple as using a paintbrush. In fact, each of these tools requires you to choose a brush like the ones you'll learn about in Chapter 12. Brush selection is pretty straightforward; in this chapter you'll learn to make basic brush choices.

TIP To smooth out blotchy or blemished skin, check out the Surface Blur filter, explained on page 395. It's good to try for minor touch-ups that affect large areas. In contrast, the tools described in this section are better for fixing individual imperfections.

The Spot Healing Brush: Fixing Small Areas

The Spot Healing brush excels at fixing minor blemishes: pimples, lipstick smudges, stray lint, and so on. Simply paint over the area you want to repair, and Elements searches the surrounding areas and blends them into the spot you're brushing. Figure 9-2 shows what a great job this tool can do. (Download the file peppers.jpg from the Missing CD page at www.missingmanuals.com if you'd like to experiment with this tool.)

The Spot Healing brush's ability to borrow information from surrounding areas is great in some situations, but a drawback in others. The larger the area you drag the brush over, the wider Elements searches for replacement material. So if there's contrasting material too close to the area you're trying to fix, it can get pulled into the repair. For instance, if you're trying to fix a spot on an eyelid, you may wind up with some of the color from the eye itself mixed in with your repair.

You get best results from this brush when you choose a brush size that barely covers the spot you're trying to fix. If you need to drag to fix an oblong area, use a brush the smallest brush width that covers the flaw. The Spot Healing brush also works much better when there's a large surrounding area that looks the way you want your repaired spot to look.

Figure 9-2:

The trick to using the Spot Healing brush is to work on tiny areas. If you choose too large a brush or drag over too large an area, you're more likely to pick up undesired shades and details from the surrounding area

Top: Say you want to show off your garden's pepper crop but there's a large blemish on the largest pepper.

Bottom: One click with the Spot Healing brush (with a brush barely larger than the bruise) and you have a truly invisible fix.

- Brush. You can use this pull-down menu to choose a different brush style (see Chapter 12 for more about brushes), but you're usually best off sticking to the standard brush that Elements starts with and just changing the size, if necessary.
- Size. Use this box to set the brush's size.
- Type. These radio buttons let you adjust how the brush works. Proximity Match tells Elements to search the surrounding area for replacement pixels, and Create Texture tells it to blend only from the area you drag it over. Generally speaking, if Proximity Match doesn't work well, you'll get better results by switching to the regular Healing brush than by choosing Create Texture, though Adobe suggests that you may like the results you get from Create Texture better if you drag over a spot more than once.
- · Sample All Layers. Turn this on if you want the brush to look for replacement material in all your photo's visible layers. If you don't turn it on, Elements only chooses material from the active layer. (Another reason to turn this on: If you created a new, blank layer to heal on so you can blend your work in later by adjusting the healed area's opacity.)

You won't believe how easy it is to fix problem areas with the Spot Healing brush. All you do is:

1. Activate the Spot Healing brush.

Click the Healing brush icon (the Band-Aid) in the Tools panel or press J, and then choose the Spot Healing brush—the one with the dotted selection lines extending from it—from the pop-out menu.

2. Choose a brush size just barely bigger than the flaw.

You can choose your brush size from the Options bar Size slider or by pressing] (the close bracket key) for a larger brush or [(the open bracket key) for a smaller brush.

3. Click the bad spot.

If the brush doesn't quite cover the flaw, drag over the blemished area.

4. When you release the mouse button, Elements repairs the blemish.

You may see a weird dark gray area as you drag. Don't worry—it disappears when Elements fixes the photo after you let go.

Sometimes you get great results with the Spot Healing brush on a larger area if it's surrounded by a field that's similar in tone to the spot you're trying to fix. Most of the time, though, you're better off using the regular Healing brush for large areas and for flaws whose replacement material isn't right next to the bad spot. Read on to learn how.

The Healing Brush: Fixing Larger Areas

The Healing brush lets you fix much bigger areas than you can usually manage with the Spot Healing brush. The main difference is that with the regular Healing brush, *you* choose the area that gets blended into the repair. The blending makes your repair look natural, as Figure 9-3 shows.

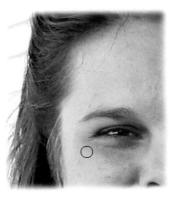

Figure 9-3: The Healing brush is especially remarkable because it also blends the textures of the areas where you use it.

Left: This photo shows the crow's-feet at the corner of the woman's eye.

Right: The Healing brush eliminates them without creating a phony, airbrushed effect.

The basic procedure for using the Healing brush is similar to that for the Spot Healing brush: Drag over the flaw you want to fix. The difference is that with the Healing brush, you first Option-click where you want Elements to look for replacement pixels. The repair material doesn't have to be nearby; in fact, you can sample from a totally different photo if you like. To sample material from another photo, just arrange both photos in your workspace so you can easily move the cursor from one to the other.

GEM IN THE ROUGH

Dust and Scratches

Scratched, dusty prints can create giant headaches when you scan them. Cleaning your scanner's glass helps, but lots of photos come with dust marks already in the print, or in the file itself if the lens or sensor of your digital camera was dusty.

A similar problem is caused by *artifacts*, blobbish areas of color caused by JPEG compression. If you take a close look at the sky in a JPEG photo, for instance, you may see that instead of a smooth swath of blue, there are lots of little distinct clumps of each shade of blue.

The Healing brushes are usually your best first line of defense for fixing these problems, but if the specks are widespread, Elements offers a couple other options.

The first is the JPEG artifacts option in the Reduce Noise filter (page 389). If you're lucky, that will take care of things.

If it doesn't, another possible solution is the Despeckle filter (Filter → Noise → Despeckle). And if that doesn't get everything, undo it and try the Dust and Scratches filter (Filter → Noise → Dust and Scratches), or the Median filter (Filter → Noise → Median). The Radius setting for these last two filters tells Elements how far to search for dissimilar pixels for its calculations; keep that number as low as possible. The downside to using the filters in this group is that they smooth things out in a way that can make your image look blurred, so you'll probably want to make a selection first to confine their effects to the areas that need repair. Generally, Despeckle is the filter that's least destructive to your image's focus.

You can also try creating a duplicate layer (Layer \rightarrow Duplicate), running the Surface Blur filter (page 395) on it and then, in the Layers panel, reducing the opacity of the filtered layer.

The Healing brush offers you quite a few choices in the Options bar:

- Brush. Click the brush thumbnail for a pop-out palette that lets you customize the size, shape, and hardness of your brush (see page 347). But generally, the standard brush works well, so you don't have to change things other than the size. If you have a graphics tablet (page 491), you can use the menu at the bottom of the palette to tell Elements you want to control the brush size by how hard you press on the stylus or the stylus's scroll wheel.
- Mode. You can choose some blend modes (page 361) here, but most of the time, you want one of the top two options: Normal and Replace. Normal is usually your best choice, but if your replacement pixels make the area you work on show a visibly different texture than the surrounding area, choose Replace instead, which preserves the grain of your photo.

- Source. You can sample an area to use as a replacement, or you can blend in a pattern. Using the Healing brush with patterns is explained on page 276.
- Pattern thumbnails. If you decide to use a pattern, this box becomes active. Click it to select a pattern.
- Aligned. If you turn on this checkbox, Elements keeps sampling new material in your source as you use the tool. The sampling follows the direction of your brush. Even if you let go of the mouse button, Elements continues to sample new material as long as you continue brushing. If you leave Aligned turned off, all the material comes from the area where you first defined your source point.

Generally, for both the Healing brush and the Clone Stamp, it's easier to leave Aligned turned off. You can still change your source point by Option-clicking another spot, but you often get better results if *you* make the decision about when to move on to another location rather than letting Elements decide.

- Sample All Layers. This checkbox tells Elements to sample from all the visible layers (page 166) in the area where you set your source point. You'd also use it if you want to heal on a new blank layer. Leave it turned off and Elements samples only the active layer.
- Overlay Options. Click this icon (the gray overlapping squares) for a pop-out menu that lets you turn on and adjust a visible overlay for your photo. It lets you see a floating, ghostly overlay of the source area where you're sampling in relation to your original, so you can tell exactly how things line up for accurate healing. You can also adjust the opacity of the overlay or invert it (make the light areas dark and the dark areas light so that you can see details better, if necessary) for a better view. Turning on the Auto Hide checkbox makes the overlay disappear when you click so it's not in your way as you work. The Clipped option pins the overlay to your current brush so that you see only a brush-sized piece of overlay rather than one that covers the entire image. (If you notice strange gray circles following your brush around, this setting is turned on.)

If you're a beginner, you'll probably want to leave the overlay off, but advanced healers may find it useful. It's also available for the Clone Stamp, and the settings you choose for one tool apply when you switch to the other tool.

It's almost as simple to use the Healing brush as it is to use the Spot Healing brush:

1. Activate the Healing brush.

Click the Healing brush's icon (the Band-Aid) in the Tools panel or press J and choose it from the pop-out menu.

2. Find a good spot to use in the repair and Option-click it.

When you Option-click the good spot, your cursor temporarily turns into a circle with crosshairs in it to indicate that this is the point from which Elements will retrieve your repair material. (If you want to use a source point in a different photo, both the source photo and the one you're repairing have to be in the same *color mode*—see page 51.)

3. Drag over the area you want to repair.

You can see where Elements is sampling the repair material from because Elements displays a cross in that spot. As with the Spot Healing brush, the area you drag over turns dark until you release the mouse button.

4. When you release the mouse, Elements blends the sampled area into the problem area.

Often you don't know how effective you were until Elements is through working its magic, because it may take a few seconds for the program to finish its calculations and blend in the repair. If you don't like what Elements does, press **%**-Z to undo it and try again.

You can also heal on a separate layer. The advantage of doing this is that if you find the end result is a little too much—your granny suddenly looks like a Stepford wife, say—you can back things off a bit by reducing the opacity (page 166) of the healed layer to let the original show through. This is also a good plan when using the Clone Stamp (explained next). Just press \$\mathbf{H}\$-Shift-N to create a new layer and then turn on Sample All Layers in the Options bar.

The Clone Stamp

The Clone Stamp is like the Healing brush in that you add material from a source point that you select. The main difference between the two tools is that the Clone Stamp doesn't *blend in* the new material—it just covers up the underlying area. This makes the Clone Stamp great for when you don't want to leave any trace of what you're repairing. Figure 9-4 shows an example of when cloning is a better choice than healing.

Figure 9-4:

Here's an example of when you'd choose cloning over healing.

Top left: Say you want to get rid of the distracting white bottom part of this banner.

Top right: Using the Healing brush leaves a chalky whiteness from where it's blended the sign and the replacement brick.

Bottom: The Clone Stamp works much better. Only the lower-right portion was fixed, but you can see how much better the Clone Stamp covers up the banner. The choices you make in the Options bar for the Clone Stamp are important in getting the best results:

- Brush. You can use this pull-down menu to select a different brush style (see Chapter 12 for more about brushes), but the standard brush style usually works pretty well. If the soft edges of the cloned areas bother you, you may be tempted to switch to a harder brush, but that usually makes your photo look like you threw confetti on it, because hard edges don't blend with what's already there.
- Size. Choose a brush that's just big enough to get your sample without picking up other details that you don't want in your repair. While it may be tempting to clone huge chunks to speed things up, most of the time you'll do better using the smallest brush that gets the sample you want.
- Mode. You can choose any blend mode (page 361) for cloning, but Normal is usually your best bet. Other modes can create interesting special effects.
- Opacity. Elements automatically uses 100-percent opacity for cloning, but you can reduce this setting to let some details from your original show through.

TIP You gain more control by placing your clone on another layer (see page 161) than by adjusting the Clone Stamp's opacity.

- Aligned. This setting works exactly the way it does for the Healing brush (page 271). Turn it on and Elements keeps sampling at a uniform distance from your cursor as you clone. Turn it off and you keep putting down the same source material. Figure 9-5 shows an example of when you'd turn on Aligned. (If you drag rather than click with the Clone Stamp, Elements turns on the Aligned checkbox automatically.)
- Sample All Layers. When you turn on this checkbox, Elements takes its samples from all the visible layers in the area where you set your source point. When it's off, Elements samples only the active layer.
- Overlay Options. Click this icon (the two overlapping rectangles) and choose Show Overlay to turn on a pale overlay that shows the clone source area floating over the original, so you can see how your possible source material aligns with the original. This is confusing at first, but once you get the hang of it, it's helpful when cloning precise patterns. If you've ever used the Clone Stamp before and accidentally cloned from the wrong spot, or dragged in details you didn't mean to grab, you'll love this feature. The options for adjusting the overlay are the same as for the Healing brush (page 271), which shares this feature. Settings you choose here apply when you use the Healing brush and vice versa.

The Clone Stamp shares its space in the Tools panel with the Pattern Stamp, which is explained on page 278. (You can tell which is which because the Pattern Stamp icon has a blue checkerboard to its left.) Using the Clone Stamp is much like using the Healing brush; only the result is different.

Figure 9-5:

One way to get rid of the power line in this photo is to use the Clone Stamp's Alignment option. The thick power line entered this photo at the upper left, above the smaller lines you can still see in the background. By choosing a brush barely larger than the power line and sampling just above the line, you can replace the entire thing in one long sweep, despite the many changes in the background as you go.

WORKAROUND WORKSHOP

Repairing Tears and Stains

With Elements, you can do a lot to bring damaged photos back to life. The Healing brush and the Clone Stamp are major players when it comes to restoring pictures. It's fiddly work that takes some persistence, but you can achieve wonders if you have the patience.

If you're lucky enough to have good-sized useable replacement sections in your photo, you can use the Move tool to copy the good bits into the problem area. First, select the part you want to copy. Then press V to activate the Move tool and Option-drag the good piece where you want it. (Page 150 has more about the Move tool.)

You can use the Rotate commands to flip your selection if you need a mirror image. For example, if the left leg of a chair is fine but the right one is missing, try selecting and Option-dragging the left leg with the Move tool. When it's where you want it, go to Image \rightarrow Rotate \rightarrow Flip Selection Horizontal to turn the copied left leg into a new right leg.

If you don't need to rotate an object, sometimes you can just increase the Clone Stamp's brush size and clone the object where you need a duplicate. This technique works well only when the background is the same in both areas.

1. Activate the Clone Stamp.

Click its icon (the rubber stamp) in the Tools panel or press S, and then choose it from the pop-out menu.

TIP You can clone on a separate layer, just as you can use the Healing tool on a dedicated layer. This lets you adjust the opacity of your repair afterwards. Press Shift-**%**-N to create a new layer and then turn on Sample All Layers in the Options bar. It's a good idea to clone on a separate layer, since cloning is so much more opaque than healing.

2. Find the spot in your photo that you want to repair.

You may need to zoom way, way in to get a good enough look at what you're doing. Page 82 tells you how to adjust the view.

3. Find a good spot to sample as a replacement for the bad area.

You want an area that has the same tone as the area you're fixing. The Clone Stamp doesn't do any blending the way the Healing brush does, so tone differences are pretty obvious.

4. Option-click the spot you want to clone from.

When you click, the cursor turns to a circle with crosshairs in it, indicating the source point for the repair. (Once you're actually working with the Clone Stamp, you see a cross marking the sampling point.)

5. Click the spot you want to cover.

Elements puts whatever you just selected on top of your image, concealing the original. You can drag with the Clone Stamp, but that makes it act like it's in Aligned mode (described in the previous list), so it's often preferable to click several times for areas that are larger than your sample. (The only difference between real Aligned mode and what you get from dragging is that with dragging, when you let go of the mouse, your source point snaps back to where you started. If you turn on Aligned, your source point stays where you stopped.)

6. Continue until you've covered the area.

With the Clone Stamp, unlike the Healing brush, what you see as you click is what you get—Elements doesn't do any further blending or smoothing.

The Clone Stamp is a powerful tool, but it's crotchety, too. See the box below for some suggestions on how to make it behave.

TROUBLESHOOTING MOMENT

Keeping the Clone Stamp Under Control

The Clone Stamp is a great tool, but it sometimes has a mind of its own.

If you suddenly see spots of a different shade appearing as you clone, take a look at the Aligned checkbox in the Options bar. It has a tendency to insist on staying turned on, and even if you turn it off, it can turn itself back on when you aren't paying attention.

Once in a great while, the Clone Stamp just won't reset itself when you try to select a new sampling point. Try clicking the tiny down arrow on the left end of the Options

bar and choosing the Reset Tool option, as shown in Figure 9-6. If that doesn't do it, quit Elements and then relaunch it and delete Elements' preferences file. Here's how: Hold down %-Option-Shift immediately after launching Elements. You get a dialog box asking if you want to delete the program's settings. Click Yes. This returns all your Elements settings to where they were the first time you launched the program, and usually cures about 80 percent of the problems you may run into in Elements.

Figure 9-6:

Left: You can reset the Clone Stamp (or, for that matter, any Elements tool) by clicking this tiny arrow (circled) at the left end of the Options bar

Right: From the pop-up menu, choose Reset Tool. (If you want to reset the whole Tools panel, choose Reset All Tools.) This clears up a lot of the little problems you may have when trying to make a tool behave.

Applying Patterns

In addition to solid colors, Elements lets you add patterns to your images, too. Quite a few patterns come with the program, and you can download more (see page 493) or create your own. You can use patterns to add interesting designs to your images or give more realistic textures to certain repairs.

You can use either the Healing brush or the Pattern Stamp to apply patterns. The Healing brush has a pattern option in the Options bar. The Pattern Stamp shares a Tools panel slot with the Clone Stamp, and it works much like the Clone Stamp, but puts down a preselected pattern instead of a sampled area. The tool you use to apply the pattern makes a big difference, as you can see from Figure 9-7. The next two sections explain how to use both tools.

NOTE Elements gives you lots of ways to use patterns, including creating a Fill layer that's covered with the pattern you choose. Fill layers are covered on page 180.

The Healing Brush

The Healing brush's Pattern mode is great for things like improving the texture of someone's skin by applying just the skin texture from another photo.

Using patterns with the Healing brush is just as easy and works the same way as using the brush in normal healing mode: Just drag across the area you want to fix. The only difference is that you don't have to choose a sampling point, since the pattern is your source point. When you drag, Elements blends the pattern you selected your photo.

After activating the Healing brush (keyboard shortcut: J), click the Pattern radio button in the Options bar and then choose a pattern from the pop-out palette. You can see more pattern libraries by clicking the two arrows in the palette's upper-right corner, or you can create and save your own patterns. Figure 9-8 explains how to create custom patterns for use with either the Healing brush or the Pattern Stamp.

TIP Changing the blend mode (page 361) when using patterns can help you create some interesting effects.

Figure 9-7:

The same pattern applied with the Healing brush (left) and the Pattern Stamp (right). The Healing brush blends the pattern into the underlying color (and texture, when there is any), while the Pattern Stamp just plunks down the pattern as it appears in the pop-out palette. (To get a softer edge on the Healing Brush's pattern, choose a softer brush from the popout palette.)

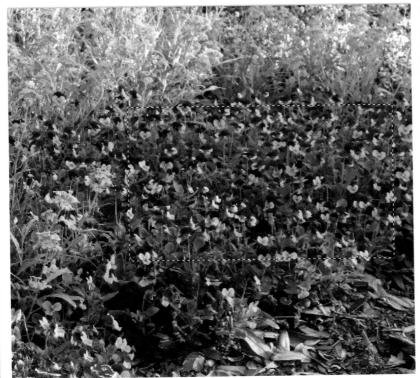

Figure 9-8:

You can easily create

your own patterns. In any image, make a rectangular, unfeathered selection, and then choose Edit → "Define Pattern from Selection". Your pattern appears at the bottom of the current pattern palette, and a dialog box pops up so you can name the new pattern. To use the whole image, don't make a selection—just go to Edit → Define Pattern. To rename or delete a pattern later, right-click (Control-click) it in the Pattern palette and make your choice. You can also download hundreds of different patterns from various online sources (see page 493).

The Pattern Stamp

This tool is like the Clone Stamp, but instead of copying sampled areas, it puts down a predefined pattern that you select from the Pattern palette. The Pattern Stamp is useful when you want to apply a pattern to your image without mixing it with what's already there. For instance, if you want to see what your patio would look like if it were a garden, you could use the Pattern Stamp to paint a lawn and a flower border on a photo of your patio.

To get started, click the Clone stamp in the Tools panel, and then choose the Pattern Stamp from the pop-out menu. Click the pattern thumbnail in the Options bar to open the Pattern palette so you can choose a pattern. Other options for this brush, like the size, hardness, and so on, are the same as for the Clone Stamp. The one extra option is the Impressionist checkbox demonstrated in Figure 9-9, which is mostly useful for creating special effects.

Once you've selected a pattern, drag in your photo where you want Elements to put that pattern.

Figure 9-9:
If you turn on Impressionist in the Options bar, Elements blurs your pattern, giving an effect vaguely like an Impressionist painting. Here you see a pattern put down with the regular Pattern Stamp (left) and the Impressionist stamp (right).

Recomposing Photos

The previous sections taught you how to remove flaws and objects you don't want in your photos by manually covering them up bit by bit. But maybe you're thinking, "It seems so last-century to have to drudge away like that. There's got to be an easier way!" You're right—there is.

One of the coolest new features of Elements 8 is the Recompose tool, which lets you eliminate unwanted objects and people from your photos by just scribbling a line over them, then pushing the edges of your photo to reshape it. Amazingly, Elements can figure out how to keep the rest of the photo undistorted as it makes the unwanted objects vanish. It's truly amazing. Take a look at Figure 9-10 to see what this tool can do. Want to get rid of your daughter's ex-boyfriend in that group shot? Just draw a line on him in the photo, push the image's edges closer together, and he's history. Couldn't get your feuding coworkers to stand close enough together in the holiday party photo? No problem—you can easily take out that empty space between them.

Figure 9-10:
Top: So what do you do if you have a wide photo of your sailboat and you'd the other boats (and also moor it off an island with less condo sprawl)?

Bottom left: Make a few marks on it with the Recompose tool (the green marks mean "Keep this" and the red ones "Lose this"), and then drag one edge toward the middle of the photo.

Bottom right: The end result: a narrow photo of the boats with fewer buildings in the background.

You can also use the Recompose tool to alter the shape of your photo without cropping it. Have a landscape-oriented photo that you wish were portrait-oriented instead? Recompose can fix that. There are limits to what it can do, but with a suitable photo, you can just shove it into the proportions you want, and everything will look perfectly normal and not at all distorted.

It takes an awesome amount of computer intelligence to make this tool work, but it's one of the easier tools in Elements to use:

1. Open a photo and activate the Recompose tool.

Adobe thinks this tool is so useful that they gave you several ways to get at it:

- From the Tools panel. In Full Edit, the Recompose tool shares a slot with the Crop tool. Their keyboard shortcut is C.
- From the Image menu. Go to Image → Recompose, or press Option-\.R.
- In Create Projects. Right-click (Control-click) in any of the Content panel's frames and Recompose Photo is one of your choices, whether you're in Create or Edit mode.

2. Tell Elements which parts of your photo you don't want to change.

You use the Protect brush to indicate which areas you want preserved. To select this brush, click the leftmost icon in the Options bar—the green paintbrush and lock. Then drag over the areas you want to keep. This is something like using the Quick Selection tool in that you don't have to select everything, just make enough marks for Elements to know which objects you mean. This tool is more literal-minded than the Quick Selection tool, so you may need more marks when using it (see Figure 9-11).

TIP The Recompose tool has a hidden menu to speed things up. Right-click (Control-click) your photo when the tool is active and you can choose Quick Highlight, which makes the whole process of telling Elements what to keep and what to eliminate go much faster. You tend to get better results with this method, too.

In addition, in the Options bar, click the "Highlight Skin tones" icon (the little green man) to automatically select the people in your photo.

3. Tell Elements what you want to get rid of.

To delete specific objects or areas, drag over them with the Remove brush (click the Options bar icon that looks like a red paintbrush and an X).

NOTE You don't always need to use both of the Recompose tool's brushes. You can try not marking anything at all, but you'll likely get better results if you give Elements a little guidance. If you make a mistake with either brush, use the matching eraser (the icon just to the brush's right) to remove the stray marks.

Figure 9-11:

Recomposing can help you change the aspect ratio of a photo, like this lotus image that's too wide for its frame.

Top: A quick scribble over the flower tells Elements to leave that part of the photo alone. Notice that there aren't any Removal marks in this image.

Bottom: Drag one of the square handles Elements puts around the image toward the middle of the photo and Recompose squishes the photo down to size without obviously distorting the leaves

Recompose your photo.

Once you're through marking up your photo, you can use the familiar bounding box around the image to resize it. It works just like the Move tool's bounding box: Grab a handle or a corner and drag to change the shape of your image. There are several Options bar settings that can help you out if you need to make the photo a specific size; they're explained below.

NOTE If you want to make your image wider or taller than it is now (to make a portrait-orientated photo into a landscape one, for example), you first need to add canvas (page 97) to your image to give the new width or height someplace to go.

Watch as the unwanted areas disappear as you drag the edges closer together. (The disappearing part doesn't work so well when you're making the image larger rather than smaller.)

5. Finish up.

When you're happy with your image, click the Commit button (the green checkmark) or press Return. If you decide you don't want to recompose after

all, or if you need to go back and adjust the marks on the picture, click the red Cancel button. When you're done, crop off any extra blank space on the edges of your photo. Cropping is explained on page 75.

NOTE Occasionally, you may find that some remnants of removed objects reappear after you press Return. Just use the Clone Stamp (page 272) or the Healing Brush (page 269) to get rid of them.

The Recompose tool has several Options bar settings to make your job easier:

- Brushes. There are four brush icons. From left to right they are: the Protect brush, "Erase highlights marked for protection" (the eraser for Protect marks you don't want), the Remove brush, and "Erase highlights marked for removal" (the eraser for Remove marks you made by mistake).
- Brush size. This is just like the size setting for any brush tool: Enter a size in pixels, scrub on the Options bar, or use the bracket key shortcuts to change the size. (Chapter 12 covers brushes in detail.)
- Highlight Skin tones. Click this icon and, if you're lucky, Elements selects the people in your photo. It's kind of dicey, though—you may find Elements prefers other objects to the folks in your pictures, but it's worth a click, since you can always undo Elements' selection.
- Preset. Normally this option is set to No Restriction, which lets you drag any way you like, but you can also choose to recompose to the photo's current aspect ratio or to one of several popular photo paper sizes. If you make a choice here or in the width and height boxes, Elements recomposes your photo to those numbers.
- W (width) and H (height). If you want to enter a custom size, do that here. Click the arrows between the boxes to swap the numbers, just as you can with the Crop tool.
- Amount. This tells Elements how much you want to protect the details from distortion. Leave it at 100%.

What's most amazing about this tool is the way your background still looks real when you're done. Someone seeing your Recomposed photo would never guess that it didn't start out looking just like it does now. Recomposing doesn't work for *every* photo, but when it does, the results are almost magical.

Color Curves: Enhancing Tone and Contrast

If you hang around photo-editing veterans, you'll hear how useful the Curves tool is. Contrary to what you might expect, Curves isn't a drawing tool. Instead, it works much like Levels (page 206), but with many more points of correction. Adobe calls the Elements version of this tool *Color Curves* to remind you what it's for. Unlike Levels, which lets you set your entire photo's white point, black point, and midtone settings, Curves lets you target specific tonal regions. For instance,

Curves lets you make only your shadows lighter or only your highlights darker. Maybe that's why some pros say, "Curves is Levels on steroids." (The box on page 211 has advice on when to use Levels and when to use Color Curves.)

Elements' Color Curves tool is a stripped-down version of its counterpart in the full version of Photoshop, which is just called Curves. With Photoshop's Curves tool, you can work on each color channel separately, as you do in the Levels dialog box. You can also drag any point on the Curves graph (like the one you see Figure 9-12) to manipulate it. For example, you can drag to adjust just the middle range of your greens. Elements doesn't give you that kind of flexibility.

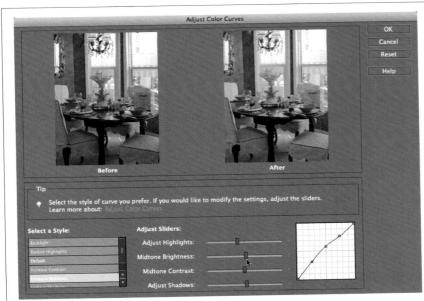

Figure 9-12:
The Adjust Color Curves dialog box gives you a good look at what you're doing to your photo with large before and after previews. Start by clicking around in the list of preset styles on the lower-left side of the window, and then use the sliders in the middle of the lower section to fine-tune the effect.

Since Curves, in its original-strength version, is a pretty complicated tool, Adobe makes it easier to use in Elements. Elements starts you with a group of preset adjustments to choose from (see Figure 9-12). These presets are shortcuts to the types of basic enhancements you'll use most often. Just click one to try it. If you like what it does, you're done. But if you aren't satisfied with any of the presets, you can easily make adjustments in the Adjust Color Curves dialog box's advanced options, to the right of the presets.

Here's how to improve a photo's appearance with Color Curves:

1. Open your photo and make a duplicate layer.

Press **%**-J or go to Layer → Duplicate Layer. Elements doesn't let you use Color Curves as an Adjustment layer (unlike Photoshop), so you're safer applying it to a duplicate layer in case you want to change something later.

To restrict your adjustment to a particular area of your photo, select it first so that Color Curves changes only the selected area. For instance, if you're happy with everything in your shot of Junior's Little League game except the catcher in the foreground, select him, and you can do a Color Curves adjustment that affects only him. (See Chapter 5 for a refresher on selections.)

2. Go to Enhance → Adjust Color → Adjust Color Curves.

Elements opens the Adjust Color Curves dialog box, where you see your original image in the preview on the left.

3. Choose a Color Curves preset.

Scroll through the list in the lower-left of the window and click the preset that seems closest to what you want. Feel free to experiment by clicking different presets. (As long as you're just clicking in the list, you don't need to click Reset between each one, since Elements starts from your original each time you click.)

The dialog box gives you a decent-sized look at how you're changing your image, but for important photos, you can also preview the effect right in your image. To do that, drag the dialog box out of the way and check your actual photo to see how you're changing things before you commit.

4. Apply the changes, or tweak them some more.

If you're satisfied, click OK. If not, go to the next step. (And if you decide not to apply any Color Curves adjustments, click Cancel.)

5. Make any further adjustments.

If you think your photo still doesn't look quite right, use the sliders shown in Figure 9-13 to tweak your photo. (The sliders are described in a moment.) Click Reset if you want to undo any of the changes you make with the sliders. Easy does it here: Notice how subtle the preset curves are; a tiny nudge of these sliders makes a big difference, so be gentle.

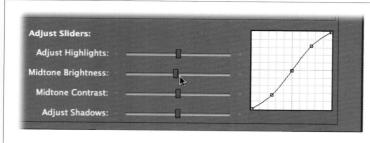

Figure 9-13:
The graph on the right side of this figure is where the Color Curves feature gets its name. When you first open the Adjust Color Curves dialog box, with no adjustments at all, the graph is a straight diagonal line. The changes you make cause the points on the graph to move, resulting in a curved line. Click Reset (not shown) to go back to the straight line again, or click Default in the list of presets.

6. When you're happy with your photo's new look, click OK.

Don't forget to save your changes. If you used a duplicate layer, you can always change your mind later on and start over on a fresh layer.

NOTE If you've used Curves add-ons in an old version of Elements—like those from Richard Lynch or Grant Dixon, for example—or if you've used the Photoshop Curves Adjustment Layers (you power user, you!), the Color Curves tool may take some getting used to. Some of the add-on toolsets for Elements still let you make corrections on a graph rather than with the sliders. See page 493 for more about add-ons.

Once you have some Color Curves experience under your belt, you probably won't be satisfied with the presets. So don't hesitate to use the sliders to adjust different tonal regions in your photo:

- Adjust Highlights. Move this slider to the left to darken your photo's highlights, or to the right to lighten them.
- Midtone Brightness. If you'd like the middle range of colors to be darker, move this slider to the left. Move it to the right to make the midtones brighter.
- Midtone Contrast. This slider works just like the one in the Shadows/Highlights feature (see page 196). Move it to the right to increase your photo's contrast, and to the left to decrease it.
- Adjust Shadows. If you want to lighten shadows, move this slider to the right. To darken shadow areas, move it to the left.

As you move the sliders, you can see the point you're adjusting move on the graph and watch the curve change shape. Although it's fun to see what's going on in the graph, you should pay more attention to what's happening in your photo.

Color Curves is such a potent tool that it can change your photo in ways you don't intend. Rather than using Color Curves to make huge adjustments, try another tool first. Then come back and use Color Curves for the final, subtle tweaks. On the other hand, you can also use Color Curves to create some wild special effects, if that's what you're after. See Figure 9-14 for an example.

TIP You can also apply the Solarize adjustment to part of your photo by using the Smart Brush tool (page 196). But if you use the brush method, you can't edit the settings afterward, so you may prefer to apply Solarize using Color Curves on a duplicate layer.

Making Colors More Vibrant

Do you drool over the luscious photos in travel magazines, the ones of vivid destinations that make regular life seem drab in comparison? What *is* it about those photos that makes them so dramatic?

Figure 9-14:
Many people prefer to use Color Curves for artwork and special effects rather than adjusting photos. Jimi Hendrix fans may like the Solarize preset, which Adobe includes to give you a starting point for funky pictures like this one. (Others say this preset should serve as a warning about going overboard with this tool.)

Often the answer is the *saturation*, or intensity, of the colors. Supersaturated color makes for darned appealing landscape and object photos, regardless of how the real thing may rate on the vividness scale.

There are various ways to adjust the saturation of your photos. Some cameras have features that help control it, but Elements lets you go even further. For example, by increasing or decreasing a photo's saturation, you can shift the perceived focal point, change the mood of the picture, or just make your photo more eye-catching.

By increasing your subject's saturation and decreasing it in the rest of the photo, you can focus your viewer's attention, even in a crowded photo. Figure 9-15 shows a somewhat exaggerated use of this technique; you can download the photo (*moth.jpg*) from the Missing CD page at *www.missingmanuals.com* to try it out for yourself.

It's easy to change saturation. You might want to start with the Raw Converter's Vibrance slider—remember that you can open other image formats there besides Raw files. If that doesn't work well, try using either of the more traditional methods: the Hue/Saturation dialog box or the Sponge tool, which are explained in the following sections. For big areas or when you want a lot of control, use Hue/Saturation. If you just want to quickly paint a different saturation level (either more or less saturation) on a small spot in your photo, the Sponge tool is faster.

TIP Many consumer-grade digital cameras are set to crank the saturation of your JPEG photos into the stratosphere. That's great if you love all the color. But if you prefer not to live in a Technicolor universe, you can desaturate your photos in Elements to remove some of the excess color.

Figure 9-15: Top: All the yellow flowers in this image are equally bright, including those in the background, so you might miss the butterfly on the front blossom.

Bottom: To make the butterfly and its flower stand out from the crowd, desaturate the rest of the image.

The Hue/Saturation Dialog Box

Hue/Saturation is one of the most popular commands in Elements. If you aren't satisfied with the results of a simple Levels adjustment, you may want to work on the hue or saturation as the next step toward getting eye-catching color.

Hue simply means the color of your image—whether it's blue or brown or purple or green. Most people use the saturation adjustments more than the hue controls, but both hue and saturation are controlled by the same dialog box, where you can adjust both or just one.

In Elements, you can use the Hue slider to actually change the color of objects in your photos, but you probably want to adjust saturation far more often than you want to shift the hue of a photo.

When you use Hue/Saturation, it's a good idea to first make most of your other corrections—like Levels or exposure corrections (see page 192). When you're ready to use the Hue/Saturation command, just follow these steps:

1. If you want to adjust only part of your photo, select the area you want.

Use whatever Selection $\operatorname{tool}(s)$ you prefer. (See Chapter 5 for more about making selections.)

2. Call up the Hue/Saturation dialog box.

Go to Enhance → Adjust Color → Adjust Hue/Saturation, or go to Layer → New Adjustment Layer → Hue/Saturation. As always, if you don't want to make changes that you can't easily reverse, use an Adjustment layer instead of working directly on your photo. (If you choose the layer, you make your changes in the Adjustments panel [page 161] rather than the dialog box, but your options are exactly the same.)

3. Move the sliders until you like what you see.

To adjust only saturation, ignore the Hue slider. Move the Saturation slider to the right to increase the amount of saturation (more color) or to the left to decrease it. If necessary, move the Lightness slider to the left to make the color darker, or to the right to make the color lighter. Incidentally, you don't have to change all the colors in your photo equally. Figure 9-16 explains how to focus on individual color channels.

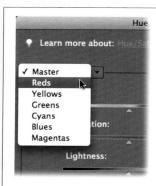

Figure 9-16:

The Hue/Saturation controls include a pull-down menu that lets you adjust individual color channels. If only the reds are excessive (a common problem with digital cameras), you can lower the saturation only for the reds without changing the other channels.

TIP Generally speaking, if you want to change a pastel to a more intense color, you'll need to increase the saturation *and* reduce the lightness (move the slider to the left) if you don't want the color to look radioactive

Adjusting Saturation with the Sponge Tool

The Sponge tool gives you another way to adjust saturation. Even though it's called a sponge, the Sponge tool works like any other brush tool in Elements. Choosing the size and hardness are the same as choosing them for any other brush (see page 347).

TIP Although the Sponge tool is handy for working on small areas, all that dragging gets old when you're working on a large chunk of your image. For those situations, use the Hue/Saturation dialog box instead.

The Sponge has a couple of unique settings:

- Mode. Here's where you choose whether to saturate (add color) or desaturate (remove color).
- Flow. This setting governs how intense the effect is; a higher number means more intensity.

To use the Sponge tool, drag over the area you want to change. Figure 9-17 shows the kind of work the Sponge does.

Figure 9-17:
Here, the Sponge tool was applied to the upper-right part of the wall, increasing the color saturation and bringing out the reddish paint colors. Approach the Sponge tool with caution: It doesn't take much to degrade in your image, especially if you've made lots of other adjustments to it. So if you start to see noise (graininess), undo your sponging and try it again at a reduced Flow setting.

You may want to press \(\mathbb{H}\)-J to create a duplicate layer before using the Sponge. Then you can always throw out the duplicate layer later if you don't like the changes. Here's how to use this tool:

1. Activate the Sponge tool.

Press O or click its icon in the Tools panel, and then choose the Sponge from the pop-out menu. Choose the brush size and the settings you want in the Options bar.

2. Drag in the area you want to change.

If you aren't seeing enough of a difference, increase the Flow setting a little. If it's too strong, reduce the Flow number.

TIP If you have a hard time coloring (or decoloring) inside the lines, select the area you want before starting with the sponge. Then the tool won't do anything outside the selection, so you can be as sloppy as you like.

Changing an Object's Color

In Chapter 4, you saw one way to change the color of an object: Select it and use the Hue and Saturation sliders in Quick Fix. Elements also gives you other ways to do this: You can use an Adjustment layer, the Replace Color command, or the Color Replacement tool. And the Smart Brush tools (page 196) offer a whole menu of color changes, too.

The method you choose depends on your photo and personal preference. Using an Adjustment layer gives you the most flexibility if you want to make changes later. Replace Color is the fastest way to change one color that's widely scattered throughout your whole image, and the Color Replacement tool lets you quickly brush a replacement color over the color you want to change. Whichever method you choose, Figure 9-18 shows the kind of complex color change you can make in a jiffy using any one of these methods.

Figure 9-18: What if you have a green-and-white vase, but you really want a red-and-white one? Call up the Replace Color tool. Elements gives you several ways to make a complicated color substitution like this, all of which are covered in this section

The Smart Brush lets you target the area you want to change and make a quick color adjustment, but the color presets are pretty limited (and pretty ugly). Also, the Smart Brush doesn't just apply a single color, but uses gradient maps (page 415) instead. If you can get the effect you like using the Smart Brush, go for it. But it's much harder to adjust the color with this tool by changing its settings, since you have to pick a different gradient or edit the gradient the Smart Brush used (page 409 tells you how). On the whole, the methods described in the following pages are much simpler to control.

Using an Adjustment Layer

You can use a Hue/Saturation Adjustment layer to make the same kind of color changes that you saw on page 290. The advantage of the Adjustment layer method is that you can change the settings or the area affected by the layer later (as opposed to changing your whole image). The process is the same as the one described on page 287, only this time, you start by selecting what you want to change:

1. Select the object whose color you want to change.

Use any of the Selection tools (see Chapter 5). If you don't make a selection before creating the Adjustment layer, you'll change your whole photo.

2. Create a new Hue/Saturation Adjustment layer.

Go to Layer \rightarrow New Adjustment Layer \rightarrow Hue/Saturation. The new layer affects only the area you selected.

3. Use the Adjustment panel's sliders to tweak the color until you see what you want, and then click OK.

Use the Hue slider first to pick the color you want. When you're close to the right color, use the Saturation slider to adjust the color's vividness and the Lightness slider to adjust its darkness.

This method is fine if it's easy to select the area you want to change. But what if you have a bunch of different areas or you want to change one shade everywhere it appears in your photo? For that, Elements offers the Replace Color command.

Replacing Specific Colors

Take a look at the green-and-white vase in Figure 9-18 again. Do you have to tediously select each green area if you want to make it a red-and-white vase? You can do it that way, but it's far easier to use the Replace Color command. It has one of those Elements dialog boxes that looks a bit intimidating, but it's a snap to use once you understand how it works. Replace Color changes every instance of the color you select, no matter how many times it appears in your image.

You don't need to start by making a selection when you use this command. As usual, if you want to keep your options for future changes open, make a duplicate layer (\mathbb{H}.J). Before you start, be sure your active layer isn't an Adjustment layer, or Replace Color won't work. Then:

1. Open the Replace Color dialog box.

Go to Enhance → Adjust Color → Replace Color. The Replace Color dialog box in Figure 9-19 appears.

TIP To protect a particular area of your chosen color from being changed, paint a mask on it by using the Selection brush in Mask mode (page 133) before you start.

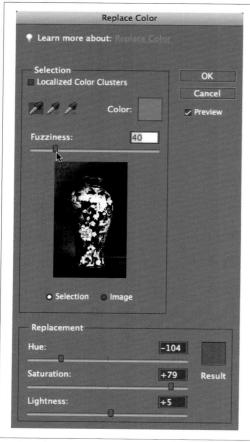

Figure 9-19:

The area of the Replace Color dialog box that looks like a negative shows you where the sliders will affect the color. Use the Hue/Saturation sliders to adjust the replacement color (shown in the bottom-right color square) the way you would with a regular Hue/Saturation adjustment. Fuzziness works a little like the Tolerance Setting for the Magic Wand, as explained in Figure 9-20. The Localized Color Clusters setting is something like Contiguous for the Magic Wand—it restricts the selection to colors near where you click.

2. Move your cursor over your photo.

The cursor changes to an eyedropper. Make sure that the left eyedropper in the Replace Color dialog box (the one without a plus or minus sign by it) is the active one.

3. Click an area of the color you want to replace.

Elements selects all the areas matching the particular shade you selected, but you won't see the marching ants in your image the way you do with the Selection tools. If you click more than once, you *change* your selection instead of adding to it, the way you would with any of the regular Selection tools. To add to your selection (that is, to select additional shades), Shift-click in your photo.

Another way to add more shades is to select the middle eyedropper (the one with the + sign next to it) and click in your photo again. To remove a color, select the right eyedropper (with the – sign) and click, or Option-click with the leftmost eyedropper. If you want to start selecting all over again, Option-click the Cancel button to turn it to a Reset button.

4. When you've selected everything you want to change, move the sliders to replace the color.

The Hue, Saturation, and Lightness sliders work exactly the way they do in the Hue/Saturation dialog box (explained earlier in this chapter). Move them and watch the color box in the Replace Color dialog box to see what color you're concocting. You can also click the color box to bring up the Color Picker (page 217) and choose a shade there. If you need to tweak the area you're changing, the Fuzziness slider adjusts the range of colors that Color Replacement affects, as shown in Figure 9-20.

Figure 9-20:
Fuzziness is similar to the Magic Wand's Tolerance setting (page 136). Take a look at the red areas of the vase. There's still a lot of green in the center of some of them. Set Fuzziness higher to change more pixels (in this image, that change would make all the green center spots turn red). If you find you're picking up bits of areas you don't want, move the Fuzziness slider to the left.

Look at your photo after you've chosen your replacement color. If the preview doesn't show the color in all the areas you want, click the missing spots with the middle eyedropper to fix them.

5. Click OK.

The Color Replacement Tool

Besides the Smart Brush, Elements gives you yet another way to brush on a color change—the Color Replacement tool, which lets you brush a different color onto the area you want to change, without changing any colors besides the one you target. Your can use pretty much any color you want with this tool, so it's more versatile than the Smart Brush for changing colors. Figure 9-21 shows how great this tool is for changing hard-to-isolate areas like feathers.

Figure 9-21:
If you'd like to put some zip into this photo by coloring the hat, the Color Replacement tool is one way to do it. Although the sampled color was a dark teal green, the Color Replacement tool in Hue mode brushes on a pale, vivid aqua. Keeping the crosshairs inside the hat ensures that only the hat changes.

The Color Replacement tool shares a Tools panel slot with the Brush tool. To select it, press B or click the Brush tool, and then choose the Color Replacement tool from the pop-out menu.

The Options bar settings make a big difference in the way the Color Replacement tool works:

- Brush options. These settings (size, hardness, angle, and so on) work the same way they do for any brush. See Chapter 12 for more about brushes.
- Mode. This controls the tool's blend mode (page 168). Generally you want Color or Hue, although you can get some funky special effects with Saturation.
- Limits. This setting tells Elements which areas of your photo to look at in its search for color. Contiguous means only areas that touch each other get changed. Discontiguous means the tool changes *all* the places it finds a color—regardless of whether they're touching.
- Tolerance. This is like the Magic Wand's Tolerance setting: The higher the number, the more shades of color are affected. Getting this setting right is the key to getting good results with this tool.

• Anti-alias. This setting smoothes the edges of the replacement color. It's best to leave it turned on.

Using the Color Replacement tool is straightforward:

1. Pick the color to use as a replacement.

Elements uses the current Foreground color as the replacement color. To change the Foreground color, click the Foreground color square in the Tools panel and then choose a new color from the Color Picker (page 217).

2. Activate the Color Replacement tool and pick a brush size.

Click the Brush tool in the Tools panel or press B and then choose the Color Replacement tool from the pop-out menu. Tor this tool, you usually want a fairly large brush, as shown in Figure 9-21. See Chapter 12 for help using brushes.

3. Click or drag in your photo to change the color.

Elements targets the color that's under the crosshairs in the center of the brush cursor.

The Color Replacement tool is great for changing large areas of color to an equivalent tone, but if you want to replace dark red with pale yellow, you probably won't like the results because it's not great for colors where the lightness is very different. To be honest, this tool hasn't been as useful in the past couple of versions of Elements as it once was, but you may sometimes find it's the best tool for the job.

You may want to use the Color Replacement tool on a duplicate layer (**%**-J) so you can adjust the layer's opacity to control the effect.

Special Effects

Elements gives you some other useful ways of drastically changing the look of your image. You can apply these effects as Adjustment layers (Layer → New Adjustment Layer) or by going to Filter → Adjustments (there's much more about filters in Chapter 13). Either method gives you the same options, which you can see in action in Figure 9-22.

In most cases, you use these adjustments as steps along the way in a more complex treatment of your photo, but they're effective by themselves, too. Here's what each one does (listed in the order they appear in the Filter menu):

• Equalize makes the darkest pixel black and the lightest one white, and redistributes the brightness values for all the colors in the photo to give them all equal weight. When you have an active selection, Elements brings up a dialog box that lets you choose between simply equalizing your whole photo and equalizing it based on a selection. It doesn't always work, but sometimes Equalize is great for bringing up the brightness of a dim photo. (This choice isn't available as an Adjustment layer, only as a filter.)

Figure 9-22:

You can get some interesting special effects with the Adjustment commands, whether you apply them as filters or Adjustment layers. If you want to use them as filters, it's not a bad idea to start with a duplicate layer.

Top row (left to right): The original photo, Invert, Equalize.

Bottom row (left to right): Posterize and Threshold.

- Gradient Map is pretty complicated. According to Adobe, it "maps the grayscale range of an image to the colors of a specified gradient fill." If you want to know what the heck *that* means, turn to page 415. Basically, a gradient map lets you apply a gradient based on the light and dark areas of your photo; the gradient's colors replace the existing colors. There's a lot more to it than that, though.
- Invert makes your photo look like a negative. It's so useful in doing artistic effects that Elements also lets you invert at any time just by pressing **%**-I. (If you want to invert part of an image, check out the Smart Brush tools [page 196], which have some interesting variations on inversion in their Special Effects menus.)

NOTE If you think choosing the Invert option sounds like a great way to get negatives you scanned in with a basic flatbed scanner turned into positive images, that won't work unless your negatives are black and white. Color negatives have an orange mask on them that Elements can't easily undo. You're best off with a dedicated film scanner that's designed to cope with negatives, or at least with a scanner that has software for dealing with the mask.

• Posterize reduces the total number of colors in your photo, giving a less detailed, more poster-like effect. The lower the number you enter in the dialog box, the fewer colors you get and the more extreme the result. If you want blocky, poster-like edges in your photo, try Filter → Artistic → Poster Edges instead of—or in addition to—this.

• Threshold turns every pixel in your photo to pure white or pure black. You won't find any shades of gray here. Figure 9-23 explains how to tweak this adjustment's settings.

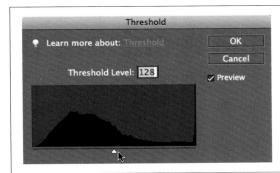

Figure 9-23: This slider controls the dividing point between black and white pixels in a Threshold adjustment. Slide to the left if you want more white pixels, and to the right for more black ones. The

graph is a histogram (page 207) showing the light-to-dark distribution of the pixels in your image.

• Photo Filter makes color corrections, like removing color casts from your photos. You can read about it in detail on page 256.

Removing and Adding Color

If you love classic black-and-white photography, or if you yearn to be the next Ansel Adams, you'll be over the moon with the high-quality black-and-white conversions Elements can do. If you can't imagine why anyone would willingly abandon color, consider that in a world crammed with eye-popping colors, black and white really stands out. Or you may need to have something printed where you can't use color illustrations. And for artistic photography, there's nothing like black and white, where tone and contrast make or break the photo, without colors to distract you from its underlying structure.

In this chapter, you'll learn how to make a color photo black and white, and how to create images that are partly in color and partly black and white. You'll also learn how to colorize black-and-white images and, along the way, how to use and edit *layer masks*, an important technique for advanced Elements work.

Method One: Making Color Photos Black and White

A stunning black-and-white image is so much more than just a color photo without color. Generally, just removing the color from a photo produces a flat-looking, uninteresting image. A good black-and-white photo usually needs more contrast. You can create different effects and moods in your photo, depending on what you decide to emphasize in the black-and-white version. Black-and-white conversion has traditionally been a pretty complicated process. If you do a Google search, you'll find literally dozens of recipes for making conversions. Fortunately for you, Elements makes it easy to perform these conversions, and even do sophisticated tweaking of the different color channels. Just follow these steps:

1. Open the photo you want to convert.

If the photo has multiple layers, flatten it (Layer → Flatten Image) or make sure the layer you want to convert is the active layer (click it in the Layers panel). To convert only a part of your photo, select the area you want to make black and white. As always, it's best to do this on a copy, not on your original photo.

2. Go to Enhance → "Convert to Black and White", or press Option-\.B.

The "Convert to Black and White" dialog box appears. It includes helpful before and after previews of your image, and the controls shown in Figure 10-1.

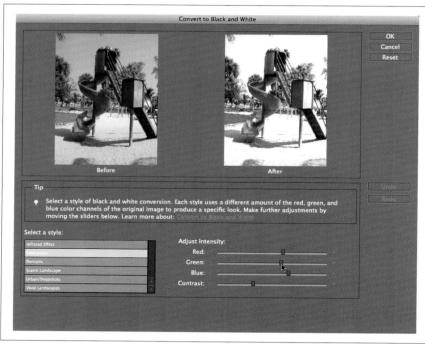

Figure 10-1:
The "Convert to Black
and White" dialog box
makes it easy to
transform your images,
even if you don't have
any idea what you're
doing. First, choose a
conversion style from the
list in the bottom left, and
then use the sliders on
the right to tweak the
result. if necessary.

3. Choose a conversion style.

Elements gives you various preset styles for the conversion. Click a style in the list to apply it to your photo. Try different styles to see which suits your photo best.

4. Tweak the conversion, if necessary.

Use the Adjust Intensity sliders below the preview area (Red, Green, and so on) to increase or decrease the prominence of each color channel (page 206). You don't need to understand color channels to do this; just move the sliders around and see what creates the effect you like (the After image shows how you're changing your photo). Go gently—it doesn't take much to make a big difference.

Once you move a slider, the Undo and Redo buttons on the right side of the dialog box become clickable. Use them to step backward and forward through your changes. To start from scratch, click Reset.

5. When you're satisfied with how your photo looks, click OK.

Be sure to carefully examine your actual image—don't rely on just the smallish preview window. Move the dialog box around your screen so you can see your whole photo before you accept the conversion. If you decide against creating a black-and-white image, click Cancel.

TIP You may want to emphasize certain details in your photo without making additional changes to the overall tonality. To do that, use the Dodge and Burn tools (page 358) once you've completed your conversion.

While the different conversion styles have descriptive names, like Portraits and Scenic Landscape, don't put too much stock in those names. They're simply less intimidating ways of describing preset collections of color-channel settings. Be sure to test out the various styles to see which works best on your photo. For instance, you may prefer the way Uncle Julio looks when you choose the Newspaper style instead of the Portraits style.

But wait a minute: Changes to the color channels? That's right. Back in Chapter 7, you read about how your photo consists of three separate color channels: red, blue, and green. In your camera's original file, each of these channels is recorded as variations in light and dark tones; in other words, as a black-and-white image. Your image file tells the computer or printer to render a particular channel as all red, blue, or green, and the blending of the three monotone channels makes all the colors you see.

When you convert your photo back to black and white, each of these channels contains varying amounts of details from your photo, depending on the color of your original subject. So, the green channel might have more detail from your subject's eyelashes, while the red channel may have more detail from the bark on the tree she's standing under. (Remember, the color channels themselves don't necessarily correspond to the color of the objects you see in your final photo. Or, put another way: Your camera uses a mixture of red, blue, and green to create what looks like bark to us humans.) And there's often more noise (graininess) in one channel than the others.

The "Convert to Black and White" dialog box's Red, Green, and Blue Adjust Intensity sliders let you increase or decrease the presence of each color channel. So you can adjust how prominent various details in your photo are by changing the importance of that color channel in the complete photo. These adjustments can greatly change the appearance of the final conversion. The Contrast slider adjusts the contrast (page 108) for the combined channels.

That's the theory behind those color channel sliders, but fortunately, you don't have to understand it to use them effectively. Just be sure you have a good view of your photo (zoom and, if necessary, move the dialog box around), and move the sliders till you're happy with what you see. If you plan to print your converted photo, the box on page 303 has some tips on how to get a good black-and-white print from a color inkjet printer.

Elements gives you an even easier way to convert your photo to black and white, but it's an all-or-nothing scenario—you can't adjust the tones in your image. The Effects panel includes a nice black-and-white tint effect. Go to the Effects panel (choose Window → Effects if it's not already visible), and then choose Photo Effects (it's the third icon from the left at the top of the panel). From the drop-down menu, choose Monotone Color, and then double-click the black-and-white apple to apply the effect. Also, some frames in the Frames section of the Content panel (page 450)—like a few of the Color Tint frames—automatically convert your photo to black and white when you place it in the frame. Page 441 explains how to use these frames.

Method Two: Removing Color from a Photo

Since one size never fits all, Elements gives you a few other, fundamentally different ways to remove the color from your image. The instructions in the preceding section are usually your best bet when you want to convert your whole photo to black and white. But if you want to drain the color from just part of your image, or if you're looking to do something artistic, like changing a color photo into a drawing or a painting, you can try one of these three methods:

- Convert Mode. You may remember from page 51 that you need to choose a color mode for your photo: RGB, Bitmap, or Grayscale. You can remove the color from your photo by changing its mode to Grayscale: Go to Image → Mode → Grayscale. This method is quick, but it's also a bit destructive, since you can't apply it to a layer: Your whole photo is either grayscale or not.
- Remove Color. You can keep your photo as an RGB file and drain the color from it by going to Enhance → Adjust Color → Remove Color (or pressing Shift-\(\mathbb{H}\)-U). This command removes the color only from the active layer, so if your photo has more than one layer, you need to flatten it first (Layer → Flatten Image) or the other layers keep their color.

Remove Color is really just another way to completely desaturate your photo—like you might do when using the Hue/Saturation command (described next). Remove Color is faster but you don't get as much control as with the Hue/Saturation command. Figure 10-2 shows the difference between applying the Remove Color command versus converting your entire image to grayscale.

Figure 10-2: Uncoloring your photo can generate very different results depending on the method you use.

Top: Each of these rabbits has a pure color value of 255. In other words, you're looking at rabbits that are 100 percent blue, green, and red (respectively), with zero as the value for the other two channels.

Middle: The same images with the mode converted to grayscale (Image \rightarrow Mode \rightarrow Grayscale).

Bottom: Using the Remove Color command gives you quite different results.

• Hue/Saturation. You can also call up the Hue/Saturation dialog box (page 287) and move the Saturation slider all the way to the left, or type –100 into the Saturation box. The advantage of this method is that if you don't care for the shade of gray you get, you can desaturate each color channel separately by using the pull-down menu in the dialog box. This method lets you tweak the settings a bit to eliminate any color cast you may get from your printer.

OUTSIDE ELEMENTS

Digital Black and White

If you love black-and-white photography, there's good news for you in the digital world: The quality of digital black-and-white printing is improving by leaps and bounds, and now you can get decent black-and-white photos from even some of the lowest-priced printers.

For all the wonders of digitizing, though, there's still nothing that can duplicate the effect of a traditional silver print—although digital printing has made great strides in the past few years.

If you plan to print lots of black-and-white photos, you may still want to look into buying a photo printer that lets you substitute several shades of gray for your color cartridges. These special inks are constantly improving, and you can get much better prints now than you could even a year or two ago. You can buy special grayscale ink cartridge sets for even inexpensive inkjet printers, and more and more printer drivers have settings for grayscale printing. (Printer driver controls appear when you launch the Elements Print dialog box, as explained on page 468.)

TIP If you're planning to print the results of your conversion, the paper you use can make a *big* difference in the gray tones you get. If you don't like the results you get with your usual paper, try a different weight or brand. You'll need to experiment because the inks for different printer models interact differently with different brands of paper.

Creating Spot Color

Removing almost all the color from a photo but leaving one or two objects in vivid tones, called *spot color*, is an effective artistic device that's long been popular in the print industry. (In the commercial printing business, "spot color" means something else—it refers to the use of special inks for a particular color in a multicolor image.)

Figure 10-3 shows an example of spot color. To practice the maneuvers you're about to learn, download the photo (caboose.jpg) from the Missing CD page at www.missingmanuals.com.

Figure 10-3: With Elements, you can easily remove the color from only part of an image.

Left: Here, the photo is a reaular color image.

Right: The color is gone from everything except the caboose. You'll learn four easy methods for removing color in this section.

This section walks you through four of the easiest methods to create spot color. (The fifth way, explained earlier in this chapter [page 299], is to select the area you want to make black and white, and then use the "Convert to Black and White" feature.) You can paint out color, erase your way back to color, change only a selected area to black and white, or use an Adjustment layer. (With that last method, you'll also learn how to edit the Adjustment layer's layer mask so that you can control which the area the adjustment affects.) The end result looks the same no matter which method you choose. Just use the one you find easiest for your photo.

TIP If you have a newish digital camera, check your special effects settings for a spot or accent color setting. Many cameras can now create a black-and-white image with only one shade left in color.

Brushing Away Color

Creating black-and-white areas in a color photo is super easy in Elements. You can use the Smart Brush to convert an area to black and white while making your selection (see Figure 10-4). In other words, you paint the object you wish to make black and white, and Elements selects and converts it—while preserving the color in the rest of your photo. If you want to keep most of your image in color while converting only small portions of it to black and white, or vice versa, definitely try this method first.

Figure 10-4:

With the Smart Brush, converting part of your photo to black and white is as simple as making a selection.

Top: The puppy is really cute, but the bright blue shirt draws your eye away from him.

Bottom: Drag over the puppy with the Smart Brush with the Inverse option turned on, and he stays in color while the rest of the photo turns black and white.

To paint away color with the Smart Brush:

1. Open a photo in Full Edit mode, and then activate the Smart Brush.

Press F or click its icon in the Tools panel, and then choose the brush from the pop-out menu. The Smart Brush puts its changes on their own layer, so you don't need to create a duplicate layer before using it.

NOTE You can also do this in Quick Fix, but you don't get a choice of styles, so skip Step 2 if you do it there. (You also can't edit the settings later for conversions made in Quick Fix. If you try to do that, Elements displays an error message.)

2. Choose the style of black-and-white conversion you want.

Find the thumbnail at the right end of the Smart Brush's Options bar settings. This is actually the pop-out menu for the Smart Brush presets (which Adobe calls Smart Paint). Click the thumbnail and then, in the preset palette that appears, click the pull-down menu and choose "Black and White". Then click the thumbnail that looks most like what you want. (If you don't like it once it's applied, you can always change it later.) Elements has a number of different conversion styles, and the names don't mean much. It's best to go by the thumbnail preview when choosing a conversion style.

3. Drag over the object in your photo that you want to make black and white.

The Smart Brush should select the object and convert it, all in one go. If you have a hard time getting a good selection, go back to Elements' main Tools panel, and use the Detail Smart Brush (page 197) instead. (It works like the regular Selection brush, changing only the area directly under the cursor, so you'll have more work to do, but you'll get a more accurate selection.)

That's all there is to it. If you don't like the conversion style you chose or want to change the area the brush affects, click the pin that appears when the Smart Brush is active and then make your changes. (See page 198 for more about how to fine-tune Smart Brush edits.) You can also adjust the affected area by editing the Smart Brush's layer mask, as explained on page 308.

The Smart Brush is great when you want a photo that's mostly in color with only a small area of black and white. If you want the opposite—a photo that's mostly black and white with only a small area of color—brush over the area you want to keep in color and then, in the Options bar, turn on the Inverse checkbox, which reverses the area changed by the effect. The part of your image you made black and white gets recolored, while the rest of the photo (where you didn't brush) turns black and white. You can also use one of the methods listed in the following sections.

NOTE The black-and-white conversion settings aren't always editable. Instead, you may see a confusing message that the Adjustment layer was created in Photoshop, even though you just created it in Elements. Adobe uses the Smart Brush to make some Photoshop-only conversion styles available to you so you can apply them but not tweak them once you're done, because Elements can't edit those styles.

Erasing Colors from a Duplicate Layer

You can also easily remove colors from parts of your image with the Eraser tool. (See page 365 for more about Elements' different erasers.) With this method, you place a color-free layer over your colored original, and then erase bits of the top layer to let the color below show through. Here's how:

1. Make a duplicate layer.

Press **ૠ**-J or go to Layer → Duplicate Layer. This layer will be black and white.

2. Remove the color from the new top layer.

Make sure the top layer (the new one you just created) is the active layer, and then go to Enhance → "Convert to Black and White", or to Enhance → Adjust Color → Remove Color. You should now see a black-and-white version of your image.

3. Erase the areas on the top layer where you want to see color.

Use the Eraser tool (page 365) to remove parts of the top layer so the colored layer underneath shows through. Usually you'll get the best results with a fairly soft brush.

If you want an image that's mostly colored with only a few black-and-white areas, reverse this technique: Remove the color from the bottom layer, and leave the top layer in color; then erase as described above.

When finished, you can flatten the layers if you want. But by keeping them separate, you give yourself the option of going back and erase more of the top layer later on. And you can trash the layer you erased and make a new duplicate of the bottom layer if you want to start over.

Removing Color from Selections

If you don't want to have multiple layers, you can also make a selection and then use the Enhance menu's "Convert to Black and White" option or the Remove Color command. Just make sure you perform this technique on a copy, not your original—you don't want to risk wrecking your original photo.

While the Smart Brush is the handiest tool for uncoloring small areas, as explained above, the method described here is best if you don't like any of the Smart Paint presets or if you're dead set against having a new layer. Here's what you do:

1. Mask out the area of your image where you want to keep the color.

Use the Selection brush in Mask mode (see page 133) to paint a mask over the area where you want to *keep* the color, to protect it from being changed in step 2. In other words, you'll make everything black and white *except* where you paint with the Selection brush.

If you want to keep the color in most of your photo and remove the color from only one or two objects, paint over them with the brush in Selection mode instead, or use the Quick Selection tool.

2. Remove the color from the selected area.

Go to Enhance → "Convert to Black and White", or to Enhance → Adjust Color → Remove Color, or press Shift-\(\mathbb{H}\)-U. Elements removes the color from the areas not protected by the mask, but leaves the area under the mask untouched. (You can also do this by going to Enhance → Adjust Color → Adjust Hue/Saturation, and then moving the Saturation slider all the way to the left.)

You should see a photo with color only in the areas that you didn't select. This method is the least flexible of all the ones described in this chapter because once you close your image, the change is permanent and not undoable, which is why you don't want to use this method on your original photo.

Using an Adjustment Layer and the Saturation Slider

If you want to keep your options open so you can change your mind about which areas to keep in color, and you don't like any of the Smart Brush presets, you can remove the color with a Hue/Saturation Adjustment layer. This is the most flexible method (though it doesn't offer you the tone adjustments you can make when using the Enhance menu's "Convert to Black and White" option). Using an Adjustment layer lets you both add and subtract areas of color later if you like. Here's what you do:

1. Select the area where you want to remove the color.

Use any Selection tool you like (see Chapter 5 for more about Selection tools). If it's easier to select the area where you want to keep the color, do that, and then press Shift-\#-I to invert your selection so the area that will lose its color is selected instead.

2. Create a Hue/Saturation Adjustment layer.

Go to Layer → New Adjustment Layer → Hue/Saturation, or click the Layers panel's New Adjustment Layer icon (the half-black, half-white circle), and then choose a Hue/Saturation layer.

3. In the Hue/Saturation dialog box that appears, remove the color.

Move the Saturation slider all the way to the left to get rid of the color.

Why is this method better? Well, for one thing, you can always discard the Adjustment layer if you change your mind. And you can edit the Adjustment layer's layer mask (see page 183 for more about layer masks) to change which parts of your photo are in color, even days or weeks later.

Remember the caboose image from Figure 10-3 (page 304)? Say you drained the color from everything except the caboose using a Hue/Saturation Adjustment layer. But then you change your mind and want to leave the trees in color. Or maybe you wish you'd made the stairs black and white. You can easily fix everything by editing the layer mask. The next section tells you how.

Editing a layer mask

Elements lets you make changes to an Adjustment layer's layer mask any time you want—as long as you haven't merged the layer into another layer or flattened the image. For example, you may want to edit the layer mask if your original selection needs some cleaning up, or if you want to change which area the Adjustment layer

affects. You can use this same technique to change the area affected by a Smart Brush adjustment, too, although usually it's simpler just to click the pin in the image and activate the layer mask that way (see page 198 for more details on how all *that* works).

NOTE Remember that masking something means it *won't* be affected by a change. So the area that shows up in black or red on your layer mask is the area that *won't* be changed by your adjustment. If you don't see any black or red when looking at a layer mask, the Adjustment layer will change your whole photo.

You can work on the mask by painting directly in the image window, or make the layer mask visible and work in either of two special mask views, which are sometimes helpful when you have tricky edges, or if you need to check for missed spots. Here's the simplest way to make changes to the area covered by a layer mask:

1. Make sure the Adjustment layer is the active layer.

If it isn't, click it in the Layers panel. (This step is important: If the Adjustment layer isn't the active layer, you may wind up adding paint to the actual image.)

2. Set your Foreground and Background colors to black and white, respectively.

Press D and Elements makes black the Foreground color and white the Background color. If you want to paint with white, press X to swap the colors so that white (the Background color) becomes the Foreground color.

3. Paint directly on your image.

Use the Brush tool to paint on the image. Paint an area black to keep it from being affected by the adjustment, or with white to include it in the area affected by the adjustment. In other words, black masks an area, while white increases your selected area.

You can also use the Selection tools (the same way you would on any other selection) to change the mask's area. Just keep in mind that what's selected gets changed by the adjustment, while what's not selected doesn't change. (See Chapter 5 if you need help making selections.) If you watch the layer mask's thumbnail in the Layers panel, you'll see that it changes to show where you've painted.

To make a layer mask visible, click it in the Layers panel. Elements gives you a choice of two different ways to see the masked area, as shown in Figure 10-5. You merely Option-click the right-hand thumbnail (the one without the gears on it) for the Adjustment layer in the Layers panel to see the black layer mask (instead of your photo) in the image window. Add the Shift key when you click to see a red overlay on the photo instead of the black-and-white view. Press the same keys again to get back to a regular view of your image.

The black mask view shows only the mask itself, not your photo beneath it. This is a good choice when checking to see how clean the edges of your selection are. But if you're adding or subtracting areas of your photo, choose the red overlay view so

Figure 10-5:
Elements lets you edit your layer
mask and gives you two different
ways to see it. Here are two different
views of the layer mask from
Figure 10-2.

Left: To see the masked area in black, Option-click the layer's right-hand thumbnail in the Layers panel.

Right: To see the masked area in red, Option-Shift-click the right-hand thumbnail instead.

you can see the objects in your photo as you paint over them. You can use the method described above to paint in either view.

That's all there is to it, though you can also edit a layer mask in other ways. You can use shades of gray to adjust the mask's transparency. When you paint on your mask with gray, you can adjust the opacity of the changes made by the Adjustment layer. So you can let a little color show through the mask, for instance, without letting the full vividness of the color come through. The lighter the shade of gray you choose, the more color shows through. Figure 10-6 shows an example of how you'd use this technique.

Colorizing Black-and-White Photos

So far, you've read about ways to make all or part of a color photo black and white. But what about when you have a black-and-white photo and you want to add color to it? Elements makes that easy (or if not easy, at least possible). For instance, you can give an old photo the sort of hand-tinted effect you sometimes see in antique prints, as shown in Figure 10-7.

You can easily color things with Elements. But before you start tinting a photo, first make any needed repairs. (See page 274 for repair strategies, or page 192 for exposure fixes.) When your image is in good shape, here's how to color it:

1. Make sure your photo is in RGB mode.

Go to Image \rightarrow Mode \rightarrow RGB Color. Your photo has to be in RGB mode or you can't color it.

Figure 10-6: By painting with different shades of aray on the laver mask, vou can make the effect of the adjustment partially transparent. Here, a fairly light gray was used to paint over the trees and around on the left side of the image so that a little areen and brown shows, but it's not the bright, saturated color of the original photo. (Only part of the left side of the image was painted so you can see the contrast with what was there before.)

2. Create a new layer in Color blend mode.

Go to Layer \rightarrow New \rightarrow Layer and select Color as the layer's mode. With the layer in Color mode, you can paint on the layer and the image's details still show through.

3. Paint on the layer.

Use the Brush tool (page 347) and choose a color in the Tools panel's Foreground color square (page 216). Keep changing the Foreground color as needed. If the coverage is too heavy, reduce the brush's opacity in the Options bar.

Figure 10-7:
Left: If you decide to color an old black-and-white or sepia photo, put each color on its own layer. That way you can adjust the transparency or change the hue or saturation of one color without changing the other colors, too.

Right: A very low opacity is enough for old photos like this one if you want to give the impression of a print that was hand-colored.

You can also paint directly on the original layer (try switching the brush's blend mode to Color for this). But with that method, you'll find it far more difficult to fix things if you make a mistake when you're well into your project. Using the original layer also doesn't give you much of an out if you decide later that the lip color you painted first doesn't look so great with the skin color you just chose.

The methods just described are handy for when you want to use many different colors on a photo, but if you want to add only a single color to part of the photo, the easiest way is to use the Smart Brush:

1. Be sure your photo is in RGB mode.

Go to Image \rightarrow Mode \rightarrow RGB Color. If your photo isn't in RGB mode, the Smart Brush paints only in shades of gray rather than the color you select.

2. Activate the Smart Brush, and then choose a color to paint with.

Press F or click the Smart Brush's icon in the Tools panel, and then go to the Choose a Preset setting in the Options bar (click the thumbnail to the right of Refine Edge) and then, on the palette that appears, choose Color from the pull-down menu. From the menu thumbnails, select the color you want.

3. Drag over what you want to color.

The Smart Brush automatically creates your selection and colors it. If you don't get a good selection with the regular Smart Brush, switch to the Detail Smart Brush.

4. Tweak the effect.

The color choices tend to be pretty heavy, so you may prefer to go to the Layers panel and reduce the Smart Brush layer's opacity (see page 166 for more about layer opacity).

The Smart Brush works well if you happen to like one of the available color choices. But if you don't like any of the colors it offers, use the new-layer method described earlier in this section, which is much more flexible, since you can choose any color you want.

SPECIAL EFFECTS

Hints for Coloring Old Photographs

If you want to add some color to an antique black-and-white image, it's easier to put each part of a face that you're going to color—lips, eyes, cheeks, skin—on a separate layer than to try to control different shades on one layer. That way, you can easily change just one color later on. (You can always merge the layers—Layer → Merge Visible, or Merge Down—later when you know for sure that you're done.) Here are some other tips when you're aiming for that 19th-century look:

 To create a photo that looks like it was hand-colored a century ago, paint at less than 100-percent opacity—the tinting on old photos is very transparent.

- If you select the area before you paint, you don't have to worry about getting color where you don't want it, because your paint is confined to your selection.
- Skin colors are really hard to create in the Color Picker. Try sampling skin tones from another photo instead. If it's a family photo, after all, the odds are good that the current generation's basic skin tones are reasonably close to Great-Granddad's. (If you're comfortable using Elements' more advanced features, a gradient map [page 415] can be an excellent way to create realistic skin shading, although it usually takes lots of gradient editing to get things just right.)

Tinting a Whole Photo

You can give an entire photo a single color tint all over, even if the original is a grayscale photo. Tinting is a great way to create a variety of different moods.

You have two basic ways to tint photos. (Actually, there are a lot more than two, but these two should get you started.) The first method described here (Layer style) is faster, but the second (Colorize) lets you tweak your settings more. Figure 10-8 shows the result of using the Layer-style method on a color photo. (For a more subtle effect, you can also use Photo Filters, described on page 256.) Photo Effects also has some terrific monotone tint effects, as explained on page 397.

For either method, if you want to keep the original color (or lack thereof) in part of your photo, use the Selection brush in Mask mode (page 133) to mask out the area you don't want to change.

TIP Some of the frame effects in the Content panel automatically add a tint to your photo when you apply them. The Effects panel also has some handy monochrome tint effects in its Photo Effects section.

Figure 10-8:

You can most easily create a monochrome color scheme for your photo with the Photographic Effects Layer styles, which are explained in Chapter 13. This image had the Teal Tone style applied to the original color photo. Elements removed the existing color and recolored the image in one click. The downside is that you can't edit the color once you're done if you later decide you'd rather have, say, orange.

Using a Layer style

Although many people never dig down far enough to find them, Adobe gives you some Photographic Effects Layer styles that make tinting a photo as easy as double-clicking. You'll learn more about Layer styles on page 401, but this section tells you all you need to know to use the Photographic styles. It's a simple process:

1. Create a duplicate layer.

Go to Layer → Duplicate Layer or press **%**-J. (If you don't create a duplicate layer and your original has only a Background layer, you're asked to convert it to a layer when you apply the style; click Yes.)

2. If necessary, change the mode to RGB.

Go to Image \rightarrow Mode \rightarrow RGB Color. With this method, it doesn't matter if your original is in color or not. The Layer style gets rid of the original color and tints the photo all at the same time.

3. Choose a Layer style.

Go to the Effects panel and, at the top of the panel, click the Layer Styles icon, which looks like two overlapping rectangles. Then, from the panel's pull-down menu, choose Photographic Effects. Double-click the color square you like, drag it onto the photo, or click it once in the panel, and then click the Apply button. You can click around and try different colors to see which you prefer. Undo (\mathbb{H}-Z) after each style you try.

4. When you like what you see, you're done.

The drawback to this method is that you can't easily go back and edit the color you get from the Layer style. Even if you call up the Style Settings dialog box (see page 403), you don't get any active checkboxes, because these styles don't use those settings. Instead, you need to use a Hue/Saturation adjustment (see page 291) or Color Variations (page 215) to go back later and change the Layer style's tint color.

The Content panel's tint effects

The Content panel includes some frames that automatically apply a tint to your photo, as shown in Figure 10-9. These range from simple all-over colors like Sepia to fading gradients. (See page 404 for more about gradients.)

Figure 10-9:
Using the Content panel, you can apply elaborate effects—like this fading gradient, drop shadow, and frame—with just a double-click. The effect used here is the Color Tint Blue Fadeout 20px.

You can read more about using the Content panel's frames on page 444. To tint your photo, choose Type → Frames, and then scroll down toward the bottom of the list of thumbnails.

NOTE The Photo Effects section of the Effects panel also has some very effective color tints. Page 397 tells you how to apply Effects.

Using Colorize

You can use the Colorize checkbox in the Hue/Saturation dialog box or Adjustments panel settings to add a color tint to a grayscale photo or to change the color of a photo that already has color in it. With this method, you can choose any color you like, as opposed to the limited color choices of the Layer styles explained in the previous section. You can also adjust the intensity of the color with the Saturation slider once you've selected the shade you want.

Figure 10-10 explains how the Colorize setting changes the way the Hue/Saturation command works.

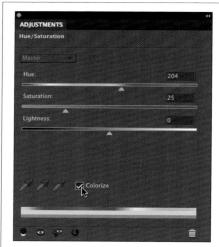

Figure 10-10:

To color something that doesn't have any color info in it, like a white shirt or a grayscale image, in the Adjustments panel's Hue/Saturation settings, turn on Colorize (where the cursor is here). (If you don't use an Adjustment layer, you get the same checkbox in the Hue/Saturation dialog box, but it's in a slightly different spot.) If you don't turn on this checkbox, you can adjust the hue, saturation, and lightness of white all day long—all you'll do is go from white to gray to black because there's no color info there for Elements to work with. Also, if something is pure white (that is, contains no color data at all), you may need to darken it by moving the Lightness slider to the left before any color shows up.

Here's how to work with the Colorize checkbox:

1. Make sure your photo is in RGB mode.

Go to Image \rightarrow Mode \rightarrow RGB Color.

2. Remove the photo's color, if necessary.

Press Shift-\(\mathbb{H}\)-U to remove the color. Do this if the photo has become yellowed or discolored from age, for example. If your whites are really dingy, you might want to make a Levels adjustment (page 206) to brighten them before removing the color.

3. Colorize your photo on a new layer.

Go to Layer → New Adjustment Layer → Hue/Saturation, and then in the Adjustments panel, turn on the Colorize checkbox. When you turn this setting on, Elements fills your image with the Foreground color. If you don't like it, that's fine—you're going to change it in the next step.

4. Adjust the color until it looks the way you want it to.

Move the Hue, Saturation, and Lightness sliders until you find the look you want, and then click OK. Figure 10-11 shows the results.

TIP Want to turn a full-color photo to a monotone image in a hurry? Just turn on the Colorize checkbox—you don't need to remove your photo's color first. Colorize automatically reduces your photo to just one color. The advantage to using this method rather than a layer style is that you can use the sliders to create any color you want.

Figure 10-11:
This photo was tinted with purple by turning on the Colorize checkbox in the Hue/
Saturation dialog box. The gold ornaments were masked out so that they stay in full color.

If you selected and masked an area, that part should still show the original color.

Colorizing Black-and-White Photos

You can change your mind about the colorizing by double-clicking the layer's left-most icon (the one with the gears on it) in the Layers panel. That brings up the controls for the Hue/Saturation adjustment again so you can change your settings. And you can also edit the layer mask, as described on page 308, if you want to change the area that's affected by the Adjustment layer.

When you're done, if you merge layers (or press \mathbb{H}-Option-Shift-E to produce a new merged layer above the existing layers), you can use Levels (page 206), Color Variations (page 215), and the other color-editing tools to tweak the tint effect.

Photomerge: Creating Panoramas, Group Shots, and More

Everyone's had the experience of trying to photograph an awesome view—a city skyline or a mountain range, say—only to find the scene is too wide to fit into one picture. Elements, once again, comes to the rescue. With the Photomerge command, you can stitch together a group of photos you shot while panning across the horizon to create a panorama that's much larger than any single photo your camera can take. Panoramas can become addictive once you've tried them, and they're a great way to get those wide, wide shots that are beyond the capability of your camera lens.

Elements includes the same great Photomerge feature that's part of Photoshop, which makes it incredibly easy to create super panoramas. Not only that, but Adobe also gives you a couple of fun twists on Photomerge that are unique to Elements: Faces and Group Shot, which let you easily move features from one face to another and replace folks in group photos. And Elements 8 brings yet another new kind of merge: Scene Cleaner, for those times when your almost-perfect vacation shot is spoiled by strangers walking into your perfectly composed scene.

NOTE Elements 8 includes one more kind of merge: Photomerge Exposure, which lets you blend differently exposed versions of the same scene (like photos taken using your camera's exposure bracketing feature) to create one image that's perfectly exposed from the deepest shadows to the brightest highlights. Learn all about it on page 251.

If you're into photographing buildings (especially tall ones), you know that you often need some kind of perspective correction: The building appears to lean backward or sideways as a result of distortion caused by your camera's lens. This chapter shows you how to use the Correct Camera Distortion filter to straighten things

back up. You'll also learn how to use the Transform commands to adjust or warp your images.

Creating Panoramas

It's incredibly simple to make panoramas in Elements. (If you're upgrading from Elements 4 or earlier, you know that other programs made better, easier panoramas than Elements used to make. Not anymore: Elements' Photomerge feature does an amazing job, automatically.) To make a panorama in Elements, you just tell the program which photos to use, and Elements automatically stitches them together. Figure 11-1 shows what a great job it does.

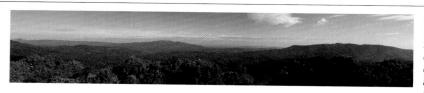

Figure 11-1: With subjects like the Smoky Mountains, you can never capture the entire scene in one shot. Here's a six-photo panorama made with Photomerge. The individual photos had huge variations in exposure and were taken without a tripod. Elements took the images-straight from the camera with no adjusting-and blended them seamlessly.

Elements can merge as many photos as you want to include in a panorama. The only real size limitation comes when you want to print your compositions. If you create a five-photo horizontal panorama but your paper is letter size, your print-out will only be a couple of inches high, even if you rotate the panorama to print lengthwise. However, you can buy printers with attachments that let you print on rolls of paper, so that there's no limit to the longest dimension of your panorama. (These printers are popular with panorama addicts.) You can also use an online printing service, like the Kodak Gallery, to get larger prints than you can make at home. See page 460 for more about how to order prints online.

You'll get the best results creating a panorama if you plan ahead when shooting your photos. The pictures should be side by side, of course, and they should overlap each other by at least 30 percent. Also, you'll minimize the biggest panorama problem—matching the color in your photos—if you make sure they all have identical exposures. While Elements can do a lot to blend exposures that don't match well, for the best panorama, adjust your photos *before* you start creating a panorama, as explained in Figure 11-2. (The box on page 325 has more tips for taking merge-ready shots.)

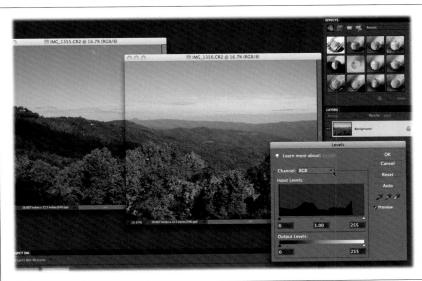

Figure 11-2: While Elements did a credible iob with the panorama in Figure 11-1, if you look closely you can see there's some variation in lighting between the end photos and the middle section. For even better results. use Elements to correct your photos so that the colors are as close as possible before creating your panorama. It helps to keep them side by side so you can compare them as you work. (See page 83 to learn how to arrange your photos on the Elements desktop.)

When the photos you want to combine look good, you're ready to create a panorama. Just follow these steps:

1. Start your merge.

Go to File \rightarrow New \rightarrow Photomerge Panorama. The Photomerge dialog box appears.

2. Choose your photos.

If the photos you want to include are already open, click the Add Open Files button. Otherwise, in the pull-down menu, choose Files or Folder; then click the Browse button to navigate to the photos you want. As you click them in the window that appears, Elements adds them to the list in the Photomerge dialog box. Add more files by clicking Browse again. To remove a file, click it in the dialog box's list, and then click the Remove button.

NOTE You can merge directly from Raw files, although you don't have any controls for adjusting the file conversions. Photomerge works only with 8-bit files, so if you have 16-bit files, Elements asks if you want to convert them when it begins merging. For faster Raw merges, set the Raw converter to 8 bits (page 247) before you start.

3. From the Layout list on the left side of the dialog box, choose a merge style.

Ninety-nine percent of the time you want to choose Auto, the first Layout option. That's usually all you need to do. When you click OK, your completed panorama is darned near perfect. You also get some other merge style choices for use in special situations:

- Perspective. Elements adjusts the other images to match the middle image using skewing and other Transform commands to create a realistic view.
- Cylindrical. Sometimes when you adjust perspective, you create a panorama shaped like a giant bow tie. Cylindrical mapping corrects this distortion. (It's called "cylindrical" because it's like looking at the label on a bottle—the middle part seems the largest, and the image gets smaller as it fades into the distance, similar to a label wrapping around the sides of a bottle.) You may want to use this style for very wide panoramas.

NOTE If you choose Auto, Elements may use either Perspective or Cylindrical mapping when it creates your panorama, depending on what it thinks will do the best job on your photos.

- Reposition Only. Elements overlaps your photos and blends the exposure, but it doesn't make any changes to the perspective of the images.
- Interactive Layout. This style lets you position your images manually. It takes you to a window that's similar to the Photomerge window in early versions of Elements; the next section explains it in detail.

4. Click OK to create your panorama.

Elements whirls into action, combining, adjusting, looking for the most invisible places to put the seams, and whips up a completed panorama for you. That's all there is to it.

NOTE Elements has a lot of complex calculations to make when creating a panorama, especially if you have lots of images or there are big exposure differences between the photos, so it may take awhile. Don't assume that Elements is stuck; give it time to think about what it's doing. It may need a few minutes to finish everything.

You'll probably want to crop your panorama (page 75), but otherwise, you're all done. You can use any of the editing tools on the final panorama once Photomerge is through, if you like. You can do anything to your panorama that you can do to any other photo. The new Recompose tool (page 278) is especially useful for adjusting the proportions of your panoramas, if you need to do that.

NOTE Elements has a quirk that may cause the program to display an out-of-memory error message when you try to save a panorama. If you run into this, just flatten your panorama (Layer \rightarrow Flatten Image) and you should be able to save it.

Manual Positioning with Interactive Layout

If you find that you absolutely must do some manual positioning of your photos, choose Interactive Layout from the Photomerge dialog box's Layout list. When you click OK, Elements does its best to combine your photos, and presents them to you in the window shown in Figure 11-3.

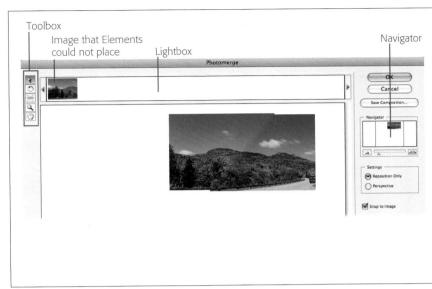

Figure 11-3: You don't often need to intervene when Elements makes a panorama, but if you want to control the process vourself, Interactive Layout lets you position your photos manually. Note how obvious the differences in exposure are in the merged photos here. Elements applies Advanced Blending only after you click OK to create your final panorama. Then the obvious exposure banding shown here disappears so vou aet a smooth merge.

You can help Elements blend your photos better. Your panorama in its current state appears in the large preview area, surrounded by special tools to help you get a better merge. On the left of the window is a special toolbox. The Lightbox, which contains any photos that Elements couldn't figure out how to place, is across the top, and there are special controls down the right side. You can use any combination of these features to improve your panorama.

You can manually drag files from the Lightbox into the merged photos, and reposition photos already in your panorama. Just grab them with the Select Image tool (explained below), and then drag them to the correct spot in the merge.

If you try to nudge a photo into position and it keeps jumping away from where you place it, turn off the "Snap to Image" checkbox on the right side of the Photomerge window. Then you should be able to put your photo exactly where you want it. However, Elements isn't doing the figuring for you anymore, so use the Zoom tool to get a good look at the alignment afterward. You may need to microadjust the photo's exact position.

There's a little toolbox at the top left of the Photomerge window. Some tools are familiar, and others are just for panoramas:

• Select Image. Use this tool to move individual photos into or out of your merged photo or to reposition them. When the Select Image tool is active, you can drag photos into or out of the Lightbox. Press A or click the tool's icon to activate it.

- Rotate Image. Elements usually rotates images automatically when merging them, but if it doesn't or if it guesses wrong, press R to activate this tool, and then click the photo you want to rotate. You see handles on the image, just the way you would with the regular Rotate commands (page 70). Simply grab a corner and turn the photo until it fits in properly. Usually, you don't need to drastically change a photo's orientation, but this tool helps you make small changes to line things up better.
- Set Vanishing Point. To understand what this tool does, think of standing on a long, straight, country road and looking off into the distance. The point at which the two parallel lines of the road seem to converge and meet the horizon is called the *vanishing point*. Elements' Vanishing Point tool tells Photomerge where you want that point to be in your finished panorama. Knowing the vanishing point helps Elements figure out the correct perspective. Press V to activate this tool. Figure 11-4 shows an example of how it can change your results.

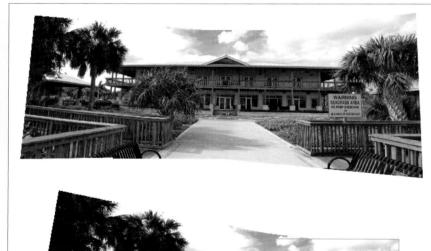

Figure 11-4: You can radically alter the perspective of your panorama by selecting a vanishing point.

Top: The result of clicking the center photo.

Bottom: The result of clicking on the righthand image. Note that the tool selects an entire image in the merge, not a specific point within the photo. You can click any photo to put your vanishing point there, but if you then try to tweak it by clicking a higher or lower point in the same photo, nothing happens. To change the vanishing point you've set, just click a different photo.

• Zoom tool. This is the same Zoom tool (page 86) you meet everywhere else in Elements. Click the magnifying glass in the toolbox or press Z to activate it.

• Move View tool. You use this tool the way you use the Hand tool (page 88) when you need to scoot your *entire* merged image around to see a different part of it. Click the hand icon in the toolbox or press H to activate it. (If you want to move just one photo within your panorama, use the Select Image tool instead.)

To control your onscreen view of your panorama, use the Navigator on the right side of the Photomerge window. It works just like the regular Navigator described on page 89. Move the slider to resize the view of your panorama. Drag to the right to zoom in on an area, or to the left to shrink the view so that you can see the whole thing at once. To target a particular spot in your merge, drag the red rectangle to control the area that's onscreen.

Also, at the bottom and right side of the preview window are scroll bars and two arrows. Click an arrow to move in the direction the arrow points (so click the right-facing arrow at the bottom of the window to slide your image to the right, for example). At certain view sizes you'll also see a square, something like a checkbox, at the bottom and/or right side of the image. You can drag that like a handle to manipulate the view, too.

IN THE FIELD

Shooting Tips for Good Merges

The most important part of creating an impressive and plausible panorama starts before you even launch Elements. You can save yourself a lot of grief by planning ahead when shooting photos.

Most of the time, you know *before* you shoot that you'll want to merge your photos. You don't often say, "Wow, I have seven photos of the SpongeBob SquarePants balloon at the Thanksgiving Day parade that just happen to be exactly in line and have a 30-percent overlap between each one! Guess I'll try a merge."

So before you take pictures for a panorama, set your camera to be as much in manual mode as possible. The biggest headache in panorama making is trying to get the exposure, color, brightness, and so on to blend seamlessly. (Elements is darned good about blending the outlines of the physical objects in your photos.) So lock your camera's settings so that the exposure of each image is as identical as possible. Even on small digital cameras that don't have much in the way of manual controls, you may have some kind of panorama setting—like Canon's Stitch Assist mode—that does the same thing.

(Your camera may actually be able to make merges that are at least as good as what Elements can do, because the camera does the image-blending internally. Check whether your model has a panorama feature.)

The more your photos overlap, the better. Elements does what it can with what you give it, but it's really happy if about a third of each image overlaps with the next.

Use a tripod if you have one, and *pan heads* (tripod heads that let you swivel your camera in an absolutely straight line) were made for panoramas. Actually, as long as your shots aren't wildly out of line, Elements can usually cope. But you may have to do quite a bit of cropping to get even edges on the finished result if you don't use a tripod.

Whether or not you use a tripod, keep the camerarather than the horizon—level to avoid distortion. In other words, focus your attention more on leveling the body of the camera than what you see through the viewfinder. Use the same focal length for each image, and try not to use the zoom, unless it's manual, so that you can keep it exactly the same for every image. Below the Navigator box are two radio buttons—Reposition Only and Perspective—that adjust the viewing angle of your panorama:

- Reposition Only. This button merely overlaps the edges of your photos, with no changes to the perspective. If you don't like the way the angles in your panorama look, try clicking Perspective instead. (Elements always blends the exposures of your images to make the transitions smooth; there's no way to turn that off.)
- Perspective. If you click this button, Elements tries to apply perspective to your panorama to make it look more realistic. Sometimes Elements does a bang-up job, but usually you get better results if you help it out by setting a vanishing point, as explained on page 324. If you still get a weird result, go ahead and create the merge anyway. Then correct the perspective afterward using one of the Transform commands covered in the next section.

Once your photos are arranged to your satisfaction, click OK, and Elements creates your final panorama.

NOTE Elements always creates layered panoramas. So before you send your panorama out for printing, flatten it (Layer \rightarrow Flatten Image), since most commercial printers don't accept layered files. Also, if you enlarge the view of your layered panorama and zoom in on the seams, you may see what look like hairline cracks. Merging or flattening the layers gets rid of these cracks.

Merging Different Faces

Merging isn't just for making panoramas. One of the Elements-only tools that Adobe gives you is Faces, a fun (okay, let's be honest—silly) feature that lets you merge parts of one person's face with another person's face. You can use it to create caricature-like photos, or to paste your new sweetie's face over your old sweetie's face in last year's holiday photo. Figure 11-5 shows an example of what Faces can do. (Elements' other special tools, Group Shot and Scene Cleaner, are explained later in this chapter.)

Figure 11-5:
Faces is really just for fun. You can create composite images like this one, and then use Elements' other tools to make your photo even sillier, if you like.

Although you'd be hard put to think of a serious use for Faces (it *may* work for something like copying a smile from one photo to another image of the same person with a more serious expression, but the end result may not be top quality), it's fun to play with, and quite simple to use:

1. Choose the photos to combine.

You need to have at least two photos selected in the Project bin before you start.

2. Call up the Faces window.

You can get to it either from File \rightarrow New \rightarrow Photomerge Faces, or from Guided Edit \rightarrow Photomerge \rightarrow Faces.

A dialog box asks you to choose the photos you want to include. In the Project bin, **%**-click to select the photos you want to use, or choose Open All from the dialog box. Elements then opens the Faces window, which has a preview area on the left and an instruction pane on the right.

3. Pick a Final photo.

This photo is the main photo into which you'll paste parts of a face from one or more photos. Drag a photo from the bin into the Final Image area (the right-hand preview).

4. Choose your Source photo.

This is the photo from which you'll copy part of a face to move to the Final image you just selected. Double-click it in the Project bin, and it appears in the left-hand preview area. You can copy from many different photos, but you can work only with one Source photo at a time. (When you're done working with a photo, just double-click the next one you want. This way you can use the ears from one photo, the nose from another, and so on.)

5. Align your photos.

This step is very important, because otherwise Elements can't adjust for any differences in size or angle between the two shots. Click the Alignment tool button in the Photomerge pane, and the three little targets shown in Figure 11-6 appear in each image.

Position the markers over the eyes and mouth in each photo, and then click the Align Photos button. (If you need help seeing what you're doing, there's a little toolbox on the left with your old friends, the Zoom [page 86] and Hand [page 88] tools, so you can reposition the photo for the best view.) Elements adjusts the photos so they're the same size and sit at the same angle to make a good blend.

6. Tell Elements what features to move from the Source image to the Final image.

Click the Pencil tool in the Photomerge pane and, in the Source photo, draw over the area you want to move. In a few seconds you should see the selected area appear in the Final photo. You only need to draw a quick line—don't try to

Figure 11-6:
To tell Elements how to align your photos, drag one of these three targets over each eye and the mouth in each photo.

color over all the material you want to move. In the Options bar, you can adjust the size of the Pencil tool if it's hard to see what you're doing, or if it's grabbing too much of the surrounding area.

If Elements moves too much stuff from the Source photo, use the Faces Eraser tool to remove part of your line. Watch the preview in the Final image to see how you're changing the selection. If you want to start over, click the Reset button.

7. When you're happy, click Done.

Elements creates your merge as a layered file. Now you can edit it using any Elements tools, if you want, to do things like clean up the edges or to manually clone (page 272) a little more material than Elements moved. And you can make your image even sillier with the Transform commands (page 337), the Liquify filter (page 431), and so on.

You can adjust two settings in the Photomerge pane:

- · Show Strokes. If you want to see what you're selecting, leave this checkbox on.
- Show Regions. Turn this on, and you see a translucent overlay over the Final image, which makes it easier to tell which regions you're copying over from your Source photo. This is something like the overlay option for the Healing brush (page 271) and the Clone Stamp (page 272).

It would be nice if you could use this feature to merge things besides faces, but it doesn't do a very good job of that. Even for faces, if you're doing something important, like repairing an old photo with parts from another picture of the same person, you may prefer to do your own selections and manually move and adjust things (see page 184). But the Faces feature's alignment tools can simplify the process enough that it's worth giving it a try to see if it can do what you need.

Arranging a Group Shot

Have you ever tried taking photos of a whole group of people? Almost every time, you get a photo where everything is perfect—except for that one person with his eyes shut. In another shot, that person is fine, but other people are yawning or looking away from the camera. You probably thought, "Dang, I wish I could move Ed from that photo to this one. Then I'd have a perfect shot." Adobe hears your wishes, and Group Shot is the result. It's designed for moving one person in a group from one photo to another, similar photo.

You launch Group Shot by going to File → New → Photomerge Group Shot, or Guided Edit → Photomerge → Group Shot. The steps for using Group Shot are the same as for Faces, except that you don't normally need to align the photos, since Group Shot is intended for situations where you were saying, "Just one more, everybody—and hold it!" as opposed to moving people from photos taken at different times with different angles and lighting.

If you do need to align your photos, you can do that with the advanced options (click Advanced Options in the Photomerge pane to get to them). Just place the markers the same way you do in Faces (see Figure 11-6). Another advanced option is Pixel Blending, which adjusts the moved material to make it closer in tone to the rest of the Final image.

NOTE It would be great if you could use Group Shot for things like creating a photo showing many generations of your family by combining images from photos taken over many years. However, Group Shot moves someone from the Source photo and pastes that person into the same spot in the Final photo, and then creates a composite layer in the completed merge. That means the relocated person is merged into the Background image, and isn't left as an extracted object, which makes it impossible to put that person in a completely different spot. So you need to tackle your generational photo the old-fashioned way: by moving each person onto a separate layer (see page 184) and then repositioning everybody where you want them.

Tidying Up with Scene Cleaner

Elements 8 brings you a useful new spin to photo merging. Scene Cleaner lets you eliminate unwanted people or elements in your photos. Think of all those travel magazine photos that show famous sights in their lonely glory, without any tourists cluttering up the scene. If you've ever waited patiently for what seemed like hours, trying to get a perfect shot of a famous landmark, you'll appreciate Scene Cleaner.

Or you've probably had this experience when showing your vacation photos: "Here's a shot of Jodi and Taylor at the rim of the Grand Canyon. Those other people? No idea. They just got in front of the camera somehow." Scene Cleaner was made to fix photos like these.

Scene Cleaner is quite easy to use, but you'll get better results if you can plan ahead when taking your photos. In order to get a people-less landscape, you need to shoot multiple photos from nearly the same angle. All the areas you want to feature should be uninhabited in at least one photo. So, for instance, if you can get one shot of the Statue of Liberty where all the tourists are on the left side of her crown and one where they're on the right side, you're all set. Then, use Scene Cleaner to create a more perfect world:

1. Open the photos you want to combine.

In addition to being taken from nearly the same vantage point, the images should have similar exposures. If a cloud was passing, for instance, so that one photo is bright and one is shadowy, you'll have to do some fancy touch-ups afterward to blend the tones. It's usually easier to do this beforehand. Chapter 7 has the full story on exposure correction.

2. Call up Scene Cleaner.

In Full Edit, go to File \rightarrow New \rightarrow Photomerge Scene Cleaner, or go to Guided Edit \rightarrow Photomerge \rightarrow Scene Cleaner. In either case, you wind up in Guided Edit to create your merged image. Elements automatically aligns your photos, so there may be a slight delay before you see the Scene Cleaner window.

3. Choose a Final image.

This is the base image into which you'll put parts of your other photo(s). Drag the photo you choose from the Project bin into the Final preview area (the right-hand slot).

4. Choose a Source image.

Look through your photos to find one that has an empty area where the people or objects you want to remove from the Final photo are. Click that photo in the Project bin, and it appears in the Source preview area (the left-hand slot). (As with Faces, you can use many Source images, but you work with only one at a time—move on to the next Source photo when you're done.)

5. Align your photos manually, if necessary.

Usually you don't need to do this, but if Elements didn't do a good job of automatically aligning your photos, in the Photomerge pane, click the flippy triangle next to Advanced Options (you may have to scroll down to see it), and then click the Alignment tool. You see the three markers described in the section on Faces (page 327). This time, instead of eyes and mouth, place them over three similar locations in each photo, and then click the Align Photos button.

6. Tell Elements what you want to move.

If the Pencil tool isn't active, click it in the Photomerge pane. Then, in the Source image, draw over the area you want to move to the Final photo. Just draw a quick line—Elements figures out the exact area to move. (You can also go to the Final preview and draw over the area you want to cover—Elements can figure it out either way.)

7. Adjust the areas if needed.

Use the Pencil tool again to add more areas, or the Eraser tool to remove bits if you moved too much. You can use the Eraser in either preview, Source or Final. If you have more than two photos to work with, in the Project bin, click another photo to move it to the Source slot, and then select the area you want. If you need to see the edges of the areas that Elements is moving, turn on Show Regions, as explained in Figure 11-7. If the exposures don't blend well, go the Advanced Options and turn on Pixel Blending for a smoother merge.

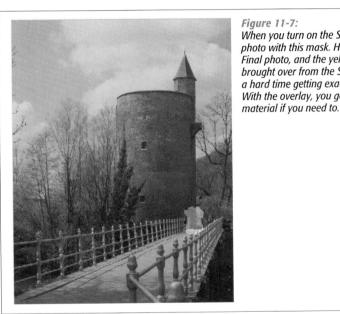

Figure 11-7:
When you turn on the Show Regions checkbox, Elements covers your photo with this mask. Here the blue shows the original area from the Final photo, and the yellow shows the section (without tourists) brought over from the Source photo. The mask is helpful if you have a hard time getting exactly the amount of source material you want. With the overlay, you get a better idea of where to erase or add

8. When you're happy, click Done.

Don't forget to save your work. If you want to start over, click Reset. If you decide to give up on the merge, click Cancel.

Most of the time, you need only the Pencil tool and the Eraser, but Adobe gives you some additional options to help you out when necessary:

• Show Strokes. Leave this turned on or you can't see where you're drawing with the tools.

331

- Show Regions. Scene Cleaner actually brings over chunks of the Source image. If you turn this option on, you can see a blue-and-yellow overlay showing the exact size of the material you're moving (see Figure 11-7).
- Alignment Tool. This advanced option lets you manually set the comparison points. Use these points if you don't like Elements automatic choices. Step 5 above explains how to use the Alignment tool.
- Pixel Blending. Just as in Faces, you turn on Pixel Blending when there's a discrepancy in color or exposure between your photos, so that they combine more seamlessly.

It's not always easy to get enough clear areas to blend, even with multiple photos, but when you have the right kind of source photos, you can create the impression that you and your pals had a private tour of your favorite places.

Correcting Lens Distortion

If you ever photograph buildings, you know that it can be tough getting good shots with a fixed-lens digital camera. When you get too close to the building, your lens causes distortion, as shown in Figure 11-8. You can buy special perspective-correcting lenses, but they're expensive (and if you have a pocket camera, they aren't even an option). Fortunately, you can use Elements' Correct Camera Distortion filter to fix photos after you take them. This is another popular Photoshop tool that Adobe transferred over to Elements, minus a couple of advanced options.

Correct Camera Distortion is a terrifically helpful filter, and not just for buildings. You can also use it to correct the slight balloon effect you sometimes see in close-ups of people's faces (especially in shots taken with a wide-angle setting). You can even deploy the filter for creative purposes, like producing the effect of a fish-eye lens by pushing the filter's settings to their extremes.

Here are some telltale signs that it's time to summon Correct Camera Distortion:

- You've used the Straighten tool (page 71) but things still don't look right.
- Your horizon is straight, but your photo has no true right angles. In other words, the objects in your photo lean in misleading ways. For instance, buildings lean in from the edges of the frame, or back away from you.
- Every time you straighten to a new reference line, something else gets out of whack. For example, say you keep choosing different lines in your photo that ought to be level, but no matter which one you choose, something else in the photo goes out of plumb.
- If you have a problem with vignetting—a dark, shadowy effect in your photo's corners—you can fix that with Correct Camera Distortion, too. You can also *create* vignetting for special effects.

Figure 11-8:
Here's a classic candidate for Elements' Correct
Camera Distortion filter.
This type of distortion is common when you're using a point-and-shoot camera in a narrow space that doesn't let you get far enough away from your subject. You can fix such problems in a jiffy with the help of this filter.

Adobe's made this filter extremely easy to use. Just follow these steps:

1. Open a photo, and then go to Filter → Correct Camera Distortion.

The large dialog box shown in Figure 11-9 appears.

NOTE Even though Correct Camera Distortion is in the Filter menu, you can't reapply it using the **%**-F keyboard shortcut, the way you can with most other filters. You always have to select it from the Filter menu.

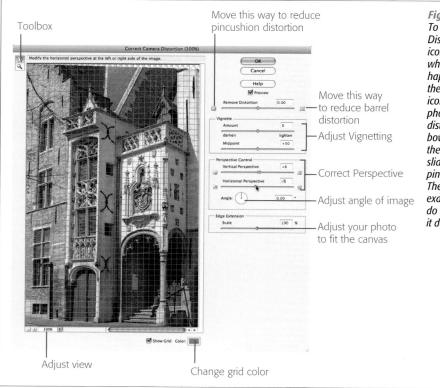

Figure 11-9: To use Correct Camera Distortion, look at the icons next to each slider. which show you what happens when you move the slider toward the icon. For instance, if your photo suffers from barrel distortion (everything bows outwards), move the Remove Distortion slider toward the pinched-in pincushion. The icon illustrates exactly what you want to do to your photo-slim it down.

2. If necessary, use the Hand tool (page 88) to adjust your photo in the window.

You want a clear view of a reference line—something you know you want to correct, like the edge of a building.

If the distortion is really bad, this mission may be impossible, but try to find at least one line as closely aligned to the grid as you can, so you have a reference for changing the photo. You can also use the usual view controls (including zoom in and out buttons) in the dialog box's lower-left corner. The Hand tool adjusts both your photo and the grid, so you can't use it to position your photo relative to the grid. Also, the Hand tool doesn't do anything unless you set the view to more than 100 percent.

The Show Grid checkbox lets you turn the grid on and off, but since you're going to be aligning your image, you'll almost always want to keep it on. To change the grid's color, next to the Show Grid checkbox, click the Color box.

3. Make your adjustments.

This filter lets you fix three different kinds of problems: barrel/pincushion distortion, vignetting, and perspective problems. These errors are the ones you're most likely to run into, and correcting them is as easy as dragging sliders

around. The small icons on each side of some of the sliders show you how your photo will change if you move in that direction. You may need to make only one adjustment, or you may need many (the bulleted list that follows helps you decide which controls to use).

Watch the grid carefully to see how things are lining up. When everything is straightened to your satisfaction, you're done. If you want to start over, Option-click the Cancel button to change it to a Reset button and return your photo to the state it was in when you summoned this filter.

4. Scale your photo, if you wish.

As you make your adjustments, you'll probably notice some empty space appearing on either side of your canvas (the background area of your file). This often happens when Elements pinches and stretches your photo to correct the distortion. To make things right, you have two options. You can click OK now and then crop the photo yourself using any of the methods you learned about starting on page 75. Or, you can stay here and use the Edge Extension slider to enlarge your photo so that it fills the window. If you use this second method, Elements crops some of the photo, and you have little control over what it crops. After all the effort you've put into using this filter, you may as well do your own cropping to get the best possible results.

5. Click OK to apply your changes.

If you don't like the way things are turning out, you can reset your photo by Option-clicking the Cancel button. If you just want a quick look at where you started (without undoing your work), toggle the Preview checkbox on and off.

The Correct Camera Distortion filter gives you a few different ways to adjust your image. Your choices are divided into sections according to the kinds of distortion they fix:

- Remove Distortion. Use this slider to fix *barrel distortion* (objects in your photo balloon out, like the sides of a barrel, as shown in Figure 11-10), and its opposite, *pincushion distortion* (your photo has a pinched look, with the edges of objects pushing in toward the center). Move the slider to the right to fix barrel distortion, and to the left to fix pincushion distortion.
 - TIP Barrel distortion is usually worst when you use wide-angle lens settings, while pincushion distortion generally appears when a telephoto lens is fully extended. Barreling's more common than the pincushion effect, especially when you use a small point-and-shoot camera at a wide-angle lens setting. You can often reduce barrel distortion in a small camera by simply avoiding your lens's widest setting. For instance, if you go from f2.8 to f5.6, you may see significantly less distortion.
- Vignette. If your photo has dark corners (usually caused by shadows from the lens or lens hood), you need to spend time with these sliders. Vignetting typically afflicts owners of digital single-lens reflex cameras, or people who use addon lenses with fixed-lens cameras. Move the Amount slider to the right to

335

Figure 11-10:
A classic case of barrel distortion. This photo was already straightened with the Straighten tool (page 71), but things are still out of plumb here. Notice how the columns and walls lean in toward the top of the photo. You can even see a bit of a curve in the pillar on the far right. Barrel distortion is the most common kind of lens distortion, and you can easily fix it with the Correct Camera Distortion filter.

lighten the corners, and to the left to darken them. The Midpoint slider controls how much of your photo is affected by the Amount slider. Move it to the left to increase the area (to bring it toward the center of the photo), or to the right to keep the vignette correction near the edges. Also consider turning off the Show Grid checkbox so that you have an unobstructed view of how you're changing the lightness values in your photo. Turn it back on again if you have other adjustments to make afterward.

• Perspective Control. Use these sliders to correct objects like buildings that appear to be tilted or leaning backward. It's easiest to understand these sliders by looking at the icons at both ends, which show the effect you'll get by moving the slider in that direction. The Vertical Perspective slider spreads the top of your photo wider as you move the slider to the left, and makes the bottom wider as you move it to the right. (If buildings seem like they're leaning backward, move it to the left first.) The Horizontal Perspective slider is for when your subject doesn't seem to be straight on in relation to the lens (for example, if it appears rotated a few degrees to the right or left). Move the slider to the left to bring the left side of the photo toward you, and to the right to bring the right side closer.

• Angle. You can rotate your entire photo by moving the line in this circle to the angle you want, or by typing a number into the box. A small change here has a huge effect. Here's how it works: There are 360 degrees in a circle. Your photo's starting point is 0.00 degrees. To rotate your photo to the left (counterclockwise), start from 0.01, and then go up in small increments to increase the rotation. To go clockwise, start with 359.99, and then reduce the number. In other words, 350 is further to the right than 355.

TIP Each of the adjustment settings is accompanied by a box where you can type a number instead of using the sliders. If you want to make the same adjustments to many photos, take note of the numbers you used to fix your first photo, and then plug those numbers into the boxes for the other photos.

• Edge Extension. As explained in step 4 above, when you're done fixing your photo, you're likely to end up with some blank areas along the edge of your photo's canvas. Move the Scale slider to the right to enlarge your photo and get rid of those blank areas. Moving the slider to the left shrinks your photo and enlarges the blank areas, but you'll rarely need to do that.

Unlike the Zoom tool, the Scale slider changes your *actual* photo, not just your view of it. So when you click the Correct Camera Distortion dialog box's OK button, Elements resizes and crops your photo. If you want the objects in your photo to stay the same size, don't use this slider. Instead, just click OK, and then crop using any of the methods discussed starting on page 75.

The most important thing to remember when using Correct Camera Distortion is that a little goes a long way. For most corrections, start small and work in tiny increments. These distortions can be subtle, and you often need to make only subtle adjustments to correct them.

TIP The Correct Camera Distortion filter isn't just for corrections. You can use it to make your sour-tempered boss look truly prune-y, for example, by pincushioning him. (Just make sure you do it at home.) Or, you can add vignettes to photos for special effects, and use the filter on shapes (simplify them first [page 373]), artwork, or anything else that strikes your fancy.

Transforming Images

You'll probably end up using the Correct Camera Distortion filter, explained in the previous section, for most of your straightening and warp-correction needs. But Elements also includes a set of Transform commands, shown in Figure 11-11. Transforming comes in handy when you want to make a change to just *one* side of a photo, for example, or for final tweaking to a correction you made with Correct Camera Distortion. You can also apply these commands just for fun to create wacky photos or text effects.

Figure 11-11:
Left: While you can use
Correct Camera Distortion
(page 332) to straighten a
slanting building like this, you
can also use the Transform
commands, which are a
better choice when you need
to adjust only one side, as in
this image.

Right: Here, it took only a dose of Skew and a bit of Distort to pull the building straight and make it tall again.

Skew, Distort, and Perspective

Elements gives you four Transform commands, including three specialized ones—skew, distort, and perspective—to help straighten up the objects in your photos. They all move your photo in different directions, but the way you use them is the same. The Transform commands have the same box-like handles that you see when using the Move tool. You choose the command you want, and then the handles appear around your photo. Just drag a handle in the direction you want your photo to move. Figure 11-12 shows how to use the Transform commands.

To see the list of Transform commands, go to Image → Transform. The first one, Free Transform, is the most powerful because it includes all the others—you'll learn about it in the next section.

NOTE Transform works only on layers or active selections. If you have only a Background layer, Elements turns it into a regular layer when you try to use Transform.

The other Transform commands, which are more specialized, are:

- Skew slants an image. If you have a building that looks like it's leaning to the right, you can use Skew to pull it to the left and straighten it back up again.
- Distort stretches your photo in the direction you pull it. Use it to make buildings (or people) taller and skinnier, or shorter and squatter.
- Perspective stretches your photo to make it look like parts are nearer or farther away. For example, if a building in your photo looks like it's leaning away from you, you can use Perspective to pull the top back toward you.

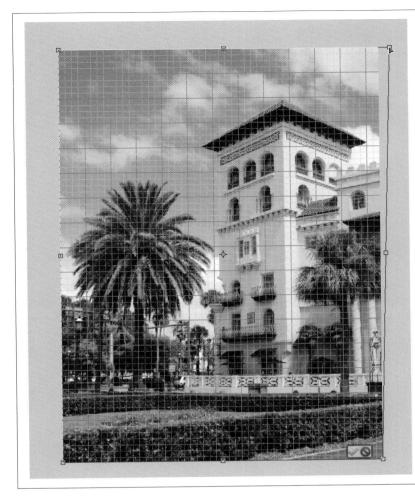

Figure 11-12: Here's an example of how you'd use the Skew command to pull a building upright. To apply the Transform commands, make sure you can reach the handles on the image's corners. It helps to enlarge your image window far beyond the size of the actual image to give yourself room to pull. If you're using tabbed windows (page 84), vou don't need to do anything, because you already have plenty of space around the image. With floating windows, just drag the lower-right corner to enlarge the window.

Although Free Transform is the most capable command, it can also be trickier to use. You may find it easier to use one of the specialized Transform commands so you don't have to worry about inadvertently moving a photo in an unwanted direction.

TIP If you have an active selection, then you can apply the Transform commands just to the selection, as long as you're not working on a Background layer.

All the Transform commands, including Free Transform, have the same Options bar settings, shown in Figure 11-13.

339

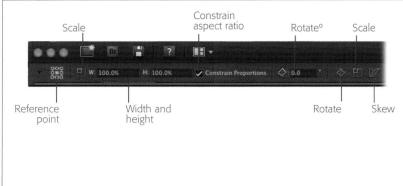

Figure 11-13: The Options bar for the Transform commands. The W (width) and H (height) boxes let you specify dimensions when resizing your image (click the Scale button to their left once vou're done enterina the numbers). To scale by dragging, click the Scale button toward the right side of the tool options, and then drag any of the scaling handles (not shown) that appear on the bounding box around your image.

From left to right, the Options bar settings control:

• Reference point location. This strange little doodad (shown in Figure 11-14) lets you tell Elements where the fixed point should be when you transform something. It's a miniature cousin of the Canvas Size dialog box's placement grid (page 97). The reference point starts out in the image's center, but you can tell Elements to move everything using the upper-left corner or the bottom-right corner as the reference point instead. To do that, click the square you want to use as the reference.

Figure 11-14:

This nine-box icon in the Options bar is where you set the reference point for transformations, which tells Elements the central point for rotations. For example, if you want your photo to spin around the lower-left corner instead of the center, click the lower-left square. For the Transform commands, this also tells Elements the point to work from.

- Scale. You can resize your image by dragging, or enter a percentage in the W or H box here. Turn on the Constrain Proportions checkbox to keep the original proportions of your image.
- Rotate. The box next to the small rotated squares (to the right of Constrain Proportions) lets you enter the number of degrees you want Elements to rotate your image or selection.
- **Rotate.** Click this next pair of rotated squares and you can grab a corner of your image to make a free rotation (see page 73).
 - **TIP** If you Shift-drag when turning your image, you force it to turn in 15-degree increments.
- Scale. Click here if you want to resize your image by dragging rather than entering numbers in the W and H boxes.

• Skew. Click here, and then pull a corner of your image to the left or right, the way you do with the Skew command.

In most cases, you can transform your object without paying much attention to these settings. The easiest way to transform your photo is to grab a handle and drag. Here's what you do:

1. Position your image to give yourself room to work.

Position your photo so that you have room to drag the handles far beyond its edges. Figure 11-12 is a good example of an image window that's sufficiently expanded to make lots of transformations. If you're using tabbed windows (page 83), you probably have plenty of room.

2. Choose how to transform your image.

Go to Image → Transform, and then select the command you want. It's not always easy to tell which is best for a given photo, so you may want to try all three in turn. You can always change your mind and undo your changes by pressing Esc before you accept a change, or undo by pressing \(\mathbb{H}\)-Z after you've made the change.

You can apply Transform commands only to layers, so if your image has only a Background layer, the first thing Elements does is ask you to convert that layer to a regular layer; click Yes. (You can apply Transform commands to a *selection* on a Background layer without converting it to a regular layer, though.) Once the Transform command is active, handles appear around your image.

3. Transform your image.

Grab a handle and pull in the direction you want the image to move. You can switch to another handle to pull in a different direction too. If you decide you made a mistake, press Esc to return to your original photo.

4. When you're happy with how your photo looks, accept the change.

Click the Commit button (the green checkmark) in your photo or press Return. Click the Cancel button (the red No symbol) instead if you decide not to apply the transformation after all.

TIP Before clicking the Commit button, you can switch to another Transform command and add that transformation to your image, too.

Free Transform

Free Transform combines all the other Transform commands into one, and lets you warp your image in many different ways. If you aren't sure what you need to do, Free Transform is a good choice.

You use Free Transform exactly the way you use the other Transform tools, following the steps in the previous section. The difference is that with Free Transform, you can pull in *any* direction, using keystroke-drag combinations to tell Elements which kind of transformation you want to apply. Each of the following transformations does exactly the same thing it would if you selected it from the Image → Transform menu:

- Distort. To make your photo taller or shorter, **%**-drag any handle. Your cursor turns into a gray arrowhead.
- Skew. To make your photo lean to the left or right, \(\mathcal{H}\)-Shift-drag a handle in the middle of a side. You cursor turns into a gray arrowhead with a tiny double-arrow next to it.
- Perspective. To correct an object that appears to lean away from or toward you, press \(\mathbb{H}\)-Option-Shift and drag a corner. You see the same gray arrowhead cursor as when you're distorting.

Free Transform is the most powerful of all the Transform commands, but when you're pulling in several different directions, it's tricky to avoid distorting your photo. That's why some people prefer the simpler Transform commands, and apply multiple transformations instead.

TIP To transform only a selected area, check out the new Transform Selection command (page 147), which lets you make any of these changes to a selection's outline without calling up Free Transform. To change the *contents* of the selection, use the tools covered in this chapter.

Part Four: Artistic Elements

Chapter 12: Drawing with Brushes, Shapes, and Other Tools

Chapter 13: Filters, Effects, Layer Styles, and Gradients

Chapter 14: Text in Elements

Drawing with Brushes, Shapes, and Other Tools

If you're not of the artistic persuasion, you may be tempted to skip this chapter. After all, you probably just want to fix and enhance your photos—why should you care about brush techniques? Surprisingly enough, you should care quite a lot. In Elements, brushes aren't just for painting a moustache and horns on a picture of someone you don't like, or for blackening your sister's teeth in an old school photo.

Many Elements tools use brushes to apply their effects. So far, you've already run into the Selection brush, the Clone Stamp, and the Color Replacement brush, to name just a few. And even with the Brush tool, you can paint with lots of things besides color—like light or shadows, for example. In Elements, when you want to apply an effect in a precise manner, you often use some sort of brush to do it.

If you're used to working with real brushes, their digital cousins can take some getting used to, but there are many serious artists who paint primarily in Photoshop. With Elements, you have access to many of the same tools as in full Photoshop, just with fewer settings. Figure 12-1 shows an example of the detailed work you can do with Elements and some artistic ability.

This chapter explains how to use the Brush tool, some of the other brush-like tools (like the Erasers), and how to draw shapes even if you can't hold a pencil steady. You also get some practical applications for your new skills, like dodging and burning your photos to enhance them, and an easy way to create sophisticated, artistic crops for your photos—a favorite feature of scrapbookers.

Figure 12-1:
Artist Jodi Frye created this complex drawing entirely in Elements. If you learn to wield all of Elements' drawing power, you can create amazingly detailed artwork.

Picking and Using a Basic Brush

If you look at the Tools panel, you'll see the Brush tool icon below the Eraser (in a single-column Tools panel) or below the Clone Stamp (in a double-column Tools panel). (Don't confuse it with the Selection brushes or the Smart Brush.) Click the Brush tool's icon or press B to activate it.

The Brush is one of the tools that include a hidden pop-out menu—you can choose between the Brush, the Impressionist brush, the Color Replacement tool, and the Pencil tool. You can read about the Impressionist brush and the Pencil tool later in this chapter, and about the Color Replacement tool on page 294. This section is about the regular Brush tool.

The Options bar (Figure 12-2) gives you lots of ways to customize the Brush tool.

Figure 12-2:
The Brush tool's Options bar. By changing the settings shown here, as well as the hidden settings—revealed when you click the Additional Brush Options button—you can dramatically alter any brush's behavior.

Here's a quick rundown of the Brush's options (from left to right):

• Brushstroke thumbnail. The Options bar displays a thumbnail of the stroke you'd get with the current brush. Click the thumbnail to view the complete Brush palette. Elements gives you a bunch of basic brush collections, which you can view and select here. You can also download more from various websites (see page 493).

If you click the pull-down menu, you'll see that you get more than just hard or soft brushes of various sizes (see Figure 12-3). You also have special brushes for drop shadows, brushes that are sensitive to pen pressure if you're using a graphics tablet (you can also use them with a mouse, but you don't have as many options), and brushes that paint shapes and designs. (Page 491 explains graphics tablets.)

NOTE One cool feature of the brushes is that any changes you make to a brush are reflected in the brushstroke thumbnail in the Brush palette.

Figure 12-3:

Elements gives you a pretty good list of different brushes to choose from, and you can add your own. Here you see just one of the many brush libraries included with Elements, the Default Brushes. The way Elements starts off showing the brushes (black thumbnails on a dark gray background) is hard to see. Click the double arrows in the palette's upper right and choose Stroke Thumbnail for this black-on-white view. You can make brushes, too, as explained on page 354.

• Size. This slider lets you adjust the size of your brush—anywhere from 1 pixel up to sizes that may be too big to fit on your monitor. Or you can just type in a size. Figure 12-4 shows you an easy way to adjust brush size using your mouse. As you're working, you can press the close bracket key (]) to quickly increase brush size, or the open bracket key ([) to decrease it.

Figure 12-4:

You don't need to open pull-down menus like the one shown here that says "13 px". Just move your cursor over the word "size", and the cursor changes into a pointing hand with a double-headed arrow. Now you can "scrub" (click and drag) back and forth right on the Options bar to make the changes—left for smaller, right for larger. This trick also works anywhere you see a numerical pop-out slider (as in the Layers palette's Opacity menu, for example).

- Mode. Here's where you choose the brush's blend mode. Your choice determines how the brush's color interacts with what's in your image. For example, Normal simply paints the current Foreground color (more about all the Mode choices later).
- Opacity. This option controls how thoroughly your brushing covers what's beneath it. You can use the pull-down menu's slider or type in a percentage from 1 to 100; 100 percent gives you total coverage (at least in Normal mode). Or you can scrub, as shown in Figure 12-4.
- Airbrush. Clicking the pen-like icon just to the right of the Opacity control lets you use the brush as an airbrush. Figure 12-5 shows you how this works.
- Tablet Options. Click the tiny arrow to the right of the airbrush to see some checkboxes. If you have a graphics tablet, use these settings to tell Elements which brush characteristics should respond to the pressure of your stroke. There's more about graphics tablets on page 491.

Figure 12-5:
As with real airbrushes, the airbrush option causes Elements to continue to "spray" paint as long as you hold down the mouse button, whether or not you are moving the mouse.

Top: Here's what you get with one click with the brush in Regular mode.

Bottom: Here's the effect of one click with the same brush in Airbrush mode. See how far the color spread beyond the cursor (the circle)? Not every brush offers the airbrush option.

• Additional Brush Options. Clicking this icon brings up the Additional Brush Options palette, which gives you oodles of ways to customize your brush, all of which are covered in the next section. If you're using your brush for artistic purposes, it pays to familiarize yourself with these settings, since this is where you can set a chiseled stroke or a fade, for example.

TIP To return a brush to its original settings, click the Reset button (the tiny black arrow) on the left end of the Options bar and then click Reset Tool in the pop-up menu that appears.

To use the Brush, enter your settings—make sure you've selected the color you want in the Foreground color square (page 216)—and then drag across your image wherever you want to paint.

TIP If you're used to painting with long, sweeping strokes, keep in mind that in Elements, that technique can be frustrating. That's because when you undo a mistake (by pressing 98-Z), Elements undoes *everything* you did while you've been holding down the mouse button. In tricky spots, you can save yourself aggravation by using shorter strokes so you don't have to lose that whole long curve you painstakingly worked on just because you wobbled a bit at the end. (The Eraser tool [page 365] is handy for tidying up in these situations, too.)

One of the biggest differences between drawing with a mouse and drawing with a real brush is that, on a computer, it doesn't matter how hard you press the mouse. But if you have a *graphics tablet*, an electronic pad that causes your pen movements to appear onscreen instantly, you can replicate real-world brushing, including pressure effects. Page 491 tells you all about using a tablet.

TIP To draw or paint a straight line, hold down the Shift key while moving your mouse. If you click where you want the line to start, and press and hold Shift, and then click at the end point, Elements draws a straight line between those two points. Remember to click first and *then* press Shift, or you may draw lines where you don't want them.

Modifying Your Brush

When you click the Options bar's Additional Brush Options button, Elements displays a palette that lets you customize the brush in a number of ways. (You'll run into a version of this palette for some of the other brush-like tools, such as the Healing brush.) The Additional Brush Options palette lets you change the way your brush behaves in a number of sophisticated and fun ways. Mastering these settings goes a long way toward getting artistic results in Elements.

TROUBLESHOOTING MOMENT

What Happened to My Cursor?

One thing that drives Elements newcomers nuts is having the Brush cursor change from a circle to crosshairs, seemingly spontaneously. This is one of those "It's not a bug; it's a feature" situations. Many tools in Elements offer you the option of what's called the *precise cursor*, shown in Figure 12-6. There are situations where you may prefer to see those little crosshairs so that you can tell *exactly* where you're working.

You toggle the precise cursor by pressing the Caps Lock key. So, if you hit that key by accident, you may find yourself in precise cursor mode with no idea how you got there. Just press it again to turn it off.

There's one other way you may wind up with the precise cursor, and this time you have no choice in the matter. It happens when your image is so small in proportion to the cursor that Elements *has to* display the crosshairs to show the brush in the right scale for your image. Zooming in usually gets your regular cursor back, unless you're working with a 1-pixel brush, which always uses crosshairs.

You can also elect to always see the crosshairs within the regular cursor circle. In the Preferences dialog box, at the bottom of the list of painting cursors, turn on the "Show Crosshair in Brush Tip" checkbox and you'll always have a mark for the center of your brush.

Figure 12-6:

Adobe calls these crosshairs the precise cursor. Elements sometimes makes your tool look like this when you're zoomed way out on an image. To get the normal cursor back, you can zoom; read the box above for further advice.

• Fade controls how fast the brushstroke fades out—the same way a real brush does when you run out of paint. A lower number means it fades out quickly while a higher one means the fade happens slowly. (Counterintuitively, zero is no fading at all—the stroke is the same at the end as it is at the beginning.)

You can pick a number up to 9999, so with a little fiddling, you should be able to get just what you want. If the brush isn't fading fast enough, decrease the number. If it fades too fast, increase it. A smaller brush usually needs a higher number than a larger brush does. You may find that you need to set the brush spacing (see below) up into the 20s or higher to make fading visible.

• Hue Jitter controls how fast the brush switches between the Background and Foreground colors. Some brushes, especially the ones that you'd use to paint objects like leaves, automatically vary the color for a more interesting or realistic effect. The higher the number (percentage) here, the faster the color moves from Foreground to Background. A lower number means the brush takes a longer distance to get from one color to the other. Brushes that acknowledge hue jitter don't put down only the two colors, but a range of hues in between. Not all brushes respond to this setting, but for the ones that do, it's a cool feature. Figure 12-7 shows how it works.

Figure 12-7: Top: A brushstroke with no hue jitter.

Middle: The same brushstroke with a medium hue jitter value.

Bottom: The same brushstroke with a high hue jitter value. The Foreground and Background colors here are red and blue, respectively. Notice how the brush automatically does a little shading, even without allowing for jitter. It takes a fairly high number to get all the way to blue in a stroke this short.

- Scatter means just what it says—how far the marks are distributed in your brushstroke. (When you paint with an Elements brush, you're actually putting down many repetitions of the brush shape rather than an actual line.) If you set scatter to a low number (percentage), you get a dense, line-like stroke, whereas a higher value gives an effect more like random spots.
- Spacing controls how far apart the brush marks are laid down when you paint. A lower number makes them close together, a higher number farther apart, as shown in Figure 12-8.

Figure 12-8:

The same brushstroke with the spacing set at 5 percent, 75 percent, and 150 percent (respectively, from top to bottom). You may have wondered why some of the brush thumbnails look like long caterpillars, when the brush should paint an object, like a star or leaf. The reason? Cramped spacing: The thumbnail shows the spacing as Elements originally sets it. Widen the spacing to see separate objects instead of a clump.

- Hardness controls whether the brush's edge is sharp or fuzzy. This setting isn't available for all brushes, but when it is, you can choose any value between zero and 100 percent. 100 percent is the most defined edge, zero the fuzziest.
- Angle and Roundness are settings you'll understand right away if you've ever
 painted with a real brush. They let you create a more chiseled edge to your
 brush and then rotate it so it's not always painting with the edge facing the same
 direction. Painters don't use only round brushes, and you don't have to in Elements, either.

There are some brushes in the libraries that aren't round, like the calligraphy and chalk brushes. But you can adjust any brush's roundness to make it more suitable for chiseled strokes, as shown in Figure 12-9.

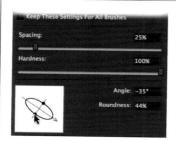

Figure 12-9:

Here's the bottom of the Additional Brush Options palette. To adjust the angle and roundness of a brush, push the black dots to make the brush rounder or narrower and then grab the arrow and spin it to the angle you want. You can also type a number into either the Angle or Roundness box.

You can turn on the Keep These Settings For All Brushes checkbox if you want to make all brushes behave exactly the same way. The checkbox keeps only the settings that appear *above* it in the palette, though, not the ones below it (spacing, hardness, angle, and roundness).

Saving Modified Brush Settings

If you modify a brush and like your creation, you can save it as a custom brush. You can alter any of the existing brushes and save the result—a great feature if you're working on a project that's going to last awhile and don't want to keep modifying the settings again and again. (Don't worry: When you modify an existing brush, Elements keeps a copy of the original.) To create your own brush:

1. Choose a brush to modify.

Select a brush in the Brush palette. You can customize any of the brushes.

2. Make the changes you want.

Change the brush's settings until you get what you're after. Watch the brush thumbnail in the Options bar; it changes to reflect your new settings.

3. Tell Elements you want to keep the new brush.

Click the double arrow in the upper-right corner of the brush thumbnails palette and choose Save Brush. Elements asks you to name it; you don't have to, but naming brushes makes them easier to keep track of. (The name will appear as pop-up text when you hover over the brush's thumbnail in the pop-out palette.)

4. Click OK.

The brush shows up at the bottom of your current list of brushes. If you make lots of custom brushes, you may want to create a special set for them. The Preset Manager (page 495) can help you do that.

Deleting brushes is pretty straightforward. You can select the brush in the Brush palette and then click the upper-right double arrows and choose Delete Brush from the pop-out menu. Or you can Option-click the brush's thumbnail in the palette. The cursor changes into a pair of scissors when you hold down the Option key; simply click with the scissors to delete the brush. Finally, you can also right-click (Control-click) the thumbnail and choose Delete from the menu that appears.

You can also make a selection from an image and save it as a brush, if you like (the next section explains how). But remember that brushes by definition don't have color, so you save only the *shape* of the selection, not the color of it. The color you get is whichever color you choose to apply. If you want to save a full color sample, try saving your selection as a pattern (page 277) or use the Clone Stamp repeatedly instead.

The Specialty Brushes

So far you've learned about brushes that behave much as brushes do in the real world—they paint a stripe of something, whether that's color, light, or even transparency. But in the digital world, a brush doesn't have to be just a brush. With some of Elements' brushes, you can paint stars, flowers, or even rubber ducks with just one stroke, as shown in Figure 12-10.

If you click the arrow next to the brush's thumbnail in the Options bar, you'll see the list of brushes in the current category and a pull-down menu that lets you investigate Elements' other brush sets. The brushes used in Figure 12-10, for example, came from several different categories. Most brushes are sensitive to your pen pressure if you're using a graphics tablet (page 491).

The Specialty brushes readily respond to changes in the Additional Brush Options palette's settings (covered earlier in this chapter). Your choices there can make a huge difference in the effect you get—whether you're painting swaths of smooth grass, like a lawn, or scattered sprigs of dune grass, for instance.

Figure 12-10:
You can digitally doodle using Elements' brushes, even if you can't draw a straight line. Everything in this drawing was done with brushes that come with Elements. The leaves were painted with a brush that paints leaves; the yellow ducks come from a brush that paints rubber ducks, and so on.

TIP If you've tried some of the special effects brushes and found the results rather anemic, you can always go back once you've painted and punch up the color with a Multiply layer, just as you would do for an overexposed photo (see page 193).

Making a Custom Brush

You can turn any picture, or selection within a picture, into a brush that paints the shape you've selected. Figure 12-11 shows what a poinsettia looks—and behaves—like when it's been turned into a brush.

It's surprisingly easy to create a custom brush from any object in a picture:

1. Open a photo or drawing that includes what you want to use as a brush.

You can choose an area as large as 2500 pixels square. (Remember, you can resize your selection once it's a brush, just the way you can resize any other brush, so don't worry if it's a big area. That said, if you choose a tiny size for a super-detailed brush, you may lose some definition when you use it.)

2. Select the object or region you want.

Use any of the Selection tools to do this. It's a good idea to inspect your selection with the Selection brush in Mask mode as a last step (page 133), because any stray areas you include by mistake get painted with each stroke.

Figure 12-11: Left: To make a brush that draws poinsettias, select one in a photo and save it as a brush.

Right: You can paint better than you thought! And with the brush, your poinsettias can be any color you like.

3. Create your brush.

Go to Edit → "Define Brush from Selection". A dialog box appears showing the selection's shape and asking you to name the new brush. Check the thumbnail to be sure it's exactly what you had in mind. If not, click Cancel and try again. If you like it, click OK.

The new brush shows up at the bottom of the current list of brushes. If you want to get rid of it, Option-click the brush's thumbnail or highlight the thumbnail, click the double arrows on the right side of the palette, and then choose Delete Brush.

The Impressionist Brush

When you paint with the Impressionist brush, you blur and blend the edges of the objects in your photo, like in an Impressionist painting. At least that's what's *supposed* to happen. This brush is tricky to control, but you can get some interesting effects with it, especially if you paint on a duplicate layer and play with the Opacity setting (page 166). Usually you want a very low opacity with this brush, or some of the curlier styles will make your image look like it's made from poodle hair. Changing the Mode (page 361) can also help to control the effect.

To activate the Impressionist brush, press B or click the Brush tool's Tools panel icon and select it from the pop-out menu. This brush has most of the same options as the regular Brush, but if you click the More Options button (the icon to the right of the Opacity setting), you'll see these three settings:

- Style determines what kind of brushstroke effect the tool creates.
- Area tells Elements the diameter of the painting area.

• Tolerance is how similar in color pixels have to be before they're affected by the brush.

If you want to create a hand-painted look, you may prefer the brushstroke filters (Filter → Brush Strokes); page 383 explains how to use them. The Impressionist brush isn't really the best tool for creating true Impressionist effects, although its blurring abilities can sometimes be useful because it covers large areas faster than the Blur tool. The Smudge tool (page 364) is another excellent, though time-consuming, way to create a painted effect.

The Pencil Tool

Basically just another brush, the Pencil tool shares the Brush tool's slot in the Tools panel. Choose the Pencil from the pop-out menu or press N to activate it.

The Pencil has many of the same settings as the Brush tool—like size, mode, and opacity—but it offers only hard-edged brushes. In other words, you can't draw fuzzy lines with the Pencil, not even the kind of lines you'd sketch with a soft pencil; the Pencil tool's lines are always well defined. It's especially useful when you want to work on a pixel-by-pixel basis.

You use the Pencil tool the same way you use any other brush. The big difference is the Auto Erase checkbox in the Options bar. This setting makes the Pencil paint with the Background color over areas that contain the Foreground color. But if you start dragging in an area that doesn't include the Foreground color, it paints with the Foreground color instead. This is confusing until you try it. Take a look at Figure 12-12 for help understanding this setting, or better yet, create a blank file (page 50) and try it yourself.

Figure 12-12:

The slightly confusing Auto Erase option was used here to create two lines: a horizontal one of the Foreground color (purple) and a vertical one of the Background color (green). The horizontal line was drawn by starting with the cursor in the background (so the Pencil erased the green, leaving a purple line across the circle). The vertical line was drawn by starting in the purple circle, exposing the Background color.

The Paint Bucket

When you want to fill a large area with color in a hurry, grab the Paint Bucket. It's right below the Brush in the Tools panel if you have two rows of tools, or below the Smart brush if you have a single row. If you click it (keyboard shortcut: K) and then click in your image, all the available area (either your whole image or the current selection) gets flooded with color. Just as the Magic Wand selects only the color you click, the Paint Bucket fills only the color you click.

NOTE Make any Options bar setting adjustments before clicking in your photo.

Most of the Paint Bucket's Options bar settings are probably familiar:

- Pattern. The Paint Bucket normally fills an area with the Foreground color (page 216). But turn on this checkbox and it uses a pattern (page 276) instead. Choose an existing pattern (listed in the Pattern drop-down menu in the Options bar) or create your own (see page 277).
- Mode. You can use the Paint Bucket in any blend mode, as explained later in this chapter (page 361).
- Opacity. One hundred-percent opacity gives you total coverage; nothing shows through the paint you put down. Lower the percentage for a more transparent effect.
- Tolerance. This setting works the same way it does for the Magic Wand (page 136). The higher the number, the more shades the paint fills.
- Anti-alias. This setting smoothes the edges of the fill. Leave it turned on unless you have a specific reason not to.
- Contiguous. This is another option you're familiar with from using it with the Magic Wand (page 135). If you leave this option on, you change only areas of the chosen color that touch each other. Turn it off and all areas of the color you click are changed, whether or not they're contiguous.
- All Layers. Fills any pixels that meet your criteria, no matter what layer they're on. (The Paint Bucket actually paints on the active layer, but with this checkbox turned on, it looks in all the layers in your image for pixels to change.) To exclude a layer, click the eye icon next to it in the Layers panel to hide it. Don't forget that you can lock the transparent and translucent parts of layers in the Layers panel (see page 167).

You can undo a Paint Bucket fill with the usual ₩-Z.

TIP You can sometimes improve blown-out skies by using the Eyedropper to select an appropriate shade of blue from another photo and then filling the blown-out areas of your sky using the Paint Bucket at a very low opacity.

Dodging and Burning

Dodging and burning are old darkroom techniques for enhancing photos and emphasize particular areas. Dodging *lightens* and brings out the hidden details in the range you specify (midtones, shadows, or highlights), and burning *darkens* and brings out details in a given range. Both tools live with the Sponge tool in the Tools panel.

You may think that, given the Shadows/Highlights command, you don't need these tools. But they're handy because they let you make *selective* changes, rather than affecting the entire image or requiring tedious selections the way Shadows/Highlights does. When you dodge or burn, you just paint your changes. Figure 12-13 shows an example of when you might need to work on a particular area. Of course, you can also make a selection and then use Shadows/Highlights on just that area, which you may want to try as well as dodging and burning.

Figure 12-13:
Although the overall shadow/
highlight balance of this photo
is about right, the detail in the
face of this little concert-goer is
obscured by backlighting and
by her father's shadow.
Careful dodging and burning
can really improve these
problems, as you can see in
Figure 12-14.

Skillful use of dodging and burning can greatly improve your photos, although it helps to have an artistic eye to spot what to emphasize and what to downplay. Use these tools along with Elements' black-and-white conversion feature (page 299) to emphasize certain areas of your photos. Masters of black-and-white photography, like Ansel Adams, relied heavily on dodging and burning (in the darkroom, in those days) to create their greatest images.

The Dodge and Burn tools are really just variants of the Brush tool, except they don't apply color—they only affect the colors and tones that are already in your photo. Adobe refers to these two as the "toning tools."

A word of warning about these tools: Unless you use them on a duplicate layer, you can't undo the effect once you close your photo. So be careful with how you use them. Many people prefer to dodge and burn using the method described in the box on page 363, rather than with the actual Dodge and Burn tools, unless they're working on a black-and-white photo.

TIP You may also want to try some of the Smart Brush's (page 196) lighting settings for making adjustments to only part of your photo. A little experimenting will give you a sense of which tools you prefer to use in different situations.

Dodging

Use the Dodge tool to lighten areas of your image and bring out details hidden in shadows. It's a good idea to create a separate layer (Layer → Duplicate Layer or **%**-J) when using this tool, to preserve your image if you go overboard. (Be sure you apply the Dodge tool to a layer that has something in it, or nothing happens.) Here's how to use it:

1. Activate the Dodge tool.

Click the Sponge tool in the Tools panel or press O, and then choose the Dodge tool (the lollipop-like paddle) from the pop-out menu. You'll see the usual brush options, but with two differences: a Range setting that controls whether the tool works on highlights, midtones, or shadows; and an Exposure setting that determines the strength of the effect.

2. Drag over the area you want to change.

Choose a low Exposure setting for the Dodge tool (and the Burn tool as well) and drag more than once to get a more realistic result (see Figure 12-14). After you're done, if the tool's effect is too strong, you can always reduce the layer's opacity (as long as you're working on a duplicate layer).

Burning

The Burn tool works just like the Dodge tool but does exactly the opposite: It darkens. Use the Burn tool to uncover details in highlights. (Of course, there have to be *some* details there for the tool to work.) If your photo's highlights are blown out (see page 195), you won't get any results, no matter how much you apply the tool.

Figure 12-14: Figure 12-13 after a dose of the Dodge and Burn tools. The girl's features are much easier to see, but if you look closely, the colors in her face are a bit flat. See page 363 to learn another method for selectively adjusting highlights and shadows. Both methods have advantages and disadvantages. (The effects are deliberately a bit too strong in both figures to show you the perils of getting overzealous with either method.)

The Burn tool is grouped in the Tools panel with the Sponge and Dodge tools. Its icon is a curled hand.

Most of the time, you'll probably want to use the Dodge and Burn tools in combination. They can help draw attention to specific parts of your photo, but they work best for subtle changes. Applying them too vigorously—especially on color photos—creates a faked look. Black-and-white pictures (or color images converted to black and white) can generally stand much stronger contrasts.

Blending and Smudging

You can control how Elements blends the color you add to an image with the colors that are already there. This section takes a look at two different blending methods—using *blend modes* to determine how the colors you paint change what's already in your image, and using the Smudge tool to mix parts of your image together.

Blend Modes

Blend modes are almost limitless in the ways they can manipulate images. They control how the color you add when you paint reacts with the existing pixels in an image—whether you add color (Normal mode), make the existing color darker (Multiply mode), or change the saturation (Saturation mode).

Image-editing experts have developed many sophisticated techniques using blend modes. Thorough coverage of these maneuvers would turn this into a book the size of the Yellow Pages, but Figure 12-15 shows a few examples of how simply changing a brush's blend mode can radically change your results. There are so many ways to combine blend modes that even Elements pros can't always predict the results, so experimenting is the best way to learn about them.

Figure 12-15:
This photo shows the effect of different blend modes used with the Brush tool. The same color was used for each vertical stripe—you can see how different the result is from just changing the mode. From left to right, the modes are: Normal, Color Burn, Color Dodge, Vivid Light, Difference, and Saturation.

Elements groups blend modes according to the effects they have. You won't always see every group or all the choices, but generally speaking, in Elements menus (such as the Options bar menu for the Brush tool) the top group includes what you might call painting modes, followed by modes for darkening, lightening, adjusting light, special effects, and adjusting color.

Keep in mind that the modes work differently with layers than with tools. In other words, painting with a brush in Dissolve mode produces an effect quite different than creating a layer in Dissolve mode and painting on it, as shown in Figure 12-16.

Figure 12-16:
Blend modes behave differently when used in layers than they do when using a tool set to the same mode. Both these strokes were done using Dissolve mode in pure black at 100-percent opacity. The difference is that the top stroke is painted with the Brush tool in Dissolve mode, while the bottom one is a brush stroke in Normal mode on a Dissolve layer.

Modes are cool and useful once you get used to them, but if you're just starting out in Elements, there's no need to worry about them right away.

TIP To learn more about how each mode works, there are a lot of useful tutorials on the Web. A good place to start is *www.photoshopgurus.com/tutorials/t010.html*. (Ignore the section "Additional blend mode information"—that's only for Photoshop folks.)

The Smudge Tool

The Smudge tool does just what you'd think: You can use it to smear the colors in your image as if you were rubbing them with your finger. You can even "finger paint" with this tool, if you feel the call of your inner preschooler. Adobe describes the effect of the Smudge tool as being "like a finger dragged through wet paint." It's sort of like a cousin to the Liquify filter (page 431), but without as many options.

POWER USERS' CLINIC

Blend Modes Instead of Dodge and Burn

You can do a lot in Elements without ever touching blend modes. But if you take time to familiarize yourself with them, you might find they become a regular part of your image-editing toolkit. For instance, you may prefer the effect you get using a layer in Overlay mode to that of the Dodge and Burn tools.

To adjust a photo using a layer in Overlay blend mode, first make basic adjustments like Levels or Shadows/ Highlights. Then, when you're ready to fine-tune your photo by painting over the details you want to enhance, here's what you do:

- Create a new layer. Go to Layer → New → Layer or press Shift-%-N.
- Before dismissing the New Layer dialog box, choose the Overlay blend mode for your new layer. Select Overlay from the Mode menu and turn on the checkbox that says "Fill with Overlayneutral color (50% gray)." You won't see anything happen yet.

- Set the Foreground and Background colors to black and white, respectively. Press D to set the Foreground and Background squares to black and white.
- 4. Activate the Brush tool. Choose a brush (set to Normal mode) and set the opacity very low, say 17 percent or less. (You'll need to experiment a bit to see how low a setting is low enough.)
- 5. Paint the areas you want to adjust. Paint with white to bring up the detail in dark areas and with black to darken overly light areas. (Remember that you can switch from one color to the other by pressing X.) The detail on your photo appears like magic.

Figure 12-17 shows the results of using Overlay mode on the image from Figure 12-13 so you can compare the results. This method has the added advantage that you can adjust the effect by changing the opacity of the Overlay layer. You can carry this technique to extremes for interesting effects, like when you want an artistic rather than realistic result.

Figure 12-17:
Here's the girl from again, this time after using Overlay blending, as described in the box above. Unlike the results of using the Dodge and Burn tools, the color isn't grayish—as dodging made it—but the contrast where shadowed areas meet bright ones still needs some work.

If you want to turn your photos into paintings (Figure 12-18), the humble Smudge tool is your most valuable resource. For artistic smudging, you need a graphics tablet so you can vary the stroke pressure. You can use this tool without a tablet, but you won't get nearly as good an effect. If you'd like to learn more about this kind of smudging, you can find some excellent tutorials at the Retouching forum at Digital Photography Review (www.dpreview.com; search for smudging). The forums at www.retouchpro.com are also a favorite hangout of expert smudgers.

Figure 12-18: With the help of a graphics tablet, you can join the ranks of the many skilled smudgers who create amazing effects using only this tool. The bottom three petals of this hibiscus show preliminary smudging. The brushes you use determine whether the effect is smooth, as you see here, or more heavily stroked. When you want to blend in other colors, use the Finger Painting option. In effect, the Smudge tool lets you turn your photo into a painting.

TIP If you're serious about smudging, check out Scott Deardorff's online classes at www. digitalartacademy.com. (Most of the classes there are for a different program, Corel Painter, but his smudging classes cover Photoshop and Elements.) Scott is one of the most talented smudgers out there. Visit his website at www.scottdeardorffportraits.com to see some outstanding examples of what skilled hands can accomplish with the humble Smudge tool.

A warning: If you have a slow computer, there's quite a bit of lag between when you apply the Smudge tool and when the effect actually shows up. This delay makes the tool tricky to control, because you need to resist the temptation to keep going over the area until you see results.

You'll find the Smudge tool hidden under the Blur tool in the Tools panel. Click the Blur tool or press R and, from the pop-out menu, choose the Smudge tool (its icon, not surprisingly, is a finger that looks like it's painting).

The Smudge tool offers mostly the same settings as a regular brush, but it also includes the Sample All Layers checkbox (page 271), just like the Healing brush and the Clone Stamp. It also has two additional settings:

• Strength. This setting means just what it says—it controls how much the tool smudges the colors together. A higher number results in more blending.

• Finger Painting. Turning on this checkbox makes the Smudge tool smear the Foreground color at the start of each stroke. When this box is turned off, the tool uses the color that's under the cursor at the start of each stroke. Figure 12-19 shows the difference. This option is useful for creating artistic smudges. If you want a bit of a contrasting color to help your strokes stand out more, choose a Foreground color (page 216) and turn this checkbox on.

Figure 12-19:
The Smudge tool smears colors together. The stroke on the left was done with the Finger Painting checkbox turned on, which lets you introduce a bit of the Foreground color (orange, in this case) into the beginning of each stroke. This technique is useful for shading or when you need to mix in a touch of another color. The smudging on the right was done with Finger Painting turned off, so it uses only the colors that are already in the image.

TIP Use the Eyedropper (page 219) to sample other areas of your image to add Finger Painting colors that harmonize well with the area you're smudging.

Once you've chosen your settings, smudge away.

NOTE When using the Smudge tool, you only see results where two colors come together because it blends the pixel colors where edges meet. If you use Smudge in the middle of a solid-colored area, nothing happens unless you've turned on Finger Painting.

The Eraser Tool

Everyone makes mistakes, so Adobe has thoughtfully included three mistake-fixers. If you click and hold the Eraser icon in the Tools panel, you'll see the Eraser, the Magic Eraser, and the Background Eraser. (You can also activate the Eraser by pressing E.) You'll probably use all three Erasers at one time or another. This section covers all your options.

Using the Eraser

The Eraser is basically just another kind of brush tool, only instead of adding color to your image, it removes color from the pixels. How it works varies depending on where you use it. If you use the Eraser on a regular layer, it replaces the color with transparency. On a Background layer, or one in which transparency is locked, it replaces whatever color is there with the Background color (see Chapter 6 for more about how layers work).

The Eraser's settings are much the same as for any other brush—including brush style, size, and opacity—but a couple of them work differently:

- Mode. For this tool, Mode doesn't have anything to do with blend modes (page 361), but rather tells Elements the shape of the eraser you want to work with. Your choices are Brush, Pencil, and Block. You can see the difference in how the Eraser will work by watching the brush style preview in the Options bar as you change modes. Picking Brush or Pencil mode lets you use the Eraser as you would those tools—you can choose any brush you like. The Brush option lets you make soft-edged erasures, while Pencil mode makes only hard-edged erasures. Choosing Block mode changes the cursor to a square, so that you can use it the way you would an artist's erasing block—sort of.
- Opacity. This tool determines how much color is removed—at 100 percent, it's all gone (or replaced with the Background color).

To use the Eraser:

1. Activate the Eraser.

Click its icon in the Tools panel—it's a pink eraser, so it's easy to find—or press E.

2. Choose your settings.

Choose a size, mode, and opacity. (As noted earlier, these mode and opacity settings work differently than they do for regular brushes.)

3. Drag anywhere in your image to remove what you don't want.

You may need to change the size of the Eraser a few times. It's usually easiest to use a small Eraser (or the Background Eraser—page 367) to accurately clear around the edges of the object you want to keep, as shown in Figure 12-20. Then you can use a larger brush to get rid of the remaining chunks, once you don't have to worry about accidentally going into the area you want to keep. You can also erase in a straight line by clicking where you want to start, holding down Shift, and clicking again at the end, the same way you paint straight lines with the Brush tool.

TIP You can use a selection (see Chapter 5) to limit where the Eraser operates.

It's tedious to erase around a long outline or to remove entire backgrounds, so Elements has two other kinds of Erasers for those situations.

The Magic Eraser

Once you try it, you're likely to wonder why the heck Adobe gave this pedestrian tool such an intriguing name. What's so magic about the Magic Eraser? Not much, really. It's called "magic" because it works a lot like the Magic Wand tool (page 135) in that you can use it to select pixels of a single color or range (depending on the tolerance settings). Its icon even has the same sparklies as the Magic Wand to remind you of their relationship.

Figure 12-20: Accurate erasing around an object usually means zooming way, way in so you can control which pixels the Eraser changes.

The problem, as Figure 12-21 shows, is that the Magic Eraser isn't as clean in its work as the other erasers. Still, it can be a big help in eliminating large chunks of solid color. And if you're lucky, you may be able to clean up the edges with Refine Edge (you'll need to make a selection to use it) or the Defringe command (Enhance → Adjust Color → Defringe Layer). To use Refine Edge, select the layer's contents, or click in the empty background area with the Magic Wand (page 135) and then choose Select → Invert. (There's more about Refine Edge on page 131 and about Defringing on page 146.)

It's usually best to use the Magic Eraser in combination with at least one of the other erasers if you want clean results. One sometimes-useful side effect of the Magic Eraser is that when you click your photo with it, Elements automatically transforms your Background layer into a regular layer, the way the Background Eraser does. So if you want to do something to the remaining object that requires a regular layer—applying a Layer style, for instance—you save yourself a step.

The Background Eraser

Lots of people think *this* eraser deserves the name "Magic" much more than the Magic Eraser tool. The Background Eraser is a tremendous help when you want to remove all the background around an object. This tool erases all the pixels under the brush (but outside the edges of the object) and renders the area it's used on transparent, even if it's a Background layer. (If you click with it on a Background layer, your computer may hesitate for a sec because it's busy transforming your Background to a regular layer.)

Here's how to use it:

1. Select the Background Eraser.

Press E or, in the Tools panel, click the Eraser icon. Then choose the Background Eraser from the pop-out menu. (Its icon is an eraser with a pair of scissors next to it.)

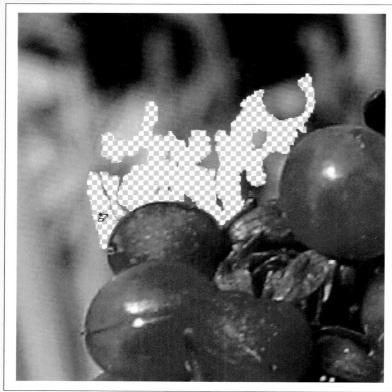

Figure 12-21: Here's a close-up look at the Magic Eraser at work on the background behind a cluster of berries. A couple of clicks got rid of much of the background, and setting the tolerance higher would've removed even more. But if you look closely, you can see the disadvantage of this tool: The edges of the berries are fringed with dark, ragged areas it didn't eliminate. You may be able to clean up the edges with Enhance → Adjust Color → Defringe Layer (page 146), or Refine Edge (page 131), but those methods aren't always 100 percent successful.

2. In the Options bar, choose a brush size.

The cursor turns into a circle with crosshairs in it. These crosshairs are important: They're the Background Eraser's "hot spot." Elements turns any color that you drag them over into transparency. The circle size changes depending on how large a brush you choose, but the crosshairs stay the same size. As you can see in Figure 12-22, with a large brush, there may be a lot of space around the crosshairs. That makes it easy to remove big chunks of the background at once, since everything in the circle gets eliminated.

TIP If you start seeing *all* your brushes (not just the Background Eraser) as crosshairs, the box on page 350 tells you how to get back to your regular cursor.

3. Drag in your photo.

Move around the edge of the object you want to keep, being careful not to let the crosshairs move into the object, or else you'll start erasing that, too. If you make a mistake, use **%**-Z to undo.

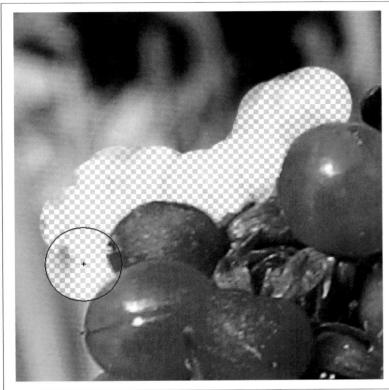

Figure 12-22:
The Background Eraser does a careful job of separating the berries from their background.
Just be sure to keep the crosshairs away from the color you want to keep. Here, because the crosshairs are outside the red, only the background is getting removed. But if you moved the crosshairs over a berry, you bite chunks out of it.

The Background Eraser has three Options bar settings to help refine how it works:

- Brush. If you want a different brush style, choose it from this pull-down menu.
- Limits. Do you want the Background Eraser to remove only contiguous color, or all the patches of a certain color? This works exactly like the Magic Wand's Contiguous setting (page 135).
- Tolerance. This setting tells the Background Eraser how similar colors have to be for it to remove them (again, just like the Magic Wand's setting [page 136]).

You may not need to change any of these settings to get the results you want.

An effective way to remove the background around an object is to start with the Background Eraser around the edge of your object, and then use the other Erasers to clean up afterward. The advantage of this method is that you don't have to clean up junk left over from the Magic Eraser. It's also easier to maneuver the Background Eraser than the regular Eraser, especially if you don't have a graphics tablet.

Drawing with Shapes

Wow, so many brush options and Adobe still isn't done—there's yet another way to draw things in Elements. The program includes the Shape tool (which is actually a group of tools that share one slot in the Tools panel), which lets you draw geometrically perfect shapes, regardless of your artistic ability. And not just simple shapes like circles and rectangles: You can draw animals, plants, starbursts, picture frames—all sorts of things, as shown in Figure 12-23. This tool should appeal to anyone whose grade-school "masterpieces" never got displayed on the fridge.

Figure 12-23:
Here are just a few of the shapes that you can draw with Elements, even if you flunked elementary school art class. These objects look even more impressive once you gussy them up with Layer styles (page 401).

Turning yourself into an artist by using Elements' Shape tool is easy:

1. Open an image or create a new one.

You can add shapes to any file you can open in Elements.

2. Activate the Shape tool.

Click the Shape tool in the Tools panel or press U. The Shape tool can be confusing to Elements newcomers because its icon reflects the shape that's currently active—so it may be a rectangle, polygon, or line, for instance. (You see a blue rectangle before you've used this tool for the first time.)

3. Select the shape you want to draw.

Use the Tools panel's menu to choose a rectangle, rounded rectangle, ellipse, polygon, line, or custom shape. (If you choose the custom shape, you have lots of shapes to choose from. Click the Shape pull-down menu in the Options bar to pick the one you want.) All the shapes, and their accompanying options, are described in the following sections.

4. Adjust the Options bar's settings.

Choose a color by clicking the color square in the Options bar or use the Foreground color square (page 216). Clicking the Options bar's color square brings up the Color Picker (page 217). If you click the arrow to the right of the square, you get the Color Swatches panel instead (page 220).

If you have special requirements, like a rectangle that's exactly $1" \times 2"$, click the downward-facing arrow just to the right of the shape's thumbnail to open the Shape Options panel, where you can enter a size for your shape.

There's also an Options bar setting that lets you apply a Layer style (see page 401) as you draw the shape. Just click the downward-facing arrow to the right of the Style box and then choose the style you want from the pop-out panel. To go back to drawing without applying a style, choose the rectangle with the diagonal red line through it.

5. Drag in your image to draw the shape.

Notice that *how* you drag the cursor affects the shape's appearance. For example, the way you drag determines the proportions of your figure. If you're drawing a fish, you can drag so that it's long and skinny or short and fat. Even with practice, it may take a couple of tries to get exactly the proportions you want.

TIP If you're trying to create copies of a particular shape you've already drawn, use the Shape Selection tool (page 376) to create duplicates of the original.

The Shape tool automatically puts each shape on its own layer. If you don't want it to do that, or need to control how shapes interact, use the squares in the middle of the Options bar. They're the same as the ones for managing selections (page 128), with one exception: Exclude Overlapping Shape Areas. Use them to add more than one shape to a layer, subtract a shape from another shape, keep only the area where shapes intersect, or exclude the areas where they intersect.

TIP To draw multiple shapes on one layer, click the "Add to Shape" rectangle in the Options bar. Then, everything you do is on the same layer. The shapes don't have to touch or overlap to use this option.

You can also turn any shape from an infinitely resizable *vector image* into a *raster image* (which your computer draws pixel by pixel) by clicking the Options bar's Simplify button. The box on page 373 tells you about the difference between vector and raster images.

You can add custom shapes by choosing them in the Content panel (page 450). In the panel, double-click the shape you want, or click the shape's thumbnail and then click Apply.

The following sections describe the main shape categories and their settings.

Rectangle and Rounded Rectangle

The Rectangle and Rounded Rectangle tools work much the same way and are handy for creating web page buttons. With either tool active, in the Options bar, you can click the blue version of the shape to display a menu (the menu's name depends on which shape tool you're using; for simplicity's sake, this section calls it the Shape Options menu) where you'll find the following settings:

- Unconstrained. Elements selects this option automatically. It lets you draw a rectangle with whatever dimensions you want—how you drag determines its proportions.
- Square. To draw a square instead of a rectangle, click this radio button before you drag, or hold down the Shift key as you drag.
- Fixed Size. This setting makes Elements draw your shape the size you specify. Enter the dimensions you want in inches, pixels, or centimeters.
- Proportional. Type numbers here if you know the proportions you want your rectangle to have, but not the exact size. So if you enter a width of 2 and a height of 1, no matter where you drag, the shape is always twice as long as it is high.
- From Center. This setting lets you draw your shape from its center instead of from a corner. It's useful when you know where you want the shape but aren't sure how big it needs to be.
- Snap to Pixels. This checkbox ensures that the edge of the rectangle falls exactly on the edge of a pixel. You'll get crisper-looking edges with this setting turned on. It's available only for the Rectangle and Rounded Rectangle tools.

Most of the Shape tools have similar options. The Rounded Rectangle has one Options bar setting of its own, though: *Radius*, which is the amount (in pixels) that the corners are rounded off. A higher number means more rounding.

TIP Looking to add a simple, empty rectangle, square, circle, or ellipse? See the box on page 377.

Ellipse

The Ellipse tool has the same Shape Options settings as the Rectangle tool. The only difference is that you can opt for a circle instead of a square. To draw a circle, press the Shift key while you drag.

Polygon

You can draw many kinds of regular polygons using this tool. Use the Options bar to set the number of sides. The Shape Options menu choices are a bit different for this tool:

 Radius. This setting controls the distance from the center to the outermost points.

UP TO SPEED

Rasterizing Vector Shapes

Back in Chapter 3, you read that the majority of your images (definitely your photos) are just a bunch of pixels to Elements—they're known as *raster* images. The shapes you draw with the Shape tools work a little differently; they're called *vector* images.

A vector image is made up of a set of directions that tell your computer what kind of geometric shapes to draw. The advantage of vector images is that you can size them way up or down without producing the kind of pixelation you see when you resize a raster image too much.

Your shape keeps its vector characteristics until you *simplify* the layer that it's on. Simplifying, also called *rasterizing*, just means that Elements turns your shape into regular pixels (in other words, a raster image). Once you simplify, you have the same limitations on resizing as you do for a regular photo. For example, you can make your image smaller, but you can't make it larger than 100 percent without losing quality. Sooner or later, you may want to transform your vector image into a raster image so that you can do certain things to it, like add filters or effects.

If you try to do something that requires simplifying a layer, Elements generally asks you to do so, via a dialog box. To rasterize your shape, click OK, or click the Simplify button in the Options bar. Remember that once you've rasterized a shape, if you try to resize, you won't get the clean, unpixelated results that you could when it was a vector image. If you need to resize a shape, it's easiest to start over with a new shape—if that's feasible (yet another good reason to use layers).

Also, before you simplified the layer, you could change the shape's color by clicking the Options bar's color box, but now the shape ignores what you do in the Options bar. That's because simplifying affects the *whole* layer–everything on it is simplified, or nothing on it is. Once you simplify a shape, you have to select it and change its color the way you would on any detail in a photo.

The Content panel brings yet another wrinkle to the raster/vector situation—Smart Objects. The items in the Content panel (frames, backgrounds, and other doodads) act as vector objects, except that they may seek out a particular place in the layer stack. (Page 448 has more on Smart Objects.)

- Smooth Corners. If you don't want sharp edges at the corners, turn on this checkbox. In recent versions of Elements, turning on this setting applies so much smoothing that polygons turn into circles.
- Star. This setting inverts the angles to create a star-like shape, as shown in Figure 12-24.

Figure 12-24: Left: A hexagon drawn with the Shape tool.

Right: Turning on the Star checkbox inverts the polygon's angles, so instead of a hexagon, you create a star.

- Indent Sides By. If you're drawing a star, this sets how much (in a percentage) you want the sides to indent.
- Smooth Indents. Turn this checkbox on if you don't want sharp *interior* angles on your star.

Line Tool

Not surprisingly, you use this tool to draw straight lines and arrows. Specify the weight (width) of the line in pixels in the Options bar. If you want an arrowhead on your line, the Shape Options menu lets you control what it looks like:

- Start/End. Do you want the arrowhead at the start or the end of the line you draw? Tell Elements your preference by turning on the appropriate checkbox.
- Width and Length. These settings control how wide and long the arrowhead is. The measurement unit is the percentage of the line width, so if you enter a number lower than 100, your arrowhead is narrower than the line it's attached to. You can pick values between 10 and 5,000 percent. If your length setting is too low, the result looks more like a T than an arrow.
- Concavity. Use this setting if you want the sides of the arrowhead indented. The number determines the amount of indentation on the widest part of the arrowhead (see Figure 12-25). Pick a setting between –50 percent and +50 percent.

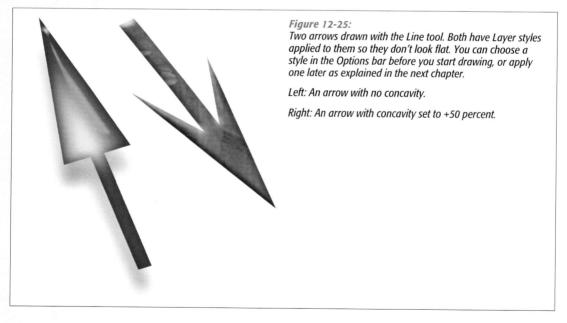

TIP If you prefer fancier arrows, you can make some with the Custom Shape tool, explained next.

The Custom Shape Tool

This tool lets you draw a huge variety of different objects, as you can see in Figure 12-26. Its Tools panel icon is the blue heart. Click it or press U and then choose the Custom Shape tool from the pop-out menu.

Figure 12-26: Here's just a small part of the shape library you can choose from in the Shape Picker.

Once the Custom Shape tool is active, the Options bar displays a thumbnail labeled Shape with the arrow for a pull-down menu next to it. Click this arrow to bring up the Shape Picker palette. Various shapes automatically appear, but if you click the double arrows at the palette's upper-right corner, you get a menu with lots more choices. To scroll through them, choose All Elements Shapes.

TIP There's a copyright symbol shape if you want something official-looking that's easy to size up for use as a watermark on your photos (page 264).

The Custom Shape tool also has a few Shape Options settings:

- Unconstrained. This setting lets you control the proportions of your shape by dragging.
- **Defined Proportions.** The shape keeps the proportions that the designer who created the shape gave it.
- Defined Size. The shape is always the size it was originally created to be—dragging won't make it bigger or smaller. It just plinks out at a fixed size that you can't control (except by resizing after the fact).
- Fixed Size. Enter the dimensions you want in inches, pixels, or centimeters.
- From Center. Lets you start drawing in the center of the object.

NOTE You can add shapes to Elements (page 498 explains how), but they appear in the Content panel, not the Shape Picker. Look for files that end in .csh when you're downloading new shapes.

The Shape Selection Tool

The gray, upward-pointing arrow in the Options bar (just to the left of the any Shape tool's icon) is the Shape Selection tool. This is a special kind of Move tool (page 150) that works only on shapes that haven't been simplified yet (page 373), as explained in Figure 12-27. (You can also activate the Shape Selection tool from the Tools panel's pop-out menu.)

Figure 12-27:

The Shape Selection tool gives you the same kind of bounding box as the Move tool, and it works the same way, but only on shapes that haven't been simplified. You can also apply transformations like skewing and rotating (page 337) when the Shape Selection tool is active. Once you simplify a shape's layer, you have to use the regular Move tool to move it around. You can always use the Move tool, even on shapes that haven't been simplified, where you could use the Shape Selection tool instead.

This tool may seem unnecessary, but if you're working with many shapes, it saves a lot of time because you don't have to keep switching tools when you want to move one shape. Click the Shape Selection tool and then move your shape. (The shape doesn't have to be on the active layer.) You can also use this tool to combine multiple shapes into one by clicking the Options bar's Combine button. You also have the options that you have when using any of the shape tools: add, subtract, intersect, and exclude.

The Shape Selection tool works just like the Move tool: You can drag to move, hold down Option to copy (instead of moving) the original shape, drag the handles to resize the shape, and so on. Unfortunately, you can't align and distribute shapes with this tool the way you can with the Move tool. If you need to line things up, use the regular Move tool instead.

The Cookie Cutter Tool

At first glance, you may think the Cookie Cutter is a silly tool. But it's actually really handy, and you may use it all the time once you understand it. The Cookie Cutter creates the same shapes as the Custom Shape tool, but you use it to crop a photo to the shape you chose. Want a heart-shaped portrait of your sweetie? The Cookie Cutter is your tool. If you're a scrapbooker, with a couple of clicks you can get results that would have taken ages and special scissors to create with paper.

WORKAROUND WORKSHOP

Drawing Outlines and Borders

If you've played around with the Shape tool, you may have noticed that you can't draw shapes that are just outlines (that is, not filled with color). No matter what you do, the result is always a solid shape (except for the frame shapes). So how the heck do you get a simple, plain-colored border around a photo?

The easiest way to create an outline is to make a selection using the Marquee tool or another selection tool and then select Edit → Stroke (Outline) Selection. The Stroke dialog box pops up and lets you enter the width of the line in pixels and choose a color.

You'll also see choices for Location, which tell Elements where you want the line: around the inside edge of the selection, centered on the edge of the selection, or around the outside. (If you're bordering an entire photo, don't choose Outside, or the border won't show up because it's off the edge of your image.)

You can also choose a blend mode (page 361) and set the stroke's opacity. Using a mode can give you a more subtle edge than a normal stroke does. The Preserve Transparency checkbox just ensures that any transparent areas in your layer stay transparent. When you're finished adjusting the Stroke dialog box's settings, click OK and then deselect (press %-D or just click someplace else in the image) to turn off your Marquee, and you've got yourself an outlined shape.

Be sure to also check out some of the simpler frame designs in the Content panel (page 450). They let you apply a simple border with just a double-click.

If you're not into that sort of thing, don't go away, because hidden in the shapes library are some of the most sophisticated, artistic crop shapes around. You can use them to get the kinds of effects that people pay commercial artists big bucks to create—like abstract crops that give your photo jagged or worn edges (great for contemporary effects).

You can also combine the result with a stroked edge, as explained in the box above, and maybe even a Layer style (page 401). Even without any additional frills, your photo's shape will be more interesting, as shown in Figure 12-28.

You use the Cookie Cutter just like the Custom Shape tool, but you cut a shape from a photo, instead of drawing a shape:

1. Activate the Cookie Cutter tool.

Click the Cookie Cutter in the Tools panel (its icon is a star) or press Q.

2. Select the shape you want your photo to be.

Choose a shape from the Shape Picker palette by clicking the down arrow next to the shape displayed in the Options bar. You have access to all the custom shapes, but pay special attention to the Crop Shapes category. Click the palette's double arrow to see all the shape categories it contains, or choose All Elements Shapes.

Figure 12-28:

A quick drag with the Cookie Cutter is all it took to create the bottom graphic from the top photo. If you want to create custom album or scrapbook pages, you can rotate or skew your crops before you commit them. Page 337 explains how to rotate and skew your images. The Frames section of the Content panel also includes a bunch of crops, ranging from simple shapes like stars to elaborate edges that make your photo look like a half-completed jigsaw puzzle.

3. Adjust your settings, if necessary.

You have the same Shape Options described earlier for the Custom Shape tool (page 375), so you can set a fixed size or constrain proportions if you want. Click the Shape Options button to see your choices. You can choose to feather the edge of your shape, too. Just enter the amount in pixels. (See page 137 for more about feathering.) The Crop checkbox makes Elements crop the edges of your photo so they're just large enough to contain the shape.

4. Drag in your photo.

A mask appears over your photo and you see only the area that will still be there once you crop, surrounded by transparency.

5. Adjust your crop if necessary.

You can reposition the shape mask or drag its corners to resize it. Although the cropped areas disappear, they'll reappear as you reposition the mask if you move it so that they're included again.

Once you've created the shape, you'll see the Transform options (page 337) in the Options bar (which means that you can skew or distort it if you want) until you *commit* your shape, as explained in the next step. You can drag the mask around to reposition it, or Shift-drag a corner to resize it without altering its proportions. It may take a little maneuvering to get exactly the parts of your photo that you want inside the crop.

6. When everything's lined up the way you want, click the Commit button (the green checkmark) in the image window or press Enter.

If you don't like the results, click the Cancel button (the red circle) or press Esc. Once you've made your crop, you can use \%-Z if you want to undo it and try something else.

TIP The Cookie Cutter replaces the areas it removes with transparency. If the transparency checkerboard makes it hard for you to get a clear look at what you've done, temporarily create a new white or colored Fill layer (page 181) beneath the cropped layer. You can delete it once you're happy with your crop.

Filters, Effects, Layer Styles, and Gradients

There's a popular saying among artistic types who use software in their studios: *Tools don't equal talent*. And it's true: No mere program is going to turn a klutz into a Klimt. But Elements has some special tools—*filters, effects,* and *Layer styles*—that can sure help you fool a lot of people. It's amazing what a difference you can make in the appearance of an image with only a couple of clicks.

Filters are a jaw-droppingly easy way to change how an image looks. You can use certain filters for enhancing and correcting images, but Elements also gives you a bunch of other filters that are great for unleashing all your artistic impulses, as shown in Figure 13-1. You'll find the original photos (rooftops.jpg and bauhinia. jpg) on the Missing CD page at www.missingmanuals.com, if you want to play around with these images yourself.

Most filters have settings you can adjust to control how the filter changes your photo. Elements comes with more than a hundred different filters, so there isn't room in this chapter to cover each filter individually, but you'll learn the basics of applying filters and get in-depth coverage of some of the filters you're most likely to use.

Effects, on the other hand, are like little macros or scripts designed to make elaborate changes to your image, like creating a three-dimensional frame around it or making it look like a pencil sketch or an oil pastel. They're easy to apply—you just double-click a button—but you can't tweak their settings as easily as you can with filters, since effects are programmed to make specific changes. (Adobe calls them Photo Effects, but you can apply them to any kind of image, not just photos.)

Top: These figures show how you can make a photo resemble a colored-steel engraving.

Bottom: These figures show how you can create a watercolor look.

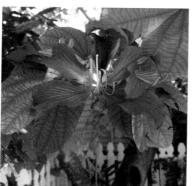

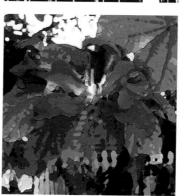

If you've used Elements before, you may know that the effects are also known as *actions*. Full-featured Photoshop lets you record and save your own actions and install actions created by others. Elements has an actions player so you can use certain Photoshop actions in Elements, but you can't *create* actions in Elements.

Layer styles change the appearance of only one layer of your photo (see Chapter 6 for more about layers). They're great for creating impressive-looking text, but you also can apply them to objects and shapes. Most Layer styles include settings you can easily modify.

You can combine filters, effects, and Layer styles on the same image if you like. And you may spend hours trying different groupings, because it's addicting to watch the often-unpredictable results you get when mixing them up.

The last section of this chapter focuses on *gradients*. A gradient is a rainbow-like range of color that you can use to color in an object or a background. You can also use gradients and *gradient maps*—gradients that are distributed according to the brightness values in your photo—for precise retouching effects.

Using Filters

Filters let you change the look of your photos in complex ways, but applying them is as easy as double-clicking a button. Elements gives you a ton of filters, grouped into categories to help you choose one that does what you want. This section offers a quick tour through the filter categories and some info about using a few of the most popular filters, like Noise and Blur.

To make it easy to work with filters, Elements lets you apply them from two different places: the Filter menu and the Effects panel. (The menu is the only place where you can see *every* filter. Some filters, like the Adjustment filters, don't appear in the panel.) Elements also includes the Filter Gallery, a great feature that helps you get an idea of how your photo will look when you apply the artistic filters. The next part of this section explains all three methods.

Applying Filters

In the Filter menu, you choose a filter from the list by category and then by name. In the Effects panel, thumbnail images give you a preview of what the filters do by showing how they affect a picture of an apple. The filters do the same thing no matter which way you choose them.

The Filter Gallery shows you a preview of what a filter looks like when applied to *your* image. Some filters automatically open the Filter Gallery when you choose them from the menu or the panel. You can call up the Gallery without first choosing a filter by going to Filter → Filter Gallery. You can't apply every filter from the Gallery—only some of the ones with adjustable settings.

You can easily apply the same filter repeatedly: Press **%**-F and Elements applies the last filter you used, with whatever settings you last used. The top listing in the Filter menu also shows the name of this same filter (selecting it has the same effect as the keyboard shortcut: Elements applies that filter with the same settings you just used). Press **%**-Option-F to bring up the dialog box for the last filter you used so you can change its settings.

Filter menu

The Filter menu groups filters into 13 categories (Correct Camera Distortion [page 332] is all by itself at the top of the list, not in a category). There's a divider below the bottom category (Other). When you first install Elements, the Digimarc filter is the only filter below this line, but other filters you download or purchase will appear here, too.

When you choose a filter from the list, one of three things happens:

- Elements applies the filter. This happens if the filter's name doesn't have an ellipsis (...) after it. Just look at the result in your photo, and if you don't like its effect, press **%**-Z to undo it. If you do like it, you're done.
- You see a dialog box. Filters that have adjustable settings have an ellipsis (...) after their names. These filters (mostly corrective filters, like Dust & Scratches, for example) open a dialog box where you can tweak their settings. Adjust the settings while watching the small preview in the dialog box to see what you're doing, and then click OK.
- You see the Filter Gallery. Some of the more artistic, adjustable filters call up the Filter Gallery so you can see a large preview of what you're doing and rearrange the order of multiple filters before applying them. Page 385 explains how to apply filters from the Gallery.

Regardless of how you apply a filter, if you're not happy with its effect you can undo it by pressing **%**-Z. If you like it, just save your image.

TIP Since you can't undo filters after you've closed your image, many people apply filters to duplicate layers. Press **%**-J to create a duplicate layer.

Effects panel

If you're more comfortable with visual clues when choosing a filter, you can also find most filters in the Effects panel (Figure 13-2), which is, logically enough, also where you apply effects (page 397).

Figure 13-2:

The Effects panel shows you what every filter looks like when applied to the same picture of an apple. Click the Filters button (circled), and then, from the pull-down menu (the one that says "Artistic" here), choose a category. If you know what you want a filter to do but don't know what it's called, scrolling through these thumbnail images should help you find the one you want. To apply a filter from the panel, double-click the appropriate thumbnail, or click the thumbnail once and then click Apply. You can also drag the filter's thumbnail from the panel onto your image.

The Effects panel is one of the panels in the Panel bin the first time you launch Elements. If it's not there waiting for you, go to Window → Effects, and then click the Filters button (circled in Figure 13-2). Choose a category from the pull-down menu or choose Show All. The categories are the same as the ones in the Filter menu, except that Adjustments is available only through the menu, and Sharpen appears in the panel, but not the menu.

To apply a filter from the panel, double-click its thumbnail or drag the thumbnail onto your image. If the filter has adjustable settings, you see the same dialog box or Filter Gallery window you'd see when applying it from the Filter menu, as described earlier.

One small drawback to applying filters from the panel is that you can't tell from the thumbnail whether a filter is one that Elements applies automatically, with no adjustable settings. There's no clue like an ellipsis (...) to tell you which group a filter falls into.

Filter Gallery

The Filter Gallery (Filter → Filter Gallery), shown in Figure 13-3, is a popular feature. It gives you a large preview window, a look at all the green-apple thumbnails so you can tell what each filter does, and, most important, it lets you apply filters like layers—you can stack them up and change the order in which Elements applies them to your image. Changing the order can make some big differences in how filters affect your image. For example, you get very different results if you apply Ink Outlines after the Sprayed Strokes filter compared to the other way around. The Gallery makes it easy to play around and see which order gives you the look you want. The layer-like behavior of the filters in the gallery is only for previewing, though—you don't end up with any new layers after you apply the filter(s).

The Gallery is more for artistic filters than corrective ones. You can't apply the Adjustment or Noise filters from here, for instance. All the Gallery filters are in the artistic, brushstroke, distort, sketch, stylize, and texture categories. (The next section includes an overview of all the filter categories.)

The Filter Gallery window is divided into three panes. On the left is a preview of what your image will look like when you apply the filter. The center panel holds thumbnails for the different filters, and the right side contains the settings for the current filter. Your *filter layers* are at the bottom of the settings pane, where you can see what filters you've applied, add or subtract filters, and rearrange their order.

NOTE You don't create any new, permanent layers when you use the Filter Gallery. Filter layers work something like regular layers (see Chapter 6), but they're just what you might call "working layers": They're only to help you figure out which order to apply filters in; they don't actually become new layers in your image. In other words, you have separate filter layers only until you click OK in the Filter Gallery. Then all your chosen filters get applied to your image at once. You can't apply the filters, close your photo, come back later, and still see the filters as individual, changeable layers. And most important, your filters become part of the layer to which you apply them.

If you've used a recent version of the full-featured Photoshop, be aware that Elements doesn't create editable smart filters the way Photoshop does—it handles filters the way earlier versions of Photoshop (Photoshop CS2 and below) did. Keep this in mind if you're trying to do something based on instructions written for Photoshop (directions you've found online, say).

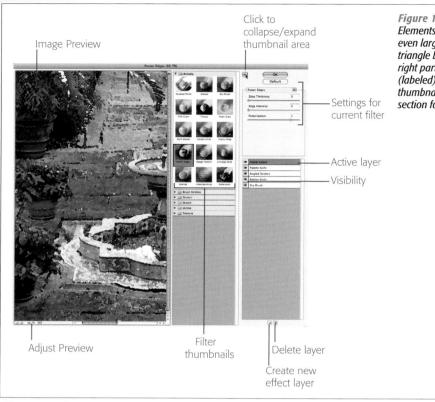

Figure 13-3:
Elements' Filter Gallery. For an even larger preview, click the triangle button in the upperright part of the window (labeled) to collapse the thumbnails and regain that section for preview space.

In addition to letting you adjust the settings for a given filter, the Filter Gallery lets you perform a few other tricks:

- Adjust your view of the image. In the Gallery's lower-left corner, click the percentage or the arrow next to it to bring up a list of preset views to choose from. You can also click the + and buttons to zoom the view in or out. Easier still, use the \(\mathbb{H}\)-= (the \(\mathbb{H}\) key plus the equal sign key) and \(\mathbb{H}\)- (the \(\mathbb{H}\) key plus the minus key) shortcuts to zoom in and out with your keyboard.
- Choose a new filter. Click a filter's thumbnail once, and Elements displays the settings for that filter and updates the image preview—usually. (See the box on page 389 for details.)
- Add a new filter layer. Each time you click the New Filter Layer icon (see Figure 13-4), Elements adds another filter layer.
- Change the position of filter layers. Drag them up and down in the stack to change the order Elements will apply them to your image.
- Hide filter layers. Click the eye next to a filter layer in the filter layer panel to turn off its visibility, as in the regular Layers panel (page 166).

Figure 13-4:

If you've used layers before (see Chapter 6), these icons (circled) should look familiar. In the Filter Gallery, they make new filter layers instead of regular layers. Click the square icon to add a new filter layer to your image, or the trashcan icon to delete a filter layer. The eye icons next to each filter layers turn visibility on and off just as they do in the Layers panel. Remember, filter layers don't show up as real layers in the Layers panel—only in the Filter Gallery.

- Delete filter layers. Highlight any filter layer by clicking it, and then click the trashcan icon to delete it.
- Change the content of a filter layer. You can change what kind of filter is in a particular layer. For instance, if you applied several filters and wish you could change the Smudge Stick filter to the Glass filter, you don't have to delete the Smudge Stick layer. Just highlight the Smudge layer, and then click the Glass filter button to change that layer's contents.

TIP If you press **%**-F while using the Filter Gallery, Elements reapplies all the filters that were in your last gallery set. Pressing **%**-Option-F brings up the dialog box for the last filter so you can change your settings before applying it again.

Filter Categories

Elements divides filters into categories to help you track down the one you want. Some categories, like Distort, contain filters that vary hugely in what they do to your photo. Other categories, like the Brush Stroke filters, contain filters that are obviously related to one another. Here's a breakdown of the categories:

- Correct Camera Distortion. This isn't a category, but rather a single filter that lets you correct perspective distortion (think tall buildings) as well as vignetting (shadows) caused by your camera's lens. It's explained in detail on page 332.
- Adjustments. These filters apply some photographic, stylistic, and artistic changes to your photo. Most of the adjustments are explained on page 295; the Photo Filters are covered on page 256.
- Artistic. This huge group of filters can do everything from giving your photo a cut-from-paper look (Cutout) to making it resemble a quick sketch (Rough Pastels). You generally get the best effects with these filters by using multiple filters or applying the same one several times.
- Blur. The blur filters let you soften focus and add artistic effects. They're explained on page 392.
- Brush Strokes. These filters apply brushstroke effects and create a hand-painted look.

- Distort. These filters warp images in a variety of ways. The Liquify filter is the most powerful, and page 431 explains how to use it.
- Noise. Use these filters to add or remove grain. They're explained on page 389.
- Pixelate. These filters break your image up in different ways, making it show the dot pattern of a magazine or newspaper's printed image (Halftone), or the fragmented look you see on television when a show conceals someone's identity.

NOTE The Color Halftone filter makes your image look like it's made of many dots of color, like a magazine or other printed illustration, or comic-style pop art. But, it's not the same as true halftone screening, which Elements can't do. If the print shop you're working with needs a halftone, you need to either use the full-featured Photoshop or ask the printer to create the halftone for you.

- Render. This group includes a diverse bunch of filters that let you do things like create a lens flare effect (Lens Flare), and make your image look like fibers (Fibers) or clouds (Clouds). The Lighting Effects filter, a powerful but confusing filter that's like a whole program in itself, helps you change the way lighting appears in your image. For a full rundown on what this filter does and how to use it, check out the Missing CD page at www.missingmanuals.com.
- Sharpen. This category, which contains only the Unsharp Mask filter (page 223), appears in the Effects panel but not the Filter menu. (The sharpening commands are in the Enhance menu instead.)
- Sketch. These filters can make your photo look like it was drawn with charcoal, chalk, crayon, or some other material, or like it was embossed in wet plaster, photocopied, or stamped with a rubber stamp.
- Stylize. These filters create special effects by increasing the contrast in your photo and displacing pixels. You can make your photo look radioactive, like the objects in it are moving quickly, or reduce it to outlines.
- Texture. These filters change the surface of your photo to look like it was made from another material. Use them to create a crackled finish (Craquelure), a stained-glass look (Stained Glass), or a mosaic effect (Mosaic Tiles).
- Video. These filters are for creating and editing images for (and from) videos.
- Other. This is a group of technical, customizable filters. The High Pass filter is explained on page 227. You can use Offset to shift an image or a layer a bit, or to position tiled image layers.
- Digimarc. Use this filter to check for Digimarc watermarks in photos. (Digimarc is a company that lets subscribers enter their info in a database so that anyone who gets one of their photos can find out who holds the copyright.)

You can find a number of filter plug-ins online, ranging from free to very expensive. Page 493 suggests some places to start looking. Once you install new filters, they appear at the bottom of the Filter menu.

NOTE Filters are platform specific, which means you can't use plug-ins written for the Windows version of Elements if you're using a Mac. And for Elements 8, plug-ins have to be written specifically for Intel Macs; plug-ins written for older PowerPC Macs won't work (see page 4).

UNDER THE HOOD

Filter Performance Hints

If Elements could speak, it would say, "Easy for you" on the subject of filters and effects. Although you don't have to do much to apply them, the program has a huge amount of work to do. Elements is pretty fast, but if your computer is slow or memory-challenged, it can take a long time to apply filters or update the preview. You can speed things up by applying filters to a selection for previewing. Filters that have their own dialog boxes—as opposed to the Filter Gallery—display a flashing line under the size percentage (below the preview area) to show their progress.

Here are a few other filter-related tips worth remembering:

 Filters don't do anything if they don't have pixels to work on, so be sure you're targeting a layer with something in it, and not an Adjustment layer.

- If you apply a filter to a selection, you'll usually want to feather (page 137) or refine (page 131) the filtered edges to help the edges blend into the rest of your photo.
- Option-click the Cancel button in the Gallery or in any filter dialog box to turn it into a Reset button. Clicking Cancel closes the window, while Reset lets you start over without having to call up the filter again.
- If filters are grayed out in the Filter menu, check to be sure you're not in 16-bit mode (page 241) or in grayscale, bitmapped, or index color mode (all explained on page 51).

Useful Filter Solutions

This section covers how to use some of Elements' most popular and useful filters to correct your photos and create a few special effects. For instance, you'll learn how to modify graininess to create an aged effect or smooth out a repair job. And you'll find out how to blur photos to create a soft-focus effect or make objects look like they're moving.

Removing noise: Getting rid of graininess

Noise, undesired graininess in an image, is a big problem with many digital cameras, especially those with small sensors and high megapixel counts, like most recent point-and-shoot cameras. It's rare to find a fixed-lens camera with more than 5 megapixels that doesn't have some trouble with noise, especially in underexposed areas.

If you shoot using the Raw format, you can correct a fair amount of noise right in the Raw Converter (page 245). But the Raw Converter may give unpredictable results if you use it on JPEGs. And even Raw files may need further noise reduction once you've edited a photo after converting it.

Elements' Reduce Noise filter is designed to help get rid of noise in your photos. To get to it, go to Filter \rightarrow Noise \rightarrow Reduce Noise. You get a dialog box with a preview window on the left and settings on the right. To apply the filter, first use the controls below the preview to set the zoom level to 100 percent or higher. You need to see the individual pixels in your photo so you can tell how the filter is changing them as you adjust the settings.

You get three settings, each of which you control with a slider:

- Strength. This controls the overall impact of the filter, which reduces the same kind of noise as the Luminance Smoothing setting in the Raw converter (page 246). The higher this setting is, the greater the risk of softening your photo.
- Preserve Details. Using noise reduction can soften the appearance of your photo, giving it a blurry look. This setting tells Elements how much care to take to preserve details.
- Reduce Color Noise. This control adjusts uneven color distribution in your image. You can set the slider pretty high without harming your photo.

The Remove JPEG Artifact checkbox tells Elements to minimize *JPEG artifacts*—the uneven areas of color caused by JPEG compression (see page 62). A mottled pattern in what should be a clear blue sky is a classic example of JPEG artifacting. Turn on this checkbox to help smooth things out.

For each setting, move the slider to the right if you want it to have more of an impact and to the left if you want less. Watch the effect in the preview window to see how you like the changes. (You may notice a little lag time before the preview updates.) When you see what you want, click OK to apply the filter.

The Reduce Noise filter does an OK job on areas with a small amount of noise, like the sky in many JPEG photos, but it's not one of Elements' strongest tools. If your camera has major noise problems, you may need special noise reduction software. Some of the most popular programs are Noise Ninja (www.picturecode.com), Neat Image (www.neatimage.com), Topaz (www.topazlabs.com), and Noiseware (www.imagenomic.com). All have demo versions you can download to try them out. If you search on Google for "noise reduction software," you'll get a variety of other options as well, including several free programs.

Adding noise: Smoothing out repair jobs

Elements also gives you a filter for *creating* noise. Why do that when most of the time you try to get rid of noise? One reason is when you're trying to age your photo: If you want to make it look like it came from an old newspaper, for instance, you'd add some noise.

Another common use for noise is to help make repaired spots blend in with the rest of an image. If you've altered part of a photo in Elements, especially by painting on it, odds are the repaired area looks perfectly smooth. That's great if the rest of the photo is noise free, but if the photo is a little grainy, that smooth patch will stand out like a sore thumb. Adding a bit of noise makes it blend in better, as

shown in Figure 13-5. Also, if you see color banding when you print, adding a little noise to the photo may help fix that.

Figure 13-5:
Top: If you use the Average Blur filter in a repair on this noisy photo, the blended area stands out, making the repair obvious.

To add noise to a photo, start by selecting the area you want to make noisier. Using a duplicate layer (\(\mathbb{H} \text{-J} \)) for the noise is a good idea, since you can always undo changes if they're on their own layer. Here's what you do:

1. Call up the Add Noise filter.

Go to Filter → Noise → Add Noise to bring up the filter's dialog box.

2. Adjust the filter's settings.

The settings are explained in the following list. Use the dialog box's preview window to check how the changes are affecting your photo.

3. When you're satisfied, click OK.

You have three options in the Add Noise dialog box:

- Amount. This controls how heavy the noise will be. Drag the slider to the right for more noise or to the left for less. You can also type in a number; a higher percentage means more noise.
- Uniform or Gaussian. These buttons control how the noise gets distributed through your image. Uniform is just what it says—the same all over. Gaussian produces a more speckled effect. If you're adding noise to duplicate existing noise in a grainy photo, you probably want Gaussian distribution. For an oldnewspaper-photo look, try Uniform. In either case, experiment until you get what you want.

• Monochromatic. This setting limits you to grayscale noise. Take a look at the middle image in Figure 13-6, and notice how many more colors you can see in the noise, compared to the solid red of the original. The bottom-left bell's noise was applied with the Monochromatic setting turned off.

Figure 13-6: Filters can really spruce up solid objects.

Top: An unfiltered, solid red bell drawn with the Shape tool (page 375).

Bottom left: The same bell after adding some uniform noise.

Bottom right: Adding the Angled Strokes filter gives the bell a hand-painted look. If you don't add noise before applying the filter, you won't see any texture change from the top graphic when applying the filter.

Noise can also help when you want to apply special effects to blocks of solid color, as shown in Figure 13-6. If you try to apply the Angled Strokes filter to a solid color, you don't see the strokes. Adding noise gives the filter something to work on. You can also create a blank file, add noise, and then run various filters to create an abstract background to use in a project.

Gaussian Blur: Drawing attention to an object

Probably the most frequently used of the Blur filters, Gaussian Blur (Filter → Blur → Gaussian Blur) lets you control how much an image is blurred. Besides using it to blur large areas, like the background in Figure 13-7, bottom, you can apply this filter at a very low setting to soften lines—useful when you're going for a sketched effect. To try out the different blurs, download the hawk photo (*yellowbeak.jpg*) from the Missing CD page at *www.missingmanuals.com*.

Figure 13-7:
Top: This little guy felt hidden enough to let the camera get pretty close, and he was almost right: It's hard to focus on him with all the stuff in the background. Blurring the background will center the focus on the bird rather than the distracting details.

Bottom: Applying the Gaussian Blur filter to the background makes the bird the clear focal point.

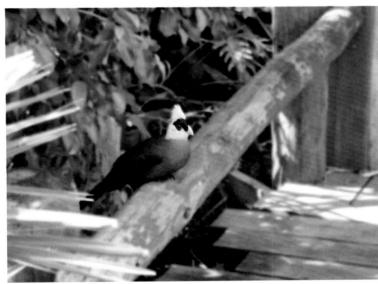

When using the Gaussian Blur, you have to set the *radius*, which controls how much the filter blurs things. A higher radius produces more blurring; use the filter's preview window to see what you're doing.

Radial Blur: Producing a sense of motion

As you can see in Figure 13-8, the Radial Blur filter creates a sense of motion. It has two styles: Zoom, which is designed to give the effect of a camera zooming in, and Spin, which produces a circular effect around a center point you designate.

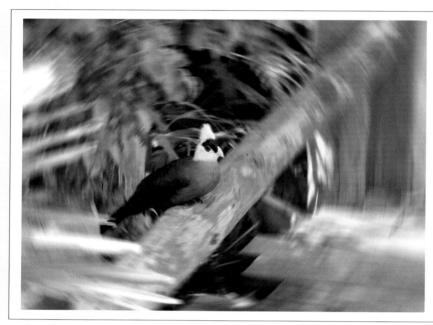

Figure 13-8:
A Radial Blur applied in Spin mode. As you can see, this filter can produce an almost vertiginous sense of motion. If you don't want to give people motion sickness, go easy on the Amount setting. This is a setting of 5, but unless you're looking for a psychedelic 60s effect, 1 or 2 is usually plenty.

The Radial Blur dialog box looks complicated, but it's really not. (Call it up by going to Filter → Blur → Radial Blur.) Unfortunately, you don't get a preview with this filter, because it drains so much processor power. That's why you have a choice between Draft, Good, and Best Quality. Use Draft for a quick look at roughly what you'll get. Then, most of the time, choose Good for the final version. Good and Best aren't very different except on large images, so don't feel you have to choose Best for the final version.

After choosing your method (Zoom or Spin), set the amount, which controls how intense a blur Elements applies. Next, click in the Blur Center box to tell Elements where you want the blur centered, as shown in Figure 13-9. Click OK when you're finished.

Color correcting with the Average Blur filter

If you've already given the Average Blur filter a whirl, you may be wondering what on earth Adobe was thinking when they created it. If you use it on a whole photo, your image disappears under a hideous soup, something like what you'd get by pureeing together all the colors in your photo. Oddly enough, this effect makes the

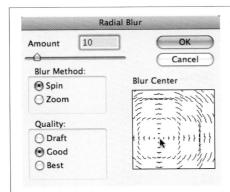

Figure 13-9:

The Blur Center box lets you pick a center point for the Radial Blur filter's effect. Drag the ripple drawing inside the box in any direction; here, the center point was moved just to the left and down from its original position in the center of the box.

filter a great tool for getting rid of color casts (page 213). You can use the Average Blur to create a sort of custom Photo Filter (page 256) toned specially for the image you use it on. The secret is using blend modes (page 168). Here's how:

1. Open your image and make a duplicate layer.

Press **%**-J or go to Layer → Duplicate Layer.

2. Apply the Average Blur filter.

Make sure your duplicate layer is the active layer (click it in the Layers panel if it isn't), and then go to Filter → Blur → Average. Your photo disappears under a layer of (probably) unpleasing solid color, but you'll fix that next.

3. Change the blur layer's blend mode.

In the Layers panel, from the Mode pull-down menu, choose Color. Already things are starting to look better.

4. Invert the blur layer.

Press \#-I to invert the colors.

5. Reduce the blur layer's opacity do any other necessary tweaking.

Use the Layers panel's opacity slider; start at 50 percent. By now, the color should look right—no more color cast. Tweak if necessary, and then save your work.

TIP You may want to add a Hue/Saturation layer (page 181) if you find that no matter how you adjust the opacity slider, the photo still looks a little flat.

The Average Blur filter is a particularly good way to color-correct underwater photos, where it's hard to get a realistic white balance using your camera's built-in settings.

Improving skin texture with the Surface Blur filter

The Surface Blur filter is yet another way to blur images. At this point you may be thinking that you have enough ways to eliminate details in your photos, but Surface

Blur is actually really handy, especially for pictures of people. This filter is smart enough to avoid blurring details and areas of high contrast, which makes it great for fixing skin. If you want to eliminate pores, for instance, or reduce the visibility of freckles, this is your tool, as shown in Figure 13-10, and it's simple to use, too:

1. Open your image and make a duplicate layer.

Press **\%**-J or go to Layer → Duplicate Layer.

TIP For best results, you may want to start by selecting the area you want to blur (see Chapter 5 for help with selections). Then make your duplicate layer from the selection, in order to maintain maximum detail in the areas you *aren't* trying to fix. For example, select only the skin of your subject's face, leaving out the mouth and eyes so they won't be affected by the blur.

2. Apply the Surface Blur filter.

Make sure your duplicate layer is the active layer (click it in the Layers panel if it isn't), and then go to Filter \rightarrow Blur \rightarrow Surface Blur. Move the dialog box out of the way, if necessary, so that you can watch what you're doing in the main image window and in the dialog box's preview area.

3. Tweak the filter's settings till you like the effect.

The sliders are explained below. Be cautious—it doesn't take much to make your photo look like a painting. Click OK when the flaws are concealed as much as possible without losing important details like eyelashes.

4. If you want, change the duplicate layer's blend mode and/or opacity.

Use the Layers panel's sliders for this step. If you want to eliminate blemishes, for example, try Lighten blend mode.

Figure 13-10: The Surface Blur filter is handy for creating better-looking skin, minimizing lines and flaws, or reducing the visibility of pores.

Left: The original photo.

Right: A dose of Surface Blur evens out fine lines in the skin and preserves individual hairs that have good definition. But if you look closely, the areas of hair with less definition got blurred along with the skin. In cases like that, use a selection to limit where the blur gets applied.

The Surface Blur filter isn't hard to understand, but you usually have to do a fair amount of fiddling with the sliders to get the best balance between softening and preserving detail for a natural-looking effect. Here's what the sliders do:

- Radius. As with other filters, this setting controls how far Elements should blur your image. Move the slider to the left for a smaller blur, and to the right for a wider blur.
- Threshold. This slider controls the level at which Elements begins to blur. A low setting means less blurring, a higher setting means more blurring.

TIP When you have to do a lot of experimenting, sometimes it's easier to highlight the number in each setting's box and use the up and down arrow keys to adjust the effect.

Adding Effects

Like filters, effects give you loads of ways to modify your photo's appearance—from adding lizard-skin textures to surrounding your image with a classy picture frame. Although you apply effects with a simple double-click, these clicks trigger a series of changes. Some effects involve many complex steps, but Elements works so quickly you might not notice all the changes it makes.

NOTE You usually can't customize or change an effect's settings—they're all or nothing. For example, if you use one of the Frame effects, you either take the frame size as Elements applies it to your image, or you don't; you can't adjust the scale of the frame relative to your photo. This quality is why most of the frames are now Smart Objects (page 448) that you apply from the Content panel, rather than effects—you have more control over Smart Objects.

You'll find effects in a few different spots in Elements:

- The Effects panel is home to most photo effects—things like photo tinting (Figure 13-11)—and a few frames. The panel is explained after this list.
- The Content panel houses some effects. They're intended primarily for text, but sometimes you can use them for other purposes. They create cool results with shapes, too, for instance. Page 450 has the scoop.
- Guided Edit. Elements has a few effects that Adobe included as part of its let-usshow-you-how section; you'll find them at the bottom of the list of tasks, and Guided Edit walks you through applying them. (Page 30 tells you more about Guided Edit.)

To apply an effect from the Effects panel, choose Window → Effects, and then click the Photo Effects button (it shows a rectangle with little sparkles around it). Just as with filters, use the panel's pull-down menu to see all your choices or pick from only one category. The thumbnail images give you a preview of how each effect changes your image.

Figure 13-11:
The Effects panel's Photo Effects section lets you age a photo by applying an antique look to it, as shown here. This was a color photo until the Vintage Photo effect was applied to it.

To apply an effect, double-click its thumbnail in the Effects panel, or click the thumbnail once, and then click Apply. You can also drag the thumbnail onto your photo. That's all there is to it. If you don't like the result, press \mathbb{H}-Z to undo it, since you can't do much to tweak it.

Here are a couple effects-related tips to help you get the most out of these nifty-but-quirky features:

- A few effects flatten (page 179) or simplify (page 373) your image, so it's usually best to make a copy of your image, or wait until you're done making all your other edits, before applying an effect.
- Many effects create new layers; check the Layers panel once you're done applying them. You may want to flatten your image to reduce the file size before printing or storing it. (See Chapter 6 if you need a refresher on layers.)

Using Actions

If you hang around people who use Photoshop, you'll hear talk about *actions* and how useful they are. An action is a little script—similar to a macro in a program like Word—that automates the steps for doing something, which can save tons of

time. For example, imagine an action that applies your favorite filter and crops a photo to a certain size, or one that creates a complicated artistic effect, like a colorful watercolor look that would take many steps to do manually. Wouldn't it be great to be able to use actions in Elements?

Well, in a way Elements has always been able to use actions—under the hood, effects are really actions. And you could always add some Photoshop actions to Elements, although the process used to be complicated. But not anymore: Recent versions of Elements include the Action Player, which lets you run many Photoshop actions in Elements.

It's easy to use actions in Elements. Adobe gives you a few useful ones to get you started, and you can add your own, as explained later in this section. To run an action:

1. Open a photo and then go to the Action Player.

Click the Edit tab → EDIT Guided → Automated Actions → Action Player.

2. From the first pull-down menu, choose the Action set you want.

Action sets are groups of related actions. The sets that come with Elements let you choose between actions to add captions (and canvas to display the captions), trim weight from your subjects, resize and crop your photos, or apply special effects to them.

3. From the second pull-down menu, choose a specific action.

You can choose how much thinner to make someone with the Lose Weight actions, for example, or what color canvas (white, gray, or black) to add for a caption.

4. Run the action.

Click the Play Action button and Elements does its thing. The actions that come with Elements happen pretty much instantly, but if you add actions from other sources, you may see pop-up dialog boxes to adjust settings for some steps. Just make any changes, click OK, and the action resumes and finishes up. If you don't like the results, click the Reset button or press \(\mathbb{H}-Z\) to undo the action, and then try another one instead. (You can't step backward in the Elements Action Player.)

5. When you like the results, click Done.

If you decide you don't want to use an action after all, click Cancel instead.

One of the best things about the Action Player is that you can easily add more actions to it. You can't *create* new actions in Elements—you need Photoshop for that—but there are thousands of free actions on the Internet that you can download and add to Elements. Page 493 suggests some places to look for them.

Once you download an action, save it in $Hard\ Drive ounder Library ounder Application\ Support ounder Adobe ounder Photoshop\ Elements ounder 8.0 ounder Locale ounder en_US ounder Workflow\ Panels ounder Actions (the "en_US" part is different if you aren't in the U.S.). The next time you start Elements, you'll see your action in the drop-down menu shown in Figure 13-12.$

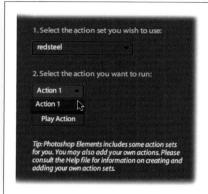

Figure 13-12:

If you add an action that isn't part of an action set, you still have to make a choice in both Guided Edit panel menus. Just choose its name in the first menu, and then, in the Action menu, choose Action 1 as shown here.

Redsteel is the action used to create the building image in Figure 13-1. You can download it from the Missing CD page at www.missingmanuals.com if you want to try installing actions. It works best on photos with lots of detail. On images with large blocks of color, the effect is more like pop art than a colored steel engraving.

It's important to understand a few differences between actions in Photoshop and in Elements. Photoshop can run an action on a whole folder of images at once. In Elements, you're restricted to one photo at a time. Also, Elements can't fully perform actions that invoke Photoshop-only commands. For example, if you run an action that includes creating a history snapshot, you see the dialog box shown in Figure 13-13.

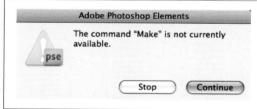

Figure 13-13:

When you run an action in Elements, you may see dialog boxes asking for your input as the action works through the steps. If you see this dialog box, you're trying to run an action that includes a step that Elements can't do. You don't have to stop the action, but be aware that you won't get the same results as you would in Photoshop.

If you like to play it safe, find actions written specifically for Elements. Page 493 tells you where to look for them.

NOTE While the Action Player is great, there's one disadvantage to having it in Guided Edit: You can't access the Layers panel, which is annoying if you're running an action that requires you to choose a layer mid-action, because you can't select a particular layer without the Layers panel. The good news is that you can install actions in the Effects panel. This lets you use actions in Full Edit, where you can get to the Layers panel anytime an action requires it. By installing in the Effects panel, you can still use the add-on tools for Elements that are actually actions that use or create layers, like the various free toolsets available online. You'll find much more about downloading and installing these in Chapter 18.

Adding Layer Styles

Like filters and effects, Layer styles let you transform objects by giving them new characteristics such as drop shadows. Layer styles are especially useful for modifying individual objects, like text and buttons, because you can edit the text and change the button's shape even *after* you've applied the Layer style.

Layer styles, as their name suggests, work on the contents of one layer—rather than on your whole image. That's important. A Layer style affects everything on a layer. If you want to apply a Layer style to just one object in your picture, select the object, and then put it on its own layer by pressing ℜ-J (or going to Layer → New → "Layer via Copy") or ℜ-Shft-J (or going to New → "Layer via Cut"). Figure 13-14 shows what you can do with Layer styles.

Figure 13-14:
Layer styles are great for making fancy buttons for websites. Changing this plain black Custom Shape was as simple as double-clicking the Star Glow Layer style (in Complex Styles). Changing something like the drop shadow is easy to do once you've applied the style. Keep reading to learn how to edit Layer styles.

You apply Layer styles from the Effects panel (Window → Effects). Click the Layer Styles button (which has two overlapping squares on it) and then—from the pull-down menu—choose a category or Show All. Finally, select the layer you want to modify (by highlighting it in the Layers panel), and then double-click the thumbnail for the Layer style you want to use, or click it once and then click Apply. (You can also drag a style's thumbnail to a layer to apply it.) The box on page 403 shows you how to modify a style's settings once you've applied it.

NOTE Some tools, like the Type tool (see page 419), have an Options bar setting that lets you choose a Layer style.

Here's a rundown of the choices available in each Layer style category:

• Bevels give objects a 3-D look by making them appear raised from the page or embossed into it. Figure 13-15 shows how combining a bevel and a drop shadow can add dimension to a simple shape.

Figure 13-15: Here's the bell image from earlier in this chapter. Adding a bevel and a drop shadow gives it much more dimension and depth.

- Complex includes a variety of elaborate styles that make objects look like they're made from metal, cactus, or several other materials. These styles are particularly useful for applying to type.
- Drop Shadows adds shadow effects that make your object look like it's floating above the page.

NOTE To add a drop shadow to an entire photo, you have to also add canvas (see page 97) to give the shadow someplace to fall.

- Glass Buttons are supposed to make objects look like, well, glass buttons, but many people think they look more like plastic. They're useful for creating web page buttons.
- Image Effects give you tons of ways to transform your photo, including fading it and making it look like the pieces of a puzzle or a tile mosaic.
- Inner Glows add light around the inside edge of your object.
- Inner Shadows give your image a hollow or recessed look by casting a shadow within the object, rather than outside it the way drop shadows do.
- Outer Glows create the same kind of light effects that Inner Glows do, only around the outer edge of your image.
- Patterns apply an overall pattern to your image. Want to make something look like it's made from metal or dried mud, or to fill in a dull background with a vivid pattern? You'll find lots of choices here.

- Photographic Effects include traditional photographic techniques. You can add a variety of monochrome effects, like good old-fashioned sepia.
- Strokes let you put a black or colored border around the edge of a layer, or an object on its own layer. They're great for making outlined text, too.
- Visibility changes the opacity and visibility of your layer. Use these styles to create a ghosted effect, or when you're applying multiple Layer styles and want to use an object's outline without having the object itself visible.
- Wow Chrome, Neon, and Plastic styles make objects look like they're made from shiny chrome, outlined in neon, or made from plastic.

NOTE You can apply Layer styles only to regular layers. If you try to apply one to a Background layer, Elements asks you to convert it to a regular layer first.

If someone sends you a file made using Layer styles that you don't have, you can snag them for your own use by highlighting the layer with the styles on it, and then going to Layer \rightarrow Layer Style \rightarrow Copy Layer Style. To use these styles in your own image, click the layer you want to modify, and then choose Layer \rightarrow Layer Style \rightarrow Paste Layer Style. This command applies all the styles used in the original image to the layer you targeted.

POWER USERS' CLINIC

Editing Layer Styles

You can customize Layer styles in Elements (see Figure 13-16). Start by applying a Layer style, and then you can edit it as much as you like. Just double-click the Layer Styles icon in the Layers panel (the little italic "fx" to the right of the layer's thumbnail) or select Layer → Layer Style → Style Settings. Once the Style Settings dialog box appears, you can edit your style in many different ways:

- Drop Shadow. You can change the shadow's direction, distance, opacity, or even its color.
 When the Style Settings dialog box is open, you can drag the shadow around in your image window until it's positioned where you want it.
- Glow. You can set the color, size, and opacity for both inner and outer glows, and turn each one on or off.

- Bevel. Change the size or direction of the bevel.
- Stroke. A stroke is a border around the edge of the style (like a line). You can change the color, size, and opacity of the stroke.

Elements lets you customize styles in so many ways that you can practically make your own style from an existing one. There's only one hitch: You can't change the standard settings for each style or save your custom style, so any changes you make affect the style only as you're currently applying it.

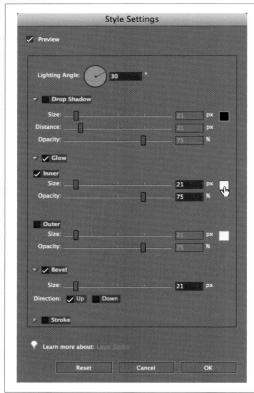

Figure 13-16:

The Style Settings dialog box gives you a lot of choices. Use the flippy triangles on the left to see the settings for a particular style characteristic or to collapse the ones you don't care about to get them out of your way. To apply a new characteristic to a style (like adding a glow to a style that doesn't already have one), turn on its checkbox. Click the color squares to the right of a slider to bring up the Color Picker (page 217) and then choose a new color for that setting.

To remove a Layer style from your image, in the Layers panel, right-click (Controlclick) the layer, and then choose Clear Layer Style, or go to Layer \rightarrow Layer Style \rightarrow Clear Layer Style. These commands are all-or-nothing: If your layer has multiple styles, they all go away. To remove one style at a time, use the Undo History panel (page 32) instead.

TIP To see what your image looks like without the styles you've applied to it, go to Layer \rightarrow Layer Style \rightarrow Hide All Effects.

You can download hundreds of additional Layer styles from the Web (see page 493 for tips on where to look and how to install them). It's easy to get addicted to collecting Layer styles because they're so much fun to use. You've been warned.

Applying Gradients

You may have noticed that a few of the Layer styles and effects apply a color tint that fades away at the edges of your layer or image. Elements lets you fade and blend colors in almost any way you can imagine by using *gradients*. With gradients,

you can create anything from a multicolored rainbow extravaganza to a single color that fades away into transparency. Figure 13-17 shows a few examples of what you can do with gradients. The only limit is your imagination.

Figure 13-17: Here are three examples of gradients drawn with the Gradient tool.

Top: This figure shows a gradient that creates a rainbow effect.

Middle: If you play with the Gradient Editor (page 409), you can create all sorts of interesting effects. Here's the gradient from the top figure again, only this time it's applied left to right instead of top to bottom. It looks so different because the noise option was used (see page 413). Click the Randomize button a couple of times to get this effect.

Bottom: This figure shows a gradient you can create if you want a landscape background for artwork.

You can apply gradients directly to your image using the Gradient tool, or create *Gradient Fill layers*, which are whole layers filled with—you guessed it—gradients. You can even edit gradients and create new ones using the Gradient Editor. Finally, there's a special kind of gradient called a *gradient map* that lets you replace the colors in your image with the colors from a gradient. This section covers the basics of using all these tools and methods.

The Gradient Tool

If you want to apply a gradient to an object in your image, the Gradient tool is the fastest way to do so. This tool seems complicated at first, but it's actually easy to use. Start by activating the Gradient tool in the Tools panel (the yellow-and-blue rectangle) or by pressing G. Figure 13-18 shows the Gradient tool's Options bar.

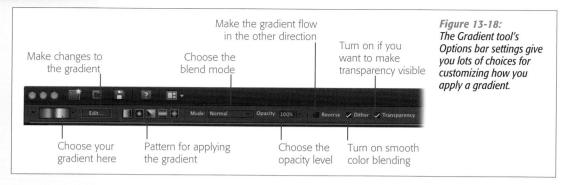

Using the Gradient tool is as easy as dragging. Click where you want the gradient to begin, and then drag to the point where you want it to stop (you'll see a line connecting the beginning and ending points). When you release the mouse button, the gradient covers the available space.

For example, say you're using a yellow-to-white gradient. If you click to end the gradient one-third of the way into your photo, the yellow stops transitioning at that point, since you told Elements to stop the gradient there, and the remaining two-thirds of your photo get covered with white. (In other words, something put down by the tool covers the entire space—your whole photo, in this case. Clicking stops the color *transition*—no more yellow beyond that point—but the end color from the gradient fills in everyplace else.) Drag the gradient within a selection to confine the area it covers (see Chapter 5 if you need a refresher on making selections) so that the entire photo or layer isn't affected by the gradient's colors.

TIP The Gradient tool puts the gradient on the same layer as the image you apply it to, which means that it's hard to change anything about a gradient after you apply it. If you think you might want to alter a gradient, use a Gradient Fill layer (page 408) instead.

Some of Element's gradients use your Foreground and Background colors as the two colors that generate the gradient. But Elements also offers a number of preset gradients with different color schemes. Click the arrow to the right of the gradient thumbnail in the Options bar to see a panel of different gradients, some of which use your selected colors, and others that have their own color schemes. The gradients are grouped into categories. In the upper-right corner of the gradient thumbnails panel, click the double arrow to see all the gradient categories. Choose one to see the gradients in that category. You can work only with the gradients in one category at a time.

You can download gradients from the Web and add them to your library using the Preset Manager (see page 495), or create your own gradients from scratch. (Page 493 has suggestions of where to look for new gradients.) Creating and editing gradients is explained later in this chapter, in the section about the Gradient Editor.

To apply a gradient with the Gradient tool, first make a selection if you don't want to see the gradient in your whole image. Then:

1. Choose the colors you want to use for your gradient.

Click the Foreground and Background color squares (page 216) to choose colors. (Some gradients ignore these colors and use their own preset colors instead.)

2. Activate the Gradient tool.

Click it in the Tools panel or press G.

3. Select a gradient.

Go to the Options bar, click the Gradient thumbnail, and then choose the gradient style you want. Then make any other necessary changes to the Options bar settings (your options are explained in a moment), like reversing the gradient.

4. Apply the gradient.

Drag in your image to mark where the gradient should run. If you're using a linear gradient, you can make it run vertically by dragging up or down, or make it go horizontally by dragging sideways. For Radial, Reflection, and Diamond gradients, try dragging from the center of your image to an edge. If you don't like the result, press \(\mathbb{K} - \mathbb{Z} \) to undo it. Once you like the way the gradient looks, you don't need to do anything special to accept it; just save your image before you close it.

You can customize gradients in several ways, even without using the Gradient Editor. When the Gradient tool is active, the Options bar offers the following settings:

- Gradient. Click the arrow to the right of the thumbnail to choose a different gradient.
- Edit. Click this button to bring up the Gradient Editor (page 409).
- Gradient types. Use these five buttons to determine the way the colors flow in your gradient. From left to right, your choices are: Linear (in a straight line), Radial (a sunburst effect), Angle (a counterclockwise sweep around the starting point), Reflected (from the center out to each edge in a mirror image), and Diamond. Figure 13-19 shows what each one looks like.
- Mode. You can apply a gradient in any blend mode (see page 168).
- Opacity. If you want your image to be visible through the gradient, reduce this setting.
- Reverse. This setting changes the direction in which the colors are applied so that, for example, instead of yellow to blue from left to right, you get blue to yellow.

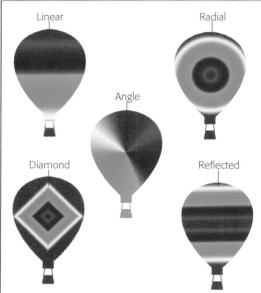

Figure 13-19: The same gradient pattern applied using the different gradient types: Linear, Radial, Angle, Diamond, and Reflected.

- Dither. Turn on this checkbox and Elements uses fewer colors but simulates the full color range using a noise pattern. This can help to prevent banding of your colors, making smoother transitions between them.
- Transparency. If you want to fade to transparency anywhere in your gradient, turn on this checkbox. Otherwise, the gradient can't show transparent regions.

Gradient Fill Layers

You can also apply a gradient using a special Fill layer. Most of the time, this method is better than the Gradient tool, especially if you want to be able to make changes to your gradient later on.

To create a Gradient Fill layer, go to Layer → New Fill Layer → Gradient. The Gradient Fill dialog box appears so you can set the layer's opacity and blend mode (page 168). Once you click OK, the new layer fills with the currently selected gradient, and the dialog box shown in Figure 13-20 pops up. You can change many of the settings for your gradient here or choose a different gradient.

The Gradient Fill dialog box's settings are much the same as those in the Options bar for the Gradient tool:

Gradient. To choose a different gradient, click the arrow next to the thumbnail
to see the gradient thumbnails panel. To choose from a different gradient category, click the double arrow in the panel's upper right, and then choose the
category you want.

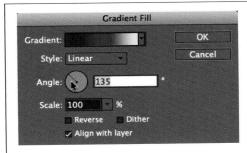

Figure 13-20:

The Gradient Fill dialog box gives you access to most of the same settings you find in the Options bar for the Gradient tool. The major difference is that in the Fill layer, you set the direction of your gradient by typing in a number for the angle or by changing the direction of the line in the circle as shown here (the cursor is pointing to the line you drag to change the angle). With a Gradient Fill layer, you don't get a chance to set the direction by dragging directly in your image as you do with the Gradient tool, but while the dialog box is onscreen you can drag the gradient in your image to change where it transitions.

- Style. You have the same choices as for the tool (Linear, Diamond, and so on). In this dialog box, you see only the name of the style, not a thumbnail of it. Choose a different style and Elements previews it in the layer.
- Angle. This setting controls the direction the colors will run. To change the
 direction of the flow, enter a number in degrees or spin the line in the circle by
 dragging it.
- Scale. This setting determines how large your gradient is relative to the layer. One hundred percent means they're the same size; at 150 percent, the gradient is bigger than your layer, which means you see only a portion of the gradient in the layer. For example, if you had a black-to-white gradient, you'd see only shades of gray in your image. If you turn off the "Align with layer" checkbox, you can adjust the location of the gradient relative to your image by dragging the gradient.
- Reverse. Turn on this checkbox to make colors flow in the opposite direction.
- Dither. Use this setting to avoid banding and create smooth color transitions.
- Align with layer. This setting keeps the gradient in line with the layer. Turn it off and you can pull the gradient around in your image to place it exactly where you want it. At least, that's how it's supposed to work. Usually you can drag while the dialog box is visible but not after you click OK.

When the gradient looks good, click OK to create the layer. You can edit it later by double-clicking its left icon (the one with the gradient on it) in the Layers panel. That brings up the Gradient Fill Layer dialog box again, so you can change its settings or choose a different gradient.

Editing Gradients

Elements' Gradient Editor lets you create gradients that include any colors you like. You can even make gradients in which the color fades to transparency, or modify existing gradient presets. The Gradient Editor isn't the easiest tool in the world to use. This section tells you the basics you need to get started. Then, as is the case with so many of Elements' features, a little playing around with the Gradient Editor is the best way to understand how it works.

You have to activate the Gradient tool to launch the Gradient Editor. In the Options bar, click the Edit button to see the Gradient Editor (see Figure 13-21).

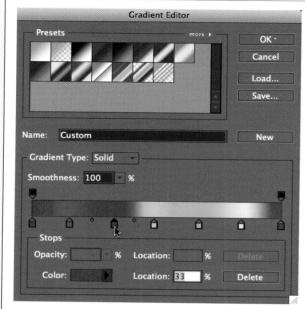

Figure 13-21:

The powerful and complex Gradient Editor. Here, the blue stop (where the cursor is) was clicked to make it active. The black triangle above the stop is Elements' way of telling you it's the active stop. The two tiny diamonds on either side of the active stop mark the midpoint of the transition between the selected color and its neighbors. You can move these diamonds to change the midpoints.

The Gradient Editor opens showing the current gradient. You can choose a different gradient by picking from the thumbnails at the top of the Gradient Editor window, or by clicking the word "more" in the window's upper right and choosing a new category from the list. (You'll learn how to save your custom gradients later in this chapter.)

To get started using the Gradient Editor, first choose your gradient's type and smoothness settings:

- Gradient Type. Your choices are Solid or Noise. Solid gradients are the most common; they let you create transitions between solid blocks of color. Noise gradients, which are covered later in this section, produce bands of color, as you might see in a spectrometer.
- Smoothness. This setting controls how even the transitions between colors are.

You do most of your work in the Gradient Editor's *Gradient bar*, the long colored bar where Elements displays the current gradient. The little boxes (called *stops*) and diamonds surrounding the Gradient bar let you control the color and transparency of your gradient.

For now, you care only about the stops *beneath* the Gradient bar. Each one is a *color stop*; it represents where a particular color falls in the gradient. (You need at least two color stops in a gradient.) If you click a stop, the pointed end becomes black, letting you know that it's the active stop. Anything you do at this point will affect the area governed by that stop. You can slide the stops around to change where the colors transition.

The color stops let you customize your gradient in lots of different ways. Using them, you can:

- Change where the color transitions. Click a color stop and you see a tiny diamond appear under the bar. The diamond is the midpoint of the color change. Diamonds always appear between two color stops. You can drag the diamond in either direction to skew the color range between two color stops so that it more heavily represents one color over another. (You know you've successfully grabbed the diamond when it turns black.) Wherever you place the diamond tells Elements that's where the color change should be half completed.
- Change one of the colors in the gradient. Click any color stop, and then click the color square (at the bottom of the Gradient Editor, in the Stops section) to bring up the Color Picker (page 217). Choose a new color, and the gradient automatically reflects your change. You can also pick a new color by moving your cursor over the Gradient bar; the cursor turns into an eyedropper that lets you sample a color. If you click the arrow to the right of the Color square, you can select the Foreground or Background color without having to go to the Color Picker (The User Color option just means the normal behavior happens, where moving over the bar brings up the eyedropper.)
- Add a color to the gradient. Click a color stop, and then click again (not in the bar, but anywhere just beneath it) to indicate where you want the new color to appear. Elements adds a new color stop where you clicked. Next, click the Color square at the bottom of the window to bring up the Color Picker so you can choose the color to add. The new color appears in the gradient at the new stop. Repeat as many times as you want, adding a new color each time. If you want your stop to be precisely positioned, you can enter numbers (indicating percentage) in the Location box below the Gradient bar. For example, 50 percent positions a stop at the bar's midpoint. To duplicate an existing color from your gradient, click its stop, and then click below the bar where you want to use that color again.
- Remove a color from a gradient. If a gradient is *almost* what you want but you don't like one of the colors, you don't have to live with it. You can remove a color by clicking its stop to make it the active color. Then click the Delete button at the bottom right of the Gradient Editor, or just drag the stop downward off the bar. The Delete button is grayed out if no color stop is active.

Transparency in gradients

You can also use the Gradient Editor to adjust the transparency in a gradient. Elements gives you nearly unlimited control over the transparency in gradients, and the opacity of any color at any point in the gradient. Adjusting opacity in the Gradient Editor is much like using the color stops to edit the colors, but instead of color stops you use *opacity stops*.

NOTE Transparency is particularly nice in images for Web use, but remember that you need to save in a format that preserves transparency, like GIF, or you lose the transparency. If you save your file as a JPEG, the transparent areas become opaque white. See page 475 for more about file formats for the Web.

The opacity stops are the little boxes *above* the Gradient bar. You can move an opacity stop to wherever you want, and then adjust the transparency using the settings in the Gradient Editor's Stops section. Click above the Gradient bar wherever you want to add an opacity stop. The more opacity stops the Gradient bar has, the more points you have where you can adjust your gradient's opacity.

Here's how to add an opacity stop and adjust its opacity setting:

1. Click one of the existing opacity stops.

If the little square on the stop is black, the stop is completely opaque. A white square is totally transparent. The new stop you're about to create will have the same opacity as the stop you click in this step, but you can adjust the new stop once you create it. (You can actually skip this step, but it lets you predetermine the opacity of your new stop.)

2. Add a stop.

Click just above the Gradient bar where you want to add a stop. If you want your stop to be precisely positioned, then you can enter numbers (indicating percentage) in the Location box below the Gradient bar. For example, 50 percent positions a stop at the bar's midpoint.

3. Adjust the new stop's opacity.

Go to the Opacity box below the Gradient bar and either enter a percentage or click the arrow to the right of the number and then move the slider to change the opacity setting. To get rid of a stop, click its tab, and then press Delete, or drag the stop upward away from the bar.

By adding stops, you can make your gradient fade in and out, as shown in the background of Figure 13-22, which has a simple vertical blue-to-transparent linear gradient that's been edited so that it fades in and out a few times.

THE CASTLETON LITTLE THEATRE PRESENTS:

Figure 13-22: You can make a gradient fade in and out like this background by adding more opacity stops and reducing the opacity of each stop.

Creating noise gradients

Elements also lets you create what Adobe calls *noise gradients*, which aren't speckled as you might expect if you're thinking of camera noise (page 389). Instead, noise gradients randomly distribute their colors within the range you specify, giving them a banded or spectrometer-like look. The effect is interesting, but noise gradients can be unpredictable. The noisier a gradient is, the more stripes of the colors you see, and the greater the number of random colors.

With the Gradient tool active, you can create a noise gradient by going to the Options bar and clicking the down arrow to the right of the gradient's thumbnail. This opens the gradient thumbnail panel. Click the double arrow at the panel's upper right and then, in the pop-out list of categories, select Noise Samples. You can edit them by clicking the gradient thumbnail in the Options bar to bring up the Gradient Editor or, if you want to start without a Noise Sample preset, you can click the Edit button to bring up the Gradient Editor, and then choose Noise from the Gradient Type menu.

Noise gradients have some special Gradient Editor settings of their own:

- Roughness controls how often the gradient transitions (see Figure 13-23).
- Color Model determines which color mode you work in—RGB or HSB. RGB gives you red, green, and blue color sliders, while HSB lets you set hue, saturation, and brightness (see page 221 for more about these settings).
- Restrict Colors keeps your colors from getting too saturated.

Figure 13-23: The amount of noise in a gradient can make quite a difference in the effect you get.

Top: Here's a solid gradient.

Middle: A gradient with the same colors and 50 percent noise.

Bottom: A gradient with the same colors and 90 percent noise.

- Add Transparency puts random amounts of transparency into your gradient.
- Randomize adds random colors (and transparency, too, if you turned on that checkbox). Keep clicking the Randomize button until you see an effect you like.

Saving Gradients

After all that work, you probably want to save your gradient so you can use it again. You have two ways to save a gradient from the Gradient Editor:

- Click the New button. In the Name box, enter a name for your gradient. Your gradient gets added to the current category. Elements creates a thumbnail of your gradient in the gradient thumbnails panel, in the currently visible set of gradients.
 - **TIP** If you forget and click the New button before naming your gradient (or if you just want to change its name), in the Gradient Editor, right-click (Control-click) the gradient's thumbnail, and then choose Rename Gradient
- Click Save. The Save dialog box appears and Elements asks you to name the gradient. You'll save the new gradients in a special Gradients folder, which Elements automatically takes you to in the Save dialog box. This method resaves the entire set of presets that's visible when you create your gradient. When you want to use the gradient again, click the Gradient Editor's Load button, and then select it from the list of gradients that appears. The new set appears at the bottom of the list of gradient libraries when you click the double arrows in the palette's upper right.

TIP You can also save and load gradients from the Options bar's gradient thumbnail panel's upper-right menu (the one you call up by clicking the double arrows).

Gradient Maps

Gradient maps let you use gradients in nonlinear ways. So instead of a rainbow that shades from one direction to another, in a gradient map, the gradient colors are substituted for the existing colors in your image. You can use gradient maps for funky special effects or for serious photo corrections.

When you create a gradient map, Elements plots out the brightness values in your image and applies those values to a gradient (light to dark). Then Elements replaces the existing colors with the gradient you choose, using the lightness values as a guide for which color goes where. That sounds complicated, but if you try it, you'll quickly see what's going on. Take a look at Figure 13-24, where applying a gradient map dramatically livens up a dull photo. But that's not all gradient maps are good for. Gradients and gradient maps can also be valuable tools for straight retouching. See the box on page 417 to learn how to use gradients to fix the color in photos.

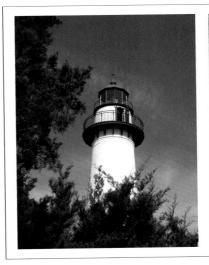

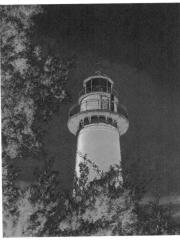

Figure 13-24: Left: An ordinary shot of a lighthouse.

Right: The image becomes altogether different when you apply a gradient map adjustment.

You can apply a gradient map directly to your image by going to Filter → Adjustments → Gradient Map. (You can also apply a gradient map with the Smart Brush [page 196]. In the Options bar's Smart Paint setting, choose Special Effects → Rainbow Map.) But most times, for maximum control you'll want to use a Gradient Map Adjustment layer, because it's easier to edit after you've created the layer. Here's how:

1. Create a Gradient Map Adjustment layer.

Go to Layer → New Adjustment Layer → Gradient Map. The New Layer dialog box appears so you can choose the color mode and opacity for your new layer, and name it if you want. Click OK, and a gradient map appears in your photo, but don't worry if it's not what you had in mind. You can modify it by going to the Adjustments panel, shown in Figure 13-25.

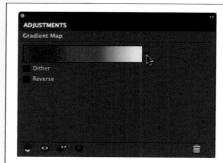

Figure 13-25:

The Gradient Map Adjustments panel. Clicking the tiny arrow to the right of the thumbnail (where the cursor is here) displays a drop-down menu showing the available gradient patterns. Click in the pattern preview area to bring up the Gradient Editor (page 409) if you want to make changes to the gradient you chose.

2. Choose a gradient.

In the panel, you see a gradient whose colors are based on your current Fore-ground and Background colors (see page 216). That gradient is the map that Elements made of the lightness/darkness values in your image. If you want your image to show color, choose a color gradient rather than a black- or gray-to-white one. At the right of the gradient thumbnail, click the arrow, and then choose a color gradient.

The Dither checkbox adds a little random noise to make the gradient's transitions smoother. The Reverse checkbox switches the direction in which Elements applies the gradient to the map. For example, if you chose a red-to-green gradient, reversing it would put green where it would have previously been red, and vice versa. It's worth giving this setting a try—you can get some interesting effects.

3. Keep editing until you're satisfied with the result.

Elements automatically replaces the colors in your image with the equivalent values from the gradient you chose, so you can watch each one as you click around in the gradient libraries. When you like what you see, save your image. You can also edit your gradient map layer by clicking it in the Layers panel, as explained in Figure 13-25.

Remember that you don't have to use your gradient in Normal blend mode—you can use any layer blend mode (page 168). You can spend hours playing around with the different effects you can get with the gradient map. Other filters and adjustments can produce unexpected results when used with it.

TIP Try equalizing your image (Filter → Adjustments → Equalize) after applying a gradient map adjustment. The colors can shift dramatically. Equalizing is a good thing to try if your gradient map makes your image look dull or dingy. You may need to merge the image's layers (page 177) to get this command to work, since you can't equalize an Adjustment layer. (See page 295 for more about the Equalize command.)

POWER USERS' CLINIC

Using Gradients for Color Correction

If you just want to use Elements to enhance and correct your photos, you may think that all this gradient business is a big waste of time. But gradients and gradient maps aren't just for introducing lurid colors into your photos—they're also powerful tools for correcting images.

For instance, say you have a photo where one side is darker than the other and you want to apply an Adjustment layer so it affects only the dark side of the image. You can pull off this trick by bringing up the Adjustment layer's layer mask (see page 308), and then applying your gradient directly to the mask.

You can also use Gradient Map Adjustment layers in different blend modes to help balance out the colors in your photos, although you may need to use the Gradient Editor to play with the distribution of light and dark values to get the best effect.

Gradient maps are also useful for colorizing skin in blackand-white photos. Set up a gradient based on three or more skin tones, and you can get a more realistic distribution of color tones than you can by painting.

Text in Elements

Elements makes it easy to add text to your images. You can quickly create all kinds of fancy text to use on greeting cards, as newsletter headlines, or as graphics for web pages. The program gives you lots of ways to jazz up your text: You can apply Layer styles, effects, and gradients to it, or warp it into psychedelic shapes. And the Type Mask tools let you fill individual letters with the contents of a photo. Best of all, most Type tools let you change your text with just a few clicks (see Figure 14-1). By the time you finish this chapter, you'll know how to add pizzazz to your text.

Adding Text to an Image

It's a cinch to add text to an image in Elements. Just select the Type tool, choose a font from the Options bar, and type away. The Type tool's Toolbox icon is easy to recognize: a capital T.

Elements actually gives you four different Type tools, all of which are hidden behind the Toolbox icon's pop-out menu: the Horizontal Type tool, the Vertical Type tool, the Horizontal Type Mask tool, and the Vertical Type Mask tool. You'll learn about the Type Mask tools later in this chapter (see page 434). To get started, you'll focus on the regular Horizontal and Vertical Type tools. As their names imply, the Horizontal Type tool lets you enter text that runs left to right, while the Vertical Type tool is for creating text that runs down the page.

When you use the Type tools, Elements automatically puts your text on its own layer, which makes it easy to throw out that text and start over. When the Type tool is active, you start another Text layer each time you click in your image.

Happy Anniversary

Figure 14-1:

With Elements, you can take basic text and turn it into the kind of snazzy headlines you see on greeting cards and magazine covers. It took only a couple of clicks—a couple of Layer styles (Angled Spectrum and a bevel) and some warping—to turn the plain black letters (top) into an extravaganza (bottom).

Happy Anniversary

TROUBLESHOOTING MOMENT

Why Does the Type Tool Turn My Photo Red?

If your image gets covered with an ugly reddish film every time you click it with the Type tool, you've got one of the Type Mask tools activated. (Type masks, covered later in this chapter, are useful when you want to create text that's cut from an image.)

To switch over to the regular Type tools, click the Type tool's icon in the Elements Toolbox, and then use the pop-out menu to select either of the regular Type tools (horizontal or vertical).

Text Options

Whether you select the Horizontal or Vertical Type tool, the first thing you'll want to do is look at the Options bar settings (Figure 14-2). These choices let you control pretty much every aspect of your text, including the font, font, and alignment.

Your choices from left to right are:

• Font Family. Choose your font, listed here by name. Elements uses the fonts installed on your computer.

TIP The font family menu displays the word "Sample" in the actual fonts to make it easier for you to find the one you want. To see all your fonts, in the Options bar, click the down arrow to the right of the font name box for a pop-out menu. You can also adjust the size of the preview samples by going to Photoshop Elements \rightarrow Preferences \rightarrow Type.

• Font Style. Here's where you select a style for your font, like Bold or Italic.

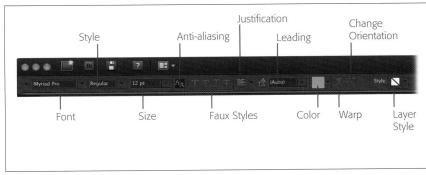

Figure 14-2:
The Type tool's Options
bar lets you control lots
of different settings, most
of which are pretty
standard, like the font
and the size of the
letters. The choices
toward the right end of
the bar—like Warp and
Layer style—are where
the fun begins.

• Size. This is where you choose how big the text should be. Text is traditionally measured in *points*. You can choose from the list of preset sizes in the pull-down menu or type in a size. You aren't limited to the sizes shown in the menu—you can enter any number you want. (See the box below for help understanding the relationship between points and actual size in Elements.) If points make you nervous, you can change the measurement unit to millimeters or pixels by going to Photoshop Elements → Preferences → Units & Rulers.

TROUBLESHOOTING MOMENT

How Resolution Affects Font Size

It's easy enough to pick a font size in the Text tool's Options bar. But you may find that what you thought would be big, bold, headline-size text is so tiny in your image that you can hardly see it. What gives?

In Elements, the size of text in your image is tied to the image's resolution. So, if you thought that choosing 72-point text would give you a headline that's an inch high, it will be only if the *resolution* of your file is 72 pixels per inch (ppi). The higher the resolution, the smaller that same text will be. If the resolution is 144 ppi, your 72-point text prints half an inch high. In a 216-ppi image, it'll be one-third of an inch high, and so on.

If you're working with high-resolution images, you have to increase the size of your fonts to allow for the extra pixel packing that comes from increased resolution. It's not uncommon to have to choose sizes *much* higher than anything listed in the Options bar's size menu. Don't be afraid of really big sizes if you need them—just keep entering larger numbers in the size box until the text looks right in proportion to your image.

Another thing about text in Elements that can be confusing is that the program creates text based on the *actual* size of your image, not the view size. So if you're zoomed way in on your image and add some text that looks like it's a reasonable size, it may actually be much smaller when you see the image at actual size or print it. People often put small text on a large image and wonder why it's so hard to read. If you aren't sure about the actual size of your document, go to View \rightarrow Print Size before typing. This view offers only an approximation, but it helps you get a better idea of what your text will look like.

• Anti-aliased. This setting smoothes the edges of your text. Turn it on or off by clicking the square with the two As on it. Anti-aliasing is explained on page 137; usually you want it turned on.

- Faux Styles. Faux as in "fake." If your chosen font doesn't have a bold, italic, underline, or strikethrough version, here's where you tell Elements to simulate that style by clicking one of these four icons. (These options aren't available for some fonts.)
- Justification. This pull-down menu tells Elements how to align your text, like in a word-processing program. If you enter multiple lines of text, this is where you tell Elements whether you want it lined up left, right, or centered (for horizontal text). If you select the Vertical Type tool, you can align the top, bottom, or middle.

TIP If you use the Vertical Type tool, your columns of text run from right to left (each time you start a new column) instead of left to right. If you want vertical text columns to run left to right, put each column on its own layer and position them manually. You can use the Move tool's Distribute option (page 172) to space them evenly.

- Leading. This setting (whose name rhymes with "bedding") controls the amount of spacing between the lines of text, measured in points. For horizontal text, leading is the difference between the baselines (the bottom of the letters) on each line. For vertical text, leading is the distance from the center of one column to the center of the column next to it. Figure 14-3 shows what a difference leading can make. The first setting you'll always see here is Auto, which is Elements' guess about what looks best. You can change the leading by choosing a number from the list or entering the amount you want (in points, unless you changed the measurement unit in Elements' preferences).
- Color. Click this square to bring up the Color Picker (page 217) and set the color of your text. Or click the arrow to the right of the square to bring up Color Swatches (page 220). When you've made your selection, the Foreground color square (page 216) changes to the new color. (Page 216 explains how to use the Toolbox's color-picking squares.)

NOTE When the Type tool cursor is active in your image, you can't use the keyboard commands to reset Elements' standard colors (black and white) or to switch them. You have to click the relevant buttons in the Toolbox instead.

- Warp. The little T over a curved line hides options for distorting your text in lots of interesting ways. There's more about this option on page 427. (The Warp Text command is also available from Layer → Type → Warp Text.) This setting is grayed out until you type something.
- Orientation. This button, which shows a T with two arrows next to it, changes your text from horizontal to vertical, or vice versa. You can also change text's orientation by going to Layer → Type → Horizontal or Vertical. You can't change the orientation of text till you have some text, so this setting is also grayed out until you type something.

- · Heliskiing
- Parasailing
- Cave Diving
- · On-Site Medical Facility
- Figure 14-3: Leading is the space between lines of text.

Top: A list of four items with Auto leading.

Bottom: The same list with the leading set a bit higher. (If you adjust the leading of vertical text, you change the space between the columns, rather than between letters within a column. See the box on page 426 to learn how to tighten up the space between letters that are stacked vertically.)

- Heliskiing
- Parasailing
- Cave Diving
- · On-Site Medical Facility
- Style. You can add funky visual effects to your text with Layer styles (page 401). First, enter some text and then, on the Options bar, click the Commit button (the green checkmark). Next, click the Style box and choose a Layer style from the pop-out palette. If you want to remove a style that you just applied, go to Layer → Layer Style → Clear Layer Style or click the double arrows in the Style palette's upper-right corner and choose Remove Style from the menu that appears.

These two choices don't show up at all until you type something:

- Cancel. When you add text to your image, Elements automatically places the
 text on its own layer. Click the Cancel button (the red circle with a slash) to
 delete this newly-created Text layer. This button works only if you click it before
 you click the Commit button (described next). To delete text after you've committed it, drag its layer to the trashcan icon in the Layers panel.
- Commit. Click this green checkmark after you type on your image to tell Elements that yes, you want the text to stay the way it is.

When you see these buttons in the Options bar, it means you haven't committed your text, and you can't use many menu selections and tools until you do. When

you see these buttons, you're in *Edit mode*, where you can make changes to your text, but most of the rest of Elements features aren't available to you. Click Commit or Cancel to get the rest of the program's options back.

Creating Text

Now that you're familiar with the choices in the Options bar, you're ready to start adding text to your image. You can add text to an existing image or create a new file (if you want to make text to use as a graphic by itself, say). To use either the Horizontal or Vertical Type tools, follow these steps:

1. Activate the Type tool.

Click the tool's icon in the Toolbox or press T, and then select the Horizontal Type tool or the Vertical Type tool from the pop-out menu.

2. Modify any settings you want to change on the Options bar.

See the list in the previous section for a rundown of your choices. You can make changes after you enter your text, too, so your choices aren't set in stone yet. Elements lets you edit your text until you simplify the Text layer. (See page 373 for more about what simplifying a layer means.)

3. Key in your text.

Click in your image where you want the text to go and start typing. Elements automatically creates a new layer for your text when you use the Type tools. If you're using the Horizontal Type tool, the horizontal line is the baseline your letters sit on. If you're typing vertically, the vertical part of the cursor is the centerline of your characters.

Type the way you would in a word processor, using the Return key to create new lines. If you want Elements to *wrap* your text (adjust it to fit a given space), drag with the Type tool in your image to create a text box before you start typing. Otherwise, you need to insert returns manually. If you create a text box, you can resize it to adjust the text's flow by dragging the handles after you finish typing. (This won't work after you simplify the layer.)

As noted earlier, if you want to use the Vertical Type tool, you can't make the columns of text run left to right. So if you need multiple vertical columns of English text, enter one column and then click the Commit button. Then start over for the next column, so that each column is on its own layer.

NOTE Be careful about clicking when the Type tool is active. Each click starts a new layer. That's great if you're creating lots of separate text boxes to position individually, but it's easy to create a layer when you don't mean to. If you accidentally add a layer, just delete it in the Layers panel, or merge it (page 177) with your existing Text layer.

4. Move your text if you don't like where it's positioned.

Sometimes the text doesn't end up where you want it. As long as you haven't committed the text by clicking the green checkmark, you can move it with the Type tool. As long as you can still see the little black square at the beginning of the baseline and the underline below your words, move your cursor just outside the text you typed. When the cursor changes to an arrow with a cross next to it, you can drag the text where you like. If you've already committed your text (explained in the next step), first go to the Layers panel and double-click the text layer's icon (the rectangle with the T on it) to reactivate the text. If you need to move vertical text columns, wait until you've committed the text to rearrange the columns.

If you like what you see, click the checkmark in the Options bar to commit the text.

When you commit your text, you tell Elements that you accept what you've created. The Type tool cursor is no longer active in your photo once you commit. If you don't like what you typed, click the Options bar's Cancel button instead and the whole Text layer goes away.

Once you've entered text, you can modify it using most of Elements editing tools—add Layer styles (page 401), move it with the Move tool (page 150), rotate it, make color adjustments, and so on.

TIP If you try to paste text into Elements by copying it from your word processor, the results can be unpredictable. Sometimes things work fine, but you may find the text comes in as one long line of words. If that happens, it's often easier to type your text into Elements from scratch than to try to reformat pasted text. If you have a lot of text, you can try pasting into TextEdit—an application that comes with every Mac—saving it as plain text, and then copying and pasting from there.

Editing Text

In Elements, you can change your text after you've entered it, just like in a word processor. You can change not only words, but the font and its size, too, even if you've applied lots of Layer styles. You modify text by highlighting it (by dragging over it or double-clicking it) and making the correction or changing your settings in the Options bar. Figure 14-4 shows you the easy way to highlight text for editing.

TIP As mentioned earlier, you see the word "Sample" in the font family menu displayed in the actual fonts. Even better, Elements also gives you a quick way to preview what your actual text will look like in other fonts. First, select the text, and then click in the Options bar's Font box. Use the up and down arrow keys to run through the font list. Elements displays your words in each font as you go through the list. There's a bit of a bug, though: You may find that when you reach a symbol font, the font name box goes blank and you have to use the pop-out menu to scroll to the next font and continue on.

WORKAROUND WORKSHOP

Using Asian Text Options to Control Spacing

Getting letters spaced correctly when using the Vertical Type tool can be tough. Elements lets you set the *leading* (page 422), but with vertical text, the leading affects the spacing between *columns* of letters, not between the letters within a column. Also, sometimes you may want to adjust the spacing between letters on a horizontal baseline. Elements lets you make either of these fixes, but you need to enlist the help of the program's Asian Text Options—even if you're writing in English.

To get started, go to Photoshop Elements → Preferences → Type and turn on the Show Asian Text Options checkbox. Now when you click in an image with the Type tool, you'll see an Asian character in the Options bar, just to the left of the Cancel button.

Click the character to see a pop-out menu with three options: *Tate-Chuu-Yoko, Mojikumi*, and a pull-down menu with percentages on it. You want the pull-down menu, which is for *Tsume*, a setting that reduces the amount of space around the characters you apply it to. To apply Tsume, highlight the characters you want to change and then select a percentage from the pull-down menu. The higher the percentage, the tighter the spacing becomes.

You can select a single letter or a whole word when using Tsume. Since it reduces the space all the way around each letter you apply it to, you can use it for either vertical or horizontal text, although for horizontal text, you're most likely to use it to tidy up the spacing of just one or two letters. For vertical text, Tsume is a great way to tighten up the spacing of all the characters.

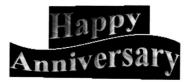

Figure 14-4:

If you change your mind about what you want to say, no problem. Just select the text and you can change the letters while keeping the formatting intact. If you find it hard to highlight your text by dragging, go to the Layers panel and double-click the layer's text icon (the white rectangle with the T in it). When you do, the text on that layer gets highlighted so it's ready for any changes.

You can make all these changes as long as you don't *simplify* your text. Simplifying changes text from a vector shape that's easy to edit to a rasterized graphic (see the box on page 373 for details). In this respect, text works just like the shapes you learned about in Chapter 12: Once you simplify text, Elements doesn't see it as text anymore, but as a bunch of regular pixels.

You can either simplify text yourself (by selecting Layer \rightarrow Simplify Layer) or wait for Elements to prompt you to simplify, which it'll do when you try to do things like apply a filter or add an effect to your text.

NOTE While the text effects included with Elements don't simplify your text, it's possible that effects you download may automatically simplify your text without asking first. So it's a good idea to make sure you've made all the text edits you want before using any effects you've downloaded.

Smoothing text: anti-aliasing

Anti-aliasing smoothes the edges of your text. In Chapter 5 (page 137), you read about anti-aliasing graphics, and it has a similar effect on text. It gets rid of any jaggedness by blending the edge pixels on letters to make the outline look even, as shown in Figure 14-5.

AA

Figure 14-5:

An extremely close look at the same letter with and without anti-aliasing. The left letter A has antialiasing turned on, making the edges smooth (well, smoother). The edges on the right A are much more jagged and rough looking.

Elements always starts with anti-aliasing turned on, and 99 percent of the time you'll want to keep it on. The main reason to turn it off is to avoid *fringing*—a line of unwanted pixels that make text look like it was cut out from an image with a colored background.

You turn anti-aliasing on and off by clicking the Options bar's Anti-aliased button (the two As). (The button has a dark background when anti-aliasing is on.) You can also turn anti-aliasing off and on by going to Layer → Type → Anti-Alias Off or Anti-Alias On. Once you simplify text, you can't change its anti-aliasing setting.

TIP If you see really jagged text even when anti-aliasing is turned on, check your resolution. Text often looks poor at low resolution settings—just as photos do. See page 93 for more about resolution.

Warping Text

With Elements, you can warp text in all sorts of fun ways. You can make it wave like a flag, bulge out, twist like a fish, arc up or down, and lots more. These complex effects are easy to apply, and best of all, you can still edit the text once you've applied them. Figure 14-6 shows a few examples of what you can do. If you add a Layer style (explained on page 401), warping is even more effective.

To warp your text, follow these steps:

1. Enter some text.

Use the Move tool (page 150) to reposition the text, if necessary.

2. Select the text you want to warp.

Make sure the Text layer is the active layer, or you won't be able to select what you typed. Click the Text layer in the Layers panel if it's not already highlighted there.

3. Click the Create Warped Text button in the Options bar.

The Type tool has to be active for the Create Warped Text button (the T with a curved line under it) to show up. When you click it, the Warp Text dialog box, shown in Figure 14-7, appears.

Big Red Balloon Factory

Fred's Flag Shop

Simpson's Fish and Bail

Wilhelmina Sells Shells and Sandals

Figure 14-6: Elements gives you oodles of ways to warp text. Here are just a few of the basic warps, applied using their standard settings. Clockwise from the upper left: Inflate, Fish, Rise, and Flag. You can tweak these effects endlessly using the sliders in the Warp dialog box. (These examples also have Layer styles applied to them.)

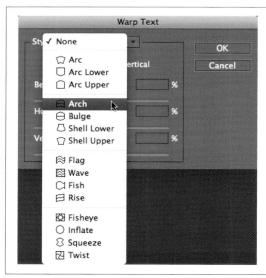

Figure 14-7:

As you can see, you have lots of ways to warp your text. Once you choose a warp style, Elements displays sliders in the dialog box that you can use to customize the effect.

4. Tell Elements how to warp your text.

Select a warp from the Style pull-down list. Then make any changes you want to the sliders or the horizontal/vertical orientation of the warp (tweaking these settings can radically alter the effect). Drag the sliders around to experiment. You can preview the results right in your image. Your options are described in more detail in a moment.

5. When you come up with something you like, click OK.

NOTE You can't warp text that has the Faux Bold style applied to it. (You can warp the other styles to your heart's content.) If you try to do so, Elements politely reminds you. The program even offers to remove the style and continue with your warp.

Elements gives you lots of warp styles to choose from, and you can customize the look of each style by using the settings in the Warp Text dialog box, which comes up when you click the Create Warped Text button. The settings are pretty straightforward:

- Style. This is where you choose from the warping patterns like Arc, Flag, and so on. To help you select, Elements includes thumbnails in the list that show the general shape of each warp.
- Horizontal/Vertical. These radio buttons control the orientation of the warping. Most of the time, you'll want to leave the button the same as the text's orientation, but you can get interesting effects by warping the opposite way. A vertical warp on horizontal text gives more of a perspective effect, like the text is moving toward you or away from you.
- Bend. This is where you tell Elements how much of an arc you want, if you'd like to change it from Element's standard setting. Type a percentage in the box or just move the slider until you get what you want. A higher positive percentage makes a bigger warp. A negative number makes your text warp in the opposite direction. For example, if you want an inverted arc, choose the Arc style and then move the slider to the left into the negative region.
- Horizontal/Vertical Distortion. These settings control how much your text warps in the horizontal or vertical plane. Moving the sliders gives you precise control over how and where your text warps. They work pretty much the same way as the Bend setting—type in a negative or positive number or move the sliders.

The best way to find the look you want is to experiment. It's lots of fun, especially if you apply a Layer style first (page 401) to give your text a 3-D look before warping it.

TIP Many of the warps look best on two lines of text, so that the lines bend in opposite directions. However, you can also get interesting effects by putting two lines of text on separate layers and applying a different warp to each.

To edit your warp after it's done, double-click the Text layer's Warp thumbnail icon in the Layers panel (it's a T with a curved line under it). Doing that automatically makes the Text layer active and highlights the text. Then, click the Create Warped Text button in the Options bar to open the Warp dialog showing your current settings. Make any changes you want or set the style to None to get rid of it.

Adding Special Effects

Besides warping your text, you can apply all kinds of Layer styles, filters, and special *text effects* to make text look more elaborate. You can change its color, make the letters look 3-D, add brushstrokes for a painted effect, and so on. (There's more about Layer styles, filters, and effects in Chapter 13.)

Elements gives you lots of different ways to add special effects to your text. The following sections demonstrate three of the most interesting: applying the text effects, using a gradient to make rainbow-colored text, and using the Liquify filter to warp text in truly odd ways.

Text Effects

The Content panel (page 450) has an entire category dedicated to effects for text (Figure 14-8). You apply Text effects the way you apply any other effect: Make the Text layer active and then double-click the effect you want.

Figure 14-8:
The Content panel includes a section of text effects. Most, like Animal Fur Zebra and Denim, are unique to this section. Others, like Bevel, are shortcuts to effects you could also achieve using Layer styles, gradients, or other Elements tools.

If you already have Layer styles on your text, it's hard to predict how much the effects will respect the existing Layer styles. Some effects build onto the Layer styles' changes, but most undo anything you've done before. Experimenting is the best way to find out what happens when you combine Layer styles and effects.

Text Gradients

Gradients fill your text with a spectrum of color. The simplest way to get these rainbow effects is to apply one of the Layer styles or text effects that include a gradient. But those methods don't give you any control over the colors or direction of the gradient. If you have a specific look in mind, you may have to start from scratch and do it yourself. The easiest way is to start with a type mask, as explained on page 43. But if you already have some existing text, as long as you haven't simplified it, you can easily fill it with a gradient.

TIP Heavier, chunkier fonts show off gradients better than thin, spidery ones. Fonts with names that end in Extended, Black, or Extra Bold are good, like Helvetica Black or Rockwell Extra Bold.

First, make sure your image has some text, and then follow these steps:

1. Create a new layer for your gradient directly above your Text layer.

You're going to clip the two layers (page 175), which is why they need to be next to each other. To create the new layer, press **%**-Shift-N or go to Layer → New → Layer. In the New Layer dialog box, turn on the "Use Previous Layer to Create Clipping Mask" checkbox.

Look at the Layers panel to be sure the new layer is the active layer and that it's right above the Text layer. If it isn't active, click it in the Layers panel to highlight it. If it's not above the Text layer, drag it to the right spot.

2. Activate the Gradient tool.

Click the Gradient tool in the Toolbox or press G and then choose a gradient style in the Options bar. (See page 404 for more about how to select, modify, and apply gradients.)

3. Drag across your new layer in the direction you want the gradient to run.

Because the layers are grouped, the gradient appears only in your text. If you don't like the effect, press **%**-Z and drag again until you like what you see. That's all you have to do, except save your file. (You can also activate the Move tool [page 150] and drag the gradient layer around till your text shows the color range you wanted. You won't see the gradient layer itself as you move it, but the colors of your text will change.)

TIP You may have noticed that the Smart Brush tool (page 196) includes Rainbow Map as one of the adjustments you can brush onto your image. Sounds like it might be the ticket for avoiding all this layer creation and so on, doesn't it? Unfortunately, it applies a gradient *map* (see page 415), not a regular gradient, to your image. Because text is all the same tonal level, you'll just get a one-color result on the letters with the Smart Brush Rainbow Map, not a rainbow.

Applying the Liquify Filter to Text

The Options bar's Create Warped Text button (explained on page 427) gives you lots of ways to reshape your text. But there's an even more powerful way to warp text: the Liquify filter (see Figure 14-9).

NOTE You can use the Liquify filter to warp *anything* in an image—not just text. Use it to alter objects in photographs and drawings: Fix someone's nose, make your brother look like E.T., give a scene a watery reflection, and so on.

To use the Liquify filter, you first need to simplify the text's layer (go to Layer → Simplify Layer, or click OK when the Liquify filter asks if you want to simplify; just remember that you can't edit your text once you simplify it.) Then, call up the Liquify dialog box by going to Filter → Distort → Liquify. You can also open it by double-clicking the Liquify filter's thumbnail in the Distort section of the filters in the Effects panel.

Pool Party

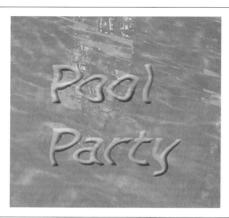

Figure 14-9:

The Liquify filter can reshape text in many different ways, including making text undulate like it's underwater (as shown here), making words twirl around on themselves, or adding a flame-like effect.

Left: Plain black text.

Right: After adding a Wow Plastic Layer Style, you can use the Liquify filter's Turbulence tool to make your letters look like they're swimming.

You see yet another large Elements dialog box. Like most of them, it's fairly straightforward once you learn your way around it. In the upper-left corner is a toolbox with some special tools (see Figure 14-10).

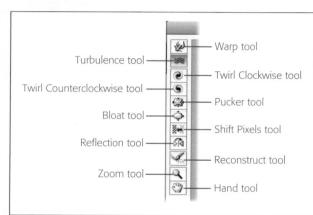

Figure 14-10:

The Liquify dialog box has its own toolbox. Along with the standard Hand and Zoom tools to help you adjust the view as you work, it has specialized tools found nowhere else in Elements.

Each tool has its own keyboard shortcut that works only in this window (given here in parentheses after the tool's name). From top to bottom they are:

- Warp tool (W). This lets you push the pixels of your image in any direction, although it usually takes a fair amount of coaxing to create much of an effect.
- Turbulence tool (T). You can use this tool to create clouds and waves. Its effect depends on the Turbulent Jitter setting on the right side of the dialog box (explained later); a higher number creates a smoother effect.
- Twirl Clockwise tool (C). Click your image and hold down the mouse button, and the pixels under your cursor spin clockwise. The longer you apply this tool, the more extreme the spin effect.

- Twirl Counterclockwise tool (L). The opposite of the Twirl Clockwise tool, this one makes the pixels spin counterclockwise.
- Pucker tool (P). This tool makes the pixels under the cursor move toward the center of the brush.
- Bloat tool (B). The opposite of the Pucker tool, this one makes pixels move away from the center of the brush.
- Shift Pixels tool (S). The pixels you drag this tool over move perpendicularly in relation to the direction of your stroke. So if you drag from the top of an image in a straight line down, the pixels you pass over move to the right. Option-drag to change the direction of the shift.
- Reflection tool (M). Drag to create a reflection of the area the tool passes over. Overlapping strokes create a watery effect.
- Reconstruct tool (E). Pass this wonderful tool over areas where you've gone too far, and you selectively return them to their original condition without wrecking the rest of your changes.
- Zoom (Z) and Hand (H) tools. These are the same Zoom (page 88) and Hand (page 86) tools you find elsewhere in Elements.

Your image appears in the preview window in the center of the dialog box. You can adjust the view with the Zoom tool or by using the magnification menu in the dialog box's lower-left corner.

TIP It often helps to zoom way in when using the Liquify filter. If you've added text to a large image, select the text with the Marquee tool (page 125) before activating the Liquify filter. Then you'll see only the selected area in the filter's dialog box, which makes it easier to get a close look.

On the right side of the dialog box are the filter's Tool Options settings:

- Brush Size. You can enter a number as low as 1 pixel or as large as 600 here.
- Brush Pressure. This is how much the brush affects the pixels you drag over. The range is from 1 to 100. The higher the pressure, the stronger the brush's effect. If you're using a graphics tablet, turn on the Stylus Pressure checkbox so that the harder you press, the more effect you get.
- Turbulent Jitter. This controls how smooth your changes look. The higher the number, the smoother the effect.
- Stylus Pressure. Turn this on if you're using a graphics tablet (page 491) to make the tools sensitive to how hard you press.

To use the filter, pick a tool, modify the Tool Options (if you want), and then drag across your image. This is a processor-intense filter, so there may be a fair amount of lag time before you see results, especially if your computer is slow. Give Elements time to work.

If you like what you see in the preview, click OK and wait a few seconds while Elements applies your transformations. Then you're done. If you don't like the effect, you can have another go at it. Click the Revert button, which returns your image to its condition before you started using the Liquify filter. Or Option-click the Cancel button to turn it to a Reset button (which resets the tool settings as well as your image).

Type Masks: Setting an Image in Text

So far in this chapter, you've read about how to create regular text and glam it up by applying Layer styles and effects. But in Elements, you can also create text by filling letters with the contents of a photo, as shown in Figure 14-11. (You'll find *sunset.jpg*, the photo used as the basis for Figure 14-11 and Figure 14-12, on the Missing CD page at *www.missingmanuals.com*.)

Sunset Vacation Cottages

Figure 14-11:

Using the Type Mask tools, you can create text that's made from an image. You can also use these tools to emboss text into your photo (see Figure 14-13).

The Type Mask tools work by creating selections in the shape of letters. Essentially, you're creating a kind of stencil that you'll place on top of your image. Once you've used the type mask to create your text-shaped selections, you can perform all sorts of modifications to your text: emboss the text into your image (which makes it looks like it's been stamped there); apply a stroke to the outline of your text (useful if the font doesn't have a built-in outline option); or copy and move it to another document.

Using the Type Mask Tools

Here's how to create a type mask and lay it over an image so that the letters you create are filled with whatever's in your image:

- 1. Open the image you want to use as your source for creating the text.
- 2. Activate one of the Type Mask tools.

Click the Type tool in the Toolbox or press T. Then select the Type Mask tool you want—horizontal or vertical—from the pop-out menu. The Type Mask tools behave like the regular Type tools: A horizontal mask goes across the page; a vertical mask goes up and down. The Type Mask tools also have the same Options bar settings as the regular Type tools, except for Color and Style.

3. Click your image and start typing.

When you click, a red film covers your whole image. The red indicates the area that *won't* be part of your letters. By typing, you'll cut a selection through the red area (see Chapter 5 if you need a refresher on selections). In other words, when you type, you're creating a text-shaped selection instead of regular text. You can see the shape of the selection as you go. It's important to choose a blocky font for the type mask, since you can't see much of the image if you use thin or small text.

It's hard to reposition the words once you've committed them, so take a good look at what you have. While the mask is active, you can move the mask by dragging it, as explained in Figure 14-12.

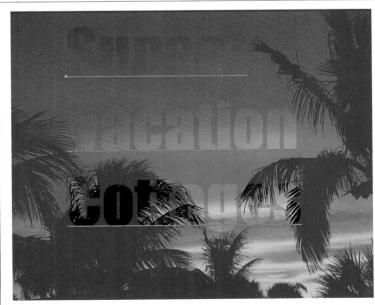

Figure 14-12:
Once you've activated the Type
Mask tool and clicked on your
image, a red mask appears over
your picture. As you type, your text
appears, as shown here. As long as
you haven't committed the text yet,
you can easily move it by holding
down % and dragging it around.
As soon as you let go of your
mouse, Elements turns the text into
a text-shaped selection.

4. When you're happy with your selection, click the Commit button.

Don't click the Commit button (the green checkmark on the right side of the Options bar) until you're satisfied with what you have. After you click Commit, you can't alter your text as easily as you can with the regular Type tools. That's because the regular tools create their own layers, while the Type Mask tools create selections. Once you commit, your text is like any other selection—Elements doesn't see it as text anymore, so you can no longer do things like change its size. (If you drag your selection when the mask is active, Elements automatically commits your text when you let go of the mouse button.)

Once you click Commit, you see the outline of your text as an active selection. You can move the selection by nudging it with the arrow keys. and you can use Transform selection command (page 147) to scoot it around in your image or to resize, transform, or rotate it (This can make the letters look a little strange, though, so watch the effects carefully.)

5. Remove the non-text portion of your image.

Go to Select → Inverse and then press the Delete key to remove the rest of the image. Or you can copy and paste the selection into another document. For a transparent background, double-click the Background layer to turn it into a regular layer before you remove the background.

Figure 14-13 shows the effect of pressing \(\mathbb{H}\)-J and placing a type mask selection on a duplicate layer of its own, and then adding Layer styles (page 401) to the new layer.

Figure 14-13:
By copying text to another layer, you can bevel or emboss it into your photo. This photo shows something you need to watch out for: text that's hard to see because it blends into the image. You may need to place your text a few times before you get it positioned correctly. Or you can add a colored outline to make

it stand out more, as described in the next section.

Creating Outlined Text

If the font you're using doesn't come with a built-in outline style, there are three ways to create outlined text in Elements. The text effects in the Content panel (page 450) include an outlined text effect that you can apply with just a double-click. If you don't like what you get with that, you can also use the Stroke Layer styles or the Type Mask tools to outline text. Both these methods (which are explained in this section) are easy, but they require a bit more time than using the Content panel. The tradeoff is that you have more control over the result. Use the Layer styles method if you want your text outline to be filled in, since the type mask gives you an empty outline.

Using the Stroke Layer style

To add an outline to text:

1. Open your image or create a new one, and then activate the Type tool.

Click it in the Toolbox or press T until you get either the Horizontal or Vertical Type tool (not the Type *Mask* tool).

2. Choose your Options bar settings.

Select the font, size, style, and so on.

3. Enter the text and commit it.

After you type your text, press Return or click the green checkmark in the Options bar.

4. Apply a Stroke Layer style.

Go to the Effects panel and click the Layer styles icon (the two overlapping rectangles), choose Strokes from the pull-down menu, and then double-click the style you want. If you don't like any of the Stroke styles, that's okay because you can edit the result in the next step.

5. Edit the outline if you wish.

In the Layers panel, double-click the text layer's Layer style icon (the "fx" to the right of the layer's name) to bring up the Style Settings dialog box, where you can change the width and color of the stroke (see page 403).

Using the Type Mask tool

To make a text outline like the one shown in Figure 14-14:

1. Open your image or create a new one (if you want the text by itself), and then activate the Type Mask tool of your choice.

Click the Type tool or press T, and then select either of the Type Mask tools.

Figure 14-14:

By using the Type Mask tools, you can create outlined text almost as quickly as ordinary text.

Choose your font and size.

Use the Options bar's settings to pick a font you like, determine its size, and so on. Outlined text works best with a fairly heavy font. Bold fonts also work well here.

3. Enter your text.

Click in your image to place the text, and then type away. If you want to warp your text, do it now, before you commit it.

4. Click the Options bar's Commit button (the checkmark).

Be sure you like what you have first, because once you commit the text, it changes to a selection that's hard to edit. If you'd rather start over, click the Cancel button (the red circle with a slash) instead.

5. Add a stroke to your outline.

Be sure the text selection is active, and go to Edit → Stroke (Outline) Selection. Choose a line width in pixels and the color you want, and then click OK. (There's more about your other choices in the Stroke dialog box on page 377.) Your selection turns into an outline of the text you typed.

NOTE You can also create a hollow outline using the Stroke Layer styles: After you type some text, simplify the Text layer (Layer → Simplify). Next, go to the Effects panel and choose a stroke Layer style in a contrasting color. Then select the color of the text itself (as opposed to the outline) with the Magic Wand (page 135; be sure to turn off Contiguous), and delete that color. The downside to this approach is that you can't edit the text once you simplify it.

Part Five: Sharing Your Images

Chapter 15: Creating Projects

Chapter 16: Printing Your Photos

Chapter 17: Email and the Web

Creating Projects

If you're into making scrapbooks, greeting cards, or other photo concoctions, Elements is perfect for you. You can dress up your pictures in all sorts of creative ways without any other software. Elements is crammed with add-on graphics, frames, and other special effects. You can even create multipage documents and basic PDF slideshows.

This chapter kicks off with an in-depth look at how to create a photo collage. Once you have those steps under your belt, all the other projects (summarized starting on page 452) use the same basic method.

NOTE You can also create online galleries (photo-filled web pages) in Elements. You'll learn all about them in Chapter 17.

Photo Collages

The Create tab helps you make fancy pages featuring your photos, which you can share as either printouts or digital files. Although Elements gives you lots of preset layouts to start from, you can customize every aspect of them to create projects that are totally your own.

A photo collage is a page displaying one or more of your photos, with or without a themed background. (Flip ahead to Figure 15-3 to get a glimpse of what Elements can help you do.) Elements presents you with a series of guided questions that lead you from start to finish. All the collage styles begin with one or more suggested photo placeholders, but you can add or remove photos at will. You can also change the background, frame styles, and other details.

NOTE Photo collages, like all the printable projects in the Create menu, start off at a resolution of 220 ppi. That's perfectly fine print quality for most people's taste. But if you want a higher resolution, your best bet is to cook up your own project from scratch by creating a blank document in Full Edit and adding items from the Content panel (see page 450), since increasing the resolution of a prebuilt Elements project often throws the layout out of whack.

To create a photo collage:

1. Open some photos.

This step is optional, but if you preselect photos, Elements can automatically place them into the layout for you.

2. Go to the Create tab's Projects panel and click the Photo Collage button.

The panel shown in Figure 15-1 appears.

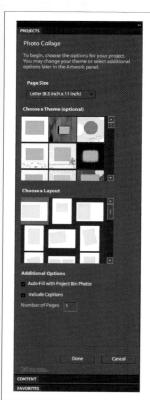

Figure 15-1

To preview your collage theme choices, click a thumbnail for an expanded pop-out view of that theme. In addition to scrolling in the "Choose a Theme" and "Choose a Layout" areas, you may need to scroll the whole panel to see the options for automatically including Project bin photos, adding captions, or for creating multiple pages. When you're ready to customize your collage, double-click the Content panel's tab (visible at the bottom of the window).

3. Choose an option from the Page Size pull-down menu.

If you don't like the unit of measurement listed in the Page Size menu, you can change it. Go to Photoshop Elements → Preferences → Units & Rulers, and change the Photo Project Units setting to inches or centimeters.

4. If you want, select a theme from the "Choose a Theme" section.

Themes give you coordinated backgrounds and frames for your photos. (You can choose a different background later if you don't like the one that comes with the frame, or a new frame to replace the one that comes with the background.) Click a theme's thumbnail to select it, and a larger thumbnail appears, giving you a closer look at your choice.

If you pick a theme and then decide you don't want any theme at all, click the upper-left thumbnail (the blank white one) in the list of theme thumbnails to choose No Theme. If you go theme-less, you get a blank background, but you can add backgrounds from the Content panel later.

5. Choose a Layout style.

Scroll through the thumbnails and click the one you like. You can rearrange your layout after you've chosen it by adding, removing, and rotating the images, among other things. The layouts are arranged from one picture per page at the start of the list, to many pictures per page at the bottom of the list.

6. Adjust the Additional Options settings, if you like.

If you turn on the "Auto-Fill with Project Bin Photos" checkbox, the pictures you chose in the Project bin automatically appear in your collage when Elements creates it. If *you* want to determine which photos go into which slots in the layout, turn off this checkbox.

There's also a checkbox for having any captions you've added to your photos appear in the collage. (You can add text or edit the captions later, so you're not tied to what's in the Caption field.) This checkbox is grayed out if you haven't selected any photos with captions.

If you selected some photos before you started, the "Number of Pages" box tells you how many pages long your creation will be. This number updates to reflect your current Layout choice. So, for example, if you select three photos and choose a single photo per page, the number in this box is 3. If you click a layout that uses three photos per page, the number changes to 1. (If you haven't selected any photos, you can specify how many pages you want by typing in a number. If you don't select photos and you don't type a number, Elements creates just one page, but you can add more later as explained on page 447.)

7. When you've made all your choices, click the Done button.

Elements gets to work creating your collage. It puts each image in the collage on its own layer. If you preselected photos and left the Auto-Fill checkbox turned on, Elements puts your photos into the frames for you. If you didn't select any photos, you see the text "Click here to add photo or Drag photo here" inside each frame. That's fine, because you can add photos in the next step.

8. Adjust your photos.

If you haven't already picked photos for your project, click an empty frame in the collage and then choose a photo from the dialog box that appears, or drag a photo from the Project bin to a frame. (To add photos to a frame in Full Edit, click the Move tool first.)

Regardless of how you get photos into the collage, you can make a number of adjustments to them once they're in. Click once to resize the frame, or double-click any photo to bring up the controls shown in Figure 15-2, which let you make tweaks without changing the frame's size. Click the Commit button (the green checkmark) to apply your changes, or the red Cancel button to get rid of them.

Figure 15-2:
When you double-click a photo in a collage, you see these controls for adjusting it. To resize your picture, move the slider to the left (smaller) or right (larger). Rotate your photo by clicking the blue rectangles (next to the slider), or click the folder icon to choose a different photo. You can also drag a handle of the photo's bounding box to resize your photo or do a manual rotation, the way you'd use the Move tool (page 150).

You can also change a frame's style by choosing a new style from the Content panel (page 450). To change to the new frame, double-click the new style or drag it to the photo. You can also click it once and then click Apply.

9. Customize your collage.

Here's the fun part: Click a photo in your collage and drag it to a different position. Drag in art from the Content panel; these graphics are vector images (page 373), which means they'll look great no matter how big or small you make them. You can also add text to your collage (find out how to do that in Chapter 14) and change the background by selecting a new one in the Content panel (page 450). You can even flatten your image and use filters on the entire page. Figure 15-3 shows an example of what you can do with a photo collage.

NOTE Elements' new guides feature (page 74) is handy for aligning additions to your project.

Figure 15-3: This composition was created as a photo collage. All the artwork except for the photos themselves came from the Content panel. The photos and some of the background graphics (like the leaves) were added first, the file was flattened, and then several filters were applied to give it a painted effect (see Chapter 13 for more about filters). Finally, the remaining graphics (the pen, the flower, and the paperclips) were added to make them look like they're lying on a painted page.

If you click back to Full Edit, you can use any tool or filter on your collage, but you may need to simplify a layer (page 373) or flatten your image first, so save that step till you're sure you like your collage. You can use the Move tool to rearrange your collage's layers after you simplify them, but once you simplify layers, you can't enlarge their contents without losing quality, as with any normal photo.

10. Save your collage.

When you're finished, press **%**-S to name your project and save it. You can save it in any standard file format if it's a one-page collage, but if you have more than one page, you have to save it as a PSE file—a special format just for multipage Elements documents (see the box on page 450 for details)—or as a PDF file.

There's almost no limit to what you can do in a photo collage. Anything you've read in the other chapters of this book works here, too. Plus, you can do a few special things with photos in a collage:

- Remove a photo from your collage. Right-click (Control-click) the photo and then choose Clear Photo. To remove the photo's placeholder and frame as well, choose Clear Frame instead.
- Make your photo appear without a frame. Right-click (Control-click) and then choose Clear Frame.
- Resize a frame. You can resize a frame either before or after you put a photo into it. Click once on the frame to bring up handles, and then drag a corner of the frame to make it larger. You can also rotate a framed photo using these handles.
- Resize the frame to fit the photo. If you want to make the frame fit the photo, instead of the other way around, right-click (Control-click) the photo and then choose "Fit Frame to Photo".
- Recompose the photo to fit the frame. You can use the Recompose tool (page 278) right in your photo collage. For instance, you might have a landscape-orientation photo you want to fit into a portrait-orientation frame. Just recompose your photo so you don't have to crop it.

TIP You can do all of the above in Full Edit, too, once your collage is complete, but you need to activate the Move tool first, or you won't see the correct options when you right-click (Control-click).

• Add another photo. Drag a frame from the Content panel to a blank area in your collage. If you get too close to an existing frame, the new frame may replace it. If that happens, just press \(\mathbb{K}-Z \) to undo it and drag again, more carefully, to the blank spot. You can also drag a photo into your collage from the Project bin.

- Change your theme. If you wish you'd gone with a different theme after you've already created your collage, go to the Content panel and select By Type from the first pull-down menu and Themes from the second to see a list of all the Create themes. To pick a theme, double-click its thumbnail, drag it onto your collage, or click the thumbnail once and then click Apply. Presto—your layout features new frames and a new background.
- Edit a frame's Layer style. Most of the frames have a Layer style applied to them. Right-click (Control-click) the frame and choose Edit Layer Style to change things like the size of the frame's drop shadow. You can also edit the styles from the Layers panel in Full Edit the same way you'd edit any Layer style. (See page 403 for more about editing Layer styles.)

You can also add and delete *pages* from photo collages, as explained in the next section.

TIP You can apply artwork from the Content panel to any image, not just those in photo collages and other Create projects.

Creating Multipage Documents

Elements makes it easy to create a file that's more than one page long. A photo collage automatically starts with as many pages as it needs to hold all your preselected photos, but you can add pages to any of the Create projects anytime—and remove them, too. (You can add and remove pages from any Elements file, not just the Create projects.)

The size and resolution of your existing page determine the size and resolution of pages you add. So if your current file is a single $3"\times 5"$ photo and you add a page to it, the new page is $3"\times 5"$, too. If you want to add a letter-size page to a small photo file, first add canvas to the photo (page 97) or resize it. But check out page 96 to see why resizing a small photo to letter size probably won't work well.

To add a new page to your document, go to the Edit menu, and choose one of the following commands:

- Add Blank Page (Option-\(\mathbb{#}-G \)). This command creates a new, empty page with the same dimensions and resolution as your existing page.
- Add Page Using Current Layout (Option-Shift-%-G). When you choose this option, Elements creates a page that's exactly like the current state of your existing page, including any changes you've made, except that instead of photos, there are placeholders for you to fill in. So, for example, if you've changed frame styles and dragged a photo to another position, the new frame and positioning (without the photo) appears in your new page. Any graphics you've added from the Content panel show up as well. This command is a big help when you're making photo books or scrapbooks.

POWER USERS' CLINIC

Smart Objects

Smart Objects are one of the ways Adobe makes Elements projects so fun and easy. Like their big-shot cousins in the full version of Photoshop, these objects seem to know where they are and what you're trying to do—and behave accordingly. Here are some of the things that make Smart Objects so smart:

- When you apply a new background from the Content panel, it immediately zooms down to the bottom of the layer stack to replace the existing background, without any assistance from you.
- The frames in the Content panel automatically target your photos. Want to frame an image? Just go to the Content panel and double-click a frame. It automatically appears in your image, though you may need to adjust its size or the area that it frames once it's in your photo.
- You can resize, transform, and distort objects from the Content panel's graphics section as much as you want without affecting the image quality. This behavior is something like how vector art works, but what's going on under the hood is quite a bit different. (The preview may appear pixelated if you enlarge a graphic a lot, but the actual object should be okay once you click the green checkmark Commit button.)

Anything you add to an image or project with the Place command (File → Place) becomes a Smart Object (you can resize it to any size, for instance). Also, anything you drag into one of the Create projects (photos, graphics, whatever) becomes a Smart Object. However, there are a few things you can do to Smart Objects only if you simplify them. For example, if you try to paint on a Smart Object, you just get the dialog box shown in Figure 15-4.

Figure 15-4:

You can enlarge, shrink, transform, and distort Smart Objects, but if you try to paint on them or apply filters or effects to them, you see this message. It's fine to click OK, but once you do, your formerly Smart Object will behave like any other object. (You can't increase its size to more than 100 percent, for instance, or it'll go all pixely on you.)

You can navigate through all the pages in your document using the Project bin, as shown in Figure 15-5. If you have too many pages, go to Edit → Delete Current Page, and the currently active page is history. You can also add and delete pages right from the Project bin by right-clicking (Control-clicking) and choosing what you want to do from the pop-out menu, a big help when you're editing a multipage project.

Figure 15-5: You can expand and collapse the

pages of your file so they don't hog the Project bin.

Top: A collapsed photo book and a multipage photo collage in the Project bin. (Note how each type of project reflects the project's page shape and even shows its theme.) Collapsed multipage documents have a special outline in the bin to make them easy to recognize.

Bottom: Here's the expanded thumbnail for the collage, so you can select a single page to edit. Click the arrow (circled) again to collapse the thumbnail. To choose pages for editing, single click them rather than double-clicking (as you do for photos).

No matter what kind of file you start with—whether it's a Create project or a regular JPEG—you have to save your file as a PSE or PDF format file if you add pages to it. Elements reminds you with the dialog box in Figure 15-6. While it's really nice to be able to create multipage documents in Elements, the PSE format has some drawbacks, as explained in the box on page 450.

Figure 15-6:

You can't save a document with multiple pages in common file formats like TIFF or PSD. Your only option is PSE, as this dialog box reminds you whenever you add a second page to a document. See the box on page 450 to learn why PSE format is a mixed blessing. (Actually, this message isn't totally true-you can also save a multipage file as a PDF file, but your options for editing a PDF are limited, so do that last, when vou're sure you're done making changes.)

Working with the Content and Favorites Panels

Adobe gives you a ton of artistic goodies to use for customizing your projects, and a special panel just to hold it all: the Content panel. You also get a Favorites panel, where you can keep the items you use most often from the Content panel (and from the Effects panel, too).

TROUBLESHOOTING MOMENT

About PSE Files

Anytime you create a multipage document in Elements, you get a special file format choice when it's time to save—PSE. This special format has both advantages and disadvantages.

When you create a PSE file, you actually create a *folder* containing a separate .psd file for each page (or for each double-page spread if you're creating a photo book), and a PSE *project file*, which contains all the info Elements needs to reassemble your document the next time you open it. That's handy when you're working in Elements, but the drawback is that hardly any other program can read these files. PSE files work just fine if you print at home, but you can't upload them to any online services. (The Windows version of Elements can send PSE files to Kodak Gallery, but only because Elements for Windows automatically converts them before uploading.)

The rub comes if you want to use a different printing service. If you make, say, a book that you want to print at Lulu.com or MyPublisher.com, they can't work with PSE files—at least not as of this writing. Most printing services require PDF files. Fortunately, Elements can save your multipage PSE file as a multipage PDF that you can upload to your printing service of choice. (Beware, though, that Elements creates *huge* PDF files.) Usually you want to wait till you're through editing to create your PDF. Keep the file as a PSE file as long as you still have work to do.

The Content Panel

This panel holds backgrounds, frames, graphics, shapes, text effects, and themes you can use in projects. The Content panel is something like the Effects panel, with menus and a row of icons for each of its major categories (see Figure 15-7). Here's how it works:

1. Make the Content panel visible.

This panel is always visible in Create, but you can make it visible in Full Edit by going to Window → Content. (The Content panel still appears in Create, even when you make it visible in Full Edit. You can't remove it from Create.)

2. Choose how to search.

In the left-hand pull-down menu, choose to search by type (like backgrounds, frames, and so on), or pick Show All to see everything in the panel.

3. Refine your search.

In the right-hand pull-down menu, choose what you specifically want. What's in this menu changes depending on your choice in the left-hand menu. So if you choose By Type on the left, you see Backgrounds, Frames, Graphics, and so on in this menu. If you choose By Mood on the left instead, the right-hand menu offers you choices like Active, Adventurous, Fun, Romantic, and Thoughtful.

Figure 15-7:

Once you've winnowed down your choices by selecting from the two pull-down menus shown here, use these category icons (labeled) to further control which thumbnails appear in the Content panel. Elements starts you off by including all the categories (a dark-gray outline around a button means it's active and that its category is included in your search). Click any of the buttons to turn them off and exclude their categories from your search. Here you see the results of searching By Event — Celebration. And since the Frames button is turned off, no frames appear in the thumbnail area.

4. If you like, filter your results.

Here's where those category buttons below the menus come into play. (From left to right the buttons are Backgrounds, Frames, Graphics, Shapes, Text Effects, and Themes.) You may get an awful lot of results from some of your menu choices, so you can use the buttons to filter out items you don't want. If you chose By Seasons and Winter in the menus, respectively, but don't want to see frames, just turn off the Frames button (click it to get rid of the dark-gray highlight around it), and Elements excludes frames from your results.

You can turn on and off as many buttons as you want in order to include or exclude various kinds of content. To bring something you've excluded back into your search results, click its button again to turn it back on.

NOTE If you're like a lot of people, most of the time you'll want to stick with By Type and choose the category you want. If you do that, you can't use these buttons.

5. Add your choice to your image.

To use something from the Content panel, double-click its thumbnail or drag it onto your image. (You can also click your selection once and then click Apply.)

To remove what you've added, press **%**-Z if you just added it, or click the object with the Move tool and then press Delete. If you use the Delete key, Elements asks if you want to "Delete the Layer"—you do.

A word of warning: Don't use the Content panel's trashcan icon to delete an object from your project. That seems like a logical thing to do—after all, that's how it works in the Layers panel. But with the Content panel, the trashcan deletes the graphic, frame, or whatever from the *panel*, not just from your image. Only use the trashcan for Content panel items you never want to use again. For example, if you've downloaded and installed a frame (as described on page 498) and know you

won't use it again, drag it to the panel's trashcan. If that seems like a lot of navigation, the Favorites panel (described in the next section) is a faster way to reach Content panel items you use a lot.

NOTE Windows users have some different options in the Content panel because the Windows version also displays items that folks can download from Photoshop.com. These aren't available in the Mac version of Elements 8, but there are plenty of other places to look for extras. See page 493 for some suggestions.

The Favorites Panel

If you use the same effects, graphics, and styles over and over, you may find it tedious to keep navigating to them in the Content or Effects panels. Simplify things by saving your Content and Effects standbys in the Favorites panel. Then you can get to these items with just a click or two.

To display the Favorites panel, click the Create tab, and you should see the Favorites panel at the very bottom of the Panel bin. To see the Favorites panel in Full Edit, go to Window → Favorites to bring it up.

To add an item to the Favorites panel, right-click (Control-click) its thumbnail in the Content or Effects panel and then choose "Add to Favorites", or just drag its thumbnail to the Favorites panel.

To delete a favorite, right-click (Control-click) its thumbnail in the Favorites panel and then choose "Remove from Favorites", or click it once to highlight it, and then click the trashcan icon at the bottom of the panel (unlike with the Content panel, trashing something here just removes it as a favorite, not from Elements altogether). If you forget what a thumbnail is for, right-click (Control-click) it and choose Details to see a description of it.

Photo Books

Elements lets you create several sizes of pages to use in a bound book of photos—a popular gift item. From the Create tab, you can create a standard photo book that you can save as a PDF, which is the format most print shops prefer.

NOTE If you're looking for the online printing options that were in Elements 6, you won't find them in Elements 8. All the online projects are gone, from both Bridge and Elements. Just save whatever you do as a PDF and you can get it printed almost anywhere.

Creating a photo book is something like creating a collage (page 441). Elements walks you through the process with plenty of handholding:

1. If you want, choose your photos.

If you'd like Elements to automatically lay out your photos in the book, make sure you have them open in the Project bin and in the correct order before you start. Or you can wait and add each picture manually after you create the book's layout.

NOTE Photo books usually have a cutout cover through which you can see one large image on the title page. This page has a different layout from the rest of the book. If you're using photos in the Project bin, drag the photo you want for the title page so that it's the first one in the lineup. Or you can wait and choose a title-page photo after you complete the book layout.

2. Start your book.

Go to the Create tab's Projects panel and click the Photo Book button. Elements displays your first set of choices for the book.

3. Choose a page size.

Use the drop-down menu to pick dimensions for your pages. You can select several different sizes, but $10.25"\times9"$ is the one most commonly used by online services.

4. Choose a layout.

You have two options:

- Random Photo Layout. Elements makes the decisions for you about how many photos will be on each page; every page may be different. It's best to avoid this option unless you have a *lot* of photos, since some of the layouts have as many as 20 tiny photos on a page—although, of course, you can edit things later.
- Choose Photo Layout. Click this option and Elements presents you with a long list of page-layout thumbnails. Click a thumbnail to select that layout. You need to pick left- and right-hand page layouts, which can be the same or different. Click Next to select a theme.

5. Choose a theme.

If you picked "Choose a Photo Layout", you'll see themes on the next screen. (If you're using a random layout, scroll down in the same screen to see the themes.) When you click a thumbnail in the theme list, Elements displays a thumbnail showing the selected theme.

Your other choices here are the same as for a photo collage (page 441). If you plan to send the book out for printing, you probably need a minimum of 20 pages.

6. Create your book.

Click Create, and Elements creates and opens a PSE file for you. You can edit anything in the file the same way you can change things in a photo collage. Elements gives you some special controls for navigating through the layout, as explained in Figure 15-8.

Don't forget to save the PSE file so that you can make changes later. When you're all through tweaking, you can save it as a PDF file if you want to send the book out for printing.

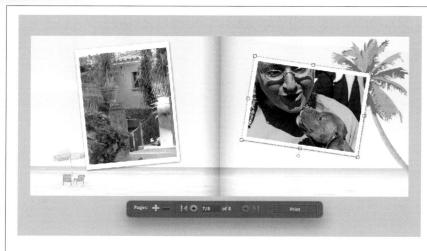

Figure 15-8: When you click Create. Elements gives you a helpful, double-page view of your book so you can edit the pictures or change the layout. The control strip shown here below the book lets you move through the pages to see each double-page spread, or add or remove pages. You can drag the strip anywhere in the work area so it doesn't cover up your photos. Here you see the controls for adjusting the right photo and frame so they match up better.

Greeting Cards

Adobe calls them "greeting cards", but they're more like what most people call postcards. An Elements greeting card is a $4"\times6"$ or $5"\times7"$ single-sided page rather than a folded card. To create one, go to the Create tab's Projects panel and click the Greeting Card button to get started. The layout and template choices are identical to those for photo collages, and the process is the same, so follow the steps on page 441.

CD/DVD Jackets

Elements lets you create CD jewel case inserts and DVD inserts, which appear on the front and back of the case. To make a CD insert, go to the Create tab's Projects panel, click More Options, and pick CD Jacket. You see a variety of templates, all the right size to fit in a CD case.

The steps for creating a CD jacket are the same as for a photo collage (page 441), but the layout choices are different. Pay special attention to the photo placement when choosing your layout: The right side of the layout is the front cover. Turn the "Auto-Fill with Project Bin Photos" checkbox off or on to suit you. (If you have five photos in the Project bin, you don't want to get a five-page CD jacket, which is what may happen: If there aren't enough slots on one page for all the open photos, Elements just adds extra pages for the open images. So turn Auto-Fill off if you don't want Elements to use all your open photos.)

Unfortunately, only the "2 Centered" CD-insert layout even approximately marks out the general spine area, where most CDs display their titles. If you decide to enter text that will appear on the spine, click the Horizontal Type tool (page 419), type away, and then go to Image → Rotate → Layer 90° Left. Then use the Move tool to place the text where you want it. (You *could* use the Vertical Type tool, but it's usually hard to get the type to look good, and most English speakers find it easier to read horizontally typed text sideways than long columns of vertical text.)

TIP If you use a theme (page 443) and want to add spine text, remember that home inkjet printers don't do a good job printing small, white type on a dark background. You're better off going with dark type on a light background.

Creating a DVD Jacket (Create tab \rightarrow Projects panel \rightarrow More Options \rightarrow DVD Jacket) is identical except for the layout choices.

CD/DVD Labels

You can create stick-on labels for CDs and DVDs with Elements (Create tab \rightarrow Projects panel \rightarrow More Options \rightarrow CD/DVD Label) and print them on blank label sheets from any office supply store. Elements gives you templates that create a single-label layout. When you're done, you need to place your work into the template that goes with your specific brand of labels. (Most CD or DVD labels print two to a page.) The major brands, like Avery (www.avery.com) and Neato (www.neato.com), have free downloadable templates on their websites to help you position the labels properly on the page.

NOTE While labels make your discs look great, it's risky to put a stick-on label on any disc you'll use in a computer: If the label gets stuck in the disk drive, you may have to replace the drive. Consider using a marker to label discs for computer use, or buying printable discs if you have a printer that will take them.

PDF Projects

You can create a variety of PDF projects in Bridge, including contact sheets (see page 469) and a basic PDF slideshow—sort of. The PDF slideshows you can make with the Mac version of Elements are the same ones you can make in Photoshop: They're very basic, more like multi-page documents that allow you to see one page at a time with transitions between them. They're nothing like the elaborate slideshows you can make in iPhoto, iMovie, or iDVD.

NOTE Frankly, you can make a much better slideshow by creating a web gallery, as described in the next chapter, and sharing that using one of the methods explained on page 488. Your friends can view your gallery in any web browser.

Oddly, the process for creating any of the PDF projects is the same whether you're making a contact sheet to print out or a slideshow to view on your monitor. (You can even make a contact-sheet slideshow if you really want to.) Here's how to create a PDF project:

1. Gather your photos.

You'll be working in Bridge, so put all the photos you want to use in your project in one place so it's easy to select them in the Bridge window. (If you have to click around to different folders once you're in the Output panel [explained in a moment], you'll lose the images you chose in the previous folder.) Collections (page 58) are great for this. There's no point in opening photos in Elements for this; they won't automatically be included when you get to Bridge.

2. Start your project.

You can begin from Elements by clicking the PDF Slideshow button in either the Create or Share tab, or start from Bridge by going to Window → Workspace → Output. Either way, you wind up in Adobe Bridge, where you can make any of the Bridge projects.

3. Choose to make a PDF.

In the Output panel on the right side of the screen, click the PDF button. (If you want to make a web gallery, see page 486.)

4. Select your photos.

Choose the photos you want to include in your project by selecting them in Bridge's Content panel.

5. Choose a template.

Make a selection from the Template pull-down menu. There isn't an option called "Slideshow". (You can make any document with more than one page's worth of photos play as a slideshow by using the options further down in the panel.) The template that looks the most like a conventional slideshow view is Maximize Size. You can audition the different templates by clicking the Refresh Preview button each time you choose a different one. Bridge updates the Output Preview area in the center of your screen each time you click Refresh Preview.

6. Choose a page size and a background color.

In the Document section of the Output panel, choose a category from the Page Preset menu. The menu includes much the same categories that you have in Elements. You can choose between paper sizes, photo sizes, web sizes, and a custom size. After you choose a preset, the Size menu changes to display only sizes available for that preset. You can also create a custom size.

Use the Background menu to choose a color for your project's background or click the color square to its right and choose from the OS X color picker. If you pick a color other than black or white, the menu changes to say Custom, but you won't see your chosen color in the preview area until you click the Refresh Preview button.

7. Adjust the other settings.

Your options are explained after this list. To see your changes reflected in the Output Preview area, click Refresh Preview. If you're making a slideshow, you can't preview it in real time, so you have to guess about the transition you want. There's no easy way to audition the various transitions.

8. Save your PDF.

Click the Save button at the bottom of the Output panel and name and save your PDF in the window that appears. If you want to see your slideshow or project immediately, turn on the Output panel's "View PDF After Save" checkbox before clicking the Save button there.

The Output panel offers you a number of presets to get you started, but you can customize your PDF to be pretty much anything you want. You can type in a page size instead of using one of the presets, for instance, and you can change the layout for any of the templates after you choose one. Here are your options in the various sections of the Output panel:

- Document. Choose a preset size as described above or enter your own page size here. You can also choose the quality of PDF you want to create (usually you'd leave this set to High Quality), the background color of your document, and whether to require a password to view it. You might want to require a password if you're sending PDF proofs of commercial wedding photos, for instance, so that only certain people can view them. Turn on the Open Password checkbox and then enter a password. (The Permissions Password checkbox is for use with the Version Cue program that's part of the full Adobe Creative Suite.) Then only people who know the password will be able to view the PDF. You can also keep people from being able to print out the PDF by turning on the Disable Printing checkbox after assigning a password (it's grayed out until you do). But remember that there's no way to prevent people from making screen captures of the PDF if they can view it, so if you're worried about this, use small images and choose Low Quality.
- Layout. You can choose how many rows and columns of images your project will have. You probably wouldn't use this option in creating a slideshow, but it lets you customize contact sheets and presentations. You can also choose where on the page the images are placed. Auto spacing lets Bridge do the work for you. You may need to turn off the "Rotate for Best Fit" checkbox so Bridge doesn't put some of your images sideways on the page. The "Repeat One Photo per Page" setting makes Bridge fill each page with a single photo.

- Overlays. This section is where you can tell Bridge to display the file's name and/or format extension beneath each image, and pick a font, size, and color for this info.
- Playback. If you're creating a slideshow, these are the important settings. Here you can determine whether the PDF automatically opens in a fullscreen view, how quickly to advance from one page to the next, and whether to use transitions between pages. If you decide to use transitions, you can choose the type of transition, too, but it's the same for all pages—you can't combine different transitions in one slideshow. For some transitions, you get to pick a direction and speed for the transition. Unfortunately, the preview you see in Bridge is static; you can't watch your slideshow play in the preview area before you save it. Also, once you create your slideshow, you can't edit the PDF. You have to go back to Bridge and create a new PDF incorporating your changes, so it's a good idea to check out your finished product before making any changes to the photo group that's visible in the Bridge window.

TIP If you're creating a multipage document for printing, turning off the Playback options helps reduce the file size

• Watermark. This section lets you put watermark text (page 262) over your images to show the copyright or info to discourage printing. Type the text you want in the Watermark Text box, and then choose a font, size, color, and opacity. Figure 15-9 explains the Foreground/Background choices.

Figure 15-9: Left: The Foreground setting puts the watermark text on top of your photo, so choose a low opacity if you pick this option.

Right: The Background setting puts the text behind the photo. You might choose this if you want people to have a unobstructed view of your photos while making sure they know the images on the page are copyrighted.

You probably won't want to create a full-scale slideshow with Bridge, but it's a useful way to create an elegant presentation file. You could use the Fine Art Mat template, for instance, and add transitions to create a self-advancing view of your portfolio for prospective clients. Of course, you need to be sure the people who get your PDF have a program (like Adobe Reader) with which to view it. (Macs with OS X can use Preview to open and view these presentations, even without Adobe Reader.)

Printing Your Photos

Now that you've gone to so much trouble making your photos look terrific, you probably want to share them with other people. This chapter and the next look at the many options Elements gives you for sharing photos with the world at large.

This chapter covers the traditional method: printing images. You can print them at home on an inkjet printer, take them to a printing kiosk at a local store, or use an online printing service. And you're not limited to ordinary prints these days: You can create hardcover books, calendars, album pages, and greeting cards with online services, too.

Getting Ready to Print

Whether printing at home or sending photos to a printing service, make sure your image file is set up to give you good-looking prints. The first thing to check is your photo's resolution, which controls the number of pixels per inch (ppi). If your photo doesn't have enough pixels, your print will look grainy and pixelated. Most photo afficionados consider 300 ppi ideal; a quality print needs at least 150 ppi to avoid the grainy look you see in low-resolution photos. See page 93 for more on reviewing and setting your photo's resolution.

TIP Be sure to set your resolution to a whole number—decimals may cause some printers to put black lines on your prints. So a ppi of 247 ppi is fine, but you may have problems if the ppi is 247.32. (Older printers are most likely to have trouble with decimals.)

When printing on photo paper or sending your photos out for printing, make sure your images are cropped to fit a standard paper size. (Cropping is covered starting on page 75.) When printing at home, the paper and ink you use make a big difference in the color and quality of your printed photo. It may seem like a marketing scam, but you really will get the best results by using your printer manufacturer's recommended paper and ink.

Ordering Prints

You don't need to own a printer to print photos—there's no shortage of companies hoping you'll choose them for the privilege of printing your photos. You can order prints online or use a print kiosk at a local store. Elements makes it easy to prepare your photos for printing either way. Just save your photos in a compatible file format (see page 59 for more about picking a file format). JPEG format is usually your best bet, but check with the service you plan to use to see if it has any special requirements.

If you plan to take your photos somewhere for printing (as opposed to ordering them online), burn the files to a CD and take that in, or copy your photos to a memory card or portable USB drive.

TIP You can burn a CD from within Elements. Just be sure to save your photos in the correct format (see page 63.)

Elements 8 for Mac doesn't include the quick connection to online printing services that was in Elements 6, but the process is simple nonetheless. Go to the website of the service you want to use and their online assistant will help you upload your photos for printing. There are lots of online print services to choose from, including Kodak (www.kodakgallery.com), Shutterfly (www.shutterfly.com), and Snapfish (www.snapfish.com), in addition to the websites for most drugstores and many chain stores. If you use iPhoto or Aperture, you can order prints and books directly from those programs.

Printing at Home

You can print right from Elements, whether you want to make a single image, a contact sheet with lots of thumbnails, or a picture package that includes different sizes of one image, like you'd get from a professional photographer.

One of the new features in Elements 8 is a redesigned print window for making individual prints (the contact sheet and picture package features haven't changed). Adobe wanted to make it quick and easy to create the kind of prints you'd order online (as described above) or get from a store kiosk—prints on typical photosized paper. You can still do more advanced printing (where you control the color options and so on) from Elements, but the workflow is a bit different in Elements 8. It may take you a little while to get used to it.

Printing One Photo Per Page

Here's how to print at home:

1. Choose the photo(s) you want to print.

Select your photos in the Project bin if you want to print more than one. Otherwise Elements prints only the active photo, or if you haven't selected a photo, it prints everything in the bin. You can add or remove photos once you're in the Print window, too, as explained in Figure 16-1.

Figure 16-1:
To add more photos to the group that you're printing, click the green Add button (the + sign) and choose your images in the OS X window that opens. If you decide you don't want to print a photo, click it in the list and then click the red Remove button (the - sign).

2. Go to File → Print, press #-P, or click the Create tab's Photo Prints button.

Either way, the Print window appears. It's divided into three main sections: On the left is a filmstrip-like view where you can add or remove photos to print (see Figure 16-1). In the middle is a preview area, where you see the image you're going to print and some controls for rotating and adjusting the image (there's a blue outline around the area that will print). And on the right is a strip of numbered controls, listed in the order in which you need to make your choices.

3. Pick the printer you want to use.

Select it from the drop-down menu on the right side of the window (Step 1). This replaces using Page Setup to select your printer, the way you do in other programs. Select your printer here and it's automatically chosen in Page Setup, too.

4. Choose a paper size.

Click the Select Paper Size menu (Step 2) for a list of paper sizes available for your printer. Your options are determined by the printer you chose in Step 1.

5. Select a print size.

Use the Step 3 drop-down menu to pick a size. If your print isn't one of the preset sizes, choose Actual Size or Custom. If you select Custom, you see a window with the Custom Size choices from the More Options window, which is explained on page 465. Enter your choices and click OK.

If you turn off the "Crop to Fit" checkbox, Elements prints your whole image as large as it can be within the Print Size you chose, even if that means leaving empty space at some of the edges. If you want to make your image fill the available space, leave "Crop to Fit" turned on and Elements trims your image to fit the print size you choose. Figure 16-2 shows the difference this setting makes.

Figure 16-2: Left: Here's how this photo will print with "Crop to Fit" turned off. Notice the white space at the top and bottom of the blue bounding box.

Right: Leave "Crop to Fit" turned on and Elements enlarges the photo to fill all the space before cropping off the excess.

6. Choose how many copies of each page you want.

To print more than one copy of each page, enter the number of copies you want in the Print box below the "Crop to Fit" checkbox. (Elements prints this many copies of *every* print in this batch—you can't make three copies of one photo and two of another, for example.)

7. Print your photos.

Click Print, and the OS X Print dialog box opens. You'll want to make some choices there, as explained on page 468. Once you're ready, click the Print button, and Elements prints your photos. If you change your mind, click Cancel instead.

NOTE That's the basic process for printing in Elements 8. If you're in a hurry or not fussy, this process can give you a handful of prints in short order. But odds are that you're using Elements because you *are* fussy about your photos and you may want to tweak several other settings. The next sections cover all the ways you can customize things like how your photo sits on the page, its color management, and so forth. (The Print window isn't *color managed*, which means that what you see in the window isn't meant to show you the exact colors that will print. Instead, you're looking only at the position of your photo.)

Positioning Your Image

There are two main ways to adjust the relationship between your image and the paper you print it on. Elements' Print window has some controls for rotating and sizing your image, which is normally all you'll need. You can even scoot your photo around within the preview area to determine which part of it will print, if you don't want to print the entire image. And you can call up the OS X Page Setup dialog box, which is the same for all programs on your computer. The following sections explain your options.

Print window settings

When you open Elements' Print window (File \rightarrow Print), you see your photo surrounded by a blue outline (called a *bounding box*) in a white preview area. The white area is your paper, and the blue box represents the printing boundaries of your photo. (The blue outline doesn't print. Incidentally, Adobe's official name for the area surrounded by the blue outline is the Print Well, in case you run into it in any tutorials.) Your first impulse may be to grab the box and try to adjust the placement of your photo on the page. But if you do this, rather than moving the blue box, you move your image *within* the box.

If you've used a previous version of Elements, you may be looking for where to turn off the Center Image setting. (In older versions of Elements, turning off this setting let you move your photo around on the page to position it wherever you wanted it to print on the paper.) Unfortunately, in Elements 8, there's no such setting. You can't move the blue box because it's *always* where Elements decides it should be: smack in the middle of the page, fixed in place, even if you're printing, say, a 4"×6"-photo on a letter-sized piece of paper. Elements is in charge in the Print window. (If this news makes your blood pressure rise, head over to the box on page 465 for a workaround.)

Though you can't move the bounding box, there are several ways to change how your image appears within it.

• Rotate your photo. Below the preview area are the same rotation icons you see elsewhere in Elements. Click one to rotate your photo within the bounding box. (You may need to go to Page Setup—explained below—if you want to rotate the *box*, and it may or not change relative to the page orientation.)

- Resize your photo. If you don't want to print the whole image, you can zoom in on part of your photo by using the slider below the preview to control which part of it appears in the box. Be careful with this feature: You can easily enlarge your image beyond a reasonable pixel density. (When you click Print, Elements will warn you if the image will print at less than 220 ppi, but as a general rule it's best to take care of any resizing *before* you open the Print window.)
- Reposition your photo in the box. You can drag your image around in the preview area to determine which part of it will print. (If you accidentally drag your image almost out of view, just choose a different print size in the right-hand part of the window, and then switch back to the original size. Elements re-centers your image in the Print Well each time you change this setting.)

NOTE If you turn on the "Crop to Fit" checkbox, Elements crops based on the *original* position of your image; it doesn't take into account any dragging you do. In other words, you can't control which part of your photo gets printed if you use "Crop to Fit". If you start dragging and "Crop to Fit" is turned on, Elements automatically turns it off.

- Make your image and the print size the same. If you decide to make a 4"×6"-inch print of an image that's the right aspect ratio (shape) for a 5"×7"-inch print, for example, you'll have some empty space on the edges because the print size and the aspect ratio aren't equivalent. There are two ways around this. First, you can turn on "Crop to Fit", and Elements will chop off the extra edges of your photo. Or, in the Select Print Size menu, choose Actual Size if you've already cropped your image to a photo-paper size. You can also use a Custom size, as explained next.
- Custom Print Size. Either choose Custom from the Print window's Select Print Size menu, or click the More Options button at the bottom of the Print window and then click Custom Print Size to see your options. You can type in the height and width you want to print, in inches, centimeters, millimeters, points, or pixels. Below the Height, Weight, and Units boxes, Elements lists the resolution you'll have at that size (see page 93 for more about resolution).
- Make your image fill the paper. If you choose Custom from the Select Print Size menu or click the More Options button and then click Custom Print Size, you can turn on the "Scale to Fit Media" checkbox, and Elements makes your image larger or smaller so that all of it fits into your desired page size. You may need to use the OS X Page Setup dialog box (described below) to change the paper orientation after turning on this setting.

None of these options will let you print your image at the upper-right corner of the page, or put more than one photo on a page. Use the workaround in the box on page 465 to do that, or use a picture package (page 471) to print multiple photos on one page.

OS X Page Setup dialog box

In the lower-left corner of Elements' Print window is a Page Setup button. Click it to bring up the OS X Page Setup dialog box. Normally, you don't need to use this dialog box at all in Elements 8—choosing your printer in the window's Step 1 area takes care of things. But once you have everything set up in Elements' Print window, you can use Page Setup to override Elements' settings. So, for example, if you want to rotate the paper 90 degrees relative to the blue bounding box, this is where you do it. You can also select a printer here, but normally choosing a printer in the Print window changes Page Setup to match.

WORKAROUND WORKSHOP

Placing Your Photo Where You Want It

As explained on page 463, Elements' automatically decides where on the page to print your photos. Adobe seems to think that most people don't care where on the page their photos print as long as they print, or that you like the idea of letting Elements call the photo-placement shots for you. That's fine if you agree, but if you're of the "It's my darned photo on my darned paper in my darned printer" school of thought, or if you don't want every print centered on the page, you may not appreciate this new feature. Don't worry—there's a way around it, and it only adds one more step to printing. Before you print your image:

 Create a new, blank document the same size as your paper. Go to File → New → Blank File. Choose a white or transparent background, and set the resolution to 300 ppi or whatever you normally use for printing. (See page 93 if you need help choosing a resolution.) Save the blank file with a name like Printing Template. From now on, when you want to print an image on a particular part of the page, open this file and copy and paste your photo(s) into it. Then use the Move tool (page 150) to position the image wherever you like.

If you have trouble getting photos centered on the page because of the way your printer feeds the paper (some printers have to hang on to one end of the sheet and so always put a wider margin there) you can use Elements' new guides feature (page 74) to put a nonprinting guideline as a mark in the blank document to remind you where the end of the printable area of the page is, so you know what your real boundaries are. You can even use this method to create your own picture package for multiple prints, as explained on page 471.

Finally, if you print a lot and can't deal with all these workarounds, remember that you can always save your photo and print it from Preview.

Additional Print Options

Elements includes a number of other useful ways to tweak your photo, like putting a border around it, printing crop marks as guides for trimming the print, or even flipping it for printing as an iron-on transfer. You'll find these options by clicking the Print window's More Options button and then, on the dialog box's left, clicking Printing Choices:

• Photo Details. You can print the image's shot or creation date, caption, and/or file name on the page with your photo by turning on the relevant checkbox(es) here. (The image preview area shows where your text will be printed.) You can go to File → File Info in either Elements or Bridge to add a caption in the Description field.

- Border. To add a border to your photo, turn on the Thickness checkbox, and enter the size you want for your border (in inches, millimeters, or points). Elements shrinks your photo to accommodate the border, even if there's plenty of empty space around the picture, so you may need to enlarge the photo a bit before printing to get the size you originally chose. Click the white square that appears to bring up the Color Picker (see page 217) so you can choose a border color. If the page has empty space you want to fill with a background color, turn on the Background checkbox, and click its color square to bring up the Color Picker.
- Iron-on Transfer. Turn on the Flip Image checkbox to horizontally reverse your image. Use this when printing transfers for projects like t-shirts.
- Trim Guidelines. The Print Crop Marks checkbox lets you print guidelines in the margins of your photo to make it easier to trim. Crop marks are useful mainly for trimming bordered photos so that the borders are exactly even.

WORKAROUND WORKSHOP

Economical Print Experiments

If you went out and bought top-quality photo paper, you may be suffering from sticker shock and thinking, "Great. Now I'm supposed to use this stuff up experimenting to find how to get the most accurate color? At that price?"

The good news is, while you have to bite the bullet and sacrifice a sheet or two, you don't need to waste the whole box. Instead, try this: First follow the directions in the box on page 465 for creating a blank file so you can put your image where you want it on the paper. Next, make a small selection somewhere in a photo you want to print, press %-C, and then make your blank file the active file and paste your selection into it (%-V). You now have a file with only a small piece of your photo in it.

This is your test print. Activate the Move tool and drag your small photo to the upper-left corner of the page. Try printing the page using Elements' standard settings. If your print looks good, you're ready to print the whole photo.

If you don't like the result, try again but this time, move your test strip over to the right a bit. Change your settings (keeping note of the changes you've made) and print again on the same piece of paper. Your new test prints beside the first strip. Keep moving the test area around on the page, and you can try out quite a few different combinations of settings on one sheet of paper.

Color management

If you click the Print window's More Options button and then click Color Management on the left side of the dialog box, you see several advanced color-related settings. If you're content with the way your prints look without adjusting these settings, you can ignore them. But if you don't like the color you're getting from Elements, use these controls to make adjustments.

You may remember from Chapter 7 that Elements is a *color-managed* program, which means it tries to coordinate the color settings used by various devices and programs: your photo (which may retain color settings applied by your camera), your monitor, your Elements settings, and your printer. Sometimes you need to help Elements decide which settings are best, since different devices and programs can have different interpretations of what colors look like.

The most important choice to make is whether you want Elements or your printer to manage your photo's color settings. (It's possible to let both Elements *and* your printer have a say in color management, but that almost always mucks things up. The good news is that Elements 8 does its best to keep you from making that kind of color-management mistake, and it tries to make managing the color in your prints as painless as possible.)

You have four color-management choices to make:

• Color Handling. Here's where you decide who's going to be in charge: Elements (select Photoshop Elements Manages Colors), your printer (Printer Manages Colors), or nobody (No Color Management). The choice you make here determines your options in the rest of the settings. Elements also gives you some hints about your printer settings, as you can see in Figure 16-3. Keep reading to learn which option to choose.

Figure 16-3: Here's where you decide whether Elements or your printer is in charge of color. In case you get confused about color management, when you choose "Printer Manages Colors", Elements reminds you to turn on color management in your printer's driver (that's what Elements means by "printer preferences" in the "Did you remember...?" message below the pop-out menu: the driver options in the OS X print window, described on page 468). If you choose Photoshop Elements Manages Colors, the text changes to remind you to disable color management in the driver.

- Source Space. This setting shows you which, if any, color space is assigned to your file (for example, sRGB or Adobe RGB). You don't actually choose anything here; this line is just FYI. Page 204 has more about color spaces.
- Printer Profile. This setting is grayed out unless you chose Photoshop Elements
 Manages Color in the Color Handling menu. If Elements is managing color,
 you can choose a profile from this list, which includes all the profiles Elements
 can find on your computer.
- Rendering Intent. This setting lets you tell Elements what to do if your photo contains colors that fall outside the color range of the print color space you're using. Your choices are explained in the box on page 468. (If you set the Color Handling menu to No Color Management, this setting isn't available.)

The easiest way to set up color management, and a good way to start, is to choose Printer Manages Color. This means that Elements hands your photo over to your printer and lets the printer take care of the color-management duties. Then all you need to do is select the proper paper profile and settings for your printer (more on that in a moment).

NOTE If your camera takes photos in sRGB and you've been editing them in No Color Management or "Always Optimize Colors for Computer Screens" as your main Elements color setting, don't choose Adobe RGB for the printer profile or your colors may shift drastically. If you want to change the color space for the printer, first go to Image \rightarrow Convert Color Profile \rightarrow Convert to Adobe RGB. If you aren't absolutely sure that your printer understands Adobe RGB (many inkjets don't), and you don't have a compelling reason for changing this setting, it's best to leave things alone.

There are limitless variations on how you can use the color-management settings in Elements, and you may need to experiment a bit to find what works best. (The box on page 466 has advice on how to cheaply test out a bunch of different print settings.) If you go looking for more info, you'll find that this is a very controversial subject. Everyone has a different approach that's the "right" one. In fact, you have many options that can lead to good results.

UNDER THE HOOD

What's Your Intent?

The Rendering Intent setting in the Color Management section of Elements' Print window is the most confusing of the color management options. Here are the basics you need to know to choose a setting.

The Rendering Intent setting tells Elements what to do if your photo contains colors that fall outside the boundaries of the print space you're using. You have four choices:

 Perceptual tells Elements to preserve the relationship between the colors in your image—even if that means it has to do some visible color shifting to make all the colors fit.

- Saturation makes colors vivid but not necessarily accurate. This setting is more for special effects than for regular photo printing.
- Relative Colorimetric tries to preserve the colors in both the source and the output space by shifting things to the closest matching color in the printer profile's space. Relative Colorimetric is Elements' standard setting, and it's usually what you want because it keeps your colors as close as possible to what you see on your screen.
- Absolute Colorimetric lets you simulate another printer and paper. This setting is for specialized proofing situations.

The OS X Print Dialog Box

As mentioned earlier, after you adjust the Elements Print window's settings and click the Print button, you see the OS X system print dialog box, where you make your final print setting choices—like paper profile and color management. First,

choose your printer from the top pull-down menu. Next, click the blue downarrow button to the right of the printer's name to expand the dialog box, and then choose your paper and color options from the pull-down menu that says Layout when you first open the OS X print dialog box.

Your paper and color options vary depending on the kind of printer you have. Selecting a paper profile may sound complicated, but it's usually as simple as selecting the kind of paper you plan to use (Photo Paper Plus Glossy, say) from a list of choices. Setting color options can be as easy as choosing "high-quality photo" from a list of quality settings, and usually you'll have someplace to specify Printer Color Management, although probably not in the same menu item.

When everything's all set, click Print.

Printing Multiple Images

Elements makes it easy to create and customize contact sheets that show lots of thumbnails on one page. You can also print picture packages with several different-sized photos on one page, and you can edit both these layouts to get exactly the arrangement you want. This section teaches you how.

Contact Sheets

Contact sheets show a bunch of thumbnails of different photos. You can use them to keep track of the photos on a CD or as a record of all the photos you took in one shooting session, for example. The plug-in that comes with Elements (see page 494 for more about plug-ins) makes it a snap to create a contact sheet that's laid out the way you want. To create a contact sheet:

1. Organize your photos.

You can make a contact sheet of all your open photos, all the photos in a folder, or selected photos in Bridge. So decide which photos you want to use and open them in Elements, put them in a folder, or select them in Bridge.

2. Call up the Contact Sheet dialog box.

In Elements, press Option-\(\mathrev{\pmathrev{H}}\)-P or go to File \(\to \) Contact Sheet II. (There's no Contact Sheet I option in Elements 8—it was replaced by this one long ago.) In Bridge, go to Tools \(\to \) Photoshop Elements \(\to \) Contact Sheet II. No matter where you start, you end up in Elements, where you see the dialog box shown in Figure 16-4.

3. Choose your settings.

You have lots of options:

• Source Images. This is where you pick which photos to include. You can select the files currently open in Elements, files in a certain folder, or files you selected in Bridge.

469

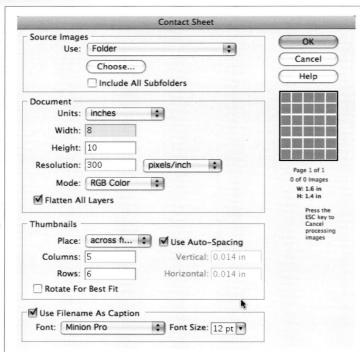

Figure 16-4:
You can customize your contact sheet by adjusting things like the amount of space between your thumbnails. As you tweak settings, the layout thumbnail on the right side of the dialog box changes to reflect your choices, and Elements keeps a running tally of the number of pages needed to fit your photos in the current layout.

- Document. Here's where you select the overall settings for your page. Set the page size in inches, centimeters, or pixels. Then enter a resolution and choose between RGB and grayscale color mode (see page 51). The Flatten All Layers checkbox doesn't affect your originals—it just creates a contact sheet where text and images are on the same layer. You can leave Flatten All Layers turned on to keep your file smaller.
- Thumbnails. These settings let you control how the thumbnails are laid out. Choose whether you want your pictures to go across the page or down (as they're being laid out), how many columns and rows you'd like, and whether you want Elements to figure out the spacing between images or set the spacing yourself. Turn on the Rotate For Best Fit checkbox if you want Elements to rotate the thumbnails so they fit on the paper most efficiently. If you don't like having photos improperly oriented, leave this setting off.
- Use Filename As Caption. Use this setting if you want the name of each photo to appear as a caption. Your font choices are Myriad Pro, Minion Pro, or Lucida Grande. Getting a font size you like may take some experimenting.

4. Click OK to create your contact sheet.

Elements goes to work, and you see your images flash back and forth. The contact sheet thumbnail in the Project bin updates to show each new photo as Elements places it. If you change your mind about making a contact sheet while Elements is working, press the Esc key.

5. Save or print your contact sheet.

Your finished contact sheet is just like any other file: You can save it in the format of your choice, print it out, burn it to disc along with the photos it contains (see page 63), whatever. If you included so many photos that they don't all fit on one page, each page is a separate document.

PDF Contact Sheets in Bridge

You can also create a PDF contact sheet in Bridge, following the steps for PDF projects described on page 455. You can't *print* from Bridge, though, so you need to create the PDF file and then open it in another program like Preview to print it. The only real advantages to creating contact sheets this way are the few layout choices not offered in the Contact Sheet dialog box—like Triptych (three on a page)—and the fact that it's easy to add a copyright watermarks to your images in Bridge. Also, you have more font choices in the Bridge Contact Sheet.

Picture Packages

You can also print a group of pictures, called a picture package, on one page. You can make packages that feature one photo printed in several different sizes, or packages that include more than one photo. Here's how:

1. Start your package.

You can start a picture package from Elements (File → Picture Package) or from Bridge (Tools → Photoshop Elements → Picture Package). You don't need to select any photos first, but you can. The Picture Package dialog box opens in Elements, even if you start from Bridge.

2. Choose your photo(s).

The Use drop-down menu is where you choose the pictures you want in the package. If you choose lots of files, Elements uses as many pages as necessary to fit them all in. You can use a single file, a folder of photos, the frontmost open photo, pictures you preselected in Bridge, or all open photos. Elements starts by filling the entire layout with copies of one photo, but you can change that in step 4 if you want more than one image per page.

3. Choose your page size and layout settings.

Elements gives you lots of options:

• Document. This is where you pick the overall settings for your package. You can set the page size (8" \times 10", 11" \times 16", or 11" \times 17"), the layout (how many photos appear on one page and their sizes), resolution, and whether to use RGB or grayscale color mode (see page 51). The Flatten All Layers setting works the same way as it does for contact sheets (see step 3 on page 469). The page size options are all photo paper sizes, but you can print the 8" \times 10" layout on standard 8.5" \times 11" paper.

• Label. This is where you can tell Elements to put text on your photos. If you don't want any text, leave Content set to None. If you want text, you can use the file name, copyright, description, credit, or title from the file's metadata (see page 55), or enter custom text. The other options are for the text itself: font, size, color, opacity, and position. If you don't want black text, click the Color box to bring up the Color Picker (see page 217). The Rotate menu lets you tell Elements to rotate the text so that if your photos print sideways, the text still prints right side up on the photo. You can use the Opacity and Position settings to create a watermark, as explained on page 262.

If all these options aren't enough for you, check out the next section, which explains how to customize your picture package even further.

4. Adjust the placement of your photos.

Figure 16-5 explains how to change the contents of a particular placeholder (Adobe calls them *zones*). Keep clicking zones to put as many different shots on a page as you have zones to hold them.

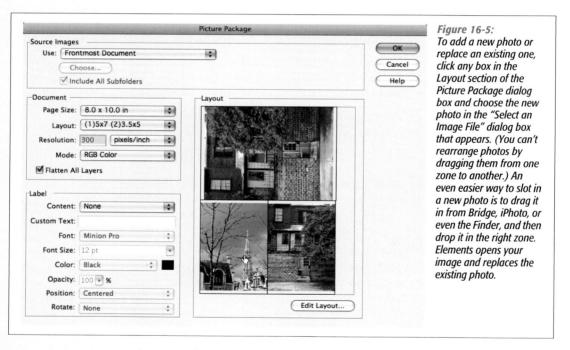

5. When everything's arranged to your liking, click OK to create your package.

If your settings required more than one page to fit your photos, each page is a separate file. You can print them or save them in any format that suits you, just like a single photo.

Customizing your picture package

You're not limited to the picture package layouts Elements offers. You can customize a layout in all sorts of ways and then save it to use again. Start by choosing the built-in layout that's closest to what you want. Then click the Edit Layout button in the bottom right of the Picture Package window to call up the dialog box shown in Figure 16-6.

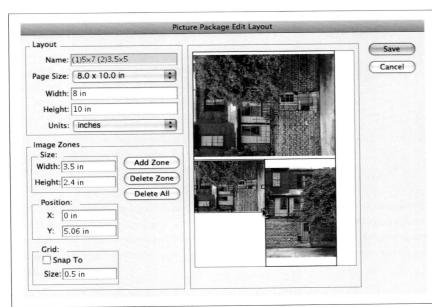

Figure 16-6: There are lots of ways to customize a picture package's layout. Enter numbers on the left side of the dialog box or just click a zone to bring up resizing handles. Resizing works just like using the Move tool (page 150) you can drag or resize a zone, or Option-click it to see a pop-up menu that includes some standard sizes. To delete a zone, click it and then click the Delete Zone button. To start from scratch, click Delete All.

You can choose a preset page size or type in a custom size in inches, centimeters, millimeters, or pixels. As Figure 16-6 explains, you can also change the size and location of the images in your package. (The boxes for typing in custom sizes are grayed out until you select a zone.) If you click a zone and then click Add Zone, Elements creates an additional zone instead of replacing the one you clicked.

If there's no space that's big enough for the new zone, Elements just dumps the new zone on top of the existing layout and leaves you to sort things out. Just delete an existing zone to make room for the new one. The Snap To checkbox in the dialog box's Grid section helps you line up your zones.

When you're happy with your custom layout, name it by typing something in the Name box, and then click Save. (Be sure to give your layout a new name so you don't overwrite the built-in layout you started with.) Make sure you save it in the folder <your hard drive> → Applications → Adobe Photoshop Elements 8.0 → Presets → Layouts. That way, your new layout will show up in the list of preset layouts.

If this method of customizing a picture package doesn't meet your needs, the box below explains another way to create a custom package.

WORKAROUND WORKSHOP

Creating Your Own Package

You may want a different layout for your picture package than any of the choices that Elements offers. It's easy to make your own picture package from scratch. Here's how:

- Save all the photos you want to use at the same resolution. See page 459 for more about setting a file's resolution.
- 2. Create a new document (%-N or File → New). Make sure it's the size you want your complete package to be and that it has the same resolution as your photos. You can save time by choosing the Letter preset size from the US Paper presets in the New file menu—that's already set to 300 ppi.
- 3. **Drag each photo into your new document.** Drag the photos from the Project bin (page 25) and then position them as you wish, or just copy (%-C) and paste (%-V) them. You can use the Move tool (page 150) or the Scale command (page 337) to resize them. Each photo comes in on its own layer, so it's easy to reposition them individually.

When you have all your photos positioned and sized to suit you, save the combined file and print it. You can make the file smaller by flattening the layers (Layer → Flatten Image). Flatten only if you don't think you'll want to tweak your layout later.

Email and the Web

Printing your photos is great, but it costs money, takes time, and doesn't do much to instantly impress faraway friends. And to many people, printing is just so 20th century. Fortunately, Elements comes packed with tools that make it easy to prep them for emailing or posting on the Web. You can even create simple web galleries.

NOTE If you've used Elements 6 and you're wondering where all the menus and buttons for uploading your photos to various online sites for printing and sharing went, they're gone. But that only adds one extra step to the process of using Elements with various websites: Just save your photos to the desktop, connect to your favorite site, and use their uploading features or iPhoto, Aperture, or any other application that has a direct connection to the service of your choice.

Image Formats and the Web

Back in the Web's early days, making your graphic files small was important because most Internet connections were as slow as snails. Nowadays, file size isn't as crucial. The main thing to keep in mind when creating graphics for the Web is ensuring they're compatible with the web browsers people use to view them. That means you'll probably want to use one of the two most popular image formats, JPEG and GIF:

• JPEG (Joint Photographic Experts' Group) is the most popular choice for images with lots of details, and when you need smooth color transitions. Photos are almost always posted on the Web as JPEGs.

TIP JPEGs can't have transparent areas, although there's a workaround for that. Fill the background around your image with the same color as the web page you want to post it on. That way, the background blends into the web page, giving the impression that your object is surrounded by transparency. See Figure 17-4 (page 480) for details on how this trick works.

- GIF (Graphics Interchange Format) files are great for images with a limited number of colors, like corporate logos and headlines. Text looks much sharper in GIF format than it does as a JPEG. GIFs also let you have transparent areas.
- PNG (Portable Network Graphic) is a web graphics format that was created to overcome some of the disadvantages of JPEGs and GIFs. There's a lot to like about PNG files: They can include transparent areas and they're relatively small without losing data, as happens with JPEG files (see page 62 for more about that). PNG files' big drawback is that only newer web browsers deal with them well. Older versions of Internet Explorer don't understand the PNG format, so if you think people might try to view your images with ancient computers, you probably don't want to use PNG.

Elements makes it a breeze to save your images in any of these formats using the Save For Web dialog box, covered in the next section.

Saving Images for the Web or Email

If you plan to email your photos or put them on a website, Save For Web is a terrific feature that saves any open image in a web-friendly format. It also gives you options to help maintain maximum image quality while keeping the file size to a minimum. Save For Web aims to create as small a file as possible without compromising the image's onscreen quality.

Save For Web creates smaller JPEG files than you get using Save As, because it strips out the EXIF data, the information about your camera's settings (see page 55). To get started with Save For Web, go to File → "Save for Web" or press Option-Shift-ૠ-S. The dialog box shown in Figure 17-1 appears.

The most important point to remember when saving images for the Web is that the resolution (measured in pixels per inch, or ppi) is completely irrelevant. You care only about the image's pixel dimensions, such as 400×600 . If you're working with a photo that's optimized for print, you almost certainly want to downsize it; Save For Web makes that a snap.

The Save For Web dialog box has some useful tools, like Hand (page 88) and Zoom (page 86) for adjusting your view. But the main attraction is the before-and-after image preview in the two main preview panes. On the left is your original and on the right is how the image will look after you save it.

The file size is listed below each image preview. Below the right preview, you see the estimated download time, which you can adjust by modifying your assumptions about the viewer's Internet connection speed, as shown in Figure 17-2.

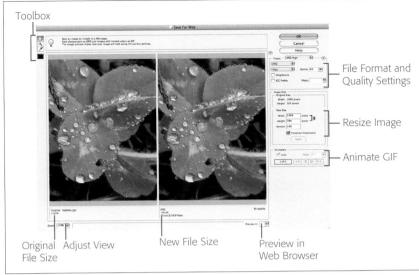

Figure 17-1:
The Save For Web dialog box makes it easy to get the exact image size and quality you want. The left image is your original photo, and the right image shows what your webfriendly image will look like at its new file size, format, and quality.

Figure 17-2:
The Save For Web dialog box gives you an estimate of how long it'll take to download your image. If you want to change the download settings (for example, the speed of the Internet connection), go to the upperright corner of the preview area and click the arrow button to see this list.

You can also change the zoom percentage (using the Zoom menu in the dialog box's bottom left), but you should usually stick with 100 percent because that's how big your image will be on the Web.

The upper-right corner of the window has your file-format and quality choices (what you see varies a bit depending on which format you've chosen). Below that are your options for resizing the image. If you want to create animated GIFs (those tiny moving images you see on web pages), set up the animation at the bottom of the settings area. Creating animated GIFs is explained on page 482.

Using Save For Web

When you're ready to use Save For Web, follow these steps:

- 1. Open the image you want to modify.
- 2. Launch the Save For Web dialog box.

Go to File → "Save for Web" or press Option-Shift-\%-S.

NOTE If you're working with a large file, you may see a dialog box stating that "The image exceeds the size Save for Web was designed for", along with dire-sounding warnings about slow performance and out-of-memory errors. Just click Yes to tell Elements that you want to continue anyway. You won't have any problems.

3. Choose the format and quality settings you want.

Use the pull-down menu below the word "Preset" to choose a format. Your choices are explained in the following section.

4. If necessary, change your image's dimensions.

If you want to make sure that anyone can see the whole image, no matter how small his monitor, enter 650 pixels or less for the longest side of your photo in the New Size area. (About 650 pixels is the largest size that fits on small monitors without scrolling. If all your friends have big, new monitors, you can go much higher.) As long as the Constrain Proportions checkbox is turned on, you don't have to enter the dimension for the other side of your photo. Remember, large photos can take a long time to download on dial-up connections. Elements helps you out by telling you the download times for various connections, as explained in Figure 17-2. You can also resize your image by entering a percentage (for example, entering 90 shrinks your image by 10 percent). When you're finished entering the new dimensions, click Apply.

5. Check your results.

Look at the file size again to see if it's small enough, and take a close look at the image in the right-hand preview area. Use Elements' file-size optimization feature (explained in Figure 17-3), if necessary. You can also preview your image in your web browser (see page 481).

Figure 17-3:

Save For Web's file-size optimization feature is helpful when you need to send a file someplace that puts limits on your total file size.

Top: When you click this triangle next to the Preset menu and then choose "Optimize to File Size", Elements displays a dialog box where you can enter your desired file size.

Bottom: Kilobytes (K) is the unit of measurement in the Optimize To File Size dialog box. Type in the number of kilobytes you want your file to be. Picking Current Settings tells Elements to start with whatever settings you've entered in the Save For Web dialog box, like the format and quality. Picking Auto Select GIF/JPEG means you want Elements to decide between GIF and JPEG for you. Once you've finished making your selections, click OK, and Elements shrinks your image to the size you entered.

6. When everything looks good, click OK.

Name the new file, and then save it wherever you like. There's no Undo option in the Save For Web dialog box, but you can Option-click the Cancel button to change it to a Reset button. If you're processing several photos with the same settings, press the Option key to change the Help button to a Remember button, and then click it. That way, the next time you open Save For Web, your current settings are already selected.

Save For Web format options

You can reduce file size by changing the length and width of your image, as explained in Step 4 above. But you can also make your file smaller by adjusting the quality settings. The quality options you see in the Save For Web dialog box vary depending on which format you choose to save the file as:

• GIF. The fewer colors a GIF contains, the smaller the file. In Elements, the GIF format names in the Preset menu tell you the number of colors that will be in your GIF. For example, GIF-128 means 128 colors, and GIF-32 means 32 colors. You can also use the Colors box to set the number of colors. Use the arrows on the left edge of the box to scroll to the number you want, or just type it in the box.

If you turn on the Interlaced checkbox, your image downloads in multiple passes (sort of like an image coming into focus). Interlacing isn't as useful today as it used to be on slower machines. If you want to keep transparent areas transparent, leave the Transparency checkbox turned on; if you don't, choose a matte color the way you do for a JPEG (see the next bullet point). If you're creating a GIF that you plan to animate, turn on the Animation checkbox. (You need a layered file to make an animated GIF; see page 482.)

Dither is an important setting. The GIF format works by compressing and flattening large areas of colors. When you use dithering, Elements blends existing colors to make the image look like it has more colors than it actually does. For instance, Elements may mix red and blue pixels in an area to create purple. You can choose how much dither you want by entering a percentage. Depending on your image, you may not want any dithering; in that case, set the Dither field to 0%.

• JPEG. Elements offers you a variety of basic JPEG quality settings: Low, Medium, High, Very High, and Maximum. You can fine-tune these settings by entering a number in the Quality box on the right (not surprisingly, a higher number means higher quality). Medium is usually good enough if you're saving for web use. If you're using Save For Web to make JPEG files for printing, pick Maximum instead.

If you turn on the Progressive checkbox, your JPEG loads from the top down. This option was popular for large files when everyone had slow dial-up connections, but it makes a slightly larger file, so it's not as popular today. Turning on the ICC Profile checkbox tells Elements to embed a color-space profile in your image. (See page 204 for more about color spaces.)

With the Matte menu, you can set the color of any area that's transparent in your original (see Figure 17-4). If you don't set a matte color, Elements uses white. By choosing a matte color that matches the background of your web page, you can make it *look* like your image is surrounded by transparency. You have three ways to select the color: Click the arrow on the right side of the Matte box, and then choose from the pull-down menu; click the arrow on the right side of the Matte box, and then sample a color from your image with the Eyedropper tool; or click the Matte box's color square to call up the Color Picker. (See page 217 for more about using the Color Picker.)

- PNG-8. The more basic of your PNG choices in Elements, this format gives you much the same options as you get with GIF. Both formats give you advanced options for how to display colors (in other words, to have Elements generate the color lookup table if you're a web-design maven). The menu below the file-format menu lists your options (Elements chooses Selective unless you change it). You can safely ignore this menu, but if you're curious, here are your choices: Selective, the standard setting, favors broad areas of color and keeps to web-safe colors; Perceptual favors colors to which the human eye is more sensitive; Adaptive samples colors from the spectrum appearing most commonly in the image; and Restrictive keeps everything within the old 216-color web palette.
- PNG-24. This is the more advanced level of PNG. Technically, both PNG formats let you use transparency, but more web browsers understand transparent areas in PNG-24 than in PNG-8. You can also choose a matte color like you do for JPEG files, and Interlacing, which is the same as it is for GIFs.

Figure 17-4:

JPEG format doesn't preserve transparent areas when you save your image, but Elements helps you simulate transparency by letting you choose a matte color, which replaces the transparency. When you choose a matte color that's identical to your web page's background, you create a transparent effect. For example, the purple matte around this hibiscus blossom will blend into the purple background of the page it goes on.

TIP The Elements Color Picker lets you limit your choices to web-safe colors—just turn on the Only Web Colors checkbox in its lower-left corner. But do you *have* to stick to this limited color palette for web graphics? Not really. You need to worry about keeping to web-safe colors only if you know the majority of people looking at your image use *very* old web browsers. All modern browsers can cope with a normal color range. Getting colors to display consistently in all browsers is another kettle of fish; see the next section for details.

Previewing Images and Adjusting Color

Elements gives you a few ways to preview how your image will look in a web browser. You can start by looking at your image in any browser you have on your computer (see Figure 17-5).

Figure 17-5:

To preview your image in a web browser, click the Preview In box in the Save For Web dialog box's bottom right to launch your Mac's standard web browser. (Elements should display your chosen browser's icon, or the last browser you used for previewing in Elements, but there's a bug that may cause it to show a blank white area instead. This doesn't affect how it works, though.) Or you can click the arrow and choose a browser from the list. The first time you click this arrow, you may need to pick Edit List, as shown in the figure, and then click Find All to use the browser you want. Elements sniffs out every browser on your computer and adds what it finds to the list.

To add a new browser, in the Save For Web dialog box, click the Preview In pull-down list, and then choose Edit List. In the Browsers dialog box that appears, click the Add button and navigate to the browser you want. If you want to have *all* your browsers listed, click Find All instead. From now on, you can pick any browser from the list. When you do, Elements launches the browser with your image in it.

To get a rough idea of how your image will look on other people's monitors, in the Save For Web dialog box, click the arrow next to the upper-right corner of the right-hand preview window. The list that appears (shown in Figure 17-2) includes the following options:

- Browser Dither. If an image contains more colors than a web browser can display, the browser uses dithering (see page 480) to create the additional colors. Select this option to get an idea of how your image will look if a browser has to dither the colors.
- Uncompensated Color. This option shows colors the way they normally appear on your monitor, without adjusting them.
- Standard Windows Color. This option displays colors the way they should look on an average Windows monitor.
- Standard Macintosh Color. This option shows colors the way they should look on an average Mac monitor.
- Use Document Color Profile. If you kept the image's ICC profile (page 204), this setting tries to show how your image will look as a result.

Keep in mind that these are all only rough approximations. You need only take a stroll down the monitor aisle at your local electronics store to see what a wacky bunch of color variations are possible. You really can't control how other people will see your image without going into their homes and adjusting their monitors.

NOTE Changing any of these color options affects only the way the image displays on your monitor in Save For Web; it doesn't change anything in the image itself or the way it displays in other parts of Elements.

Creating Animated GIFs

With Elements, it's easy to create *animated GIFs*, those little illustrations that make web pages look annoyingly jumbled or delightfully active, depending on your tastes. If you've ever seen a strip of movie film or the cels for a cartoon, Elements creates a similar series of frames with these specialized GIFs.

Animated GIFs are made up of layers. (If you download an animated GIF and open it in Elements, it appears as a multilayered image.) To create an animated GIF, you make a new layer for each frame. Save For Web creates the actual animation, which you can preview in a web browser.

NOTE It's a shame that you can't easily animate a JPEG the way you can a GIF. Most elaborate web animations involving photographs are done with Flash, which is another program altogether. (If you want the full story on Flash, pick up a copy of *Flash CS4: The Missing Manual*).

The best way to learn how to create an animated GIF is to make one. Here's how to make twinkling stars:

1. Set your Background color to black and your Foreground color to some shade of yellow.

See page 217 if you need help setting the Foreground and Background colors.

2. Create a new document.

Press **%**-N. In the New dialog box, set the size to 200 pixels × 200 pixels, the resolution to 72 ppi, the color mode to RGB, and background contents to Background Color.

3. Activate the Custom Shape tool (page 375) and choose a star shape.

In the Options bar, click the down arrow to the right of the Shape field to open the Shapes palette. Then click the double arrow in the palette's upper right and, from the menu, select Nature. Click the Sun 2 shape, which is in the top row, second from the left.

4. Draw some stars.

Drag to draw a yellow star, and then, in the Options bar, click the "Add to shape area" button before drawing four or five more. (This step puts all the stars on the same layer, which is important so you won't have a bunch of layers to merge.)

5. Merge the star layer and the Background layer.

Choose Layer \rightarrow Merge Down. You now have one layer with yellow stars on a black background, like the bottom layer shown in Figure 17-6.

Figure 17-6:

This animated GIF has only two frames, which makes for a pretty crude animation. The more frames you have, the smoother the animation. But more frames make a bigger file, too. On a tiny image like this one, size doesn't matter, but with a larger image, your file can get huge fast.

6. Duplicate the layer.

Choose Layer → Duplicate Layer or press \#-J. You now have two identical layers.

7. Rotate the top layer 90 degrees.

Click any tool in the Tools panel other than the Shape tool, and then go to Image → Rotate → Layer 90° Left (if the Shape Selection tool is active, the Rotate command doesn't work). You should now have two layers with stars in different places on each one.

8. Animate your GIF.

Go to File → Save For Web, and in the dialog box that appears, turn on the Animation checkbox. (If you don't see the Animation checkbox, make sure GIF is listed in the box below the word "Preset"; if it's not, select it from the pull-down menu.) In the Animation section of the dialog box, leave the Loop checkbox turned on so the animation repeats over and over. (If you turn it off, your animation plays just once and stops.)

NOTE: Unfortunately, there's a bug in Elements 8 (an old one, as you know if you've used Elements 6) that won't let you change the frame rate of an animated GIF. You can make changes in the Delay box by putting your cursor in the Percent box and using the Tab key to get to the Delay settings, and even change the numbers there, but they have no effect on the actual animation rate.

9. Preview your animation.

You can use the arrows in the Animation section to step through your animation one frame at a time, but for a more realistic preview, view the image in a web browser as explained in the previous section. The stars should twinkle. Well, OK, they flash off and on—think of twinkle lights. Save your animation, if you like, by clicking OK.

Emailing Photos

Elements lets you send photos as email attachments, but it's a limited feature more of a convenience than anything. You can start from Bridge or Elements. Just follow these steps:

1. Choose your photo(s).

Open a photo in Elements, or select it in Bridge. You can only attach one photo per message from Elements, but you can send multiple photos from Bridge. If you've made changes to your photo in Elements, they won't appear in the emailed image unless you save the file in Elements first.

ON THE WEB

Creating Web Buttons

Elements makes it a snap to create buttons to use on web pages. Here's what you do:

- Create a new blank file (%-N). In the New dialog box's Preset menu, choose Web and pick a size you like; from the Background Contents menu, choose Transparent. Then click OK.
- Set the Foreground color square to the color to use for your button, and use the Shape tool to draw the shape you want. (It helps to choose Actual Pixels for your view size when doing web work, because that shows you what you'll see in a web browser.)
- Apply one or more Layer styles (page 401) to make your button look 3-D. Bevels, some of the Complex Layer styles, and the Wow Layer styles are all popular choices.
- Add any necessary text using the Type tool (page 419). You may want to apply a Layer style to the text, too.
- 5. Save as a GIF.

Easy, huh?

2. Send your photo.

Auto Convert

In either Elements or Bridge, go to File \rightarrow "Attach to Email". In Elements, you can also go to Share \rightarrow Email Attachments. If you send from Bridge, your photo(s) get attached with no arguing, but if you try to send a large file from Elements you see the window shown in Figure 17-7.

Attach to Email Warning: The image you are sending may be too large for some recipients to download. Would you like Photoshop Elements to Auto Convert it to a smaller size or send the file as is?

Cancel

Figure 17-7:

If you try to send a big photo from Elements, it offers to make a smaller JPEG file for you. Click Auto Convert if that's what you want to do, or click Send As Is if you want to send the full-sized, original-format file, in which case you'll be asked again if you're sure you don't want to send a JPEG instead.

If you choose Send As Is and your image isn't a JPEG file, you see another window offering to convert it to a JPEG. Click Send As Is in that window, too, if you want to send the original format, or Auto Convert to send a JPEG version. (If you try to email a Raw file, either program automatically sends a JPEG instead so the recipient can see it without needing any kind of conversion software to convert it to a viewable format.)

Send As Is

Your regular email program pops up, with your photo attached to a new message.

It's convenient to send photos right from Elements, but not many people actually use this feature, since you have no control over how Auto Convert resizes it. (If you start with a really big image, you may still have a large file after Auto Convert is done—maybe too big to send to dial-up users.) You may prefer to use something like Save For Web (page 476) to create a small file, and then use the Attach button in OS X Mail or whatever email program you use.

TIP If you're jealous of all the fancy email stationery in the Windows version of Elements, don't be: In either OS X 10.5 or 10.6, just create a new message in OS X Mail and click the Show Stationery button in the top bar of the message window for a bunch of formatting choices, all created by Apple designers. (The button says Photo Browser until there's a photo in your message.)

Creating a Web Photo Gallery

With the Mac version of Elements, you can create the same web photo galleries that you can make with full-blown Photoshop. The gallery styles are pretty basic (they're the same in Photoshop), but if you want to create quick galleries right from Elements (well, Bridge, really), this feature is handy. However, Elements galleries are only intended to show off your photos, not to be full-blown websites. (You can't add large blocks of text on the page with your images, for example.) Figure 17-8 shows a typical gallery. Here's how to create one:

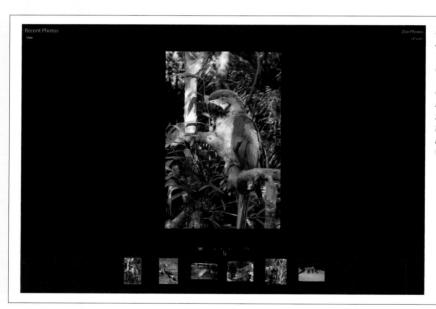

Figure 17-8:
A completed Elements web gallery. This one is in the Filmstrip template. Your site visitors use the controls below the main image to play the sideshow, or click a thumbnail in the filmstrip below to see a larger version of that image.

1. Start your gallery.

First, gather your photos so you'll be able to see them all at the same time in Bridge. You might want to put them all into the same folder, for example.

2. Call up the Web Gallery panel.

You can start your gallery from either Elements or Bridge. In Elements, go to the Share tab and click the Web Photo Gallery button. In Bridge, go to Window → Workspace → Output. Either way, you wind up in Bridge. In the Output panel, click the WEB GALLERY button if it's not already active.

3. Choose your photos.

If you start from Elements, your open photos don't automatically come along for the ride; you have to choose your photos in Bridge before you can proceed. Click the ones you want to include.

4. Choose a template and a style.

At the top of the Output panel are two pull-down menus. First, use the Template menu to choose the general arrangement of your photos and the kind of gallery you want to create. Then use the Style menu to pick from the options available for the template you selected. Your choices vary quite a bit. If you select the Filmstrip template, for instance, the Style menu offers "Darkroom" as your only choice, while choosing the Lightroom Flash Gallery template gives you a number of different color schemes and arrangements to pick from. You can also do some customizing in the next step, no matter which template and style you choose.

To preview the choices, click the Refresh Preview button each time you make a change, or you won't see your changes in the Output Preview panel in the center of the window. This is true for any change you make in the Web Gallery panel—click Refresh Preview each time you make a change to see its effects.

5. Enter the info you want your visitors to see.

In the Site Info section of the Output panel, enter a name for your gallery, text for the About this Gallery page (see Figure 17-9), and the contact and copyright info you want to include. Each style also includes either a Gallery Caption or Collection Title where you can add a few lines of additional information about your photos.

Figure 17-9:

"About this Gallery" is the only place where you can enter a large amount of text in any of the Elements galleries (and it's only available for certain templates), but it can be hard for your visitors to find that page of your site. In the finished gallery, they'll need to click the View menu to see the words "About this Gallery", and then click that phrase to see the text you entered in this box.

6. Customize your gallery's look.

The Output panel's Color Palette section includes a list of the various components of the gallery, like text, header text, background, and so on. Each of these has a color square to its left. Click the square to bring up the Apple Color Picker and choose a new color for any item you want to change.

TIP You can customize all the templates, but if you want a colorful look, check out the Lightroom Flash Gallery Styles, many of which include more vivid color schemes than the rest of the templates do.

The choices in the Appearance section change quite a bit from template to template. For templates that include a slideshow view, you see choices for how long each photo should remain onscreen and what kind of transition to use between slides. In other templates you may see options for size of the preview images, where the previews should be located relative to the large image, or how many rows and columns of preview thumbnails there should be. For the templates that have "Journal" in their names, you get the option to show shooting metadata (page 55) from your images, a useful way to share that info.

7. Create your gallery.

In the bottom section of the panel, name your gallery (this is the file name, not the name that appears onscreen) and decide how you want Bridge to output it. You have two choices here:

• Save to Disk. If you don't want to upload your gallery directly to a website, or if you want to burn it to disc and send it to people that way, choose this option. Click the Browse button to select where to save the file, and then click Save.

NOTE To view one of these galleries without going online, open the gallery folder and find the file labeled Index.html. Double-click it to open it in your browser, just as you'd see it on the Web.

• Upload. You can send your gallery directly to your website right from Bridge. Your Web server administrator can help you with the exact upload settings if you aren't sure what they are. If you use these galleries a lot, you can turn on Remember Password so you don't have to type it every time. You can also tell Bridge to remember the server as a preset by clicking the square to the right of the Custom option.

Part Six: Additional Elements

Chapter 18: Beyond the Basics

Beyond the Basics

So far, everything in this book has been about what you can do with Elements right out of the box. But as with many things digital, there's a thriving cottage industry devoted to souping up Elements. You can add new brushes, shapes, Layer styles, actions, and fancy filters. Many of the tools are designed to make Elements behave more like Photoshop. And best of all, a lot of what's out there is free. This chapter looks at some of these extras, how to manage the stuff you collect, and how to know when you need the full version of Photoshop instead. You'll also learn about the many resources available for expanding your knowledge of Elements beyond this book.

Graphics Tablets

Probably the most popular Elements accessory is a *graphics tablet*, which lets you draw and paint with a pen-like stylus instead of a mouse. A tablet is like a souped-up substitute for a mouse: You control your onscreen cursor by drawing directly on the tablet's surface—an action that many artists find offers them greater control. If trying to use the Lasso tool with a mouse makes you feel like you're trying to write on a mirror with a bar of soap, a graphics tablet is for you.

NOTE Some deluxe-model graphics tablets act as monitors and let you work directly on your image, but you need to budget close to a thousand dollars for that kind of convenience.

Most tablets work like the one shown in Figure 18-1: You use the special pen on the tablet as you would a mouse on a mousepad; any changes you make appear right on your monitor.

Figure 18-1:

A Wacom Graphire tablet in action. This tablet is 6"

× 8". The working area is inside the rectangle on the tablet's surface. For basic photo retouching, a small size is usually fine once you get used to it. If you want to do more drawing and you generally use sweeping strokes when you draw, you may want a larger tablet.

For most people, it's much easier to control fine motions with a tablet's stylus than with a mouse. And when you use a tablet, many of Elements' brushes and tools become *pressure sensitive*—the harder you press, the darker and wider the line becomes. The stylus lets you create much more realistic paint strokes, as shown in Figure 18-2.

Figure 18-2: Two almost identical paint strokes, starting with fairly firm pressure and then easing up. Both were made using the same brush and color settings. The only difference is that the stroke on the left was drawn with a mouse, and the one on the right came from a tablet. You can see what a difference the pressure sensitivity makes.

When using the Brush tool, you'll see a tiny black triangle in the Options bar just to the right of the Airbrush setting; that lets you access the tool's Tablet Options. Many brushes and tools are automatically pressure sensitive when you hook up a tablet. These settings let you choose whether to let the pressure control the size, opacity, roundness, hue jitter, and scatter for your brushes. (See page 347 for more about Brush settings.)

With a tablet, you can also create hand-drawn line art—even if you don't have an artistic bone in your body—by placing a picture of what you want to draw on the surface of the tablet and tracing over it. Also, if you find constant mousing troublesome, you may have fewer hand problems when using a stylus. Most tablets come with a wireless mouse, which works only on the surface of the tablet. Or you can use your regular mouse on a mousepad or on your desk the way you always do, if you like to switch between the stylus and a mouse.

Tablets now start at less than a hundred dollars, a big drop from what they used to cost. There are lots of different models, and their features vary widely. Sophisticated tablets offer more levels of sensitivity and respond when you change the angle at which you hold the stylus.

Wacom, one of the big tablet manufacturers, has some nifty demos on its website (www.wacom.com) if you click on the various product tours. You can't actually simulate what it's like to use a tablet, but the animations give you a good idea of what your life would be like if you were to go the tablet route.

Free Stuff from the Internet

You have to spend some money if you want a graphics tablet, but there's a ton of free stuff—tutorials, brushes, textures, and Layer styles, for example—available online that you can add to Elements. Most of these add-ons say they work with Photoshop, but since Elements is based on Photoshop, you can use many of them in Elements, too.

Here are some popular places to go treasure hunting:

- Adobe Exchange (www.adobe.com/cfusion/exchange/). On Adobe's own website, you can find hundreds and hundreds of downloads, including more Layer styles than you could ever use, brushes, textures, and custom shapes to use with the Shape tool. Many are free once you register. This site is one of the best resources for extra stuff. About 99 percent of the items listed are made specifically for Photoshop, but Photoshop's brushes, swatches, textures, shapes, and Layer styles work in Elements, too. See the box on page 498 for help with installing your finds in Elements.
- MyJanee (www.myjanee.com). You'll find lots of tutorials and free downloads on this site.
- Sue Chastain (http://graphicssoft.about.com). This is another site with lots of downloads and many tutorials.

- Panosfx (www.panosfx.com). Panos Efstathiadis produces some wonderful actions (see the next section for more about actions) for Photoshop, and he's adapted many of them for Elements as well. Most are free; some cost a few dollars.
- Hidden Elements (www.hiddenelements.com). Richard Lynch has been creating wonderful add-on tools for Elements practically as long as the program has existed. Some are free, many are not, but all are worth the investment.
- Grant's Tools (www.cavesofice.org/~grant/Challenge/Tools/index.html). Here's another source of popular free tools for Elements. The current set of tools is for Elements 6, but Grant Dixon may update them for Elements 8, and most of the existing tools should work anyway.
- onOne Essentials (www.ononesoftware.com). This company makes a popular suite of plug-ins—add-ons—for Elements that's just been updated for Elements 8. The new version, Essentials 3, includes a number of new image effects, in addition to the resizing, framing, masking, and retouching modules in earlier versions. The suites aren't cheap and you can do most of what they do in other ways, but lots of people like the convenience of these plug-ins. There's a discount coupon for the suite in each boxed version of Elements 8, or you can find it by going to www.ononesoftware.com/psetmm.
- ShutterFreaks (*www.shutterfreaks.com*). This website has a number of Elements add-ons. Some are free, but most cost a few dollars. You'll find tutorials on this site, too.
- Simple Photoshop (http://simplephotoshop.com). The home of the popular (though not free) Elements+ add-on tools, and also some tutorials.

If you're willing to pay a little bit, you have even more choices. You can find everything from more elaborate ways to sharpen photos to really cool collections of special edges and visual effects. Prices range from donationware (pay if you like it) to some sophisticated plug-ins that cost hundreds of dollars. You can also buy books like the *Wow!* series (Peachpit Press), which have loads of illustrations showing the styles available on the included CD.

NOTE Elements 8 is based on Photoshop CS4, so CS4 downloads are compatible with it. Plugins and other goodies designed for older versions of Photoshop or Elements usually work with newer versions, but not the other way around. For example, a brush made for Photoshop CS4 works in Elements 8 but not in Elements 3.

Windows plug-ins don't work with Macs, and vice versa, but many plug-ins offer two versions, one for each platform. When buying a plug-in, check with the developer to be sure it works with Elements 8 for Mac. Also, remember that Elements 8 doesn't run in Rosetta (see page 4), so any plug-ins you buy must be Intel-native, meaning they're not written for older PowerPC Macs. (This shift away from Rosetta doesn't have any effect on actions, Layer styles, shapes, brushes, and gradients—only plug-ins.) So most plug-ins that are more than a few years old won't work with Elements 8.

With so many goodies available, it's easy get overwhelmed trying to keep track of everything you've added to Elements. Your best bet is to make backup copies of everything you download, so you'll have it if you ever need to reinstall Elements. Elements also includes a Preset Manager (Figure 18-3) that can help you keep track of certain kinds of downloads. Go to Edit → Preset Manager to launch it.

Figure 18-3:
Elements' Preset Manager
lets you see all your
brushes, swatches,
gradients, and patterns in
one place. You can use it to
change which groups are
loaded, to add or remove
items, and so on—the same
way you do in the main
brush window.

When You Really Need Photoshop

In Photoshop you get more of everything: more choices, more tools, more settings, more types of Adjustment layers, and so on. You can do a ton with Elements, but some people do need the full version of Photoshop. For example, if you want to write your own *actions* (little scripts, like macros, that automate certain things in Photoshop and Elements) or if you have to work extensively in CMYK mode, you need Photoshop.

CMYK is the color mode used for commercial printing—it stands for Cyan, Magenta, Yellow, and black, which are the colors professional printers use. When you send a file to a print shop, the printer usually needs it to be a CMYK file. You can't convert files to CMYK in Elements, so if you need CMYK files on a regular basis, it's worth the extra price of Photoshop. If you only occasionally need CMYK, ask your printer about converting the file for you for an additional charge.

TIP You can technically use Mac OS X's Preview application to convert your photos to CMYK mode, but it's usually best not to. Good CMYK conversion is *device-dependent*, which means you need to know about the machine that will print your image and the kind of ink and paper it'll use in order to know how to adjust your image to get a printed version close to your original. Preview simply doesn't give you all the tools you need to get optimum results. So, while it's better than no CMYK conversion at all, your best bet is to talk your print shop about CMYK.

If you have to use Preview to create a CMYK file, here's how: Head to where your image is saved and right-click (Control-click) it and, in the menu that appears, select Open With \rightarrow Preview. Once you're in Preview, go to Tools \rightarrow "Match to Profile" \rightarrow Color Model \rightarrow CMYK, and then choose the CMYK profile you want.

Beyond This Book

You can do thousands of interesting things with Elements that are beyond the scope of this book. The Help menu gives you access to some interesting tutorials right from Elements. Also, bookstores have loads of titles on Elements and Photoshop, and a lot of procedures are the same in both programs. You can find all kinds of specialized books on everything from color management to making selections to scrapbooking.

POWER USERS' CLINIC

Making Elements Behave More Like Photoshop

Ever since Elements first came out, there's been quite a cottage industry devoted to figuring out ways to get Elements to behave more like Photoshop. If you've used Elements 3 or earlier versions, odds are that you're familiar with the extra tools and action players created by Richard Lynch, Paul Shipley, Grant Dixon, and Ling Nero. Unfortunately, Adobe decided to write Elements 4 in a way that disabled the traditional route used by add-on tools to access some of the underlying Photoshop code needed for these additional features to work. That meant that many of the existing add-on tools stopped working in Elements 4.

For now, it's best to stick to actions written for Elements versions 4 and higher to be sure they'll work. (See the box on page 498 for more about installing action-based tools.) If you've been using extra tools or actions in Elements 3, you may want to keep the older version of the program around just for them if you're using 10.5. (You can have as many different versions of Elements as you like installed on your computer, and you can even run more than one version at a time, although it's best to launch the oldest version first.)

In addition, you'll find hundreds of tutorial sites on the Web. Besides those mentioned earlier in the chapter, other popular sites include:

- Adobe (www.adobe.com). You'll find plenty of free online training for Elements here.
- Photoshop Roadmap (www.photoshoproadmap.com). This site has tutorials and plug-ins for Photoshop, but there's a big section of Elements tutorials, too.

- Photoshop Support (www.photoshopsupport.com/elements/tutorials.html).
 Despite the name, this site isn't run by Adobe, but it has a whole section of Elements tutorials.
- YouTube (www.youtube.com). Yep, that's right: You can find videos about almost anything on YouTube, including lots of Elements tutorials.
- Photoshop Elements Techniques (www.photoshopelementsuser.com). This is the website for a subscriber-only print newsletter, but it includes some free online video tutorials, a forum, and a good collection of links. This is the only publication especially for Elements. Their forums are hosted at www.elementsvillage.com.
- Graphic Reporter (http://graphicreporter.com). The website of Photoshop maven Lesa Snider includes many well-written Elements tutorials.
- Eclectic Academy (www.eclecticacademy.com). This site offers popular, inexpensive online courses in Elements.

If you search around online, you're sure to find a tutorial for any project you have in mind, although many of them are written for Photoshop. In most cases, you can adapt them for Elements. If you get stuck or need help with any other aspect of Elements, there's an active online community that's sure to have an answer for you. Besides the sites already mentioned, try:

- Adobe Support forum (http://forums.adobe.com/community/photoshop_elements). The official Adobe Photoshop Elements User-to-User forum, where you can connect with lots of helpful and friendly people. This is your best bet for getting answers without calling Adobe support.
- Digital Photography Review (www.dpreview.com). This site has a bunch of camera-specific forums. You can also get a lot of Elements answers in the Retouching forum if you specify in your question that you have Elements rather than Photoshop.
- RetouchPRO (www.retouchpro.com). The forums here cover all kinds of retouching and artistic uses for Elements and Photoshop. They also host frequent webcasts about digital imaging.
- Photoshop Creative Elements (www.photoshopcreativeelements.com). Another forum for Elements enthusiasts.

Many sites are devoted to scrapbooking with Elements. A good place to start is Scrapper's Guide (www.scrappersguide.com), a commercial site run by Linda Sattgast.

No matter what you're looking for—add-ons, tutorials, communities—try a Google search, and you're sure to find a site that has what you want.

There's no question about it: Once you get familiar with Elements, it's addictive. Lots of folks have found out how much fun this program is, so you shouldn't have any trouble finding the answer to any question you have. The only limit to what you can do with Elements is your imagination. Enjoy!

POWER USERS' CLINIC

Adding Layer Styles, Shapes, and Actions

Adding your online finds to Elements 8 is a good news/bad news situation: It's easy to add Layer styles, shapes, and actions (see the box on page 496 for more about actions), but if you want to categorize them or have them show up in your Content panel searches, you're in for a trip through some pretty techie territory.

To add your extras, just put them into the folders described below; the next time you launch Elements, they'll show up in the Show All section of the relevant palette. Here's how to add them:

- Layer styles. Put them into <your hard drive> →
 Library → Application Support → Adobe → Photoshop Elements → 8.0 → Photo Creations → Layer
 Styles. (You have three Library folders on your computer. This is the one at the *top* level of your hard drive, not the one in <your username> →
 Library or the one in System → Library.) The files should have the extension .asl.
- Actions. The easiest way to install most actions is
 via Guided Edit's Action Player, explained on page
 398. The drawback is that if you install an action
 that requires you to use the Layers panel during a
 step (to choose the target layer for the action's
 next step, for instance), you can't do that in
 Guided Edit. And since many add-on tools for Elements are really actions, you want to be able to
 use them in Full Edit. But you can't do that with
 actions installed in the Action Player.

If you want to use actions in Full Edit, things get a bit more complicated. First, you need two files: one for the action itself (the .atn file) and one to use as a thumbnail so that you can find the action to launch it. The thumbnail needs to be a 64-pixel square PNG image with *exactly* the same name as the action (except for the file extension), including spacing, capitalization, and so on. Put both the thumbnail and the .atn file (individually, not in a folder) into <your hard drive> → Library → Application Support → Adobe → Photoshop Elements → 8.0 → Photo Creations → photo effects.

• **Shapes.** Put your downloaded shape files (which need to have the .csh file extension) into <your hard drive> → Library → Application Support → Adobe → Photoshop Elements → 8.0 → Photo Creations → shapes.

Once you've put everything in the right place, your Layer style or shape will show up in Show All in the Content panel. Actions installed using the directions listed here also appear in the Effects panel → Photo Effects → Show All. For mere mortals, that's all there is to it, but if you're a techie who understands XML, read on.

You can make your content appear in its own category if you also create an XML file (a snippet of code that gives Elements directions for categorizing the file and searching for it). The easiest way to do this is to find an XML file for an existing Layer style, photo effect, or whatever, duplicate it, and then edit its contents. The XML file goes into the same folder as the item you're adding. You'll see that each Layer style, shape, and so on that came with Elements has one of these files.

Regardless of whether you completed the XML steps, when you want to remove content that you've added, right-click (Control-click) its icon in the panel, and then choose Delete Content from the shortcut menu, or click the icon once and then click the trashcan icon at the bottom of the panel. If you created a metadata (XML) file, go dig that out and remove it as well.

Whether or not you created XML files, if you're sure you put your new items in the right place and they still don't show up in the Content panel, go to <your hard drive> → Library → Application Support → Adobe → Photoshop Elements → 8.0 → Locale → en_US (the "en_US" part is different if you aren't in the U.S.) and delete the file named mediaDatabase.db3. The next time you launch Elements, wait before you do anything. Elements needs to rebuild the contents of the Effects panel and that may take a few minutes. Don't try to use the program till you see the thumbnails reappear in the panel.

Part Seven: Appendixes

Appendix A: Elements, Menu by Menu

Appendix B: Installation and Troubleshooting

Appendix C: Bridge CS4, Menu by Menu

Elements, Menu by Menu

Elements has some pretty complicated menus. All three editing modes—Full Edit, Quick Fix, and Guided Edit—have the same menus, although some choices are grayed out when you're in Quick Fix or Guided Edit. When you need a menu item that's not available in Quick Fix or Guided Edit, just switch back to Full Edit to use it.

Several of the menus in Elements are *dynamic*: They change quite a bit to reflect the choices currently applicable to your image. That means the choices you see in this appendix represent only what you *may* see depending on the situation. The Layer menu, for instance, offers very different options depending on the current state of your image and which layer is active.

NOTE The leftmost item in your menu bar, the **t** menu, is system-wide and not part of Elements.

Photoshop Elements Menu

These menu choices provide info about Elements, let you adjust some of its settings, and control the program's visibility.

About Photoshop Elements

Choose this to see a window about the version of Elements you have. It includes a long list of patents and credits—a testimony to the complexity of the engineering that went into Elements.

About Plug-in

Select this option for a long pop-out menu displaying all the plug-ins (page 494) in your copy of Elements. Choose a plug-in from the list to see its version and date info.

Patent and Legal Notices

This item displays a list of the various patents for Elements, as well as trademark information for some of the components used in the program.

Preferences

This menu item gives you access to the many Elements settings you can customize. You'll find the following preference windows available from this menu:

- **General** (or press **%**-K)
- Saving Files
- **Performance** (where you set the number of history states and assign scratch disks)
- · Display & Cursors
- Transparency
- · Units & Rulers
- · Guides & Grid
- Plug-Ins
- Type

Services

This is where you can access the OS X utility programs like Grab (for taking screenshots) or TextEdit (for copying text). Your exact choices in the submenu depend on what programs you have installed on your Mac. It's normal for some to be grayed out. Dictionary, for instance, isn't available unless some text is highlighted. In Snow Leopard, you can control what appears in this menu (it may show no choices when you first install Elements) by going to System Preferences → Keyboard → Keyboard Shortcuts → Services.

Hide Photoshop Elements

If you don't want Elements to be visible, choose this or press Control-\#-H.

Hide Others

If you want Elements to be your only visible program, choose this or press Option-\#-H.

Show All

Use this to bring all your hidden programs back into view.

Quit Photoshop Elements

You can shut Elements down by choosing this menu item, or by pressing **%**-Q.

File Menu

The commands listed here let you create, import, open, save, and print files.

New

Choose this item if you want to start a new file in Elements. Your options are:

- Blank file (or press \%-N).
- Image from Clipboard automatically pastes anything you've copied into a new file.
- **Photomerge Group Shot** lets you move a person from one photo of a group into another photo of the same group (page 329).
- **Photomerge Faces** lets you combine parts of different faces for caricatures and other fun effects (page 326).
- Photomerge Scene Cleaner lets you remove unwanted people or other details from a photo by copying over bits of other photos (page 329). This feature is new to Elements 8.
- **Photomerge Panorama** lets you combine your photos into panoramas (page 520).
- **Photomerge Exposure** lets you combine bracketed shots into one properly exposed photo (page 251). This feature is new to Elements 8.

Open

Choose this menu item or press ₩-O to open an existing file.

Browse with Bridge

Select this, and Elements switches you over to Adobe Bridge so you can browse through all your available image files (see page 18).

Open Recently Edited File

Here you'll find a pop-out list of the most recent files you opened in Elements.

Duplicate

When you need to make a copy of your photo, choose this option.

Close

To close the active image window, choose this menu item or press **₩**-W.

Close All

To close all your open image windows, choose this option or press Option-\%-W.

Save

To save your work, select this option or press **%**-S.

Save As

To save your image under another name or in a different format, choose this command or press Shift-\(\mathbb{H} - \mathbb{S} \).

Save For Web

To save an image so that it's optimized for posting on a web page or sending by email, choose this menu item or press Option-Shift-\(\mathbb{H}\)-S. For more on the Save For Web window, see page 476.

Adobe Photo Downloader

If you want to use the Adobe Downloader (page 19) to get photos from your camera or card reader, you can launch it here.

Attach to Email

To send a photo directly from Elements, choose this menu item (see page 484).

Create Web Photo Gallery

If you want to use Elements to make an online gallery, this is where you start (page 486).

File Info

Choose this menu item to bring up the File Info window, which displays general info about your image (file creation date, file format, and so on). You can also add or edit metadata here (see page 55).

Place

Use this command to place a PDF, Adobe Illustrator, or EPS file into an image as a new layer. If the artwork is larger than the image you place it in, Elements automatically makes it small enough to fit. In Elements 8, anything (including objects from images in regular formats like TIFF or JPEG) that you put into a file with this command becomes a Smart Object (page 448).

Process Multiple Files

This is where you batch process files to rename them, change their format, add copyright info, and so on (see page 258 for everything that Elements lets you do to groups of files).

Import

This is where you bring certain file formats into Elements. It's also where you can connect to external devices like scanners. (They'll show up in this menu if you install their drivers.) Your basic choices before you connect or install anything are:

- Anti-aliased PICT. This is for importing PICT objects created in programs like MacDraw or Canvas. Anti-aliasing makes them appear smooth.
- **PICT Resource.** A type of PICT file used in the resource fork of a Mac file, for things like an application's opening screen.
- Frame From Video (page 49).

Export

This command is always grayed out. That's normal. Adobe left it in for the benefit of any third-party plug-ins that may need it to be there—but you don't need it to use Elements' standard tools and commands.

Automation Tools

You can make a PDF slideshow here, starting from the pop-out menu (page 458).

Print

Choose this command and you get the Print window, which is discussed in detail in Chapter 16. Keyboard shortcut: **%**-P.

Contact Sheet II

To make a contact sheet showing thumbnails of many photos (see page 469), choose this menu item.

Picture Package

To print several photos—or multiple copies of one photo—in different sizes on one page (see page 471), choose this command.

Edit Menu

The menu choices listed here let you make changes to your files.

Undo

You can back out of your last action by selecting this item or pressing **%**-Z. You can keep applying this command to undo as many steps as you've set in the Undo History panel's preferences (Photoshop Elements → Preferences → Performance → History States). You can also use the Undo button at the top of your screen.

Redo

If you undo something and then change your mind, you can redo it here (or click the Redo button at the top of your screen, or press \(\mathbb{H} - \text{Y} \).

Revert

Choose this command to return your image to the state it was in the last time you saved it.

Cut

To remove something from your image and store it on the Clipboard (so that you can paste it into another file), choose this menu item or press **ૠ**-X.

Copy

To copy something to the Clipboard, highlight it and select this menu item or press **%**-C. The Copy command copies only the active layer in a layered file. To copy *all* the layers in your selected area, use Copy Merged instead.

Copy Merged

To copy all the layers in the selected area to the Clipboard, choose this menu item or press Shift-\(\mathbb{H}\)-C. To copy only a single layer to the Clipboard, make it the active layer, and then use Copy instead.

Paste

Use this command or press **%**-V to put whatever you've cut or copied into an image.

Paste Into Selection

Use this special command for pasting something within the confines of an existing selection; page 127 has more on how it works. Keyboard shortcut: Shift-\(\mathbb{H}\)-V.

Delete

This command removes what you've selected without copying it to the Clipboard—it's just gone. You can press the Delete key to do the same thing.

Fill Layer, Fill Selection

Choose this menu item to fill your active layer with a color or pattern (page 276). You can also choose a blend mode and opacity for your fill. When you make a selection, this menu item changes to read "Fill Selection".

Stroke (Outline) Selection

This command lets you put a colored border around the edges of a selection.

Define Brush, Define Brush from Selection

If you want to create a custom brush from your photo or from an area of your photo, choose this command. The process is explained in detail on page 354.

Define Pattern, Define Pattern from Selection

This command creates a pattern from your image or selection. See page 276 for more about applying patterns.

Clear

Use this command to permanently remove info from the Undo History panel, Clipboard, or both (select All). If you have a corrupt image in the Clipboard (or one that's too large), it may cause Elements to slow way down or quit on you. Once in a while, the Clipboard may get stuck, too—you try to copy and paste an item but still get whatever you copied previously. Clear fixes all these problems.

Add Blank Page

This command lets you add a new, blank page to your current project. Page 447 has more about working with multipage files. Keyboard shortcut: Option-\mathbb{H}-G.

Add Page Using Current Layout

If you're working on a photo collage (page 441) and you want to use that page as a template for new pages, choose this command instead of Add Blank Page. Keyboard shortcut: Option-Shift-\(\mathbb{H}\)-G.

Delete Current Page

If you're working with a multipage document and you decide you want to get rid of the current page, choose this command.

Color Settings

Here's where you choose your color space for Elements (page 204). Keyboard shortcut: Shift-\(\mathbb{H} \)-K.

Preset Manager

This is where you access the window that helps you manage your brushes, swatches, gradients, and patterns. See page 495 for more on how the Preset Manager works.

Image Menu

This menu lets you make changes to your image like rotating it, changing its shape, cropping or resizing it, or changing its color mode.

Rotate

Use these commands to change your image's orientation (page 70). The first group of options applies to your whole image:

- · 90° Left
- · 90° Right
- · 180°
- Custom
- · Flip Horizontal
- Flip Vertical

The next group does the same thing but on a layer or selection. The menu choices change depending on whether you have an active selection. If you do, you'll see the word "Selection" instead of "Layer".

- Free Rotate Layer
- · Layer 90° Left
- Layer 90° Right
- Layer 180°
- Flip Layer Horizontal
- Flip Layer Vertical

Finally, you can choose to:

- Straighten and Crop Image
- · Straighten Image

These last two commands are mostly for use with scanned images when you need to straighten the whole image. To straighten the *contents* of an image, use the Straighten tool (page 71) instead.

Transform

These commands let you change the shape of your image by pulling it in different directions. They're explained in detail on page 337. Your choices are:

- Free Transform (\mathbb{H}-T) incorporates the other three commands.
- Skew slants an image.
- Distort stretches your photo in the direction you pull it.
- **Perspective** stretches your photo to make it look like parts are nearer or farther away.

TIP You might prefer to use the Correct Camera Distortion filter to transform your images to correct perspective. See page 332.

Crop

Choose this menu item to crop your image to the area you've selected (page 75).

Recompose

Use this to bring up the new Recompose tool (page 278), which lets you reshape your photos without distorting them and eliminate unwanted objects. You can also press Option-\(\mathbb{H}\)-\(\mathbb{H}\)-R or click its icon in the Tools panel.

Divide Scanned Photos

You can create a group scan by placing several photos on your scanner at once and then choosing this command. Elements cuts your photos apart and straightens and crops each photo. See page 67 for more about how this works.

Resize

Here's where you change the actual size of your image (as opposed to changing the size of what you see on your screen). Resizing is explained in Chapter 3. Your choices are:

- Image Size (page 90). Keyboard shortcut: Option-\.I.
- Canvas Size (page 97). Keyboard shortcut: Option-\(\mathbb{H} C. \)
- Reveal All. If you drag a layer from another image into your photo and part of the layer falls outside the perimeter of the target image, use this command to see the entire dragged layer. It basically resizes the canvas to fit all of the image(s). Also, some versions of Photoshop hide the area outside a selection when you use the Crop tool. If someone sends you one of these images, use this command to see the area that was hidden by the crop.
- **Scale** (page 337).

Mode

This is where you can change your image's color mode (page 51). Your choices are:

- · Bitmap
- Grayscale
- · Indexed Color
- · RGB Color

You'll find two other commands in this menu:

- 8 Bits/Channel reduces images from 16-bit color to 8-bit (see page 247).
- **Color Table** shows the color table (the colors of your image as swatches) for an Indexed Color image.

Convert Color Profile

If you need to change an image's ICC (International Color Consortium) profile, you can do that from this menu, which lets you apply an sRGB or Adobe RGB profile, or remove the profile from an image. For more on color profiles, go to page 204.

Magic Extractor

Use this command or press Option-Shift-\(\mathbb{H}\)-V to call up the Magic Extractor window, which automates the process of selecting an object and removing it from its background. See page 141 for details.

Enhance Menu

This menu contains the commands you use to adjust the color and lighting of your images. The first six options apply changes automatically, and the remainder let you adjust your changes.

Auto Smart Fix

Choose this option or press Option-\(\mathbb{H}\)-M to adjust lighting, color, and contrast at the same time (page 106).

Auto Levels

Use this command or press Shift-\(\mathbb{H}\)-L to adjust the individual color channels of your image (page 108).

Auto Contrast

Choose this command or press Option-Shift-\(\mathbb{H}\)-L to adjust the brightness and darkness of your image without changing the colors (page 108).

Auto Color Correction

Use this option or press Shift-\(\mathbb{H}\)-B to adjust your image's color in much the same way that Levels does. This command looks at different info in your photo to make its decisions, though (page 110).

Auto Sharpen

This command applies the same one-click sharpening as the Auto Sharpen button in Quick Fix (page 112).

Auto Red Eye Fix

Use this command or press **%**-R to automatically fix the red pupils caused by a camera's flash (page 104).

Adjust Smart Fix

This command is the same as the Auto Smart Fix button in Quick Fix, except you get a slider to adjust the degree of change Elements makes to your photo. Keyboard shortcut: Shift-\mathbb{H}-M.

Adjust Lighting

Your choices for adjusting the light and dark values in your photos are:

- Shadows/Highlights (page 194).
- Brightness/Contrast (page 193).
- Levels. You can also press **%**-L to bring up the Levels dialog box (page 206).

Adjust Color

With these settings you can change a color, replace a color, remove a color cast, remove all the color from your image, or add color to a black-and-white photo. Choose from:

- Remove Color Cast (page 213).
- Adjust Hue/Saturation (page 287). Keyboard shortcut: #-U.
- Remove Color (page 302). Keyboard shortcut: Shift-\(\mathbb{H} U. \)
- Replace Color (page 282).
- Adjust Color Curves (page 282). The Color Curves tool lets you adjust the brightness and contrast of specific tonal ranges (like highlights or midtones) in your photo.
- Adjust Color for Skin Tone (page 117). This setting adjusts the colors in your image based on the skin tones of someone you select in the photo.

- **Defringe Layer** (page 146). This setting gets rid of the rim of contrasting pixels you may get when you remove an object from its background.
- Color Variations (page 215).

Convert to Black and White

Use this menu item or press Option-\(\mathbb{H}\)-B to convert a color photo to a black-and-white image (page 299).

Unsharp Mask

This is the most popular traditional method for sharpening your photos (page 223).

Adjust Sharpness

Choose this menu item to use Adobe's newest sharpening tool (page 225).

Layer Menu

Here's where you'll find the commands for creating and managing Layers. (Chapter 6 is all about Layers.) This is the most dynamic menu in Elements—what you see at the bottom of the menu changes depending on the layers in the image that's open and on the characteristics of the active layer. This is a basic rundown of the main menu options you'll usually see if your open image has only a Background layer. (Sometimes you'll see choices that are visible but grayed out.) The options for merging and combining layers change the most as your layers change.

New

This is where you create new, regular (as opposed to Adjustment) layers. Your options are:

- Layer (or press Shift-\%-N).
- Layer From Background.
- Layer via Copy (or press ₩-J).
- Layer via Cut (or press Shift-\------\---J).

If your image doesn't currently have a Background layer, you see "Background From Layer" instead of "Layer From Background".

Duplicate Layer

Use this command to make a copy of the active layer. As long as you don't have a selection, you can also use **\%**-J to do the same thing.

Delete Layer

If you want to get rid of a layer, click it in the Layers panel to make it the active layer and then choose this command.

Rename Layer

Choose this option to—you guessed it—rename a layer. You can also double-click the layer's name in the Layers panel to do the same thing.

Layer Style

If a layer has a Layer style applied to it (page 401), you can adjust it here. Your options are:

- Style Settings brings up the dialog box where you can adjust some of the Layer style's settings. Double-clicking the Layer style icon in the Layers panel (the little "fx" to the right of the layer's name) brings up the same dialog box.
- Copy Layer Style lets you copy any styles applied to a layer to the Clipboard so you can apply them to another image or layer.
- Paste Layer Style applies your copied style to a new layer, even in a new image.
- · Clear Layer Style removes all the styles applied to a layer.
- **Hide All Effects** hides all the styles applied to a layer so you can see what your image looks like without them. If you hide all the styles, this menu item changes to read "Show All Effects".
- Scale Effects lets you adjust the size of certain aspects of Layer styles.

New Fill Layer

Choose this option to create a layer that's filled with a color, gradient, or pattern. (You can also do this from the Layers panel by clicking the Create Adjustment layer icon.) Your options are:

- Solid Color (page 181)
- Gradient (page 408)
- Pattern (page 181)

New Adjustment Layer

This command creates a new Adjustment layer (page 181). The types of layers you can create are:

- Levels (page 181)
- Brightness/Contrast (page 182)
- Hue/Saturation (page 182)

- Gradient Map (page 182)
- Photo Filter (page 182)
- Invert (page 182)
- Threshold (page 182)
- Posterize (page 182)

Layer Content Options

For Fill layers, this menu item brings up the dialog box where you can adjust the active layer's settings. For Adjustment layers, it makes the Adjustments panel display the settings for the selected layer. You can also double-click the left icon for the layer in the Layers panel (the one with two gears).

Type

This menu item gives you ways to modify a Text layer, as long as you haven't simplified it (page 373). You can choose:

- Horizontal. Change vertical type to horizontal type.
- Vertical. Change horizontal type to vertical type.
- Anti-Alias Off. Anti-aliasing is explained on page 427.
- · Anti-Alias On.
- Warp Text. See page 427.
- Update All Text Layers.
- Replace All Missing Fonts. When your image is missing fonts, this command replaces them, but you can't choose the replacement. It's usually just as easy to replace fonts by highlighting the text and selecting a new font in the Options bar.

Simplify Layer

This command rasterizes your layer, turning the layer's content from a vector or Smart Object to one that's built pixel by pixel. See page 373 for more about the difference between vectors and pixels.

Create/Release Clipping Mask

This command links two layers together so the bottom layer determines the opacity of the upper layer (page 175). If you've used earlier versions of Elements, this is the same as the old "Group with Previous" command. When you have clipped layers, this item reads "Release Clipping Mask" instead. Keyboard shortcut for either: \Re -G.

Arrange

Use these commands to change the order of layers in the layers stack, or just drag them in the Layers panel. Here are your options (Front is the top of the stack, and Back is directly above the Background layer):

- Bring to Front (or press Shift-\%-]).
- Bring Forward (or press \#-]).
- Send Backward (or press \#-[).
- Send to Back (or press Shift-\(\mathbb{H}-[)\).
- Reverse. Select two or more layers, and this command reverses the order in which they appear in the layer stack.

See page 170 for details on rearranging layers.

Merge Layers

Choose this command or press **%**-E to combine multiple layers into one. You may also see Merge Down here, which merges a layer with the layer immediately beneath it, or Merge Clipping Mask, which merges clipped layers.

Merge Visible

Use this option or press Shift-\#-E to merge all the visible layers into one layer.

Flatten Image

This command merges all the layers into one Background layer.

Select Menu

Here's where you make, modify, and save selections. Chapter 5 has more about selections.

All

Choose this command or press \%-A to select your whole image.

Deselect

Use this command or press **%**-D to remove all selections from your image.

Reselect

If you use the Deselect command and then change your mind, choose this menu item or press Shift-\mathbb{H}-D to get your selection back.

Inverse

This command switches the selected and unselected areas of your image so the area that wasn't previously selected is selected, and the previously selected area is not. Keyboard shortcut: Shift-\(\mathbb{H}\)-I.

All Layers

Use this command to select every layer in your image, including hidden layers.

Deselect Layers

Choose this option to unselect all layers in your image.

Similar Layers

This command selects all layers of your image that are the same type as the active layer, such as Adjustment layers or regular layers.

Feather

Choose this option to blur the edges of a selection (page 137).

NOTE Although there's a keyboard shortcut listed for feathering (Option- \Re -D) those are the same keys used for the OS X system command for hiding/showing the dock, so it doesn't work unless you first disable the OS X command. To do that, go to System Preferences \rightarrow Keyboard and Mouse \rightarrow Keyboard Shortcuts \rightarrow "Dock, Exposé, and Dashboard", and turn it off. Then you can use those keys for the Feather shortcut in Elements.

Refine Edge

This command lets you groom the edges of a selection (page 131).

Modify

These items let you change the size or edges of your selection:

- Border selects the edge of your selection (page 151).
- Smooth rounds the corners of selections (page 151).
- Expand moves the edge of your selection outward (page 149).
- Contract moves the edge of your selection inward (page 149).

Grow

This command expands your selection to include more contiguous areas of similar color (page 149).

Similar

This option expands your selection to include more areas of similar color, but—unlike the Grow command—it doesn't restrict the growth to contiguous areas (page 149).

Transform Selection

This new command lets you adjust the size of a selection by dragging its edges (page 147). You can also apply any of the Transform commands (page 337) after selecting this command.

Load Selection

If you saved a selection, choose this command to use it again.

Save Selection

To save a selection so you can use it later, use this command (page 152).

Delete Selection

Choose this command to permanently remove a saved selection.

Filter Menu

Filters let you change the appearance of your image in all sorts of ways. Elements comes with some filters that are mostly for correcting and improving photos, while others create artistic effects. The filters are grouped into categories to make it easier to find the one you want. (You can also apply filters from the Effects panel.) Learn more about using filters in Chapter 13. Every image responds to filters differently, so the descriptions here are a very rough guide.

Last Filter

The top item in the Filter menu features the last filter you applied. Choose it or press **%**-F to reapply that filter with the same settings you previously used. If you want to change the settings, choose the filter from its regular place in the list of filters or press **%**-Option-F.

Filter Gallery

This option lets you try the effects of different filters, rearrange them, and preview what they'll look like in your photo (page 385).

Correct Camera Distortion

Use this filter to correct various kinds of lens distortion problems (page 332).

Adjustments

This group of filters is used primarily (but not exclusively) for correcting and enhancing photos. The filters are discussed on page 295, unless otherwise noted:

- Equalize
- Gradient Map (page 415)
- Invert (or press \#-I)
- Posterize
- Threshold
- **Photo Filter** (page 256)

Artistic

Use these filters to apply a variety of artistic effects to your image, ranging from a pencil-sketch look to a watercolor effect.

- Colored Pencil makes your photo look like it was sketched with colored pencils on a solid-colored background.
- Cutout makes your image look like it was cut from pieces of paper.
- Dry Brush makes your photo look like it was painted using a dry brush technique.
- Film Grain adds grain to make your photo look like old film.
- Fresco makes your photo look like it was painted quickly in a dabbing style.
- Neon Glow adds vivid color to your image while softening the details.
- Paint Daubs gives your photo a painted look.
- Palette Knife makes your photo look like you painted it with—you guessed it—
 a palette knife. While you may think of a palette knife as a tool for blending
 heavy paint daubs, Adobe describes the effect of this filter as looking like a thin
 layer of paint that reveals the canvas beneath it.
- Plastic Wrap makes your image look like it's covered in plastic.
- **Poster Edges** gives your image accented, dark edges while reducing the number of colors in the rest of the photo.
- Rough Pastels makes your image look like it was quickly sketched with pastels.
- Smudge Stick uses short diagonal strokes that soften the image by smearing the details.
- **Sponge** paints with highly textured areas of contrasting color like you'd get by sponging on color.

- Underpainting makes your image look like it's painted on a textured background.
- Watercolor simplifies the details in your image the way they would be if you were painting with watercolors.

Blur

Soften and blur your images with these filters:

- Average (page 395)
- · Blur
- · Blur More
- Gaussian Blur (page 392)
- Motion Blur. You apply this much the same way as the Radial blur, described on page 394, but it creates a one-way blur, like you'd see behind Road Runner when he's scooting away from Wile E. Coyote.
- Radial Blur (page 394)
- Smart Blur. This filter reduces grain and noise without affecting the edge sharpness of your photo. You can also use it for special artistic effects.
- Surface Blur. This new filter blurs without reducing edge contrast (page 395).

Brush Strokes

These filters give your image a hand-painted look:

- Accented Edges emphasizes the edges of objects as though they were drawn in black ink or white chalk.
- Angled Strokes creates diagonal brush strokes that all run in the same direction.
- Crosshatch creates diagonal brush strokes that crisscross.
- Dark Strokes paints dark areas of your image with short, tight, dark strokes, and light areas with long, white strokes.
- Ink Outlines makes your image look like it was drawn with fine ink lines.
- Spatter gives the effect you'd get from a spatter airbrush.
- Sprayed Strokes paints your image with diagonal, sprayed strokes in its dominant colors.
- Sumi-e gives the effect of drawing with a wet brush full of black ink, in a Japanese-influenced style.

Distort

These filters warp your image in a variety of ways:

- Diffuse Glow makes your image look as though you're viewing it through a soft diffusion filter.
- Displace lets you create a map to tell Elements how to distort your image.
- Glass makes your image look like you're viewing it through various kinds of glass, depending on the settings you choose.
- Liquify is explained on page 431.
- Ocean Ripple gives an underwater effect by adding ripples to your image.
- Pinch pulls the edges of your photo inward toward the center.
- **Polar Coordinates** lets you create what's called a cylinder anamorphosis. With this kind of distortion, the image looks normal when you see it in a mirrored cylinder.
- **Ripple** creates a pattern like ripples on the surface of water.
- Shear distorts your image along a curve.
- Spherize makes your image expand out like a balloon.
- **Twirl** spins your photo, rotating a selection more in the center than at the edge, producing a twirled pattern.
- Wave creates a rippled pattern but with more control than the Ripple filter gives you.
- **Zigzag** creates a bent, zigzagging effect that's stronger in the center of the area you apply the filter to.

Noise

Use these filters to add *noise* (graininess) to your photos or remove noise from them. (Unless otherwise specified, these filters are explained on page 270.)

- Add Noise (page 390)
- Despeckle
- Dust & Scratches
- Median
- Reduce Noise (page 399)

Pixelate

These filters break up your photo into spots or blocks of various kinds:

- **Color Halftone** adds the kind of dotted pattern you see in items that are color printed by a commercial press.
- Crystallize breaks your image into polygonal blocks of color.
- Facet reduces your image to blocks of solid color.
- Fragment makes your image look blurry and offset.
- Mezzotint creates an effect something like that of a mezzotint engraving.
- Mosaic breaks your image down to square blocks of color.
- **Pointillize** creates a pointillist effect by making your photo look like it's made of many dots of color.

Render

This is a diverse but powerful group of filters that transform your photo in many ways:

- Clouds covers your image with clouds using the Foreground and Background colors.
- Difference Clouds also creates clouds, but blends them into your image using Difference blend mode.
- Fibers creates an effect like spun and woven fibers.
- Lens Flare creates starry bright spots like you'd get from a camera lens flare.
- **Lighting Effects** is a powerful and complex filter for changing the light in your photo. For an in-depth tutorial on how to use this filter, see the Missing CD page at www.missingmanuals.com.
- Texture Fill lets you use a grayscale image as a texture for your photo.

Sketch

Here's another group of artistic filters. Most of them make your image look like it was drawn with a pencil or graphics pen.

- Bas Relief gives your photo a slightly raised appearance, as though it's carved in low relief.
- Chalk & Charcoal makes your photo look like it was sketched with a combination of chalk and charcoal.
- · Charcoal gives a smudgy effect to your image, like a charcoal drawing.
- **Chrome** is supposed to make your image look like polished chrome, but you might prefer the Wow chrome Layer styles in the Effects panel.

- Conté Crayon makes your image look like it was drawn with conté crayons (a drawing medium originally made of graphite and wax, now made from chalks, that's used for making bold strokes) using the Foreground and Background colors.
- **Graphic Pen** makes the details in your image look like they were drawn with a fine pen using the Foreground color on paper that matches the Background color.
- **Halftone Pattern** gives the dotted effect of a halftone screen, like you see in printed illustrations. The effect only *looks* like a halftone, though—this filter doesn't create a true halftone that a print shop might request.
- Note Paper makes your image look like it's on handmade paper. The Background color shows through in spots in dark areas.
- **Photocopy** makes your photo look like a Xerox copy.
- Plaster makes your image look like it was molded in wet plaster.
- **Reticulation** creates an effect you might get from film emulsion—dark areas clump and brighter areas appear more lightly grained.
- **Stamp** makes your image look like an impression from a rubber stamp.
- Torn Edges makes your photo look it's made from torn pieces of paper.
- Water Paper makes your photo look like it was painted on wet paper so the colors run together.

Stylize

These filters create special effects by displacing the pixels in your image or increasing contrast:

- **Diffuse** makes your photo less focused by shuffling the pixels according to the settings you choose.
- Emboss makes objects in your image appear stamped or raised.
- Extrude gives a 3-D effect by pushing some of the pixels in your image up, something like toothpaste squeezed from a tube.
- Find Edges emphasizes the edges of your image against a white background.
- Glowing Edges adds a neon-like glow to the edges of objects in your photo.
- **Solarize** produces an effect like what you'd get by briefly exposing a photo print to light while you're developing it. It combines a negative and a positive image.
- Tiles breaks your image up into individual tiles. You can choose how much to offset them.
- **Trace Contour** outlines areas where there are major transitions in brightness. The result is supposed to be something like a contour map.
- · Wind makes your image appear windblown.

Texture

These filters change the surface of your photo to look like it was made from another material:

- Craquelure produces a surface effect like cracked plaster.
- Grain adds different kinds of graininess to your photo.
- Mosaic Tiles is supposed to make your photo look like it's made of mosaic tiles with grout between them.
- Patchwork reduces your image to squares filled with the image's predominant colors.
- Stained Glass is supposed to make your photo look like it's made of stained glass, but the effect is usually more like a mosaic.
- Texturizer makes your photo look like it's on canvas or brick. You can select a file to use as a texture.

Video

These filters are for use with video images:

- De-Interlace smoothes images captured from video by removing the odd or even interlaced lines.
- NTSC Colors restricts your colors to those suitable for viewing on a TV.

Other

This is a group of fairly technical filters:

- Custom lets you create your own filter.
- **High Pass** is discussed on page 227.
- Maximum replaces pixel brightness values with the highest and lowest values of surrounding pixels. It spreads out white areas and shrinks dark areas.
- Minimum does the opposite of the Maximum filter: It spreads out dark areas and shrinks white ones.
- Offset moves your selection by the number of pixels you specify.

Digimarc

Use this filter to check for Digimarc watermarks in photos. Digimarc is a commercial system that lets subscribers enter their info in a database so that anyone who gets one of their photos can find out who the copyright holder is by searching the Digimarc database.

View Menu

This menu features different ways to adjust how you see an image on your screen. For more details on adjusting your view, see page 82.

New Window for...

This command lets you create a duplicate window for your image so you can see it at two different magnification levels at once. It doesn't create a copy of your photo—the new window goes away when you close your image.

Zoom In

To increase the view size, you can choose this menu item or press **%**-=. You can also use the Zoom tool (page 88).

Zoom Out

To reduce the view size, choose this menu item or press **%**-- (the minus key). You can also use the Zoom tool (page 88).

Fit on Screen

Use this command or press **\mathbb{H}**-0 to make your photo as large as it can be without you having to scroll to see all of it.

Actual Pixels

Choose this option or press \(\mathbb{H} - 1 \) to see your image the exact size it would appear on the Web or in other programs that can't adjust view size (as Elements can).

Print Size

Select this item and Elements makes its best guess as to how large your image would print at its current resolution (page 93).

Selection

When this menu item is turned on, the outlines of your selections are visible. You can toggle the setting off and on here, or by pressing **%**-H.

Rulers

If you want to see rulers around the edges of your image window, toggle them on (and off) here, or by pressing Shift-ૠ-R. You can adjust the unit of measurement in Photoshop Elements → Preferences → Units & Rulers.

Grid

If you want to see a measurement and alignment grid on your photo, use this setting to toggle it on and off. The keystroke shortcut is \Re -' (the apostrophe key). You can adjust the grid size in Photoshop Elements \rightarrow Preferences \rightarrow Grid.

Guides

Guides (page 74) are a new feature in Elements 8 that help you align objects in your files. If your image has guides in it, toggle them off and on here, or press \(\mathbb{H} \)-; (the semi-colon key).

Notes

If you receive an image created in Photoshop that includes notes, choose this menu item to see them.

Snap to

If you want to control Elements' autogrid (a hidden system that determines how precisely you can place things when you move them in your images—see page 74), use these commands.

- **Guides.** When you're working with a file that includes guidelines, this is where you toggle on and off whether objects you add to your photo snap to the guidelines.
- **Grid.** When this setting is turned on, objects automatically jump to the nearest gridline. If the way your tools and selections keep jumping away from you bothers you, turn this off and everything stays exactly where you place it. You have to make the Grid visible (View → Grid) before you can change its settings.

Lock Guides

If you've created guides (page 74) and don't want them to move, select this menu item or press Option-\(\mathbb{H} \)-; (the semi-colon key) to fix them in place.

Clear Guides

If you have guides (page 74) in your image and you want to get rid of them, choose this menu item.

New Guide

To create a nonprinting guideline (page 74) so you can easily align objects, select this menu item.

Window Menu

This menu controls which panels and bins you see, as well as letting you adjust how your image windows display. The frontmost open window has a checkmark next to its name.

Images

Use these commands to control how your images display. The choices are explained in detail on page 83:

- Tile. Your images appear edge to edge so that all the windows or tabs are equally visible.
- Cascade. Your image windows appear in overlapping stacks. (Cascade is the usual view when you start Elements for the first time.) You can't choose this menu item when using tabs.
- Float in Window. Choose this to make the active image tab into a floating window. (You first have to turn on floating windows in Photoshop Elements → Preferences → General.)
- Float All in Windows. If you've turned on floating windows, choose this and all your image tabs turn into windows.
- Consolidate All to Tabs. If you have floating windows and you want to go back to tabbed view, select this item.
- New Window. This is the same as the View menu's "New Window for..." command: It opens a separate view of your image, not a duplicate file.
- Minimize. Use this command or press **%**-M to send the active image window to the Dock. Click the image in the Dock to bring it back into Elements.
- Bring All to Front. This brings all your open Elements image windows back to the front so you can see them. It's useful when you have windows from many programs open at the same time.
- Match Zoom. Choose this item to get the same magnification level in all open windows as in the active image window.
- Match Location. When you have only part of a photo visible in a window, choose this command to make all open windows display the same part of their images, like the upper-left corner, for example.

Tools

This menu item hides and shows the Tools panel (page 26).

Adjustments

This shows and hides the Adjustments panel (page 161).

Color Swatches

Use Color Swatches to show and hide the Color Swatches panel (page 220).

Content

The Content panel holds frames, backgrounds, graphics, shapes, themes, and text effects to use in projects. It's always visible in Create mode, but if you want to see it in Edit mode as well, this is where you make it visible. See page 450 for more about how to use this panel.

Effects

Effects shows and hides the Effects panel, from which you apply filters, photo effects, and Layer styles. See page 397.

Favorites

You can put your favorite items from the Content and Effects panels into the Favorites panel for easier access (page 452). Like the Content panel, it's always visible in Create mode, but you can use this menu item to make it visible in Full Edit or hide it again once it's visible.

Histogram

Use the Histogram to show or hide the Histogram in its own panel (page 207).

Info

Use this setting to bring up a palette with information about your photos, like the file size and color value numbers.

Layers

Make the Layers panel visible or hidden by toggling this setting. See page 158.

Navigator

Turn the Navigator off and on here. The Navigator lets you adjust which portion of a large image is visible on your screen and adjust the zoom. See page 89.

Undo History

This item makes the Undo History panel visible or hides it. The panel shows a record of all the changes you've made to the image up to the number of states you set in Photoshop Elements → Preferences → Performance → History States. Page 32 has more about the Undo History panel.

Application Frame

When this is turned on, Elements appears as a solid, resizable window. Turn it off and you lose the solid desktop background and the rest of the Elements interface clings around the edges of your screen, the way it did in Elements 6. When Application Frame is turned on, the Application Bar is grayed out, because it's always on when the Application Frame is on.

Application Bar

This is the top bar of the Elements window, the one that shows the Elements logo (the little blue square with "pse" on it), the shortcut buttons for New File, Bridge, Save, and Help, the Arrange Documents Menu (page 83), and the buttons for Reset Panels, Undo, and Redo. If you want, you can hide it by turning it off here, but only if you first turn off the Application Frame, described above.

Panel Bin

This setting minimizes (hides) and maximizes (reopens) the Panel bin (page 23). You can also click the edge of the bin to hide or expand it.

Reset Panels

Use this command to return all panels to their original locations.

Welcome

Choose this menu item to see the Welcome screen that appears when Elements starts up.

Project Bin

This setting shows and hides the Project bin.

Image Windows/Tabs

At the bottom of the Window menu is a list of all the files you have open in Elements. Choose one to bring it to the front as the active window or tab.

Help Menu

The Help menu is where you find Elements' Help files, as well as info about the program itself.

Search Box

You can type a term into this box to search the program's menus, not the Elements Help Files. Page 29 has more about this feature.

Photoshop Elements Help

When you call up the Elements Help files here, your Web browser launches and takes you to the online Help files.

Getting Started

This menu item takes you to a section of Adobe's website that includes video tutorials to help newbies.

Key Concepts

If you're wondering what a particular digital-imaging term means, choose this menu item and it'll take you to an online glossary so you can look it up.

Support

Select this to go to Adobe's online Support area and knowledgebase.

Video Tutorials

Choose this menu item to go to the video tutorials section of Adobe's support site, where you can watch videos on how to do popular Elements tasks.

Forum

This takes you to Adobe's online support forum for Photoshop Elements.

System Info

Choose this item to see a window with basic info about your Mac (like the amount of RAM and your serial number), your OS X version, and the plug-ins installed on your computer.

Registration

If you didn't register Elements with Adobe when you installed it, you can choose this menu item to bring up the registration window again.

Deactivate

Elements 8 includes *activation*, a process that limits the number of computers on which you can install your copy of the program (see page 533). If you need to uninstall Elements to move it to a new computer, be sure to use this command to deactivate it on the old computer so you can install it on the new one.

Updates

This is where you check for updates to Elements components. When you select this item, the Adobe Updater dialog box appears. Click the Preferences button to adjust the settings for how you want Elements to handle updates.

Installation and Troubleshooting

Elements is easy to install and is pretty trouble free once it's up and running. This appendix explains a couple of things you can do to ensure that your installation goes smoothly, and also provides cures for most of the glitches that can crop up once you're using the program.

Installing Elements

There's not much you need to do prior to installing Elements, but if you have any antivirus software or any Norton/Symantec products, you should disable those before you start. (Remember to turn them on again when you're through installing Elements.)

You need to install Elements from an administrative user account. (If you have only one user account on your Mac, you're an administrator. To double-check your status, go to ♠ → System Preferences → Accounts, and make sure the "Allow user to administer this computer" checkbox is turned on.) Elements won't install (nor run well) from accounts without administrative powers.

You don't have to remove previous versions of Elements to install Elements 8, and the installer won't remove them for you, even if you *do* want to get rid of them. Each version of Elements is a separate, standalone program, and you can have as many versions as you like on one computer. You can even run them simultaneously, provided you launch the older version(s) before the newer one(s). (If you have Leopard—OS X 10.5—Elements 3 is the oldest version that will run on your system. In 10.6, Elements 4 is the oldest version that installs reliably, and then only if you first install Rosetta [page 4]. It runs well for some people but not for everyone.)

If you want to remove older versions, just drag their folders from Applications to the Trash, except for Elements 6, which you have to remove by running its uninstaller, which is the same as its installer (in the first installer screen, choose "Remove Adobe Photoshop Elements Components," click Next, and then click Install). If you don't have the disc or download file to get to the installer, there's an emergency uninstaller in Applications → Utilities, but it's much better to use the Elements disc's installer if you can. (Fortunately, Elements 8 has a much better system for uninstalling, explained on page 535.)

Make sure you have your Elements serial number handy—you won't be able to install the program without it. Then:

1. Put the install DVD in your Mac's DVD or combo drive.

Double-click the DVD icon to see the disk's contents.

2. Double-click the Setup icon to launch the installer.

Enter your OS X account password when Setup asks for it.

3. Enter your serial number and then click Next.

If you have a retail version of Elements, the serial number is on the label on the install disc's case. If you got it bundled with something else (a tablet, for example), you'll usually find the serial number on the paper sleeve the disc is in. (It's not a bad idea to write your serial number on the disc itself so that you'll always have it around if you need to reinstall.) If you bought the program as a download, Adobe emailed you the serial number.

You can install Elements without a serial number, but it will only run as a trial for 30 days, and then stop working.

4. Choose a language for the software agreement.

Give the agreement a quick read and then click Accept.

5. Choose a language and Install Elements.

Elements 8 has a multi-language installer. Choose the language you want to use, and then make any other changes in the window. Unless you have a specific reason not to (if you install all your programs on a separate drive, for instance), just agree to the location the installer suggests, which is the main Applications folder on your Mac. Leave the other options in the window (the fonts, Extension Manager, and so on) turned on unless you are sure you understand why you're disabling them. Click Install, and the Elements installer does its thing, which takes a few minutes (you can watch the installer's progress in the window).

Register Elements.

When the installer finishes, Elements pops up a registration window. You don't have to register Elements, but you do need to let it activate itself, as explained in the next section. If you don't have an Internet connection when you install Elements, the activation process completes the first time you launch Elements

when you have an active connection. If you don't register Elements when you install it, it annoys you with a Registration window each time you start the program. After a few times, though, you'll see a button at the bottom of the window that says Never Register. Click it, and the Registration window won't come back. If you change your mind later, go to Help → Registration to bring the Registration window back so you can register Elements.

TIP Once you install and register Elements, Adobe hangs onto a record of your serial number, so if you ever misplace the number, you can get it from Adobe. Also, when Adobe releases new versions of Elements, they usually offer a rebate for registered owners of previous versions. And if you agree to let Adobe send you email, they often offer discounts on other programs, like on the full version of Photoshop, if you want to move on later.

7. Click Exit to close the installer.

That's it!

NOTE It's a really good idea to repair permissions after installing Elements. Go to Applications \rightarrow Utilities \rightarrow Disk Utility and click your hard drive in the list that appears on the left, then click Repair Permissions. In OS X 10.5, this can take half an hour; it's much faster in 10.6.

To launch Elements, click its icon in the Dock. If the installer didn't create an icon, launch Elements from the Applications folder. Go to Applications → Adobe Photoshop Elements 8.0, and double-click the Elements program icon (the blue square with "pse" on it). To keep Elements in the Dock, simply click the Dock icon while Elements is running and choose "Keep in Dock" from the pop-out menu. (You can also drag the program—not the whole Elements folder—into the Dock when Elements isn't running.) If you add Elements to your Dock and then change your mind, just drag the icon out of the Dock and watch it vanish in a puff of smoke.

Activation

Elements 8 brings a new wrinkle to installation: *activation*. That's a process where Elements collects info about the computer you install it on and sends that to Adobe. Your installations are physically tied to the computers Adobe knows about. You can install your copy of Elements on two different computers (technically two hard drives—installing Elements on two different drives in the same Mac Pro, for example, will use up both your activations). If you want to install it on a third computer, you have to *deactivate* it on one of the first two before you can do that.

Even if you normally don't allow your computer online, you have to let Elements connect to the Internet at least once so it can send your activation info. This is a change from earlier versions, where your license to use Elements had the same restrictions, but Adobe didn't do anything to prevent you from installing it on twenty computers. Activation is "silent," meaning you don't have to do anything

and you don't see any dialog boxes or notifications that it's been completed. If you want to check whether Elements is activated, go to the Help menu. If you see "Deactivate" as a choice, your activation is complete.

You can run Elements for a while without activating it, but it just runs as a trial, and when the 30 days are up, that's it unless you activate it. If you uninstall Elements, remember to deactivate it first (go to Help → Deactivate). After that, you can't use Elements on that machine again until you reactivate it by entering your serial number. It's especially important to deactivate Elements if you're selling your computer or replacing your hard drive.

You can uninstall and reinstall Elements on the same machine without deactivating it first, but it's safest to deactivate each time you uninstall. That way, if something happens before you reinstall, like a lightning strike that requires a hard drive replacement, you won't have any problems. The only solution for activation problems is to contact Adobe.

Scratch Disks

Elements uses a *scratch disk*—reserve space on a hard drive to supplement your computer's memory—when it's busy making your photos gorgeous. The calculations Elements makes behind the scenes are complex, and Elements needs someplace to write stuff down while it's figuring out how to make changes to your image. It does so by using a scratch disk if the task at hand is too heavy-duty for your system's main memory to cope with alone.

You probably have just one hard drive in your computer, and Elements automatically uses that drive as the scratch disk. That's fine, and Elements can run very happily without a dedicated scratch disk.

If you're fortunate enough to have a computer with more than one internal drive, you can designate a separate disk as the scratch disk to improve Elements' performance. Your scratch disk needs to be as fast as the drive Elements is installed on or there's no point in setting up a special scratch disk. (If you have a USB external drive, for instance, forget it—USB isn't fast enough, even USB 2.0, so just leave your main drive as your scratch disk.)

To assign a scratch disk, go to Photoshop Elements \rightarrow Preferences \rightarrow Performance and choose your preferred disk. You can choose up to four disks to use as scratch disks.

Troubleshooting

If Elements behaves badly from the moment you install it, something probably went funky during your installation. That's easy to fix. Simply uninstall Elements and reinstall it, but be sure to use the Elements' uninstaller to remove Elements 8, since Elements installs files in many places around your hard drive, unlike the usual tidy Mac application package. You can uninstall Elements by dragging it to

the Trash, but this method won't get rid of all the files that the program puts on your computer; running the uninstaller should delete 'em all (you might still want to search manually if the idea of not getting rid of every last file bugs you).

Here's how to use the uninstaller to get rid of Elements:

1. Deactivate Elements.

Go to Help → Deactivate. This isn't strictly necessary if you're going to reinstall again right away, but it's a good idea to do it anyway, just in case.

2. Go to Applications → Adobe Photoshop Elements 8, and double-click Uninstall Adobe Photoshop Elements 8.

Give the Uninstaller your OS X password when it asks for it.

3. Uninstall Elements.

In the Uninstaller window, it's a good idea to turn on the checkbox for Remove Application Preferences before you click Uninstall.

4. Click Exit to close the Installer.

However, it's rarely necessary to completely uninstall Elements to fix problems you're having. There are several things you can try before uninstalling:

- Reset a tool. If a single tool stops working, go to the far-left part of the Options bar. Click the tiny, black, downward-facing arrow there (it's hard to see) to display a pop-up menu with two items in it. Choose Reset Tool to clear any settings the tool has that may be making it act up.
- **Delete Preferences.** If resetting a tool doesn't solve your problem, or if Elements is generally misbehaving, try resetting your preferences as explained next.

Fortunately, Adobe makes good software that looks after itself well. There's one simple procedure you can perform if Elements starts acting funny: Delete your Elements *preferences file*, which is where Elements keeps track of your preferred settings. Deleting it fixes the overwhelming majority of problems you may develop. Elements makes a fresh copy of the preferences after you delete the old one—it doesn't harm the program to get rid of this file.

NOTE You'll sometimes run across instructions in online forums and tutorials to rename this file instead of deleting it. That's totally unnecessary. Just send it to the Trash, since it always regenerates the next time you start Elements. In the unlikely event that you ever want your old copy back, you can just haul it out of the Trash and put it back where it was.

Here's how to delete your Elements preferences file:

- 1. If Elements is running, quit the program (\mathbb{H}-Q).
- 2. Before you restart Elements, press %-Option-Shift and hold the keys down.

This keystroke combination tells Elements you want to delete its preferences.

3. While still pressing those three keys, launch Elements and keep holding the keys down as the program starts up.

After a few seconds, a window should appear asking if you want to delete the Elements settings file (which stores your preferences). If Elements starts up and you don't see this window, quit Elements and hop back to step 2 to try again. (This process generally works pretty well, so if you have trouble, check to be sure you're holding down the right keys.)

4. Confirm that you want to delete your settings.

In the window, click Yes. Elements deletes your settings file and, hopefully, starts behaving itself. You'll need to redo any changes you'd made to Elements' settings—like grouping panels, for example—after doing this.

You can use these same keys when starting up Bridge. They bring up a window with checkboxes giving you the option to delete Bridge's preferences, purge the thumbnail cache (for faster thumbnail rendering in the Content panel), or reset the Bridge window (workspace) to look the way it did the first time you opened the program. You can choose to do any or all of these things by turning on the relevant boxes. However, it's not very common to need to delete Bridge's preferences. But for Elements, deleting preferences fixes about 90 percent of the things that can go wrong with the program.

Bridge CS4, Menu by Menu

Bridge CS4 is Adobe's ultra-deluxe file-browsing program that you get with the full version of Photoshop and with Elements 8 for Mac (Elements 8 for Windows includes the Organizer instead). Bridge is closely connected with Elements, but it's also a standalone program that lets you browse for photos to edit in Elements, organize your photos, assign keywords to them, rate them, and do some batch processing, like renaming or applying metadata templates to a bunch of images at once. As explained in various chapters, you can start lots of Elements projects by selecting your photos in Bridge. This appendix gives you a tour of all of Bridge's menus.

NOTE The version of Bridge you get with Elements includes several features that are only useful for the collaborative features of the full Creative Suite, like Version Cue's meetings feature (you can *join* a Version Cue meeting from Elements, but you can't start one). Since these are useless to most people who only use Elements, they're normally hidden so they won't confuse you.

However, it's possible that they might appear in your Bridge menus, especially if you ever have to delete Bridge's preference files. In this appendix, you'll find several references to these normally hidden menu items, just in case. For items like these, this appendix includes a note telling you that this is a feature you normally won't see.

Adobe Bridge CS4 Menu

This menu is where you can get info about Bridge, adjust your settings, and control how Bridge interacts with other programs.

About Bridge

Choose this item to see which version of Bridge you have, as well as a long scrolling list of the names of the many, many people who helped develop the program, and a list of patent numbers.

Camera Raw Preferences

These are the preferences for the full Creative Suite Raw Converter, which you can launch by right-clicking (Control-clicking) a photo's thumbnail and choosing "Open in Camera Raw" (see page 235).

Preferences

Here's where you adjust your settings for Bridge. Your options are:

- General. Use the Appearance sliders to adjust the brightness of Bridge's background and choose a different text highlight color. This is also where you turn on the Photo Downloader (page 19) if you want it to grab photos any time you plug in a camera or card reader. Also, you can set the number of files displayed in Bridge's Recent Items menu, and choose what to see in the Favorites panel (page 41). Finally, if you've disabled any warning dialog boxes, you can reset them all with the button at the bottom of the window.
- Thumbnails. The text box at the top of this window lets you tell Bridge to ignore files beyond a certain size. Unless Bridge is really struggling with your files, leave the number there as it is. With the controls in the bottom half, you can choose to display additional info beneath thumbnails besides the file name. You have a long list of metadata items (page 55) to select from, and you can add up to four items. You can also control whether you want to see tooltips when you hover your cursor over things (tooltips are brief descriptions of whatever your cursor is over).
- Playback. If you want to flip through all the photos in a stack (page 53) like an animation, choose a frame rate (how long each photo displays) here. Since Bridge also recognizes audio and video files, you have some settings for whether to have these types of files play automatically when you preview them, and whether to have them loop (play continuously) when previewed.
- Metadata. This window lets you control the various types of metadata (page 55) from your photos, audio files, and videos that you can view in the Metadata pane. It's also where you turn the Metadata placard (page 55) off or on.
- **Keywords.** If you use Bridge to assign keywords, this window gives you a couple of fairly technical choices about encoding hierarchical keywords (keyword and sub-keyword relationships). You can also choose to have Bridge automatically apply parent keywords here (meaning that if you apply a sub-keyword, the keyword it belongs to also gets applied). See page 55 for more about keywords.

- Labels. Bridge lets you assign colored labels to your photos (see page 54). This is where you can change what the different colors stand for.
- File Type Associations. Choose what program files open in when you double-click them in Bridge (page 43).
- Cache. Bridge stores thumbnails and info about your photos (like ratings) in a special cache file. The Automatically Export Caches To Folders When Possible checkbox lets you tell Bridge to create caches within the folders where your photos are saved. That way, when you send a folder to someone, your Bridge info goes along. If you don't care about sharing that info, leave this checkbox turned off, and Bridge saves to one main cache. Sometimes the cache gets so large it impedes Bridge's performance, so you can compact or purge the cache here to speed things up (Bridge rebuilds it automatically).
- Startup Scripts. Bridge runs special scripts to let it communicate with other programs, to make the Elements options (like the Picture Package) work. You can disable them here, but usually you don't want to do that.
- Advanced. Choose your language and your keyboard layout for Bridge here. You can also disable hardware acceleration for previews and Slideshow view, but you don't want to do that unless you understand what that means and have a good reason for changing it. If you want Bridge to start up every time you log into your Mac, you can set that behavior here, and you can tell Bridge that you want image previews as large as your monitor allows.
- Output. These settings are for the Bridge Output panel, where you create PDF files (page 455) and web galleries. The "Use Solo Mode for Output Panel Behavior" checkbox lets you see only one group of settings in the Output panel at a time. When you click another group, the first collapses to just its title bar. Leave "Convert Multi-Byte Filenames to Full ASCII" turned on, since it's important for making sure that your image file names always get transferred into your gallery in a way that browsers can understand. Turn on Preserve Embed Color Profile if you want to keep your photos' original color profiles in your gallery or PDF file.

Services

This is where you can access OS X utility programs like Grab (for taking screenshots) or TextEdit (for copying text). Your actual choices in the submenu depend on what programs are installed on your Mac. It's normal for some to be grayed out. Dictionary, for instance, isn't available unless you've highlighted some text. What you see here varies quite a lot depending on whether you're using 10.5 or 10.6, which lets you customize your Service choices by going to System Preferences → Keyboard → Keyboard Shortcuts → Services.

Hide Adobe Bridge CS4

To put Bridge out of sight, choose this item or press ₩-H.

Hide Others

If you want Bridge to be your only visible program, choose this or press Option-\$\mathfrak{H}\$.

Show All

Use this to bring back your hidden programs so they're visible on the desktop again.

Quit Adobe Bridge CS4

You can shut Bridge down by choosing this menu item or pressing **ૠ**-Q.

File Menu

This menu lets you create new Bridge windows or new folders for your photos, open photos in Elements or other programs, move or delete images, email them, or burn them to CDs and DVDs.

New Window

Choose this item or press \(\mathbb{H}\)-N to open a duplicate Bridge window. You'd do this if you wanted to use two different workspaces at once. For instance, you could have one window in the default thumbnail view and one in Metadata view, so you could see details about the thumbnails you click on.

New Folder

If you're organizing photos in Bridge, choose this command or press **%**-Shift-N to create a new folder in your current location.

Open

To open a photo in Elements (or whatever program you chose in File Type Associations [page 43]), choose this item, press ്8-O, or double-click the photo's thumbnail.

Open With

If you want to open a photo with a different program than you usually use, go here and select the program from the list. Next time, the photo will open with whatever program you normally use.

Open Recent

This item lets you open a photo you've recently opened from Bridge—just pick a photo from the list that appears. If you want to change the number of items that appear here, go to Adobe Bridge CS4 → Preferences → General.

Open in Camera Raw

To adjust the settings for your Raw files without going into Elements, select them, and then choose this menu item or press **%**-R. This takes you to the full, complete Raw Converter that comes with the Creative Suite products rather than the simplified Elements Converter. You can edit other image formats like JPEG and TIFF as well as Raw files, and save your conversions in other formats without launching Elements. See the box on page 235 for more info.

Close Window

To make the Bridge window go away, choose this option or press **%**-W. This doesn't quit the program, it just closes the window.

Move to Trash

Want to say goodbye to one of your photos forever? Select a photo (or photos), and then choose this menu item or press \(\mathbb{H}\)-Delete. Your photo plunks into the OS X Trash so you can get it back if you change your mind, as long as you haven't emptied the Trash.

Eject

If you've been getting photos from a camera, card reader, or CD, you can eject it from here, press **%**-E, or use the Eject button on your keyboard.

Return to...

To go back to Elements without opening a photo, choose this menu item or press Option-%-O. If you open Bridge from Elements, this item reads "Return to Adobe Photoshop Elements", and that's where it takes you. If you open Bridge another way (double-clicking it in the Applications folder, for instance), it just reads "Return to..." and if you happen to have Photoshop CS4 installed, it says "Photoshop" and that's where it'll take you, rather than to Elements.

Reveal in Finder

To bring up the Finder to see where a photo is saved, choose this option.

Reveal in Bridge

This is a holdover from Adobe's Creative Suite—it's normally grayed out if you only have Elements. If you're in a Version Cue project, you can use this command on project files to see their locations in Bridge.

Get Photos from Camera

This launches the Adobe Photo Downloader (page 19).

Burn CD/DVD

Choose this option to make a CD or DVD of your selected Bridge photos (see page 63). Discs burned this way are cross platform, which means they should work on both Macs and Windows computers.

Attach to Email

Select a photo and choose this to send it to Elements for automatic resizing and attaching to a new email message (see page 484).

Move To

Select a photo or folder and use this command to move it someplace else. The popout menu shows a list of your most recently used folders, or you can browse to another location.

Copy To

This works just like Move To, only it makes and moves a copy instead of your original.

Place

This works the same way as Elements' Place command (page 448). If you only have Elements, it's your only application choice in the submenu. If you have Adobe Creative Suite applications, they appear as options here, too.

Add to Favorites/Remove from Favorites

Select an image or a folder and use this command to put into the Favorites panel for fast access, or just drag it to the panel. If an item is a favorite, this option changes to "Remove from Favorites", for when you don't want it in the panel anymore.

File Info

Choose this menu item to bring up the File Info window, which displays all sorts of info about your image file (creation date, format, and so on). You can also add or edit metadata here (see page 55). Option-Shift-\#-I is the keyboard shortcut.

Edit Menu

You can't really edit photos from this menu, but it contains the usual Mac short-cuts for copying and pasting, and you can rotate and search for images from here.

TIP Copying and pasting only work within Bridge—you can't copy from Bridge and paste into another program.

Undo

This item is grayed out much of the time, but for the few things you can undo, this is where you do it, or just press \%-Z.

Cut

This command *should* remove a photo from where it is and place it onto the Clipboard so you can paste it somewhere else, but this feature doesn't work well in Bridge. It usually doesn't do anything. If you try it and it doesn't work, just copy the file instead.

Copy

To copy a photo from Bridge, select it, and then choose this command or press **%**-C. You can only copy and paste within Bridge, so you can use this command to copy a photo from one folder to another, but not to a Pages or Word document, for example.

Paste

To put something you've copied into another file within Bridge, use this menu item or press **%**-V.

Duplicate

Choose this item or press **%**-D to create a copy of the selected image in the same folder.

Select All

Use this item or press **ૠ**-A to select all the photos visible in Bridge.

Deselect All

Select Inverse

If you've selected some photos in Bridge and now want to pick all the unselected photos instead, choose this item or press Shift-\(\mathbb{H} - I. \)

Find

Choose this command or press **%**-F to bring up the helpful Find window, which gives you a bunch of ways to search for photos (see page 57).

Develop Settings

This is a shortcut for copying and applying various conversion settings to your Raw files without opening the Raw Converter. To copy the settings from one file to another or to a group of photos, first copy the settings from one image by selecting its thumbnail and pressing \mathbb{H}-Option-C. Then select the file(s) you want to apply those settings to and press \mathbb{H}-Option-V, or use the menu items here to copy and paste them.

Rotate 180°

This turns the selected image(s) upside down (see page 70).

Rotate 90° Clockwise

You can rotate a photo by choosing this command, clicking the right-hand Rotate arrow in the upper-right part of the Bridge window, or pressing \(\mathbb{H} - \] (the close bracket key).

Rotate 90° Counterclockwise

Use this command, the left-hand Rotate arrow in the upper-right part of the Bridge window, or press \(\mathbb{H} - \)[(the open bracket key).

Creative Suite Color Settings

This doesn't do anything if you only have Elements, but if you have the full Creative Suite, you can synchronize your color settings for all the CS programs here.

View Menu

This menu controls the various ways of looking at your photos in Bridge.

Full Screen Preview

Choose this menu item or press the spacebar to see a full-screen view of your currently selected images. Use the left and right arrow keys to step through them, and press the spacebar again to exit Full Screen view.

Slideshow

To see a full-screen slideshow of the photos currently visible in Bridge, choose this or press **%**-L You can't save this slideshow—it's just a view within Bridge. The Esc key takes you back to your previous view of the Bridge window.

Slideshow Options

Use this menu item or press Shift-\#-L to make choices about how Bridge displays photos in slideshow mode. The Zoom Back And Forth setting, for instance, causes

Bridge to zoom in on one slide and zoom back out on the next. You can also control how long each slide appears, choose whether there are transitions between slides, and adjust other aspects of how your images display.

Review Mode

Choose this menu item or press \mathbb{H}-B for a full-screen view where you see a large view of one image surrounded by smaller views of the rest of your selected images. Click an image to bring it to the forefront so it's the large image. There's a little toolbox in the lower right of your screen, which gives you the Loupe tool (page 42), and a button for creating a collection (page 58) from the photos currently onscreen. Press the X button to leave Review mode.

Compact Mode

Choose this item or press **%**-Return and Bridge shrinks itself into a much smaller window that you can keep open without losing much desktop space. Choose this item or press the same keys again to return it to Full mode.

As Thumbnails

Use this menu item and the next to toggle the Content panel view. This option is the way Bridge usually works—it shows thumbnails with file names underneath.

As Details

Instead of just thumbnails and file names, you also see a list of info about each image. It's some of the same stuff you see in Metadata view, but it appears only in the Content panel.

As List

Choose this option and the Content panel shows you a list of your images' names, creation dates, sizes, and file types, along with a thumbnail for each.

Show Thumbnail Only

Choose this item or press **%**-T to hide the file names under the thumbnails. Choose it again to toggle them back on.

Grid Lock

Turn this on, and instead of allocating space for each thumbnail based on whether it's in portrait or landscape orientation, the Content panel gives every thumbnail the same amount of space.

Show Reject Files

When this is turned on, you can see photos to which you've given a Reject rating (page 54). To hide them, turn this setting off.

Show Hidden Files

Bridge normally only displays thumbnails of image files, but if you also want to see other files like the .thm files your camera creates for your Raw files, turn this on.

Show Folders

This is usually turned on, but if you don't want to see folders in Bridge, turn them off here.

Show Items from Subfolders

This is a handy command: Choose it and you don't have to root around in all the subfolders inside the current folder when you want to find a photo. Bridge generates thumbnails of all the photos in the current folder, no matter how deeply they're buried in subfolders. It can take a while to accomplish this, though, if you have a lot of photos.

Sort

If you want to change how Bridge sorts your photos, choose a new criterion from this item's submenu. You can also choose to sort by ascending or descending order

Refresh

Press F5 or choose this item and Bridge redraws the thumbnails for your current view. (When you do this, you lose any photo selections you've made.) You can use this command if you find that Bridge has stopped rendering thumbnails correctly.

Stacks Menu

Bridge lets you group photos into *stacks* (page 53), where you see only one photo as the icon for the whole group to make it easier to keep track of them. This menu is your command center for creating and managing stacks.

Group as Stack

Select the photos you want to stack, and then use this command or press **\mathbb{H}**-G to corral them into a new stack.

Ungroup from Stack

To remove a photo from a stack, expand the stack, click the photo's thumbnail, and then choose this menu item or press Shift-\(\mathbb{H}\)-G. To totally get rid of a stack, expand it and select all the photos in it before doing this.

Open Stack

To expand a stack so you can see all the photos in it, press **%**-the right arrow key or choose this menu item.

Close Stack

To collapse an expanded stack, use this menu item or press **ૠ**-the left arrow key.

Promote to Top of Stack

If you'd rather use a different photo from the group as the one visible when the stack is collapsed, expand the stack, click the photo you want, and then choose this item.

Expand All Stacks

If you have lots of stacks and you want to see all the photos in all of them, choose this option or press Option-\mathbb{H}-the right arrow key.

Collapse All Stacks

To make all your stacks shrink back to single-photo view, choose this item or press Option-\(\mathbb{H}\)-the left arrow key.

Frame Rate

You can quickly view all the photos in a stack of ten or more like an animated GIF or a cartoon by pressing the play button that appears when you click on a stack. This menu sets the frame rate—how fast each photo succeeds the next. (The upper numbers are the slowest, the bottom the fastest.) You can also use the slider below the stack preview to change the frame rate.

Label Menu

To help you sort your photos, you can assign labels and ratings to them. See page 54 for more about these features.

Ratings

You can rate photos from one to five stars or mark the ones you don't want with a Reject tag. To rate a photo, select it and then choose your rating from this menu or press \(\mathbb{R} \) and the number of stars you want to assign—\(\mathbb{R}-3 \) to assign three stars, for example. Pressing \(\mathbb{R}-0 \) (the number zero) makes a photo unrated, and pressing Option-Delete assigns the Reject tag. You can also bump the number of stars up one star by pressing \(\mathbb{R}-, \) (the comma key); each time you tap the comma key you add a star. To decrease the number of stars, press \(\mathbb{R}-. \) (the period key) instead.

Label

Bridge lets you assign colored labels to your photos. Adobe gives the various labels default meanings (Select, Second, and so on) but you can assign your own meanings by going to Adobe Bridge CS4 \rightarrow Preferences \rightarrow Labels and typing in whatever you want. There are keyboard shortcuts for each label (except "To Do"), which appear in the Label menu to the right of the labels (they're **%**-the numbers 6 through 9). To assign a label, simply select a photo and then choose the appropriate menu item or use the label's keyboard shortcut. (Bridge labels are visible only within Bridge, not in other programs or in the Finder.)

Tools Menu

Here you can rename your files, use them in projects, and add and edit their metadata (page 55).

Batch Rename

Choose this command or press Shift-\(\mathbb{H}\)-R to change the names of several images at once. The resulting window gives you more options for creating custom names than Elements' Process Multiple Files command does (see page 258), including moving the files as you rename them and preserving the original file names in the metadata (page 55) so you can still search by the old names.

Create Metadata Template

This option lets you create a list of metadata to apply to multiple images—including a huge variety of info like copyright, usage terms, website addresses, descriptions, and more—and then save it as a template to use over and over again. Page 55 has the details.

Edit Metadata Template

To make changes to a template you've created, choose the template from this item's pop-out list.

Append Metadata

Choose a template from this item's pop-out list, and that template's info gets applied to your selected photos in addition to the metadata they already have.

Replace Metadata

Use this command, and the info in your metadata template overwrites the existing metadata in the files you've selected. You generally don't want to do this because you can lose important information; in most cases, Append Metadata is a better option.

Cache

Bridge stores thumbnails and info about your photos in a file called the cache. This is where you can manage your cache (you can also go to Adobe Bridge CS4 → Preferences → Cache). Here you can:

- Build and Export Cache. To send cache info along with photos you share, choose the folder the images are in, and then select this menu item.
- Purge Cache For Folder... If your cache gets too big, it'll slow down Bridge. Choose this option to force Bridge to create a new cache to speed things up.

Photoshop Elements

Use this menu item to send photos to Elements for use in projects. You can start the following projects from Bridge:

- Contact Sheet II lets you print several thumbnails on one page (page 469).
- Picture Package lets you print a group of photos of different sizes all on one page (page 471).
- **Photomerge Faces** lets you combine parts of different faces, just for fun (page 326).
- **Photomerge Groupshot** lets you replace just one person in a group photo—the one with his eyes closed or the one yawning (page 329).
- **Photomerge Panorama** is Elements' great feature for stitching together multiple photos for an image wider than you can capture with your camera (page 320).
- **Photomerge Scene Cleaner** is a new feature that lets you combine images to remove unwanted people and distracting items (page 329).
- **Photomerge Exposure** lets you blend two (or more) different exposures of the same image for one perfectly exposed photo (page 251).
- **Recompose** lets you reshape your photo to remove unwanted objects or people without distortion (page 278).

Window Menu

This menu lets you customize Bridge's appearance.

New Synchronized Window

Choose this command or press Option-\(\mathbb{H}\)-N to create a new window that shows the same photos as your original window. For example, you could have one window in Metadata view so you can see file info about your image, and a second window in one of the Filmstrip views for a large preview. (When you change to viewing another folder in one window, the other window also changes—hence the word "synchronized".)

Workspace

This is where you select the general setup for your Bridge window and save your customized layouts, called *workspaces*. You can choose:

- Reset Workspace. If things get all confused and you want to go back to what Bridge looked like the first time you opened it, choose this option.
- New Workspace. You can start a brand new workspace customization from here, or, if you've already created a customized workspace, this is how you save it for the future. Then you can choose it by clicking its name at the top of the main Bridge window.
- **Delete Workspace.** If you're tired of a saved workspace, this is how to remove it from your list of available workspaces. Just choose its name from the menu in the window that appears, and click Delete.

The next part of this menu lists the basic workspace setups that you can customize:

- My Workspace. This is your workspace just the way you left it the last time you closed Bridge. Keyboard shortcut: \mathbb{H}-F1.
- Essentials. This workspace has thumbnails in the middle with space for panels on either side. Keyboard shortcut: \mathbb{H}-F2.
- Filmstrip. This is the way Bridge starts you out. This workspace has a large preview area in the center, with thumbnails below and panels on the left of the window. Keyboard shortcut: #8-F3.
- Metadata. Instead of a grid of thumbnails, you see a list of images with file info to the right of their names. Keyboard shortcut: **%**-F4.
- Output. This is where you create PDF files (page 455) and web galleries (page 486). You see a folder view on the left, a large preview area with thumbnails beneath in the center, and the Output panel on the right. Once you choose a template and refresh the preview, the center area shows a preview of your project instead of thumbnails. Keyboard shortcut: **%**-F5.
- Keywords. This puts the Content panel into Detail view (page 545), with the Folders, Favorites, and Keywords panels on the left so you can easily assign keywords (page 56) to your photos. Keyboard shortcut: **%**-F6.
- **Preview.** This shows a large image preview area, with a vertical strip of thumbnails to its left, and a pane for other panels on the far left of the screen.
- Light Table. This workspace only shows thumbnails, with no other panes or panels.
- Folders. Shows a large thumbnail area with the Folders and Favorites panels on the left.

Folders Panel

This item shows a folder view of your computer you can use to find your photos. Turn it off and on by selecting it here.

Favorites Panel

The Favorites panel holds anything you want to get to quickly. You can drag photos or folders into it so they're always at hand. Use this menu item to show or hide the panel.

Metadata Panel

This is where you can turn on (or off) the panel that shows your images' metadata (page 55).

Keywords Panel

Turn on this panel if you want to use Bridge to assign keywords to your photos (page 56).

Filter Panel

This panel lets you set parameters for what photos to view (see page 57). For instance, you can choose to see only photos with certain ratings or keywords, or only specific file types. It's automatically turned on in some workspaces, but you can turn it off and on.

Preview Panel

This panel shows a larger view of the selected image(s). It's on for all workspaces, but if you don't like it you can turn it off (or back on again) here.

Inspector Panel

For most people who use Elements, this is a totally useless panel and you'll want to leave it turned off. It would only show anything if you were in a Version Cue meeting with people using Adobe's Creative Suite.

Collections Panel

Bridge lets you organize your images into *collections*, groups of photos that you want to use for the same purpose, or otherwise keep together (page 58). You do that in this panel.

Path Bar

The Path bar is the strip just below the Shortcuts bar at the top of the main Bridge window. It lets you see the file path for the image you select, and has buttons for choosing how Bridge displays thumbnails, and for rating, sorting, and rotating your photos. You can also sort your photos and create new folders here. Finally, you can delete images by clicking the trashcan icon at the right side of this bar.

Minimize

To minimize the Bridge window to the Dock, choose this item or press **%**-M as you would with any program. Click the tiny Bridge window in the Dock to bring it back again.

Bring All to Front

This brings all your open Bridge windows to the front on your desktop.

Current Folder Location

The bottom of the Window menu shows the name of the current folder. If you have multiple views, it shows the location of all windows, so you'll see a folder name repeated if you have two windows open to the same folder.

Help Menu

This menu lets you search for info, open the Bridge Help files, and check for updates.

Search Box

You can use this box to search Bridge's menus, as explained on page 30.

Adobe Bridge Help

Choose this item or press F1 to go to the Bridge Online Help Center, a useful website where you'll find not only the Bridge Help Files, but many tutorials from some of the biggest names in digital imaging.

Manage Extensions

If you didn't turn off the Extensions Manager option when installing Elements, this menu item brings up the Adobe Extension Manager CS4. Several people have created add-ons for Bridge that give you extra functions, like enhanced navigation features or special batch conversion features. This is where you install and keep track of any Bridge extras that you download. Most of these extras are found in the Bridge section of Adobe Exchange (www.adobe.com/cfusion/exchange) and there's a button you can click right in the Manager to take you there so you can browse through what's available.

Updates

Select this option and Bridge searches for updates to all your Adobe programs, not just Bridge. If you want to disable auto-updating, choose this item, click Preferences in the dialog box that appears, and then turn off the "Automatically check for Adobe updates" checkbox.

Index

Numbers for special effects, 295 8-bit color files, 247-248 for spot color, 308-310 16-bit color files, 247-248 Adjustments filters, 387 90 degrees Left command, Rotate, 70 Adobe Bridge CS4 menu, 537-540 90 degrees Right command, Rotate, 70 Adobe Bridge. See Bridge 180 degrees command, Rotate, 70 Adobe Camera Raw Converter. See Raw Converter Adobe Exchange website, 493 A Adobe Photo Downloader. See Photo Action Player command, 399-400 Downloader actions Adobe Photoshop Elements. See Photoshop add-ons for, 498 Elements differences from full Photoshop, 400 Adobe Support forum website, 497 downloading and adding to Elements, Adobe website, 496 399-400 After views, Quick Fix window, 103 old versions of, compatibility of, 496 aging effect for images, 390-392 running, 398-399 airbrush, 348 writing, Photoshop required for, 495 albums. See photo books; scrapbook pages See also Effects aligning layers, 172-173 activating Photoshop Elements, 533-534 animated GIFs, 482-484 active lavers, 159 anti-aliasing (smoothing) Actual Pixels command, 86 images, 137 add-ons for Photoshop Elements, 493-495, text, 421, 427 496-497 ants, marching, indicating selection, 124 Adjust Color for Skin Tone command, Aperture, sending images to Elements 117-118, 214 from, 46 Adjust Sharpness tool, 225-227 Apple's Me.com, 64 Adjustment layers, 180-183 Apple's Time Machine, 64 for color changes, 290-291 Arrange command, 170 for gradient maps, 415

for Hue/Saturation changes, 288

arrows in this book, 10	bottom layer. See background (bottom) layer
Artistic filters, 387	bounding box (Print Well), 463
Auto Color Correction command, 213	Bridge , 39–44, 47, 52
Auto Smart Fix tool, 34	burning images to CDs or DVDs, 63-65
autogrid, 79	collections in, 58
See also grid, viewing	features of, in Elements vs. full
Average Blur filter, 214, 394–395	Photoshop, 41
	file associations for, setting, 43
В	labeling images, 54
1. 1	metadata in, moving to and from other
background (bottom) layer, 160	programs, 57
choosing for new images, 51–52	metadata, adding to images, 55, 56-57
color for, choosing, 216–222	opening images, 45
converting regular layer to, 160	organizing images, 18-19, 53-54
converting to regular layer, 160	panels in, 41
creating from flattening, 179	PDF projects in, 455-458, 471
limitations of, 160	photo gallery for web pages, 486-488
removing objects from, 141–145	rating images, 54
Background Eraser tool, 160, 367	searching and filtering images, 57–59
backups of images, 64	starting, 40
balance, adjusting, 34, 108	starting automatically, 40
barrel distortion, correcting, 335	starting from Welcome screen, 16
batch processing, 180, 258–264	using Raw Converter in, 235
Before views, Quick Fix window, 103	workspace for, 41-43
Bevels Layer styles, 401, 403	workspace for, customizing, 44
bit depth, 247–248	brightness, adjusting, 34, 108, 285, 295
bitmap color mode, 51	Brightness/Contrast command, 193
Black and White - High Contrast tool, 114 black and white images	Bring All to Front command, 85
colorizing, 310–318	Browse with Adobe Bridge, Welcome
colorizing skin in, 417	screen, 16
converting color images to, 114, 297,	browser, previewing images for, 481-482
299–303	See also websites
leaving spot color in, 304–310	Brush Strokes filters, 387
printing, 303	Brush tool , 347–356
blemishes, fixing, 265–278	airbrush, 348
Clone Stamp for, 267, 272–275	angle of brush edge, 352
Healing Brush for, 267, 269–272, 276	blending mode of, 348
patterns for, 276–278	custom brushes, creating from objects, 354
Spot Healing Brush for, 266, 267–269	custom brushes, provided with
blend modes, 168–169, 361–362	Elements, 353
blending exposures, 251–256	custom brushes, saving brush settings
blowouts, avoiding, 195	as, 352
blue bounding box (Print Well), 463	deleting brushes, 353
blue outline when dragging, 87	fading of, 350
blueness of sky, increasing, 113	graphics tablet used with, 348, 349
Blur filters, 387, 392–397	hardness of brush edge, 352
BMP files (.bmp), 61	hue jitter of, 351
books. See photo books; scrapbook pages	opacity of, 348
Border command, 151	painting objects with, 353–355
borders or outlines	roundness of brush tip, 352
	saving settings of, for all brushes, 352
for edges of selections, 151 for images, 377	scatter of, 351
	selections, saving as brushes, 353
for toxt 437, 438	size of, 348
for text, 437–438	spacing between strokes, 351

stroke length, recommendations for, 349	blueness of sky, increasing, 113
type of, 347	choosing for Background or Foreground
brushes	color, 216–222
Healing Brush, 267, 269–272, 276	color casts, correcting, 213-216
Impressionist brush, 355	correcting with Average Blur filter, 394–395
Selection Brush, 132–134	correcting with gradients, 417
Spot Healing Brush, 266, 267–269	for email and websites, 481
See also Brush tool; custom brushes; Smart	gradients of, 404–416
Brush tool	hue, adjusting, 111, 287–288, 290–295
Burn tool , 358–359, 363	red eye, removing, 101, 102, 104–105, 238
buttons for web pages, 485	saturation, adjusting, 111, 244–245,
buttons for web pages, 403	285–289
C	skin tones, adjusting, 117–118
	smudging, 362–365
calibrating monitor, 109, 202	specific regions of, adjusting, 282–285
camera distortion, correcting, 332-337	spot color, 304–310
camera profiles, editing, 249	temperature, adjusting, 111
Camera Raw Converter. See Raw Converter	tint, adjusting, 111, 313–318
camera, importing images from, 19-20,	whitening teeth, 113
37–39	color of text, 422
Canvas Size command, 97	Color panel, 110–112
canvas, adding, 97	Color Picker, 217, 221
captions for images	color profile, 59, 202, 206
creating, 262–264	Color Replacement tool, 294–295
printing, 465	color sampling, 219–220
Cascade command, 84	color scheme for Photoshop Elements, 23
CDs	color space, choosing, 204–206
burning images to, 63-65	Color Swatches panel, 220–222
jackets for, 454–455	Color Tint frames, 302
labels for, 455	Color Variations dialog, 214, 215-216
Chrome Layer styles, 403	colorimeter, 202
circle cursor, changing to crosshairs, 350	Colorize settings, 316–318
clarity, adjusting, 244	colorizing black and white images, 310-318,
clicking the mouse, 9	417
Clipboard, Export, 124	comments about this book, 11
clipping mask for layers, 175-177	Complex Layer styles, 402
Clone Stamp, 267, 272–275	composition of images, changing, 278-282
CMYK color mode, 495	CompuServe GIF files (.gif), 60
collages, photo. See photo collages	Consolidate All to Tabs command, 84
Collections panel, Bridge, 41, 58	contact sheets
color casts, correcting, 213–216	in PDF files, 455–458, 471
Color Curves tool , 211, 282–285	printing, 469-471
Color Halftone filter, 388	Content panel, Bridge, 41
color management, 109, 200	Content panel, Photoshop Elements
calibrating monitor for, 109, 202	Effects in, 397
color space for, 204-206	for projects, 450–452
for printing, 466–468	tinting entire images, 315
color mode, 51	contrast, adjusting, 108, 110, 285
color of images, 110-112, 282-285	Convert to Black and White command,
as displayed in Photoshop Elements,	299-302, 307-308
adjusting, 200-206	Cookie Cutter tool, 82, 376–379
balance, adjusting, 34, 108	Copy Merged command, 124
black and white, converting color to, 114,	copying images, 33
297, 299–303	Correct Camera Distortion command,
blend modes for, 168-169, 361-362	332–337, 387

Index 555

Crop tool, 77–79, 101 cropping images, 75–82, 238 crosshairs cursor, changing to circle, 350 cursor, changing display of, 350 Curves tool. See Color Curves tool custom brushes creating from objects, 354 provided with Elements, 353 saving brush settings as, 352 Custom command, Rotate, 70 Custom Shape tool, 375	panels in Bridge, 44 panels in Photoshop Elements, 23–24 windows, 26, 87 drawing shapes. See shapes Drop Shadows Layer styles, 402, 403 dust, fixing, 270 See also blemishes, fixing DVDs burning images to, 63–65 jackets for, 454–455 labels for, 455
D	E
damaged photos, restoring, 274 dark color scheme, 23 darkness, adjusting Brightness/Contrast command for, 193 Burn tool for, 358–359, 363 Color Curves tool for, 282–285 Levels for, 206–207 Screen layers for, 193–194 Shadow/Highlights command for, 109, 194–196 Smart Brush tool for, 196–200 See also exposure dates, printing, 465 deactivating Photoshop Elements, 535 deselecting all selections, 124 Detail panel, 112–113 Digimare filters, 388 Digital Negative files (.dng), 61 Digital Photography Review website, 497 Distort command, 337–342 Distort filters, 388 distorting images, 337–342, 388 distorting text. See warping text distortion, correcting, 332–337 distributing layers, 172–173 Dither gradients, 408	Eclectic Academy website, 497 edges of selections bordering, 151 refining, 131–132 smoothing, 151 Edit menu, Bridge, 542–544 Edit menu, Photoshop Elements, 505–508 EDIT Quick command. See Quick Fix window Editor, 20–34 Full Edit window, 20 Guided Edit window, 21, 30–31 hiding everything except images and menus, 22 light or dark color scheme for, 23 modes in, 20–21 Panel bin, 23–24 resizing, 22 tools in, 26–28 See also Quick Fix window Effects, 381, 397–400 Effects panel, 397 converting to black and white using, 302 filters in, 384–385 Layer styles in, 401 Elements. See Photoshop Elements Ellipse tool, 372
Divide Scanned Photos command, 68 dividing (splitting) images, 68–69 DNG (.dng) files, 19, 61, 237, 249–250 DNG Converter, 237, 249–250 DNG Profile Editor, 249 Dock icon for Photoshop Elements,	elliptical areas, selecting, 125–127 email image color for, 481 image file size for, 475, 476, 478, 479 image formats for, 475–476, 479–480 resizing images for, 90–93
creating, 15 Dodge tool, 358–359, 363 double-clicking the mouse, 9 Downloader. See Photo Downloader dragging and dropping blue outline when dragging, 87 images in Bridge, 53	saving images for, 476–480 sending images using, 484–485 Enhance menu, 510–512 EPS files (.eps), 61 Equalize command, 295 Eraser tool, 365–369 Background Eraser tool, 160, 367
images in Project bin, 25 importing images from camera, 38 objects between layers, 184	Magic Eraser tool, 160, 366 spot color, creating, 306–307

Export Clipboard, 124	Fit on Screen command, 86
	flattening layers, 179
	Flip Horizontal command, 70
portions too light or too dark. See Shadows/	Flip Vertical command, 70
Highlights command; Smart Brush	flipping images
tool	horizontally or vertically, 70
sublte changes to. See Brightness/Contrast	horizontally, for printing, 466
command	Float All in Windows command, 84
too dark overall (underexposed). See Levels;	Float in Window command, 84
Screen layers	floating panels, 23, 24
too light overall (overexposed). See Levels;	Folders panel, Bridge, 41
Multiply layers	fonts. See text
Eyedropper tool, 106, 219–220	Foreground color, choosing, 216–222
eyes, removing red from, 101, 102, 104–105,	format of image. See image formats
238	Free Rotate Layer command, 73-75
	Free Transform command, 341–342
F	Full Edit window, 20
	See also Editor
faces	
merging, 326–329	G
moving from one image to another, 329	C : Pl Clt 202
removing from an image, 329–332	Gaussian Blur filter, 392
fading layers, 170	GIF files (.gif), 60
fading of Brush tool, 350	animated GIFs, 482–484
faux styles for text, 422	for email and websites, 475, 479
Favorites panel, Bridge, 41	Glass Buttons Layer styles, 402
Favorites panel, Photoshop Elements, 452	Gradient Fill layer, 408–409
feathering, 137	Gradient Map command, 296
file formats. See image formats	Gradient tool, 405–408
File menu, Bridge, 540–542	gradients, 404–416
File menu, Photoshop Elements, 503–505	applying to images, 407
file size for images, 50, 475, 476, 478, 479	applying to text, 430–431
filenames, printing, 465	color correcting using, 417
fill layers, 180–181, 183	customizing, 407
Filter Gallery, 385–387	editing, 409–414
filter layers, 385, 386–387	Gradient Fill layer, 408–409
Filter menu, 383–384, 517–523	gradient maps, 415–416
Filter panel, Bridge, 41	grayscale, applying to color images, 296
filtering on metadata, 57–59	noise gradients, 413–414
filters, 381, 383–397	opacity of, 412
adding noise using, 390-392	saving, 414
applying, 383–387	transparency of, 412
applying repeatedly, 383, 387	types of, 407–408
blurring using, 387, 392-397	Grant's Tools website, 494
categories of, 387–388	Graphic Converter, 62
color correcting using, 394–395	Graphic Reporter website, 497
motion effect using, 394	Graphics Interchange Format. See GIF files
performance of, 389	graphics tablet, 348, 349, 491–493
Photo Filter command, 214, 256-258, 297	graphics. See images
plug-ins for, 388	grayscale color mode, 51
removing noise using, 389-390	Grayscale mode, 302
skin texture, improving, 395–397	greeting cards, 454
undoing effects of, 384	grid, viewing, 74
See also specific filters	See also autogrid
Finder, opening images in, 45	group shots, 329

grouping layers into a set 161	·
grouping layers into a set, 161	image windows, 26
grouping panels, 24	images
Guided Edit window, 21, 30–31	anti-aliasing (smoothing), 137
See also Editor	background of. See background (bottom)
guides, viewing, 74	layer
п	backups of, 64
H	bit depth for, 247–248
halftone screening, 388	blemishes, fixing, 265–278
Hand tool, 88–89, 101	borders for, 377, 466
HDR (high dynamic range), 251	brightness, adjusting, 34, 108, 285, 295
Healing Brush, 267, 269–272, 276	browsing and organizing. See Aperture;
help	Bridge; iPhoto; Lightroom
in dialog boxes, 29	burning, 358–359, 363
tooltips, 29	burning to CDs and DVDs, 63-64
Help files, 6	canvas for, adding, 97
Help menu, Bridge, 552	captions for, 262–264
Help menu, Photoshop Elements, 29,	clarity, adjusting, 244
528–529	color mode for, choosing, 51
Hidden Elements website, 494	color, adjusting. See color of images
	composition of, changing, 278-282
hiding everything except images and	contrast, adjusting, 108, 110, 285
menus, 22	copying, 33
high dynamic range (HDR), 251	copying and pasting to another
High Pass filter, 227–228	program, 124
highlights, adjusting, 110, 285	creating, 50-52
See also darkness, adjusting; lightness,	cropping, 75-82, 238
adjusting	damaged, restoring, 274
Histogram, 207–209	darkness of. See darkness, adjusting
Horizontal Type tool, 419–425	dodging, 358-359, 363
hue jitter of Brush tool, 351	editing. See Editor
hue, adjusting, 111, 287–288, 290–295	emailing. See email
See also color of images	exposure of. See exposure
Hue/Saturation dialog, 287–288, 291	file size for, 50, 475, 476, 478, 479
converting to black and white using, 303	flipping, 70, 466
spot color, creating, 308–310	format of. See image formats
tinting entire images, 316–318	highlights in. See highlights, adjusting
T .	imperfections, fixing. See blemishes, fixing
I	importing from camera, 19–20, 37–39
ICC profile 206	labeling in Bridge, 54
ICC profile, 206 Image Capture, importing images from	labels for, 262–264, 465
	layers of. See layers
camera, 38	lighting for, 107–110
Image Effects Layer styles, 402	lightness of. See lightness, adjusting
image formats, 60	metadata for. See metadata
changing when saving, 63	midtone contrast, adjusting, 110
converting between, 261–262	multiple, processing, 233, 258–264
converting from unsupported file	noise, reducing, 245–246
formats, 62	opening with Bridge, 39–44, 45
for email and websites, 475, 479–480	opening with Finder, 45
for multiple page projects, 449, 450	organizing in Bridge, 53–54
list of, 59–62	
lossless (non-lossy), 63	originals, not editing, 33
See also specific formats	perspective of, 326, 338–342
Image menu, 508–510	printing. See printing images
Image Size command, 93, 94–96	rating in Bridge, 54
	renaming multiple images, 260-261

resampling, 96	justification for text, 422
resolution for. <i>See</i> resolution rotating, 70–71, 238, 463	K
saturation, adjusting, 111, 244–245,	K
285–289	keyboard shortcuts, 10, 29
saving, 34, 59–63	keywords for images. See metadata
selecting part of. See selections	Kodak print service, 460
sending to Elements from other	
programs, 46	L
shadows in. See shadows, adjusting	7. 1. 1
sharpening, 112–113, 222–230, 245–246	Label menu, Bridge, 547
size of, 90–97, 261–262	labels for CDs or DVDs, 455
spacing between objects in, adjusting,	labels for images
172–173	creating, 262–264
splitting after scanning, 68–69	printing, 465
straightening, 67–69, 238	See also text
straightening contents of, 71–75	Lasso tool, 136–140
text in. See text	layer masks, 183 Layer menu, 512–515
tone, adjusting, 240–242	
touch ups for, 113–115	Layer styles , 382, 401–404 add-ons for, 498
uploading to online sites, 475, 488	applying to one object, 401
vibrance, adjusting, 244–245	applying to the object, 101
views of, 83–86	categories of, 401–403
watermarks for, 262	editing, 403
white balance, adjusting, 238-240	removing from an image, 404
zooming, 86, 86–88, 100	tinting entire images, 314–315
imperfections, fixing. See blemishes, fixing	viewing image without, 404
Import from Camera, Welcome screen, 16	layers, 155–158
Import from Scanner, Welcome screen, 16	active, 159
Impressionist brush, 355	adding, 161–162
Inner Glows Layer styles, 402, 403	Adjustment layers. See Adjustment layers
Inner Shadows Layer styles, 402	aligning, 172–173
installing Photoshop Elements, 531–533	automatically created, 156, 162
intensity, adjusting. See saturation,	background layer. See background (bottom)
adjusting	layer
Internet. See websites	blend mode of, 168
Inverse command, 147	combining into a new layer, 178
Invert command, 296	copying or cutting selections from,
iPhoto	164–165, 184–187
configuring to use Raw Converter with, 233	copying or moving to another image,
importing images from camera, 38	184–187
sending images to Elements from, 46	copying to a new document, 166
version sets in, 46	deleting, 162
irregular areas, selecting, 127–140	distributing, 172–173
Y	duplicating, 163-164, 166
J	fading, 170
jackets for CDs or DVDs, 454-455	file formats supporting, 161
Joint Photographic Experts' Group. See JPEG	fill layers, 180–181, 183
files	flattening, 179
JPEG 2000 files (.jpf, .jpx, .jp2), 61	grouping into a set, 161
JPEG files (.jpg, .jpeg, .jpe), 60, 62	grouping with clipping mask, 175–177
for email and websites, 475, 480	linking, 173
layers not saved in, 161	locking, 167
using Raw Converter with, 247	merging, 177-179

layers (continued) naming, 164 number of, limitations on, 162 opacity of, adjusting, 166 rearranging, 170–172 saving images with, 59 spacing between, adjusting, 172–173 straightening, 73 Touch Up tools creating, 115 visibility of, changing, 166 Layers panel, 158–159	merging exposures, 251–256 merging faces, 326–329 merging layers, 177–179 merging photos, 320–322, 329 metadata adding to images, 56–57 adding to images while importing, 19 moving to and from other programs, 57 searching and filtering on, 57–59 midtone contrast, adjusting, 110 Minimize command, 85
leading for text, 422, 426	mirror image of photos. See flipping image
learning Photoshop Elements, 6, 8	mistakes, undoing, 32-34
lens distortion, correcting, 332–337	Mode gradients, 407
Levels, 206–207 adjusting on Auto, 108	monitor, calibrating, 109, 202
adjusting on Auto, 108 adjusting with eyedropper, 210	motion effect for images, 394
adjusting with slider, 211–213	mouse, using, 9 Move tool, 150–152, 171–172
Color Curves as alternative to, 211	multiple files, processing
correcting color using, 213	in Process Multiple Files tool, 258–264
Histogram and, 207–209	in Raw Converter, 233
light color scheme for Elements, 23	Multiply layers, 193–194
Lighting panel, 107–110 lighting, adjusting, 107–110	multi-session discs, 65
lightness, adjusting	MyJanee website, 493
Brightness/Contrast command for, 193	N
Color Curves tool for, 282–285	
Dodge tool for, 358–359, 363	naming layers, 164
Levels for, 206–207	naming multiple images, 260–261 negative effect. See Invert command
Multiply layers for, 193–194 Shadow/Highlights command for, 109,	Neon Layer styles, 403
194–196	New Window command, 85
Smart Brush tool for, 196–200	New Window for command, 86
. See also exposure	Noise filters , 388, 389–392
Lightroom, sending images to Elements	noise gradients, 413-414
from, 46	noise, reducing, 245–246
Line tool, 374	non-lossy formats, 63
linking layers, 173 Liquify filter, 431–434	0
locking layers, 167	
lossless formats, 63	online communities for Photoshop
,	Elements, 497
M	online printing services, 460 onOne Essentials website, 494
Magic Eraser tool, 160, 366	Opacity gradients, 407
Magic Extractor tool, 141–145	opacity of layers, 166
Magic Wand tool, 135–136	orientation of image. See rotating images
Magnetic Lasso tool, 139–140	orientation of text, 422
Make Dull Skies Blue tool, 113	OS X, versions supported, 7
marching ants indicating selection, 124	Outer Glows Layer styles, 402, 403
Marquee tool, 80–82, 125–127	outlines or borders
Match Location command, 85	for edges of selections, 151 for images, 377
Match Zoom and Location command, 85 Match Zoom command, 85	for printed images, 466
Me.com (Apple), 64	for text, 437–438
(,

P	Photo Downloader, 19–20
nackages 471 473	importing images from camera, 38
packages, 471–473 Page Setup dialog, 465	metadata, adding to images, 19
Paint Bucket, 357	raw files, converting to DNG, 19
palettes. See Panel bin; panels	starting, 20
Panel bin, 23–24	starting from Welcome screen, 16 Photo Effects. See Effects
closing, 23	Photo Filter command , 214, 256–258, 297
default panels in, 24	photo gallery for web pages, 486–488
in Quick Fix window, 102-103	Photo Project files (.pse), 60, 449, 450
minimizing, 23, 24	Photographic Effects Layer styles, 403
panels	Photomerge Exposure command, 251–256
floating, 23, 24	Photomerge Faces command, 326-329
grouping, 24	Photomerge Group Shot command, 329
in Bridge, 41	Photomerge Panorama command, 320–322
minimizing, 23, 24	Photomerge Scene Cleaner command,
moving into Panel bin, 24	329–332
moving out of Panel bin, 23	photos. See images
separating from group, 24	Photoshop
See also specific panels	compared to Photoshop Elements, 5, 495
panoramas	version of, corresponding to Elements, 494
camera features for, 325	Photoshop Creative Elements website, 497
creating, 320–322	Photoshop Elements, 1
layers used in, 326	activating, 533-534
manual positioning of, 322–326	add-ons for, 493-495, 496-497
perspective of, changing, 326	compared to full version of Photoshop, 5,
preparing for, 320, 325	495
saving, memory errors during, 322	creating new images, 50–52
Panosfx website, 494	deactivating, 535
Paste command, 127	differences from Windows version, 5
Paste Into Selection command, 127	Dock icon for, creating, 15
Pattern Stamp, 278	features of, 2–5
Patterns Layer styles, 402	Help files for, 6
patterns, applying to images, 276–278	history of, 1
.pct (PICT) files, 61	installing, 531–533
PCX files, 62	learning, 6, 8
.pdd (Photoshop) files, 59	light or dark color scheme for, 23
PDF files (.pdf, .pdp), 60	multiple versions of, running, 4
contact sheets or slide shows in, 455–458	online communities for, 497
opening in Elements, 47	opening images in, 39–47
saving projects as, 449, 450 Pencil tool, 106, 356	quick reference guide for, 6
people, removing from an image, 329–332	release schedule of, 1
See also faces	resizing window, 22
perspective	saving images, 34, 59–63
for images, 338–342	scanning images into, 47–49
for panoramas, 326	scratch disks for, 534
Perspective command, 337–342	starting, 15
photo books, 452–453	tools in, 26–28
photo collages, 441–449	uninstalling, 534–535 version of Photoshop corresponding to, 494
creating, 441–446	version of Photosnop corresponding to, 494 version of, determining, 4, 16
editing, 446–447	video frames, capturing, 49
frames in, 443, 446	Photoshop Elements menu, 501–503
multiple pages in, 447–449	Photoshop Elements Techniques
resolution of, 442	website, 497
theme for, 443, 447	Photoshop EPS files (.eps), 61

Index

Photoshop Raw files, 62 Photoshop Support website, 496 Photoshop Support website, 497 PICT files (.pct), 61 picture packages, 471–473 pictures. See images PIXAR files, 62 Pixelate filters, 388 Plastic Layer styles, 403 Polygon tool, 372–374 Polygonal Lasso tool, 140 Portable Network Graphic. See PNG files postcards, 454 Posterize command, 296 precise cursor, 550 preferences, deleting, 535–536 presets, Quick Fix window, 102 Print Size command, 86 Print Well (bounding box), 463 printer profile, 467 printing images, 459–473 at print kiosk, 460 borders for, 466 captions included in, 465 color management settings for, 466–468 color options, 468 contact sheets, 469–471 dates included in, 465 horizontally reversing image, 466 in projects, 450 multiple images, 469–473 one photo per page, 461–462 online printing services, 460 paper options, 468 picture packages, 471–473 positioning photo on page, 463–465 rendering intent for, 467, 468 resizing for, 93–96, 464 resolution for, 459 rotating image for, 463 test prints, 466 Process Multiple Files tool, 180, 258–264 profiles Camera, 249 color, 59, 202, 206 ICC, 206 Project bin, 25 projects CD or DVD Jackets, 454–455 CD or DVD Jackets, 450–452 CD or DVD	Photoshop files (.psd, .pdd), 59	Favorites panel for, 452
Photoshop Support website, 497 PICT files (.pct), 61 picture packages, 471–473 pictures. See images PIXAR files, 62 Pixelate filters, 388 Plastic Layer styles, 403 PNG files, 61, 475, 480 Polygonal Lasso tool, 140 Portable Network Graphic. See PNG files postcards, 454 Posterize command, 296 precise cursor, 350 preferences, deleting, 535–536 presets, Quick Fix window, 102 Print Size command, 86 Print Well (bounding box), 463 printer profile, 467 printing images, 459–473 at print kiosk, 460 borders for, 466 captions included in, 465 color management settings for, 466-468 color options, 468 contact sheets, 469–471 dates included in, 465 filename included in, 465 filename included in, 465 filename included in, 465 multiple images, 469–473 one photo per page, 461–462 online printing services, 460 paper options, 468 resizing for, 93–96, 464 resolution for, 459 rotating image for, 463 test prints, 466 trim guidelines included in, 466 Process Multiple Files tool, 180, 258–264 profiles camera, 249 color, 59, 202, 206 ICC, 206 Project bin, 25 projects CD or DVD Jakets, 455	Photoshop Raw files, 62	formats for, 449, 450
PICT files (.pct), 61 pictures packages, 471–473 pictures. See images PIXAR files, 62 Pixelate filters, 388 Plastic Layer styles, 403 PNG files, 61, 475, 480 Polygon tool, 372–374 Polygonal Lasso tool, 140 Portable Network Graphic. See PNG files postcards, 454 Posterize command, 296 precise cursor, 350 preferences, deleting, 535–536 presets, Quick Fix window, 102 Print Size command, 86 Print Well (bounding box), 463 printerp profile, 467 printing images, 459–473 at print kiosk, 460 borders for, 466 captions included in, 465 filename included in, 466 paper options, 468 priotture packages, 471–473 positioning photo on page, 463 test prints, 466 trim guidelines included in, 466 Process Multiple Files tool, 180, 258–264 profiles camera, 249 color, 59, 202, 206 [CC, 206 Project bin, 25 projects CD or DVD jackets, 455 CD or DVD jackets, 455 CD or DVD jackets, 455 CD or DVD labels, 455	Photoshop Roadmap website, 496	greeting cards or postcards, 454
picture packages, 471-473 pictures. See images PIXAR files, 62 Pixelate filters, 388 Plastic Layer styles, 403 PNG files, 61, 475, 480 Polygon tool, 372-374 Polygonal Lasso tool, 140 Portable Network Graphic. See PNG files postcards, 454 Posterize command, 296 precise cursor, 350 preferences, deleting, 535-536 presets, Quick Fix window, 102 Print Size command, 86 Print Well (bounding box), 463 printer profile, 467 printing images, 459-473 at print kosk, 460 borders for, 466 captions included in, 465 color management settings for, 466-468 color options, 468 contact sheets, 469-471 dates included in, 465 filename included in, 465 filename included in, 465 filename included in, 465 multiple images, 469-473 positioning photo on page, 463-465 rendering intent for, 467, 468 resizing for, 93-96, 464 resolution for, 459 rotating image for, 463 test prints, 466 Process Multiple Files tool, 180, 258-264 profiles camera, 249 color, 59, 202, 206 ICC, 206 Project bin, 25 projects CD or DVD Jakets, 455	Photoshop Support website, 497	moving images into, 25
pictures. See images PIXAR files, 62 Pixelate filters, 388 Plastic Layer styles, 403 PNG files, 61, 475, 480 Polygon tool, 372–374 Polygonal Lasso tool, 140 Portable Network Graphic. See PNG files postcards, 454 Posterize command, 296 precise cursor, 350 preferences, deleting, 535–536 presets, Quick Fix window, 102 Print Size command, 86 Print Well (bounding box), 463 printer profile, 467 printing images, 459–473 at print kiosk, 460 borders for, 466 captions included in, 465 color orptions, 468 contact sheets, 469–471 dates included in, 465 filename included in, 465 filename included in, 465 filename included in, 465 filename included in, 465 nor photo per page, 461–462 online printing services, 460 paper options, 468 picture packages, 471–473 positioning photo on page, 463–465 rendering intent for, 467, 468 resizing for, 93–96, 464 resolution for, 459 rotating image for, 463 test printis, 466 trim guidelines included in, 466 Process Multiple Files tool, 180, 258–264 profiles camera, 249 color, 59, 202, 206 LCC, 206 Project bin, 25 projects CD or DVD Jackets, 454–455 CD or DVD Jackets, 454–55 CD or DVD labels, 455	PICT files (.pct), 61	PDF contact sheets or slide shows, 455–458
PixAR files, 62 Pixelate filters, 388 Plastic Layer styles, 403 PNG files, 61, 475, 480 Polygon tool, 372–374 Polygonal Lasso tool, 140 Portable Network Graphic. See PNG files postcards, 454 Posterize command, 296 preferences, deleting, 535–536 presets, Quick Fix window, 102 Print Size command, 86 Print Well (bounding box), 463 printer profile, 467 printing images, 459–473 at print kiosk, 460 borders for, 466 captions included in, 465 color management settings for, 466-468 color options, 468 contact sheets, 469–471 dates included in, 465 filename included in, 465 filename included in, 465 filename included in, 465 filename included in, 465 on multiple images, 469–473 one photo per page, 461–462 online printing services, 460 paper options, 468 picture packages, 471–473 positioning photo on page, 463–465 rendering intent for, 467, 468 resizing for, 93–96, 464 resolution for, 459 rotating image for, 463 test prints, 466 Process Multiple Files tool, 180, 258–264 profiles camera, 249 color, 59, 202, 206 ICC, 206 Project bin, 25 projects CD or DVD Jabels, 455	picture packages, 471–473	photo books, 452-453
PixAR files, 62 Pixelate filters, 388 Plastic Layer styles, 403 PNG files, 61, 475, 480 Polygon tool, 372–374 Polygonal Lasso tool, 140 Portable Network Graphic. See PNG files postcards, 454 Posterize command, 296 preferences, deleting, 535–536 presets, Quick Fix window, 102 Print Size command, 86 Print Well (bounding box), 463 printer profile, 467 printing images, 459–473 at print kiosk, 460 borders for, 466 captions included in, 465 color management settings for, 466-468 color options, 468 contact sheets, 469–471 dates included in, 465 filename included in, 465 filename included in, 465 filename included in, 465 filename included in, 465 on multiple images, 469–473 one photo per page, 461–462 online printing services, 460 paper options, 468 picture packages, 471–473 positioning photo on page, 463–465 rendering intent for, 467, 468 resizing for, 93–96, 464 resolution for, 459 rotating image for, 463 test prints, 466 Process Multiple Files tool, 180, 258–264 profiles camera, 249 color, 59, 202, 206 ICC, 206 Project bin, 25 projects CD or DVD Jabels, 455	pictures. See images	photo collages. See photo collages
Pixelate filters, 388 Plastic Layer styles, 403 PNG files, 61, 475, 480 Polygonal Lasso tool, 140 Portable Network Graphic. See PNG files postcards, 454 Posterize command, 296 precise cursor, 350 preferences, deleting, 535–536 presets, Quick Fix window, 102 Print Size command, 86 Print Well (bounding box), 463 printer profile, 467 printing images, 459–473 at print kiosk, 460 borders for, 466 captions included in, 465 color management settings for, 466–468 color options, 468 contact sheets, 469–471 dates included in, 465 horizontally reversing image, 466 in projects, 450 multiple images, 469–473 one photo per page, 461–462 online printing services, 460 paper options, 468 picture packages, 471–473 positioning photo on page, 463–465 rendering intent for, 467, 468 resizing for, 93–96, 464 resolution for, 459 rotating image for, 463 test prints, 466 trin guidelines included in, 466 Process Multiple Files tool, 180, 258–264 profiles camera, 249 color, 59, 202, 206 LCC, 206 Project bin, 25 projects CD or DVD Jakets, 454–455 CD or DVD Jakets, 455		photo gallery for web pages, 486–488
Plastic Layer styles, 403 PNG files, 61, 475, 480 Polygon tool, 372–374 Polygonal Lasso tool, 140 Portable Network Graphic. See PNG files postcards, 454 Posterize command, 296 precise cursor, 350 preserts, Quick Fix window, 102 Print Size command, 86 Print Well (bounding box), 463 printer profile, 467 printing images, 459–473 at print kiosk, 460 borders for, 466 captions included in, 465 color management settings for, 466–468 color options, 468 contact sheets, 469–471 dates included in, 465 filename included in, 465 filename included in, 465 filename included in, 465 one photo per page, 461–462 online printing services, 460 paper options, 468 resizing for, 93–96, 464 resolution for, 459 rotating image for, 463 test prints, 466 Process Multiple Files tool, 180, 258–264 profiles Camera, 249 color, 59, 202, 206 ICC, 206 Project bin, 25 projects CD or DVD Jakets, 454–455 CD or DVD Jakets, 455	Pixelate filters, 388	
PNG files, 61, 475, 480 Polygon tool, 372–374 Polygonal Lasso tool, 140 Portable Network Graphic. See PNG files postcards, 454 Posterize command, 296 precise cursor, 350 presets, Quick Fix window, 102 Print Size command, 86 Print Well (bounding box), 463 printer profile, 467 printing images, 459–473 at print kiosk, 460 borders for, 466 captions included in, 465 color management settings for, 466–468 color options, 468 contact sheets, 469–471 dates included in, 465 filename included in, 465 filename included in, 465 filename included in, 465 online printing services, 460 paper options, 468 picture packages, 471–473 positioning photo on page, 463–465 rendering intent for, 467, 468 resizing for, 93–96, 464 resolution for, 459 rotating image for, 463 test prints, 466 Process Multiple Files tool, 180, 258–264 profiles camera, 249 color, 59, 202, 206 LCC, 206 Project bin, 25 projects CD or DVD Jackets, 454–455 CD or DVD Jackets, 455 CD or DVD Jackets, 456 CD or DVD Jackets, 456 C	Plastic Layer styles, 403	
Polygon tool, 372–374 Polygonal Lasso tool, 140 Portable Network Graphic. See PNG files postcards, 454 Posterize command, 296 precise cursor, 350 preferences, deleting, 535–536 presets, Quick Fix window, 102 Print Size command, 86 Print Well (bounding box), 463 printer profile, 467 printing images, 459–473 at print kiosk, 460 borders for, 466 captions included in, 465 color management settings for, 466–468 color options, 468 contact sheets, 469–471 dates included in, 465 filename included in, 465 filename included in, 465 filename included in, 465 online printing services, 460 paper options, 468 picture packages, 471–473 positioning photo on page, 463–465 rendering intent for, 467, 468 resizing for, 93–96, 464 resolution for, 459 rotating image for, 463 test prints, 466 trim guidelines included in, 466 Process Multiple Files tool, 180, 258–264 profiles camera, 249 color, 59, 202, 206 ICC, 206 Project bin, 25 projects CD or DVD Jackets, 454–455 CD or DVD Jackets, 455	and the same of th	
Polygonal Lasso tool, 140 Portable Network Graphic. See PNG files postcards, 454 Posterize command, 296 precise cursor, 350 presets, Quick Fix window, 21, 99–103 Adjust Color for Skin Tone command, 117–118 Before and After views in, 103 Black and White - High Contrast tool, 114 Color panel, 110–112 Detail panel, 112–113 Lighting panel, 107–110 Make Dull Skies Blue tool, 113 Panel bin in, 102–103 presets in, 102 Red Eye tool, 101, 102, 104–105 Smart Fix command, 34, 106–107 suggested workflow using, 116 tools in, 100–102 Touch Up tools, 102, 113–115 using on multiple files, 262 Whiten Teeth tool, 113 quick reference guide, 6 Quick Fix window, 21, 99–103 Adjust Color for Skin Tone command, 117–118 Before and After views in, 103 Black and White - High Contrast tool, 114 Color panel, 110–112 Detail panel, 112–113 Lighting panel, 107–110 Make Dull Skies Blue tool, 113 Panel bin in, 102–103 presets in, 102 Red Eye tool, 101, 102, 104–105 Smart Fix command, 34, 106–107 suggested workflow using, 116 tools in, 100–102 Touch Up tools, 102, 113–115 using on multiple files, 262 Whiten Teeth tool, 113 quick reference guide, 6 Quick Fix window, 21, 99–103 Adjust Color for Skin Tone command, 117–118 Before and After views in, 103 Black and White - High Contrast tool, 114 Color panel, 110–112 Detail panel, 112–113 Lighting panel, 107–110 Make Dull Skies Blue tool, 113 Panel bin in, 102–103 presets in, 102 Red Eye tool, 101, 102, 104–105 Smart Fix command, 34, 106–107 suggested workflow using, 116 tools in, 100–102 Touch Up tools, 102, 113–115 using on multiple files, 262 Whiten Teeth tool, 113 quick reference guide, 6 Quick Fix window, 21, 99–103		· F · · · · · · · · · · · · · · · · · ·
Portable Network Graphic. See PNG files postcards, 454 Posterize command, 296 precise cursor, 350 preferences, deleting, 535–536 presets, Quick Fix window, 102 Print Size command, 86 Print Well (bounding box), 463 printer profile, 467 printing images, 459–473 at print kiosk, 460 borders for, 466 captions included in, 465 color options, 468 contact sheets, 469–471 dates included in, 465 filename included in, 465 filename included in, 465 horizontally reversing image, 466 in projects, 450 multiple images, 469–473 one photo per page, 461–462 online printing services, 460 paper options, 468 picture packages, 471–473 positioning photo on page, 463–465 rendering intent for, 467, 468 resizing for, 93–96, 464 resolution for, 459 rotating image for, 463 test prints, 466 Process Multiple Files tool, 180, 258–264 profiles camera, 249 color, 59, 202, 206 ICC, 206 Project bin, 25 projects CD or DVD Jackets, 454–455 CD or DVD Jackets, 454–455 CD or DVD Jackets, 455 Quick Fix window, 21, 99–103 Adjust Color for Skin Tone command, 117–118 Before and After views in, 103 Black and White - High Contrast tool, 114 Color panel, 110–112 Detail panel, 112–113 Lighting panel, 107–110 Make Dull Skies Blue tool, 113 Panel bin in, 102–103 presets in, 102 Red Eye tool, 101, 102, 104–105 Smart Fix command, 34, 106–107 suggested workflow using, 116 tools in, 100–102 Touch Up tools, 102, 113–115 using on multiple files, 262 Whiten Teeth tool, 113 quick reference guide, 6 Quick Fix window, 21, 99–103 Adjust Color for Skin Tone command, 117–118 Before and After views in, 103 Black and White - High Contrast tool, 114 Color panel, 107–110 Make Dull Skies Blue tool, 113 Panel bin in, 102–103 presets in, 102 Red Eye tool, 101, 102, 104–105 Smart Fix command, 34, 106–107 suggested workflow using, 116 tools in, 100–102 Touch Up tools, 102, 113–115 using on multiple files, 262 Whiten Teeth tool, 113 quick reference guide, 6 Quick Fix window in, 103 Back and White - High Contrast to	, c	0
postcards, 454 Posterize command, 296 precise cursor, 350 preferences, deleting, 535–536 presets, Quick Fix window, 102 Print Size command, 86 Print Well (bounding box), 463 printer profile, 467 printing images, 459–473 at print kiosk, 460 borders for, 466 captions included in, 465 color management settings for, 466–468 color options, 468 contact sheets, 469–471 dates included in, 465 filename included in, 465 filename included in, 465 multiple images, 469–473 one photo per page, 461–462 online printing services, 460 paper options, 468 picture packages, 471–473 positioning photo on page, 463–465 rendering intent for, 467, 468 resizing for, 93–96, 464 resolution for, 459 rotating image for, 463 test prints, 466 Process Multiple Files tool, 180, 258–264 profiles camera, 249 color, 59, 202, 206 ICC, 206 Project bin, 25 projects CD or DVD Jackets, 454–455 CD or DVD Jackets, 455		٧
Posterize command, 296 precise cursor, 350 preferences, deleting, 535–536 presets, Quick Fix window, 102 Print Size command, 86 Print Well (bounding box), 463 printer profile, 467 printing images, 459–473 at print kiosk, 460 borders for, 466 captions included in, 465 color management settings for, 466–468 color options, 468 contact sheets, 469–471 dates included in, 465 filename included in, 465 filename included in, 465 in projects, 450 multiple images, 469–473 one photo per page, 461–462 online printing services, 460 paper options, 468 picture packages, 471–473 positioning photo on page, 463–465 rendering intent for, 467, 468 resizing for, 93–96, 464 resolution for, 459 rotating image for, 463 test prints, 466 trim guidelines included in, 466 Process Multiple Files tool, 180, 258–264 profiles camera, 249 color, 59, 202, 206 ICC, 206 Project bin, 25 projects CD or DVD Jackets, 454–455 CD or DVD Jackets, 454–455 CD or DVD Jackets, 455		Quick Fix window, 21, 99-103
precise cursor, 350 preferences, deleting, 535–536 presets, Quick Fix window, 102 Print Size command, 86 Print Well (bounding box), 463 printer profile, 467 printing images, 459–473 at print kiosk, 460 borders for, 466 captions included in, 465 color management settings for, 466–468 color options, 468 contact sheets, 469–471 dates included in, 465 filename included in, 465 filename included in, 465 filename included in, 465 multiple images, 469–473 one photo per page, 461–462 online printing services, 460 paper options, 468 picture packages, 471–473 positioning photo on page, 463–465 rendering intent for, 467, 468 resizing for, 93–96, 464 resolution for, 459 rotating image for, 463 test prints, 466 trim guidelines included in, 466 Process Multiple Files tool, 180, 258–264 profiles camera, 249 color, 59, 202, 206 ICC, 206 Project bin, 25 projects CD or DVD Jackets, 454–455 CD or DVD Jackets, 454–455 CD or DVD Jackets, 455		Adjust Color for Skin Tone command,
preferences, deleting, 535–536 presets, Quick Fix window, 102 Print Size command, 86 Print Well (bounding box), 463 printer profile, 467 printing images, 459–473 at print kiosk, 460 borders for, 466 captions included in, 465 color management settings for, 466–468 color options, 468 contact sheets, 469–471 dates included in, 465 filename included in, 465 filename included in, 465 multiple images, 469–473 one photo per page, 461–462 online printing services, 460 paper options, 468 picture packages, 471–473 positioning photo on page, 463–465 rendering intent for, 467, 468 resizing for, 93–96, 464 resolution for, 459 rotating image for, 463 test prints, 466 Process Multiple Files tool, 180, 258–264 profiles camera, 249 color, 59, 202, 206 ICC, 206 Project bin, 25 projects CD or DVD Jackets, 454–455 CD or DVD Jakets, 455		·
presets, Quick Fix window, 102 Print Size command, 86 Print Well (bounding box), 463 printer profile, 467 printing images, 459–473 at print kiosk, 460 borders for, 466 captions included in, 465 color options, 468 contact sheets, 469–471 dates included in, 465 filename included in, 465 filename included in, 465 filename included in, 465 horizontally reversing image, 466 in projects, 450 multiple images, 469–473 one photo per page, 461–462 online printing services, 460 paper options, 468 picture packages, 471–473 positioning photo on page, 463–465 rendering intent for, 467, 468 resizing for, 93–96, 464 resolution for, 459 rotating image for, 463 test prints, 466 Process Multiple Files tool, 180, 258–264 profiles Camera, 249 color, 59, 202, 206 ICC, 206 Project bin, 25 projects CD or DVD Jackets, 454–455 CD or DVD labels, 455 Black and White - High Contrast tool, 114 Color panel, 110–112 Detail panel, 112–113 Lighting panel, 107–110 Make Dull Skies Blue tool, 113 Panel bin in, 102–103 presets in, 102 Red Eye tool, 101, 102, 104–105 Smart Fix command, 34, 106–107 suggested workflow using, 116 tools in, 100–102 Touch Up tools, 102, 113–115 using on multiple files, 262 Whiten Teeth tool, 113 quick reference guide, 6 Quick Selection tool, 101, 129–132 R Radial Blur filter, 394 radio buttons, 9 rasterizing vector images, 373 Raw Converter (Adobe), 231–234 bit depth, choosing, 247–248 camera profiles, editing, 249 clarity, adjusting, 244 correcting color using, 213 cropping images, 238 DNG converter in, 237, 249–250 files never overwritten by, 234 iPhoto not using, 233 noise, reducing, 245–246 opening files in, 233–234, 247 red eye, removing, 238 rotating images, 238 saturation, adjusting, 244–245, 286 saturation, adjusting, 244–245, 286		Before and After views in, 103
Print Size command, 86 Print Well (bounding box), 463 printer profile, 467 printing images, 459–473 at print kiosk, 460 borders for, 466 captions included in, 465 color management settings for, 466–468 color options, 468 contact sheets, 469–471 dates included in, 465 filename included in, 465 filename included in, 465 horizontally reversing image, 466 in projects, 450 multiple images, 469–473 one photo per page, 461–462 online printing services, 460 paper options, 468 picture packages, 471–473 positioning photo on page, 463–465 rendering intent for, 467, 468 resizing for, 93–96, 464 resolution for, 459 rotating image for, 463 test prints, 466 Process Multiple Files tool, 180, 258–264 profiles Camera, 249 color, 59, 202, 206 ICC, 206 Project bin, 25 projects CD or DVD Jackets, 454–455 CD or DVD labels, 455 COlor panel, 110–112 Detail panel, 172–113 Lighting panel, 107–110 Make Dull Skies Blue tool, 113 Panel bin in, 102–103 presets in, 102 Red Eye tool, 101, 102, 104–105 Smart Fix command, 34, 106–107 suggested workflow using, 116 tools in, 100–102 Touch Up tools, 102, 113–115 using on multiple files, 262 Whiten Teeth tool, 113 quick reference guide, 6 Quick Selection tool, 101, 129–132 R Radial Blur filter, 394 radio buttons, 9 rasterizing vector images, 373 Raw Converter (Adobe), 231–234 bit depth, choosing, 247–248 camera profiles, editing, 249 clarity, adjusting, 244 correcting color using, 213 cropping images, 238 DNG converter in, 237, 249–250 files never overwritten by, 234 iPhoto not using, 233 noise, reducing, 245–246 opening files in, 233–234, 247 red eye, removing, 238 rotating images, 238 saturation, adjusting, 244–245, 286		
Print Well (bounding box), 463 printer profile, 467 printing images, 459–473 at print kiosk, 460 borders for, 466 captions included in, 465 color management settings for, 466–468 color options, 468 contact sheets, 469–471 dates included in, 465 filename included in, 465 filename included in, 465 multiple images, 469–473 one photo per page, 461–462 online printing services, 460 paper options, 468 picture packages, 471–473 positioning photo on page, 463–465 rendering intent for, 467, 468 resizing for, 93–96, 464 resolution for, 459 rotating image for, 463 test prints, 466 Process Multiple Files tool, 180, 258–264 profiles camera, 249 color, 59, 202, 206 ICC, 206 Project bin, 25 projects CD or DVD Jackets, 454–455 CD or DVD Jabels, 455		
printer profile, 467 printing images, 459–473 at print kiosk, 460 borders for, 466 captions included in, 465 color options, 468 contact sheets, 469–471 dates included in, 465 filename included in, 465 filename included in, 465 multiple images, 469–473 one photo per page, 461–462 online printing services, 460 paper options, 468 picture packages, 471–473 positioning photo on page, 463 resizing for, 93–96, 464 resolution for, 459 rotating image for, 463 test prints, 466 trim guidelines included in, 466 Process Multiple Files tool, 180, 258–264 profiles camera, 249 color, 59, 202, 206 ICC, 206 Project bin, 25 projects CD or DVD Jakets, 454–455 CD or DVD Jabels, 455 Lighting panel, 107–110 Make Dull Skies Blue tool, 113 Panel bin in, 102–103 Presets in, 102 Red Eye tool, 101, 102, 104–105 Smart Fix command, 34, 106–107 suggested workflow using, 116 tools in, 100–102 Touch Up tools, 102, 113–115 using on multiple files, 262 Whiten Teeth tool, 113 quick reference guide, 6 Quick Selection tool, 101, 129–132 R Radial Blur filter, 394 radio buttons, 9 rasterizing vector images, 373 Raw Converter (Adobe), 231–234 bit depth, choosing, 247–248 camera profiles, editing, 249 clarity, adjusting, 244 correcting color using, 213 cropping images, 238 DNG converter in, 237, 249–250 files never overwritten by, 234 iPhoto not using, 233 noise, reducing, 245–246 opening files in, 233–234, 247 red eye, removing, 238 rotating images, 248		•
printing images, 459–473 at print kiosk, 460 borders for, 466 captions included in, 465 color options, 468 contact sheets, 469–471 dates included in, 465 filename included in, 465 horizontally reversing image, 466 in projects, 450 multiple images, 469–473 one photo per page, 461–462 online printing services, 460 paper options, 468 picture packages, 471–473 positioning photo on page, 463–465 rendering intent for, 467, 468 resizing for, 93–96, 464 resolution for, 459 rotating image for, 463 test prints, 466 trim guidelines included in, 466 Process Multiple Files tool, 180, 258–264 profiles camera, 249 color, 59, 202, 206 ICC, 206 Project bin, 25 projects CD or DVD Jackets, 454–455 CD or DVD Jabels, 455 Make Dull Skies Blue tool, 113 panel bin in, 102–103 presets in, 102 Red Eye tool, 101, 102, 104–105 Smart Fix command, 34, 106–107 suggested workflow using, 116 tools in, 100–102 Touch Up tools, 102, 113–115 using on multiple files, 262 Whiten Teeth tool, 113 quick reference guide, 6 Quick Selection tool, 101, 129–132 R Radial Blur filter, 394 radio buttons, 9 rasterizing vector images, 373 Raw Converter (Adobe), 231–234 bit depth, choosing, 247–248 camera profiles, editing, 249 clarity, adjusting, 244 correcting color using, 213 cropping images, 238 DNG converter in, 237, 249–250 files never overwritten by, 234 iPhoto not using, 233 noise, reducing, 245–246 opening files in, 233–234, 247 red eye, removing, 238 rotating images, 248		
at print kiosk, 460 borders for, 466 captions included in, 465 color management settings for, 466–468 color options, 468 contact sheets, 469–471 dates included in, 465 filename included in, 465 in projects, 450 multiple images, 469–473 one photo per page, 461–462 online printing services, 460 paper options, 468 resizing for, 93–96, 464 resolution for, 459 rotating image for, 463 test prints, 466 trim guidelines included in, 466 Process Multiple Files tool, 180, 258–264 profiles camera, 249 color, 59, 202, 206 ICC, 206 Project bin, 25 projects CD or DVD labels, 455 Panel bin in, 102–103 presets in, 102 Red Eye tool, 101, 102, 104–105 Smart Fix command, 34, 106–107 suggested workflow using, 116 tools in, 100–102 Touch Up tools, 102, 113–115 using on multiple files, 262 Whiten Teeth tool, 113 quick reference guide, 6 Quick Selection tool, 101, 129–132 R Radial Blur filter, 394 radio buttons, 9 rasterizing vector images, 373 Raw Converter (Adobe), 231–234 bit depth, choosing, 247–248 camera profiles, editing, 249 clarity, adjusting, 244 correcting color using, 213 cropping images, 238 DNG converter in, 237, 249–250 files never overwritten by, 234 iPhoto not using, 233 noise, reducing, 245–246 opening files in, 233–234, 247 red eye, removing, 238 rotating images, 238 saturation, adjusting, 244–245, 286		
borders for, 466 captions included in, 465 color management settings for, 466–468 color options, 468 contact sheets, 469–471 dates included in, 465 filename included in, 465 filename included in, 465 multiple images, 469–473 one photo per page, 461–462 online printing services, 460 paper options, 468 picture packages, 471–473 positioning photo on page, 463–465 rendering intent for, 467, 468 resizing for, 93–96, 464 resolution for, 459 rotating image for, 463 test prints, 466 trim guidelines included in, 466 Process Multiple Files tool, 180, 258–264 profiles camera, 249 color, 59, 202, 206 ICC, 206 Project bin, 25 projects CD or DVD labels, 455 method for the file of t		
captions included in, 465 color management settings for, 466–468 color options, 468 contact sheets, 469–471 dates included in, 465 filename included in, 465 horizontally reversing image, 466 in projects, 450 multiple images, 469–473 one photo per page, 461–462 online printing services, 460 paper options, 468 picture packages, 471–473 positioning photo on page, 463–465 rendering intent for, 467, 468 resizing for, 93–96, 464 resolution for, 459 rotating image for, 463 test prints, 466 trim guidelines included in, 466 Process Multiple Files tool, 180, 258–264 profiles camera, 249 color, 59, 202, 206 ICC, 206 Project bin, 25 projects CD or DVD Jackets, 454–455 CD or DVD labels, 455 Red Eye tool, 101, 102, 104–105 Smart Fix command, 34, 106–107 suggested workflow using, 116 tools in, 100–102 Touch Up tools, 102, 113–115 using on multiple files, 262 Whiten Teeth tool, 113 quick reference guide, 6 Quick Selection tool, 101, 129–132 R Radial Blur filter, 394 radio buttons, 9 rasterizing vector images, 373 Raw Converter (Adobe), 231–234 bit depth, choosing, 247–248 camera profiles, editing, 249 clarity, adjusting, 244 correcting color using, 213 cropping images, 238 DNG converter in, 237, 249–250 files never overwritten by, 234 iPhoto not using, 233 noise, reducing, 245–246 opening files in, 233–234, 247 red eye, removing, 238 rotating images, 238 rotating images, 238 saturation, adjusting, 244–245, 286	1	
color management settings for, 466–468 color options, 468 contact sheets, 469–471 dates included in, 465 filename included in, 465 in projects, 450 multiple images, 469–473 one photo per page, 461–462 online printing services, 460 paper options, 468 picture packages, 471–473 positioning photo on page, 463–465 rendering intent for, 467, 468 resizing for, 93–96, 464 resolution for, 459 rotating image for, 463 test prints, 466 Process Multiple Files tool, 180, 258–264 profiles camera, 249 color, 59, 202, 206 ICC, 206 Project bin, 25 projects CD or DVD Jackets, 454–455 CD or DVD labels, 455 Smart Fix command, 34, 106–107 suggested workflow using, 116 tools in, 100–102 Touch Up tools, 102, 113–115 using on multiple files, 262 Whiten Teeth tool, 113 quick reference guide, 6 Quick Selection tool, 101, 129–132 R Radial Blur filter, 394 radio buttons, 9 rasterizing vector images, 373 Raw Converter (Adobe), 231–234 bit depth, choosing, 247–248 camera profiles, editing, 249 clarity, adjusting, 244 correcting color using, 213 cropping images, 238 DNG converter in, 237, 249–250 files never overwritten by, 234 iPhoto not using, 233 noise, reducing, 245–246 opening files in, 233–234, 247 red eye, removing, 238 rotating images, 238 saturation, adjusting, 244–245, 286 serving fileshed files, 248		
suggested workflow using, 116 tools in, 100–102 Touch Up tools, 102, 113–115 using on multiple files, 262 Whiten Teeth tool, 113 quick reference guide, 6 Quick Selection tool, 101, 129–132 R Radial Blur filter, 394 radio buttons, 9 rasterizing vector images, 373 Raw Converter (Adobe), 231–234 bit depth, choosing, 247–248 camera, 249 color, 59, 202, 206 ICC, 206 Project bin, 25 projects CD or DVD Jackets, 454–455 CD or DVD Jackets, 455 Suggested workflow using, 116 tools in, 100–102 Touch Up tools, 102, 113–115 using on multiple files, 262 Whiten Teeth tool, 113 quick reference guide, 6 Quick Selection tool, 101, 129–132 R Radial Blur filter, 394 radio buttons, 9 rasterizing vector images, 373 Raw Converter (Adobe), 231–234 bit depth, choosing, 247–248 camera profiles, editing, 249 clarity, adjusting, 244 correcting color using, 213 cropping images, 238 DNG converter in, 237, 249–250 files never overwritten by, 234 iPhoto not using, 233 noise, reducing, 245–246 opening files in, 233–234, 247 red eye, removing, 238 rotating images, 238 saturation, adjusting, 244–245, 286 saturation, adjusting, 244–245, 286		
contact sheets, 469–471 dates included in, 465 filename included in, 465 horizontally reversing image, 466 in projects, 450 multiple images, 469–473 one photo per page, 461–462 online printing services, 460 paper options, 468 picture packages, 471–473 positioning photo on page, 463–465 rendering intent for, 467, 468 resizing for, 93–96, 464 resolution for, 459 rotating image for, 463 test prints, 466 trim guidelines included in, 466 Process Multiple Files tool, 180, 258–264 profiles	e e	
dates included in, 465 filename included in, 465 horizontally reversing image, 466 in projects, 450 multiple images, 469–473 one photo per page, 461–462 online printing services, 460 paper options, 468 picture packages, 471–473 positioning photo on page, 463–465 rendering intent for, 467, 468 resizing for, 93–96, 464 resolution for, 459 rotating image for, 463 test prints, 466 trim guidelines included in, 466 Process Multiple Files tool, 180, 258–264 profiles camera, 249 color, 59, 202, 206 ICC, 206 Project bin, 25 projects CD or DVD jackets, 454–455 CD or DVD labels, 455 Touch Up tools, 102, 113–115 using on multiple files, 262 Whiten Teeth tool, 113 quick reference guide, 6 Quick Selection tool, 101, 129–132 R Radial Blur filter, 394 radio buttons, 9 rasterizing vector images, 373 Raw Converter (Adobe), 231–234 bit depth, choosing, 247–248 camera profiles, editing, 249 clarity, adjusting, 244 correcting color using, 213 cropping images, 238 DNG converter in, 237, 249–250 files never overwritten by, 234 iPhoto not using, 233 noise, reducing, 245–246 opening files in, 233–234, 247 red eye, removing, 238 rotating images, 238 saturation, adjusting, 244–245, 286		
filename included in, 465 horizontally reversing image, 466 in projects, 450 multiple images, 469–473 one photo per page, 461–462 online printing services, 460 paper options, 468 picture packages, 471–473 positioning photo on page, 463–465 rendering intent for, 467, 468 resizing for, 93–96, 464 resolution for, 459 rotating image for, 463 test prints, 466 trim guidelines included in, 466 Process Multiple Files tool, 180, 258–264 profiles		
horizontally reversing image, 466 in projects, 450 multiple images, 469–473 one photo per page, 461–462 online printing services, 460 paper options, 468 picture packages, 471–473 positioning photo on page, 463–465 rendering intent for, 467, 468 resizing for, 93–96, 464 resolution for, 459 rotating image for, 463 test prints, 466 Process Multiple Files tool, 180, 258–264 profiles camera, 249 color, 59, 202, 206 ICC, 206 Project bin, 25 projects CD or DVD jackets, 454–455 CD or DVD labels, 455 Whiten Teeth tool, 113 quick reference guide, 6 Quick Selection tool, 101, 129–132 R Radial Blur filter, 394 radio buttons, 9 rasterizing vector images, 373 Raw Converter (Adobe), 231–234 bit depth, choosing, 247–248 camera profiles, editing, 249 clarity, adjusting, 244 correcting color using, 213 cropping images, 238 DNG converter in, 237, 249–250 files never overwritten by, 234 iPhoto not using, 233 noise, reducing, 245–246 opening files in, 233–234, 247 red eye, removing, 238 rotating images, 238 saturation, adjusting, 244–245, 286		
in projects, 450 multiple images, 469–473 one photo per page, 461–462 online printing services, 460 paper options, 468 picture packages, 471–473 positioning photo on page, 463–465 rendering intent for, 467, 468 resizing for, 93–96, 464 resolution for, 459 rotating image for, 463 test prints, 466 trim guidelines included in, 466 Process Multiple Files tool, 180, 258–264 profiles camera, 249 color, 59, 202, 206 ICC, 206 Project bin, 25 projects CD or DVD jackets, 454–455 CD or DVD labels, 455 quick reference guide, 6 Quick Selection tool, 101, 129–132 R Radial Blur filter, 394 radio buttons, 9 rasterizing vector images, 373 Raw Converter (Adobe), 231–234 bit depth, choosing, 247–248 camera profiles, editing, 249 clarity, adjusting, 244 correcting color using, 213 cropping images, 238 DNG converter in, 237, 249–250 files never overwritten by, 234 iPhoto not using, 233 noise, reducing, 245–246 opening files in, 233–234, 247 red eye, removing, 238 rotating images, 238 saturation, adjusting, 244–245, 286 saving fonished files, 249		
multiple images, 469–473 one photo per page, 461–462 online printing services, 460 paper options, 468 picture packages, 471–473 positioning photo on page, 463–465 rendering intent for, 467, 468 resizing for, 93–96, 464 resolution for, 459 rotating image for, 463 test prints, 466 trim guidelines included in, 466 Process Multiple Files tool, 180, 258–264 profiles camera, 249 color, 59, 202, 206 ICC, 206 Project bin, 25 projects CD or DVD jackets, 454–455 CD or DVD labels, 455 Quick Selection tool, 101, 129–132 R Radial Blur filter, 394 radio buttons, 9 rasterizing vector images, 373 Raw Converter (Adobe), 231–234 bit depth, choosing, 247–248 camera profiles, editing, 249 clarity, adjusting, 244 correcting color using, 213 cropping images, 238 DNG converter in, 237, 249–250 files never overwritten by, 234 iPhoto not using, 233 noise, reducing, 245–246 opening files in, 233–234, 247 red eye, removing, 238 rotating images, 238 saturation, adjusting, 244–245, 286 saving fonished files, 249		
one photo per page, 461–462 online printing services, 460 paper options, 468 picture packages, 471–473 positioning photo on page, 463–465 rendering intent for, 467, 468 resizing for, 93–96, 464 resolution for, 459 rotating image for, 463 test prints, 466 trim guidelines included in, 466 Process Multiple Files tool, 180, 258–264 profiles camera, 249 color, 59, 202, 206 ICC, 206 Project bin, 25 projects CD or DVD jackets, 454–455 CD or DVD labels, 455 Radial Blur filter, 394 radio buttons, 9 rasterizing vector images, 373 Raw Converter (Adobe), 231–234 bit depth, choosing, 247–248 camera profiles, editing, 249 clarity, adjusting, 244 correcting color using, 213 cropping images, 238 DNG converter in, 237, 249–250 files never overwritten by, 234 iPhoto not using, 233 noise, reducing, 245–246 opening files in, 233–234, 247 red eye, removing, 238 rotating images, 238 saturation, adjusting, 244–245, 286 saving finished files, 249		
online printing services, 460 paper options, 468 picture packages, 471–473 positioning photo on page, 463–465 rendering intent for, 467, 468 resizing for, 93–96, 464 resolution for, 459 rotating image for, 463 test prints, 466 trim guidelines included in, 466 Process Multiple Files tool, 180, 258–264 profiles camera, 249 color, 59, 202, 206 ICC, 206 Project bin, 25 projects CD or DVD jackets, 454–455 CD or DVD labels, 455 Radial Blur filter, 394 radio buttons, 9 rasterizing vector images, 373 Raw Converter (Adobe), 231–234 bit depth, choosing, 247–248 camera profiles, editing, 249 clarity, adjusting, 244 correcting color using, 213 cropping images, 238 DNG converter in, 237, 249–250 files never overwritten by, 234 iPhoto not using, 233 noise, reducing, 245–246 opening files in, 233–234, 247 red eye, removing, 238 rotating images, 238 saturation, adjusting, 244–245, 286 saving finished files, 249		Quick Selection (601, 101, 129–132
paper options, 468 picture packages, 471–473 positioning photo on page, 463–465 rendering intent for, 467, 468 resizing for, 93–96, 464 resolution for, 459 rotating image for, 463 test prints, 466 trim guidelines included in, 466 Process Multiple Files tool, 180, 258–264 profiles camera, 249 color, 59, 202, 206 ICC, 206 Project bin, 25 projects CD or DVD jackets, 454–455 CD or DVD labels, 455 Radial Blur filter, 394 radio buttons, 9 rasterizing vector images, 373 Raw Converter (Adobe), 231–234 bit depth, choosing, 247–248 camera profiles, editing, 249 clarity, adjusting, 244 correcting color using, 213 cropping images, 238 DNG converter in, 237, 249–250 files never overwritten by, 234 iPhoto not using, 233 noise, reducing, 245–246 opening files in, 233–234, 247 red eye, removing, 238 rotating images, 238 saturation, adjusting, 244–245, 286 saving finished files, 249		P
picture packages, 471–473 positioning photo on page, 463–465 rendering intent for, 467, 468 resizing for, 93–96, 464 resolution for, 459 rotating image for, 463 test prints, 466 trim guidelines included in, 466 Process Multiple Files tool, 180, 258–264 profiles camera, 249 color, 59, 202, 206 ICC, 206 Project bin, 25 projects CD or DVD jackets, 454–455 CD or DVD labels, 455 Radia But fine, 394 radio buttons, 9 rasterizing vector images, 373 Raw Converter (Adobe), 231–234 bit depth, choosing, 247–248 camera profiles, editing, 249 clarity, adjusting, 244 correcting color using, 213 cropping images, 238 DNG converter in, 237, 249–250 files never overwritten by, 234 iPhoto not using, 233 noise, reducing, 245–246 opening files in, 233–234, 247 red eye, removing, 238 rotating images, 238 saturation, adjusting, 244–245, 286 saving frequency		<u> </u>
positioning photo on page, 463–465 rendering intent for, 467, 468 resizing for, 93–96, 464 resolution for, 459 rotating image for, 463 test prints, 466 trim guidelines included in, 466 Process Multiple Files tool, 180, 258–264 profiles camera, 249 color, 59, 202, 206 ICC, 206 Project bin, 25 projects CD or DVD jackets, 454–455 CD or DVD labels, 455 radio buttons, 9 rasterizing vector images, 373 Raw Converter (Adobe), 231–234 bit depth, choosing, 247–248 camera profiles, editing, 249 clarity, adjusting, 244 correcting color using, 213 cropping images, 238 DNG converter in, 237, 249–250 files never overwritten by, 234 iPhoto not using, 233 noise, reducing, 245–246 opening files in, 233–234, 247 red eye, removing, 238 rotating images, 238 saturation, adjusting, 244–245, 286 saving finished files, 249		Radial Blur filter, 394
rendering intent for, 467, 468 resizing for, 93–96, 464 resolution for, 459 rotating image for, 463 test prints, 466 trim guidelines included in, 466 Process Multiple Files tool, 180, 258–264 profiles camera, 249 color, 59, 202, 206 ICC, 206 Project bin, 25 projects CD or DVD jackets, 454–455 CD or DVD labels, 455 rasterizing vector images, 373 Raw Converter (Adobe), 231–234 bit depth, choosing, 249 camera profiles, editing, 249 camera profiles, edi		
resizing for, 93–96, 464 resolution for, 459 rotating image for, 463 test prints, 466 trim guidelines included in, 466 Process Multiple Files tool, 180, 258–264 profiles camera, 249 color, 59, 202, 206 ICC, 206 Project bin, 25 projects CD or DVD jackets, 454–455 CD or DVD labels, 455 Raw Converter (Adobe), 231–234 bit depth, choosing, 247–248 camera profiles, editing, 249 clarity, adjusting, 244 correcting color using, 213 cropping images, 238 DNG converter in, 237, 249–250 files never overwritten by, 234 iPhoto not using, 233 noise, reducing, 245–246 opening files in, 233–234, 247 red eye, removing, 238 rotating images, 238 saturation, adjusting, 244–245, 286 saving finished files, 249		
restZing for, 95–96, 464 resolution for, 459 rotating image for, 463 test prints, 466 trim guidelines included in, 466 Process Multiple Files tool, 180, 258–264 profiles camera, 249 color, 59, 202, 206 ICC, 206 Project bin, 25 projects CD or DVD jackets, 454–455 CD or DVD labels, 455 bit depth, choosing, 247–248 camera profiles, editing, 249 colarity, adjusting, 244 correcting color using, 213 cropping images, 238 DNG converter in, 237, 249–250 files never overwritten by, 234 iPhoto not using, 233 noise, reducing, 245–246 opening files in, 233–234, 247 red eye, removing, 238 rotating images, 238 saturation, adjusting, 244–245, 286 saving finished files, 249		
resolution for, 439 rotating image for, 463 test prints, 466 trim guidelines included in, 466 Process Multiple Files tool, 180, 258–264 profiles camera, 249 color, 59, 202, 206 ICC, 206 Project bin, 25 projects CD or DVD jackets, 454–455 CD or DVD labels, 455 camera profiles, editing, 249 clarity, adjusting, 244 correcting color using, 213 cropping images, 238 DNG converter in, 237, 249–250 files never overwritten by, 234 iPhoto not using, 233 noise, reducing, 245–246 opening files in, 233–234, 247 red eye, removing, 238 rotating images, 238 saturation, adjusting, 244–245, 286 saving finished files, 249		
test prints, 466 trim guidelines included in, 466 Process Multiple Files tool, 180, 258–264 profiles camera, 249 color, 59, 202, 206 ICC, 206 Project bin, 25 projects CD or DVD jackets, 454–455 CD or DVD labels, 455 clarity, adjusting, 244 correcting color using, 213 cropping images, 238 DNG converter in, 237, 249–250 files never overwritten by, 234 iPhoto not using, 233 noise, reducing, 245–246 opening files in, 233–234, 247 red eye, removing, 238 rotating images, 238 saturation, adjusting, 244–245, 286 saving finished files, 249		
trim guidelines included in, 466 Process Multiple Files tool, 180, 258–264 profiles camera, 249 color, 59, 202, 206 ICC, 206 Project bin, 25 projects CD or DVD jackets, 454–455 CD or DVD labels, 455 Correcting color using, 213 cropping images, 238 DNG converter in, 237, 249–250 files never overwritten by, 234 iPhoto not using, 233 noise, reducing, 245–246 opening files in, 233–234, 247 red eye, removing, 238 rotating images, 238 saturation, adjusting, 244–245, 286 saving finished files, 249	6 6	
Process Multiple Files tool, 180, 258–264 profiles camera, 249 color, 59, 202, 206 ICC, 206 Project bin, 25 projects CD or DVD jackets, 454–455 CD or DVD labels, 455 Cropping images, 238 DNG converter in, 237, 249–250 files never overwritten by, 234 iPhoto not using, 233 noise, reducing, 245–246 opening files in, 233–234, 247 red eye, removing, 238 rotating images, 238 saturation, adjusting, 244–245, 286 saving finished files, 249		
profiles		
camera, 249 color, 59, 202, 206 ICC, 206 Project bin, 25 projects CD or DVD jackets, 454–455 CD or DVD labels, 455 files never overwritten by, 234 iPhoto not using, 233 noise, reducing, 245–246 opening files in, 233–234, 247 red eye, removing, 238 rotating images, 238 saturation, adjusting, 244–245, 286 saving finished files, 249		
color, 59, 202, 206 ICC, 206 Project bin, 25 projects CD or DVD jackets, 454–455 CD or DVD labels, 455 iPhoto not using, 233 noise, reducing, 245–246 opening files in, 233–234, 247 red eye, removing, 238 rotating images, 238 saturation, adjusting, 244–245, 286 saturation, adjusting, 244–245, 286		
rotor, 59, 202, 206 ICC, 206 Project bin, 25 Projects CD or DVD jackets, 454–455 CD or DVD labels, 455 noise, reducing, 245–246 opening files in, 233–234, 247 red eye, removing, 238 rotating images, 238 saturation, adjusting, 244–245, 286 saturation, adjusting, 244–245, 286		
Project bin, 25 projects CD or DVD jackets, 454–455 CD or DVD labels, 455 CD or DVD labels, 455 opening files in, 233–234, 247 red eye, removing, 238 rotating images, 238 saturation, adjusting, 244–245, 286 saving finished files, 248		
projects red eye, removing, 238 CD or DVD jackets, 454–455 CD or DVD labels, 455 red eye, removing, 238 rotating images, 238 saturation, adjusting, 244–245, 286 saving finished files, 248		
CD or DVD jackets, 454–455 CD or DVD labels, 455 CD or DVD labels, 455 con pvd labels, 455	Project bin, 25	
CD of DVD Jackets, 434–435 saturation, adjusting, 244–245, 286 cD or DVD labels, 455 saving finished files, 248		
coving finished files 249	CD or DVD jackets, 454–455	esturation adjusting 244 245 296
Content panel for, 450–452	CD or DVD labels, 455	
	Content panel for, 450-452	saving infisticu files, 248

saving settings in, 242–244	S
sending finished files to editor, 248	compling a color 210 220
sharpness, adjusting, 245–246	sampling a color, 219–220
straightening images, 238	saturation, adjusting, 111, 244–245, 285–289
tone, adjusting, 240–242	scanning images, 16, 47–49
updates for, 232	scatter of Brush tool, 351
using in Bridge, 235	Scene Cleaner command, 329–332
using with multiple files, 233	Scitex CT files, 62
using with non-Raw files, 247	Scott Deardorff's online smudging
vibrance, adjusting, 244–245	classes, 364
viewing images with, 235–236	scrapbook pages, 497 See also photo collages
white balance, adjusting, 238–240	Scrapper's Guide website, 497
Raw converter (built in to OS X), 234	scratch disks, 534
Raw files, 232	scratches, fixing, 270
advantages and disadvantages of, 237	See also blemishes, fixing
converting to DNG, 19, 237, 249–250	Screen layers, 193–194
Recompose tool, 278–282	searching on metadata, 57–59
Rectangle tool, 372	Select All command, 124
rectangular areas, selecting, 125–127	Select menu, 515–517
Red Eye tool, 101, 102, 104–105, 238	Selection Brush, 132–134
Redo command, 32 Reduce Noise filter, 389–390	selections
	adding to, 128
Refine Edge option, Quick Selection tool, 131–132	copying and pasting to another image, 150,
Remove Color Cast command, 214–215	152, 184–187
Remove Color command, 302, 307–308	copying and pasting to another
removing people or objects from an	program, 124
image, 141–145, 329–332	copying and pasting to another
renaming multiple images, 260-261	selection, 127
Render filters, 388	copying or cutting within layers, 164
rendering intent for printing, 467, 468	deselecting everything, 124
Replace Color command, 291-293	determining if there is a selection, 124
resampling images, 96	edges of, bordering, 151
reselecting previous selection, 124	edges of, refining, 131–132
Reset Tool command, 79	edges of, smoothing, 151
resizing images, 90-97, 464	elliptical areas, 125–127
resizing window, 22	entire image, 124
resolution, 50	hiding selection, 124
affecting text size, 421	intersections of, 128
for printing, 459	inverting, 146
of photo collages, 442	irregular areas, 127–140
resources. See website resources	marching ants indicating, 124
restoring damaged photos, 274	moving, 127, 150–152
Retouching forum, Digital Photography	rectangular areas, 125–127
Review, 364	reselecting previous selection, 124
RetouchPRO website, 497	saving, 152
Reverse gradients, 407	saving as brushes, 353
RGB color mode , 51, 310, 312	size of, changing, 147–149
right-clicking the mouse, 9	subtracting from, 128
rotating images, 70-71, 238, 463	set, of layers, 161
Rounded Rectangle tool, 372	Shadow/Highlights command, 109, 194–196
rulers, viewing, 74	shadows, adjusting, 110, 285 See also darkness, adjusting; lightness,
	adjusting
	Shape Selection tool, 376
	onape detection tool, 570

Shape tool, 370–376	Straighten tool, 71–73
shapes	straightening contents of images, 71–75
add-ons for, 498	straightening images, 67-69, 238
drawing with Cookie Cutter tool, 82,	straightening layers, 73
376-379	Strokes Layer styles, 403, 437-438
drawing with Line tool, 374	Stylize filters, 388
drawing with Shape tool, 370-376	subtools, selecting, 27
See also selections	Sue Chastain website, 493
Sharpen filters, 388	Surface Blur filter, 395–397
Sharpen tool, 229	
sharpening images, 112–113, 222–230, 245–246	T
Shutterfly print service, 460	tabs, viewing images in, 84, 87
ShutterFreaks website, 494	Targa files, 62
Simple Photoshop website, 494	Targa TGA files, 62
Simplify Layer command, 426	tears, fixing, 274
size of images, 90–97, 261–262	See also blemishes, fixing
See also file size for images	teeth, whitening, 113
Sketch filters, 388	temperature of color, adjusting, 111
Skew command, 337–342	text
skewing images, 337–342	adding to images, 419-425
skin texture, improving, 395–397	anti-aliasing (smoothing), 421, 427
skin tones, adjusting, 117–118	canceling before committing, 423
sky, making more blue, 113	color, 422
slide shows in PDF files, 455–458	commiting, 423, 425
See also photo gallery for web pages	editing, 425–427
	faux styles for, 422
Smart Brush tool, 196–200	font family, 420
colorizing black and white images, 312	font size, 421
spot color, creating, 305–306	font style, 420
smart collections, 59	gradients for, 430–431
Smart Fix command, 34, 106–107	justification, 422
Smart Objects, 448	Layer styles with, 423
Smart Paint settings, 201	leading, 422, 426
Smooth command, 151	Liquify filter for, 431–434
smoothing	moving, 425
edges of selections, 151	orientation, 422
repairs to images, 390–392	
See also anti-aliasing	outlining, 437–438
Smudge tool, 362–365	pasting from another program, 425
Snap to Grid command, 79	resolution affecting, 421
Snapfish print service, 460	setting an image in. See Type Mask tools
spacing between layers, 172–173	simplifying (converting to raster
spacing of Brush tool strokes, 351	graphics), 426
splitting images, 68-69	special effects for, 429–434
Sponge tool, 288–289	warping, 422, 427–429
spot color , 304–310	wrapping, 424
Eraser tool for, 306-307	See also labels for images
Smart Brush tool for, 305-306	text effects, 430
Spot Healing Brush, 266, 267-269	Texture filters, 388
Stacks menu, Bridge, 546–547	Threshold command, 297
stains, fixing, 274	TIFF files (.tif, .tiff), 60
See also blemishes, fixing	Tile command, 83
Stamp Visible command, 178	Time Machine (Apple), 64
Start from Scratch, Welcome screen, 16	tint, adjusting, 111, 313–318
Straighten and Crop Image command, 69	tone, adjusting, 240–242
ottaighten and crop image command, 09	, , ,

toning tools. See Burn tool; Dodge tool	selections restricting edits to image, 124
tools, 26–28	time required to start up, 16
keyboard shortcuts for, 29	uninstalling Photoshop Elements, 534–535
resetting, 535	Welcome screen, getting rid of, 17
selected, changing, 29	Type Mask tools, 434–438
subtools, selecting, 27	Type tools, 419–425
See also specific tools	1) pe tools, 115 125
	U
Tools menu, Bridge, 548–549	0
Tools panel, 27–28	Undo command, 32
tooltips, 29	Undo History panel, 32–33
Touch Up tools, 102, 113–115	
Transform Selection command, 147–149	uninstalling Photoshop Elements, 534–535
transforming images, 337–342	Unsharp Mask tool, 223–224
Transparency gradients, 408	uploading images to online sites, 475, 488
troubleshooting	
actions for previous versions not	V
working, 496	
Adobe RGB printer profile, color shifts	vector images, rasterizing, 373
using, 468	version sets, 46
	Vertical Type tool, 419–425, 426
anti-aliased text looking jagged, 427	vibrance, adjusting, 244-245
blowouts, avoiding, 195	Video filters, 388
centering photos on paper, problems	video frames, capturing into Elements, 49
with, 465	View menu, Bridge, 544–546
Clone Stamp, problems with, 275	View menu, Photoshop Elements, 524–525
color mode restricting features of	views of images, 83-86
Elements, 51	vignetting, correcting, 335
color of images looks bad in Elements, 109	
Crop tool, difficulty controlling, 79	Visibility Layer styles, 403
error "No pixels are more than 50%	visibility of layers, 166
selected", 137	***
error for out-of-memory for	W
	TV 11 + 11 + 402
panoramas, 322	Wacom graphics tablets, 493
error stating Adjustment layer created in	warping text, 422, 427–429
Photoshop, 306	See also Liquify filter
filters, performance problems with, 389	watermarks
flaky spots in photos, 112	for images, 262
font name box going blank on symbol	for PDF projects, 458
fonts, 425	web gallery. See photo gallery for web pages
group scans, unable to separate	web-safe colors, 481
images in, 69	website resources
halos around objects, 112	add-ons for Photoshop Elements, 493–494,
image turning red when using Type	496–497
tools, 420	Apple's Me.com, 64
layers restricting edits to image, 115	camera profiles, 249
Magic Extractor, problems with large	DNG Converter, 250
files, 142	filter plug-ins, 388
multiple layers selected, restricting	for this book, 7, 10
commands, 172	Graphic Converter, 62
panoramas causing out-of-memory	online communities for Photoshop
error, 322	Elements, 497
panoramas takino a jono titue to	online printing services 460
panoramas taking a long time to	online printing services, 460
process, 322	Raw Converter updates, 232
process, 322 pasting text from another program, 425	Raw Converter updates, 232 Retouching forum, Digital Photography
process, 322	Raw Converter updates, 232

Index 565

website resources (continued)

Scott Deardorff's online smudging classes, 364

Wacom graphics tablets, 493

websites

animated GIFs for, 482–484 buttons for, creating, 485 image color for, 481 image file size for, 90–93, 475, 476, 478, 479 image formats for, 475–476 photo gallery for, 486–488 previewing image in browser for, 481–482 saving images for, 476–480 uploading images to, 475, 488

Welcome screen, 16–17 white balance, adjusting, 238–240 Whiten Teeth tool, 113 whitening teeth, 113 Window menu, Bridge, 549–552

Window menu, Photoshop Elements,

526-528

windows

dragging and dropping, 26, 87 resizing, 22 viewing images in, 84, 87 See also specific windows

Windows version, differences from, 5 Wow Chrome Layer styles, 403 wrapping text, 424

Y

YouTube website, 497

Z

Zoom In/Out command, 86 Zoom tool, 86–88, 100

Colophon

Loranah Dimant and Sarah Schneider provided quality control for *Photoshop Elements 8 for Mac: The Missing Manual.*

The cover of this book is based on a series design originally created by David Freedman and modified by Mike Kohnke, Karen Montgomery, and Fitch (www.fitch.com). Back cover deisgn, dog illustration, and color selection by Fitch.

David Futato designed the interior layout, based on a series design by Phil Simpson. This book was converted by Abby Fox to FrameMaker 5.5.6. The text font is Adobe Minion; the heading font is Adobe Formata Condensed; and the code font is LucasFont's TheSansMonoCondensed. The illustrations that appear in the book were produced by Robert Romano using Adobe Illustrator CS4 and Adobe Photoshop CS4.

THE MISSING MANUALS

The books that should have been in the box

Answers found here!

Most how-to books bury the good stuff beneath bad writing, lame jokes, and fuzzy explanations. Not the Missing Manuals. Written in a unique, witty style that helps you learn quickly, our books help you get things done. Whether you're looking for guidance on software, gadgets, or how to live a healthy life, you'll find the answers in a Missing Manual.

Mac OS X Snow Leopard: The Missing Manual
By David Pogue, ISBN 9780596153281
\$34.99 US, 43.99 CAN

Your Body: The Missing Manual By Matthew MacDonald ISBN 9780596801748 \$24.99 US, 31.99 CAN

Living Green: The Missing Manual By Nancy Conner ISBN 9780596801724 \$19.99 US, 24.99 CAN

Netbooks: The Missing Manual By J. D. Biersdorfer ISBN 9780596802233 \$24.99 US, 31.99 CAN

iPod: The Missing Manual, Eighth Edition By J. D. Biersdorfer with David Pogue ISBN 9780596804312 \$19.99 US, 24.99 CAN

Look for these and other Missing Manuals at your favorite bookstore or online.

www.missingmanuals.com

POGUE PRESS"
O'REILLY"

Get even more for your money.

Join the O'Reilly Community, and register the O'Reilly books you own.It's free, and you'll get:

- 40% upgrade offer on O'Reilly books
- Membership discounts on books and events
- Free lifetime updates to electronic formats of books
- Multiple ebook formats, DRM FREE
- Participation in the O'Reilly community
- Newsletters
- Account management
- 100% Satisfaction Guarantee

Signing up is easy:

- 1. Go to: oreilly.com/go/register
- 2. Create an O'Reilly login.
- 3. Provide your address.
- 4. Register your books.

Note: English-language books only

To order books online:

oreilly.com/order_new

For questions about products or an order:

orders@oreilly.com

To sign up to get topic-specific email announcements and/or news about upcoming books, conferences, special offers, and new technologies:

elists@oreilly.com

For technical questions about book content:

booktech@oreilly.com

To submit new book proposals to our editors:

proposals@oreilly.com

Many O'Reilly books are available in PDF and several ebook formats. For more information:

oreilly.com/ebooks

Buy this book and get access to the online edition for 45 days—for free!

Photoshop Elements 8 for Mac: The Missing Manual

By Barbara Brundage October 2009, \$44.99 ISBN 9780596804961

With Safari Books Online, you can:

Access the contents of thousands of technology and business books

- Quickly search over 7000 books and certification guides
- Download whole books or chapters in PDF format, at no extra cost, to print or read on the go
- Copy and paste code
- Save up to 35% on O'Reilly print books
- New! Access mobile-friendly books directly from cell phones and mobile devices

Stay up-to-date on emerging topics before the books are published

- Get on-demand access to evolving manuscripts.
- Interact directly with authors of upcoming books

Explore thousands of hours of video on technology and design topics

- Learn from expert video tutorials
- Watch and replay recorded conference sessions

To try out Safari and the online edition of this book FREE for 45 days, go to www.oreilly.com/go/safarienabled and enter the coupon code VNXKYFA.

To see the complete Safari Library, visit safari.oreilly.com.